The Amateur Photographer's Handbook

Books by Aaron Sussman

The Amateur Photographer's Handbook
(8th revised edition) 1973

The Magic of Walking
(with Ruth Goode) 1967

The Art of Selfishness
(with Dr. David Seabury) 1964

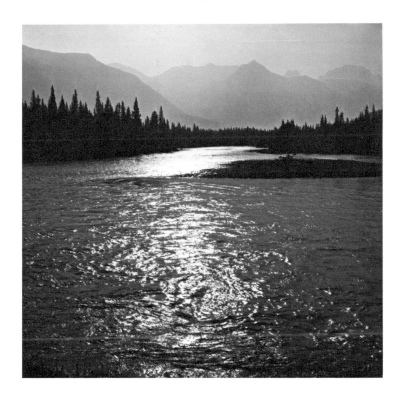

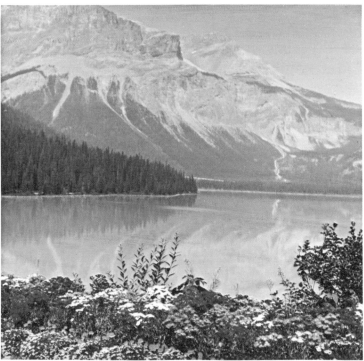

Must color be wild to be effective? Here are two Rolleiflex shots
on Ektachrome Professional film which suggest an answer:
Gold River and *Emerald Lake*. Both taken at Alberta, Canada.

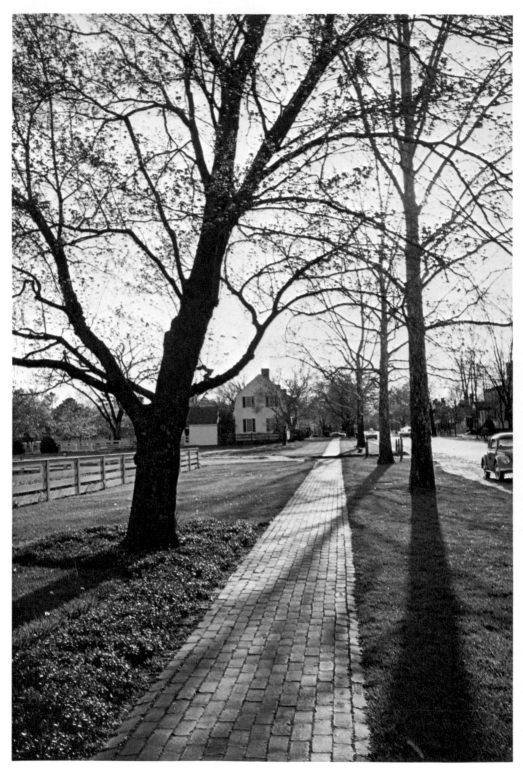

A wide-angle shot of a quiet street in Colonial Williamsburg, Virginia.
Leica M3, 35mm Summicron, Kodachrome II.

The Amateur

Photographer's

Handbook

Aaron Sussman

Eighth Revised Edition

THOMAS Y. CROWELL COMPANY

New York, Established 1834

Designed by ABIGAIL MOSELEY

Manufactured in the United States of America

ISBN 0–690–05782–2

5 6 7 8 9 10

Library of Congress Cataloging in Publication Data

 Sussman, Aaron.
 The amateur photographer's handbook.

 Previous editions are entered under title.
 1. Photography—Handbooks, manuals, etc.

 I. Title.
 TR146.S887 1973 770 72–8868
 ISBN 0–690–05782–2

Foreword

It has been a race.

The hare of photographic tools and techniques against the tortoise of revision.

Attempting to keep pace with the inevitable, *The Amateur Photographer's Handbook* has jogged through seven revisions since it first appeared in 1941. The previous versions were published in 1948, 1950, 1952, 1955, 1958, 1962, and 1965. There were ten printings of the seventh edition.

This is the *eighth* revision.

It has been substantially rewritten. Most of the illustrations are new. Besides the corrections and additions suggested by alert readers, there are the changes made necessary because photography, like time, marches on.

One of the sad things about this ineluctable process is what happens to old friends. They drop out, or they are pushed. Here, for instance, are some that have disappeared: the superb chlorobromide paper, *Illustrator's Special; Adox, Isopan F,* and Perutz *Pergrano* 35mm film; the *Flexichrome* process for coloring prints (since replaced by *Hibadye*); the Contax, Kalart, and Brownie box cameras; and many other devices and materials designed for the photographic good life.

To balance this, new friends have begun to arrive: rare-earth glass for sharper lenses; developers for higher acutance and for tones as velvety as old platinum prints; variable contrast and instant gloss papers to make the darkroom a happy place; new *color* chemistry and equipment for home processing of prints, negatives, and transparencies; flashbulbs that can be *focused;* cameras and slide projectors that are *self*-focusing; electronic flash units that set themselves automatically for the right exposure and can then be recharged in minutes; *rangefinder* enlargers to make sharper prints; an infallible method to tell whether old film is still good; *spray* developers for color and monochrome; a

simple way to time any film in any developer; and finally, new films and lenses to make it possible to *photograph anything your own eyes can see* (according to Dr. Wesley Hanson, director of research at Eastman Kodak).

But photography, as I have said before, can be perfectly described by that sage French proverb: *The more things change, the more they are the same.* True, techniques have been improved; materials and equipment are better, faster, or easier to use. But the eye and heart of the photographer are still the same, and the simplest camera with ordinary film can still make great pictures if the artist sees clearly and presses the button at the decisive moment.

Photography is more than a means of recording the obvious.

It is a way of feeling, of touching, of loving. What you have caught on film is captured forever, whether it be a face or a flower, a place or a thing, a day or a moment. The camera is a perfect companion. It makes no demands, imposes no obligations. It becomes your notebook and your reference library, your microscope and your telescope. It sees what you are too lazy or too careless to notice, and it remembers little things, long after you have forgotten everything.

I am indebted to many people: Leon Arden, Dennis Clifford, Jack Deschin, Norman R. Field, Dorothy Gelatt, Lloyd Godlin, Arthur Hickman, Ardleigh Hilton, Timothy B. Huber, Henry J. Kaska, Mike Kinzer, D. L. Knowles, Norman Lipton, Oscar Mestel, Hugh Rawson, Bernard Skydell, Fred Smith, Michael D. Sullivan, and Caryl Wallack, for help in various ways.

I am also grateful to the following (for charts, slides, color plates, tables, and photographs): Agfa-Gevaert, Berkey, Eastman Kodak, GAF-Ansco, Ilford Limited, Leitz of London, Morgan & Morgan, Sangamo Weston of England, Weston of New Jersey, and others mentioned in the text.

The use of TtL throughout this book, as an abbreviation for *through-the-lens,* is not intended as an infringing use of the TTL trademark owned and used on their products by Spiratone, Inc.

My special thanks to John Antonuk, who was never too busy to solve an art or production problem; and to Jacqueline Wein, for tireless and meticulous help in preparing the manuscript.

AARON SUSSMAN

Contents

Photographic Illustrations

Who would believe that so small a space could contain the image of all the universe? O mighty process! What talent can avail to penetrate a nature such as these? What tongue will it be that can unfold so great a wonder? Verily, none! This it is that guides the human discourse to the considering of divine things. Here the figures, here the colors, here all the images of every part of the universe are contracted to a point. O what a point is so marvelous! —LEONARDO DA VINCI

Once you really commence to see things, then you really commence to feel things. —EDWARD J. STEICHEN

Every photograph, no matter how painstaking the observation of the photographer or how long the actual exposure, is essentially a snapshot; it is an attempt to penetrate and capture the unique esthetic moment that singles itself out of the thousands of chance compositions, uncrystallized and insignificant, that occur in the course of a day. —LEWIS MUMFORD

There is no particular virtue, it seems to me, in wasting time to find out for yourself what already has been discovered. One should save one's skill in research for what has not yet been discovered. —MORTIMER J. ADLER

The possibilities of natural light are so infinitely great they can never be exhausted. In a lifetime you could hardly exhaust all of the light-possibilities for a single subject. . . . The important thing is that you stay with whatever equipment you choose until it becomes an automatic extension of your own vision, a third eye. Then, through this photographic eye you will be able to look out on a new light-world, a world for the most part uncharted and unexplored, a world that lies waiting to be discovered and revealed. —EDWARD WESTON

There should be a Society for the Perpetuation of Plain Simple Facts. —ANSEL ADAMS

Ideas won't keep. Something must be done about them. —ALFRED NORTH WHITEHEAD

It's about time we started to take photography seriously and treat it as a hobby. —ELLIOTT ERWITT

We have been cocksure of many things that were not so. —OLIVER WENDELL HOLMES

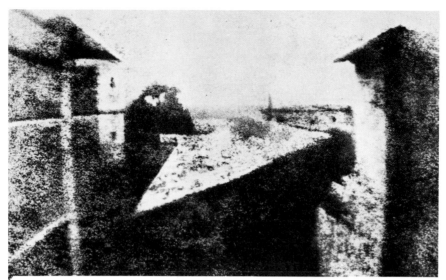

This is the first photograph ever made . . . an eight-hour exposure taken by Niépce, in 1826, of a view outside his window.

1 A Science Becomes an Art

Everybody likes to look at pictures. Even the ancients indulged. This led one among them, a kinsman of Confucius, to say that a thousand words could not tell as much or speak as eloquently as one picture. The advent of TV, and the arrival of the large circulation picture newspapers and magazines (like the New York *Daily News,* with a circulation of over three million, and *Life,* with a circulation of over eight-and-a-half million), all seem to bear this out.

We have been trained to think pictorially; there is no time to translate words into pictures. It's a desperate new world of instant comprehension. We're impatient of verbal explanations. We have to *see* to understand. And that's what TV and the picture media offer. Through them we can look, react, enjoy, even identify.

Mechanically, we have had some progress. But people haven't changed much. They're still intensely curious about others, which is no more than neighborly; they continue to gape at the never-ending miracles of science, which is properly respectful; and they are always itching to go to strange places and do new things, even if only by armchair, which is a lazy answer to the call of adventure.

This is the history of the science that became an art.

Until about a hundred and fifty years ago, and except for a few gifted men and women with artistic talent, there was no way for any of us to make a satisfactory permanent record of what we saw. Then, a young Frenchman by the name of Joseph Nicéphore Niépce discovered the secret of transferring and preserving the image seen with a mirror device used by artists. He died before his own picture could be taken, but not before giving *photography* a good name and a magnificent start. History honors him as *"the world's first photographer."* What he did was to open up a new and wonderful world of self-expression for millions of perceptive, though sometimes inarticulate, people. But his story comes later. We are only concerned now with what he gave us.

Photography is a means of recording forever the things one sees for a moment.

It is better than memory, because it not only recalls things to *our* mind, but it enables us to show others, with *absolute realism,* what we have done, where we have been, what we have seen, even what we have thought. *And it is more accurate than memory.* With one glance, our eye can only take in the *big* things, and sometimes it even misses those, or fails to understand them. The camera lens, however, with what is often a fortunate disregard for *our* opinion of what's important, captures everything simultaneously. Then, with the aid of a little simple chemistry, it preserves that everything for us, to inspect as searchingly as we choose, wherever, whenever, or as often as we like. Which is not to say that such a facsimile cannot be altered to suit our fancy; it can, and in many ways, as we shall see later. But if we *wish* to picture it exactly as it was, we can do so with a photograph—and the least part of the scene registers on the film at the same moment as all the others, without any change whatever except that which we ourselves deliberately impose.

A Snapshot History

The history of photography is the history of a toy that was taken seriously. The toy is the *camera obscura,* a gadget consisting of a light-tight box with a mirror, a ground-glass or parchment screen, and a pinhole or lens. It is used by artists to help them convert large, three-dimensional scenes into small two-dimensional ones. We don't know who first invented it.

The principle involved seems to have been casually noted as much as ten thousand years ago, when the first civilized human beings, who were careful observers of nature, moved from the great plateau that is now Iran to such lands as Chaldea and Egypt. There, the sun burned more fiercely and people hid from its rays in darkened tents and still darker huts. Whenever there was a hole in the tent or a chink in the

hut, and a sunlit camel or other object was in a line with it outside, the light was reflected back through the hole, making a colored, upside-down picture inside. Lying there, away from the hot sun, watching people and things move slowly by, must have been a pleasant relaxation for the tired Egyptian business man. Today, we have improved on this diversion somewhat. For one thing, the image is right-side-up, and brighter. For another, our scene is more varied, and we have added sound effects. But we have to sit up, instead of lying down; and, unless we are wealthy enough or important enough to demand privacy and get it, we have to watch these sights with thousands of others all crowded into one large room; and sometimes these others interfere with our pleasure in the sights and sounds. So, some ways considered, the Egyptians had the better of it at that.

Thousands of years after our Egyptian business man first noticed his inverted street show, Euclid, inventor of geometry, made use of the same principles to prove to his geometry pupils that light travels in straight lines. Later, about 350 B.C., Aristotle, dozing under a tree one afternoon, noticed the sun's round image on the ground. He looked around and saw that the image was coming through a small rectangular hole made by an accidental arrangement of the leaves on a branch above him. In effect, the rectangle formed by the leaves was like the pinhole lens in an old-fashioned camera. By interposing a sheet of papyrus between the rays of light and the ground and altering the distance between the papyrus and the hole in the leaves, Aristotle found he could change the size of the sun's image. But wise as Aristotle was in other ways, he failed to appreciate the significance of this discovery and he went no further with his experiments.

In the year 1267, the illustrious Roger Bacon described, in rather vague terms, an instrument that used a mirror for viewing pictures that *may* have been the first *precamera*. But it isn't until we come to that man of wonder, Leonardo da Vinci, in the early years of the sixteenth century, that we find an exact and full account of what we know today as the *camera obscura*. Leonardo, in his famous *Notebooks*,[1] showed a working diagram of the camera, explained how to operate it, but did not claim it as his own discovery.

For no other reason than that he was the first to popularize its use (he neither thought it up nor improved it), history seems to have thrust the honor of being the "inventor of the camera" on a precocious young Neapolitan, a writer of popular reference works, named John Baptista Porta. Porta was a sort of H. G. Wells of the sixteenth century. In 1553,

[1] A fine English translation by *Edward MacCurdy* was published by Reynal and Hitchcock in 1938. It is currently available from George Braziller, Publisher, 1 Park Avenue, New York, N.Y. 10016.

when he was only fifteen, he published a work called *Natural Magic,* in which he described the *camera obscura* and suggested its use for a peep show! Actually, he did nothing more for the camera than mention it.

The man who first used a *lens,* instead of a pinhole, in a camera box was Daniel Barbaro, a Venetian nobleman, in the year 1568. He explained, in his book, *Practice of Perspective,* the value of using a smaller diaphragm opening to make the picture sharper, described how to move the paper screen until it came within the focus of the lens, and discussed the application of a method for drawing in true perspective. Here is what he says about the camera he invented:

> 1. Seeing, therefore, on the paper the outline of things, you can draw with a pencil all the perspective and the shading and coloring, according to nature. . . .
>
> 2. You should choose the glass [lens] which does the best, and you should cover it so much that you leave a little in the middle clear and open and you will see a still brighter effect.

The lens he used was an old man's *convex* spectacle lens. He had tried a *concave* lens, but found that it wouldn't work. Barbaro's camera was nothing more than an artist's prop; he intended only to sketch the pictures projected on its screen.

Johann Kepler, the great astronomer, added much to the effectiveness of Barbaro's camera. In 1611, in a book called *Dioptrice,* he not only named Barbaro's instrument the *camera obscura,* but he also laid down certain laws by which both single and compound lenses projected images, explained why the image was reversed, and how one could go about projecting enlarged images on paper by the use of a concave lens set at the right distance behind the convex. From that time on better lenses, specifically designed for the purpose, began to be used in the camera.

Fixing the Image

While all this was going on, another group of men, artists mostly ("terrible painters," M. F. Agha called them), were hard at work trying to crack the seemingly insoluble problem of how to make the camera image *stay put.* Naturally, this would have been a great boon to all artists. Since their work was painstaking and slow, and since light conditions outdoors, and facial expressions indoors, changed rapidly and were hard to recapture, it would have been of tremendous help if someone could transfer the camera image permanently to another surface so that an artist might be able to study it later, at his leisure. I am

sure that it was some such tempting idea as this which drove Louis Jacques Mandé Daguerre, a mediocre French painter, famous in Paris for the success of his *Diorama* (a show with huge paintings and marvelous light and sound effects, housed in a special building) to continue his experiments on the camera image for five, fruitless years. Finally, through the good offices of the optician in whose shop he traded, Daguerre met another customer who had been working on the very same problem but with little more success. The other customer was Joseph Nicéphore Niépce, of *Chalon* on the Seine.

Now, Niépce was a chemist, not a painter, but he had a son who was a painter; so the problem was still in the family. Besides, he used to putter around making lithographs—and one of his dreams was the multiplication of designs by means of light. The pictures produced by Niépce required exposures of many hours, so only still-life subjects were attempted. The famous pewter-plate exposure, taken in 1826, of the courtyard outside of his workshop window is the *first* authentic photograph ever made. It took eight hours.

The two men began to work together on the problem in 1829, and they kept at it for many years. Niépce's method was to coat a copper plate with a thin layer of asphaltum, place a drawing made on transparent paper in contact with it and expose it to the light of the sun. The sun hardened the asphaltum. Where the lines of the drawing obscured the light of the sun, however, the asphaltum remained soft, and this was the secret of his process. He washed away the soft asphaltum with a special solvent, which exposed the metal surface of the plate. Next, he etched the plate with nitric acid, removed all of the asphaltum, inked the plate, and then printed with it. This was the *heliogravure* process which Niépce had been trying to apply to the image of the *camera obscura*. It didn't work, because the asphaltum plate was not sensitive enough.

In 1831, the two men began to experiment with *silver plates* coated with *silver salts,* but their luck was no better. Niépce died in 1833, and Daguerre had to continue the experiments alone. It was not easy for him to do so. His wife had begun to nag him to go on with his painting and leave the camera alone. His income from portrait commissions had ceased; and, most depressing, his savings began to run low. He seemed to be getting nowhere. Then, quite by accident, he stumbled upon it.

He had been experimenting with *iodized* silver plates. He discovered that picture contrast could be improved by blackening the bare parts of the silver plate with iodine vapor in an iodizing box. One sunny day he began to expose a plate as usual, but clouds blew up and obscured the sun. Discouraged, Daguerre packed up his equipment and went home. He started out the next morning to try again, but discovered to his con-

fusion and delight that yesterday's underexposed plate, which he was about to throw away, had somehow, in the meantime, acquired an entrancing likeness of yesterday's scene. What a moment for Daguerre! But he still had to discover what had happened. Further experiments revealed that it was the fumes of *mercury*, in an open container in his cupboard, which had so magically developed the invisible image, and that Herschel's *sodium thiosulphate* (*hypo*, to you) could *fix* it. And so the thing was done.

The Negative

But few great discoveries are ever left by nature to the efforts of just one man. Many people, working in different parts of the world, and independently of one another, suddenly attack a problem when the need for its solution arises. For example, when better and faster communication became necessary, the telephone appeared, invented in 1876 by Bell, but also in that same year by Elisha Grey, who worked it out quite independently of Bell. Again, we have the motorcar engine, invented in 1879 by Selden in America, but also in 1879 by Carl Benz of Germany; the electric lamp, invented in 1880 by Thomas A. Edison in America, and by J. W. Swan in England—both men having hit on the idea of using carbon filaments in a vacuum, though neither one was aware of what the other was doing.

And so it was with photography. While Daguerre was being honored in 1839, for his discovery, by the French Academy, an English scientist named William Henry Fox Talbot perfected, that same year, a way of printing pictures on white paper coated with silver chloride. Talbot was probably the first man to print through a paper *negative*. Daguerre's pictures, as you may recall, were *positives* and could not be duplicated. But Talbot's prints on silver paper were reversed, white to black, as our negatives are today, and could be used to make as many positives as he wanted to. He called his invention the *calotype process*, and his pictures *photogenic drawings*. We still nod to Talbot, you see, when we speak of a comely lady with shapely limbs as being *photogenic*.

Talbot was an ingenious experimenter. He was the first man to try *high-speed*, or *stroboscopic*, photography. In 1851 he attached a copy of the London *Times* to a whirring wheel upon which he had focused his camera. He loaded the camera, darkened the room, opened the shutter, and flashed a brilliant high-voltage electric spark. The photograph he got in this way stopped the motion of the wheel and made it possible to read, clearly, every word of the newspaper.

Talbot's discovery of the calotype process, like Daguerre's in this one respect, was an accident. His cat upset an extract of nutgalls (from

which we get *pyro*) on some half-exposed papers coated with *silver chloride*. The rest was easy. Have you noticed, by the way, how nature has a habit of jogging a man's elbow if he doesn't get on with his work fast enough, or if he gets lost in the woods of experimentation? It's a comforting thought.

A curious footnote to the history of photography is revealed in Henry H. Snelling's daguerreotype manual, *The History and Practice of the Art of Photography*, originally published in 1849 and republished in 1970 by Morgan & Morgan. There he reports that photography was invented not only in France and England, but also in *Indiana* (in 1828) by James M. Wattles, who withheld any announcement for "want of encouragement and fear of ridicule."

Other men, and one woman, who have contributed to the advance of the photographic process, are:

The Alchemists, who in the sixteenth century began a furtive search for ways of converting base metals to gold, and for an elixir of life to make men immortal. They found neither, but did discover *silver nitrate* (lunar caustic) which darkened in the sun (and gave us photographic film and paper), and they learned how to make clear glass for lenses (to sharpen the eyes of our cameras).

Johann Heinrich Schulze, an absent-minded German doctor, who forgot in 1727 to remove a flask filled with chalk, silver and nitric acid from his laboratory window; *the sun darkened it.* He tried this again in another way, by coating some paper with silver nitrate and exposing it to the sun; the same thing happened. By cutting out a stencil, he produced photographic lettering for the amusement of his friends. But the image disappeared after a time, and he never learned why it appeared or how it faded.

Carl William Scheele, a Swedish apothecary, who in 1777 was experimenting with the nitrate and chloride salts of silver and discovered that they turned brown under light because they had been converted to *metallic silver*. He also found, by throwing the rainbow of refracted light from a prism on these salts, that the violet end of the spectrum acted more quickly to darken them than the colors at the other end.

Thomas Wedgwood, a son of the famous potter of England, who experimented with silver nitrate, in 1802, and though he made pictures on paper with light, by using paintings on glass for negatives, he was unable to keep them from fading. His co-worker was *Humphry Davy*.

Sir John Herschel, the British astronomer, who discovered in 1819 that hypo was a solvent of silver salts. He also made the first silver chloride printing paper and introduced the words *photograph* and *photography*.

Christian Friedrich Schoenbein, a German chemist of the nine-

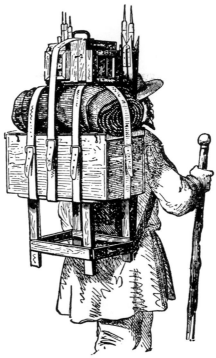

WHAT THE WELL-DRESSED PHOTOGRAPHER OF 1850 WORE

teenth century, who dissolved guncotton in alcohol and ether and produced *collodion*, the first base film for glass plates. It adhered well to glass, and could be sensitized.

Joseph Petzval, of Vienna, who designed the first, fast portrait lens in 1841. The lens covered a field of 25 degrees and had an aperture of $f/3.4$. The previous landscape lenses used in the daguerreotype cameras had had a maximum aperture of $f/11$. Petzval's lens was therefore ten times as fast!

Frederick Scott Archer, an Englishman, who made the first *collodion wet plate* in 1851 by adding potassium and iodine to the collodion and then dipping the coated plate in a solution of silver nitrate. The plates had to be exposed immediately after being coated, and developed within a few minutes after exposure. If you think the modern amateur carries a lot of equipment, look at what the well-dressed photographer wore, and carried, in those days.

Nadar, otherwise known as Gaspard Felix Tournachon, who started life as a newspaper man and caricaturist. When it occurred to him that his job as a caricaturist could be made a lot easier if he first took candid

and realistic photographs of his intended victims, he turned to photography and acquired a justified fame for his photographic albums of the celebrities of his time. As a result, he has become known as "the photographer of an epoch." Among the artists, writers, and musicians that he caught with his lens are: *Baudelaire, Berlioz, Cézanne, Daumier, Degas, Delacroix, Doré, Dumas, Millet, Renoir, Rossini, Wagner,* and many others. It was he who invented the photo-interview, and took the first aerial photograph (from a balloon).

C. Piazza Smyth, Astronomer Royal for Scotland, whose "little Egyptian camera," made in 1861 for a photographic trip to the Pyramids, was the first true *miniature camera.* The negative, a wet collodion plate, was one inch square; the lens, a perfectly corrected anastigmat of his own design, had a focal length of 1¾ inches and an aperture of f/4.5; focusing was precise; and the shutter, a clever focal-plane arrangement, was adjusted to give longer exposures to foreground than to sky.

Mathew B. Brady, whose documentary photographs of the American Civil War, among the first such ever recorded, proved that a photographer's courage and daring have to exceed even his technical skill.

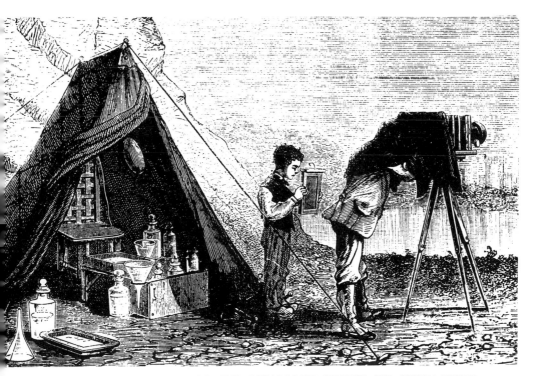

AND HOW THE LANDSCAPE CHANGED WHEN HE UNPACKED

ONE OF THE FIRST FOLDING CAMERAS. An ingenious bit of
equipment devised by Richard Willat of London in 1851. Portable and
surprisingly light in weight, it took pictures that were 10½ by 8½ inches
in size, yet it measured only 4 inches in depth when collapsed for travel.
The back of the camera was connected to a sliding plate, but could be
held rigid at any distance from the lens. This made it possible to use lenses
of various focal lengths. Courtesy of the Helmut and Alison Gernsheim
Collection.

Brady used the bulky, and therefore conspicuous, daguerreotype equip-
ment; so he was constantly under fire. Others who worked with him were
Alexander Gardner (who was responsible for one of the most famous of
all Civil War photographs, *The Dead Sharpshooter at Gettysburg*); and
Timothy O'Sullivan, a fighting Irishman, whose taste for danger and
excitement made him one of Brady's most intrepid combat camera men.

William Henry Jackson, whose affectionate photographic report on
Yellowstone persuaded the government to set it aside as a National Park.
I met Jackson in New York in 1941. His autobiography, *Time Exposure*,
had already been published. There was a parade; and he was using a
Kodak *Retina*. Bruce Downes and I were so fascinated by the unquench-
able vitality of the man that we waited until he was through taking
pictures, and then invited him for a beer. The idea appealed to him, so
we spent about an hour together. We were startled to discover who he
was, and that he was 98. He seemed so much younger than his years.
When I kiddingly asked him his secret, he grinned and said, "I never
resist a temptation." He died the next year, just short of a hundred.

Dr. R. L. Maddox, of London, who produced the first dry plate in
1871 by substituting gelatin for collodion.

H. W. Vogel, a German chemist, who found in 1873 that the addi-
tion of a dye to an emulsion made it sensitive to the light rays absorbed
by that dye. *Orthochromatic* film (sensitive to all colors except *spectral
red*) was the result of his discovery.

Charles Bennet, who further improved the dry plate by cooking the gelatin emulsion and thereby increasing its sensitivity. This ended the use of the wet plate, in 1878. By 1880, George Eastman was marketing dry plates in America.

Hannibal Goodwin, an American clergyman, who was the first to patent, in 1887, the invention of the modern transparent roll films. Eastman's roll film, marketed earlier, was really a paper film coated with a layer of soluble gelatin, which was in turn coated with the emulsion proper. The emulsion was later stripped from the paper base for use as a negative. It is interesting to reread what the *British Photographic Almanac* had to say about this in 1889:

> The American films have been brought to that stage of perfection that very little improvement can be desired. Of course, we all hope to see the time when a transparent flexible film is discovered that will do away with stripping altogether, but while many efforts and experiments have been made in this direction, we believe nothing practicable has yet been found; and while there may be room for improvement in this respect, it cannot be denied that the present mode of stripping is both reliable and satisfactory in results, and is withal a very interesting operation.

Hurter and *Driffield*, two British amateur photographers, whose efforts, in 1890, to find out why equal increases of exposure did not produce equal increases in the density of the silver deposit on an emulsion, led to the discovery of the *characteristic curve*, known to most of

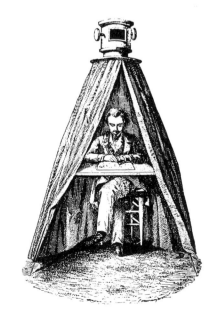

TENT TYPE CAMERA OBSCURA. The eye at the top could be rotated and worked like a periscope. This one appeared about 1850 and resembled the one used by Kepler in the 17th century. Courtesy Gernsheim Collection.

us as the *H. and D. curve.* What this means is that, no matter what the exposure, there is an optimum developing time for best results with each emulsion, depending on the temperature of the developer. This easy *time and temperature* method of developing is the one we all use today.

David Octavius Hill, a Scotch artist, who was the first to use calotypes for portraiture on an extensive scale. Having been commissioned, in 1843, to paint a gigantic group portrait of 500 heads on a canvas twelve feet long, he decided to simplify the job a bit by using calotypes of the sitters to sketch from. He got a young chemist, Robert Adamson, to help him. The photographs were all taken out of doors in brilliant sunlight, and a mirror reflector was used to soften the harsh shadows. Hill posed and lighted the models while Adamson developed and printed the negatives. No one today remembers Hill's painting; but his camera portraits are still treasured as among the finest ever made.

George Eastman, who is responsible for the fabulous spread of amateur photography. He manufactured the first compact roll-film camera, the *Kodak* (thus named because the word was odd, easy to remember, and sounded "like the click of a shutter"), as well as the first daylight-loading black-paper-backed roll film, and innumerable other devices and materials to make photography easy and pleasant.

Dr. Paul Rudolph, who in 1902 designed what has since become the most popular lens of all time, the Zeiss Tessar. According to some, however, the *finest* lens he ever produced is his Plasmat, offered by Meyer of Goerlitz in 1918.

E. König, a brilliant chemist in the dye works at Hoechst, Germany, who produced in 1904 the series of sensitizing cyanine-dyes that made *panchromatic* films (sensitive to *all* colors) possible.

Louis Philippe Clerc, whose touchstone work, *La Technique Photographique,* first appeared in 1926, was translated into English by George E. Brown, then the editor of the British Journal of Photography, and was subsequently published in New York and London under the awkward title, *Photography: theory and practice.* This extraordinary book, the result of one man's passion for photography over a full lifetime (he died in 1959 at the age of 84), has gone through many revisions since its republication in 1930. It became the world's first photographic textbook. No man did more than Clerc to keep abreast of the discoveries and changes in photographic technique, and few men have influenced so many so much. Clerc had an astonishing memory, which was backed up by a tremendous card index file which he painstakingly kept in order himself. He was charming, gifted, and witty. These traits shine through the pages of his book, even in translation. About *amateur darkrooms* he said: "There is no need of a specially equipped darkroom for the production of *good* photographs," and, "Do not let the darkroom be so

large as to lead to its subsequent conversion into a lumber-room." Such good advice, so well expressed, is rare in a cyclopedia, and rarer still in a work of instruction. The most recent edition of this work, now republished in seven volumes under the general title of L. P. CLERC'S PHOTOGRAPHY, was revised and updated by D. A. Spencer in 1970. Hastings House is the new publisher.

Alfred Stieglitz, the grand old man of photography, whose magazine *Camera Work* is one of the finest monuments ever erected to any art, as his own photographs are among the most perfect examples of that art. If Talbot is the father of photography, Stieglitz is spiritually its godfather. He did more to establish photography as an art than any other man living or dead. In 1924, the Royal Photographic Society of Great Britain conferred its highest honor, the Progress Medal, upon Mr. Stieglitz for "services rendered in founding and fostering Pictorial Photography in America, and particularly for the initiation and publication of *Camera Work,* the most artistic record of photography ever attempted."

Oscar Barnack, who wanted to become a landscape painter, but whose father persuaded him to start off as a mechanic's apprentice. The indirect result of this strange shift in careers was the invention of the Leica, which Barnack perfected in 1923, as an exposure pretester for movie film. It also replaced his bulky field camera on mountain hikes.

Max Berek, of Wetzlar, whose designs and calculations for sharp, fast lenses made *miniature camera* photography possible. He is responsible for the Elmar, the Summitar, and other superb lenses for small cameras.

Harold E. Edgerton, who perfected a high-powered stroboscope for ultra-high-speed photography, and made it possible for us to see what happens when a bullet passes through a light bulb, when a drop of milk hits a plate, and how a humming bird, with wings stilled by the camera, can rest on air. His usual *stroboscope* exposures, by the way, are *less* than 1/50,000 of a second . . . and recently, he made some at the incredible speed of a millionth of a second! When you consider that *quick as a wink* is no more than 1/40 of a second, you can see that the stroboscope exposures are really fast.

Leopold Godowsky, a violinist, and *Leopold Mannes,* a pianist, both enthusiastic camera amateurs, whose crude experiments in an improvised home laboratory, to find a film that could take pictures in color, attracted the attention of the Eastman Kodak Company in 1931 . . . and led finally to the discovery of *Kodachrome,* which was released to the public in 1935.

Dr. Katharine B. Blodgett, whose experiments on *glare* and reflected light, in the research laboratory of the General Electric Company in 1939, led to the remarkable conclusion that glass could be made *in-*

visible and glareproof if properly coated. By applying a thin film of soap (one-quarter of a lightwave in thickness) to the surface of glass, Dr. Blodgett was able to remove all reflections. Most lenses lose about 25 to 30 per cent of the light they collect, by reflection. With Dr. Blodgett's glass treatment, they transmit *all* of this light. According to *Geoffrey Crawley*, editor of *The British Journal of Photography*, the idea of thin-coating lens components to improve light transmission was first suggested by a British optician, *Harold Dennis Taylor*, in 1896. But nothing was done about it at that time.

Though Dr. Blodgett may not have been the original researcher in internal glare control, her work did offer the first practical and commercial use for it. Another who worked in this field was *Prof. Alexander Smakula* of Zeiss (Jena), a specialist in crystallography. He was awarded a German coating patent in 1935, but the outside world didn't learn of it until after the war. Prof. Smakula was later evacuated to the United States by the U.S. Army, for whom he worked as a research scientist until his retirement in 1966. A third pioneer was *J. Strong*, whose article on lens coating was published in the *Journal of the Optical Society of America* in 1936.

This work on antireflection glare control had an important effect on photography. It made possible the design and production of lenses of high speed and remarkable correction (coupled with the use of new rare-earth glass and electronic computer calculation techniques). Also, zoom lenses as we know them today would have been impractical without the prior discovery of lens coating to prevent glare.

Dr. C. Hawley Cartwright, a young physics professor at Massachusetts Institute of Technology, who perfected, in 1940, Dr. Blodgett's method for glare control. He coated the lens, not with a delicate film of soap, but with a hard, durable coating of evaporated calcium, magnesium or other metallic fluoride about four-one-millionths of an inch thick.

Douglas F. Winnek, of New York, who in 1940 made *three*-dimensional photography (without the use of a stereopticon) possible. By *lenticulating* ordinary film (impressing on its momentarily softened surface many minute convex lenses in the form of cylindrical ridges) he is able to make transparencies so astonishingly lifelike that the petals of a flower seem to be falling right out of the picture. Under the wing of the U.S. Navy, Winnek perfected (and in 1947 demonstrated) his process for making three-dimensional prints in black-and-white and color. In 1968, *Arthur Rothstein* of *Look* demonstrated, at *Photokina*, another process of monostereo photography which worked at all viewing distances and from all angles. This process, *Integram*, was based on a 1908 description presented by *Prof. Gabriel Lippman* to the French Academy

of Science. The image is produced by a sheet of transparent material embossed with a rash of small convex lenses, each of which forms a tiny picture on the rear surface of the photographic emulsion. The first demonstration of the Integram process was made in Moscow, 1948, by *S. P. Ivanov.* The most recent work in this field was done in New York by *Roger de Montebello,* a consultant for Cowles Communications.

Rowland S. Potter, of the Dupont Corporation, who in May, 1940, perfected a multilayer enlarging paper that is capable of yielding any grade of contrast from one negative, or prints of uniform quality from negatives of varying contrast or density. The gradations, between soft and hard, are produced by printing through blue, yellow, or other special filters. A high-speed *Varigam* appeared in 1951. Ilford introduced *Multigrade* in 1940; and Eastman, Ansco, and Haloid marketed their brands in 1957.

Edwin H. Land, of the Polaroid Corporation, who in 1947 announced what has become another milestone in the history of the photographic process . . . a revolutionary method by which a finished black-and-white print can be produced in a camera, *without the use of a negative,* in less than a minute after clicking the shutter. The trick is done by means of a sandwich consisting of a layer of light-sensitive material and a layer of positive paper between which is a pod of viscous chemical fluid. After exposure, this sandwich is drawn through a roller in the camera, the pressure of which breaks the pod, spreading the fluid evenly over the two surfaces. The result is that the chemicals, consisting of hydroquinone and sodium thiosulphate, first convert the light-exposed silver bromide in the emulsion of the negative material into metallic silver grains, in the usual way, but instead of being dissolved and removed by the hypo, the metallic silver—and this *is* revolutionary—is transferred to the positive paper, which is not light sensitive, thus creating the black-and-white positive print. The print emerges slightly damp but dries almost immediately.

First treated as a toy, then derided as a method of photography that couldn't possibly last, perhaps because the early cameras were not designed for professional use, the Polaroid system has proved more durable than its harsh-voiced critics. It has become a photographic way of life that has endeared itself to such photographic wizards as *Ansel Adams* (who has not only written and illustrated a magnificent manual on the subject, but has adapted his famous *Zone System* for Polaroid use), *Philippe Halsman* (who has already done more than a hundred covers for *Life*), *Edward Weston, Minor White, Bert Stern, Peter Gowland,* and others.

Subsequently, Edwin H. Land announced Type 55 P/N film (for 4″ x 5″ cameras) which gives you a permanent negative along with the

print in 15 seconds, and then in 1962 he released Polaroid color film (*Polacolor*). The giant armory of Polaroid films, accessories, and cameras now includes adapter backs for other cameras, strobe lights, films with speeds ranging from ASA 50 to ASA 10,000 (for special use), positive transparencies, closeup lenses, filters, copying outfits, and automatic exposure shutters. Not satisfied with all this, Dr. Land announced, September 1970, three more Polaroid products that should make photographers happy: 1. An instant color motion picture film, 2. A revolutionary new type of "thin camera" and print film, and 3. An entirely new kind of color negative. All in all, a formidable attack on the mainland of photography, with all beachheads secured.

The Western Union Telegraph Company, which in 1947 announced a new light source for enlargers: the *Zirconium* concentrated arc lamp, which produces more brilliance and more detail than is possible with conventional enlarger lamps. The advantages of this powerful point-source light are that it gives almost ten times as much illumination as a tungsten lamp, maintains its original brilliance (at a color temperature of 3400–3600° Kelvin, which is perfect for Ektachrome, Kodachrome or Ansco Color) during its full life (800 hours), and is rated at only 25 watts. Its one serious disadvantage is its extremely harsh contrast, which will require special compensating techniques for developing the negative as well as the print. Sylvania arranged to market the lamp in 1952.

Alfred and *Rudolph Simmon* (who prior to becoming two-thirds of the Simmon Brothers, manufacturers of precision photographic equipment, were respectively chief engineer at Westinghouse X-ray, and master technician supervising the design of the Rolleiflex at the Franke and Heidecke plant in Germany). They, with their dynamic brother Fred, are responsible for the distinguished series of *Omega* enlargers, and the original *Omega 120* camera (the ugly duckling of fine cameras), marketed in 1952, but later withdrawn. In 1963, in conjunction with *Konishiroku*, they brought out the *Koni-Omega*; in 1968 they followed this with the *Koni-Omega Rapid M*, and the *Koni-Omegaflex M*. This new system uses interchangeable lenses, and interchangeable backs (for both 120 and 220 film). The redesigned *Koni-Omega* is a handsome version of a sophisticated camera.

Andrew Azan, of the Aristo Corporation in Port Washington, N.Y., who pioneered in the development of cold-light grid lamps for enlargers and contact printers. In 1957 he perfected new light sources for both multi-contrast papers and type C color materials which eliminate all need for filters: the *Gradacon*, for monochrome photography, and the *Spectrocon* for color work.

Ansel Adams, superb photographer, master craftsman, and teacher-

extraordinary, who in 1930 turned from the piano to the camera with spectacular results for photography as well as the West Coast landscape. The keynote of his work has always been *The Eloquent Light*, which was not only the title of one of his recent shows but of his biography as well. We treasure his faultless and inspiring work in photography, the camera wisdom packed into his *Basic Photo* series, and the fail-safe design of his *Zone System* of exposure, which has transmuted a mob of sloppy button-pushers into a company of precision artisans.

Eliot Porter, whose luscious color books for the Sierra Club, starting with *In Wilderness is the Preservation of the World,* have set an Alpine standard for exquisite color photography and impeccable color reproduction in print. His work has not only improved the quality of color photography generally, but it has become a powerful weapon for conservationists in their fight to preserve the glens, the canyons, the trails, the woods, the swamps, and the waterways of America.

Edward Weston, who discovered photography when he was sixteen years old. The rest of his life was one long love affair with cameras, lenses, developers, darkroom work, and an unending series of experiments with light and what it did to things. He tried for the sharpest pictures and the widest range of tones, searching always for brightness and detail in every print. In 1934, with Ansel Adams and other friends, he organized the *F/64 Group.* He was the first photographer in the world to be awarded the Guggenheim Prize. Among his published books were an illustrated edition of Walt Whitman's *Leaves of Grass,* and *My Camera at Point Lobos.* He has left his guild mark on American photography.

Edward J. Steichen, who was the first man to crash the Paris Art Exhibition annual salon with a group of his *photographs,* in 1902. They were entered as *engravings.* He also hung his first oil paintings in that same exhibition, and was subsequently invited to present a one-man show of his paintings *and* photographs. (The photographs were listed as *Paintings with Light.*) Because of this slight to photography, Steichen joined Alfred Stieglitz in 1903 to form the *Photo Secession* in order to demand recognition for photography as an art. His portrait of *J. Pierpont Morgan* became famous when Morgan first rejected the picture and then, having changed his mind, tried to buy it. Though Steichen was far from being a rich young man at the time, he refused to sell the portrait to Morgan despite every offer Morgan ever made.

Marty Forscher, who started his career during the Second World War as a one-man camera clinic for Edward Steichen (then a Captain in the Navy, riding herd on a team of fifteen talented photographers). Marty had to be ingenious, since most of the "sick" cameras were German and you couldn't write away for parts. His reputation for making

"impossible" repairs spread so far and fast that when the war was over, he opened up a Professional Camera Repair Service in midtown Manhattan and drew as clients the photographers from *Life*, *Look*, and most of the picture magazines and newspapers in and out of the city. His talent at modifying and improving equipment warrants a place in this history of photography. Many of his "improvements" have ultimately become standard in the fine cameras of today.

We have traveled far. We have made many wonderful advances. But sometimes, it seems, we go in circles. In 1838, Daguerre discovers that the fumes of mercury bring out the image on his iodized-silver plates; in 1938, two chemists in the Ansco Research Laboratories announce the discovery of a new method for the hypersensitizing of photographic emulsions, *by subjecting them to the fumes of mercury!* In 1851 Talbot succeeds in stopping ultrarapid motion with an electric flash; in 1940 Edgerton does the same with the flash of his stroboscope. In 1831 Niépce coats a metal plate and takes a picture for viewing by reflection; in 1940 another inventor announces the discovery of a way to coat *aluminum* film, for projection by *reflection.* So we're back where we started, having completed a circle.

But perhaps this isn't really a circle. Maybe, like one of the characters in Edwin Abbott's delightful little book, *Flatland*, we are trying to see it as a circle with our eyes closed. Perhaps it's that wonderful freak of nature, the *vortex*. Lord Kelvin said that atoms move in a vortex. Since life itself does, why shouldn't photography?

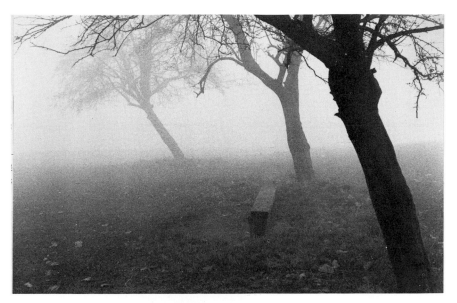

EARLY MORNING ON PRIMROSE HILL.
Photographed by *Norman Hood* (Courtesy Sangamo Weston).

*"Light glorifies everything. It transforms and ennobles
the most commonplace and ordinary subjects. The object
is nothing; light is everything."* —LEONARD MISONNE

2 The Magic of Light

Of all the wonders of the world, and there are many more than
seven, none is more wonderful than the phenomenon of light. It not
only creates life . . . the blade of grass, even man himself . . . but
it puts on, daily, a magnificent show which shames the grandest designs
of unfettered Hollywood imaginations . . . that colossal spectacle of
forms and colors known as *the changing universe.*

Whether you are eager to discover what goes on in the vast spaces
outside our world, or just curious about what goes on inside the atom,
light says, "Here's the way it is. *Look!*" With the beams of an X-ray tube,
you can see through impenetrable objects; with *infrared* light, you can
cut through the haze of distance, take pictures in the dark, recover what
has been blotted out or destroyed, penetrate camouflage from the air,
distinguish living matter (by leaf and bush chlorophyl reflection) from
inorganic. Light can open doors, and close them; it can point things out,
or hide them. And *this* is the amazing stuff which photographers use
when they carelessly take a snapshot of a Sunday.

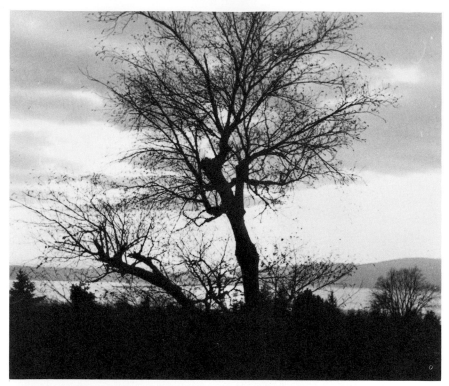

LIGHT AND SHADOW MAKE A PICTURE. A silhouette taken somewhere along the Hudson River. Leica M4, Panatomic X, developed in Neofin Blue.

Since the function of photography is to reproduce the shape, tones, texture, and color of things, and since light is the substance which makes this miracle possible, it is important, right at the start, that we learn about light—what it is, how it acts, what it does, and how to control it.

A working knowledge of light and shade will clear up most of the troubles photographers have. It cannot be said too often that light is the most important element in photography. Use it badly and all your technical skill is a waste of time; use it well and many of your technical shortcomings will never be noticed. And now for some interesting facts about light.

What It Is

Scientists have concocted many odd and ingenious theories to explain the mystery of light, but the three generally accepted today, and

the only ones about which we need concern ourselves, are the *corpuscular* theory suggested by an Englishman, *Sir Isaac Newton;* the *wave* theory proposed by a Dutchman, *Christian Huygens;* and the *quantum* theory worked out by German physicist *Max Planck*, and later confirmed by *Albert Einstein*.

According to the *corpuscular* theory, luminous bodies throw off discrete particles of matter which set up an electromagnetic disturbance, just as a stone dropped in still water will start a series of concentric waves moving outward.

According to the *wave* theory, light is just another form of electrical energy. Other electromagnetic impulses are *cosmic rays, gamma rays, X-rays, ultra-violet rays, infrared rays, radio waves* and *television waves.* Light waves differ from these others only in size; gamma rays and television waves being among the shortest; radio frequencies being among the longest; and light rays, the ones visible to the eye, being a little less than halfway between.

According to the *quantum* theory, tiny bursts of energy (*photons*) are released at such speed, and travel so close to one another, that there is practically no gap between them. These units of radiation are so small, they look continuous to us; just as ordinary matter seems continuous. All radiant energy is, by its very nature, *atomic*. This applies as well to such other forms of energy as *heat, light, electricity, X-rays,* and *audio frequencies*. But as Eddington pointed out, the atom is as porous as the solar system. If we compressed all the *protons* and *electrons* in a man's body into one solid mass, he could easily be reduced to a speck no larger than the period at the end of this sentence.

To this day there is no agreement among scientists about which theory best explains the various phenomena of light (reflection, refraction, polarization, the spectrum, its ability to go through a vacuum, etc.). But as photographers, all we need to know about light is how it *acts*. Let the scientists simmer in the arguments about *what it is.*

Though light tears through space at the incredible speed of 186,270 miles a second, it takes time to travel. The light distance between the sun and the earth, to give you an illustration, is *480 seconds*—but then the geographical distance, according to the astronomers, is 93,000,000 miles! Even so, light moves fast. Just imagine a train going around the earth at the equator at a speed of 60 miles an hour; if you were riding on that train it would take you 17¼ days to get back where you started. Riding a light wave, you could travel the same distance in just one-seventh of a second! The *speed* of light is at least one factor you will not have to worry about in photography.

Where It Comes From

NATURAL LIGHT

Practically all of the light that shines on the earth comes from the sun. The stars provide a little, and the moon reflects a bit of the light she herself gets from the sun; [1] but most of what we call natural light is direct or reflected sunlight; in other words, *daylight*.

We think of daylight as white light, but it's nothing of the sort. It's light composed of every color of the rainbow. When we see a rainbow, as a matter of fact, we are seeing the actual colors which, blended, produce white light.

Daylight changes in color from hour to hour and from place to place. At noon, with the sky clear, it is *blue-white;* in the mountains it is *violet;* while at sea level, at sundown, it turns *reddish*. We shall see, later, why all this happens.

ARTIFICIAL LIGHT

That's the light which man has learned to make for himself: twig fires in ancient days, *zirconium* arc and *fluorescent* lamps today. However, no matter how it is finally produced, it is still only secondhand sunlight. There are really only two ways to make artificial light: (1) by *chemical action*, and (2) by *electrical action*. All the other ways are combinations or variations of these two. But whatever the method, the sun can be credited with having supplied the material or the energy necessary for the action.

If it is light produced by burning one element in another, magnesium in oxygen for example, the sun is responsible since both elements came originally from the sun, or from the primordial cloud out of which the sun and planets coalesced. If it is light made by burning oil, wood or coal, the sun is still responsible, since oil is a product of sun-nourished animal life, wood and coal are products of sun-nourished plant life, and oxygen we already know about. If it is light made by an electric current which is generated by steam or water power, the sun has created that too, since the fuel necessary to move the generators is produced from plant life; and if fuel is not used, then water power must be, in which case the sun has been at work again, making clouds which produce rain and swell the rivers that turn the dynamos which create the current that lights the lamps.

[1] The exposure for scenes taken by full moon on a clear night have to be 150,000 times longer than the same scene taken by direct sunlight; that is, moonlight requires 25 minutes for each 1/100 second of sunlight.

The Kinds of Light

There are twelve kinds of light used in photography. They are:

1. Daylight
2. Carbon-arc
3. Mercury-vapor
4. Incandescent
5. Flood
6. Flash (bulbs and cubes)
7. Fluorescent
8. X-ray
9. Infrared
10. Electronic flash (stroboscopic)
11. Zirconium arc
12. Tungsten-halogen

Daylight includes: direct sunlight; the skylight created by the sun shining on the dust and vapor in the atmosphere; and reflected sunlight.

Carbon-arc lamps supply a light which, in color, is somewhere between sunlight and floodlight. To alter their light characteristics the carbons are sometimes drilled and then filled with a core of inorganic salts. They are inconvenient to use, however, being noisy and requiring attention.

Zirconium arc bulbs offer a brilliant and highly efficient point-source of light which gives ten times the light of a tungsten lamp, while drawing a mere 25 watts of power. They are used in projectors, spotlights, and enlargers. In enlargers, this bulb increases sharpness *and* contrast (perfect for aerial photography). When used as a spotlight or flood lamp, it intensifies shadows and highlights, blotting out the middle tones. The bulb requires a resistor or transformer to feed a 10-volt supply to the arc. For more information on this remarkable bulb and its use in photographic enlarger systems, see the article by *Life* photographer Bernard Hoffman (*Zirconium Arc: Breakthrough in Print Quality*) in *Camera 35*, Oct./Nov. 1966, or write to Mack Electric Devices, Inc., Wyncote, Pa., for material about their *Consarc 25*, which can be adapted to the *Omega* or almost any other enlarger. The bulb, incidentally, is supplied by Sylvania, under license from Western Union!

Mercury-vapor lamps provide a *cold* light very rich in violet rays, and therefore very active photographically. They are available as *Cooper-Hewitt* tubes (now generally replaced by *cold-cathode grid* lamps such as the fluorescent tubes described below) or as *Sunlamp* bulbs, both forms requiring special transformers. They are excellent for portrait lighting and for enlarging.

Incandescent electric light is the brilliant glow emitted by an intensely hot metal filament—usually tungsten—encased in glass with an inert gas, as in the domestic screw-in electric bulb; other sources for incandescent light are *wax candles, kerosene lamps, gas burners.* The incandescent electric bulb is, of course, the best and most popular of

these. Easy to use, quite dependable, and very low in cost, it has a useful life of approximately 1000 hours if used at its normal rated voltage. The light supplied by the regular clear or frosted bulb is constant though yellowish; but you can also buy bulbs that have been made with a *blue*-tinted glass, with a *soft*-white coating, and even in *pink* (flattering to ladies).

Flood bulbs are also incandescent electric lamps. They differ from the others in that they have a slightly heavier filament and are used at about twice their rated voltage. This overvolting shortens their working life to about two to six hours. However, their life can be extended to 1000 hours, provided they are operated at 65 volts instead of at the customary house voltage. For this reason many amateurs interpose a *variable voltage transformer* in their flood bulb lines, focusing under reduced voltage and exposing at the full voltage. This method of using flood bulbs is recommended to all amateurs who use them a great deal; it is not only easy on the pocketbook (the bulbs last longer when used that way) but easy on the eyes.

Flashbulbs are an expendable, high intensity light source of *flash* duration. They are hermetically sealed glass bulbs filled with crumpled thin sheets or finely shredded wire filaments of such metals as aluminum, magnesium, zirconium, or hafnium in an atmosphere of oxygen. They flash when ignited by an electric current (3 to 120 volts) which has been applied to the bulb's priming system. This means they can be fired by flashlight batteries or the longer-lasting photoflash batteries, as well as by regular house current. They produce an intense burst of white light, and can be synchronized with focal-plane or between-the-lens shutters. *Caution:* Cracked flashbulbs may contain air plus oxygen— *a highly explosive mixture.* If the bulb you use does not have a spot detector inside the bulb (which changes color when there is a leak) be careful; use a shield. And don't use house current unless the manufacturer specifically indicates the bulb is fused for this purpose.

Supplementing the one-shot bulb is the four-shot *flashcube* (*Sylvania, Westinghouse, General Electric*, etc.) which rotates automatically as the film and shutter are set for the next picture. Originally made for the *Instamatic* flashcube cameras in 1965, they can now be used for other cameras as well, with adapters made by *Yashica, Cannon, Minolta, Polaroid, Soligor*, and others. The Soligor can be used in flashguns made for flashbulbs (the midget type, or the #5 with a flashbulb adapter). However, with such flashcube adapters, rotation is not automatic, as it is with the cameras designed specifically for flashcube use. An ejector button at the side of the adapter releases the used flashcube, as with the former flashbulb. All flashcubes use batteries, of course.

In addition, you can now get *reloadable* flashcubes, which use the

GE-type all-glass flashbulbs. The ones I have seen are made in two parts: 1. The section that fits into the gun, and 2. The part that has four small reflectors built into one unit which holds the AG-1 *baseless* bulbs. These two click together and make a complete unit, to replace the regular flashcube. *Amplex* makes such a money-saver, as do *Vernon* and others. Both the *flashbulb* carton and the *flashcube* carton have exposure *guide number* instructions for *simple* and *adjustable* cameras.

And now, another entry: Sylvania (followed almost immediately by General Electric) set off an electrical storm when they announced (at Geneva, in June 1970) a new light, the *Magicube,* which produces *flash pictures without batteries!*

The operating device for this new flashcube is a hairpin-like mechanical firing system which sets the flash off by percussion; something like the firing of a cap pistol. No battery is needed. What a blessing this is for the amateur who is always losing shots because his batteries have weakened or gone dead, or because of corroded contact points. Though

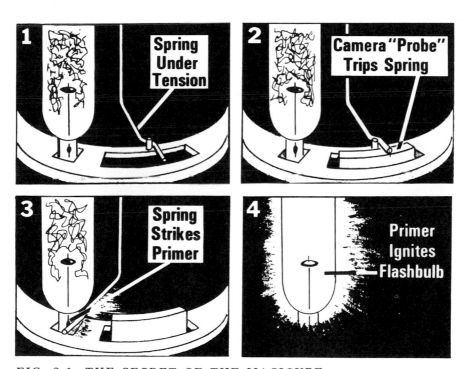

FIG. 2.1. THE SECRET OF THE MAGICUBE

The mechanical firing of the Magicube is done by a spring (1) inside the cube. Tripping the shutter lifts a probe (2) which releases the spring. This strikes the base of the bulb, ignites a primer (3), which flashes the bulb (4).

the *Magicube* now works only with the cameras built for its use, adapters for other cameras are on the way.

Another interesting sidelight. Whereas the *flashcube* reaches peak intensity in 12 milliseconds, the *Magicube* reaches its peak 7 milliseconds after ignition. This means that you can use faster shutter speeds with the *Magicube*. Besides, the shelf-life of *Magicubes* is in excess of 20 years, so the infrequent user can store them without worry.

Later, in the chapter on *Action and Flash*, we shall meet the new *Supercube*, 2.4 times more powerful than the normal, electrically fired flashcube. This bulb was introduced by General Electric for the Polaroid 400 camera series, and quickly duplicated by Sylvania. Those of you using flashcube adapters on adjustable-speed and adjustable-aperture cameras will find more flexibility in the increased light output of this bulb.

Fluorescent tubes produce a soft, cold light of great photographic intensity. They are filled with *neon, argon, krypton,* or *xenon* gas, or sometimes with a mixture of these. They require voltage transformers and starters (built into the fixtures). They can be made to supply almost any color of light, consume very little current and produce almost no heat. Argon tubes are also used in enlargers; the blue light, though strong actinically, is weak visually, which makes focusing very difficult. The visual quality of the light is improved by lining the inside walls of the tubes with fluorescent phosphors and using mercury vapor to create a *white* light. The gas merely carries, or *activates*, the electric charge; it is the mercury gas and the fluorescent lining that determine the color of the light.

X-rays are used by doctors and dentists and are of no real concern to amateur photographers. However, if the subject arouses your interest, and you want to know more about it, see your doctor. He may be willing to show you how it works.

Infrared light is one of the by-products of incandescence. Good sources are sunlight, candlelight, gaslight, electric light—almost any kind of light that produces heat. Its use indoors is rather limited, unless you can afford expensive equipment. But outdoors all you need is a roll of *infrared* film and a special dark red filter (because the film is also sensitive to other light rays, which you don't want). You can get some unusual pictures with this film: distant objects, invisible to the eye because of haze or fog, reproduce needle sharp; grass and other vegetation (chlorophyl) turns white, skies go black. In fact, using infrared rays you can take "moonlight pictures" in bright sun! Also, because sick trees and dying plants have less chlorophyl, they show up on infrared film as tones of gray (instead of black, which prints white). That's how insect infestations and fungus infections can be spotted from the air (as was

the southern leaf blight, a fungus disease that almost destroyed our 1970 corn crop). Similarly, errors in geographical charts and road maps can now more easily be detected (Gemini pictures of Cape Kennedy, for instance, revealed the fact that even our latest maps of the area failed to show some roads and constructions). Officials of the Geographical Survey, and others, are naturally delighted with this new tool for the accurate exploration of our changing earth. More recently, *color infrared* (Kodak Aero Ektachrome Infrared) has been used to expand our vision of a secret world of green sky and red grass (the way color infrared sees it). The film combines *visible* color and *infrared* radiations into one photograph. The emulsion was developed during the war to detect camouflage; but its chief use now is in science (especially medicine) and in forestry. In bright sunlight, with a K2 filter on the lens, the speed rating is ASA 100.

Extraordinary as are the feats of *stroboscopic light*, the explanation for them is simple. The stroboscope is a light that flickers! The secret, of course, is in the way it flickers. The flicker of an eye, you may remember, is about 1/40 of a second; a stroboscopic flicker is 1/1,000,000 of a second! At this speed even a bullet can be stopped in its tracks. An electric spark inside a gas-filled lamp produces the stroboscope light; the current which sets off this spark is fed first into an electrical reservoir, technically known as a condenser. While that gradually builds up, the inert gas with which the stroboscopic tube is filled begins to *ionize* (some of the molecules are converted into *ions*). When that has proceeded far enough to permit electricity to flow, the condenser is suddenly short-circuited, the stored-up current spills over and produces the lightning flash that takes the picture. Since 1/1000 of a second is about the fastest speed you can get out of a modern camera shutter (only the Leicaflex SL shutter goes up to 1/2000 of a second), and since that isn't fast enough to stop such action as a humming bird in flight, the drive of a golf club, or the speed of a bullet, no one was able to take any *ultrafast* pictures until Professor Edgerton, of the Massachusetts Institute of Technology, began to work on the problem. He neatly sidestepped the issue of a faster shutter by doing away with the shutter altogether. His lights blackout by themselves at a preset speed.

Photography owes much to Professor Edgerton, but *electronic flash* is important today not so much because of the *speed* of the flash, but because of its *repeatability*. It is significant that electronic flash units are now rated by how quickly they recycle, rather than by how fast they flash. Also, electronic flash units that have a flash duration of less than 1/700 to 1/2000 second run into serious problems of color balance and exposure error due to *reciprocity failure* (an inability of the film to compensate for unusual exposures, short or long). Normally, light inten-

sity multiplied by time equals a constant of exposure. But when flash exposures get into the range of 1/5000 to 1/50,000 second, 2 to 3 times the normal exposure, or even more, may be required.

LIGHT LOSES INTENSITY

Light travels in straight lines, and the further it has to travel the weaker it gets. Scientists have worked out a formula for this. It is called the law of inverse squares: *Light decreases as the square of the distance.* When the distance between a light source and a lighted surface is doubled, the light spreads out and covers four times the area, but each quarter gets only one-fourth as much light; at three times the distance, the light covers nine times the area but with one-ninth the intensity.[2] *Fig.* 2.2 shows why this happens.

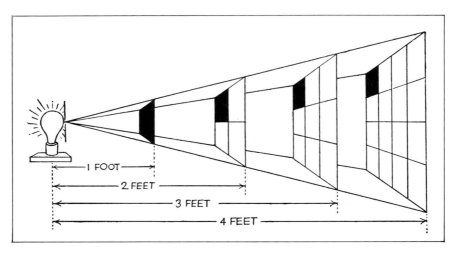

FIG. 2.2. HOW LIGHT LOSES INTENSITY

LIGHT AND CAMERA DISTANCE

There is one notable exception to the above rule, which nevertheless confirms it, and that is *camera distance.* We do not alter the exposure

[2] This law applies, theoretically, only to *point* sources of light without reflectors. The rays from a point of light are cone-shaped (*divergent*), not cylindric (*parallel*). Whether light sources are one or the other makes a big difference, as you will see later when we consider such things as shade and shadow, why condenser enlargers give more contrast, and why the new reflectors for the small flashbulbs throw so much light. Though we rarely meet a point source of light as such in photography, we are constantly making use of the law of inverse squares. It applies in every case where the *area* of the light source is no more than a small fraction of the distance between the light and the subject.

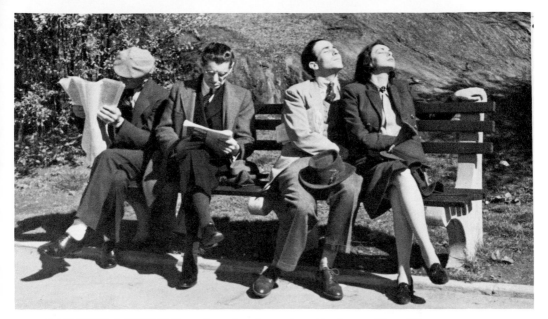

CATCHING PEOPLE on the wing is most easily done with a 35mm camera. Here my Leica was preset and focused (on a previous bench) and the shutter was released as I passed. Not even the man with glasses was aware that I had snapped his picture.

for a subject each time we move the camera away from it. And the reason, *believe it* or not, is the law of inverse squares!

Let us suppose you are taking the picture of a girl on a park bench. The first shot is a closeup, the exposure for which is based on a meter reading of the palm of your hand (as a substitute for her face, since you don't want her to know). Then you move back until all four people sitting on the bench are in the picture. The girl will now be about a fourth of her former size (on the negative), but *the exposure for her will be exactly the same.*

Why?

Because there is no change in the number and intensity of the light rays that make up the girl's image. They are merely crowded together into smaller space. The emulsion gets just as much light from the object (the girl) regardless of distance. (Within reason, of course. If she were on a mountain top, and you were a mile away, this wouldn't be true, because of the interference of such other factors as atmospheric haze, heat, ultra-violet light, etc.)

LENS DISTANCE

We have just said that the exposure remains the same, when the camera distance changes, but there's a catch to that. It remains the

same provided the distance between the lens and the film doesn't change either. But we know that it does. Normally, we don't have to worry about this at all because the distance between lens and film is increased so little in ordinary use that it's hardly enough to fuss about. (In the case of *closeups*, however, it is something to watch. Later, when we consider the *factors affecting exposure* and *close-range work*, we shall find out what to do about this.)

LIGHT IS REFLECTED

When you photograph a blazing bonfire or a burst of fireworks or the city at night, you are photographing *direct* light. What you do in each of these cases is to photograph the actual *source* of light. When you photograph the moon, water at the beach, a curvy torso in a bikini, or a face in a mirror, you are using *reflected light*. Practically all of the light used in photography is light reflected from objects.

Specular light is the kind that is reflected from a smooth, highly polished surface like a sheet of glass or chromium plate. When specular light is reflected from an object, it is difficult to see the object. That's why coated paper is hard on the eyes and why glass-covered pictures are usually difficult to view, unless you use the new type of *glare-free glass* which has a finely etched or ground surface on one side.

Diffuse light is the kind you look at when you read a book printed on "wove" paper—each fiber of the paper presents a new surface to the light, sending the rays helter skelter all over the place.

Light rays reflect like bouncing balls. When they hit a hard smooth surface at an angle, they change direction. The angle at which they leave the surface is called the *angle of reflection;* the angle at which they hit it is called the *angle of incidence*. There is an exact relation between these two. The first law that governs this relation says: *the angle of incidence is equal to the angle of reflection*. This means that a ray of light, hitting a surface at thirty degrees to one side of an imaginary perpendicular set up at the point where the light touches the surface, will be reflected from that surface at an angle of thirty degrees on the other side of the perpendicular. The second law that governs it says: *the angle of incidence, the angle of reflection, and a perpendicular to the surface are all in one plane.*

Reflection increases with the polish of the surface or with the obliqueness of the angle of incidence. To prove the obliqueness part of this, take an ordinary sheet of white paper, one that does not have a shine to it, hold it near a reading lamp and tilt it at a sharp angle so that you will be glancing across the surface at the light source. You'll

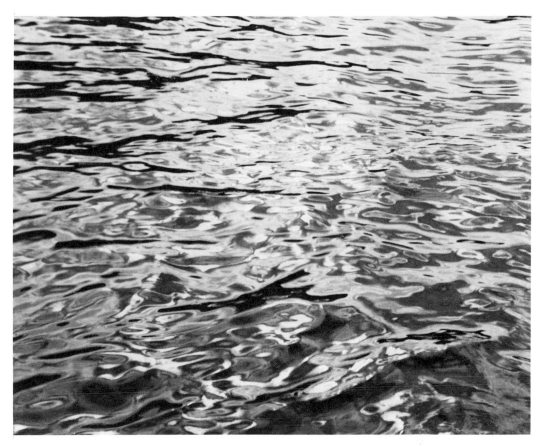

LIGHT IS REFLECTED. Water is always a great subject for photography. Taken with a Contax, Sonnar $f/1.5$ at $f/8$ and $1/250$, no filter.

see a reflected image where only a moment ago there was just diffused light.

You can see an object better by diffused light than by specular light. That's why so many people have inadvertently walked through mirrors. What they saw was not the object itself (in this case the mirror) but the specular reflection of distant objects and light sources. This becomes "an interesting problem" when you have to photograph bright metals, glassware, oil paintings, pictures under glass, or other shiny objects. See index for references to *polarizing filter* and *glassware photography*.

LIGHT IS ABSORBED

Not all the light that shines on an object is reflected or transmitted. Some of it is absorbed and converted into heat. That's why the color and reflection characteristics of the object are fully as important in photog-

raphy as the kind of light or materials being used. If the object is black and has an uneven surface, like black velvet, no more than 1 per cent of the light will be reflected; if it is white and smooth, like porcelain enamel, or if it has been coated with magnesium oxide, about 98 per cent of the light will be reflected. Colored objects present other problems in reflection and absorption. Your safelight is red because it *filters out* the other colors; what you see is the *light source*. Your blood is red because it *absorbs* the other colors; what you see is the *reflection* of the *object* (the blood). The first is an example of *subtractive* lighting; the second is an example of *additive* lighting. This distinction will be useful in your photography when you begin to take pictures in color.

LIGHT IS REFRACTED

When a ray of light travels through empty space outside the earth's atmosphere, or in a vacuum, it does so at a constant speed. But when it passes through a transparent substance like air, water, glass or quartz, it is slowed up. This slowing up depends on two things: (1) *the density of the new medium*, (2) *the wave length of the rays of light*. The denser the medium, the slower will the rays travel. And the longer the wave length of light, the less will it be affected.

As long as the ray of light stays in one medium, this slowing up causes no trouble. But when it starts moving from one medium to another, things begin to happen. One of these things is that the slowing up bends the rays out of shape. That's why a pencil, placed at an angle in a glass of water, looks broken.

LIGHT IS DISPERSED

White light is composed of seven spectral colors: *violet, indigo, blue, green, yellow, orange* and *red*. We see them as such because certain vibrations of light produce these sensations of color in our eyes. A wave length of 700 millimicrons, for instance, produces the sensation of red; a wave length of 400 millimicrons, the sensation of violet.

When these travel together in parallel lines, we get the sensation of white light. When they travel through a dense medium, the surfaces of which form an angle, the rays begin to be *dispersed;* they no longer travel together in parallel lines. The result of this is shown in *Fig. 2.3.* To decompose white light, therefore, we use a *triangular* prism. Sir Isaac Newton was the first to try this experiment. It is simply a modification of the pencil-bending phenomenon.

Newton tried two other interesting experiments with prisms to test his theory that white light was *mixed* light. In the first, he duplicated

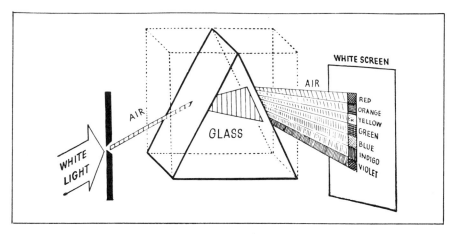

FIG. 2.3. HOW LIGHT IS DISPERSED
WHEN PASSING THROUGH A PRISM

the setup shown in *Fig.* 2.3, but instead of the white screen for the spectrum he used an opaque screen with a slit in it that would permit only the yellow rays to get through. On the other side of the screen he placed another triangular prism to refract the yellow light. *But he couldn't disperse it;* the yellow light remained yellow! He tried this also with the other six spectral colors, and discovered that none of them could be broken down. Only mixed light, he found, could be so dispersed. He concluded that the seven spectral hues were *basic* or primary colors.

In his second experiment, Newton took two prisms and arranged them so that the dispersed white light from the one would enter the inverted side of the other (the points of the triangles facing in opposite directions). In this way he showed that white light could not only be decomposed but *recomposed.* The second prism, as you guessed, gathered the dispersed rays and refracted them to reproduce white light.

LIGHT IS POLARIZED

There is still another phenomenon of light that's of interest to photographers, and that is the mysterious one known as *polarization.* This phenomenon was first studied by Huygens, who discovered that the crystals of certain translucent minerals had the property of stopping light when they were placed with their long axes at right angles to one another. The crystals act like optical slits which transmit only light vibrating in the plane of that slit. By means of a *polarizing filter* the photographer can eliminate unwanted reflections on water, in a shop window, on polished metal, on glass surfaces, or whatever. The filter transmits only the light polarized in one plane. By rotating the filter,

you can hold back all or part of the rays that interfere with your picture. Also, you can see how the filter will affect your picture by first placing it in front of your eye. When you have turned it to the position you like, place it on your lens the same way. If you have a single-lens reflex camera, of course, you can do this as you compose and focus.

LIGHT BENDS AROUND CORNERS

Place two fingers close together, almost but not quite touching, and bring them up to your eye. Now look through the fingers at a light source and you'll see one of the strangest of all the phenomena of light. First you'll see what appears to be a shadowy aura around the edge of both fingers; as you move them closer together these shadows will become a series of parallel lines darker in intensity, and resembling somewhat the lines on a contour map. Just before the fingers touch, these contour lines will seem to jump toward one another, creating what appear to be little bumps on each finger. This phenomenon, known as *diffraction,* occurs whenever light hits an edge. It causes no end of trouble in photography, as you will find out when we take up the *diaphragm* and the *critical aperture* of a lens.

What It Does

We know now what light is, and how it behaves; let's find out what it *does.* Especially its ability to (1) *cast shadows,* and (2) *create an image.* But first, answers to a few questions that have troubled the curious for ages.

WHAT MAKES A RAINBOW?

Unless we have forgotten all that we have just found out about refraction and dispersion, this one shouldn't be so tough to unravel. *The raindrops, of course, are responsible.* In other words, nature's prisms have produced the spectrum.

WHY IS THE SKY BLUE?

Nature always seems to be splitting light into its many colors or wave lengths. The *blue* sky is one example familiar to most of us; another is the *red* sunset; still others are soap bubbles, mother of pearl, peacock feathers, the iridescent shells of certain insects, a film of oil on water, the sparkle of a diamond. All are of interest to the *photographer.*

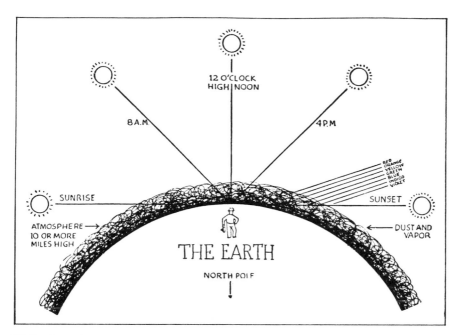

FIG. 2.4. WHY SKIES ARE BLUE AND SUNSETS RED

The blue sky is caused by the screening effect of the earth's en-
velope of atmosphere. This envelope extends upward about twelve miles
or more, and the first four or five miles are packed with dust and water
particles of all sizes hanging suspended in the air. Many of these par-
ticles are so incredibly small that they are almost the same size as the
wave lengths of blue light, about 1/600,000 of an inch. In consequence,
they *scatter the blue waves*, letting the others get through. See *Fig. 2.4.*

The illustration in *Fig. 2.4* also explains why morning and evening
sunlight is redder than the light at high noon. When the sun is low on
the horizon, the light has to push through a denser fog of atmosphere
which scatters the violet, blue, green, and some of the yellow rays and
lets the long red rays through. This change in the color of daylight, from
morning to evening, will be much more important to us later when we
take up the problems of *exposure, film sensitivity,* and *filters.*

LIGHT CASTS SHADOWS

Almost as important to photography as light itself is the *absence* of
light. Without shade or shadow, most pictures would be impossible. See
the illustrations elsewhere in this chapter in which three geometric fig-
ures have been painted white, arranged against a black background, and
photographed. They show that *shadow is part of the picture.*

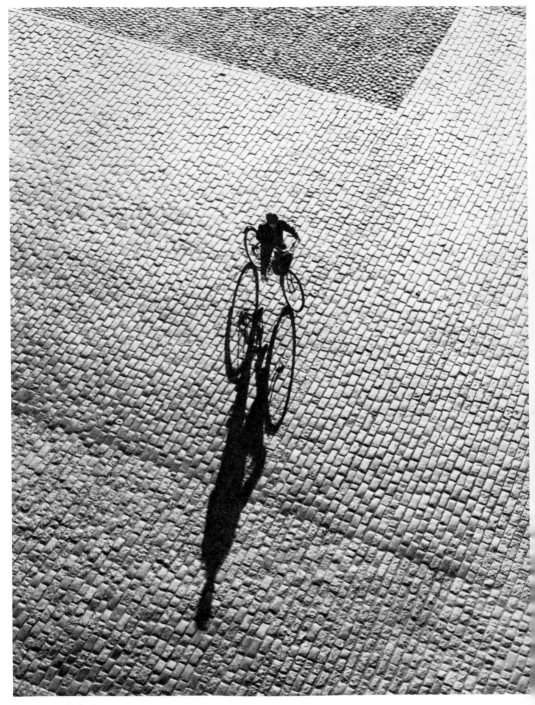

LONG SHADOWS. This beautiful picture of an
early morning in Finland was taken by *Eric Muller*.

THE KINDS OF SHADOWS

There are two kinds, those made by a *point source* of light, and those made by a *large source* of light. The difference between them is that one makes a *hard* shadow with a sharp edge and the other a *translucent* shadow with a soft edge. If you will look at *Fig.* 2.5 you will understand how this happens. Some photographers like to distinguish between the various dark areas, so they call the lighter part of a soft-edged shadow, the *shade*.

Short shadows are made by overhead lights; *long shadows*, by side lights (the lower the light, the longer the shadow). Changes in the shadows made by the sun illustrate this perfectly.

Contrast is increased between the light and dark areas of an object when the light is strong, close, raw, direct, or point source; *it is reduced* when the light is weak, distant, diffused, reflected (as from a wall or sheet or card), or large source.

Hard shadows can be softened by reflected light, by diffused or weak supplementary light, by moving the basic light further back, by changing the size and shape of the reflector (the larger the angle of the cone, the softer the light), and by changing the inside surface of the reflector (the more polished the surface, the harder the light).

And that's about all you have to know about shadows, except that there are no absolute blacks in nature, that the whitest substances found outdoors (*chalk*, for instance) reflect only 85 per cent of the light that shines on them, and that the light intensities outdoors aren't as great as most amateurs think they are. The sky (I did *not* say the sun, now) is only thirty times as bright as the deepest shadow in strong sunlight, and the sunlit road you walk on is only six times as bright as your own shadow under an open sky. If you don't believe this, take your exposure meter outdoors and make some readings.

And if you have nothing better to do, try to figure out why a bird flying over a man's head on a sunny day casts no shadow on the ground, or why no one can tell where the shadow of a church steeple stops. We've given you a clue in *Fig.* 2.5 on page 39.

LIGHT CREATES AN IMAGE

The most interesting property of light, its ability to form an image, stems from the fact that it travels in straight lines. There are three ways in which an image can be formed: (1) by *reflection*, as in a mirror, (2) by *projection*, as through a pinhole, and (3) by *refraction*, as through a

To illustrate the importance of the absence of light, these geometric shapes have been painted white and arranged against a black background. Let's light them first to eliminate all shadows. This top figure shows what you would see. Nothing three-dimensional about that, is there? If the forms had been placed against a white background, there would have been even less to show you.

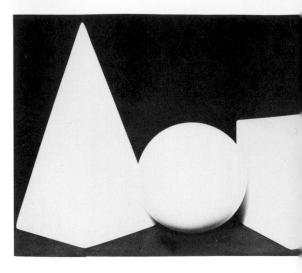

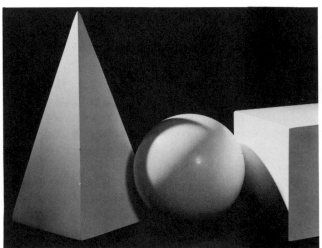

And yet there was plenty of light! Obviously, light alone cannot make a picture. Now let's take away, or intercept, some of the light. Something like this might be the result. But it's still not good enough.

So we continue to play around with the lights until we bring out the full three-dimensional quality of the objects. Note that the cube now shows a *white,* a *gray,* and a *black* side; and the sphere now looks like a ball instead of a plate. Steichen sharpened his technique by photographing a white cup and saucer hundreds of times, under all conditions, until he could previsualize the final result, and *get it every time!*

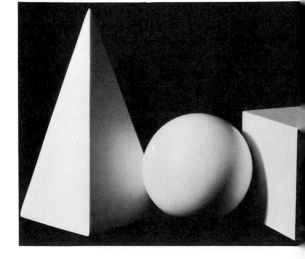

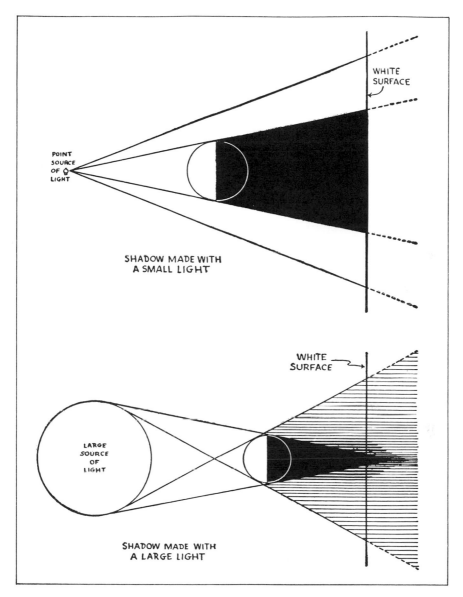

POINT
SOURCE
OF
LIGHT

WHITE
SURFACE

SHADOW MADE WITH
A SMALL LIGHT

LARGE
SOURCE
OF
LIGHT

WHITE
SURFACE

SHADOW MADE WITH
A LARGE LIGHT

FIG. 2.5. THE KINDS OF SHADOWS

lens. The third way will be the subject of the next chapter, so we won't discuss that here, but we can take up the other two now.

First, let's consider *the mirror*. The kind we have in mind is one that has a *plane* glass surface. When light from any point on an object is reflected from such a mirror, it travels with those old friends of ours, *the laws of reflection*. That is, each ray hits the mirror and leaves it at

FIG. 2.6. HOW A MIRROR
REFLECTS AN IMAGE

precisely the same angle (the angles of *incidence* and *reflection*). How does this form an image? See *Fig. 2.6*. When a ray of light is reflected, the direction it *seems to have* is the one taken by the ray just before it enters the eye. Since this kind of image is an optical illusion, it is called a *virtual* image, as distinguished from the *real* image made by a pinhole or a lens.

HOW LIGHT AND A PINHOLE FORM AN IMAGE

If you have a ceiling light with two or three bulbs in it, and your friends find you moving a card around between it and a white sheet of paper, you can show them this paragraph and the pinhole in the card to prove that there's nothing wrong with you. You are just trying to duplicate something first noticed by a tired Egyptian many years ago.

It is because light travels in straight lines that it is able to form an image on a screen when it passes through a small hole, and for the same reason the image will be upside down. This inversion of the image is made clear in the picture shown in *Fig. 2.7*. In the picture, *A* and *B* represent two points of a lighted candle, *C* the pinhole, and *D* and *E* the image on the screen.

FIG. 2.7. HOW A
PINHOLE CREATES
AN IMAGE

THE SIZE OF THE IMAGE FORMED

The size of the image of an object depends upon the distance that both the object and the screen are from the pinhole. To prove this, you need only to move the screen back and forth. The farther away the screen is from the pinhole, the larger will be the image, and the fainter it will be. This increase in size is due to the fact that the rays of light from the object which pass through the pinhole diverge on leaving it, the *A D* ray (see *Fig. 2.7*) moving down and the *B E* ray moving up. The reason the image decreases in brightness as the size is increased, is that the very small amount of light that passes through the pinhole emerging as a cone must spread over a much larger surface.

WHY A SQUARE HOLE FORMS A ROUND IMAGE

Aristotle, as you may recall, noticed that when the image of the sun came through a rectangular opening in the leaves of a tree under which he was resting, the image on the ground was round nevertheless. He couldn't explain it. But today we know that regardless of the shape of the hole, it is still only a pinhole in relation to the sun, and therefore the *real* image it produces must of necessity be a round one.

How to Control Light

Indoors, the control is pretty much in our own hands; there are many things we can do. Outdoors, however, the matter is not so simple. We cannot move the sun around the way we can a flood light, but there are other controls. The most important of these is *patience*. Yes, just that. There is a right and a wrong time to photograph everything. Study each subject and try to imagine how it would look if lighted differently. If it isn't lighted the way you'd like it to be the first time you see it, go back at another time when the light is more suitable, when the angle is better. Alfred Stieglitz once spent months studying the effects of sunlight on an old stone well in a courtyard facing his home before he took even one picture.

Later, we shall consider all of the specific techniques for the control of lighting, both indoor and out. But, in the meantime, here are some ideas to mull over: Turn your back on the *taboos* of photography. Everyone will tell you to avoid noon light outdoors or to go indoors when it rains. Pay no attention. Listen, instead, to one of America's great photographers, Edward Weston, explain why he could use *only* noon light for one of his famous photographs, *Bean Ranch:* "The clarity and mean-

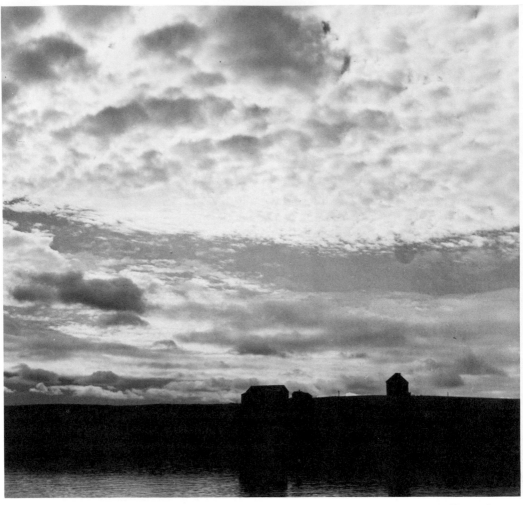

LIGHT PAINTS A PICTURE. Sunrise at Digby, Nova Scotia. Rolleicord, light green (X1) filter, fast panchromatic film developed in Edwal 12.

ing of the picture would be lost if the neat black eclipses under the trees were sprawled out across the foreground and the furrows between the plant rows were so filled with shadows as to hide the important contrast provided by the texture of the plowed earth. Noon light is by no means the only popular taboo. I have been out with photographers who felt that the day's work necessarily ended when clouds obscured the sun or fog rolled in. . . . To know the phenomena of the photographer's world only as brilliant sunlight reveals them, is to know but a small part. Mist in the air, curtains of fog, clouds and overcast skies, the afterglow when the sun has set and the dawn light before sunrise provide him with different avenues of approach to his subject matter, or, more properly,

provide him with different subject matter. For it cannot be too strongly emphasized that *reflected light is the photographer's subject matter.* Whether you photograph shoes, ships, or sealing wax, it is the light reflected from your subject that forms your image."

EVENING MIST, by John W. Doscher, of Tory Hill, South Woodstock, Vermont, successfully breaks one of the "taboos" of photography. This lovely photo was made on a rainy night in front of the New York Public Library on Fifth Avenue.

3 What the Lens Does

The eye was the first lens, and it's still the best. The most perfect lens ever made is just a clumsy affair compared to the sensitive, self-adjusting, *apochromatic* [1] zoom mechanism that functions as the eye.

The curious thing about man's long search for the perfect lens is that he pursued this search with the only perfect lens there is, and never realized it. Each new basic discovery in lens design was just a redis-covery of optical and mechanical principles already at work in the eye. Some of these are: the *diaphragm* which is the *iris* of the eye; the *compound lens* which duplicates the *liquid* and *crystalline* lens formations of the eye; the *shutter*, which is a mechanical eyelid. The eye even has an *anti-halo* backing, a layer of some black substance behind the retina which absorbs all rays not needed or not wanted to create vision. Also, it has a built-in *UV absorption filter*, is *self-cleaning*, and does not suffer from *shutter fatigue*, provided you get your quota of sleep each day.

When it's in perfect condition, the eye is a marvelous instrument: it does not suffer from *lens aberrations;* it sees no problem in *depth of*

[1] Free from chromatic and spherical aberrations.

field; it operates its *shutter* quietly; it overcomes *curvature of field* very simply by collecting the rays on a curved field (the retina); and it turns the continuously shifting upside down world right side up before registering it, in full color, in the brain. The eye finally, if you're still not impressed, is "several hundred thousand times more light sensitive than the fastest [2] photographic emulsion," according to laboratory scientists who have tested both.

How Lenses Act

HOW A CONVEX LENS REFRACTS (BENDS) LIGHT

In the preceding chapter we saw how a pinhole makes an image, and how a prism bends light. By cementing the bases of two prisms together, we can simulate the operation of a convex lens. See *Fig. 3.1.*

FIG. 3.1. THE ACTION OF LIGHT RAYS
THROUGH TWO CEMENTED PRISMS

The distance from the center of the lens to A_1 is the *focal length.* That's the distance between the lens and the film plane *when the lens is focused at infinity.* Most cameras have a lens stop at this point so that when you move the lens back toward the film as far as it can go, you will have automatically focused the lens at infinity. In practice, *infinity* may be anywhere from 100 feet to a distant horizon miles away. It depends on the size and construction of the camera and the focal

[2] In photography the expression "fast" concerns the ability to deal with light. Thus a "fast" film reacts more quickly to light than a "slow" one—requiring less exposure. A "fast" lens can be used with a wider diaphragm opening than a "slow" one of the same focal length, thus admitting *more* light in a given time.

length of its lens. The focal length determines how large an image of a subject the lens can produce, and how much of the scene it can span. A 50mm lens, for example, on a 35mm camera, can take in an angle of view of 45°; the 35mm wide angle lens for the same camera has an angle of view of 64°; while the 135mm telephoto lens has an angle of view of 18°.

Point A_1 itself is the point of *principal focus:* the closest the lens can approach the film plane and still be able to focus on *any* object. As the lens is moved away from the film plane there will be an infinite number of other possible points of focus, depending on the distance of the object from the lens. The closer the object is to the camera, the farther out must the lens be racked (away from the film plane).

The convex lens can be considered as made up of an infinite number of prisms of varying angle. The composite surface of such an arrangement of prisms would resemble the surface of a convex lens. All camera lenses, no matter how complicated their structure, are in action no different from simple convex lenses; they bring spectral rays of light [3] to a point called the *focus*.

HOW A CONVEX LENS FORMS AN IMAGE

All you have to do to form an image of an object on a screen of any sort is to let the light from an object pass through a convex lens that is placed between them. To get a sharp image of the object, move the screen back and forth until you find where it is clearest. At that point the image is said to be *in focus*, and the process by which this point is found is called *focusing*.

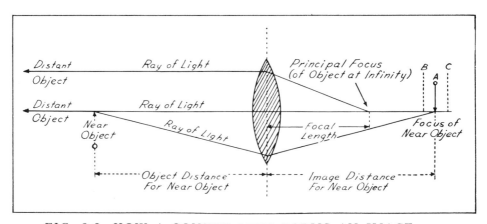

FIG. 3.2. HOW A CONVEX LENS FORMS AN IMAGE

[3] All those, that is, which are in a plane at right angles to the path of light.

The image formed by the lens, like the one made through a pinhole, will be inverted, that is upside down on the screen, and for the same reason (see *Fig. 3.2*).

But, unlike the pinhole, a lens lets a larger number of rays pass through it other than those that do so through its optical axis—as a glance at the diagram will show; thus rays coming from the top of the object which strike the upper part of the lens are refracted downward by it, while those that come from the bottom of the object and strike the lower part of the lens are refracted upward by it. These meet the rays coming through the center of the lens at a point between the *principal focus* (for objects at infinity) and any of the infinite number of *image foci* (for objects between infinity and the lens). The range of possible lens extensions (and therefore the size of the image) is determined by the construction of the camera and the lens; the greater the distance between the lens and the film plane, the larger the image of the object. The plane on which the image is focused is called the *focal plane*, and that is where the film is placed.

HOW THE FOCUS AFFECTS THE IMAGE

From the diagram in *Fig. 3.2* you can see that the image formed by a convex lens will be sharp only when the screen (or other focusing surface) is at a point in space where the light rays refracted by the lens, and those that pass through its center, meet. This is indicated by the arrow *A*. Please note that this is the focus of a *near* object. Distant objects (those at *infinity* and beyond) come to a focus at the point of *principal focus*, which is so marked on the diagram.

If the screen or focusing surface is placed ahead of this point (see broken line *B*) or behind it (see broken line *C*) they will not have met as yet at *B*, or will have met and spread at *C*. In either case, the image will not be sharp.

HOW TO FIND THE FOCUS OF A LENS

A lens makes the sharpest image of any given object on only *one* plane. When the object is at *infinity* (a distance such that reflected rays from the object pass through the lens as parallel lines; for most cameras this would be beyond 100 feet) the rays come together at the point of principal focus. As the object moves closer to the lens (or vice versa) the distance between the lens and the focal plane must also be increased or the image will not be in sharp focus. That's why we rack or turn our lens out as we move up toward an object. The closer the object to the lens, the larger will be the image (until, at a lens extension of twice the

normal focal length, the image would be the same size as the object). Since the focal length of a lens, therefore, controls both the *size* and *sharpness* of the image, it is important for us to know what this measure is, so that we can use the lens effectively. There are two ways of discovering this important fact.

1. To get the *point of principal focus* of a lens, let the rays of the sun pass through it and fall on a white surface (card or paper), as if it were a burning glass. Since the sun, optically, is at infinity, and you are bringing its image to a point, the distance between the lens center and the, by now, burning or scorched surface is the *focal length*.

2. Another way to arrive at this measure, sometimes also known as the *equivalent focus* or *image focus,* is to point the lens at a scene or object, and move the white surface back and forth, while holding it at a right angle to the axis of the lens, until the entire image is sharp. Now measure the distance between the center of the lens and the white surface. That will be your focal length.

There are formulas for calculating this distance, but it is easier to find it experimentally, as suggested above.

OTHER SHAPES OF LENSES

Besides the double convex lens, there are five lenses of other shapes which are used in various combinations with each other to get better results than can be had by using single lenses; that is to say, lenses in certain combinations will let more light through them and at the same time reduce the numerous defects to a minimum. Such lenses are shown in *Fig. 3.3.*

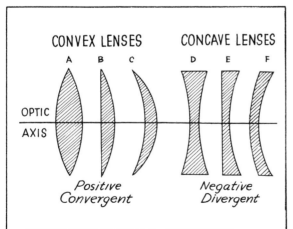

FIG. 3.3. THE DIFFERENT KINDS OF LENSES

(*A*) Double convex or biconvex.
(*B*) Plano-convex.
(*C*) Converging or positive meniscus.
(*D*) Double concave or biconcave.
(*E*) Plano-concave.
(*F*) Diverging or negative meniscus.

Depth of Field and Depth of Focus

These two are often confused for one another.

Depth of field is a measure at the scene; *depth of focus* is a measure in the camera.

As you focus your lens, the picture shifts from blur to sharpness. That's because the points on the *subject* become smaller and smaller points on the *image*. These points are produced by the *cones of light* which emanate from the scene. When you slice through one of these cones with the ground glass or film plane, you get a disk, which is known as a *circle of confusion*. When all of these circles are as small as you can make them, the image is sharp and in focus.

Depth of field is the zone, before and behind the point of focus, within which all of a scene can be registered on the film as *acceptably* sharp.

But a lens image does not have to be *optically* sharp to be *visually* sharp. Depending on the viewing distance of the final print, there is a zone of latitude where an image that is slightly out-of-focus still looks sharp.

That zone is known as the *depth of focus*. It extends as far in front of the plane of critical sharpness as behind it.

Both depth of field and depth of focus vary with the aperture, focal length, subject distance, and size of the circles of confusion.

The sharpness of a contact print viewed at 10 inches will be greater than that of the same picture blown up to poster size and seen from 10 feet. The poster may be visually sharp at 10 feet, but it will break down (seem to be out-of-focus) when you look at it from a closer distance. Not so with the contact print; it stays crisp and sharp at any viewing (seeable) distance.

Let's put this another way. If you are photographing a series of objects placed at various distances from the camera, only one of them can be truly sharp. That's the one on which you focus. The others may, with help, produce acceptably sharp images, but that will depend, as we have said, on the aperture, the focal length, the object distance, and the size of the circles of confusion.

How Focal Length Affects the Image

The pictures below illustrate the changes in image size that can be produced by lenses of different focal length. They were all taken from one spot, at Westbury on Long Island, with a Leica M4 on Panatomic X

HOW FOCAL LENGTH AFFECTS IMAGE

28mm Elmarit *f*/2.8 Panatomic X Acufine 1:1, 4′ @ 70°
ASA 80 (50 with 1Y) Westbury Gardens.

35mm Summicron *f*/2 Panatomic X Acufine 1:1, 4′ @ 70°
ASA 80 (50 with 1Y) Westbury Gardens.

50mm Summicron *f*/2 Panatomic X Acufine 1:1, 4′ @ 70°
ASA 80 (50 with 1Y) Westbury Gardens.

90mm Tele-Elmarit *f*/2.8 Panatomic X Acufine 1:1, 4′ @ 70°
ASA 80 (50 with 1Y) Westbury Gardens.

135mm Elmar *f*/4 Panatomic X Acufine 1:1, 4′ @ 70°
ASA 80 (50 with 1Y) Westbury Gardens.

28mm

35mm

50mm

90mm

135mm

developed in Acufine. A tripod was used to make sure that the camera position remained unchanged. The lenses used were the following:

28mm Elmarit $f/2.8$
35mm Summicron $f/2$
50mm Summicron $f/2$
90mm Tele-Elmarit $f/2.8$
135mm Elmar $f/4$

TABLE OF FOCAL LENGTHS AND PICTURE ANGLES

Full Frame 35mm Camera Lenses

FOCAL LENGTH	PICTURE ANGLE
21 mm	91°
28 mm	76°
35 mm	64°
50 mm	45°
65 mm	36°
90 mm	27°
105 mm	23°
135 mm	18°
150 mm	16°
200 mm	12°
250 mm	10°
500 mm	5°

Perspective, and How to Control It

A photograph is a two-dimensional view of a three-dimensional scene, with the center of perspective at the camera lens.

From the same point of view, *all* lenses give the same perspective.

Your eye is a camera and sees what your lens does. But the lens doesn't have a brain to help it compensate.

A long-focus lens produces a larger picture than one of short focus, but the depth of field of both lenses is the same.

Violent perspective is the result of getting too close to the object or too far from the print.

For natural perspective, the focal length of the lens should be the same as the diagonal of the film.

For true perspective, the print should be viewed at a distance equal to the focal length of the taking lens multiplied by the enlargement. Thus, if a miniature camera negative taken with a 50mm (2 inch) lens is enlarged 10 times, the print should be viewed at a distance of 20 inches.

The eye finds it easier to accept extreme vertical convergence than mild convergence.

In a photographic print, the eye can tolerate horizontal convergence (as in railroad tracks) with more comfort than vertical convergence (as in tall buildings).

There are two ways of altering photographic perspective: moving the camera lens relative to the scene; or moving the eye relative to the print. The first controls *true* perspective, which is fixed once the exposure is made; the second changes the *apparent* perspective, by altering print size or viewing distance.

The perspective in long-focus views seems compressed. Distant objects look larger than they really are.

In wide-angle views, objects seem separated by greater distances, and though the depth of field at any given distance seems to be more, the depth of focus at a given relative aperture is always the same.

The depth of field for a scene shot with a long-focus lens is the same as that taken with a short-focus lens, provided the camera is moved close enough for the wide-angle lens to reproduce the scene same size on the film.

How to Control Perspective in a Miniature Camera [4]

At one time there was no way for the user of a small camera to simulate the tilts, swings, and shifts of a view camera. This made it difficult for the users of such small cameras to take closeups, still-lifes, or architectural studies. Of course, some of the problems could be corrected by the adjustable lens boards of certain enlargers (and by further manipulating the position of the easel); but in general, a tilted camera meant converging verticals, or distortion, and there wasn't much you could do about it.

But now help is coming, in four ways:

1. The *Varioflex* (Vytron Corp.) [5] made for most 35mm focal-plane shutter SLR's like the *Leicaflex*, and for 2¼ inch mirror reflex cameras like the *Pentacon*, the *Hasselblad*, and the *Bronica*. The Varioflex is offered in two models, both 65mm focal length. Unit I has a tiltable and revolving mount; Unit II has these, but adds a rising and falling front.

[4] This term is generally applied to cameras using 35mm movie film as negative material for still photography. More recently it has come to be applied to any camera (like the Rolleiflex) that uses the Super-Slide size (38 x 38mm, or 1½ inch square). See index, under *lantern slides*.
[5] Vytron Corp., Box 832, Amityville, N.Y. 11701.

2. The Nikon *PC-Nikkor* 35mm *f*/2.8, which rotates 360° (with click stops at 30° positions), and shifts 11° off axis.

3. The Canon *TS 35mm f/2.8 AL*, which rotates on the camera and tilts 10° off axis. That alphabet soup of mysterious letters merely designates their *Super PC* lens (for *Perspective Control*).

4. Leitz has adapted Schneider's 35mm *f*/4 *PA-Curtagon* (for *Perspective Adjustment*), setting it in a *Leicaflex* mount. This offers a lateral shift of 7mm in any direction, and a preset diaphragm.

The Optical Defects of Lenses

A double convex lens has seven defects that must be overcome if the image it produces is to be a true likeness of the object. These are: (1) *spherical aberration*, (2) *chromatic aberration*, (3) *astigmatism*, (4) *distortion*, (5) *curvature of field*, (6) *coma*, (7) *unequal illumination*.

Spherical aberration. Now, while all the rays of light that pass through a lens are refracted to practically the same extent, there is just enough difference in the refractive powers of different annular (*i.e.*, ring-shaped) portions of a lens to prevent all the rays of light meeting at a single point on its optical axis. It is this difference in the refraction of a lens that produces what is called *spherical aberration*. See *Fig. 3.4*.

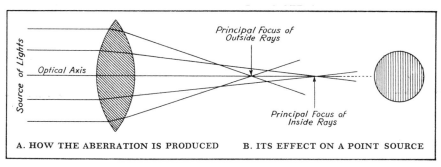

A. HOW THE ABERRATION IS PRODUCED B. ITS EFFECT ON A POINT SOURCE

FIG. 3.4. THE CAUSE AND EFFECT OF SPHERICAL ABERRATION

Spherical aberration is greater with a double convex lens than it is with a planoconvex one and, what is more, when the rays of light strike the flat side of the lens first, it is more pronounced than when it first strikes the curved side. Spherical aberration is, then, due to *the curvature of the lens* which makes it refract light unequally. The effect of this aberration, in small amounts, is to cast a haze of light over the image; in large amounts it spoils the overall sharpness of the image. This defect

becomes more troublesome and more difficult to correct, the larger the aperture (speed) of the lens.

Chromatic aberration. The light of the sun, as we have already seen, is made up of a number of distinct and identifiable colors, each with its own wave length. When these strike the retina of the eye, they produce in the brain the sensation of color. We proved this by splitting up a beam of white light with a prism, forming the seven colors in a narrow band on a screen; further, we saw how the different colors of the spectrum can be recombined by another prism so that they will produce a beam of white light once more.

When light waves of different lengths, and therefore different colors, pass through a prism or a lens, they are refracted unequally, the shortest waves, which make violet light, being bent at a greater angle than the longest waves, which make red light, as shown in the diagram *Fig. 3.5.* The result is that each ray of white light which enters the lens

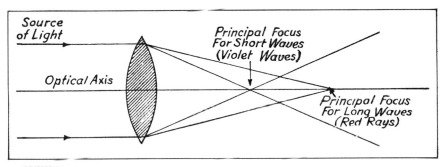

FIG. 3.5. THE CAUSE OF CHROMATIC ABERRATION

is split up into its seven component wave lengths and each of these in turn comes to a focus at a different point on the optical axis of the lens. Since most subjects reflect light of all colors, the *final* result of all this is that *seven* images are formed, each of a different spectral color, and each on a different plane of focus (and therefore of a different size). This throws the *visual* image out of focus and blurs the edges with rings of color. A photograph made with such a lens could never be sharp, since *six* of the images would always be out of focus.

Which brings us to the problem of *visual* vs. the *actual photographic focus* on the film. Except for special high red-sensitive panchromatic films used for special purposes, film is most sensitive to *violet* and *blue* light; but the human eye responds more readily to *yellow* and *green.* Also, the eye does a better job of distinguishing the sharpness of a green or yellow image than a blue one. If, then, we focus the lens visually, which is what we do when we use a ground glass as in a reflex camera,

that part of the light which affects the film most is out of focus. The result: *an unsharp picture.* To avoid this, the lens has to be corrected, to bring all the seven images together on one plane of sharp focus (see below, *How Lenses are Corrected for Chromatic Aberration*), or we must use a filter to screen out the other images. In the ordinary camera this is done quite simply by the use of a strong filter (dark green, orange or deep yellow) which cuts out most of the out-of-focus rays. The use of a filter has its limitations, however, because though we might in this way get a sharper picture, it would represent color values quite falsely. The most effective use of this phenomenon is in enlarging, where a heat-resistant blue glass, placed between the light source and the lens, will noticeably increase the sharpness of a print by screening the red rays which fuzz it up. The newer projection anastigmats, like the Kodak *Ektar,* the Schneider *Componon,* and the *El Nikkor,* are especially corrected to make *visual* and *photographic* focus coincide; with such lenses, the use of the blue glass would show no improvement. The projected image, in other words, would be sharp to begin with.

Astigmatism. This, the most serious and yet the most difficult lens fault to correct, is also a by-product of spherical aberration. Astigmatism means that a lens will not bring horizontal and vertical lines to a sharp focus at the same time on a flat screen. The result is that if a lens is not corrected for this defect, the lines running in one direction or the other will not be sharp, thus blurring the image. While it cannot be so easily corrected by giving a lens of ordinary glass a particular shape, it can be rectified by using a special kind of optical glass. A lens which corrects this fault is called an *anastigmat,* or one without the error of astigmatism.

Distortion. This is a by-product of spherical aberration which takes place at the edges of the screen. Distortion means that if a rectangular

FIG. 3.6. THE EFFECTS OF DISTORTION

figure, as shown by *A* in *Fig. 3.6,* is projected on a screen by a lens, it may appear as a barrel-shaped figure as by *B,* or as a pincushion outline as by *C.*

Curvature of field. Because *most* lenses are spherical[6] in shape, they create an image on a *curved field*, as in *Fig. 3.7.* Since the surface of a negative is *flat*, it is important that the image created by the lens also be flat; otherwise there will be a blur at all points not in focus on the plane of the negative.

FIG. 3.7. THE EFFECT OF SPHERICAL ABERRATION

Coma. This is the variation in the size and location of the image produced by the various parts of the lens. The result of this lens fault is that *points* of light at the edges of the image, traveling obliquely through the lens, emerge as *tear drops* of light. See *Fig. 3.8.*

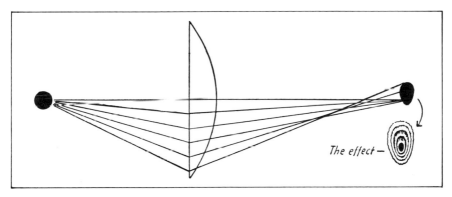

The effect—

FIG. 3.8. THE EFFECT OF COMA

Unequal illumination. Hold an open tube before your eye and swing it to one side until the outer rim begins to cut off the view. The opening of the tube, which was a perfect circle, has now become an *oval*. This is one reason why a lens cannot deliver full illumination at the edges of an image; the rays passing through obliquely are cut off by the edges of the barrel which holds the lens elements in place. The cure for this is to make the barrel as compact as possible. Another reason for unequal

[6] Aspheric lens surfaces (non-spherical, to solve the problem of spherical aberration) are now being developed by Leitz and Nikon, among others. The Leitz *Noctilux* is an example of such a lens.

illumination at the edges is *flatness of field*. Normally, a lens creates an image on a curved field (like the retina of the eye). When that happens, each point of light on that curved field having entered through a point in the center of the lens, travels the same distance to the field from the lens to the point of focus and thus delivers a proper share of the light. When the curved field is flattened, however, the light going to the outer edges has to travel farther, and is therefore weaker.

HOW LENSES ARE CORRECTED FOR SPHERICAL ABERRATION

Different schemes have been tried out to overcome or reduce the defect of spherical aberration. The most successful of these is to grind the lens so that both of its surfaces have different curvatures (depending

FIG. 3.9. HOW A LENS IS CORRECTED FOR SPHERICAL ABERRATION

on the index of refraction of the glass), when, of course, one of them will be much more convex than the other, as shown in *Fig. 3.9*. This is called an *aplanat* lens.[7]

HOW LENSES ARE CORRECTED FOR CHROMATIC ABERRATION

The splitting up of white light by a lens, through refraction of the different wave lengths or colors, is caused to a lesser or greater extent by two things. These are: (1) the kind, or nature, of the glass from which the lens is made, and (2) the refracting angle of the lens. There are two ordinary kinds of glass used for making prisms and lenses: (a) flint glass and (b) crown glass. Flint glass is made by melting sand, lead and soda together, while crown glass is made by melting sand, lime and soda together. Barium has been added to these two to make addi-

[7] See also Fig. 3.13, *The Achromatic Lens*.

tional kinds of glass with different refraction and dispersion indices. These kinds of glass are used because flint glass in general has high dispersive power with low refraction, while crown glass has high refractive power with low dispersion. The addition of barium alters these properties somewhat. The way that two prisms, one of which is made of flint glass and the other of crown glass, are arranged, so that the dispersion of the first is neutralized by the second, is shown by A in *Fig. 3.10.*

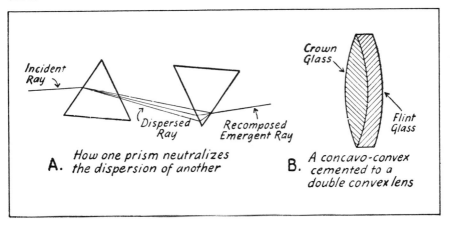

A. *How one prism neutralizes the dispersion of another*

B. *A concavo-convex cemented to a double convex lens*

FIG. 3.10. HOW A LENS IS CORRECTED
FOR CHROMATIC ABERRATION

It follows, then, that since the same principles which apply to prisms also hold good for lenses, it is possible to make a lens that will do away with chromatic aberration in the manner described above. Such a lens, shown by B, is called an *achromatic lens.*[8]

HOW LENSES ARE CORRECTED FOR DISTORTION

When a single convex lens is used, the distortion is the greatest. If you put a diaphragm (a device for controlling the size of the aperture and hence the portion of the lens used) or *stop* [9] as it is commonly called, in front of it, the barrel-shaped distortion is increased as shown by A in *Fig. 3.11;* and if you put a stop behind it, the pincushion distortion is increased as at B. But when two lenses or components are used and you put a stop between them, the distortion of each one reacts on the other and the effect is neutralized, as at C. Thus a photographic lens

[8] See also Fig. 3.13, *The Achromatic Lens.*
[9] See Chapter 4, "The Mystery of 'f.' "

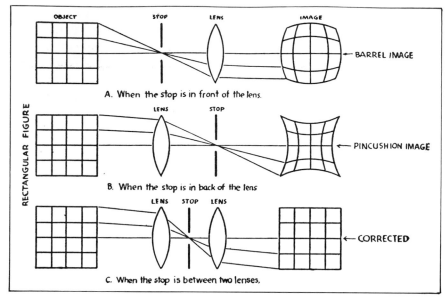

FIG. 3.11. HOW A LENS IS CORRECTED FOR DISTORTION

made with two achromatic components gets rid of the distortion. This forms what is called a *rectilinear*, or *symmetrical* lens.

HOW LENSES ARE CORRECTED FOR ASTIGMATISM

The glass used for making lenses that correct astigmatism is of a special kind, and is the result of experiments made by Abbe and Schott in Jena, Germany, ending about 1884. The new optical glass which they originated includes barium, boron and phosphorus as the extra ingredients, and it is these which give the glass its special optical properties.

Lenses made of *Jena glass,* as it is called, can be corrected for astigmatism, chromatic aberration, and field curvature, and at the same time have high transmission. This, of course, makes for speed, while they give images that are uniformly sharp from the center to the very edges, without being stopped down. Added to these good qualities, the lenses are ground and combined in accordance with advanced optical formulas, worked out by time-saving electronic computers. It now takes *minutes* to check out a formula which used to take *years*.

More recently, still other kinds of rare-earth glasses have begun to be used. Leitz, Zeiss, and Canon, for example, have all been experimenting with crystalline *calcium fluoride,* which is fragile and difficult to work, but has so low an index of color dispersion that it makes possible

the design of highly corrected telephoto lenses. The Konica *Hexanon* lenses use rare-earth glasses to which *Lanthanum* and *Zirconium* have been added. Leitz continues to develop new kinds of glass, and actually manufactures certain special types in small quantities for its own use. The recomputed *Summicrons* are the result of such research. Similarly, the recomputed *Summilux* is the result of fruitful tests with new kinds of high-refractive *Lanthanum* glasses.

HOW LENSES ARE CORRECTED
FOR CURVATURE OF FIELD

The best correction is by stopping down, making the diaphragm smaller thus cutting out the marginal rays.[10] No lens made to date can claim a perfectly flat field; the anastigmats are better in this respect than the others, but none is *fully* corrected. Factors determining the extent of the curvature produced by a lens are the kind and thickness of glass used, the position of the diaphragm, the distance between the various elements, and the distance between the object and the lens.

HOW LENSES ARE CORRECTED FOR COMA

There are two ways of correcting for this fault: (1) by the use of a *diaphragm*, as for curvature of field, which eliminates the oblique rays that produce coma, and (2) by *compensation*, which neutralizes the directional coma of one lens by the reverse coma of another. Thus, by placing two lenses together so that the coma of one corrects the coma of the other, this fault can be entirely eliminated.

HOW LENSES ARE CORRECTED
FOR UNEQUAL ILLUMINATION

Again the simplest correction is by the use of the diaphragm. Lens designers sometimes overcome this defect by increasing the diameter of the front lens, giving it a greater light-gathering power. This method was used in the design of the *Summicron* (see *Fig. 3.17*). When a lens is corrected for curvature of field, the angular rays have to travel farther to reach the surface of the film. This weakens the oblique rays (law of inverse squares) which accounts for the loss of light, along the edges of the image. The corrections here are the use of the diaphragm, a larger front lens element, and a more compact unit with a shorter barrel.

[10] *Caution:* There is a danger in too much stopping down. It will cause *diffraction*, which may ruin your picture; see *The Critical Aperture*, in the next chapter, "The Mystery of 'f.' "

How Lenses Are Made

About seventy years ago a German mathematician proved that it was theoretically, and therefore practically, impossible to make a perfect lens. Such a lens would reproduce each point of light as a *point*, each line as a *line*, all objects in their original tones and colors, place the entire image on a flat field, and have an aperture large enough to make the photographer almost independent of light sources. This dream lens can only exist in the imagination. The modern lens maker, by devoting some time to intricate and intensive calculations preparatory to actually grinding his lens, can now eliminate most of the wasteful drudgery that went with the trial-and-error method of lens manufacture used in the past. With this classic method, the first scientific approach to lens design, originally devised by Professor Abbe, Director of the University Observatory at Jena and a partner of Carl Zeiss, the lens maker can have in his hand, before he begins to grind his first lens, all the data needed to make it. Unless you're familiar with the long, drawn-out, heartbreaking process used by opticians years ago (lenses were ground and tested, reground and tested, reground and tested again, until the repeated trials proved something, *or nothing*) the saving in time and human wear by this new method would be hard to appreciate.

Almost any lens can be made to simulate a perfect lens, if it is used *monochromatically* (with a filter that screens out all but one of the seven spectral colors), if it is used to view only a *narrow field,* and if it is used at a *small enough aperture* (but not so small as to cause diffraction) and at a great enough *distance*. But that, obviously, will never satisfy the requirements of photography today. Hence the search for new and better lenses goes on.

The first step in the making of a new lens is the selection of a design. This is usually based on some old design, the characteristics of which are known, or on some modification suggested by the use of new materials. This design is then tested for aberrations *trigonometrically,* and before the advent of modern computers, required months or often years of computation. The design is then changed, and the various aberrations checked again, mathematically. More changes are made, until a formula is found which tests well *theoretically*, on paper. During all this testing, new kinds of optical glass, new lens shapes, and all sorts of focal lengths and speeds are tried. Sometimes a lens works better in one focal length than in another, in one speed better than in another. The two-inch $f/2.8$ Tessar, for instance, is said by some to be the best Tessar made; others claim this distinction for the $f/4.5$ Tessar in the six-inch size. At any rate, all these things are checked and rechecked until a good formula is found.

A sample of such a lens is then carefully made, and just as carefully tested. Too often, a lens which works out perfectly on paper is a dud in the camera. To obviate this, the new lens is put through all its paces, checked on a lens chart that exposes every one of its quirks and aberrations, it is tilted every which way to see how its definition stands up under extremes of use, and then photographs are taken with it indoors and outdoors on the most difficult subjects that can be found. While all this is going on, tests are also made for flare spots due to internal reflections, for the accuracy of the focusing scale and diaphragm numbers, and for the uniformity of the light it delivers. If the lens has any faults or weaknesses, these tests bring them out. Then, if all the tests show that the lens is satisfactory for the use for which it is intended, manufacture in quantity is begun. Even then, rigid tests all along the way check on the maintenance of a quality equal to, or better than, the model.

Kinds of Lenses

Though a simple convex lens will form an image, it has so many optical faults that it is not of much use to us in photography. The sort of lens used in even the lowliest box cameras is made of special glass and ground according to a special formula. Here are the basic types of lenses in use today: meniscus, achromatic, rectilinear, anastigmat, apochromat (used for color process and copying). Besides these, there are the lenses used for *enlarging*, and the special-view lenses known as the *wide-angle* and the *telephoto*.

Meniscus. This is a simple lens made up of only one piece of glass, and guilty of almost all the aberrations there are. As used in cheap box cameras it can deliver an image of usable sharpness, provided the negative is not enlarged. The *concave* side is usually turned toward the object, with the diaphragm and shutter *before* the lens. Today, most meniscus lenses for simple cameras are made of plastic, which is just as reliable as glass in simple lens formulas, and easier, faster, and less expensive to produce. The word meniscus means crescent-shaped.

FIG. 3.12.
MENISCUS
LENS

FIG. 3.13.
ACHROMATIC
LENS

FIG. 3.14.
RECTILINEAR
LENS

In order to understand why·a lens can have a fixed focus, it is only necessary to remember that when it is focused on an object that is not too close, everything beyond that object and away from the lens will also be fairly sharp. This holds good for *all* lenses. In small box cameras, the object distance is set at ten feet for the largest sizes, and about fifteen feet for the smallest sizes. See *Fig. 3.12.*

Achromatic. This is a single lens made up of two or more pieces of cemented glass. It is partially corrected for *spherical* and *chromatic* aberrations, and produces a passably sharp image provided the aperture is not too large, so that the unreliable outer portion of the lens is not used (at about $f/12$),[11] if only a *narrow angle of view* is used. However, depending on whether the diaphragm is used before or after the lens, it is still afflicted with distortion, which makes it unfit for use whenever a straight line has to be reproduced as such. The achromat is also sometimes known as the *aplanat* (a lens corrected for two colors to give an image as free as possible from chromatic and spherical aberration; the first such lens was introduced by Karl August von Steinheil in 1866) or the *symmetrical.* See *Fig. 3.13.*

Rectilinear. By bringing two achromatic lens combinations together as a single unit and setting the diaphragm between them, it is possible to eliminate barrel and pincushion distortion. The resulting lens is known as the *rapid rectilinear.* Its corrections make it usable at openings larger than in the case of the achromatic (as large as $f/8$). See *Fig. 3.14.*

Anastigmat. When applied to a lens, the term *an*astigmat indicates that it is *not* astigmatic—or rather, that it is *free* from astigmatism. As the apertures of rapid rectilinear lenses were made larger, the aberration of astigmatism, caused by the rays which enter the lens at an oblique angle, became more and more of a problem. Though lenses made of crown and flint glass can be corrected for chromatic and spherical aberration and for coma, they cannot be cleared of astigmatism. On the other hand, barium glass lenses can be corrected for astigmatism, but still suffer from spherical aberration. This problem was solved in 1893 by Dr. E. von Hoegh, who worked out a formula for a lens to be made of the new barium glass, just then made available at Jena, in combination with crown and flint glass. When this lens was completed, it was found that astigmatism, the curse of all other lenses produced up to that time, had been reduced to a new and remarkable low. This lens was

[11] These numbers preceded by f's ($f/2.8$, $f/12$, etc.) are to designate the size of the diaphragm opening, the size of the hole controlling the amount of light that passes through the lens. When an "$f/4.5$ lens" is referred to, as we have already referred to the "$f/4.5$ Tessar," this relates to the largest diaphragm opening that the lens has—$f/4.5$ in this case. (Such a lens would have other, smaller diaphragm openings, of course.) Notice that the larger the opening, the smaller the f number. The larger the largest stop, the faster the lens is said to be. (This use of "fast" does not concern the speed of the *shutter.*)

the Goerz *Dagor,* and it is still manufactured and sold here in America. Goerz is now a division of the Kollmorgen Corp., whose headquarters are in Pittsburgh, Pa., but the Dagors are being mounted and assembled in a plant at 369 Willis Avenue, Mineola, N.Y. 11501, as well as in Northampton, Mass., where the lens grinding and polishing are being done. Coming soon is a new version of the Dagor: the long-rumored *f*/5.6 Super-Dagors. There are two models of this: one, the SL–, for close work, and the other, the SV–, for infinity to 10 times the focal length's range. The Dagor was the first lens that could form an *overall* sharp image on a screen at *full* aperture. There are few lenses, if any, that can equal it for making crisp, sharp pictures. See *Fig. 3.15.*

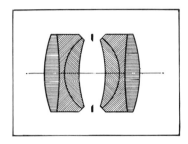

FIG. 3.15. ONE OF
THE FIRST ANASTIGMATS—
THE GOERZ DAGOR

Following this lens came other anastigmats that were made of various kinds of the new glass according to the formulas of other celebrated mathematicians and constructed by the greatest lens makers. Of these, the Zeiss anastigmats have found great favor, one type of which, called the *Protar,* has convertible components as shown by *A* in *Fig. 3.16,* and the other, the *Tessar,* has non-convertible components as shown by *B.* The Tessar structure has become a basic design, being widely copied by other lens makers.

Most anastigmats, as *A* and *B* in *Fig. 3.16* show, are made with components formed of two or more lenses, some of which are cemented together, and others separated by air spaces; the purpose, however, of all of these variations in design is the same: to give an image of the best possible definition and the flattest field, and one that is free from spherical aberration, distortion, coma and color shifting.

In the case of some anastigmats, notably the Dagor, the Protar, and the Plasmat, the front and rear components can be used independently of one another, as well as together, to get varying sizes of image from the same camera position.

The fastest anastigmats (*i.e.,* those with the widest apertures) for still cameras made today are the Canon *f*/0.95 and *f*/1.2, the Leitz *Noctilux* *f*/1.2, the Konica *Hexanon AR* *f*/1.2, and the Zeiss *Planar*

$f/1.4.$[12] They are made for use in *miniature cameras* (like the Nikon, Canon, Konica, Contarex, and Leica). Besides the $f/2.8$ *Elmar* and the $f/3.5$ *Tessar*, which are both good, one of the best corrected anastigmats for miniature camera use is the *Summicron* $f/2$. Its large front element

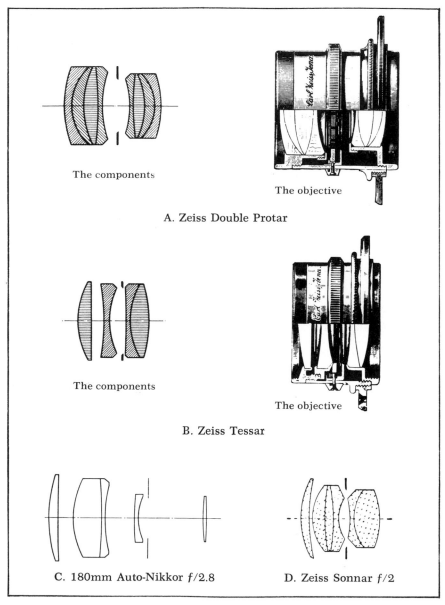

The components

The objective

A. Zeiss Double Protar

The components

The objective

B. Zeiss Tessar

C. 180mm Auto-Nikkor $f/2.8$

D. Zeiss Sonnar $f/2$

FIG. 3.16. TYPES OF ANASTIGMATS

is made of a new type optical glass which resists climatic changes, increases marginal illumination, and improves definition. Another superb lens for miniature cameras is the 50mm *Nikkor* f/1.4 (which started something of a revolution when the *Life* photographers came back from Japan with this fantastically sharp lens after the war). For wide-angle use with the *Leica*, there is the excellently corrected 35mm *Summaron* f/2.8, the 35mm *Summilux* f/1.4, and the 28mm *Elmarit* f/2.8. For the Nikon, there is the 35mm *Auto-Nikkor* f/2.8, one of the finest lenses of its kind. The Kodak Ektar, which is made in various speeds and focal lengths, is another splendid example of the anastigmat at its best; based

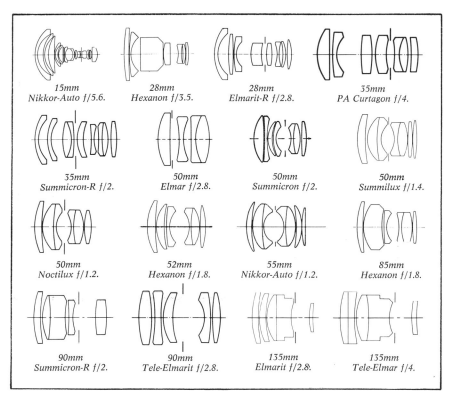

15mm
Nikkor-Auto f/5.6.

28mm
Hexanon f/3.5.

28mm
Elmarit-R f/2.8.

35mm
PA Curtagon f/4.

35mm
Summicron-R f/2.

50mm
Elmar f/2.8.

50mm
Summicron f/2.

50mm
Summilux f/1.4.

50mm
Noctilux f/1.2.

52mm
Hexanon f/1.8.

55mm
Nikkor-Auto f/1.2.

85mm
Hexanon f/1.8.

90mm
Summicron-R f/2.

90mm
Tele-Elmarit f/2.8.

135mm
Elmarit f/2.8.

135mm
Tele-Elmar f/4.

FIG. 3.17. SOME MINIATURE CAMERA LENSES

on the design of the Tessar, it has improved on the Tessar's already excellent corrections. It was one of the first lenses to have all the inside air-glass surfaces coated to increase light transmission and reduce glare.

[12] Zeiss also produced a *Planar* 50mm f/0.7, which was demonstrated in an experimental Zeiss Ikon camera in 1968, but it was never offered for sale.

Apochromatic. The exacting requirements of color process work, where the lens must produce a precise and perfect photographic copy of the object, has stimulated lens manufacturers further to improve the corrections of the anastigmat. The result is the *apochromat,* a lens so perfectly corrected that it not only produces images of equal sharpness on the same focal plane through all the various color filters, but the negative images are of exactly the same size so that color plates made from these negatives will register perfectly.

A good example of the apochromatic type of lens is the Goerz Artar, an air-spaced, uncemented combination consisting of four lens elements, two of which are symmetrically placed on each side of the diaphragm. It is said to be fully corrected for chromatic and spherical aberrations, coma and astigmatism; is free from zonal aberration and flare; and its symmetrical construction prevents linear distortion. (The maximum speed is $f/9$ and it is made in various focal lengths.) Among the manufacturers of such lenses are Goerz, Rodenstock, Carl Zeiss, and Nippon Kogaku (who also produce Nikkor lenses and the Nikon camera).

Aspheric lenses. The introduction of new rare-earth glasses of high refractive indexes (greater light-bending power) and the discovery of new manufacturing techniques (making possible the reproduction of aspheric curvatures on a mass basis) has made the production of aspheric lenses such as the 50mm Leitz *Noctilux* $f/1.2$ commercially feasible. The new rare-earth glasses alone could not have done it. Crown or flint glass could also have been used. The breakthrough in aspherics came with the new-found production skills. These obviated, to some extent, the slow and meticulous grinding and polishing which made such lenses very expensive, and therefore impractical for general use.

Aspheric means non-spherical; in other words, the deformation of a spherical surface to form an elliptic or egg-shaped surface. The advantage of such an optical form is that it can save lens elements in a design, reducing a typical 14-surface, 9-element $f/1.8$ to a more compact 10-surface, 7-element lens of the same speed.

Normal lens. The focal length of a *normal* camera lens is the *diagonal* of the picture size.

This diagonal also defines the *circle of definition* of the lens. To avoid vignetting or losing definition, a lens must be able to cover more than this minimum circle of light. The larger area which a good lens covers is called the *circle of illumination.*

The angle of view of a normal lens is about 45–50°.

For a full frame 35mm negative (Leica, Nikon, etc.) the picture size is 24 x 36mm, or about 1 x 1½ inches, and the diagonal is 43.2mm or 1.7 inches. For that, the normal lens should be 45–50mm.

Theo Kisselbach, head of the Leica Technique and School Depart-

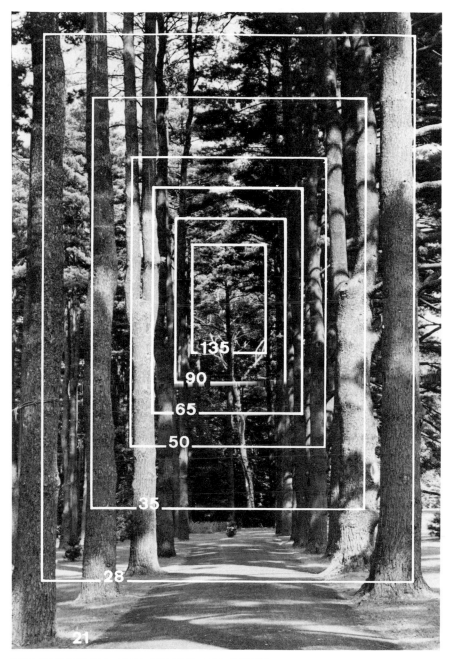

PERSPECTIVE AND FIELD OF VIEW

Here are the fields of view of seven miniature camera lenses, all used from the same spot. This illustrates the fact that when lenses of different focal length are used at the same distance, the perspective always remains the same. The perspective changes only when the viewpoint is changed.

ments at Leitz in Wetzlar, author of *The Leica Book* and editor of the third revision of Hans Windisch's *The Manual of Modern Photography* (published in English by Heering Verlag, 1971), suggests that you carry a full 35mm transparency frame with you at all times, as a way of finding the right picture area for each lens. For the normal 50mm lens, hold the frame 2 inches or 50mm from the eye; for the 90mm telephoto lens, 90mm or 3½ inches from the eye, etc.

The normal lens for a TL reflex like the 2¼ inch square (6 x 6cm) Rolleiflex, or the 2¼ inch square SL reflex like the Hasselblad 500C, the Mamiya C330, or the Rolleiflex SL66, is usually 80mm. The diagonal of the picture size in each case is roughly 3⅜ inches or 84mm.

Wide-angle lenses. To get more of the scene in, without moving the camera back (which might be impossible in many cases) we must use a lens with a broader angle of view, one whose focal length is shorter than "normal" for the film area covered. Such a lens is called a *wide-angle* lens. As a rule, the curvature of such a lens is considerably greater and the components are mounted closer together. These lenses are especially useful for photographing interiors of buildings, and for exteriors where the space around them is restricted. Because it tempts you to get closer to objects, the wide-angle lens distorts perspective; that is not, however, a fault or property of the lens itself, but rather a fault in the way it is used. Perspective, as shown by the photograph on page 69, is not a property of the lens at all.

An example of an extreme wide-angle lens is the special Nikkor shown in *Fig. 3.18,* and described below. The Leitz Elmarit 28mm *f*/2.8 is another excellent wide-angle lens. It has an angle of view of 76°.

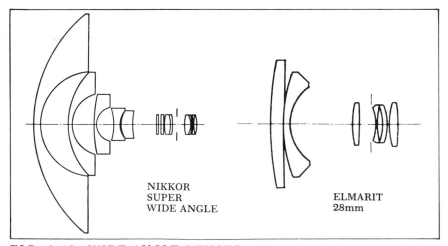

NIKKOR
SUPER
WIDE ANGLE

ELMARIT
28mm

FIG. 3.18. WIDE-ANGLE LENSES

Fisheye lens. This is an extreme or ultra-wide-angle lens. To make it possible to take in so wide an angle (from 110° to as much as 220°), fisheye lenses have a highly curved protruding front element that resembles the eye of a fish, from which they get the name. These lenses have apertures of from $f/2.8$ to about $f/8$. Their extremely short focal length makes it almost unnecessary to focus, since the depth of field extends from infinity (∞) to a few inches from the lens.

The lenses usually yield a circular image, though some do cover the full negative area. All show considerable distortion, mostly near the edges of the field, and some show a curved picture, the so-called *fisheye effect* (as if everything were being seen on the *surface* of a ball).

Though complex in design, fisheye lenses are not difficult to manufacture. They are rarely corrected for linear distortion, so their construction can be simplified.

The fisheye lens is basically a telephoto lens reversed back to front (*retrofocus*). The telephoto usually has a *positive* front element and a *negative* back element. The ultra-wide-angle, on the other hand, has a *negative* element in front and a *positive* element in the rear. This produces a much wider angle of view than a normal lens, or even a regular wide-angle lens. It's as though you were looking through the wrong end of a telescope or a monocular (half of a pair of binoculars).

An example of a super-wide lens is the Nikkor shown at left in *Fig. 3.18.* This is a Nikkor *Auto* 8mm $f/2.8$, with an angle of view of 180°, which provides full hemispherical coverage over the entire horizon. Unless you are careful, you may even get your feet into the picture when using this lens.

The 15mm Zeiss *Hologon* $f/8$ is another example of the fisheye. It has an angle of view of 110°. It is a fixed focus lens, set into a camera body that was especially made for it. Other such lenses offered by Nikon are the 6.2mm Nikkor $f/5.6$ (220°); the 7.5mm Nikkor $f/5.6$ (180°); and the 10mm Nikkor $f/5.6$ OP (180°).

Spiratone offers a variety of fisheyes. One of the most interesting is the 100° 18mm $f/3.5$ ultra-wide-angle, which does not distort straight lines (avoids the fisheye effect) and can be coupled for automatic meter operation to these focal plane SLR cameras: Canon, Exakta, Leicaflex, Mamiya, Minolta, Miranda, Nikkormat, Nikon, Pentax, Petri, Practica, and Yashica. It uses a 10-group, 12-element *retrofocus* design. The price is about $100. Another fisheye offered by Spiratone (at about half that price) is the 180° *auxiliary*, which can be fitted to your normal or telephoto lens (rangefinder or single-lens reflex, provided you have access to a ground-glass view). The image is circular. You can buy extra fittings for other lenses or cameras. For information about these and other Spira-

tone auxiliary lenses, write to Spiratone, Inc., 135–06 Northern Boulevard, Flushing, N.Y. 11354.

Telephoto. When you want a large image of a distant object; when you plan to take a *portrait* (of just the face) and want to avoid distortion; or when you are planning *candids* or *sports* shots, a telephoto lens is what you need. For portraits, presupposing that you are using a 35mm camera, either a 90mm or a 135mm lens would do fine; for sports, a 200mm lens would be excellent. A good example of such a lens is the Leitz *Telyt* shown in *Fig. 3.19*. I prefer the 200mm $f/4$ size, but it is also

FIG. 3.19. A TELEPHOTO LENS. THE LEITZ TELYT
200mm $f/4$. For use with Visoflex.

available in the 280mm, 400mm, and 560mm focal lengths (with speeds of $f/4$ to $f/5.6$). In order to enable it to bring things closer, the telephoto lens is made on the principle of the telescope, with a convex, or converging, component in the rear. The difference between a telephoto and an ordinary lens of the same focal length is illustrated in *Fig. 3.20*. The telephoto, as you see, is much more compact. The use of a negative lens to correct excess convergence makes this compact design possible. There are telephoto lenses for 35mm cameras in sizes that range from 75mm to 1200mm, and even beyond (2000mm!).

Since the weight of a camera fitted with a telephoto makes it difficult to hold steady by hand, it should either be used at high shutter speeds (1/250 to 1/1000), with electronic flash, or be mounted on a tripod or other firm support; otherwise, the image will be blurred. Also available: *Unipods*, that can be carried like a cane and are easier to use than a tripod (for intermediate speeds of 1/10 to 1/100); and *gun-stock mounts* or *shoulder braces* that are available in various styles, for animal or bird photography. The safest shutter speeds to use are 1/250 to 1/500 second. As a matter of fact, Jacob Deschin reports that an exposure

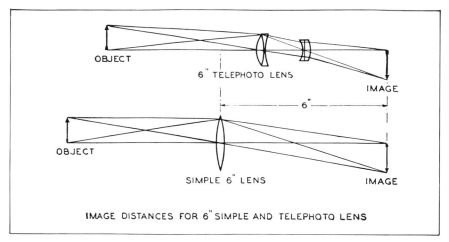

IMAGE DISTANCES FOR 6" SIMPLE AND TELEPHOTO LENS

FIG. 3.20. THE DIFFERENCE BETWEEN A LENS
OF LONG FOCUS AND A TELEPHOTO

made at 1/250 and $f/1.8$ is always sharper than 1/60 at $f/5.6$, which is supposed to be the *optimum* (sharpest) opening.

For shooting birds and other objects at vast distances, there is the superb catadioptric (lens and mirror) telescope called the *Questar*, 1400mm at $f/14$ (when close-coupled), and 1400mm at $f/16$ (with 50mm extension). It is a magnificent accessory that can be coupled to almost any good 35mm camera, and it weighs only 6.7 pounds.

Zoom lens. This is a variable focus lens, so designed that it can take the place of a whole battery of lenses. First used in motion picture and television studios, it is now available for still and motion picture cameras as well as for slide and movie projectors.

There are two types:

1. The zoom type, like the Asahi Super-Takumar 70–150mm $f/4.5$ for the Honeywell Pentax and other 35mm SL reflexes with compatible lens mounts, which focuses automatically and smoothly for each focal length between those marked. You first focus at the farthest extension (150mm), then you rotate the lens ring for the image size you prefer. For the Konica there are two Auto-zooms (the 80–200mm $f/3.5$ and the 47–100mm $f/3.5$). For the Leicaflex, there is the *Angénieux Zoom* $f/2.8$ 45–90mm, made by the internationally famous producer of zoom lenses, Angénieux of Paris. It has a fully automatic preset diaphragm with click-stops and half-stops from $f/2.8$ to $f/22$; continuous adjustment of focal length from 45 to 90mm; focusing range from ∞ to 40 inches.

2. The *non*-zoom type, like the 35–100mm *Variable Focus* Hexanon $f/2.8$ for the Konica Auto reflex T and A cameras. As you change the

focal length of this lens, the focus is upset, so manual refocusing is necessary at each new focal length. For more information, contact Konica Camera Corp., 25–20 Brooklyn Queens Expressway W., Woodside, N.Y. 11377. Another lens of this non-zoom type is the Enna 85–250mm. This has a preset diaphragm and is available in a fitting for all models of the Leitz Visoflex, as well as in mounts for the Exakta and the Pentax. For more information: Exakta Photographic Corp., 156 Fifth Ave., New York 10011.

An inexpensive way of adding an extra focal length to the telephoto you now own is to get a Spiratone *TeleXtender*, which will increase the effective focal length of your lens, but can still be focused to infinity by the use of negative lens elements. This would apply only to ground-glass cameras or single-lens reflexes. For information, contact Spiratone, Inc., 135–06 Northern Blvd., Flushing, N.Y. 11354, or check with their Manhattan store at 130 West 31st Street, if you happen to be in New York.

Also available: Soligor 2x and 3x Tele-Converters (from Allied Impex, 168 Glen Cove Road, Carle Place, New York 11514).

Macro lenses. Most lenses for SL reflex cameras are fine for infinity to medium close work, but they do not operate well at short distances, for images that are 1:1 (life-size), 1:2 (half life-size), or even 1:3 (a third life-size). If you want extreme closeups of insects, stamps, gems, or whatever, you either have to remove your lens from its regular focusing mount and remount it on a bellows focusing attachment, or you have to get one of the many macro lenses now available for that purpose.

Though the new macro lenses are offered for distance work (to infinity) as well as for closeups, these lenses were never computed to work at infinity.

Camera lenses, however, are normally corrected for infinity; but they do not work as well at short distances closer than ten times their focal length.

Enlarger lenses, on the other hand, are designed to favor close distances. The Schneider *Componon*, for example, works best in the magnification range of 10x and up. For magnification ratios between 2:1 and 6:1, Schneider offers the *Comparon* which is custom-made for negatives larger than the 35mm.

According to Herbert Keppler and Bennett Sherman of *Modern Photography* (who did much testing of macro lenses): though such lenses may be superior to regular camera lenses for close work, they are certainly not any better for distance, *and they may even be worse.*

When you are taking pictures with a macro lens, use a sturdy tripod. Keep in mind that you are operating close; the slightest vibration, or variation in distance, will destroy sharpness. And, whenever possible,

use a cable release. Furthermore, to avoid jarring the setup, flip the mirror of your SL reflex or Visoflex *before* you start the exposure.

Leitz offers two lenses that are excellent for macro work: a dual range *Summicron f/2* (which can focus as close as 19 inches with range-finder focusing and automatic parallax compensation); and their 65mm *Elmar f/3.5*, designed especially for closeup work (to 7″) with Visoflex II or III and the Universal Focusing mount.

Fiber optics. About ten years ago, the *British Journal of Photography* described a new lens designed for military use, an *f/0.57 fiber optic* with a speed 40 times greater than that of a conventional *f/2* lens. The lens is made up of bundles of flexible glass fibers which are then fused together into a solid mass, ground, and polished. Similar fused fiber bundles can be used as cathode ray tube faceplates. This means that a film can be placed directly against the faceplate of such a tube and record an image without using a lens.

The Radio Corporation of America, The American Optical Company, and Bausch and Lomb were all involved in testing and producing such optics for the U.S. Air Force. Here is a diagram of how a fiber optic works:

FIG. 3.21

Though you cannot transmit an image through an individual fiber, you can arrange a bundle of fibers in such a way that the pattern at one end duplicates exactly the pattern at the other. That way, each fiber in a bundle transmits the amount of light it receives from the part of the image it faces. The result is an image composed of light patches which duplicate those of the original.

Soft lens. Perhaps the last word in lens construction was announced in 1972 by NASA, in conjunction with Allied Research Associates. Taking a cue from the human eye, J. Howe of ARA came up with the concept of a lens mechanism that includes two outside elements made of rigid glass and a soft inside element made of an elastic transparent membrane, the curvature of which can be controlled by a pressure regulating device. The liquids (or gels) in the elastic membrane and in

the area between that and the outside glass would be of different refractive indices. The changing pressure, because it can alter the curvature of the inside lens pod, controls the focusing of the lens.

Enlarging lenses. The normal *taking* lens for a still camera is corrected for infinity. That means that it gives its *best* performance for distant objects, when the lens lies closest to the focal plane. Though a well-corrected anastigmat can be used for closeups, it does not give so flat a field, and because of the increase in oblique rays from short object distances there may be an increase of coma and other aberrations. For that reason most manufacturers recommend that a taking lens be stopped down when used for enlarging. A better way is to use another lens for this purpose—one that has been corrected especially for short distance focusing, and one that has a flatter field at those distances than the regular camera lens can possibly have. Good examples of such lenses are: the Rodenstock *Omegar, Omegaron,* and *Rodagon;* the Schneider *Componar* and *Componon;* the Kodak Enlarging *Ektar* and *Ektanon;* the *El Nikkor;* and the Wollensak Enlarging *Raptar.* The *Componar* and the *Ektar* are especially well designed for this purpose, being constructed of *uncemented,* heat resistant lens components, which make them perfect lenses for enlarging, where heat may be a problem.

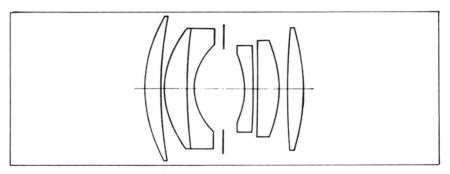

FIG. 3.22. ONE ELEMENT LESS (NEW SUMMICRON)
The recomputed *Summicron* 50mm *f*/2. The previous versions have now been replaced by this *six*-element lens (against the older *seven*). It has a continuous focusing range from infinity to 28 inches, except on the Leica M3, with which it focuses by rangefinder only to 3'4" (beyond that, at close range, you have to guess-focus by scale). The new lens is black, while the older one was finished in chrome. The simplified design yields higher image contrast, a flatter field, and greater freedom from vignetting at high apertures (*f*/2 to *f*/4).

Auxiliary lenses. For certain types of lenses and cameras, especially single-lens reflexes and those with double extension bellows, there are supplementary lenses available for shortening and increasing the focal

length of the original lens. Such telephoto and wide-angle units are available in screw-in mounts or adapter rings for series V, VI, VII, and VIII sizes. For information, contact: Saul Bower, 114 Liberty St., New York 10006; Camera Specialty Co., 705 Bronx River Road, Bronxville, N.Y. 10708; General Photographic Supply Co., 311 Cambridge St., Boston, Mass. 02114. For fisheye attachments: Allied Impex Corp., 168 Glen Cove Road, Carle Place, N.Y. 11514 and Spiratone, 135–06 Northern Blvd., Flushing, N.Y. 11354.

Another supplementary lens available for amateur use is the *soft focus* or *diffusion disk*. This deliberately blurs the photographic definition and clarity that lens makers have tried so hard to give you. The use of them, quite a vogue years ago, makes no sense at all today. It's simple enough to diffuse your image when you enlarge it (by interposing some crumpled cellophane or a nylon stocking stretched on a hoop, or by kicking the enlarger). Get the sharpest and clearest image you can on your negative; you can always lose that crisp definition later, *if you want to*. In fact, it's only too easy, as you will soon discover when you start to make enlargements.

A PERFECT LENS MAY SPOIL THE PICTURE

A curious thing about modern lenses, as Geoffrey Crawley points out in the *British Journal of Photography*, is that the closer we get to eliminating *all* aberrations in our lenses, the further away we get from the lens that makes a pleasing picture, because "residual aberrations" help make a photograph more life-like. Image quality includes *detail* and *gradation*. And the "perfect" lens (without soft gradation) may ruin our picture.

LENS COATING

Age, in combination with exposure to sun and air, frequently causes lenses to tarnish. When this occurs the surface acquires a perceptible discoloration, which has prompted some people to get rid of otherwise perfectly fine objectives. Not too many years ago it was discovered that this tarnish actually improves a lens, makes it sharper and somewhat faster. Optical scientists learned that the tarnish reduces light reflection, allowing more light to pass through the lens than was the case before it had become tarnished. Experiments finally led to one of the most important advances in the science of optics in the last thirty-five years— artificial aging, or lens coating.

Photographic lenses consist of a number of elements. Some of these are single lenses, others consist of two or more single lenses cemented

together. The points at which lenses lose efficiency in transmitting light are the free surfaces; *those*, in other words, *which are in contact with air*. Transmission loss at each such surface, according to Bausch & Lomb, optical experts, is about 5 per cent due to reflections from the surface of the glass. If a lens structure has eight such surfaces the loss of light transmission through surface reflections may amount to as much as one-third. These surface reflections also give rise to internal lens reflections causing flare, which results from shooting toward the sun or other light source.

Coating the free surfaces of lenses greatly overcomes these reflection losses and the tendency to flare. The coating, which is about four-millionths of an inch thick, has a lower refractive index than the glass elements of the lens. Practically all lens makers now include a coating machine in their assembly line. All new lenses are therefore *pre*coated.

You may not have been aware of it, but peacock feathers and oil slicks, oyster shells and soap bubbles, all have one thing in common. Those beautiful, changing patterns of iridescent color are the result of the same natural phenomenon: *optical interference in a thin layer*. The oldest use of this principle is, as we have seen, in the *single-layer* coating of camera lenses. Sometimes, single-layer coatings of *magnesium fluoride* of varying thicknesses are used to gauge the thickness of coatings on a wide variety of other optical surfaces. Comparing colors in reflected light, against color plates of known *micron* depth, reveals the depth of the new coatings. More recently, complex interference coatings have been developed in which layers of varied materials are deposited on an optical surface. Such sandwich layers are used not only to subdue unwanted reflections, but for many other reasons (such as *filters, polarizers, beam-dividers,* and *highly reflective mirrors*). Stacks of many-layered film coatings are needed for such optical systems as *lasers, color television cameras,* and *infrared missile-guidance systems.*

And now the sandwich layer has been *re*discovered by the manufacturers of camera lenses. Honeywell, the American distributor of *Takumar* lenses and the Asahi *Pentax*, began to tout the virtues of *super-multi coating* at the end of 1971.

It all started when the Optical Coating Laboratories of California found that single-layer antireflection coatings were not doing their job well with lenses of six, seven, or more elements, and especially with violet or ultraviolet light. Such lenses, in such light, and when pointed toward the sun or in very bright light, showed troublesome ghost images and developed flare problems. There was also a loss of contrast due to what was mistakenly assumed to be atmospheric haze (but which really turned out to be flare). The solution was *more of the same:* that is, from

three to *ten* coatings, depending on the construction of the lens and the way it was going to be used, instead of the former *single* coating.

A lens with six glass-air surfaces (like the *Elmar* or *Tessar*) could transmit only about 70 per cent of the incident light, *uncoated,* yet almost 90 per cent when *single*-coated. This represents a speed increase of 25 per cent! But when lenses are *super-multi* coated, their light transmission can go as high as 99.7 per cent.

Though there has been much controversy about these claims and the proof submitted by Asahi (who were among the first to put their lenses commercially through the multicoating process), impartial testing by the laboratories of at least two photo magazines (*Modern Photography* and *Popular Photography*) seems to back up the contention of Honeywell and Asahi, that super multi-coating is a useful process. Multiple-layer antireflection coatings do offer many advantages, and the more complicated the construction of the lens, the greater the advantage.

BUBBLES

When you find bubbles in your lens you can be sure that it has been made with the best new optical glass. The chemicals used in making such glass form gasses which, inevitably, create bubbles. This cannot be avoided. But unless the bubbles are large and numerous, they do not affect the performance of your lens at all. They may obstruct a few rays of light, but the total amount of this loss would not exceed 1/5000 of the total light streaming through the lens, even if stopped way down, so there's nothing to worry about. To do as much harm as one of those old-fashioned diffusion disks or an inaccurately timed shutter, the lens would have to be so full of bubbles that you could hardly see through it.[13]

Care of the Lens

To get the best out of your lens, take good care of it: (1) Always keep it covered when not in use. If the design of your camera permits it, use lens caps for both the front and rear elements. (2) Never take it apart yourself for cleaning. The lens was put together in an air-conditioned, dust-free room. If *you* try it, you'll let dust and moisture get between the elements, with sad results. (3) Do not expose it to the sun for long periods. (4) Avoid keeping it in damp or warm places. (5) Do not subject it to extreme variations of temperature. (6) Don't put your

[13] In July 1956, Dr. Masao Nagaoka of Nippon Kogaku (Nikon) announced the invention of a new type of ceramic crucible that "virtually eliminates bubbles."

fingers on its surface, *ever*. (7) Don't drop or jar it. (8) Never use alcohol or other solvents to clean it.

The best way to clean a lens is to brush its surface *gently* with a little camel's hair brush reserved only for that use, or to blow the dust away with a rubber ear syringe. If that doesn't do the trick, use some dry lens tissue, or an old linen handkerchief that has been freshly laundered, first breathing on the lens (very, very lightly) and then *softly* wiping it with the tissue in a rotary motion. *Don't clean it too often or too hard.* You may scratch or dull the highly polished lens surface.

If you follow the directions above, you should never have to do more than dust it occasionally with the brush or syringe. If the lens needs much more than this to clean it properly, send it to one of the big camera shops for servicing. They have experts on their staffs who know how to do it, and the small charge they'll make for this service is well worth it.

How to Be Sure of Sharp Pictures

The lenses on most good cameras have greater resolving power (the ability to separate more lines per square inch of image) than almost any film now made. Why, then, is it so difficult for amateurs to get sharp pictures? Perhaps it's because they neglect such obvious precautions as these:

1. Be sure to focus exactly, whether by *distance scale* (this requires testing), by *rangefinder* (check this against a ground-glass image if your camera permits it, or have the manufacturer . . . Leitz, for instance, if you own a Leica . . . check it for you), or by ground glass (see *Some Focusing Hints* at the end of chapter 8, "The Picture"). A quick check for a range-finder camera is to set the lens at infinity and then snap some building beyond 500 feet. This test is not inclusive (for any other distance) or conclusive for infinity, but it's reassuring if you're out of reach of a repair shop.

2. Be sure not to jerk the camera. Tests by experts have shown that any shutter speed slower than 1/100 second is dangerous. *Use a tripod,* a *unipod*, or a *chest brace* for slower speeds. These are the recommended speeds, except in an emergency: with *normal* lens, 1/100; with *wide angle*, 1/60 to 1/100; with *telephoto* of 135mm to 200mm, 1/250; with *400mm* or more, 1/500. If you can learn to brace the camera to your head or body, you may be able to use 1/100 to 1/250 most of the time.

3. Be sure to use the sharpest part of your lens, *the center*. You do this by stopping down (see *index:* critical aperture) to such median openings as $f/5.6$ to $f/6.3$ with a miniature, or $f/8$ to $f/11$ with a larger camera. Use the larger openings only for bad light conditions or special effects; the smaller, to get greater depth of field.

4. Check your equipment frequently to be sure it's in good working order. See chapter 17 ("What's Wrong?").

5. Use sharp-resolution films (such as *Panatomic X, Fuji Microfilm HR* with H & W *Control* developer, *Adox KB 14* and *KB 17, Plus X,* and Kodak *High Contrast Copy* film or H & W *VTE* film with H & W Control developer).

6. Use fine-grain developers that do not degrade the sharpness of the image (such as D 76; Neofin Blue, Willi Beutler's developer; D 25; Windisch 665; Microphen; Clayton P 60; Microdol; Promicrol; X 22; Acufine; Diafine; Rodinal and H & W Control developer for Kodak's High Contrast Copy film, to which it is mated to give *continuous tone* negatives). You can get information about this remarkable combination for highest resolution (High Contrast Copy film and H & W developer) from the H & W Company, Box 332, St. Johnsbury, Vermont 05819.

7. When focusing an SL reflex or an enlarger, always set the lens at the widest aperture. This increases image light, reduces depth of focus, and allows more critical visual focusing. Use of a magnifier on the ground glass of the camera enlarges image circles of confusion, making focusing more critical.

Illustrating one talent of the f/stop: its ability to bring in *foreground* as well as *distance*. See *What a Stop Does*.

4 The Mystery of "*f*"

The sixth letter of the alphabet is the most frequently used symbol in photography, yet very few really know what it stands for. It does not, as some believe, indicate the focus or focal length, expressed in inches or mm (as in 50mm Summicron). It is an abbreviation for the term *factor* and symbolizes an arithmetical proportion; the relation between the diameter of the widest lens opening, or *effective aperture*, and the *focal length* of the lens (given below in inches). For example, any of the following lens combinations would have a factor of 2, or be rated as f/2 lenses (focal length divided by the diameter of the effective lens aperture):

a 1″ lens with an aperture of ½″
a 2″ lens with an aperture of 1″
a 3″ lens with an aperture of 1½″
a 4″ lens with an aperture of 2″
a 5″ lens with an aperture of 2½″
a 6″ lens with an aperture of 3″

The "f," as you see, indicates the *speed* of the lens, or the amount of light it lets through in proportion to its focal length. Amateurs sometimes make the mistake of trying to determine the "f" value by measuring only the diameter of the front lens, without relation to aperture or focal length. The result is incorrect, of course, as you can realize from a study of the following list of lens factors; though they all vary, they apply to lenses that have exactly the same lens aperture—all *one inch in diameter:*

Focal length 2″ = $f/2$
Focal length 3″ = $f/3$
Focal length 4″ = $f/4$
Focal length 5″ = $f/5$
Focal length 6″ = $f/6$

In addition to the lens factor which determines its speed at *full* aperture, each lens has marked on it somewhere a series of other lens factors which are controlled by a *diaphragm,* or *stop.* Let's investigate this stop and find out what it is, what it does, and how it works.

What a Stop Is

In its simplest form a *diaphragm,* or *stop,* is a metal plate with a hole in it which limits the amount of light that passes through the lens. In box cameras it may be nothing more than a strip of black metal with several holes of varying size punched in it; in the better cameras it is usually an iris diaphragm, patterned on the one in the eye, which provides a hole continuously variable in size.

What a Stop Does

There are four good photographic reasons for using a stop:

1. To *make the picture sharper* than it would be with the lens wide open, especially if the lens is not an anastigmat.

2. To *equalize illumination,* from the edges of the image to its center.

3. To get *depth of field.*

4. To *control the exposure.*

HOW TO MAKE THE PICTURE SHARPER

Since no lens, not even an anastigmat, can be considered perfect— that is, absolutely free from aberration, distortion and astigmatism—a

stop helps to correct these faults by cutting off the rays of light that pass obliquely through the edge of the lens. As the only effective rays remaining are those that go through the middle, which is the area of least distortion or aberration, it is easy to see that this will form a sharper image. But since some of the rays of light are thus shut off from the film surface, the exposure loss must be compensated for by decreasing the shutter speed outdoors, and by increasing the brightness of artificial light indoors.

HOW TO EQUALIZE ILLUMINATION

The oblique rays that travel from the outside rim of a lens have farther to go and are therefore weaker when they get there. The result is that the image seems brighter in the center and weaker around the edges. If the lens formula hasn't already compensated for this fault (a surprise by-product of flatness of field), the only thing you can do is to close off the outer edge of the lens by stopping down the diaphragm and so restricting the light rays to the center of the lens. Extra exposure will be needed to compensate.

HOW TO GET DEPTH OF FIELD

When you make a photograph of, say, a landscape with a lens wide open (at its largest aperture), only that part of the scene which you focus on, and other parts at the same distance (*i.e.*, in the same plane), will be perfectly sharp. It follows that objects in the foreground and background will not be equally sharp. For ordinary work this does not spoil the effect; in fact, it adds what some photographers, even today, call atmosphere or plasticity. The scene looks natural to the eye, for the simple reason that that is the way the eye would normally see it. The extent of apparent sharpness, from the nearest object to the farthest, is called the *depth of field*. To bring *foreground* and *background* into focus at the same time, the lens must be stopped down. The smaller the stop, the greater the effect will be on the image by increasing the depth of *focus* of the foreground and background objects.

What is depth of field? Technically, a perfect lens can give a sharp image of only one *object plane* at a time. This is known as the *plane of focus*. Every point on this plane is represented, theoretically, by another point on the *image plane*. When a lens is sharply focused, each point of light from the object plane has been brought together again as a point on the image plane. We know that each of these points of light is really a *cone* of light and that if the distance between the image plane (in this case the film) and the lens is increased or decreased, the points of light

DEPTH OF FIELD

Here the lens was focused on the leaves and bench in the *near foreground*.
The three benches in the rear, therefore, are not in focus. Leica M4, 50mm
Summilux at $f/4$, 1/125 second, Panatomic X developed in Acufine.

from the object plane will become cones again. Similarly, points of light from other object planes will also reach the image plane as sections of cones, the points of which will be on other image planes. As the object planes move forward, so do the image planes; and in the same proportion. Since the film plane would slice transversely through these cones, the impression made on the film surface (except where it was in *focus*) would be that of little *circles* of light, instead of *points*. These are the famous *circles of confusion*.

The diameter of these circles is affected by the following:

1. The focal length of the lens; *the shorter the better* (since a lens of short focal length has a greater depth of field).

2. The aperture of the lens; *the smaller the better.*

3. The distance between the plane of focus and other object planes; *the more compact* (the less the distance between them), *the better.*

4. The distance between the object plane and the lens; *the greater the better.*

5. The resolving power of the lens (its ability to separate adjacent lines or points of an object); *the more highly corrected the better.*

6. The care with which focusing is done; *the finer the better.*

Now let's see how this works out in practice. If you will look at the

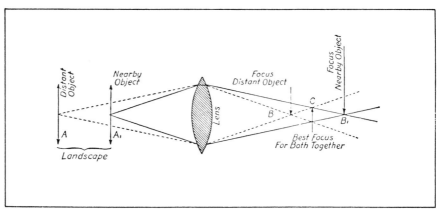

FIG. 4.1. WHAT DEPTH OF FIELD MEANS

diagram in *Fig. 4.1*, you will see that the solid black lines and the broken lines which represent rays of light start from the points marked *A* and *A₁* at different distances, or object planes, of the view you are taking. After these rays pass through the lens, they come to a focus at two points marked *B* and B_1, which, you will observe, are separated by a

small distance, and, consequently, instead of focusing at either one as a sharp point of light, they produce those little patches of light called circles of confusion.

The point, then, where the rays from A and A_1 come closest together is at C which is between B and B_1, and hence, the image formed there is the sharpest for the total landscape. Of course, this is only a compromise; a plane somewhere between A and A_1, and closer to A, will be the only plane in absolutely sharp focus. The reason such a picture looks sharp to us, nevertheless, is that the eye cannot readily distinguish between a sharp point and a circle that does not exceed certain limits. These limits vary with the viewing distance, but as a general rule the eye will still see a circle as a point if, at whatever distance it is held from the eye, the angle made by its diameter does not exceed 2 minutes of arc.[1] For a standard double-frame 35mm negative such as the Leica's (24 x 36mm), for instance, this permits a circle of confusion of 1/30mm, and so all the depth-of-field tables for Leica lenses are based on this figure.

Now let us see what happens when you put a stop in front or back of the lens as is shown in *Fig. 4.2.* It cuts off all the rays of light that pass through the edge of the lens and lets through only those that are in

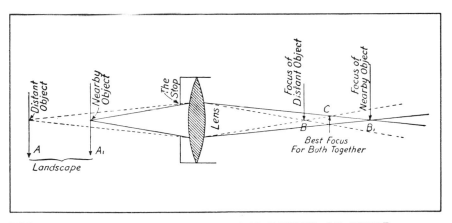

FIG. 4.2. HOW A STOP INCREASES DEPTH OF FIELD
Compare with Fig. 4.1.

a line with the center of the lens. As the angles of these rays are more acute the circle of confusion is much smaller. If a screen is now placed between the points B and B_1, the image for both distances, or planes, will seem sharper, or in other words the depth of focus will be greater.

[1] A minute of arc is 1/60 of a degree.

How Stops Are Marked

If you will look at the rim of your lens mount, you will see certain letters and numbers engraved there. One of these is the letter "f" (which may also be written as F or F/ or F: or F. or F= or f/ or f: or f= or f, or just the simple letter without diagonal, period, colon or crossbars). You already know the meaning of this letter; it indicates that the number that follows is the lens *factor*, or *fraction*—a measure of the speed of the lens, found by dividing the focal length by the diameter of the aperture.

When the f/speed of a lens is given, it is usually indicated by a number preceded by one form of the letter "f" as given above. But lens makers themselves have been perpetuating a confusion by using f's indiscriminately to indicate both the lens *factor* and its *focal length*. For example, Zeiss in their circulars, etc. speak of an f/2.8 Tessar, but the lens itself is marked:

Tessar 1:2.8
f = 8 cm

Leitz, similarly, speak of their f/3.5 Elmar, while the lens is marked:

Elmar 1:3,5
F = 50mm

To avoid further confusion, we shall distinguish between them by making the italic lowercase f/ the symbol for the *lens factor* (which it was, anyway) and the capital F the symbol for the *focal length*. This system of marking will be followed throughout this book.

You may also find the letters "mm" or "cm." "Mm" stands for millimeter and "cm" for centimeter; both are metric indications of the focal length, an inch being the equivalent roughly of 25 *mm* or 2.5 *cm*. Thus a 5 cm or 50 mm lens is a 2 inch lens; a 7.5 cm or 75 mm lens is a 3 inch lens.

WHAT THE NUMBERS MEAN

There is, as we have said, a definite relation between the size of the stop (the diameter of the hole in it) and the focal length of the lens (the distance between the optical center of the lens and the image plane when the lens is focused on infinity). When the advantage of using stops to get sharper pictures was first discovered, the relation between the factors cited above was not worked out in detail, so the photographer used a stop of the size he thought would give the necessary definition, and then exposed the plate for the length of time he guessed would be about right. In other words, he had to depend entirely upon his judgment, or just plain luck, to guide him in making the right exposure. The

vast preoccupation with methods for *reducing* and *intensifying* negatives in the past was due in part to this bungling.

Then someone found that if the stops were set so that the various aperture diameters were made proportionate in size to the focal length of the lens, the time of exposure could also be calculated proportionally. This simplified photography quite a bit; it had been pretty much of a guess-as-guess-can proposition up to that time. It now began to take on an aura of scientific exactitude which has stayed with it ever since. This has gone so far in fact that some otherwise good photographers have begun to lose sight of the main purpose of photography, the making of pictures, and have become bogged down or obsessed by laboratory technique.

The number after the letter, then, indicates the relation between the *aperture* of the stop and the *focal length* of the lens. Thus, if it is marked $f/11$ it means that the hole in the stop has a diameter one-eleventh of the focal length of the lens; $f/16$ means that the diameter of the stop is one-sixteenth of the focal length of the lens, and so on.

THE f/SYSTEM OF LENS MARKING

This simple and accurate method for predetermining the changes in light intensity due to aperture changes was conceived by some members of the Royal Photographic Society of Great Britain in 1881. They adopted as the unit *one* an aperture of $f/4$, and worked out a sequence of aperture ratios that gave each successive stop an area just half of the one which preceded it. Each numerical stop, therefore, lets through twice as much light as the next stop higher. The reason that these stops were halved, instead of quartered or divided by thirds, is that a light intensity must be *doubled* before the eye will recognize the change; this also has its application in the making of negaitves, prints and enlargements, and it explains why amateurs are often told to alter their exposures, if at all, *only* by a factor of 2; that is, if you are taking some extra shots of a scene just to be sure, there's no use trying more than half, or less than double, any indicated exposure, except possibly when exposing color transparency film of inherently high contrast under relatively contrasty lighting conditions.

Bracketing exposures. No matter how careful you may be about getting the right exposure, there are times when your eye or your meter may mislead you. If the picture you are taking is not an unrepeatable action shot, you can insure your getting the best exposure by *bracketing* (taking a series of exposures *under* and *over* the one you judge to be correct). For example, if your meter says $f/8$ at 1/100, take one shot at that exposure; and then two more, one at $f/5.6$ 1/100 and another at

f/11 1/100. If it's an especially important picture, and if the exposure is critical, take two more: one at about *f*/6.3 (between *f*/5.6 and *f*/8), and the other at about *f*/9 (between *f*/8 and *f*/11), both at 1/100. Of course, if freezing the action is an important consideration, raise the shutter speed to 1/200 or more and adjust the *f*/ opening accordingly; on the other hand, if depth of field is the problem, close down to *f*/11 or *f*/16 and adjust the shutter speed to compensate. At any speed slower that 1/100, use a tripod to get maximum sharpness.

The higher the number marked on the stop, the smaller the hole, and, hence, the longer the exposure must be. It follows, conversely, that the lower the number, the larger the hole in the stop and the shorter the exposure can be. In the *f* system, the numbers on a stop give only the proportion of the diameter of the hole to the focal length of the lens and, therefore, the numbers should really be marked 1/8, 1/11, 1/16 and so on; but the fractional form was dropped in practice and whole numbers are now used instead.

From what has just been said, it will be seen that the *f* number is not one of fixed size for all lenses, but that it varies with the focal length of the lens. Thus an *f*/8 stop with a lens having an eight-inch focal length would have a diameter of one inch; while the same numbered stop with a lens having a sixteen-inch focal length would have a diameter of two inches, and so on.

The following table shows the chief sizes of stops used in the international *f* system today.

f/1.4 2 2.8 4 5.6 8 11 16 22 32 45 64

These really represent fractions, as follows:

$$\frac{1}{1.4} \quad \frac{1}{2} \quad \frac{1}{2.8} \quad \frac{1}{4} \quad \frac{1}{5.6} \quad \frac{1}{8} \quad \frac{1}{11} \quad \frac{1}{16} \quad \frac{1}{22} \quad \frac{1}{32} \quad \frac{1}{45} \quad \frac{1}{64}$$

And the exposure ratios called for by these stops are:

⅛ ¼ ½ 1 2 4 8 16 32 64 128 256

That is, it takes 128 times as long to make an exposure at *f*/45 as it does at *f*/4; 128 times as long to make an exposure at *f*/16 as at *f*/1.4.

Some types of foreign lenses are marked with a different series of stops.[2] These would take their places in a series this way:

f/1.5 2.2 3.2 3.5 4.5 6.3 9 12.5 18 25 36
 1 2.2 4 5 9 18 36 70 144 280 576

[2] These have now been obsoleted by standardization. Where a manufacturer offers a lens with an odd maximum aperture (for competitive purposes) such as *f*/1.7, *f*/1.9, or even *f*/1.1, he must engrave the next smaller "standard" *f*/stop on the scale and proceed with the standard series, thus: <u>*f*/1.2</u>, *f*/1.4, *f*/2, *f*/2.8, etc.

RELATIVE EXPOSURES

In this series you can determine the relation of one factor to another by comparing their relative exposures. Stop $f/4.5$, for example, has a relative exposure factor of 9; $f/9$, an exposure factor of 36. To find out how much *more* exposure to give $f/9$, divide its factor, 36, by the factor for $f/4.5$, which is 9. The answer would be 4. Which means that you need four times as much light, or an exposure four times as long. Working it backwards, if you were using $f/12.5$ and wanted to find out how much less exposure you'd need at $f/3.5$, you would divide the factor for $f/12.5$, 70, by the factor for $f/3.5$, 5. Your answer would be 14. In other words, you'd need one-fourteenth as much exposure.

If it isn't convenient to carry around a relative exposure table, or if it is too complicated to commit to memory, the rule of squares may help: simply square each of the two $f/$numbers whose relative exposure factors you want to determine and divide the larger product by the smaller, for example,

$f/2$ squared $= 4$; $f/8$ squared $= 64$

Therefore, $f/2$ is 16 times as fast as $f/8$

What "Lens Speed" Means

The term the *speed of a lens* refers to the *largest* opening or stop at which it can be used. For example the lens of a *box* camera (or any simple camera) has a *speed* of $f/16$, which means that this is the largest stop that can be used with it. Consequently, the shortest exposure you can give a medium-speed film like Ilford FP4, Versapan, or Verichrome Pan with such a lens is about 1/25 of a second in sunlight. With an $f/11$ diaphragm opening, the shortest exposure would be 1/50; with an $f/8$, 1/100; with an $f/5.6$, 1/200, etc.

The practical advantage of a fast lens, then, is that it permits you to use a shorter shutter time (for action photography). But with such new fast films as Kodak Tri X Pan (ASA 400), Ilford HP4 (ASA 400), and GAF Super Hypan (ASA 500), you can still use an exposure of 1/500 (with the same $f/16$ lens in sunlight), *or ten times your original speed*. Whether the advantage of a faster shutter speed is worth the extra cost is a matter of personal judgment and finances. The $f/1.4$ Nikkor is a superb lens, even wide open, so to many photographers it is worth every bit of the extra cost. The same can be said for the $f/2$ Summicrons and the $f/2.8$ Planar (vs. the $f/3.5$). But for the majority

of your pictures an *f*/3.5 lens and a shutter that goes to 1/300 should be adequate.

Incidentally, the apertures and shutter speeds of the new breed of box cameras, like the Kodak *Instamatics* and the Argus *Magicube* (which use the 126 drop-in film cartridges) have *f*/11 and *f*/12.5 lenses, mostly plastic, and shutter speeds from 1/40 to as high as 1/90 second. The single achromatic lens which is used in some simple cameras has a speed of *f*/11 and hence under the same conditions, with the lens fully open, it takes an exposure of only 1/50 of a second. An *f*/11 stop has twice as large a hole, or opening, in it as an *f*/16 stop, and therefore, lets twice as much light through the lens.

How a Stop Is Made

Only three different types of stops are used in modern cameras. These are: (1) the fixed stop, (2) the sliding stop and (3) the iris diaphragm. (See *Fig. 4.3.*)

The fixed stop is found only in the simplest and least expensive cameras. It consists of a hole, slightly smaller than the lens aperture, punched out of a ring of black sheet metal which has been set permanently in front of the lens. Pocket magnifiers usually have such a fixed stop set between the lens elements.

The sliding stop is a thin strip of blackened metal which slides, in

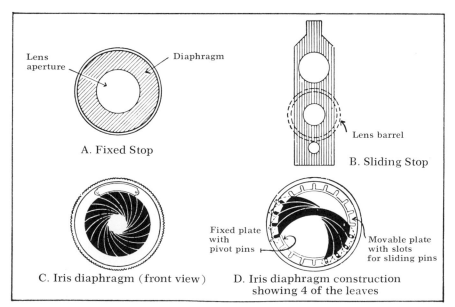

FIG. 4.3. THE KINDS OF DIAPHRAGMS OR STOPS

grooves, across the front of the lens. It usually has two or more holes of varying size to serve as apertures. This form of stop was used in the better grades of box cameras, in some European imports, and in cameras for studio use.

The iris diaphragm is a variable stop, rather ingeniously constructed, which is used in almost all other types of cameras. It consists of a number of curved leaves cut out of thin sheet metal overlapping each other and each pivoted to the inner circumference of the barrel of the lens. These leaves all work together, and by moving the knurled rim of the lens mount they can be made to slide back to the wall of the barrel, like the leaves of a fan. In this position they are wide open and give the lens its largest stop. By moving the rim the other way, the leaves close and you can reduce the opening to any size you want. The diagram, *Fig. 4.3*, illustrates the principle upon which it works.

Some foreign camera manufacturers have tried (notably in the German *Regula*, and in some models of the Japanese *Yashica* and *Minolta* cameras) to combine the lens and shutter mechanisms so that they function together. What has remained of these experiments is the *Exposure Value Scale* which is operational to a degree in the latest models of the Rollei cameras, especially the Rolleiflex T or F 2.8, and in the Rolleicord VB, all equipped with the Synchro-Compur shutter and the EVS system. If the correct exposure, as indicated by the meter, is f/8 at 1/125 (EVS 13), the other exposures possible for this EVS (see table) are f/4 at 1/500, f/5.6 at 1/250, f/11 at 1/60, f/16 at 1/30, and f/22 at 1/15. By turning the aperture wheel *or* the shutter wheel, both of which are linked to the setting pointer of the exposure meter, you not only have a free choice of settings (since each wheel works independently) but you can *preset* shutter speed or depth of field.

EXPOSURE VALUE SETTINGS (EVS)

f	2.8	3.5	4	5.6	8	11	16	22
1 sec	3	3.5	4	5	6	7	8	9
1/2	4	4.5	5	6	7	8	9	10
1/4	5	5.5	6	7	8	9	10	11
1/8	6	6.5	7	8	9	10	11	12
1/15	7	7.5	8	9	10	11	12	13
1/30	8	8.5	9	10	11	12	13	14
1/60	9	9.5	10	11	12	13	14	15
1/125	10	10.5	11	12	13	14	15	16
1/250	11	11.5	12	13	14	15	16	17
1/500	12	12.5	13	14	15	16	17	18

How to use: If the correct exposure as indicated by the meter is $f/8$ at 1/125 second, your EVS number is 13, which you can find at the horizontal and vertical intersection of these two settings. To find other settings for the same light exposure of EVS 13, work your way diagonally up and down the scale; $f/11$ at 1/60 and $f/5.6$ at 1/250, for example.

The Critical Aperture

The sharpest definition, and the maximum resolving power, that it is possible to get out of any good lens is at the largest aperture which still removes the few aberrations not corrected when it was designed. This point, which is known as the *critical aperture*, varies with each type of lens, and depends on its original f speed and focal length. If the lens is stopped down beyond this point, *diffraction* sets in and begins to degrade the image.

Diffraction is not a lens aberration; it is a spreading of an image point caused by light rings which are formed by the rays bent at the edges of the stop; it cannot be corrected in the design of the lens, nor by closing the diaphragm. The critical aperture for most of the Leica lenses is about $f/4$ to $f/5.6$; for the Zeiss Sonnar, about $f/5.6$; for most enlarger lenses it is about $f/5.6$ to $f/8$. With other lenses this point is about midway between the largest aperture and the smallest, favoring the largest.

By stopping down you will get increased depth of field; but don't confuse that with sharpness. A pinhole camera has remarkable depth of field, but absolutely no resolving power. By stopping your lens down until it resembles a pinhole, you are making it behave like one. To avoid this very thing, some lens makers take the necessary precautions in advance and prevent stopping down beyond a certain point.

More About Focal Length

There are three important lens characteristics which we haven't discussed as yet. These are: *image size, angle of view,* and *apparent perspective.* Since they are all dependent on the *focal length* of the lens, this is as good a time and place to take them up as any. *These formulas are for the mathematical minded; you can skip them if you're not.*

IMAGE SIZE

With the camera remaining in the same position, the image size will vary in *direct* proportion to the focal length of the lens; or,

I (image size) \propto (focal length)

The symbol \propto means "varies with." Mathematically translated, this becomes

$I = KF$

with the letter K standing for the *proportionality constant*. If we want to find out what size image we should get if we increased or decreased the focal length at the same camera distance, this is how we should go about it. Suppose the image size produced by our 3-inch lens is just two inches high, and we want to know what a 6-inch lens will do. The formula becomes

$2 = K\,3$

or, $K = \frac{2}{3}$

then $I = \frac{2}{3}\,F$

Now since the new F is 6, we get

$I = \frac{2}{3}$ of 6

or, $I = 4$

The new image size, therefore, would be four inches. For a 12-inch lens the formula would be

$I = \frac{2}{3}$ of 12

or, $I = 8$

The image would then be eight inches high. The principle involved is illustrated by *Figs. 4.4* and *4.5*.

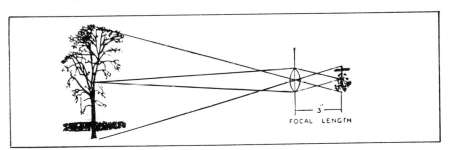

FIG. 4.4. HOW FOCAL LENGTH AFFECTS IMAGE SIZE—
SHORT FOCAL LENGTH, SMALL IMAGE

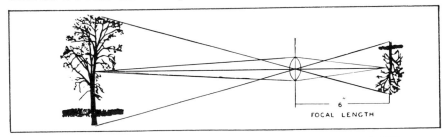

FIG. 4.5. HOW FOCAL LENGTH AFFECTS IMAGE SIZE—
LONG FOCAL LENGTH, LARGER IMAGE

The image size will also vary (focal length remaining constant) in *inverse* proportion to the distance between the object plane and the center of the lens. The formula for this is

$$I \text{ (image size)} \propto \frac{1}{D \text{ (object distance)}}$$

Mathematically translated, this becomes

$$I = K\frac{1}{D}$$

with *K* again as the proportionality constant. We use this formula in exactly the same way that we did the one above. For example, a 2-inch image at 30 feet will become a 3-inch image at 20 feet and a 6-inch image at 10 feet, thus:

$$2 = K\frac{1}{30}$$

or, K = 60

substituting the value of the constant, *K*, in the above formula, we get

$$1 = \frac{D}{60}$$

at 30 feet, therefore, the formula is

$$I = \frac{60}{30} = 2$$

at 20 feet it becomes

$$I = \frac{60}{20} = 3$$

at 10 feet it becomes

$$I = \frac{60}{10} = 6$$

We can also combine both of these formulas into one single formula, thus:

$$I = K\frac{F}{D}$$

To photograph an object *same size*, or *natural size*, the lens has to be racked out to twice its focal length. The object distance then will also be twice the focal length. This rule applies to lenses of all focal lengths.

Here is a simple formula, and some variations, by which (the focal

length remaining constant) you can figure out any *one* of four *object-image* dimensions if you know the other *three*:

$$\frac{A \text{ (object size)}}{B \text{ (image size)}} = \frac{C \text{ (object distance)}}{D \text{ (image distance)}}$$

The formula for *image size*:

$$B = \frac{A \times D}{C}$$

In other words, you multiply the object size by the image distance and divide that by the object distance, to get the size of the image.

The formula for *object size*:

$$A = \frac{B \times C}{D}$$

or, multiply the image size by the object distance and divide that by the image distance, to get the size of the object.

The formula for *object distance*:

$$C = \frac{A \times D}{B}$$

that is, multiply object size by image distance and divide that by the image size, to get the distance of the object.

The formula for *image distance*:

$$D = \frac{B \times C}{A}$$

which means, multiply image size by object distance and divide that by the object size, to get image distance.

Another formula for finding the *focal length* of a lens:

$$F = \frac{C \times D}{C + D}$$

or, multiply the object distance by the image distance and divide by the sum of the same integers, to get the focal length.

Here is a simple way to determine the angle of view of any lens by using an easy geometrical method adapted from Sowerby's *Dictionary of Photography.*

Draw a straight line AB equal to the long side, or diagonal, of your negative. Bisect this at C; from C draw a perpendicular DC equal to the focal length of your lens. Connect AD and DB. The angle included by the lens is equal to the angle ADB, which may now be measured by laying a protractor on it and reading off the degrees. The angle DCB,

FIG. 4.6

as you know, is 90°, which would be the angle of view of any lens for which angle ADB were also a right angle.

The measurements above can be in inches or metric, but should be uniform throughout.

ANGLE OF VIEW

The lens in the human eye has an angle of view of about 48 degrees (if you haven't a protractor handy, a rough approximation is the angle made by spreading out two adjacent fingers of one hand). Photographically, this is considered a normal angle, as explained previously, and is about what we get when we use a lens with a focal length equal to the diameter of the negative area. The normal lens for a 4 x 5-inch negative, for example, would have a focal length of about 6½ inches. If we want to include more of the object in our picture we either have to move back, which is sometimes impossible, or increase our angle of view.

A lens that sees more of an object plane than the normal from any given distance is called a *wide-angle*. The eye of a fish has such a lens; it is flatter in shape and sees more in all directions. The normal lens for a Canon, Nikon, Contarex, or Leica negative is one with a focal length of 2 inches, or 50 mm. (Also available, in the intermediate 28mm size, with an angle of view of 76 degrees, are the *f*/2.8 Canon, the *f*/2.8 Elmarit, the *f*/3.5 Auto-Nikkor, the *f*/2.8 Soligor, and the *f*/2.8 Vivitar. A unique lens and camera combination in this range is the Zeiss *Hologon* Ultrawide, an extreme wide-angle lens which is supplied only in its own Hologon Camera case. The lens is a 15mm *f*/8 *non-distortion* type, with an angle of view of 110 degrees.) The angle of view of such a lens is only 45 degrees to 48 degrees. To increase this angle we can use a lens with a shorter focal length, one of about 1⅜ inches or 35 mm. The wide-angle Distagon, Elmarit, Summilux, Vivitar, and Summicron, are all of this focal length, and have an angle view of about 65 degrees. For extreme wide-angle work in this size, there is the *f*/3.4 Super Angulon with a focal length of only 21 mm and an angle of view of almost 92

degrees (in the case of some Japanese single-lens reflex 35mm cameras, like the Pentax, the manufacturers favor slightly narrower angles of view of 55mm focal length, as in the Takumar; the German manufacturers, however, particularly Leitz and Rollei, and the other Japanese manufacturers like Nikon and Yashica, still prefer the 50mm). In the larger sizes, the 4 x 5-inch for example, we can get wide-angle lenses almost as extreme. The Aristostigmat, for instance, used to increase the angle of view in this size, has a focal length of 4 inches and a view of 105 degrees. The important things to remember about wide-angle lenses are that (1) while they increase the object angle, they reduce the image size in direct proportion (see *Figs. 4.4* and *4.5*); (2) they increase the apparent depth of field by reducing the size of the circles of confusion; and (3) the angle of view can be increased slightly by racking the lens back and stopping down to compensate. The Dagor is used in this way.

To increase the size of an image, from a given point of view (especially if you can't get any closer), it is necessary to use, as we have already pointed out, a lens of longer focal length. Though strictly speaking not every lens of long focal length is a *telephoto*, as we have explained earlier, it has become the custom to distinguish lenses of longer than normal focal length in that way. The lens in the eye of a bird is constructed like a telephoto; it is tubular in shape and sees less of any object than we do, but the image size is larger.

There are almost 500 different telephoto (or, rather, *long*-focus) lenses listed for 35mm and 2¼ cameras in Popular Photography's *1972 Directory and Buying Guide*, ranging from the 70mm F Zuiko Auto T to the 2000mm Telastan. Also, there are about 75 different *zoom* lenses listed, from the 35–100mm Auto Tamron to the 200–600mm Auto Nikkor.

In the larger picture sizes there are, in addition to the regular long-focus lenses, many combination sets, the separate elements of which have different focal lengths. The Plasmat and Protar sets, for example, each offer three different foci, depending on whether the front and rear components are used together or separately. The important things to keep in mind about telephoto lenses are (1) they increase size at the expense of depth of focus, (2) they not only magnify the image, but also *vibration;* for which reason (3) they should always be used with the camera set firmly on a tripod, and with an extra long cable release to avoid jarring the camera when making the exposure.

APPARENT PERSPECTIVE

Perspective is what happens to three-dimensional (solid) objects when you reproduce them on a two-dimensional (flat) surface. It is two

rails of a train track receding from where you are standing, to meet at a *vanishing point* on the horizon. It is an artist looking through a *camera obscura* (see index) before drawing a scene. It is what you see through a window pane (use only one eye), if you pretend that it is drawn *on* the glass. Remember: All lenses give exactly the same perspective, no matter what their focal length, if they are used at the same distance. The *only* way it is possible to alter perspective is by changing the distance between the lens and the object. What our eye sees in any scene, therefore, is what any lens will see, whether wide-angle, normal, or telephoto. The reason why wide-angle pictures often look badly distorted or unreal is that the photographer, in order to compensate for the inherently smaller size of a wide-angle image, comes too close to the object. You can duplicate this effect by stretching your hand out in front of you and looking at some distant object with one eye; gradually bring the hand back toward you and it will loom up larger and larger until it blots out everything else.

Fig. 4.7 illustrates the meaning of photographic perspective. Two objects of the same size, A and B, are placed at different distances from the lens, L. The resultant images are shown by A_1 and B_1. The plane F_1 on which these images are formed is that for a lens of, say, normal focal length. The result of using a telephoto lens (or a normal lens if the other is a wide-angle) is shown at F_2 by images A_2 and B_2.

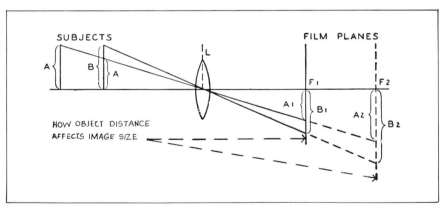

FIG. 4.7. ILLUSTRATING THE MEANS
OF PHOTOGRAPHIC PERSPECTIVE

We can apply this to the solution of actual photographic problems in this way:

1. *To increase size of A without affecting size of B,* use a telephoto lens and move back until B is the size wanted.

2. *To increase size of B without affecting size of A,* use a wide-angle lens and move forward until A is size wanted.

3. *To reduce size of A without affecting size of B,* use a wide-angle lens and move forward until B is size wanted.

4. *To reduce size of B without affecting size of A,* use a telephoto lens and move back until A is size wanted.

5. *To increase apparent distance between A and B,* use a wide-angle lens and move forward until B is size wanted.

6. *To reduce apparent distance between A and B,* use a telephoto lens and move back until B is size wanted.

7. *To reduce violent perspective,* use a telephoto lens and move back until B is size wanted.

8. *To increase violent perspective,* use a wide-angle lens and move forward until B is size wanted.

The perspective effect produced by using a long focus lens can be duplicated simply by enlarging the picture taken with an ordinary lens.

FIG. 5.1. RELATIVE SHUTTER EXPOSURES. Stroboscopic flashes through a *leaf* shutter and a *focal-plane* shutter, at 1/1000 second. Total exposure: 1/100 second. See text, page 110, for explanation of why focal-plane is 30 per cent more efficient.

5 How the Shutter Works

Basically, the photographic *shutter* is nothing more than a mechanical *light* chopper; something that lets light reach the emulsion for only a small and controlled fraction of time.

In the early days of photography, when sensitive plates were slow, they were exposed by simply removing the cap from the lens with the hand, keeping it off for the necessary length of time (determined by test), and then putting it back on again. There is an apocryphal story about the oldtimer who boasted he never had to fool around with light meters or lens shutters because he always got perfect exposures using a lens cap and counting to ten. On a dull day, for instance, he would count s-l-o-w-l-y; on bright or sunny days, he counted *fast*. Since the film of those days was exceedingly slow, and the exposures were not critical, the method worked. With the advent of faster films and better lenses, the need arose for a device that would open and close the lens more quickly and with more precision, than could be done with a cap. This led to the invention of the *shutter*.

The modern shutter can do many things for the photographer. At moderate speeds, it can eliminate camera shake, stop the action of children playing, people walking, soldiers parading; at higher speeds,

it can freeze the action of horses jumping, athletes running, cars racing, or it can even freeze motion while preserving blur, as in *panning* (where the moving subject is stopped while the background, blurred, suggests motion); at slow speeds it can give the illusion of movement, as in pictures of waterfalls, which otherwise look as though they have turned to ice. One of the primary functions of the shutter is to work with the lens aperture (as in the EVS system, see *index*) to control exposure.

Early Types of Shutters

In its first form the shutter consisted of a thin strip of wood or panel, with a hole the size of the opening of the lens at its center, and this slid in a grooved board that had a like hole in it and which fitted over the end of the barrel of the lens. When the operator wanted to make an exposure, he simply pushed the sliding strip or panel over until the hole in it was even with the opening in the lens, and after giving the time needed he pushed it back until the lens was closed. It wasn't until 1900 (six years after the appearance of roll film) that the single-blade shutter was found to be inadequate. The search for a means to stop fast motion started then (with the invention of the multiblade shutter) and has kept pace with emulsions ever since. Early modifications of the single-blade shutter included the *drop shutter* which acted like a guillotine, the *rotary shutter* which is still used in some fixed-focus cameras, the *double-leaf shutter* which had two leaves pivoting at one end and was worked with compressed air by pressing on a rubber bulb. However, most of these early before-the-lens shutters are now obsolete.

Modern Types of Shutters

This brings us to the four shutter types which are in use today, namely the *rotary shutter*, the *between-the-lens* (or *leaf*) *shutter*, the *focal-plane shutter*, and the *electronic shutter*.

Photographic engineers have often experimented with the use of *louver shutters*, but none has ever been marketed.

THE ROTARY SHUTTER

This is the simplest of all. It consists of a hinged disk with a curved slot, pivoted in front of the camera, which by means of a spring-wired trigger release is made to cut across the supporting aperture plate. The trigger is moved *once* for each snapshot exposure. The speed of such a shutter is about 1/25 of a second (the aperture being *f*/16). It is self-

setting, and has provisions for time exposure. Only the very cheap cameras use this type of shutter.

THE LEAF SHUTTER

The leaf shutter (also known as the *interlens, between-the-lens* or *behind-the-lens* shutter) is built around the lens and contains both the diaphragm as well as the shutter. The latter consists of from three to five blades which are opened and closed at the center. These blades are controlled either by an air brake, as in the Compound shutter, or by an intricately meshed chain of gears, as in the *Compur, Copal,* or *Seikosha,* which now supersede the discontinued *Supermatic* and *Kodamatic.*

As the leaf shutter opens, it forms more or less of a star-shaped aperture depending on the number of leaves it has. This gives a better distribution of light all over than was possible with the old two-leaf shutters. The speed it is possible to get with such a shutter depends on the intricacy of its mechanism (which determines its price) and on its size. Those made for larger lenses are *dial-set* (that is, by means of two small dials that are pivoted on the front edge) and start at one second but only go up to 1/200 of a second and time; the others are *rim-set* (variations in exposure being controlled by rotating a knurled rim) and range from one second to 1/300 of a second and time. Among the faster shutters there are the Supermatic, which goes up to 1/400 and time, and the Compur-Rapid which goes up to 1/500 and time. All of these, unless built into the camera (as with the twin-lens Rolleiflex which uses a Compur-Rapid shutter but encloses it within the camera body) are of the rim-set, presetting type. That is, adjustments for varying the exposure are made by rotating the rim of the shutter, and a lever has to be cocked each time to tense the spring before tripping it. The blades used in these shutters are made of exceptionally thin spring steel (those in the Supermatic being only .0015 of an inch thick); so they offer practically no resistance to air, have almost no inertia, and can therefore be opened and shut swiftly and accurately.

A special feature of the Supermatic is its two-color, speed-adjusting ring. Its eleven speeds are arranged this way: from time, bulb and one second through 1/10 of a second, the six speed-settings are marked in red *as a warning that a tripod should be used;* from 1/25 to 1/400 second the five markings are in black to indicate that hand-held exposures are okay. (*Caution: play safe;* for hand-held exposures *use nothing slower than 1/100 of a second.*)

Other types of *behind*-the-lens or *between*-the-lens leaf shutters are the *Copal* (behind-the-lens, for Ricoh 126), the *Copal-X* (between-the-

lens, for Mamiya/Sekor 5282L), the *Seikosha* (behind-the-lens, for Beseler Topcon Auto 100), the *Seikosha SLV* (behind-the-lens, for Kowa SETR2), the *Seiko SLV* (between-the-lens, for Kowa Six), the *Seiko* (between-the-lens, for Mamiya RB67), the #00 *Seiko SLV-G* (behind-the-lens, for Beseler Topcon Unirex).

Jet speed leaf shutter. Kodak announced a revolutionary new type of shutter in 1951, the *Synchro-Rapid 800*—the fastest leaf shutter ever made. It had ten speeds, from one full second and bulb to a breathtaking 1/800. It had flash-synchronization settings for all the currently available flashbulbs and strobe lights. The construction secret that made the amazing top speed possible was the way in which each leaf of the five-leaf shutter had been designed to swing one way, in a complete circle of 360°, on its own axis—avoiding the mechanical jolt that a regular leaf shutter gets when it opens, stops, and closes. The design of the Synchro-Rapid shutter not only would make for smoother operation and a faster top speed, but it would undoubtedly prolong the life of the shutter. Kodak claimed it would also give greater accuracy at all speeds. Then Kodak mysteriously withdrew this wonder shutter from the market. However, since it is historically interesting, we are retaining mention of it here.

Though most current interlens shutters have a top speed of 1/500 second, with the exception of the *Jet Speed Leaf Shutter* described above, there have been unceasing efforts to push the speed of interlens shutters beyond 1/500 second. Zeiss-Ikon/Voigtlander did announce, in 1968, the production of a 1/1000 second *Vitessa 1000 SR* camera, based on a new, highly efficient *Prontor 1000* between-the-lens leaf shutter of lightweight metal. However, it has yet to reach the market. But at the close of 1970, Carl Zeiss announced that they had constructed a new, electrically operated leaf shutter with a top speed of 1/3000 second. Unfortunately, because of design problems, and the need for bulk, it can be used only in *aerial* cameras, like the *Zeiss Aerotop*, where size is not a factor. This electrically driven camera gives a negative 9 inches square, and carries a film load for 460 pictures. The Aerotop shutter works on the principle of rotating multi-discs. The four counter-rotating discs offer a range of speeds from 1/50 second to 1/3000 second. It is obvious, however, from the bulk and weight of the motor-driven shutter mechanism, that it can be used only in large cameras.

Electronic leaf shutters. The firm of *Compur*, in Munich, announced two new shutters in 1965. They are the Compur *Electronic 5FS*, and the *Electronic 3*. These are unlike any other shutters previously produced because they do not depend on mechanical parts for the timing and movement of the shutter blades. Though the actual shutter blade remains a mechanical function, the timing has been taken over by tran-

sistorized electronic circuits. The shutter speeds are not controlled by gear escapement, nor by air brake; instead, electromagnetic triggers are used. The result is claimed shutter speeds of remarkable accuracy. Electronic shutters also create less vibration, and therefore sharper pictures. The end product of electronic, rather than mechanical, control would be more accurately exposed pictures, which should be of special interest to the color photographer. The first of these electronic shutters have been designed for use in *studio* or *view* cameras. The control mechanisms are housed in remote control boxes which are connected to the shutter by electrical cable of any desired length. *All* shutter and diaphragm operations can be worked from the control box.

An electronic shutter for the Rolleiflex? The international photography magazines, usually in a good position to know, are beginning to wonder out loud about the next model of the twin-lens Rolleiflex (which has not undergone any technical changes since it was adapted for 220 film). Could it possibly be, they ask, one with an *electronic* shutter?

Shutter releases. There are four different kinds: (1) *The trigger* (or *finger*) release. (2) The *cable* (or *antinous*) release consisting of a flexible wire through a flexible tube. This tube is usually made of fiber, though some have appeared with a flexible metal tube of a style similar to electric cable. (3) The *bulb* (or *pneumatic*) release, which is a small air piston connected by a rubber tube to a rubber bulb; pressure on the bulb compresses the air, which in turn moves the piston, which finally trips the shutter. This type of release is now obsolete, having been replaced by the *cable release*. (4) The *automatic* (or *self-timing*) release. This is a delayed-action device which, after being tripped, postpones the actual exposure for any preset interval of time. For those that are built into cameras, as for instance in the twin-lens Rolleiflex, the Leica, the Yashica, the Nikon, or in certain types of Compur shutters, this interval is about 12 seconds. However, the Kodak self-timer, which is independent of the camera and is attached to it by means of the cable release, offers variable delay intervals from ½ second to 1 minute.

THE FOCAL-PLANE SHUTTER

It is so called because it is fitted to the camera at or as near the focal plane of the lens as it is possible to get it, without actually touching the surface of the film. Since it is the fastest shutter made, giving exposures as brief as 1/2000 of a second (as in the Leicaflex and the Nikon F-2), it is used in many miniature, press, and single-lens reflex cameras. Different from all other shutters in this respect, the *focal-plane*

shutter, or *curtain shutter*, or *roller-blind shutter*, as it has been variously named, is used close to the film instead of *ahead* of or *between* the lens components. This has its advantages, but it also presents many problems.

The curtain of the early focal-plane shutter (as in the *Speed Graphic* cameras) looked like *Fig. 5.2*. This was essentially a durable, light-tight blind with five rectangular openings or slits, only one of which moved across the film when making the exposure. That part of the curtain not covering or exposing the negative was wound on rollers at each end. When the exposure was made, the curtain unrolled from the top and rerolled at the bottom, where it was kept under tension. The exposure depended on the *width* of the slit and the *tension* of the variable spring. The curtain could also be adjusted to make a *time*

FIG. 5.2. The old Graflex Graphic focal-plane curtain.

A RIM-SET LEAF SHUTTER (Synchro-Compur). Reproduced from *Basic Photography* by M. J. Langford, courtesy *Focal Press*, London.

exposure. The more recent *Graphic* models are equipped with a simplified focal-plane shutter which does away with the need for converting tension numbers into speeds. They have a single winding key, where the old one had two, and the actual speeds can be read off directly, without the need of a table.

The *effective aperture* of a lens is affected by the width of the slit in the focal-plane shutter; the wider the slit, the more accurate the exposure. When the slit is at its narrowest, it cuts off some of the pencils of light trying to reach the film. This would not be so if the shutter were actually moving in contact with the film; in that case the shutter's efficiency would be 100 per cent. But since there *is* some distance, no matter how small, between these two planes, a narrow slit cuts through each cone of light. This reduces the amount of light reaching the film, and so changes the *f*/number. The cure for this is either a larger curtain slit (slower speed), a larger lens aperture, or both.

By 1968, both Graflex and Hasselblad had dropped the use of the focal-plane shutter; Graflex because "they weren't selling enough of them," most photographers preferring the Crown Graphic, which had only a between-the-lens shutter, to the more expensive Speed Graphic which offered both; and Hasselblad, in 1958, when they brought out the 500 C model of their 2¼ inch square SLR, which the Astronauts subsequently tested on the moon. Hasselblad's reason for the shift: they could get better synchronization for flash and strobe with the interlens shutter (and undoubtedly for some of the other reasons discussed above). Graflex also stopped making that old war horse, the bulky Graflex reflex, since that, too, used a focal-plane shutter.

What remain now in the Graflex line are the Pacemaker Crown Graphic and the Pacemaker Super Graphic in the 4 x 5 size, and the Century Professional 23 in the 2¼ x 3¼ size. However, since it may be quite a while before the focal-plane Speed Graphics disappear entirely, some information about them is being retained here.

Miniature focal-plane shutters. Though basically the same in design and concept as the shutters used in the Graphic cameras, the focal-plane shutters used in the Leica, Contarex, Exakta, Nikon, and Canon cameras are smaller, and therefore more accurate and reliable.

For one thing, they are *self-capping*, which means that they are made of *two* blinds (instead of one) which unlock to different spacings as the exposure is made, and lock together again when the shutter is rewound. This prevents the accidental fogging of film.

For another thing, these shutters offer a greater range of speeds; the Contarex, for example, offering ten speeds from 1 second to 1/1000 second, plus time and bulb; the Leica offering eleven marked speeds from 1 full second to 1/1000 second as well as bulb, with the speeds

being continuously variable between click-stops, except between 1/8 and 1/15 and between 1/30 and 1/60; the red zigzag symbol between 1/30 and 1/60 indicating the strobe sync speed of 1/50. The Leica also offers delayed action.

Until recently, the *Contax* had been the only camera to use a *metal* focal-plane shutter. The Contax shutter was precision made of flexible metal sections that dropped vertically across the surface of the film. *And it was impervious to the rays of the sun.* When the camera was discontinued by Zeiss and replaced by the single-lens reflex *Contarex*, it saddened many who liked such features of the Contax as its sun-proof shutter, the handy milled focusing wheel at the top right, its fast bayonet-mount lens lock (since copied by others), its superb $f/1.5$ Sonnar lens, its paper-leader daylight-loading spool (the method now used for 220 film), and its high-speed shutter (to 1/1250 second). But now *Ricoh* has brought out two cameras with *metal* focal-plane shutters: the *Singlex* and the *TLS 401*, both of which have shutter speeds to 1/1000 second, flash synchronization to 1/125 second, and a through-the-lens (TtL) metering system.

The Copal Square S shutter, used in the Konica Autoreflex A and T, in the Argus/Cosina STL 1000, and in the Nikkormat FTN, is also made of flexible stainless steel sections, and offers speeds of 1 to 1/1000 second. The Canon F-1 shutter, made of flexible titanium foil sections, offers speeds of 1 to 1/2000 second. The shutter of the Nikon F2 (10 to 1/2000 second) is made of quilted *titanium* foil, which is claimed to be stronger and lighter than stainless steel. Also, titanium is non-magnetic, resists chemical corrosion, and there is no risk of burn-through. And finally, the Nikon shutter is coated with a protective epoxy resin that keeps it from absorbing moisture. The Leica and Exakta shutters are made of a climate-resisting rubberized cloth, and move horizontally across the film surface. To avoid distortion with these, as with all focal-plane shutters, it is better to stop down. Another thing to remember, when following action with a miniature camera, is that the direction of the shutter curtain should match the direction in which the subject is moving. If it doesn't do that normally, simply turn the camera upside down and you'll find that it will.

Shutter Efficiency

The word *efficiency* when applied to a shutter means the amount of light it lets through during the time it takes to make an exposure. As an illustration: Suppose you have two shutters, and both of them open and close in exactly the same length of time, say 1/25 of a second, but the construction of the first is such that it lets more light through than the

second. The first one clearly has a higher efficiency than the second one.

This difference in the efficiency of shutters results from the fact that some of them are so made that the entire opening of the lens is uncovered only for a very small fraction of the time that the shutter is making the total exposure, the rest of the time being taken up by the leaves' uncovering and covering up the aperture of the lens. To have 100 per cent efficiency, a shutter would have to open and close absolutely instantaneously—that is, without any time lag at all—and thus give the full aperture for the whole length of time. The focal-plane shutter comes the nearest to doing this of any that has been devised up to the present time. It delivers 30 per cent more light than the leaf shutter. (See *Fig. 5.3.*) Each strip shows a series of stroboscopic flashes occurring at intervals of 1/1000 of a second and totaling an exposure of 1/100 of a second. The leaf shutter is wide open during only the fifth and sixth flashes; the focal-plane transmits the full flash during the entire exposure. The efficiency of the leaf shutter can be increased by stopping down. When that is done, the full aperture of the reduced stop opening remains completely uncovered for a proportionally longer time.

However, there are other considerations. One of the most important of these is *distortion of image.* In this regard the leaf shutter is still supreme. When a fast-moving object (like a racing auto) is photographed at high speed with a focal-plane shutter, the wheels are apt to appear oval, and there may be other similar distortions. The reason for this is not hard to understand when you consider that the slit moves down (or sideways) across the surface of the film, and only a narrow segment of the image registers on the film at any given moment. In the

FIG. 5.3. RELATIVE EFFICIENCY OF FOCAL-PLANE
AND LEAF SHUTTERS

meantime, however, the image has also moved a little so that when the next portion registers it is not quite in line; hence the distortion. Though this sounds very bad in theory, the distortion involved (except for very fast-moving objects taken at too slow a shutter speed) is not too serious. Press photographers overcome this hazard to a great extent in three ways: (1) by using the fastest speed at all times, (2) by stopping down, which corrects the distortion of this type shutter as it improves the efficiency of the leaf shutter, and (3) by following the action with the camera; swinging the lens, that is, to keep pace and direction with the object. This is called *panning.*

Exposure Value System (*EVS*); also *Light Value Scale* (*LVS*). Invented by the makers of the Compur shutter, and introduced in the 1955 Rolleiflex, this change in shutter synchronization represents what the British *Journal of Photography* considered at that time "one of the most important developments of recent times in camera design." What it does is to link the leaf diaphragm to the shutter mechanism in such a way that once the correct exposure is determined according to light conditions and film speed, this "light value" as set operates through the entire range of shutter speeds, by the simple shifting of only one ring or lever. Thus, if you've set your camera for an exposure of, let's say, $f/8$ at $1/125$ second (equivalent to light value 13) and you suddenly have to shift to $1/250$ or even $1/500$ because the object is moving rapidly, you merely turn the milled setting ring clockwise to $1/250$ or $1/500$, and you're still set for the correct exposure as previously determined.

If the light changes, however, you still have full freedom of choice to readjust to any other exposure by moving the leaf diaphragm to another opening. This will automatically change your light-value setting to the new exposure, cross-linking the shutter and lens diaphragm to the new light-value reading. (See index for more on EVS.)

Some Shutter Hints and Cautions

1. *Never leave a shutter of any kind tensed;* you'll shorten its life if you do. If your camera is the type that prevents double exposure, which means that you have to ruin a shot when you release the shutter, find out how you can effect this release with your particular model, or leave the shutter unwound after each exposure. This is better practice in any case, since the new film brought up for use each time will not have had a chance to buckle.

2. When using the Compur shutter for bulb shots, don't make the mistake of setting it on time by mistake: *you'll ruin your negative.*

3. To remove tension from the shutter spring of the twin-lens Rolleiflex, move the indicator to B (*bulb*) before closing the case.

4. Never use the delayed-action mechanism with the highest speeds.

5. Never try to rotate a shutter dial against an arrow; *you'll strip the gears.*

6. Don't change the exposure *after* cocking the shutter; it doesn't do the shutter any good. This does not apply, however, to the Leica, Ricoh, Nikon, or Canon type cameras.

7. If your camera has two shutters (leaf and focal-plane, as in the Speed Graphic) be sure to leave one *open* when the other is in use.

8. When rewinding a focal-plane shutter be sure, on the other hand, that the leaf shutter is *closed*, the lens capped, or the film holder covered by a slide. Otherwise you'll fog the film.

9. Never try to cock a leaf shutter that is set for time and is *open.*

10. Never move from any other setting to time or bulb, or vice versa, while the shutter is cocked.

11. When using the self-capping, focal-plane shutters (as in the Leica and Nikon) be sure to continue winding until you feel a positive stop. If you don't do this your exposure will not be accurate, and your film will not be completely wound.

12. Never, under any circumstances, attempt to oil or clean a shutter of any kind yourself. The mechanism of a photographic shutter is just as delicate as that of a fine watch; if you wouldn't tamper with one, leave the other alone too. If your shutter needs adjusting or cleaning, let a skilled mechanic do it.

13. If you have a 35mm camera with a rubberized cloth focal-plane shutter (Leica, Mamiya, Pentax, Minolta) don't walk around in the sun with the lens uncovered, especially if you have it set on infinity. *The sun may burn a hole in your shutter!* To avoid this, if you must leave your lens unprotected, shift your focus from infinity to closeup (about 4 or 5 feet).

14. Don't leave a camera on the shelf for any length of time without occasionally operating the shutter. Repeated cocking and shooting, at sensible intervals between storage, will tone up the springs and redistribute the lubrication.

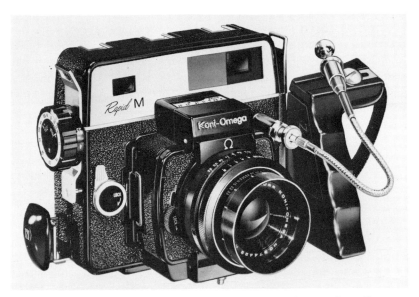

"Skill in photography is acquired by practice and not by purchase."
—PERCY W. HARRIS

6 What Camera Shall I Get?

Most amateurs devote more than half their hobby time and most of their spare cash to searching for, or trading toward, the "perfect" camera. That's why there are so many camera exchanges. The fact is, it doesn't matter what kind of a camera you get, provided that it's good of its kind and that you learn how to use it. Anyway, no one camera can serve for all purposes; so your effort to find the Universal Camera will become a never-ending search. Percy W. Harris, quoted above and elsewhere in this book, was the beloved editor of *The Miniature Camera Magazine* (later *The Modern Camera Magazine*). He made it his business to know everything that could be known about the craft of the camera. What he is saying here about the futility of searching for the *ideal* camera is the gospel according to a gentle man who spent half a century coping with the problem.

Cameras differ chiefly in *size* and *speed*. Otherwise, they all work alike. Get the best lens you can afford, because that *is* important, but don't worry too much about the style of the camera box. Styles change, and return.

At one time it was a race between the 35mm cameras (*Leica* and *Contax*) and the twin-lens reflexes (*Rolleiflex* and *Ikoflex*); now it's a

wild scramble among many: the SLR cameras of all sizes and formats (35mm, 2¼ inch square, and ideal format 6 x 7 cm); the eye-level rangefinder 35's with interchangeable lenses (*Leica M4* and *M5*); the rangefinder models with fixed lenses; the streamlined press-type cameras like the *Koni-Omega Rapid M,* the *Mamiya Press,* and the *Linhoff Press Technika;* the 126 instant-load cartridge-type cameras, like the *Insta-matic,* that give you a square slide for viewing in any 35mm slide pro-jector; the new compact 35's, pioneered by the *Rollei 35;* and finally, the ultraminiatures, like the *Minox, Yashica Ataron,* and the *Minolta Super 16;* and now there are the 110 size Pocket Instamatics.

As you grow up in photography you'll notice that your demands on material and equipment become less and less exacting. That high fever of discovery that lures you from one miracle developer to another, from one print paper to another, from one new film to another, will finally burn itself out and leave you weaker but wiser. When it's all over you may find as I did, and as almost all amateurs inevitably do, that the manufacturers of photographic products really know what they're talk-ing about. When they recommend a certain procedure with one of their products they do so because they secretly know that by following their suggestion you'll get such marvelous results that you'll continue to use the product. It's as simple as that. When the chemists at Eastman Kodak, for example, recommend that you develop Plus X in Microdol X, or D 76, they *know* that you cannot get better results or finer grain, or anything at all, by using one of the many magical supersoups now on the market. *You can't, that is, without sacrificing something.* You may get finer grain, but your pictures will not be as sharp. You may get more speed, but grain clumps will pepper your print. You may get more tones, but you will lose brilliance. Besides, you can duplicate any of these defects, if you really want to, by using D 76 and changing your exposure, your developing time, or the dilution of the developer. (Having said this much, all of which is true, I must point out that there are some devel-opers that have somehow managed to break through with remarkable combinations of film speed, acutance, tone distribution, and fine grain. Among these are *Acufine, Diafine, Neofin Blue,* X-22, *H & W Control, Ethol UFG, Ethol Blue* and, of course, that old standby, *Rodinal.*)

And so it is with cameras. The law of compensation, as Emerson so beautifully pointed out, is the law of life itself. Every advantage has its disadvantage; every loss has its gain. Do you envy the man with the f/1.4 lens? He can't stop down below f/16; he almost never uses the lens wide open because he gets sharper pictures at f/5.6. Do you envy the man with the focal-plane shutter and speeds up to 1/1000 second? When he takes a picture of a racing auto, the image moves across the

film so much faster than the shutter blind that distortion squashes the wheels and makes them look like eggs.

Your chances of needing a shutter speed faster than 1/500 second are quite remote. With an EVS index of 13, equivalent to bright sunlight (and an ASA 125 film), your meter would call for an exposure of $f/4$ at 1/500 second. A larger aperture would give you very little depth of field, so $f/2.8$ at 1/1000 wouldn't help much. The 1/1000, as you see, would only force you to use a wider aperture to get the same exposure, and that would spell trouble. Anyway, 1/500 would stop almost all the action you'll ever photograph; if you are working indoors, where you can control the light, use one of the new automatic electronic flash units which has the stopability of a shutter of from 1/1000 to 1/50,000. You can use the same electronic flash outdoors, of course, but as a *fill-in-light* to soften the shadows.

Good Pictures Have Been Taken with All Sorts of Cameras

Arnold Newman uses a *Nikon;* Ansel Adams uses a *Hasselblad,* a *Contarex,* and a *Sinar View;* Dr. D. J. Ruzicka, who first photographed the cathedral interior of Grand Central Station (with shafts of sunlight streaming down through the skyhigh windows), used a beat-up *folding Kodak;* Ralph Morse of *Life* uses a *Nikon;* Alfred Eisenstaedt is devoted to the *Leica M,* but occasionally uses a *Nikon;* Fritz Henle now uses an *SL66 Rolleiflex,* having switched recently from the TL Rollei; Edward Weston liked the contact quality of the big view camera; Philippe Halsman uses a reflex camera of his own design, as well as a *Polaroid;* Valentino Sarra still relies on his 4 x 5 *Speed Graphic;* and Eliot Porter takes those exquisite nature photographs with a *Hasselblad* or a 4 x 5 view, though he also uses an *Alpa SL-35.*

Obviously, the secret of good pictures does not lie in the choice of a camera. Is it the lens, then?

I was curious to see how much the lens had to do with success in photography, so I checked through seven hundred pictures shown at a Leica exhibit held at Radio City in New York. Here were pictures taken by all types of photographers, all over the world and under all sorts of conditions. There were pictures by professionals, press men and amateurs. What did they use? What speeds, what lenses? Well, the results were both disconcerting and heartening:

78 per cent of the pictures were taken with the normal 50mm lens!
10 per cent were taken with a wide-angle lens.

12 per cent were taken with a telephoto.
89 per cent were taken at f/3.5 or slower.
65 per cent were taken at f/6.3 or slower.
11 per cent were taken at larger apertures than f/3.5.
53 per cent were taken at 1/40 second or faster.
27 per cent were taken at 1/100 second or faster.

Not many crumbs of comfort for the camera-swapping amateur in those figures. Almost 80 per cent of the pictures could have been taken with an f/3.5 lens (which would have been stopped down to f/6.3 in most cases) and with a shutter speed between 1/40 and 1/100 second. For that you certainly wouldn't need any fancy equipment. Just keep this in mind when you visit any photo exhibits in the future; notice how often the pictures are taken at speeds of f/6.3 to f/8 at 1/40 to 1/100 second.

How to Choose a Camera

After *Edward Steichen* had put together that monumental photographic exhibition, *The Family of Man*, he summed it up by saying: "No photographer is as good as the simplest camera." What he meant, of course, was that the wonders of even a simple camera are not fathomed by one man in a lifetime. Whether it's a ten dollar *Instamatic*, or a three thousand dollar *Hasselblad* loaded with accessories, there is one magical ingredient that brings the inanimate machine to life: *the brain of the photographer.*

The modern amateur photographer is so concerned with gadgets and conveniences he often forgets that *judgment—his* judgment—is the only thing that really matters. There are many photographers who use the Leica; there is only one Cartier-Bresson. And it is his masterful, if sometimes mysterious, choice of the decisive moment that separates his great pictures from the mass of snapshots by the rest of us. We cover the same ground he does, but with such different results. No camera and no exposure meter has a brain of its own. It waits for us to give it the spark of life. What we decide makes the difference.

I was in the camera shop of Henry Herbert on Fifth Avenue many years ago when a young man came in for some advice. He had a portfolio of prints under his arm, and a now-obsolete Kodak box camera [1] in his hand. What he wanted to know was whether a better camera could

[1] *Box camera.* The simplest kind of camera, combining a lens, a shutter, a light-tight box, and a method for transporting film. Most of such cameras focused sharply at 15 feet, but since the lens aperture was small (about f/11), the depth of field was great. Kodak *Instamatic* cameras are virtually box cameras, but they have been packaged to look better.

help him take better pictures. We looked at his prints together, and marveled at their sharpness and their beauty. As for sharpness, he had discovered that the lens worked best at 15 feet and beyond, so he arranged his pictures accordingly. I asked: "How did you get those dramatic clouds?" His answer: "By waiting for the right kind of day, the right time of day, and by holding a yellow filter in front of the lens." At that point, Henry turned to me for confirmation and said: "No, a better camera will not help you take *better* pictures, but it would make things a lot easier for you. Tell you what. I'll let you have a good camera at a whopping big discount, if you're really interested. You sure deserve one." The young man bought a used *Rolleicord*, in mint condition.

The message here is that, within limits, the better camera will make better pictures *easier*, but will not necessarily make excellent pictures possible. The artist can "wait for the right kind of day," but you may want to get a picture even if it is pouring rain, because you can't wait two weeks in Moscow for clear weather.

I have a hunch that there would be more Cartier-Bressons, Edward Westons, Ansel Adamses and Edward Steichens if we all had to start with a box camera or its equivalent, and were made to prove that we could use that well, before we were allowed to touch another camera.

Unfortunately, the appeal of a camera is much like the appeal of a car. It isn't enough for us that it can get us there; it also has to have the right equipment. There is no doubt the modern cameras are made to look and handle beautifully. But they don't take any better pictures. If you doubt this, look at some of the war photographs of Roger Fenton (who photographed the Crimean battlefields in 1855) and of Matthew Brady (who photographed the Civil War from 1861 to 1865) and then realize that these magnificent silver prints and daguerreotypes were exposed, developed, and printed right on the battlefields, in clumsy covered wagons. Herbert W. Gleason, a New England cleric turned photographer, is a case in point. He was 44 in 1899, when he left the ministry and took up the camera. He spent the next 38 years traveling all over the United States, Alaska, and Canada, with a huge view camera, a tripod, and thousands of glass-plate negatives. He died in 1937.

His photographs illustrated the 20-volume 1906 edition of *Thoreau's Works* and John Muir's 1915 edition of *Travels in Alaska*. He used a large view camera fitted with a Goerz *Dagor* lens, and glass negatives. Here are four examples of his photography, from the collection of Roland Wells Robbins of Lincoln, Mass., who owns the negatives.

Just look at these beautiful photographs on the next three pages; they were taken with a clumsy view camera and glass plates!

Have we done any better lately, with all our fancy equipment?

This is not an argument to send us back a hundred-and-fifty years

THOREAU'S WORLD. A double row of Arbor Vitae near battleground, Concord. Taken by *Herbert W. Gleason*, May 18, 1902. From Roland Wells Robbins' collection.

THOREAU'S CAPE COD. Old Fish House, Pleasant Bay, South Orleans. Taken November 19, 1903, by *Herbert W. Gleason.* From the collection of Roland Wells Robbins, and with the permission of Barre Publishers, Barre, Mass.

A FOGGY EVENING in the Public Garden, Boston, Mass., November 8, 1908, taken by *Herbert W. Gleason.* From the collection of Roland Wells Robbins.

NEW ENGLAND BAYBERRIES. Taken by *Herbert W. Gleason* as one of 1230 photographs to illustrate the 20-volume edition of *Thoreau's Works*. From the collection of Roland Wells Robbins.

in time. I am only trying to point out that the camera is less important than you are; than the two indispensable gadgets you are born with, your brain and your eye. Use these well and your box camera pictures will look like masterpieces; use them badly and your Hasselblad will function like a pinhole camera.

BASIC CONSIDERATIONS

There are lenses as fast as $f/1.2$, shutters as fast as 1/2000 second, and electronic flash units that stop action at 1/50,000 of a second. What are the chances of your ever needing one of these? Unless you are a scientist, a news photographer on special assignment, or someone with an overpowering itch of curiosity and the money to support it, you'll *never* be culling any of these. A camera with a sharp $f/2.8$ or $f/2$ lens and a shutter that goes to 1/500 second are about all you'll ever require. You may want a wide-angle lens and a telephoto lens (which we covered earlier) but that's about it, as far as camera equipment goes.

If you are going to photograph mostly in *color* (and four out of five people do), you'll be showing *slides*, which are processed for you; or you

will be using *negative* color (like *Kodacolor*), in which case you'll get *color prints* back, and will not be needing a *darkroom*.

But not so fast!

With a darkroom (or even a makeshift) you can develop your own film and make your own contact prints or enlargements, *at a tremendous saving in cost.*

And as for color, you can now do it much more easily than ever before and much less expensively, using the modern methods discussed in the chapter on color. There you'll be told about every new technique and every piece of modern equipment that can make your life in the darkroom a real delight, creatively and financially.

Your choice of a camera will depend, naturally, on what you can afford to pay, how much convenience you want for that price, and how many camera virtues you are willing to do without in exchange for that convenience. If you like the compactness and ease of handling of the miniatures, you will have to pay from $1.50 to $2.00 apiece for decent-sized enlargements, or get an enlarger of your own. Also, your lens will have to be better because a small negative has to be enlarged more and therefore must be *sharper*, and thus somewhat more expensive. If you're not very good at judging distance, the blind cameras (that is, those having neither ground-glass nor coupled rangefinders) are not for you (unless you'd be satisfied with one of the fixed-focus cameras). You'd do better to get a sheet film or view camera (that is, one with ground-glass focusing). If you want to "shoot the works," you can get a coupled-rangefinder camera like the *Leica M5*, a single-lens reflex like the *Nikon F2*, or that superb electronic geewhiz, the Zeiss *Contarex SE*.

If you like clarity and sharpness in your prints, get one of the larger sizes; if you're going in for photography on the run or in the dark, get a miniature of the 35 mm size.

A good compromise size for most purposes is the 2¼" square 120/220 film size, as in the *Rolleiflex TL* and the *Rolleiflex SL66;* or the 2¼ x 2¾ inch 120/220 *ideal* film size, as in the *Mamiya RB67 Professional*, the *Honeywell Pentax 6 x 7 SLR*, or the *Konica Omega M.*

If you want speed in that size, most of the cameras have models that are now fitted with *f*/2.8 lenses. If you're more serious in your intentions, by all means get one of the film-pack or view cameras from 2¼ x 3¾ to 4 x 5 inches in size. Developing is less finicky; contact prints are often large enough for viewing; and the ground-glass focusing is exact and foolproof. Furthermore, many of these cameras can be equipped with accessory rangefinders that are coupled to the lens, if you prefer that type of focusing.

Other considerations: How fast do you have to take your pictures, and how often? Cathedrals will wait for you; animals in the game parks

of Africa are something else again. Will you need a motor-driven minia-ture, or a view camera with all the swings and shifts? Also, how much weight can you backpack? Do you plan to take many pictures in muse-ums, libraries, art galleries? Most of them have restrictions (in the Stockholm Art Gallery, there is a sign which says *"No flash. No legs"*). Are you planning much *candid* photography? Try the twin-lens cameras with the lens pointed one way, while you seem to be looking away (but seeing the scene through the ground glass) at a 90° angle.

Will one camera do the job? Not when you're traveling. A better plan is to use two camera bodies with interchangeable lenses; one for *transparency* color, the other for black-and-white or *negative* color; and use 36-exposure rolls.

A FEW CAUTIONS

It is easier to get good results with a larger camera than with a miniature. Excluding the cost of film, it is cheaper also. If you are not

VIEW FROM THE 29TH FLOOR. Taken with a *Koni-Omega M*, 180mm Hexanon lens, and 220 back. Tri X film developed in Microdol X.

planning to do your own developing and enlarging (and even if you are) a large camera is a wiser choice because it requires less diligent processing methods. In any case, whatever the camera, get the sharpest anastigmat lens you possibly can. If it's a miniature, $f/2.8$ is fast enough; if it's a larger camera even $f/4.5$ will do. Be sure, also, that the lens is set in a good, dependable shutter. The *Compur* and *Compound* shutters can always be relied on to perform well, as can the *Seiko* and *Seikosha*, the Wollensak *Rapax*, or the metal FP shutter, the *Copal Square*.

Though the lenses of miniature cameras have greater depth of field, this advantage fades as we increase the size of the prints. Contact-print quality can only be obtained by a contact print (one made with the negative in *direct contact* with the print paper, as distinguished from an *enlargement* which is made by projection); don't let anybody tell you otherwise. Obviously, then, it's best to enlarge as little as possible. A 4 x 5 inch Crown Graphic negative only needs a 2x enlargement to make an 8 x 10 inch print; a 35mm negative has to be enlarged eight times to make a print of the same size. The larger cameras, especially the view types, have certain swing and tilt movements that are invaluable for still lifes, architectural pictures, etc., but they cannot as easily be used without a tripod. The smaller cameras, however, are much more rapid in operation, use cheaper film, are lighter in weight, are less conspicuous, can be hand held, and the film is easier to buy and to handle.

Other Factors in Choosing a Camera

Seeing the picture. No matter how good the camera may be in other ways, if you find it difficult to *see* the picture in the viewfinder or on the ground glass, you'll get very little fun out of your photography. It would be like stumbling around in the dark; you might just bump into something good, but the odds are against it. A camera without a decent viewfinder is worthless. So check that first. Make certain that the picture you see in the viewfinder is the picture your camera sees (and that parallax errors are corrected, if it isn't a single-lens reflex or a camera with a ground-glass back). If you can't take the camera back off and check it with a ground glass, make certain that the dealer lets you test a roll of film before you have to make up your mind. Also, find out, by trying many types, which kind of viewer is best for your eye. Some cameras have a special eye compensator for near and far viewing; the Rolleiflex has an interchangeable focusing magnifier which can be ordered, without extra charge, in whatever diopter correction your eye needs (from minus 3 to plus 3 diopters).

If you wear glasses. Photographers who do are often disturbed by

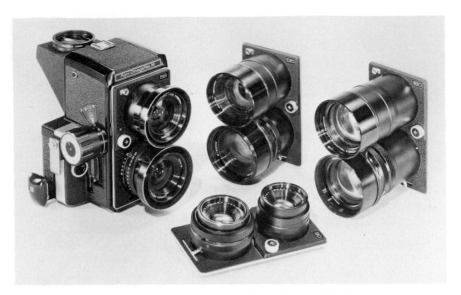

The *Koni-Omegaflex M* and its battery of interchangeable lenses.

The *Leicaflex SL*.

their inability to get close enough to the viewfinder. Here are some suggestions:

1. Find out if the manufacturer of your camera can supply a *diopter* lens that can be attached to your eyepiece, preferably one that can be swung 90 degrees (in case you have *astigmatism* and want to turn your camera for vertical pictures). Some of these correction eyepieces are made to clip on, and some to screw into the viewfinder (to replace your glasses, of course). Leitz, Zeiss, and Rollei all offer such attachments. Similar accessory lenses for other cameras may be available, or can be made. Sometimes an adjustable eyepiece is provided, as for the Rollei *Pentaprism*, or a few SLR's. Should you get a correction lens made, be sure it is for *distant* vision. If you use *bifocals*, use the upper segment for viewing through your camera viewfinder (the fact that your eye is close to the viewer has nothing to do with it; you are

still looking at a distant scene, optically). If all else fails, and your dealer can't help you, check with Marty Forscher of Professional Camera Repair Service, 37 West 47th Street, N.Y. 10036.

2. Perhaps a rubber cup can be found to fit your eyepiece, as it is for most *movie* cameras. This would exclude extraneous light and soften the contact between your glasses and the viewfinder.

3. Look into the possibility of *contact lenses* solving your problem. But first, make certain that your doctor approves of your wearing them. If you've never worn contacts, move slowly in this direction. They can be a pain in the ocular. Dust makes life with them unbearable, and they do fall out. They are made of plastic, *soft* plastic, or glass.

4. Check into the Nikon *Action Prism Finder* which permits observation of the entire finder screen when the camera is held up to 2½ *inches away from the eye.* Wonderful for action photography when wearing glasses or goggles.

Judging distance. Though it is perfectly true, as H. Postlethwaite once pointed out in *Camera World,* that you can get along with a piece of string knotted every foot, you'll enjoy your camera more if you can be sure of getting sharp pictures when you want them (though sometimes you may deliberately want to throw part of the scene out of focus). With a *box-type camera,* which is set to focus at about 15 feet, there is

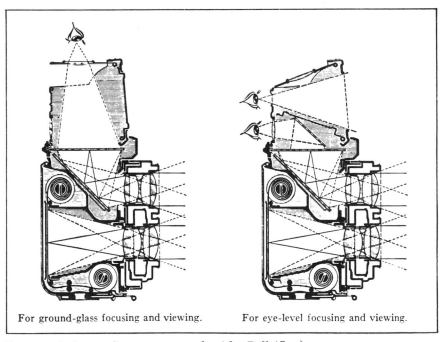

For ground-glass focusing and viewing. For eye-level focusing and viewing.

How a twin-lens reflex camera works (the Rolleiflex).

no problem and no choice. Everything from about 6 feet to infinity will be approximately though unchangeably sharp. With a lens of greater speed, however, and especially when you use it "wide open" for fast action, dim light, or to throw part of the scene out of focus, accurate focusing is a must. Here again you have to decide what is best for you as between blind-focusing (by distance scale), coupled rangefinder (split or superimposed image), ground glass (with or without accessory Fresnel lens), and the combination of both split-image and ground-glass focusing, as in many modern single-lens eye-level reflexes, originally pioneered in the Contaflex and Alpa 6 cameras. The TL *Rolleiflex,* among others, has a crossed wedge rangefinder incorporated in the center of the viewing screen. This operates as a split-image rangefinder. When the split sections merge to become a continuous image, you are sharply focused. At that point the ground-glass image around the wedge will also be sharp.

It is also important for you to check the manual mechanics of focusing. In the Rolleiflex, for instance, the focusing knob is on the right; in the Rolleicord, it is on the left; in the Contarex it is done by a milled wheel at the top, which makes it easy to focus-and-shoot; in the Polaroid there are rangefinder push-button focusing knobs on each side of the lens. In most of the other rangefinder cameras, focusing is accomplished by rotating the outer rim of the lens. In the *Koni-Omega* (and the *Rapid M*) there is a large, milled focusing knob on the right side (as you hold the camera to your eye), with color-graded distance scales for all the lenses. Try all of these focusing methods before you decide. It may make a big difference to you, for instance, if you are left-handed.

Finally, are the viewfinder and rangefinder images brought together in one large window as in the Leica M4 and M5, the Canon, the Konica, and the Koni-Omega, or are they separated, as they were in Leica F?

Loading and winding the film. Does the back of the camera swing away or come off, as in the Contarex, Nikon, Nikkorex, Leica M4 or M5, Rolleiflex, and others; or does the loading of film require an engineering degree and the skilled hands of a brain surgeon?

If you're heavy-handed and awkward, stay away from the Hasselblad.

Check on what kind of film cassettes are needed, especially in the 35mm cameras; you may want to bulk-load your own cartridges later. Felt-lined cassettes sometimes scratch, so it's better to avoid them.

Does the camera have an automatic film transport as in the Rolleiflex and the Leica? Is it coupled to the shutter to avoid double exposure? Can it be uncoupled, if necessary, as in the Rolleiflex? Are all the moving parts smooth-working, without backlash?

FOCUSING WITH A SPLIT-IMAGE RANGEFINDER. This is what
you see in the viewfinder of that superb Swiss SLR, the *Alpa* 10d
(Karl Heitz). The view on the left is out of focus (see neck of swan);
the view on the right is exact focus. Note that the overall image is degraded
at left; sharp and clear at right. *See Fig. 6.1* below (new Alpa rangefinder).

FIG. 6.1. THE NEW ALPA
RANGEFINDER. The split-image
of the *Alpa* 11e now combines a
microprism ring with a clear glass
ring, which makes it possible to focus
with greater certainty and greater
case. Signals from the three CdS cells
are center-weighted and there is
compensation for any light leakage
through the eyepiece. The two colored
arrows (shown centered in the
bottom bar) warn of *over*exposure
or *under*exposure.

 Is the film size available everywhere, or do you have to keep a large
stock of it on hand yourself to avoid missing pictures?
 Does the film have to be rewound before removal, as in most 35mm
cameras; or does it sensibly pass from a *removable* cassette to a *reload-
able* cassette, to avoid being scratched by the dust-collecting felt light
trap; and finally, does it remain in a sealed double cassette, as in the
Instamatic cameras, which require no rewinding? There are two Insta-
matic cameras that may interest the serious photographer who prefers
cartridge loading: the *Instamatic X-90*, with coupled *rangefinder*, $f/2.8$
Kodak *Ektar* lens, and automatic exposure control; and the *Instamatic
Reflex*, a single-lens reflex with seven interchangeable lenses, automatic

electronic shutter, ground-glass and split-image rangefinder focusing, instant return mirror, *Xenon f/*1.9 lens or *Xenar f/*2.8 lens. An interlock on the Xenar lens couples diaphragm to focusing when using flash; a plug-in for electronic flash, and a right-angle finder, are also available as accessories.

Picture size. Later on we will discuss cameras that use various popular film sizes. Those we have chosen are pleasing in their proportions, are available everywhere and in plentiful variety, and the enlargers needed for them are low in cost and are well constructed. The big unresolved question is: *square or rectangle?* The proponents of the rectangle say the square is a rectangle cut down; the others insist the rectangle is cut from the square. I remember something Alfred Stieglitz once told me when I commented on the fact that so many of his wonderful prints had the focus of interest in dead center: "That is the way the eye sees it."

Fritz Henle composes his pictures within the square Rollei shape, and prints them usually without alteration; Cartier-Bresson composes his Leica shots to the very margins. However, there isn't an amateur photographer alive who can't improve his picture by cropping. See *Trim When in Doubt,* page 419.

Flash synchronization. Shutters take time to open, and bulbs take time to flash. The problem of synchronizing leaf (between-the-lens) shutters is that you have to make certain the leaves are open at the very moment the bulb is at its brightest. With shutters marked M-X this can usually be accomplished at *any* speed using the M setting, and at 1/25 (to 1/60) using the X setting. Electronic flash can be synchronized *only* with the X setting; when used with the M setting, the shutter begins to open *after* the flash is over because the M setting is adjusted for a time delay equal to the number of milliseconds it takes for the flashed bulb to reach its peak.

With focal plane shutters, this problem is further complicated by the way the curtain slit swings across the film plane, exposing the negative in successive strips instead of all at once. To avoid losing part of the picture, use the M setting for flash, 1/25 to 1/60 with small cameras, and not more than 1/25 with large cameras. For electronic flash, use your leaf (front) shutter if you have one (remembering to leave your focal plane shutter open) at the X setting and at *any* of the shutter speeds, or your focal plane shutter at the X setting, but then only at the slower (1/25 to 1/60) speeds.

Where the light is mixed (daylight and flash or electronic flash) there is the additional problem of balancing or avoiding background exposure, especially at slow speeds. You do this by using the M setting (X for electronic flash) and adjusting diaphragm or shutter as explained

in the sections on *flash* and *electronic flash* photography (see *index*).

What do the letters M-F-X and FP-S mean? They describe the time-lag used to delay opening the shutter or to control the firing of the bulb: M for medium (20 milliseconds to reach full peak), F for fast (fires circuit when blades are half open, about 7–8 milliseconds), X for zero delay (fires flash at instant shutter blades are fully open), FP for focal plane (long-flash bulbs with a flat peak duration of about 40 milliseconds), S for slow (these bulbs do not reach peak until 30 milliseconds after contact; can be used with X setting at 1/10, with F setting at 1/15, with M setting at 1/25). You'll find these letters somewhere on the shutter (if it's a *Compur*, for instance) or on the body of the camera, as *flash synchronization terminals* (as on the Leica).

Exposure meters. The trend has been toward built-in meters coupled to the exposure-control mechanism as in the Leica *M4* and *M5*, the *Nikon F2*, and *Photomic FTN*, and the Yashica TL. But remember that there may be times when you'll be cussing out that built-in meter, especially after you have put your camera on a tripod and then have to take a closeup reading. That's one of the two reasons why many photographers carry with them an additional hand-held exposure meter. It enables them to read closeups without disturbing the camera on a tripod. The other reason they carry an extra meter is to avoid being caught without one if the built-in meter goes bad. In a built-in, fully *automatic exposure system*, the meter mechanism is linked to the lens aperture (or shutter speed setting). It moves this directly, depending on the amount of light that falls on the photo cell. Where such a coupled meter needs *manual* operation to line up a meter needle with a fixed or movable pointer, it is known as a *semi-automatic* (or match-needle) type of metering system.

If you use a tripod, and have occasion to shift your camera on and off quickly, get yourself a *detachable tripod mount*. There are quite a few good ones on the market: the *Rolleifix*, the *Zip Grip* (invented by Frank Rizzatti, who also invented the *Super-Slide*), the *Powerlock*, etc.

Shutter mechanism. There are two kinds: *focal plane* and *between-the-lens* (or *leaf-type*). Each has its advantages and its troubles, some of which have been mentioned previously. The important thing to check is the relation of the shutter to the lens aperture (1/25 at $f/11$, 1/50 at $f/8$, 1/100 at $f/5.6$, etc.). The exposure on the film in each case should be exactly the same, and you should test this *before* you take your camera out on an important picture mission.

The way you test it is to photograph a gray card (like the 18 per cent Gray Target sold separately by Kodak, or included in their *Kodak Master Darkroom Dataguide*). Take a reading in the kind of light that gives you an EV index of 13 ($f/8$ at 1/125 second with a film of ASA

100). Then run the gamut of linked exposures from $f/4$ and 1/500, if your shutter goes that high, and then down to $f/5.6$ and 1/250, $f/8$ and 1/125, $f/11$ and 1/60, $f/16$ and 1/30, $f/22$ and 1/15, etc. If your camera doesn't have the speeds or apertures listed here, make the necessary adjustments. After you have processed and dried the film, all the exposures should have the same intensity of gray.

Shooting fast. For taking sequence pictures you need some means of rapid film transport linked to the shutter-cocking mechanism. The Rolleiflex takes care of this with its LVS system of exposure control (since adopted by others) and its film-rewind and shutter-cocking crank handle; the Robot does this with its built-in spring motor and its many bulk film accessory magazines; the Praktina FX with its detachable rapid sequence spring motor; the Leica with the Leicavit speed base, its electronically driven motor base or, as in the M4, with the rapid wind lever which moves the film and cocks the shutter with one fast flip of the thumb.

Another camera to join these "rapid fire" ranks is the Nikon, which offers an electric motor driven by pen-light batteries as an accessory power plant for rapid film-transport-and-shutter-rewind. With this motor you can take up to four exposures per second. Nikon pioneered in the development of electrically-driven motors for fast shooting. They now have a 250-exposure magazine (like the one originally made for the *Leica FF*). Zeiss has also produced a 450-exposure magazine for the *Contarex*, which was delivered to the USA in time for the Apollo 14 launching on January 31, 1971.

Extra lenses. For portraits that have the best "drawing" (no distortion), you need a telephoto lens; for narrow street scenes and cramped-quarter interiors you need a wide-angle lens. Unless your camera is built to take interchangeable lenses, you will have to use makeshifts, such as stepping back to where you would stand with a telephoto lens and then enlarging the smaller image to compensate, or taking cramped interiors and narrow exteriors always at an angle. A trend in lens design that had a vogue for a while, but is now abating, is *the use of interchangeable front elements.* This system was pioneered by Zeiss Ikon in their *Contaflex SLR* camera. Other manufacturers who also used such lenses were Schneider (for the *Retina Reflex* series), Rodenstock, and Franke & Heidecke (for the *Rolleiflex SL26* instant-load reflex camera, now withdrawn). But experts have always claimed that the sharpness of an enlargement from such an optical system (with only *front* element interchangeability) could never quite equal that of a regular lens with *full* interchangeability.

Reflex or rangefinder; single or twin lens? When you start to shop

for a camera you'll have a child-in-a-toy-store variety of choice. And each camera type has its passionate defenders. If ground-glass focusing bothers you, try a rangefinder camera; the focusing is more precise. On the other hand, with a twin-lens reflex like the *Mamiya C330*, you'll see a large view of the scene at a comfortable waist level, and you'll have a *long bellows* for close focusing (if you should want to take pictures of flowers). If the advantages of interchangeable lenses and a slightly larger negative size interest you, try the *Mamiya RB 67*. Its focusing screen shows a bright image that "goes in and out of focus crisply." But it also has a revolving back that takes a *Graflok* accessory for 2¼ x 3¼ *Graphic* film holders, 120/220 roll film, and *Polaroid* film packs. Each lens has its own leaf shutter, which avoids the synchronization problems of the focal-plane shutter.

A camera type that has become increasingly popular over the years is the *single-lens reflex*. One complaint against these used to be the *blackout* that hid the image as the mirror snapped up to let the exposure be taken. The *Asahiflex* was the first to overcome this by a clever bit of engineering which returns the mirror to viewing position automatically the moment the exposure has been made. Others have since duplicated this *instant return* mirror, and it has become standard.

The twin-lens reflex, best exemplified in the *Rolleiflex*, has been (and continues to be) a favorite among photographers. It offers an EVS meter system that couples the shutter, the aperture, and the photoelectric exposure meter, 120/220 film; a *Rolleiclear* viewing screen with a central microprism for more accurate rangefinder-type focusing; an automatic film advance system, and an accessory pentaprism. But because many wanted interchangeable lenses in this type of camera, we now have the *Koni-Omegaflex M*, the *Mamiya C220* and the *C330*.

Another improvement is the *automatic iris* which is preset, can be opened full for focusing, and then snaps back to the preset *f/opening* you planned to use as you shoot. This makes it much easier to focus in dim light.

As for methods of focusing, many cameras (notably the *Alpa 6*, the *Praktina*, and the *Exakta*) solve this problem of choice by combining mirror-prism ground glass and split-image rangefinders with their viewfinders. The *Hasselblad* and the *Rolleiflex* offer supplementary focusing screens with split-image rangefinders. These are made of a large, matte-finished *fresnel* lens (for a brighter image) which has a *microprism* center-spot to make focusing fast and simple. You can easily insert one of these replacement screens yourself in less than a minute.

Many SLR's now combine a split-image rangefinder with a ground-glass screen. But others, notably the *Hasselblad, Rolleiflex, Nikon, Con-*

tarex, and *Icarex* (*but not the Leicaflex*) provide a wide choice of inter-changeable screens, with various types and shapes of focusing grain or crystal, useful for lenses of varied focal lengths.

Also available are clear-glass aerial-image focusing devices, com-binations with split-image rangefinders, ground-glass concentric rings, and many other kinds of focusing screens.

This leaves the question of what kind of rangefinder: *split-image* or *superimposed image*? If you do not have perfect vision, you may find it a bit easier to use the split-image type, since with these the point of exact focus can be determined more readily. In any case, the best way is to try them both. The Leica and the Koni-Omega use a superimposed or merged image; the *Alpa 10d*, a split-image. In the *split-image* type, two segments of a scene are divided (usually horizontally). When they come together, as in the illustration on page 127, sharp focus has been achieved. In the *superimposed-image* type, the segment seems out of focus, as on a ground glass, until exact focus has been reached, at which time the scene is sharp not only within the rangefinder circle, but out-side as well.

Parallax. Since it is impossible for both the lens and the viewfinder to occupy exactly the same point in space, the use of a viewfinder always introduces the error of parallax, or image displacement. If your viewfinder is not corrected for this by some device built in by the manu-facturer (as in the *Leica M4, M5*, the *Koni-Omega M*, and the *Rollei-flex*), you can overcome it by placing the subject in the finder close to the sides nearest to the lens. This will tend to center the subject on the film. A few trials, preferably made on a tripod so that you can be sure of what you are doing, will tell you how extreme this correction must be in your case.

Through-the-lens (TtL) metering. This new method of exposure control is based on the simple proposition that the best place to read the light that affects your negative is right at the negative plane, where the meter reads what the lens sees. The engineers place a tiny coin-shaped CdS sensor (sometimes they use two) in the center of the picture area. This is rigged up so that the meter, to which the sensor is connected, is calibrated to the lens aperture. The sensor has to be moved out of the way before the picture is taken.

But this presents a few problems.

In some cameras, like the Asahi *Pentax* Spotmatic (Honeywell) which has two *average-reading* CdS cells, the lens is closed down to the taking aperture when you make a reading, so the image dims.

In others, like the *Nikon F*, the CdS sensor is *center-weighted* (which means that it gives a tapered spot reading of 65 per cent at the core, with the balance edging off toward the rim). This ensures that

the meter reading is balanced in favor of the main subject area. The light meter is calibrated to the largest lens opening being used. (Ninety per cent of your readings undoubtedly will be made with the lens wide open, though the system can be used with the lens stopped down.) You open the lens wide, read the scene, and the self-compensating meter tells you what aperture to stop down to, for whatever shutter speed you have chosen. Then, when you set the shutter for that speed, the lens closes down to the predetermined aperture as you begin to take the picture.

In still others, as in the *Minolta*, the TtL metering system involves two CdS sensors, but is neither a *spot* method nor an *averaging* method (it combines something from each). One sensor is sensitive to light; the other is sensitive to dark. If the difference between them is small, the meter gives an average reading. If the scene is contrasty, and the difference between the readings is great, one sensor influences the other for CLC (contrast light compensating) readings. If you are really interested in how this works, send to the Patent Office, Washington, D.C. for Patent #3,428,403.

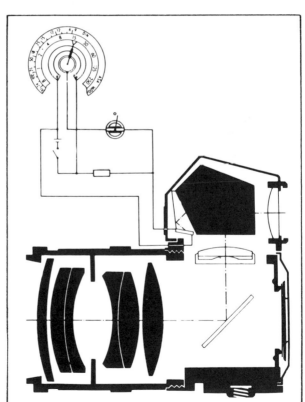

HOW A TtL
METERING SYSTEM
WORKS
This one, used in the
Pentacon (Dresden), and
available in England
and Europe, is based
on measuring the entire
in-focus image with the
lens *stopped down* to the
taking aperture. The meter
in this *Pentacon* system is
cross-coupled to both
aperture and shutter speed,
and uses *center-weighted*
and *integrated* light readings.
(See text: *Through-the-lens*
[TtL] metering.)

The problem becomes most acute in those cameras which have both electronic shutters *and* through-the-lens metering. In all such cameras (like the Zeiss SLR *Contarex SE*) the CdS cell integrates the light over the entire exposure time, and shuts off when the cell has received a preset amount of light. But where the cell does not register light during the actual exposure (because the reflex meter has to be swung out of the way) direct integrating control is not possible; an external (not TtL) meter system has to be used. This is true of the *Leica M5*, where the meter cell has to be swung out of the way during the actual exposure.

One solution is to include an extra beam-splitting system in the camera, which feeds the meter cell alone and remains in position during the exposure. Another is to bring in the *memory-hold* circuit used (and patented) by Asahi. No doubt, there will soon be other such memory-hold systems available.

The *Electro*-Spotmatic system offered in the Asahi *Pentax* provides fully automatic exposure control at *full-lens aperture* for all current super-multi-coated (SMC) *Takumar* lenses. The method is simple. You choose a lens aperture, point the camera at the scene, and *partly* depress the shutter release. If the exposure time indicated in the finder is suitable, just press to take the picture. Otherwise (for a faster shutter to stop motion or avoid blur due to hand-shake), choose a larger lens aperture and try again.

Though some noisy debates have started about which metering system is best, you must remember that all of them require some kind of compromise. A *spot* system is better than an *averaging* system (because you can *zero in* on vital areas), but *only* if you know how to use it. The spot system will not take care of objects outside of the meter's narrow viewing angle. Neither will extremely bright nor very dark parts of the scene be exposed properly unless you learn to take a number of readings (one for each important light level), and then average your readings. The *center-weighted* systems are good when you want to compensate for contrasting scenes, but they are not a cure-all for exposure problems. An accidental flash of light from a shiny object within the meter's range can upset your exposure. Then, there's the matter of whether to take the reading *wide open* (for comfortable seeing) or *closed down* (for more accuracy). Both systems, again, are good, and are being used effectively, but more and more manufacturers are leaning toward the wide-open systems, for seeing's sake.

To sum up: The TtL systems are great. But don't forget to bracket your exposures, for safety. And if you're smart, you'll take an extra meter along, just in case.

How to Buy a Camera

Don't forget that the cheapest *Leica* can, under certain conditions, make as good a picture as the latest model, especially if the lens in both is the same. And resist buying things you'll have no use for, such as slow speeds unless you're willing to use a tripod, or speeds above 1/500 (if you've never used anything faster than 1/200 before). I've had an expensive miniature for years and have yet to use the self-timer or the speeds above 1/500, yet I paid plenty to have both.

When the salesman first puts the camera in your hands, make sure you understand what each knob, wheel and lever does *before* you attempt to use it. *And don't force anything!* See that everything moves freely without sticking, and that the shutter mechanism works perfectly at each speed. If anything sounds wrong, insist on another camera or proof that the sound you heard is normal. Don't take the dealer's word for it that the stiffness or sticking will "work its way out in time." A camera is not an automobile motor; no breaking-in period should be required. And see that there is no backlash of lens-rotating or shutter elements.

If it's a secondhand camera, open the back and tap it gently over a piece of white paper. If a lot of dust and dirt falls out, don't buy it; it will probably give you trouble. Make sure the lens isn't marred or scratched, and look for any evidence that the camera has been dropped. If it was jarred badly, the lens elements as well as the rest of the delicate mechanism may be out of kilter. Such repairs are costly.

Never buy a camera, new or old, without a written guarantee and a money-back trial period! The way to avoid trouble in these matters is to deal with a recognized and reputable dealer. The extra discount you get from a sharp-shooting fly-by-night may turn out to be very expensive. Have the guarantee and the trial period arrangement written right on the bill. A reputable dealer will do this for you without question. If he argues that "it isn't necessary," or that you should "trust him," button up and get out fast.

As soon as you get the camera home, read the directions carefully. Then, go through a couple of dry runs before you load the camera with film.

When you do start the actual tests, make them complete and keep a record of everything you do. If your first test indicates that something is wrong, retest with another roll of film. It may have been your fault. Then, if you're sure that something isn't working right, take the film tests to the dealer with your camera, and have him explain, fix, or replace. But *don't* let him double-talk you out of getting a camera that's in perfect condition.

How to Take Care of Your Camera

The four chief enemies of a camera are: (1) careless handling, (2) dust, (3) moisture, and (4) heat. To give efficient service a camera must be treated as a scientific instrument should be, and that is with a good deal of care. A camera usually gets rougher usage than any other kind of optical instrument, and much of it is needless. A little thought on your part will insure its working and lasting qualities. One way to do this is to keep it in a carrying case except when it is actually in use. A waterproof canvas or plastic case will do, but a leather ever-ready case is much better.

After you have been out on a trip, it is a good scheme to wipe off all of the dust from the exposed parts with a soft piece of old linen, and you should occasionally remove the lens if you can, or open the back, and dust out the inside of the camera with a soft brush. It is the dust that finds its way into the camera which causes black spots to appear on the negative, and other mischief by reflecting the light that strikes it from the lens. Moisture spoils the real or imitation leather covering of a camera, and if the latter is built of wood, it makes the movements stick. Oil or grease should not be used to lubricate the sliding parts if these are made of wood and metal; a little *graphite* can be applied instead. The inside of the camera must always be a dead black, and if any light spots show up they can be painted over with a dead-black paint like #4 Brush Type Kodalak. If a pinhole appears in the bellows, fix it with Scotch tape #33. *And as for heat:* Never leave your camera in the glove compartment, or the trunk, of your car, especially in the summer. It will affect the cement between the lens elements, and it will spoil the film. Also, never carry the camera with the lens exposed (and set at infinity). If you happen to have a rubberized shutter, as in the Leica, your lens will focus the sun on that fragile cloth and burn a beautiful hole right through it. *Cost:* somewhere between $30 and $50, depending on how lucky you are.

To preserve leather (camera bodies, bellows, cases, straps, etc.) use one of these: *Leather Vita,* sold by Brentano's; *Lexol; Mel-O-Wax;* saddle wax; or almost any lanolin preparation. Follow directions, don't overdo it, and use *hand*-rubbing where called for.

Types of Cameras

A SURVEY OF SOME PROS AND CONS

When George Eastman introduced his first Kodak in 1888 he could hardly have foreseen the tremendous consequences of his act . . . over

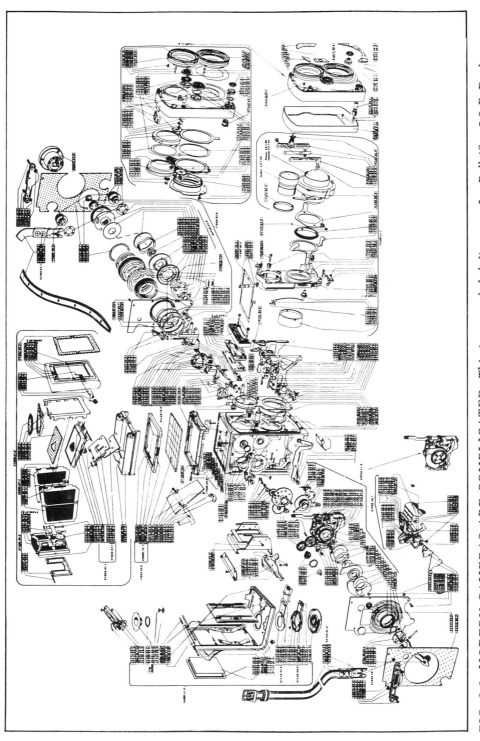

FIG. 6.2. MODERN CAMERAS ARE COMPLICATED. This is an *exploded* diagram of a *Rolleiflex 2.8 F*. Don't try taking yours apart (and that includes the lens!). Let the experts do it if it needs repair or adjustment.

75,000,000 shutterbugs clicking away happily every year, in the United States alone. But that is what happened as a direct result of his putting *roll film* and the one-dollar Brownie *box camera* on the market.

This is a book for the amateur photographer, so it is proper to point out that some of the most unforgettable pictures of our time were all made by amateurs: the tilted confusion on the deck of the sinking *Vestris*, the crying child sitting among the ruins of atom-bombed Nagasaki, the stricken Frenchman tearfully watching the Nazis roll into his beloved Paris. Having once seen these, who can ever forget them?

Strange, but as we learn to see more vividly in order to photograph more effectively, we find ourselves becoming one with the thing we see, as did each photographer of those historic moments. Dr. Jacob Bronowski has explained it well in his *Science and Human Values:* "There are no appearances to be photographed, no experiences to be copied, in which we do not take part. We remake nature by the act of discovery."

Some photographers *take* the picture, others *make* it. No matter which kind you are, here is a rundown on the various types of cameras currently available, with some pertinent comments, and perhaps a few impertinent cautions, on their good and bad qualities.

THE BOX CAMERA AND THE 126-CARTRIDGE CAMERA

The now obsolete *box camera* was probably the *only* foolproof camera ever made. It didn't have to be focused; the lens was preset at about 15 feet, which made everything sharp from 6 feet to infinity. The lens aperture was usually $f/11$, with two or three smaller stops possible; the shutter was set at 1/30 to 1/50 second, with additional *time* or *bulb* settings available in most models. The small aperture of the lens gave great depth of field, but since this was a feature that could not be controlled, the amateur photographer using a box camera often ran into trouble with his backgrounds. This required extra care in the choice of camera position and angle. Sensible use of a box camera was wonderful training in the seeing and creating of a picture.

When the previous edition of this handbook went to press, there were at least half-a-dozen manufacturers producing box cameras. Kodak had won the heart of young America with its *Brownie* cameras. And other manufacturers had jumped in with their own versions, to supply what seemed to be an insatiable market.

But now they have all disappeared.

The box camera, except for some stubborn and lonely holdouts that you may still find in the stores when you go hunting, is an extinct breed. The classic Brownie *Starflash* and *Starflex* have been replaced by the *Instamatics* (with their drop-in preloaded no-rewind cartridges, their

four-shot *flashcubes*, and their no-battery *Magicubes*). But these new instant-load cartridge-type cameras are really box cameras at heart.

There are two developments, however, that you may find interesting, even amusing:

1. Someone with a bump of ingenuity figured out that the Instamatic film cartridge is really half a camera, the removable back, so he designed a simple front to match, which consists of nothing more than a lens with a shutter mechanism in a plastic shell that clips to the 126-cartridge (*color* or *black-and-white*). And zingo, you have a complete box camera, the *Snapshooter*. The cost? About the same as a roll of film, believe it or not. The *Snapshooter*, made in the U.S.A., is being mer-

FIG. 6.3. THE SNAPSHOOTER: a plastic camera front consisting of a lens and shutter that snaps onto a cartridge of 126-cartridge film (*color* or *black-and-white*) to make a complete box camera. See text: *The Box Camera and the 126-Cartridge Camera*, under TYPES OF CAMERAS.

chandised by three outfits: Jay Norris Corp., 31 Hanse Ave., Freeport, N.Y. 11520; the Smart Camera Co., 10 James St., New Hyde Park, N.Y., and The Educational Dept. EMSM, Snapshooter Camera Co., 9810 Ashton Rd., Philadelphia, Pa. 19114.

2. *Charles Fort* once said, "One measures a circle, beginning anywhere." Let's start with some students at Ohio University, Athens, Ohio, who had complained that they weren't doing as well as others in the basic photography course because their equipment wasn't as good. *Elizabeth Truxwell*, Chairman of the Photography Department, is magnificent in her job. She put *everyone* on slim rations, stopped the use of personal equipment, and found an all-plastic camera import from Hong Kong called *Diana* which takes 16 shots on 120 film through a plastic

lens, and has several adjustments: focus, shutter, and lens aperture. The cost to students was $1.83; later, they found the same model was being sold in 5- and 10-cent stores, under other names, for less.[2] What the camera did was to free the students of *gadgetry* and *technique*. They began to *see*, and were able to concentrate on the picture.

The results were startling (some examples are shown in the January 1971 *Popular Photography*). When the students went back to their own cameras, they had learned so much about *seeing* and *feeling* that their work began to show it. Incidentally, to make it possible, economically, for the students to shoot a *lot* of pictures, Elizabeth Truxwell found a source of supply for cheap film at 15 cents a roll. This made it easy for each student to use a minimum of ten rolls a week for the three weeks he used the *Diana* camera. Naturally, this experience shook up quite a few students, and some teachers, all of whom believed that technology alone was responsible for the good things in photography.

POCKET PHOTOGRAPHY AND THE 110-CARTRIDGE CAMERA

We have now reached the era of *pocket* photography. When Oscar Barnack released the first *Leica* in 1924, he was protesting the clumsy view cameras of his day. With the help of Prof. Max Berek (who was responsible for the *Elmar* lens), he solved basic problems. The others were solved by Leitz engineers and the film manufacturers. But his compact camera (such a delight to carry) developed middle-age sag over the years, as witness the *Leica M5* (which now weighs 700 grams, or 24.7 ounces, *without* a lens) and itself stirred up a rash of subminiatures like the *Minox*, and the Yashica *Atoron*, all of which use 9.5mm film. The trouble with these is the inability of the film (about a third as large as the regular 126 film) to produce color prints of sufficient sharpness. It wasn't until Kodak scientists had produced a color film of better acutance that they were ready to release the 110-size film and the group of new slim minicameras named the Pocket *Instamatics*.

Roughly the size of a pack of long cigarettes, the new Kodak Pocket *Instamatics* are 2⅝″ x 5⅞″ x 1″ thick. They use the instant-load drop-in cartridges with the new 110-size film (16mm, giving 12 or 20 13 x 17mm exposures). All have electronic shutters (except Model 20), and

[2] *Don Cyr*, of the Department of Art, Southern Connecticut State College in New Haven, writing in *Arts and Activities* for June 1971, reports that he has found for his students a camera (imported from Hong Kong) called the Diana F which "retails for less than a dollar, is even cheaper by the dozen, and looks and feels like a 35mm camera." His students use Verichrome Pan and Tri X film in the 120 size with good results. The Diana and Diana F seem to be the same camera. It looks like an oversize Leica M, with a single-eye viewfinder centered at the top.

THE AGE OF POCKET PHOTOGRAPHY

This camera, no larger than a pack of
cigarettes, may be the forerunner
of another photographic revolution.
It is one of five new pocket *Instamatics*
released by Kodak to use their new
110-size film in the fine-grain
negative (for prints) and *positive*
(for slides) *color* film. *See text.*

TWO MODERN
BOX CAMERAS

THE REVERE 3M 1074
with *f*/2.8 38mm Proktor
lens. Can be focused.

THE KODAK
INSTAMATIC
Fixed Focus.
Accepts *Magicubes*.

all use Magicube flash. All have lens covers and a thumb-slide film advance. Color film in these new 110-size cartridges will be available as *negative* film (*Kodacolor*, to make color prints and black-and-white prints) and as *positive* film (*Kodachrome II*, to make transparency slides). 50 million *Instamatics* were sold since they were first put on the market in 1963, so it is easy to understand the excitement that has followed the release of the new pocket *Instamatics*.

SUPER SLIDES

The success of Frank Rizzatti's *Super-Slide* (also see pages 452 and 453) touched off a chain reaction. First Eastman Kodak announced the release of Ektachrome in the 127 size, which is the Super-Slide size without waste (Kodacolor was already available in that size). GAF then announced that Anscochrome would also be available in that size. Agfa-Gevaert released Agfachrome CT18 in the 127 size. Then, almost simultaneously, Kodak put a new series of 127 cameras on the market to make use of the new film, but suddenly stopped making them when the *Instamatics* were introduced (see below).

Taking a tip from their own American distributor, Franke & Heidecke redesigned and modernized their 127-size baby Rolleiflex (4 x 4 cm) which had been discontinued in 1938. Hasselblad followed with a new film magazine that used the 120 size to produce 16 Super-Slide pictures, 1⅝ x 2¼ in size, with minimum wastage. And other manufacturers hurried to produce a series of 127 miniatures of the *rangefinder, pentaprism,* or *twin-lens reflex* type.

The reason for all this excitement was the simple notion that when pictures made on a 120 size film are trimmed to the 127 size, they can be made into 2 x 2 inch slides which can then be shown in the 35mm projectors, *but with a picture that is 85% larger in total area!* Amateur and professional photographers found this idea very attractive. However, all that remain of this activity are the three color films and the Super-Slide masks for the TL 120/220 cameras. The 127 cameras have all disappeared.

126 CARTRIDGE (INSTAMATIC)

The drop-in film cartridges, to make 12- or 20-exposure loads, were first introduced by Eastman in 1963, for use in the Kodak *Instamatic* cameras. The frame size is 28mm square; the size of the color slides is 2mm less than that. They can be shown in any manual or automatic slide projector that accepts 35mm slides.

Insertion of an *instant load* cartridge automatically sets the ASA

film rating on most of the cameras (at least those that have built-in metering). Eye-level viewfinders and double-exposure prevention are standard. Film *rewinding is not necessary* when all exposures have been made.

Most of the 126-cartridge cameras use *flashcubes*, which require batteries. The *Instamatic X* cameras use *Magicubes*, which flash *without* batteries. Prices start at about ten dollars.

Kaligar has brought out two supplementary lenses which can convert your Instamatic lens to a *wide angle* (#6161) or a telephoto (#6162). Both lenses clip onto your camera without screws.

A surprise camera in this group is the *Instamatic X-90*. It has a rangefinder, automatic electric-eye exposure control, illuminated signal to *use flash*, illuminated *used-bulb warning*, automatic spring-motor film advance, automatic film wind-off, uses *Magicubes*, and has an automatic flash exposure adjustment as you focus. It also has a sharp ƒ/2.8 Kodak *Ektar* lens, and uses automatic drop-in 126-cartridge film.

The finest camera using 126 cartridges is the *Instamatic Reflex*. It is a single-lens reflex with lens interchangeability (7 lenses) plus auxiliary lenses and closeup lenses. With 50mm *Xenon* ƒ/1.9 or 45mm *Xenar* ƒ/2.8 lens; automatic electronic shutter which determines shutter speed after aperture is set (from 20 seconds to 1/500 second); ground-glass and split-image rangefinder focusing; instant return mirror; open lens for viewing; uses *Magicubes*. A sophisticated camera often used by professionals as a second or third camera for convenience, or as a "ploy."

THE 35MM CANDID CAMERA

It all started with the Leica, invented by Oscar Barnack in 1914 as a way of pretesting movie exposures to avoid costly mistakes. The model A appeared in 1924. It had no rangefinder, but it did use standard 35mm sprocket-perforated movie film (for a 1 x 1½ inch picture) and a focal-plane shutter that operated at a fixed speed of 1/40 second (like his movie camera). Later models added a rangefinder, a variable-speed shutter to 1/1000, and interchangeable lenses, but otherwise the first

The *Leica M4* with
coupled exposure meter.

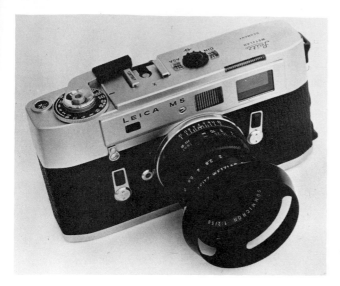

Leica M5 with 50mm
Summicron $f/2$ lens and
lens hood.

Leica did about everything the M5 does today, except that it was much
lighter, and had no built-in exposure meter.

The popularity of the *miniature* or *candid* [3] camera stemmed from
the fact that it was easy to carry, could be used swiftly and often invis-
ibly, gave more leeway in focusing (unlike the larger, long-focus-lens
cameras) since its normal or wide-angle lenses had tremendous depth
of field, and it cost less to operate (because it used inexpensive movie
film and took 36 pictures at one loading). Besides, it offered a tempting
variety of accessory gadgets that were fun to play with.

Two problems that plagued the first users of the camera, *grain* and
excessive contrast, have since been solved by the appearance of such
thin-emulsion films as H & W Control VTE Pan film (with its matching
H & W Control developer concentrate), *Panatomic X*, Ilford's *Pan F*, and
such matching developers as *Neofin*, *Microphen*, *Microdol*, *Acufine*,
Diafine, and those dependable old-timers *D 76*, *Rodinal*, *MCM 100*, *D 23*,
and *D 25*. Discovery of new, rare-earth-element glass has made it pos-
sible to design sharper and faster lenses of less complicated construc-
tion, as in the recomputed *Summicron*. Other factors in better lens
construction have been electronic computers and modern anti-reflection
coating techniques. The shutter mechanism and its flash-strobe syn-
chronization have been improved. A fast-action film-transport lever has
been added in some cases. The latest trend is toward built-in or linked

[3] *Candid* photography is a term coined by the art editor of the *London Weekly
Graphic* who used it to describe the pictures of politicians by Dr. Erich Salomon.
Others who followed him were Henri Cartier-Bresson, Alfred Eisenstaedt, and W.
Eugene Smith. The best camera for this purpose is the 35mm miniature because
it is small enough not to be noticed, and is today virtually automatic.

exposure meters, TtL (through-the-lens) metering, and pentaprism mirror-reflex viewing (where the focal-plane shutter has given way to a between-the-lens shutter).

The modern miniature is a superb photographic instrument. It's a delight to hold and a pleasure to operate. Skillfully used, it makes magnificent pictures. However, it requires faultless technique in exposure, developing and enlarging, and it demands absolute cleanliness at every stage. If you're inclined to be sloppy or careless, avoid miniature camera work. It is exciting and rewarding, but exacting. Any transgressions of procedure become magnified horrors.

The miniature is an ideal instrument for making color slides for viewing or projection. Some magazines publishers still insist on larger transparencies, but few print any better color plates than does the *National Geographic*, whose photographers use 35mm *Kodachrome II* and *Ektachrome X* almost exclusively.

The one serious defect of the miniature is its lack of camera movements (swings, tilts, rising and sliding front, and double or triple extension of the lens). This has been partially overcome by the use of extension tubes, close-up attachments, and mirror-reflex housings. Architectural distortion can often be corrected by a tilting lens board on the enlarger used in conjunction with a countertilt easel.

But someone has come up with a solution.

Have you ever heard of a swinging front for miniatures? Well, there is one called the *Varioflex* (don't confuse it with the *Visoflex*). It is made for single-lens mirror reflexes like the Leicaflex, and for 120-size film SL's like the Pentacon and the Bronica. It's a well-engineered device that enables you to swing the lens from side to side horizontally (or up

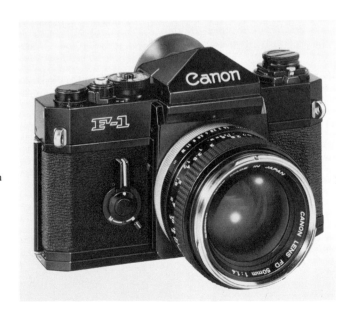

Canon F-1 with f/1.4 lens.

and down, vertically). For architectural shots, it is undoubtedly superb. You can get total sharpness over the entire picture area, or selective sharpness when you want that. Made in two models (I and II), it is offered with such lenses as the Schneider Angulon 65mm, the Schneider Symmar 100mm, and the Boyer-Beryl in 85mm to 135mm sizes.

When you start to shop for a miniature you'll have to make a choice between these types: blind, or fixed, focus (*Instamatic*); rangefinder (*Leica, Yashica, Canon, Minolta*) and the single-lens reflex (*Alpa, Canon, Exakta, Yashica TL, Contarex, Pentax SL, Argus-Cosina*). With a fixed focus camera you have to guess-focus by scale or zone. Since the normal lens is a 45mm, even slight stopping down corrects for any focusing errors.

A continuing trend in miniature camera construction is the single-lens mirror reflex with either an eye-level pentaprism viewfinder or the familiar waist-level ground-glass viewer with snap-up hood. Good examples of such cameras are the *Leicaflex, Konica Auto Reflex,* Zeiss *Contarex,* Honeywell *Pentax,* Bell & Howell *Canon, Minolta Reflex, Miranda, Nikon F* and *F2.* Almost all models take interchangeable lenses. The image is focused visually, not by scale. Some of the cameras offer two kinds of simultaneous focusing: ground-glass and split-image. Such cameras are especially good for subjects in motion, where quick focusing is essential. The waist-level mirror-and-ground-glass type shows the image upright, but reversed left to right. The *pentaprism* not only turns the image upright but corrects it left to right. Since the prism is made in one piece, and of good optical glass, it operates accurately.[4]

Though there is no parallax problem in the single-lens reflex (you see exactly what you are taking) there are two other problems, equally serious: 1. If you stop down to the iris setting you plan to use, the viewing image may become too dim. Some cameras overcome this by a *preset iris diaphragm* which enables you to view the image at full aperture, the iris closing down to the correct f/opening as you start to press the shutter release. 2. The second problem is the *blackout*, which hides the image a moment before exposure, when the reflex mirror swings up out of the way. Most single-lens reflexes have to be rewound before the mirror returns to viewing position, which is a great nuisance and makes it difficult to tell whether you really got the picture. However, the *instant-return mirror* is becoming standard in most of the new models.

A crafty and sensible solution is the one offered by the *Canon Pellix: a stationary beam-splitting mirror of micron-thin film.* The advantages? Well, for one thing, they've done away entirely with the bouncing reflex mirror. No matter how quietly the conventional mirror slaps

[4] *Pentaprisms* are also made for TL reflexes with detachable hoods, like the Rollei-flex.

FIG. 6.4. THE SECRET OF THE CANON PELLIX: a microthin two-way stationary pellicle mirror that does away with the conventional flip-up mirror and makes possible exposure measuring at the film plane by means of a lever-controlled CdS cell.

against the top of the camera, it must be responsible for some vibration. Even that little is too much. And the cameras that eliminated the *blackout* added still another bounce. The *Canon Pellix* provides a two-way *pellicle* mirror that shows you what you're taking, without bumps or blackouts. But by splitting the beam it permits light to reach the lever-controlled CdS exposure cell, which can be placed at the film plane (where it really belongs). After setting the shutter and taking the exposure reading, the aperture is determined automatically and electronically by the meter when you align two needles in the viewfinder; then the CdS cell is moved softly aside, and you can take your picture, knowing that no mechanical bang-ups engineered into the mechanism will ruin it.

Some knowledgeable critics suggest that the camera failed because it hadn't been thoroughly "debugged." They found some sharpness and exposure loss, due to the transparent mirror. Nevertheless, it's a great idea worthy of a better version.

Other improvements in miniature construction and accessories which may be worth considering: interchangeable lenses (35mm wide-angle for architecture, landscape, and crowded interiors; the 85-, 90-, or 135mm telephotos for portraits, and for landscapes where you want to increase the size of background objects without altering the size of the foreground); fast-action lever film-transport which moves film and resets shutter quickly and automatically; fast action film rewind lever (as in the Leica M4 and M5); power-drive film transport, as in the *Robot*, in the *Leica* (through a detachable motor base), and in the *Minolta SR-M*, which has a built-in motor in an upright handle at the side. The power drive enables you to shoot a burst of up to ten exposures in rapid sequence, as fast as you can press the release button, without stopping to rewind or recock the shutter.

Besides the *Leica*, which was first in the field and is still a favorite, here are some other miniatures worth looking at when you start to shop: the *Argus, Minolta, Canon, Nikon, Contarex, Konica, Olympus, Ricoh, Rollei 35, Yashica Electro 35, Fujica, Pentax, Nikkormat, Robot,* and the *Kodak Instamatic* series, especially the *Instamatic Reflex*.

THE 120/220 REFLEX CAMERA

The camera obscura, first noted by Leonardo da Vinci (see *index*), was the precursor of the modern reflex camera. The first such camera, the twin-lens *Rolleiflex* using 120 size film, appeared in 1928. It combined the speed and portability of the candid camera with the film-size advantages of the larger camera. As a result, it became the camera best seller of its time, with prices jumping to $500 for a secondhand camera in 1937 when no new ones could be imported. Half a million cameras were sold by 1947.

The twin-lens reflex deserves this immense popularity. Professionals grumble about its bulk and they used to complain about its lack of interchangeable lenses (no longer true) and the square shape of its negatives (also no longer true, the new "ideal" size is 2¼ x 2¾), but many of them still carry a TLR on their assignments.

A WINTER SCENE as recorded by a twin-lens reflex camera. Taken by a Rolleiflex on Kodak Tri X Pan developed in Microdol X, $f/8$ at 60 seconds, tripod.

What are the advantages of a reflex camera? In the twin-lens models, there is no time lag between the focusing of the picture and the exposure. You see what you are taking right up to and beyond the moment of exposure—and you see it large and clear, just as the negative will show it. You can therefore compose carefully, right up to the very edges, secure in the knowledge that parallax errors have been automatically corrected. The focusing and viewing lens is always wide open, and in most cameras it is a bit faster (has a larger f/opening) than the taking lens at full aperture. This insures sharp pictures. Because of the square shape of the negative there is no need to turn the camera around to adjust to the shape of the picture. Most of the twin-lens reflexes can be used at eye level as well as at waist level. For candid shots, the camera can be turned sideways at waist level so that the subject is not aware of your interest. The camera can also be held upside down overhead, to get better composition or to see over an obstruction (as during a parade, if people are in the way).

Among the drawbacks (aside from its bulk): When the taking lens of the twin-lens reflex is stopped down, the viewing lens cannot show the scene truthfully; the scene is shown reversed, left to right (except in those cameras that incorporate *optical reversing systems* in the form of eye-level prism attachments); parallax errors for close-ups cannot be completely corrected; like the 35mm camera, it lacks camera movements, but again these can usually be corrected in enlarging; and finally, the exposure meter (when there is one) is vulnerable to light fatigue since most TL reflexes do not provide a turn-off switch to protect the meter. The Yashica is the lone exception.[5]

What of the 120/220 single-lens reflex? Everything that was said about it in the candid camera section applies here to its larger brother. The most spectacular camera of this kind is the Swedish *Hasselblad.* It is equipped with interchangeable lenses *and* film magazines (wonderful for switching to color and back; a new magazine, the #16, makes 16 Super-Slide pictures on a 120 roll). The single-lens reflex is also available in the 3¼ x 4¼ and 4 x 5 sizes (the *Gowlandflex TLR* and the *Gowland SLR* each have a revolving back, making it unnecessary to turn the camera when shooting vertical pictures; and both accept the *Polaroid* back. Both have the universal back for 4 x 5 sheet-film holders and *Graphic* roll-film holders. In addition, the *Gowlandflex* accepts the *Linhof* back, for the new 70mm sprocket film).

[5] The *Yashica Mat 124G* not only has a new type of pressure plate that can be slid from one position for 120 film to another position for 220 film (which automatically adjusts the exposure counter), but it also features a turn-off switch for the exposure meter built-in to the focusing hood. When the hood is open, the power is on; when it is closed, the power is off.

THE HASSELBLAD. Made in Sweden, and tested on the moon. Interchangeable lenses, film holders and focusing hoods make this one of the most versatile SLRs using 120/220 film.

In 1958, Hasselblad released its sensational new 500 C model, shown here, which dropped the focal-plane shutter entirely and substituted a series of synchro-compur shutters with automatic diaphragm (for wide-open focusing). Each lens is now fitted with its own shutter, thus making flash and strobe synchronization possible at all speeds. A baffle protects film between exposures.

Other additions to the single-lens reflex roster are the *Graflex Norita* 66, a 2¼ inch square SLR that looks and feels and functions like a 35mm SLR. It has an instant-return mirror and a standard 80mm *f*/2 lens. Interchangeable lenses are available from 40mm to 240mm. It takes both 120 and 220 film. Another is the *Mamiya RB* 67, a 2¼ x 2¾ SLR with a *revolving* back, built-in exposure meter, choice of eye-level or waist-level finders, 5 interchangeable screens, choice of interchangeable backs: *Graflok* 120, 220 film, film packs, cut film, and *Polaroid*.

Still others are: the *Bronica* which offers two sizes from 120/220 film (2¼ inch square and 2¼ x 1⅝ inches); the Honeywell *Pentax 6 x 7* which makes ten 2¼ x 2¾ inch pictures on 120 film, 21 pictures on 220 film, and has interchangeable lenses; the *Rolleiflex SL66,* with an assortment of bayonet-mount lenses, automatic diaphragm, depth of field preview control, interchangeable *microprism* focusing screen, waist-level viewfinder, instant-return mirror, focal-plane shutter speed of 1 to 1/1000 second and B (and separate *Compur* shutters for the 150mm *f*/4 *Sonnar* and the 80mm *f*/4 *Distagon*). Also, combined film/shutter wind, X-FP synchronization, lever-wind film transport, bellows extension, *tilting front* (enabling you to shift the lens axis up or down through 8°: not too good for perspective control, but useful in depth of field adjustments).

Of the many good reflex cameras besides the *Rolleiflex* now on the market, these are especially worth investigating: the *Rolleicord* (which offers 5 picture sizes and 12, 16, or 24 pictures per roll of 120 film, including 16 Super-Slides perfectly framed on each roll), the *Minolta Autocord,* the Yashica (in both the exposure-meter and automatic models), and the *Koni-Omegaflex M,* a 120/220 twin-lens reflex with true lens interchangeability, and no film fogging between changes. A

group of four matched viewing and taking lenses are offered; each pair complete with lens board, and with the taking lens mounted in a flash-strobe-synchronized shutter to 1/500. Accessories include interchangeable film magazines and viewing systems. The picture size is 2¼ x 2¾, which enlarges perfectly to 8 x 10.

Such a camera is the Linhof Technika 70. It has 36 interchangeable lenses and a multifocus rangefinder that couples all those from 53mm to 240mm. The lenses are all mounted in fully-synchronized Compur Rapid shutters. Other features include a revolving, interchangeable back; the use of sheet film and film pack in the 2¼ x 3¼ size; and roll film in the 120/220 size for ten 2¼ x 2¾ exposures with an adapter, and 70mm sprocket film with a special adapter for up to 53 exposures.

PRESS AND VIEW CAMERAS

The press camera is a rugged machine with the maneuverability of a view camera wedded to the speed and compactness of a miniature. The basic film size, because of newspaper requirements, is 4 x 5 inches, though there are press cameras for other film sizes, ranging from 2¼ x 2¾ to 2¼ x 3¼ and 3¼ x 4¼.

Most press cameras have coupled rangefinders, fully synchronized focal-plane and between-the-lens shutters, interchangeable lenses, tilts, swings, and interchangeable backs. Most of them use sheet film or film packs, though a few use 120 roll film in the 2¼ x 2¾ or 2¼ x 3¼ size, or take adapters for the 70mm size.

The press camera is used mostly for sports, candids, portraits, records, street scenes and interiors. *It suffers from four troubles:* shallow depth of field, because of the focal length of the lens (usually 127 to 135mm); the danger of double exposure; the too-few exposures possible at one loading (though with film packs, sheet film magazines, and 70mm film backs, this can be overcome); and the fact that it costs more to run (in the 4 x 5 size). Balancing these is the fact that the pictures are *sharper* and that it can be used as a hand camera in almost any field of photography, color or black and white.

The archetype press camera of today is not the *4 x 5 Graphic*, but a 35mm camera, the *Nikon F!* The newspaper labs, with the help of Kodak, solved the 35mm processing problem and made such cameras as the *Nikon*, the *Leica Ms*, and the *Leicaflex*, practical for press work.

The press camera of history has been the *Speed Graphic*. Though it was first made in three sizes, Graflex has discontinued the 3¼ x 4¼, and is concentrating on a 2¼ x 3¼ (the *Century Professional 23*) and two models of the 4 x 5 (the *Pacemaker Crown Graphic* and the *Super Graphic 45*). Graflex, like Hasselblad, has finally scrapped the *focal-*

plane shutter. However, they have made other improvements: a *range-light* and an *electric shutter release* (both similar to the ones first introduced by the remarkable but short-lived *Kalart* camera, which had been designed for Kalart by a team of engineers from the Massachusetts Institute of Technology).

The *rangelight* projects two beams of light; as you focus, the beams merge. When they coincide, you are in focus. This can be a great help in *night* or *dim-light* photography. The *electric shutter release* cuts down on vibration by eliminating the sudden jerks which a manually operated release can't avoid. An accessory handgrip (the *Multigrip*) makes it easier to hold the camera.

All Graphics have built-in synchronization, dual control rack-and-pinion focusing, tilting and rising front with vertical and lateral shifts, a drop bed for wide-angle use, double-extension bellows, folding infinity stops, choice of *Graphic* or *Graflok* backs, ground-glass focusing with *Ektalite field lens*, a parallax-correcting viewfinder, a rangefinder that accepts interchangeable cams for lenses of other focal lengths, and a wire sports finder. They can also be focused by scale. As for film, they take sheet film, film packs, or roll film and, with a suitable Linhof adapter back, they use the 70mm sprocket film. With the Graflok back, a *4 x 5 Polaroid Film Holder* (for *Type 55 P/N* or *Polacolor* film) can be used.

An unusual camera that was obviously designed with the press photographer in mind is the *Koni-Omega*. The current version is the third in line (see *photo used as chapter head*). The first was the *Omega 120,* discontinued soon after its debut in 1952. In 1963, working with *Konishiroku,* the Simmon brothers (now under the aegis of Berkey) brought out the handsome and technically flawless *Koni-Omega.* In 1968, they followed this with the *Koni-Omega Rapid M* with the soft release (and the *Koni-Omegaflex M,* a twin-lens reflex offering interchangeable lenses, the use of Koni-Omega film magazines, and a series of interchangeable viewing systems). The camera uses 120/220 film in separate magazine backs, offering 10 or 20 pictures 2¼ x 2¾ in size. The strange size (now known as *ideal format*) was chosen to match the proportions of standard enlarging papers (4 x 5 and 8 x 10). The body design makes a firm, steady grip possible, to prevent jarring: *the left hand* grips and balances the camera by means of the molded handle, while the forefinger of that hand presses the *soft-touch* trigger which automatically pushes the pressure plate against the film (to insure absolute flatness under all weather conditions) and then makes the exposure; *the right hand* turns the oversize focusing knob which automatically adjusts the viewfinder for parallax correction and, after exposure, *pulls-pushes* the plunger just below the focusing knob, which changes film,

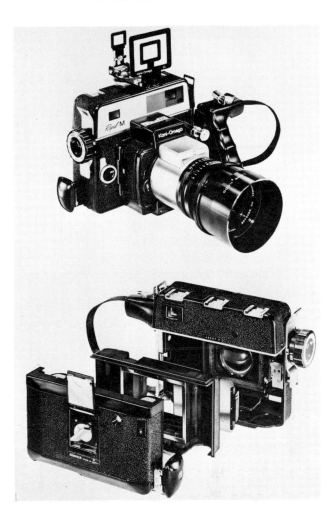

The *Koni-Omega Rapid M* and its interchangeable back.

counts exposure, and cocks the shutter, all simultaneously. The shutter, of course, is fully synchronized. The *Konica Hexanon* lenses are specially designed and make use of the latest rare-earth glass. They are anti-reflection coated on all surfaces and are exceptional in resolution and brilliance. Shutter speeds: 1 second to 1/500 and B. Shutters can be hand-cocked for intentional double exposure. A signal tells when the shutter is cocked. All settings are visible from the top, and there are click stops on both f/stops and shutter speeds which can be turned together for EV settings. Three accessory shoes at top accept wide-angle finder, flash or electronic speedlight units, sports finder, etc. A plastic flash calculator slips into position at top to give correct f/stop for all distances with whatever flash unit you are using. All lenses have their own *retractable lens hoods*, and accept standard series filters. Also available: a rubber eye cup which fits into accessory shoe over viewfinder, lock-on flash cords, precision optical *close-up attachments* with built-in rangefinder compensating prisms, close-up kits for ground-glass viewing,

reflex viewer with 2.8x magnifier, folding viewing hood, and eye-level viewer with 3x magnifier.

Other good press cameras are made by *Fujica* (rangefinder 120/220 *G-690*, with a hinged back and a roller blind to protect film, to which 4 lenses can be coupled), *Graflex, Linhof, Mamiya* (*Universal* 120/220, rangefinder couples to 9 lenses, choice of 3 interchangeable backs, picture sizes: 2¼ x 3¼, 2¼ x 2¾, and 3¼ x 4¼ Polaroid).

Linhof makes an excellent 4 x 5 *view camera*, the *Linhof Kardan Color* 45S. This new monorail camera with a universal back gives you the full (360° mechanically unlimited) range of front and back tilts, swings and shifts. It is beautifully crafted and engineered for rugged, precision use. The 4 x 5 back is reducible with adapters to 2¼ x 3¼ cut film and all 120/220 film formats. Modular design, interchangeable snap-in bellows, front and back focusing with *zero backlash*, dual alignment spirit levels, and many other Linhof improvements. The U.S. distributor is *Kling* (now a division of *Berkey*), P.O. Box 1060, Woodside, N.Y. 11377.

The view camera is the perfect camera for studio and tripod use. Though it has no portability, very shallow depth of field, is slow in operation, and shows the image upside down, it is nevertheless the ideal camera for portraits, still life, texture, detail, landscapes, architecture, and interiors. Where action isn't a factor, it is also wonderful for color. The work of Ansel Adams, Edward Weston, Samuel Chamberlain, Eliot Porter, and Edward Steichen attests to the supremacy of the view camera as the instrument of pure photography. If photography as an art form is to record detail and texture, a field in which it has no competition, there is no better camera for this purpose than the view camera. The Linhof Kardan Color and Sinar-p are good examples of what a view camera should be. They have every contortion and body movement a photographer would ever need, yet they are rock-rigid in each position.

A camera that boggles the mind on first sight is the reflex view import in the, *yes*, the 4 x 5 SLR class called the *Arca-Swiss Reflex*. Supplied in a hand model or an optical bench monorail model (and for those who prefer a smaller negative, in a 2¼ x 3¼ version), it features interchangeable lenses, each with its own modified *Compur Electro Shutter* which permits full *sync* at all shutter speeds up to 1/400 for flash and strobe. The camera has a roller-blind protective shutter in the rear which remains open when the Compur shutter is cycling. An accessory magnifier viewing hood shows the image upside down from eye level, and right side up from waist level; the eyepiece swivels to both positions. A beauty of a camera, especially for those who are partial to the 4 x 5-size negative. For more information, catalogs, and current prices on models and accessories, write to the distributor, Bogen Photo

Corporation, 232 South Van Brunt Street, P.O. Box 448, Englewood, New Jersey 07631.

Other good view cameras are made by Burke & James, Calumet, Deardorff, Plaubel, and Sinar. They come in sizes from 4 x 5 to 8 x 10.

THE POLAROID CAMERAS

The basic feature of Dr. Land's series of cameras is the production of a dry print *within seconds* after you have snapped the shutter. The original model 95 was an exciting camera, but it had many design faults, the main trouble having to do with the peculiar lens-exposure system which gave the photographer a slow lens, medium-speed film, and no choice of iris openings (substituting an arbitrary single dial key-and-number system that was quite awkward). The new films and models have corrected this. As the normal and most popular black-and-white film speed has jumped to an incredible ASA 3000 (with a 10,000 limit to *Polascope* type 410 for oscilloscope traces, photomicrography, metallography, etc.), the developing times have dropped from one minute to *15 seconds!* The new models have Zeiss Ikon rangefinders, are light-sealed for the fastest film, and are fully automatic (the electric eye operating the shutter and controlling the aperture even for films of the highest speeds). Film sizes start at 2½ x 3¼, go to 3¼ x 4¼ (107 for black-and-white; 108 for color) then to 3¼ x 3⅜ (*Polacolor* type 88, for the *Square Shooter*) and finally to 4 x 5.

Type 55 P/N film supplies a permanent negative and a print simultaneously in 20 seconds (ASA 50), and other wonders are coming.

In 1965 Polaroid released their Infrared film (Type 413), which has a speed equivalent to ASA 800, develops in 15 seconds, and can be used in most standard Polaroid cameras.

In the later models, such as the 360, the camera is supplied with a clip-on rechargeable electronic flash unit that does away with flashbulbs and takes pictures at 1/1000 of a second; an impressive automatic electronic exposure system; an automatic electronic timer that *beeps* when your picture is done; a built-in shutter blind for the electronic flash linked to the focusing mechanism so that, as you come closer to the object, less light is delivered by the louvered flash. In the 450 model, the Focused Flash was adapted for the new GE *Hi-Power* flashcube. In addition, there are Polaroid backs that are interchangeable with 4 x 5 film holders; backs that can be attached to the Hasselblad, the Linhof, and even the Rolleiflex SL66 (made by Arca Swiss for Rollei).

Among the supplementary Polaroid accessories now available, there is a photoelectric shutter that can be attached to the older models to convert them to automatic electric eye operation; a Print Copier that

can make exact duplicates of your originals, using your own camera as part of the set-up; close-up kits for portrait photography; and a wink-light flash unit that operates on a single battery for 1000 shots.

A *logical extension* of this picture-in-a-minute system is the Polaroid Land Projection Film, which has a speed of ASA 1000, produces grain-less images for projection in *two minutes,* and can be used in existing Polaroid cameras. Along with this sensational panchromatic film, Polar-oid has released the following accessories: the leakproof Dippit, for hardening the transparency surface and protecting it against fading and discoloration (it squeegees the transparency as it is removed); the Polaroid plastic Slide Mount #630 (for 2¼ x 2¼ transparencies) which snaps together and is so cleverly designed that you will always have your transparency right side up; the Polaroid Projector Model 610 (for the #630 transparencies); and the Polaroid Copymaker Model 208, with which you can photograph charts, maps, titles, small objects (in fact, anything that can fit into an 11 x 14 inch space).

Polaroid instant color (Polacolor) finally made its appearance in 1963. By 1965 a whole battery of cameras and accessories were avail-able, for either the older roll-film or the new flat-pack type of films. The development time is 75 seconds (as against the 10–15 seconds for the black and white) but no swabbing is needed to make the color prints permanent. It takes some patience to get the best results from *Polacolor,* but it's well worth the effort. The use of the UV filter helps remove excess blue from shadows in your outdoor color pictures, and the manu-facturer is so anxious for you to get good results that he supplies all sorts of booklets and instruction sheets to guide you. Furthermore, the entire process is undergoing ceaseless improvement.

In September 1970 Polaroid announced the production of an *in-stant color motion picture film,* based on an entirely new principle: the film is exposed in a "movie camera," it is then passed through a "black box" for about a minute, after which it's ready for use on television or for ordinary projection. The latent image appears a second after a trace of liquid is applied to its surface.

Other work-in-progress includes a different type of *print film,* a brand new kind of *color negative,* and a *new type of camera,* the *Aladdin,* so-called because "Aladdin in his most intoxicated moments would never have dreamed of asking his genie for it." Dr. Edwin H. Land, in June 1971, at his first news conference since 1947 (when he originally announced his pictures-in-a-minute system), predicted that this new Polaroid camera, an *utterly revolutionary compact design* (built into a case 3 x 6 inches in size), would become "the basic camera of the future." It was released as the SX-70.

And that, as we have been saying, is only a beginning.

A CHECK LIST OF CAMERAS

HERE, FOR YOUR CONVENIENCE, IS A REFERENCE GUIDE TO SOME OF THE BETTER CAMERAS NOW AVAILABLE, ARRANGED BY BASIC CATEGORIES, AND WITH ONLY ENOUGH INFORMATION ABOUT EACH TO SERVE AS A REMINDER OF SPECIAL FEATURES:

SUBMINIATURES. Beautiful little toys. It seems incredible that you can get a picture out of any of them. And yet the 16mm do produce fairly good enlargements to about 4 x 5 inches, which are roughly 8 x blowups. The 9.5's are simply not able to stand the gaff; the film just isn't sharp enough, *as yet.* Perhaps with the introduction of the *new* 110-size cartridge color film for their Pocket *Instamatics,* Kodak may release this unusual film for other uses. If they do, subminiatures may become even more popular.

Minox B. Uses 9.5mm film with a frame size of 8 x 11mm. Has a 15mm $f/3.5$ coated lens with fixed aperture and a minimum focusing distance of 8 inches. Shutter speeds of 1/2 to 1/1000 second, T and B. Electronic flash and flashcube synchronization; built-in exposure meter coupled to shutter. Push-pull body cover advances film, winds shutter, protects lens and finder when closed. Bright frame finder with automatic parallax correction. Built-in 2x green and 4x neutral density filters.

Yashica Atoron Electric. Takes 9.5mm film; 18mm *Yashinon* $f/2.8$ lens to $f/13$. Focuses from 2 feet to infinity. Parallax correction. CdS exposure system couples to electronic shutter for fully automatic operation. Warning light goes on when tripod is needed.

Minolta 16-MG. Uses 16mm film for 10 x 14mm frame negative. 20mm *Rokkor* $f/2.8$ with openings to $f/16$. Minimum focusing distance, 3½ feet. Fixed focus. Built-in selenium cell exposure meter. M flash synchronization. Knob-wind film transport.

Edixa 16. Takes 16mm single-perforated film cartridge, 12 x 17mm frame size. 25mm Schneider *Xenar* $f/2.8$ lens with apertures to $f/16$. Minimum focusing distance 16 inches. Single-stroke film advance lever. Meter fastens to camera end to provide coupled exposure control; aligning two indicators on meter sets both aperture and shutter speed.

COMPACTS. Their great virtue is that they slip easily into a pocket; and they weigh no more than a slab of chocolate.

Rollei 35. Fixed focus 40mm $f/2.5$ Zeiss *Tessar* lens and special *Compur* leaf shutter, 1/2 to 1/500 second speeds plus B and X synchronization. CdS cell meter with matched pointers couples to aperture and shutter controls. Good for average illumination, and for those who can judge distance by scale. Lens retracts within body for safekeeping, *but only after you have pushed a release button and cocked shutter.*

Tessina 35L. Takes 35mm film (usually 24 x 36mm size) for 14 x 21 frame size. 25mm *Tessinon* $f/2.8$ lens with apertures to $f/22$. Minimum focusing distance to 9 inches. Reflex ground-glass focusing, automatic parallax correction. Selenium cell exposure meter operates with shutter

speeds 1/30 to 1/500 second. Exposure control by aligning two needles on top of camera. M-X synchronization.

Fujica Compact 35. Full 35mm double frame 24 x 36mm. 38mm *Fujinon* f/2.8 lens, and 1/30 to 1/500 programmed shutter. Fully automatic selenium cell exposure meter with manual override.

Olympus Pen FT. Half-frame 35mm eye-level single-lens reflex, with behind *viewfinder* CdS integrating exposure meter. 38mm *Zuiko Auto S* f/1.8 lens with interchangeable bayonet mount. Stops to f/16; focusing to 15 inches. Metal focal-plane shutter 1 to 1/500 second plus B, M-X synchronization. Prism viewer with center microprism for rangefinder-type focusing.

35MM RANGEFINDER. It all began with the rangefinder *Leica,* and now look at the grownup baby and all its great-great-grandchildren. Many good but stubborn photographers still prefer the precision focusing of a fine rangefinder camera to anything that has been devised since.

Leica M4. Coincidence-type coupled rangefinder combined with bright-line viewfinder, through single eyepiece. Bright-line frames for 35-, 50-, 90-, 135mm lenses. Bayonet mount interchangeable lenses. Automatic parallax correction; shutter synchronized for M flash to 1/500 second, and for electronic flash to 1/50 second, with separate sockets for each. Removable *MR Leica* exposure meter couples to shutter. Single-stroke

What a *Leica* can do. Elmar lens at f/6.3 and 1/100,
Panatomic X film, developed in MCM 100.

advance lever with operating and storage positions, rapid film-loading system (*caution:* make sure film has caught and is tracking, or *no pictures!*), and canted rewind crank.

Leica M5. The latest in the evolution of the M-series cameras, which adds an exciting new through-the-lens metering system. Larger and heavier than the M4, but understandably so when you consider what has been crafted into this great camera body. An odd new feature: the carrying strap lugs are now only at one end. A hot-shoe X-sync accessory clip makes internally synchronized electronic multiflash possible (by connecting one remote head to the X-PC terminal, and inserting another in this hot shoe). Rewind lever is now in the baseplate. Unfortunately, the *rapid-load system* does not permit use of those wonderful Leica cassettes. *Caution:* Some collapsible lenses must have safety collars attached.

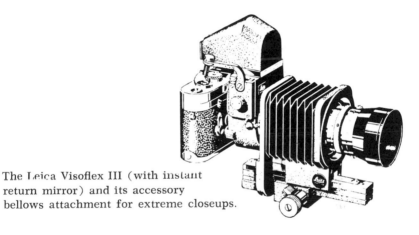

The Leica Visoflex III (with instant return mirror) and its accessory bellows attachment for extreme closeups.

Yashica Electro-35CC. 35mm *Yashinon*/DX *f*/1.8 lens with stops to *f*/16 and close focusing to 2.5 feet. Coupled rangefinder focusing; viewfinder combined with rangefinder. CdS cell coupled electronically to shutter with speeds from 8 to 1/250 second. Once aperture is set (manually), electronic shutter selects matching speed for perfect exposure. Signal lights in finder warn of *overexposure,* or *too slow* shutter speeds. Leaf shutter. Self-timer, X synchronization, single-stroke film-advance lever, battery check lamp.

Yashica Electro-AX. A fully automatic SLR with electronically controlled shutter. It has an aperture-weighted automatic exposure system, with *stepless* speeds from the slowest (about 4 seconds) to 1/1000 second. There are signal lights in the finder, and on top of the camera body.

Rolleiflex SL35. It took a long while for Rollei to flex their muscles in competition with the Japanese invasion, but with the addition of their huge plant in Singapore, they are now ready to meet all comers. This is a beautiful camera worthy of the Rollei name, with most of the latest

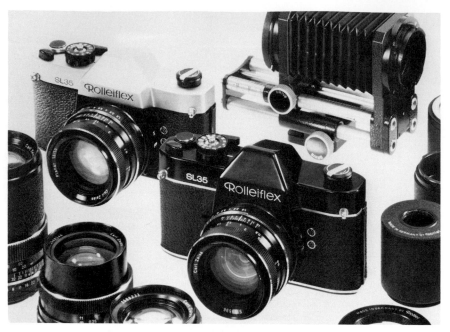

The Rolleiflex SL35, in two models, and some of its accessories.

single-lens reflex refinements, including interchangeable lenses and an electronic TtL metering system.

Robot Royal 36. Automatic rapid wind permits taking 20 exposures (or 36) without rewinding. Has Robot *all-metal* Rotor shutter with speeds from 1/4 to 1/500 second and B. Internal synchronization for all speeds. Interchangeable lenses with breech-lock bayonet mount. Film reminder. Hinged back. Shutter release automatically exposes, advances film, counts exposures, and sets shutter for next picture. Kinographic sequence release permits bursts of up to 6 *shots per second. The Robot Royal 24* takes up to 55 exposures 24 x 24 (instead of 24 x 36).

Minolta Hi-Matic E. Fully automatic CdS exposure control, *averaging* type. With an electronic shutter that sets itself for all light conditions. This unique shutter also decides whether flash is necessary, and computes the correct exposure automatically. If there is enough light without it, the meter will not fire the flash (or electronic flash). For outdoor use, where flash is often needed as a fill-in light, a manual override makes flash firing possible at will. Will focus to 2.6 feet, and is supplied with a permanent 40mm *f*/1.7 *Rokkor* lens.

35MM SINGLE-LENS REFLEX. Unless otherwise mentioned, these all use 35mm sprocket film, have rubberized focal-plane shutters, interchangeable lenses, electronic through-the-lens exposure controls, and interchangeable focusing screens with centered microprisms for rangefinder-type viewing. The 1936 *Exakta* was the first camera to offer a single-lens reflex. It now has a *removable* pentaprism with 14 interchangeable focusing screens, a

metal shutter, and an instant-return mirror; but it still boasts a shutter with speeds of 8 to 1/1000 second. *The more things change,* et cetera . . .

Exakta RTL 1000. Metal focal-plane shutter with speeds from 8 to 1/1000 second plus B. F-P-X synchronization and self-timer. Interchangeable bayonet-mount lenses, eye-level prism, and full focusing screen with central microprism. TtL exposure metering by mercury battery CdS cell, reads entire picture area at full aperture or stopped down.

Canon F-1. Titanium focal-plane shutter with speeds from 1 to 1/2000 second, plus B. F-P-X synchronization. Interchangeable lenses, eye-level prism, and full-focus screen with central microprism. TtL automatic exposure control by mercury battery-powered CdS cell which reads control-marked area (spot metering) at full or working aperture. Depth-of-field preview, mirror lock-up and self-timer. Shutter speeds visible in finder. Accessory motor drive, bulk film back, and low-light meter booster.

Nikon F2 Photomic. Features a quilted titanium-foil focal-plane shutter with speeds from 10 to 1/2000 second plus B. F-P-X synchronization. Interchangeable lenses, eye-level prism, and full-focusing *fresnel* lined screen. Silver (instead of mercury) battery-powered CdS electronic circuit, with cells on either side of finder eyepiece, controls TtL exposure metering through center-weighted spot at full aperture. Shutter speed and aperture visible in finder. Meter needle visible above prism. Mirror lock-up, self-timer. X synchronization now 1/80 second (instead of the usual 1/50). Accessory motor drive permits 5 to 7 frames per second. New *Photomic* head, the F2S, will use *red* and *green* lights, instead of meter needle, and extend sensitivity of meter to 8 seconds at $f/1.4$.

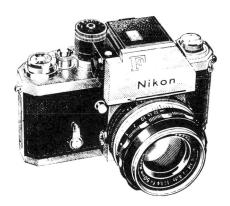

The Nikon F Photomic FTN.

Nikkormat FTN. If cost is a problem, be sure to look into this *son-of-Nikon* addition to the family. Without some of the fancy dressing (like the interchangeable viewing screens and hoods), this will do almost everything you'll ever need. It has a metal *Copal Square-S* focal-plane shutter, and a center-weighted TtL electronic exposure meter circuit that works at full aperture (no need to stop the lens down to take a reading).

Leicaflex SL. The letters stand for *selective light* measurement, which operates through a full-focusing *non*-interchangeable viewing screen which not only provides vivid viewing, but a central light-measuring identification circle which shows the shutter speed selection. Bisection of a small circle by a pointer needle indicates correct aperture, shutter speed, and light available. The TtL electronic circuit works through a central spot which exactly matches the measured area. There is no *weighting* or *integrating*, so you must read either a median tone or a range from *highlight* to *shadow. If you wear glasses,* you should be happy to know that you will be able to see the entire finder field in this camera. Has a rubberized cloth focal-plane shutter with speeds from 1 to 1/2000 second plus B, M-X synchronization, and a self-timer.

How lens metering works
in the Leicaflex SL.

Alpa 10d. A well-made reflex offering some great lenses and a complete electronic metering system. Fixed eye-level prism with a central micro-prism (and split-image rangefinder focusing) surrounded by a clear-glass collar and cross-hairs. Full focusing screen interchangeable with others. CdS exposure meter (TtL) measures center-weighted spot at shooting aperture. Quick return *diaphragm,* instant-return mirror. Leather body cover available in gold, red, green, black. *Caution:* Extraneous light coming through finder may affect meter, so keep your eye close to rubber eyecup. Alpa has tried to anticipate this problem by placing a CdS cell on either side of the eyepiece, inside the finder, with a third cell facing the rear to measure stray light from eyepiece. Current from this third cell is designed to compensate electrically for the unwanted light. The CdS meter uses the *stop-down* method with weight given to a 24 x 24mm area centered in the viewing screen.

Alpa 11e. An improved reflex of the 10d type (above) with a solid state circuit, 6 transistors, and a large *yellow* arrow which becomes visible through the eyepiece for *over*exposure, and a small *red* arrow for *under*-exposure. Complete Macro-Micro equipment available.

Praktica LLC. All metal multiblade *vertical* focal-plane shutter with speeds from 1 to 1/1000 second plus B, F-P-X synchronization. The all-new *full aperture* or *working aperture* exposure metering system uses electronic aperture coupling (which *Modern Photography* calls an "important innovation"). Using a beam splitter to siphon off a small amount of the entering light and redirecting it to a CdS cell near the front of the prism housing, the metering system thus avoids error due to stray light hitting the viewfinder eyepiece. The LLC relies on *center-weighting* rather than *averaged* readings. Unlike other focal-plane SLR's, the LLC can sync with electronic flash to 1/125 second. Though the viewfinder screen is bright (with a 1:1 image size), wearers of eyeglasses may find it difficult to see the corners.

Zeiss Contarex SE. The milled wheel at the upper left (or at the right if the camera is held to your eye) is reminiscent of the focusing wheel which was such a comfort on the old *Contax.* But this wheel is an *aperture-control ring,* part of the super electronic (SE) circuit that makes this great camera, its accurate (because electronically controlled) shutter, and its superbly sharp lenses, one of the happiest photographic instruments on the market. The TtL exposure meter measures a central spot at *full aperture,* with automatic aperture compensation for close-working distances. You focus by turning a milled ring around the lens.

Yashica TL Electro-X ITS. Copal Square SE metal focal-plane shutter with speeds from 2 to 1/1000 second, plus B, F-P-X synchronization, and self-timer. Non-interchangeable eye-level prism with central microprism. *Silver* battery-powered CdS exposure meter (through-the-lens) measures full picture area at shooting stop. With instant-return mirror and quick-return aperture. You get the proper exposure by heeding the warnings of a set of arrow lights embedded in a small black band at the bottom of the finder. Accurate and rugged, this modern Yashica offers a lot for the money.

Konica Autoreflex T. Metal *Copal S* focal-plane shutter with speeds from 1 to 1/1000 second, plus B, M-X synchronization, and self-timer. Fully automatic exposure system with a through-the-lens CdS circuit which has a manual override. Aperture and shutter speed visible in the finder. Shutter release is gentle and smooth; and so is the shutter. You can set the shutter speed, and the meter will supply aperture; or vice versa. If you don't want the reading set by the camera, you can override it by turning off the EE setting. The central microprism spot is among the easiest to focus. *Eyeglass users* may have trouble seeing the four corners of the screen.

Honeywell Pentax Spotmatic II. Interchangeable lenses, *automatic diaphragm,* ground-glass focusing with microprism spot; instant-return mirror; through-the-lens exposure meter with two CdS *average*-reading cells. Conventional focal-plane shutter, *F-P-X* synchronization, hot-shoe, lever-wind single-stroke *ratchet* advance film transport. Macro and Micro equipment available. This fine camera is manufactured by Asahi, distributed in U.S.A. by Honeywell.

The Honeywell Pentax Spotmatic II.

Asahi Pentax ES. An electronically controlled single-lens reflex of radically new design, from the originators of the SLR rapid-return mirror system. This Electro Spotmatic, with full-aperture through-the-lens metering, and an electronically controlled automatic focal-plane shutter, is *the first of its type in the world.* In other cameras with TtL metering and focal-plane shutters, you can select the shutter speed and the meter selects the correct aperture for that speed. The Pentax ES uses an electronic circuit that *remembers* the light seen through the lens before the instant-return mirror starts upward. When the mirror has completed its rise, the electronic circuit releases the shutter, but at a speed (variable and stepless through its entire range) which depends on the remembered exposure. The new metering system covers a wide range of EVS light levels, from EV 1 (1 second at $f/1.4$) to EV 18 (1/1000 at $f/16$). There are some minor design problems that will undoubtedly be solved by the time this camera reaches the American market, but the concept of an SLR which can move its shutter by setting its aperture, is going to rock camera design, as did the Asahi *instant-return mirror.* Distributed in U.S.A. by Honeywell.

120/220 TWIN-LENS REFLEX. When Franke & Heidecke produced the first *Rolleiflex,* they started a landslide that has almost buried us in camera models. The incredible thing is that so many different types of cameras were able to live together in the world market. Even in this twin-lens category, there are two basic formats: the *permanent* lens cameras, like the *Rolleis* and the *Yashicas;* and the *interchangeable,* like the *Mamiya C220* and *C330.* All those in this category supply a square 2¼ inch picture, and use both 120 and 220 film.

Rolleiflex 2.8F. This remarkable camera retains its popularity among knowledgeable photographers for a very good reason: gadgetry aside, *it's the tops!* Anyone who has ever had a Rollei in his hands can't escape the hypnotic effect of this fine instrument, sharpened and polished by years of experience. 80mm *Planar* $f/2.8$ lens, *Synchro-Compur* leaf shutter with speeds from 1 to 1/500 second. Waist-level viewing with *Rolleiclear* focusing screen, central microprism, automatic compensation for parallax, eye-level sportsfinder. Single-stroke crank advances film and sets shutter. Automatic film loading and frame counting. Can use 35mm film (with adapter). Built-in exposure meter cross-coupled (for EVS use) to shutter and lens aperture. There is a 3.5F model, and a less expensive *Rolleicord VB* which uses only 120 film, but has automatic parallax correction.

The Rolleiflex 2.8F, for 120/220 film.

Yashica Mat-124G. A "budget" photographer's dream: a handsome sleek black 2¼ twin-lens reflex that uses both 120 and 220 film, has a built-in meter, a film-advance shutter-set crank, two wheels (à la the Rollei) to set shutter and aperture, and a *Copal-SV* leaf shutter with speeds from 1 to 1/500 second.

Mamiya C330. This is the only twin-lens reflex with a long bellows for close focusing. Interchangeable lenses, parallax compensation, a choice of two shutter releases (one on the right side, another at the front of the base). With the accessory pistol grip, you have the extra option of a trigger release. The film-advance crank sets the shutter with one forward stroke (no back swing, as with the Rolleiflex). Shutter can be operated without advancing film. Regular finder can be interchanged

The Mamiya C330 twin-lens reflex.

with the *Porrofinder* (with or without CdS metering or a prism finder), giving you 2.5x more magnification and *unreversed* eye-level viewing. Will also accept 220 film (by turning pressure plate) and can be converted to sheet film use. Seven interchangeable sharp lenses. For the budget minded, there is the *Mamiya C220*.

120/220 SINGLE-LENS REFLEX. This is a variation of the 35mm SLR, which has more than earned its keep as a camera type. The first camera in this group (the *Hasselblad*) finally found its way to, and earned its stripes on, the moon. But each of the others has added refinements that have contributed greatly to the popularity of this compact reflex. Interchangeable lenses, the latest electronic circuits, interchangeable backs and screens, two lengths of film (for 12 or 24 pictures), and the option of using *focal-plane* or *leaf shutters* (depending on the camera) make this one of the most interesting formats now available.

The Yashica single-lens reflex.

Hasselblad 500C/M. Despite the fact that it still has no instant-return mirror, this is the *standard*, nevertheless, against which others are measured. Interchangeable lenses and backs, separate *Compur* leaf shutter built into each lens (with speeds of 1 to 1/500 second). Uses a variety of films (120, 220, and 70mm). If you wear eyeglasses, and find it difficult to focus on a ground-glass screen, you may find this camera hard to use. But the *fresnel* focusing screen is one of the best, especially with telephoto lenses. With the various prisms, pistol grips, and sports-finders, the Hasselblad can also be used at eye level.

Rolleiflex SL66. This has one unique feature: you can tilt the lens up or down about 8°. Though this may not help for perspective control, it can be useful in *depth-of-field* adjustments. Cloth focal-plane shutter with full focusing screen and central microprism grid. *Quick return diaphragm,* instant-return mirror, and interchangeable film backs which use a variety of films (including 12- or 24-exposure rolls and, with an adapter, *Polaroid*).

Rolleiflex SL66, with interchangeable 80mm Planar *f*/2.8 lens, and sunshade.

120/220 RANGEFINDER 67. The *ideal format* size (2¼ x 2¾) is popular because it enlarges perfectly to 4 x 5 and 8 x 10 without waste. The number 67 stands for 6 x 7 centimeters. This size negative, incidentally, is five times as large as a 35mm.

Koni-Omega M. A rugged and beautifully crafted roll film rangefinder camera that will appeal to press photographers as well as serious amateurs. Interchangeable lenses, interchangeable backs, combined view and rangefinder window, with bright frame lines for 90 and 180mm lenses, corner dots for 135mm lens. Automatic parallax correction. Push-pull shutter set. Three accessory shoes and a most comfortable, adjustable hand grip. The projected frame system is considered by experts to be the most accurate ever offered.

Linhof 220. A perfect rangefinder camera for the fastidious newsman who appreciates good engineering blended with eye appeal. Non-interchangeable 95mm *f*/3.5 *Rodenstock Technikar* lens with stops to *f*/32, focus to 3½ feet. Combined range- and viewfinder with etched frames for normal and close focusing distances (no parallax adjustment). Selenium cell exposure meter with arrow visible in finder, couples to shutter and aperture controls. Single-stroke rapid advance lever, rotating pistol grip handle with shutter release trigger. Balances beautifully in the hand. Bright, life-size viewfinder with good image separation, providing needle-sharp focus. *Synchro-Compur* leaf shutter with speeds from 1 to 1/500 second and B. M-X synchronization.

120/220 SINGLE-LENS REFLEX 67. The heft of the cameras using this format has challenged the ingenuity of the designers. The problem is simply this: the *ideal format* requires a lot of camera; but the photographer wants everything he needs in a compact handful. Here is how the manufacturers have tried to solve the problem.

Honeywell Pentax 6 x 7. To keep the size down, the Pentax engineers chose a pentaprism which covers only 85 per cent of the picture area. If you want to see *all* of the image you have to substitute a waist-level finder. The rectangular format lends itself to scaling up a 35mm SLR to this 2¼ size. And the strange thing is, it really handles like a minicam. Interchangeable lenses, *electronically controlled* rubberized cloth focal-plane shutter with speeds from 1 to 1/1000 second. F-P-X synchronization. Single-stroke advance lever, instant-return mirror (well damped), but shutter noise is quite audible. Plane flatness is said to be superior to anything else in this size.

Mamiya RB 67. This is the first 6 x 7 format SLR camera with a *revolving back*. Best for waist-level viewing. Four interchangeable lenses (from 65mm to 250mm) with a *Seiko No. 1* leaf shutter in each lens, with speeds from 1 to 1/400 second plus T and M-X synchronization. Built-in bellows permits close focusing without extension tubes. Revolving back accepts five different film holders without adapters. Uses packs, sheets, 120 and 220 roll films, as well as Polaroid 107 and 108 packs. And in each case you have the advantage of horizontal or vertical formats. Interchangeable screens (5) and hoods. Screen blacks out when shutter is released (*no instant-return mirror*).

Graflex Norita 66. A single-lens reflex designed and engineered to look and operate like a 35mm candid camera; it uses both 120 and 220 roll film. Cloth focal-plane shutter, with speeds from 1 to 1/500 second. *But no TtL electronic metering system.* The normal lens is a compact 80mm *f/2 Noritar,* but other interchangeable lenses are available from 40 to 240mm, all with *automatic diaphragms.* Other lenses are a 300mm *preset,* 90mm *macro,* as well as a 500mm and a 1000mm. Instant-return mirror, quick return diaphragm, bright viewing screen with central microprism. Eye-level and waist-level viewing.

Bronica S2A. Cloth focal-plane shutter with speeds from 1 to 1/1000 second and B. F-P and M-X synchronization, *but X sync at only 1/40 second.* Interchangeable waist-level finder with full focusing screen and central microspot for fine focusing. Quick return diaphragm, instant-return mirror, interchangeable film backs, and a flip lever for converting from 120 to 220 roll film. Close focusing to 18 inches with normal lens and built-in bellows. The bellows also incorporates tilts (as in the Rollei SL66).

Bronica EC-1. This new version of the Bronica has been completely redesigned. The bayonet-lens mount remains, but the rest of the camera has been changed. Among the improvements: an electrically coupled CdS prism; a larger, more efficient light-trapped film magazine; a magnifying hood with interchangeable eyepiece; an electronically controlled (and remarkably accurate) cloth focal-plane shutter with speeds of 4 to 1/1000 second; a *two-piece* instant-return mirror (part of which flips up, while the rest flips down) *to reduce camera vibration.* None of the screens, magazines, nor finders are interchangeable with those from previous models. The meter prism, with four separate CdS cells, provides full-area averaging measurement. Other minor features: a storage slot for the dark slide (as in the Konica Omega M), separate battery checks for meter and shutter, an ingenious ball-bearing PC cord lock, and provision for 120 *and* 220 film use.

PRESS, VIEW, AND SPECIAL. We are restricting our listing of cameras in this category to 4 x 5 or smaller. Beyond that, you would be going into professional equipment, which is of no concern at the moment to the readers of this book.

The Horseman 2¼ x 3¼. Combines the virtues of a technical camera with full swings and tilts; and a rangefinder press camera, for hand use. Has interchangeable backs for 120, 220, and sheet film. Front slide, rising front, front and rear swings and tilts. Has 10½ inch bellows for extreme close-ups. Has an accessory TtL (through-the-lens) meter; and a wide-field lens mount. Seven interchangeable rangefinder-coupled lenses. For free *Horseman Technical Camera Guidebook,* write to Calumet Photographic, Inc., Suite 3502, Empire State Building, New York, N.Y. 10001.

Linhof Technica 70. A combined press and view camera that takes 2¼ x 3¼ sheet film, plates, Polaroid, and 120 roll film (with adapters), 70mm sprocket film with Rollex back for up to 53 exposures. Choice of 36 interchangeable lenses with rangefinder coupling for each (from 53-

A typical Press camera. The 4 x 5 Crown Graphic with Stroboflash IV.

to 240mm). Rangefinder and optical viewfinder combined. Automatic parallax correction and *leveling device*. Built-in match-needle exposure meter. Triple extension bellows, revolving ground-glass back with *Ektalite* field lens and check stops for vertical or horizontal positions. All slide, tilt, and swing movements, drop bed, and *anatomical grip*.

Kardan Color 45S. A multi-format optical-bench-type monorail view camera with front and back rise, and all tilts and swings on both vertical and horizontal axis. Snap-in interchangeable bellows. Zero backlash for front and back focusing, and positive locks on all controls. Dual alignment spirit levels on rear standard.

Mamiya Universal. A handsome press camera that takes 120 or 220 roll film, 2¼ x 3¼ sheet film, film packs, and Polaroid film pack holder; coupled rangefinder with press-focus control. Eye-level viewfinder combined with rangefinder and bright frames for 90-, 100-, 150-, and 250mm focal lengths, all rangefinder-coupled in synchro shutters to 1/500 second. M-X synchronization.

Sinar Standard 4 x 5. A monorail view camera with interchangeable backs and long bellows for close-up photography. Extreme shifts, tilts and swings, front and back, and in any direction.

INSTANT LOAD CARTRIDGE CAMERAS. Over 50 million *Instamatics* have been sold since the 126 size was put on the market (see text, page 138). The new 110 size, for the *Pocket Instamatics*, will undoubtedly have as great an effect on changing the habits of photographic America. See text, page 140, for full description.

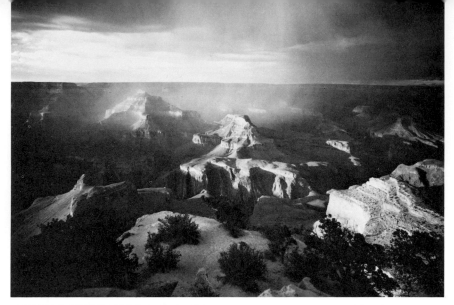

STORM OVER THE CANYON. Guessing at an exposure like this is dangerous. Use a meter and aim at the brightest section. Place reading to make that the outside limit of *over*exposure. Taken on Kodak Plus X film developed in Microdol X.

7 Film and Exposure

Some Secrets of Exposure

In the museum at Munich there is a candlestick that once served as a device to measure exposure. The candlestick was placed on a large tin plate. Into an ordinary wax candle, held upright by the candlestick, were set a series of metal balls arranged in such a way that one ball fell every 30 minutes, as the candle burned. The noise of the ball hitting the plate would signal the photographer of 125 years ago that his emulsion was properly exposed (according to Daguerre, who calculated that one of his photographic plates required a half-hour exposure in sunlight at an aperture of about $f/16$).

To reproduce a scene accurately in black and white, the perfect negative has to show all the tones the way the eye sees them, with exactly the same relative contrasts between the light and dark areas, and with the color hues converted to the correct shades of black, gray and white. Though negative contrast is determined by development, and not by exposure, nevertheless the exposure *must* be correct or the tonal relations of the subject may be falsified in the negative. You will see why, in a moment.

WHAT IS CORRECT EXPOSURE?

The average negative emulsion is so made that it can reproduce, without any loss of tones, a scene with the brightness range of 1 to 128. This means that if the brightest object is 128 times as bright as the darkest object, both can still be photographed in their true tones, with full detail visible in the shadows as well as in the highlights. Now, when the scene itself has a brightness range of 128 to 1, there can be only *one* correct exposure if the tones of the subject are to match exactly the tones of the negative. Look at the sleeping gentlemen in *Fig. 7.1*. The one in the middle fits his bed perfectly; he represents a scene brightness range of 128 on a film with a latitude of 128. If he were to move up or down in the bed, either his head would be lifted up at one end or his feet would dangle over the other. The effect on a film, if the exposure were *under* or *over*, would be somewhat similar; either the shadows would lose detail and go dense black or the highlights would jam up and go chalky white. In either case the reproduction would be false.

FIG. 7.1. ILLUSTRATING CORRECT EXPOSURE

Now, if the scene has a brightness range of only 32, whereas the film latitude is still 128, we can see at once that a considerable variation in *correct exposure* is possible. See the little fellow in the big bed at the left in *Fig. 7.1*. He could move up or down in the bed quite a bit, and still be on the bed *in toto*. Just so, the correct exposure for a scene with a brightness range of 32 on a film with a possible range of 128 would give us an exposure *latitude* of 4 to 1. Negatives exposed at shutter speeds of 1/25, 1/50, 1/75, or 1/100, though they would vary in density, would all reproduce the scene in exactly the same way.

Finally, if the scene has a brightness range of 256 as against the film range of 128, it would be possible to record accurately only half of the scene's tones; either the highlight and/or the shadows would be lost. See *Fig. 7.1* again. The big sleeper with his feet dangling over the bed

represents our scene with a brightness range of 256; there's too much contrast in the scene for the film, just as there is too much man for the bed. See the photographic reproductions on pages 175 and 176, which show how this works out in practice.

MEASURING THE EXPOSURE

The brightness of a scene or object depends not on how much light it *receives*, but on how much it *reflects*. To measure this light accurately you need a meter, either photoelectric, visual, or comparison. The visual (like the *Corfield* or the *Leudi*) were inexpensive but inaccurate; the comparison (like the *SEI Exposure Photometer*) are extremely accurate but quite expensive. The best compromise is the photoelectric, of which there are now two types.

The conventional photoelectric meters (*Weston Master 5, Sekonic, Leica-Meter, Spectra,* which is the old *Norwood* with some improvements) use a selenium cell which produces current when light hits it, activating the needle. The greater the light, the more the current, and the higher the reading. The newer meters (*Gossen Luna-Pro, Leica MR4, Metrostar, Weston Ranger 9,* for which the Ansel Adams *Zone System* scale is available as an accessory) work on an entirely new principle. The cadmium sulphide (CdS) cell which they use acts as a light-controlled resistor to a tiny mercury battery. With light, cell resistance *decreases* and current *increases*. Hence their sensitivity is extremely high; high enough to read moonlight!

The *Spectra Combi-500* (again the old Norwood, with still more improvements) combines both the selenium and CdS cells to make the meter extremely sensitive, rugged, and functional.

Also, there are some meters, like the *Gossen Pilot,* in which there is a *follow-pointer* coupled to the computer. You aim the meter, turn the computer rim until the indicator needle lines up with the follow-pointer; then you read the exposure times, f/stops, and EVS (exposure value system) settings (see *index*).

Almost all of the current exposure meters, particularly the Weston meters IV, V, Ranger 9, XM-1 (selenium photocell), XM-2 (CdS photocell), and all of the Gossen meters, include these exposure value settings. The newer Weston meters are light, compact (shirt-pocket size), and accurate. The XM-1 to about 50 footcandles; the XM-2 for much dimmer light (though the CdS meter needle, as in all such equipment, responds more slowly). Many cameras that provide for cross-coupling between shutter and aperture, as does the twin-lens Rolleiflex, likewise show EVS settings.

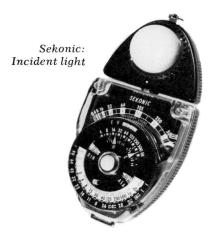

Sekonic:
Incident light

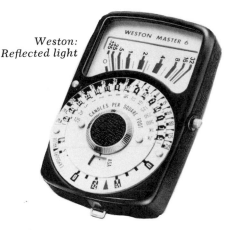

Weston:
Reflected light

TWO TYPICAL EXPOSURE METERS

Shutter speed equivalents. In recent years, cameras and exposure meters have been marked this way to show speeds in fractions of seconds: 2, 4, 8, 15, 30, 60, 125 (for ½ second, ¼ second, etc.). For most purposes, these speeds are interchangeable with the older designations still found on some cameras and meters (*Master IV, Leica M3*): 2, 5, 10, 25, 50, 100. See dials of *Sekonic,* above, and *Weston,* page 190.

FILM-SPEED RATINGS

Since the various types of available films have emulsions whose response to light differs, it is necessary to know the speed rating of each in order to operate an exposure meter. All meters are calibrated to conform to a system of speed ratings. At one time, the most widely recognized standard for films was that developed by the manufacturer of the Weston meters, but there were others, notably the General Electric system devised especially for use with the GE exposure meter.

In 1943, however, the American Standards Association [1] arrived at a method of film rating which has become *the* American Standard to be used by all exposure meter, film and flashbulb manufacturers. The figure designated for a given film is known as the *ASA Exposure Index.*

Meanwhile, as in all periods of transition from one set of rules to another, there will likely be some confusion, particularly for owners of meters calibrated on the older systems. There need be no real difficulty, however. ASA index numbers differ only slightly from those of older

[1] The American Standards Association, following two reorganizations, is known today as ANSI (the American National Standards Institute, Inc., 1430 Broadway, New York, N.Y. 10018), and it publishes listings of "American National Standards" including standards relating to exposure and other photographic functions and dimensions. *However, ASA film speeds are designated by "ASA" despite the change in organizational nomenclature.* And that is how we shall continue to refer to them.

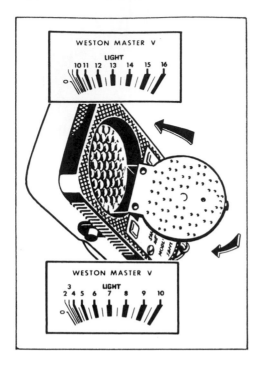

WESTON MASTER V
LIGHT
10 11 12 13 14 15 16

WESTON MASTER V
3
2 4 5 6 7 8 9 10
LIGHT

DUAL RANGE METERS

Many modern meters are so sensitive that they require two scales, one for bright light and one for dim light. Here, at left is how the Sangamo Weston Master V has solved this problem. The light scale on the left shows how the window looks when the perforated baffle covers the cell. The dim light scale moves into position when the baffle is raised and locked against the meter body. The acceptance angle of the meter cell (what it sees) depends on the baffle position. When closed, it is 50°; open, it is 70°. Keep this in mind when you try to make the readings from both scales give you identical exposures for a borderline case. You may be including 20° more or less of the scene as you shift.

exposure meter systems, and it is practical to use the different systems interchangeably because of the wide exposure latitude of modern films.

You may find DIN speeds indicated on your exposure meter. This is a system of rating emulsion speeds worked out by the *Deutsche Industrie Norm*, the German equivalent of our American Standards Association. In this system, speeds double every three degrees. For instance, a film of 18° DIN is twice as fast as (and therefore requires only half the exposure of) a film of 15° DIN; a film of 21° DIN, in turn, has twice the speed, and needs but half the exposure, of an 18° DIN film. An emulsion of ASA 125 is equivalent to 22° DIN; an emulsion of double this speed, or ASA 250, would be rated 25° DIN.

The ASA system of rating the speed of film was worked out in 1960 by the American Standards Association for monochrome emulsions, and in 1961 for color reversal materials. The ratings for monochrome are based on establishing a point along the characteristic curve (which shows how light acts on an emulsion to produce density on development) at a minimum density level above film base and fog density, and under certain conditions of slope. The characteristic curve looks like a road going up a hill, with a plateau at the top. The method of arriving at this rating is technical and somewhat involved; and there is really

no need for the amateur photographer to go into it deeply, since he will never have to work out an ASA rating himself. The ASA speed can be stated in arithmetical form, like ASA 100; or in logarithmic form, where each step represents a change in sensitivity equal to a factor of 2, as ASA 5°. Some meters, like the *Gossen Lunasix*, show the ASA numbers (ASA 6° or ASA 200) in windows set on either side of the plexiglass film-speed setting disk.

When the ASA system was first devised, the published speeds incorporated a *safety factor* of anywhere from 2.5 to 4x the minimum exposure required for a properly exposed negative. Because of this, a generation or more of amateurs suffered through the densest negatives you've ever seen, simply because Rochester and ASA insisted we couldn't be trusted to use *the minimum exposure short of underexposure.*

As a result, the manufacturers of developers had a ball. One outdid the other making wild claims about the speed of his developer. All they were doing, of course, was taking up the slack built into the film speeds by the artificial *safety factor.* An easy test against Kodak's standard developer, D 76, would have punctured the unfounded boasts for their miracle supersoups.

Subsequently, Kodak and all the other film manufacturers adopted new ASA ratings with *reduced safety factors* for all monochrome film.

The key to perfect exposure is to find the minimum exposure just short of underexposure. This will give you beautiful, thin negatives with full shadow detail, no highlight blockage (to get unblocked negatives,

THE EFFECT OF UNDER- AND OVEREXPOSURE. These were taken on *70mm Isopan IF,* developed normally in *Atomal Neu,* at ASA 25, 100, and 50 (the normal exposure). You can see that exposure *does* make a difference.

BRACKETED EXPOSURES. Here are three exposures of the same scene, photographed on Eastman Kodak *Super XX Pan* sheet film. The lightest one is a print from a negative that was *overexposed*. The darkest is a print from an *underexposed* negative. The third is from a negative that was *correctly exposed*. Compare all three and note how the highlight detail has been lost in the one, and the shadow detail and brilliance in the other. Two stops *under* and *over* the meter reading (for the correct exposure) were given in each case. Courtesy Eastman Kodak, Rochester, N.Y.

avoid overdeveloping), minimum grain, and the highest *acutance* (sharpness), since the emulsion will only be *surface developed*, which means that the entire image will be on the top layer.

The best way to calibrate the ASA speeds is to make a *test* with your own exposure-equipment-developing techniques. Put your camera on a tripod, focus carefully, use your meter the way you normally do, and then take a series of exposures from ¼ to 4x normal (in half-step stages) as indicated by your meter. Then dunk in your favorite developer (or let your photoshop develop it for you) for the normal time; fix, wash, and dry. If you have kept a record of each shot (or, better still, placed a card with this information into the scene as a permanent record) you will know, once and for all, what your ASA speed should be with *that* film and *your* processing methods. This is really the only way you can pin down the ASA exposure for the kind of negative you need for *your* enlarger and darkroom methods.

Two footnotes to all this. 1) In 1965 Kodak brought out a *new* emulsion with an old name: *Panatomic X*. In doing so, they reduced the exposure index from 40 to ASA 32. Using *Acufine*, I get an ASA reading of 100 with my equipment and processing, and that's what *I* use. 2) The other side of the coin. Bill Sumits, former chief of Life's Photographic Lab, had been waging a one-man war against the official exposure index for Plus X film. Eastman Kodak was saying (in the fact sheet that

accompanied each roll) that it was 160; Bill insisted it was 125. EK finally changed its mind. The rating is now, officially, 125. However, make your own tests. It's the only way to be sure.

EVS AND APEX: BETTER SYSTEMS
FOR DETERMINING EXPOSURE

The *f*/stop and shutter-speed system for translating exposure readings into camera settings worked well enough until the exposure indexes of films began to climb from an ASA of 10 for the old Kodachrome to an ASA of 1250 for Royal X Pan, and beyond. At that point, the new built-in meters and the new hand-held midget meters began to need the help of space-saving engineering. The result was the *Exposure Value System* (EVS), also known as the *Light Value System* (LVS); and the Additive System of Photographic EXposure (APEX). Both were devised to simplify the mathematics of exposure, and were linked to each other for convenience.

The new systems will require some readjustment in your thinking, but the extra effort should begin to pay dividends quickly. Each of the new systems has the great convenience of giving the user a full range of *aperture/shutter* combinations with a *single setting*. Moreover, the new systems actually are easier to use, since they involve fewer numbers and, in the case of black-and-white photography, eliminate such unwieldy fractions as 1/125, 1/1000, 1.4, and 5.6. Here is how they work:

Exposure value system. Many modern cameras and meters are using this system, which consists of a series of numbers designating different *shutter speeds* and *aperture stops*. For instance, in the table below, EV 3 stands for two things: a shutter setting of 1/8 second *and*

EV NUMBER	SHUTTER (SECONDS)	APERTURE (f/STOPS)
0	1	1
1	1/2	1.4
2	1/4	2
3	1/8	2.8
4	1/15	4
5	1/30	5.6
6	1/60	8
7	1/125	11
8	1/250	16
9	1/500	22
10	1/1000	32
11	1/2000	64

an aperture setting of $f/2.8$, with one digit doing the work of four. At EV 10, two digits do the work of seven.

The EV numbers are arranged so that all pairs having the same sum will have the same exposure. For example: 1/125 second has an EV number of 7; $f/2.8$ has an EV number of 3. The total is 10. Now, any other *shutter* and *aperture* combination that adds up to 10 will give you exactly the same exposure: $f/1.4$, 1/500; $f/2$, 1/250; $f/4$, 1/60, etc. Isn't it easier to add 1 and 9, 2 and 8, or 4 and 6 than to mess around with shutter speeds and $f/$stops?

The full range of shutter and aperture combinations for each exposure value is displayed in the following table. (The heavy black dots at the top indicate the *standard* lens openings marked on modern equipment all over the world.)

HOW TO CONVERT EXPOSURE VALUES TO LENS APERTURES AND SHUTTER SPEEDS

Shutter speed for stop number of: (● = standard lens openings)

Exposure value	1.4 ●	1.6	1.8	2 ●	2.2	2.5	2.8 ●	3.2	3.5	4 ●	4.5	5	5.6 ●	6.3	7	8 ●	9	10	11 ●	12.5	14	16 ●	18	20	22 ●	25	28	32 ●
20	—	—	—	—	—	—	—	—	—	—	—	—	—	—	—	—	—	—	—	—	—	—	—	—	—	—	—	1000
19	—	—	—	—	—	—	—	—	—	—	—	—	—	—	—	—	—	—	—	—	—	—	—	—	1000	800	600	500
18	—	—	—	—	—	—	—	—	—	—	—	—	—	—	—	—	—	—	—	—	—	1000	800	600	500	400	300	250
17	—	—	—	—	—	—	—	—	—	—	—	—	—	—	—	—	—	—	1000	800	600	500	400	300	250	200	150	125
16	—	—	—	—	—	—	—	—	—	—	—	—	—	—	—	1000	800	600	500	400	300	250	200	150	125	100	80	60
15	—	—	—	—	—	—	—	—	—	—	—	—	1000	800	600	500	400	300	250	200	150	125	100	80	60	50	40	30
14	—	—	—	—	—	—	—	—	—	1000	800	600	500	400	300	250	200	150	125	100	80	60	50	40	30	25	20	15
13	—	—	—	—	—	—	1000	800	600	500	400	300	250	200	150	125	100	80	60	50	40	30	25	20	15	12	10	8
12	—	—	—	1000	800	600	500	400	300	250	200	150	125	100	80	60	50	40	30	25	20	15	12	10	8	6	5	4
11	1000	800	600	500	400	300	250	200	150	125	100	80	60	50	40	30	25	20	15	12	10	8	6	5	4	3	—	2
10	500	400	300	250	200	150	125	100	80	60	50	40	30	25	20	15	12	10	8	6	5	4	3	—	2	—	—	1
9	250	200	150	125	100	80	60	50	40	30	25	20	15	12	10	8	6	5	4	3	—	2	—	—	1	—	—	—
8	125	100	80	60	50	40	30	25	20	15	12	10	8	6	5	4	3	—	2	—	—	1	—	—	—	—	—	—
7	60	50	40	30	25	20	15	12	10	8	6	5	4	3	—	2	—	1	—	—	—	—	—	—	—	—	—	—
6	30	25	20	15	12	10	8	6	5	4	3	—	2	—	1	—	—	—	—	—	—	—	—	—	—	—	—	—
5	15	12	10	8	6	5	4	3	—	2	—	1	—	—	—	—	—	—	—	—	—	—	—	—	—	—	—	—
4	8	6	5	4	3	—	2	—	1	—	—	—	—	—	—	—	—	—	—	—	—	—	—	—	—	—	—	—
3	4	3	—	2	—	1	—	—	—	—	—	—	—	—	—	—	—	—	—	—	—	—	—	—	—	—	—	—
2	2	—	1	—	—	—	—	—	—	—	—	—	—	—	—	—	—	—	—	—	—	—	—	—	—	—	—	—
1	1	—	—	—	—	—	—	—	—	—	—	—	—	—	—	—	—	—	—	—	—	—	—	—	—	—	—	—
0	—	—	—	—	—	—	—	—	—	—	—	—	—	—	—	—	—	—	—	—	—	—	—	—	—	—	—	—

Table, courtesy of Derek Keeling, *Amateur Photographer*, London.

The exposure value, of course, is determined by the speed of your film and the amount of light available. Suppose your camera is loaded with film of ASA 100, that you have set your meter accordingly, that you are measuring incident light, and that the sun is bright. The EVS window of your meter might give an exposure value of 13. This means you could use a speed of 1/125 second (EV 7, if you're thinking "new style") at $f/8$ (EV 6). Right away, this gives you access to the full range of correct shutter and aperture combinations, from $f/2.8$, 1/1000 (EV 3, EV 10) to $f/32$, 1/8 (EV 10, EV 3). You can read the combinations off by placing a straightedge directly under exposure value 13, then noting the shutter speeds and stop numbers to the right. Your meter scale also

will show these combinations. And, of course, on many of the newer cameras the shutter and aperture mechanisms are linked so that once the exposure is determined, any of the proper speed and light combinations can be obtained by moving a single ring or lever.

The EVS system enables you to adjust quickly to changing conditions. You can shift rapidly from one shutter speed to another, or change the depth of your field, without worrying about ruining your exposure. You can even compensate easily for changes in light. An average subject under a partly cloudy sky may call for an EVS of 12; suddenly, the sun appears, advance to 13; then the sun is obscured, reduce to 11. It's as simple as that.

APEX additive system of photographic exposure. In this system, the EV scale is extended to cover ASA indexes and scene brightness (the former being distinguished here by a degree mark, as in 5°, equivalent to an ASA of 100); the new factors, when added, again generate the entire range of correct combinations for time and aperture.

The new and old scales are shown in the table below. The *new* scales are contained in columns *A, C, E,* and *G;* the old scales in columns B, D, F, and H. In time, probably all the familiar old scales will be superseded by the new ones.

ADDITIVE SYSTEM OF EXPOSURE VALUES
(and how the new and old scales compare)

A	B	C	D	E	F	G	H
			FOOT CANDLES *	NEW APER-			
NEW SPEED VALUE	ASA EXPOSURE INDEX	NEW LIGHT VALUE	(BRIGHT- NESS)	TURE VALUE	f/STOP	NEW TIME VALUE	SHUTTER SPEED
0°	3	0	6	0	f/1	0	1 sec
1°	6	1	12	1	f/1.4	1	1/2 sec
2°	12	2	25	2	f/2	2	1/4 sec
3°	25	3	50	3	f/2.8	3	1/8 sec
4°	50	4	100	4	f/4	4	1/15 sec
5°	100	5	200	5	f/5.6	5	1/30 sec
6°	200	6	400	6	f/8	6	1/60 sec
7°	400	7	800	7	f/11	7	1/125 sec
8°	800	8	1600	8	f/16	8	1/250 sec
9°	1600	9	3200	9	f/22	9	1/500 sec
10°	3200	10	6400	10	f/32	10	1/1000 sec
11°	6400	11	12800	11	f/64	11	1/2000 sec
12°	12800	12	25600				
13°	25600	13	51200				

* Scene brightness measured by incident light.

With this table, you can use the *slat rule*, a memory device to which the word SLAT is the key. Thus:

$$S + L = A + T$$

where S stands for *speed*, L for *light*, A for *aperture*, and T for *time*. By adding the speed value to the light value from the table, or from a meter, you will get a number that leads to a whole range of time and aperture combinations.

For example, suppose that you are shooting with a 400 ASA film in a baseball park under night lights. The new speed value for the film is 7 and the light value, measured by incident light, could be about 4 (sunshine would give you a light value of about 12, measured the same way; an average living room might be about 1). The total for the first half of the equation, then, is 11, and any combination of aperture and time values that also adds up to this figure will provide correct exposure —$f/1.4$, $1/1000$ $(1 + 10)$ and $f/4$, $1/125$ $(4 + 7)$, among others, will balance the equation.

The numbers in column C are too widely spaced for *color* film, so fractional EVS numbers must be used in that case. Kodacolor X, for instance, with an ASA speed of 80, would use an Additive Speed of 4.5°, and the light meter (as it does in the Gossen *Lunasix*) would show half-speeds between the main ones in the window marked °ASA.

Finally, with the new speed value scale that replaces the ASA index numbers, it is possible to go back to the table for converting exposure values to lens and shutter speeds and see how they are affected by changes in film speed. For instance, if your exposure value is 13, based on using a film of ASA 100, a correct aperture/shutter combination would be $f/4$, $1/500$. Since ASA 100 is rated 5 in the new scale, and ASA 25 is rated 3, a shift to the latter film, whose emulsion is one-fourth as sensitive as the first, would reduce the exposure value from 13 to 11, and thus require four times as much exposure, $f/4$, $1/125$ as opposed to the original $f/4$, $1/500$. On the other hand, if the film you intend to use is four times as fast (ASA 400, or 7 on the new speed value scale), your aperture and shutter speed would become $f/8$, $1/500$, instead of $f/8$, $1/125$, etc. There are two ways of determining the new combinations: 1) reset your meter to ASA 400 (which brings your EV index up to 15) and read the scale, or 2) use the chart (line EV 15) to get the other combinations.

ADVANTAGES OF A NARROW-FIELD (SPOT) METER

Whenever a small area of a scene must be measured accurately, as in *portrait* photography, or in *night* photography (where the dark back-

ground produces too low a reading, with consequent overexposure of the important, lighted areas), a narrow-field exposure meter is called for. The narrower the measuring circle (acceptance angle) of the meter, the more accurate the exposure. An *integrating* meter reads the *whole* field of view, and gives an *average* reading; a *spot* meter measures only a small part of the field and can help you choose whatever area of the scene seems most important.

The area covered by a 50mm lens (*normal* for a 35mm camera) is 45°. The meter, therefore, should have an acceptance angle somewhat narrower than this.

Many meters, notably the *Gossen Lunasix* and the *Weston Ranger 9*, have a measuring area corresponding to a light acceptance angle of

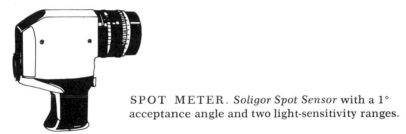

SPOT METER. *Soligor Spot Sensor* with a 1° acceptance angle and two light-sensitivity ranges.

about 30°. This matches the area covered by the 90mm lens of a 35mm camera. The Weston Ranger 9 also has an eye-level viewfinder which lets you see exactly what the meter sees. Both meters have high- and low-level scales, CdS battery systems, battery checkouts, and EVS settings.

You can usually find out what the acceptance angle of any meter is by reading the instruction manual (though some manufacturers are negligent about offering such necessary information), by asking the dealer (who *sometimes* knows), or by writing to the company that makes it.

Relating the viewing angle of the lens to that of the meter is a good idea when you are using *normal* or *telephoto* lenses. But this link is not as serious when you are working with a *wide-angle* lens because your meter functions then as a spot meter, since its view is normally narrower than that of the lens.

Are we suggesting that you get another *meter?* Only if you are really serious about your photography, or dislike being cramped. The problem of the built-in meter is that you pay for its compactness by losing out on maneuverability. When your camera is on a tripod, it's a nuisance to have to unthread it to meter a closeup. Of course, there are quick-release tripod mounts (see *index: tripod, detachable mount*), but even so, it means lugging the entire camera around for a meter reading, and often losing your carefully worked out composition.

If you are going to get a supplementary meter, get one with a narrow view, or at least a narrower view than your normal lens.

The Rolls Royce of such hand-held meters (and correspondingly priced) is the *SEI Exposure Photometer*, favored by Ansel Adams. It is a *comparison* meter, not the *extinction* type (in other words, it compares a variable light inside the meter with the spot you are measuring; this light is linked mechanically to the various scales). The SEI reads *reflected object light* (the same light that reaches the camera lens) and it measures *object brightness* selectively, regardless of *background lighting*. The meter has a minimum acceptance angle of 1°, which makes it possible for you to read a telephone pole 100 feet away. It also has a telescopic eyepiece and a telescope objective, an accurate microammeter, a pushbutton switch, a brightness-range selector, all the necessary lens and film scales, and a leather case. For information, write to Zoomar, Inc., 55 Sea Cliff Ave., Glen Cove, N.Y. 11542; or 6725 Sunset Blvd., Hollywood, California 90028.

Other narrow-view meters that are worth investigating: *Minolta Auto Spot 1°* (see illustration and caption, below); *Gossen Lunasix 3* (which has an EVS scale, and a *tele*-attachment which reduces the acceptance angle to 15° or 7.5°, at will); *Soligor Spot-Sensor* (CdS, reflected light, with 1° acceptance angle, two light-sensitivity ranges, LVS scale; *see drawing*); *Sekonic L228* (CdS reflected light *zoom* meter with *variable* acceptance angle of from 8.2° to 28°, and an EVS scale); *Honeywell-Pentax 1°/21°* (CdS reflected light meter, reads 1° spot from a 21° field of view, has an SLR optical system and a Pentax pentaprism).

To sum it up: a supplementary hand-held meter is not *necessary.* You can live without it. But when your built-in meter plays sick, it's a good thing to have an *extra* on your trip far from home. Besides, it will enable you to get the most accurate, and the most creative, exposures

NARROW FIELD EXPOSURE METER

The unusual thing about this *Minolta Auto-Spot 1°* meter is that it reads a reflected light acceptance angle of only 1 degree in an 8 degree field (when you want to get *accurate* exposure of a *small* segment of the subject). CdS battery-powered, built-in reflex viewfinder, battery check, automatic power-driven illuminated scales, full focusing; accepts neutral density filter to control the intensity of the light. See *index* (*filters for intense light*).

you've ever had, especially when you are shooting in *color*, where readings of the highlight and shadow values are critical and decisive.

Incidentally, *Eliot Porter*, who has made some of the most exquisite color photographs of our national parks for the books of the *Sierra Club*, and for *Audubon* (the incredibly beautiful magazine of the *National Audubon Society*), makes *highlight* and *shadow* readings with a *Weston* meter, which he uses like a *spot* meter. If the scene's contrast is too great for the film to record, he concentrates on detail in the *highlights* and *middle tones*, and lets the shadows fall where they will.

EXPOSURE TABLES

For outdoor use, the printed exposure tables supplied for the film you are using are a fairly reliable makeshift if you do not have a meter or if you have forgotten to take it with you. Exposure tables are only about 50 per cent accurate, but a little study of light conditions, and considerable practice, can make them very valuable tools indeed. Here is a simplified exposure table that has been found helpful by many:

OUTDOOR EXPOSURE TABLE

Subject: half light and half shadow
From 10 A.M. to 2 P.M. (ASA 32 film)
Set camera at 1/50

June	0	Brilliant sun
Apr., May, July, Aug.	1	Soft sunlight
Mar., Sept.	2	Hazy
Feb., Oct.	3	Dull
Nov., Dec., Jan.	4	Overcast

Deduct sum of both factors from 11. Subtract 1 hour for *each* hour before 10 A.M. and after 2 P.M. Result will be *f/* number.

This can be inked in on the reverse side of a regular business card and kept with you at all times. Here's how it works. Suppose you are using Panatomic X (ASA 32) on a *soft sunlit* day in *September*. You add 1 and 2 and deduct the sum from 11. The result is 8, therefore you set the shutter at 1/50 as suggested, and the aperture at *f/8*. If the film you're using has a rating of ASA 64–100, set shutter at 1/100–1/125.

The following exposure table for indoor pictures is worked out for medium-speed pan film of ASA 125 (like Plus X, Ilford FP4, GAF Versapan or Anscopan) and use of two photoflood lamps in reflectors. When using Panatomic X, H & W/VTE Pan, Isopan F, or Ilford Pan F, double the exposure.

INDOOR EXPOSURE TABLE

DISTANCE LAMPS TO SUBJECT	STOP OR DIAPHRAGM OPENING	EXPOSURE IN SECONDS	
		NO. 1 PHOTO-FLOOD LAMPS WITHOUT ADAPTER	NO. 2 PHOTO-FLOOD LAMPS WITH ADAPTER
4 feet	f/4.5	1/50	1/100
"	f/6.3	1/25	1/50
"	f/11	1/10	1/25
"	f/16	1/5	1/10
6 feet	f/4.5	1/25	1/50
"	f/6.3	1/10	1/25
"	f/11	1/5	1/10
"	f/16	1/2	1/5
10 feet	f/4.5	1/10	1/25
"	f/6.3	1/5	1/10
"	f/11	1/2	1/5
"	f/16	1	1/2

This table is for portraits and light-colored interiors. For dark-colored interiors without people, double the above exposures. For instance, if 1/10 second is given, using 1/5 second will double the exposure time.

Doubling the number of lamps will halve the exposure.

When the lamps are used for general illumination to make a picture of a room, use stop f/16 to get sufficient depth of field or range of sharpness.

With box, or simple 126 cartridge cameras, use the largest stop opening and use the exposures shown above for f/16 or f/11.

The camera should be placed on a tripod or other firm support for shutter speeds slower than 1/100 second. In emergencies, and provided you have a firm grip, you can use a slower speed (1/50, or even 1/25) but *it is dangerous, so try to avoid it.*

A TABLE OF RELATIVE LIGHT VALUES

With the gracious permission of the editor responsible, Henry M. Lester, and of the publisher, we are able to reprint here the complete table of relative values of lens stops which appeared in the 1939 edition of *The Photo-Lab-Index,* published by Morgan & Morgan. This table, as Mr. Lester points out, answers more than 324 questions which usually require a slide rule or elaborate calculations. The factors given in the table are similar to those you met in the chapter "The Mystery of 'f,'" and they can be used in the same way.

A TABLE OF RELATIVE f/ VALUES

LENS STOP f:	1.5	2.0	2.8	3.2	3.5	4	4.5	5.6	6.3	8	9	11	12.7	16	18	22	25	32
LENS STOP f: / f²	2.25	4	7.5	10	12	16	20	31	40	64	81	121	160	256	324	484	625	1024
1.5	1	2	3	4	5	7	9	14	18	28	36	54	71	114	144	215	280	455
2.0	.5	1	2	2.5	3	4	5	8	10	16	20	30	40	64	81	121	156	256
2.8	.3	.5	1	1.3	1.6	2	2.7	4	5.3	8.5	11	16	21	34	43	65	83	137
3.2	.22	.4	.75	1	1.2	1.6	2	3	4	6.5	8	12	16	26	32	48	62	102
3.5	.2	.33	.6	.83	1	1.3	1.7	2.6	3.3	5.5	7	10	13	21	27	40	52	85
4	.14	.25	.5	.6	.75	1	1.2	2	2.5	4	5	7.5	10	16	20	30	39	64
4.5	.11	.2	.37	.5	.6	.8	1	1.5	2	3	4	6	8	13	16	24	32	51
5.6	.07	.13	.25	.3	.4	.5	.7	1	1.3	2	2.5	4	5	8	10	16	20	32
6.3	.06	.1	.2	.25	.3	.4	.5	.8	1	1.6	2	3	4	6.5	8	12	16	25
8	.04	.06	.12	.16	.2	.25	.3	.5	.6	1	1.3	2	2.5	4	5	7.5	10	16
9	.03	.05	.1	.12	.15	.2	.25	.4	.5	.8	1	1.5	2	3	4	6	8	13
11	.019	.033	.06	.08	.1	.13	.16	.25	.3	.5	.7	1	1.3	2	2.7	4	5	8.5
12.7	.014	.025	.05	.06	.08	.1	.12	.2	.25	.4	.5	.75	1	1.6	2	3	4	6.4
16	.009	.016	.03	.04	.05	.06	.08	.12	.16	.25	.3	.5	.6	1	1.3	2	2.5	4
18	.007	.012	.023	.03	.037	.05	.06	.1	.12	.2	.25	.4	.5	.8	1	1.5	2	3
22	.005	.008	.015	.02	.025	.033	.04	.06	.08	.13	.17	.25	.3	.5	.7	1	1.3	2
25	.004	.006	.012	.016	.02	.025	.03	.05	.06	.1	.13	.2	.25	.4	.5	.8	1	1.6
32	.002	.004	.007	.01	.012	.016	.02	.03	.04	.06	.08	.12	.16	.25	.3	.5	.6	1

Reprinted from The Photo-Lab-Index, Copyright 1939—Morgan & Morgan.

Directions. The lens apertures (*f*/stops) are shown in two places—horizontally across the top, and also vertically at the extreme left. Directly below the horizontal row of lens stops, and set in *italics*, you will find their respective squares (rounded off for convenience).

The relation of any two lens stops will be found at the intersection of the horizontal and vertical rows identified by their *f* numbers. Thus to find out how much more exposure is needed when we stop down from *f*/4 to, say, *f*/22, just find *f*/4 in the left column and *f*/22 in the top row. Where these two rows join you'll find the number 30. That's your *relative light factor.* It means that you need 30 times as much exposure at *f*/22 as at *f*/4, or 30 times as much light. It also means, of course, that a lens at *f*/4 transmits 30 times as much light as at *f*/22.

If you already know the correct exposure, which, say, is 1/100 of a second at *f*/3.5, and you want to convert this to *f*/22, there are two methods, both simple, by which you can do this:

1. Find *f*/3.5 in the left column, *f*/22 at the top and where the two rows cross you'll find the number 40. Multiply your exposure by this factor and you'll get 40/100 or 2/5 of a second.

2. Find *f*/3.5 in the *top* row, follow this down until you are on a row opposite *f*/22 at the extreme left. You'll find the factor .025. Divide 1/100 by .025 and you'll get the same result, 2/5 of a second.

There is still a third way to use the table. Suppose you know the exposure is 1 second at *f*/22, but there's action to be stopped and you need a shutter speed of 1/100 second. Look down the column of lens stops at the extreme left until you reach 22, follow this across *horizontally* until you get to the figure nearest to .01 (1/100 of 1 second). That figure is .008. Now follow this up *vertically* until you reach the top and you'll find that this calls for a lens stop of *f*/2.

Though this table is not absolutely exact mathematically (round figures have been used to make calculations less cumbersome) the ratios nevertheless exceed the limits of accuracy needed for most amateur photography.[2]

THE CAMERA AS ITS OWN METER

In dim light, indoors, neither the photoelectric meter nor any chart or table is much help in calculating the correct exposure. The best

[2] The *Photo-Lab-Index*, by the way, is a *must* for any serious amateur. It is the most comprehensive cyclopedia of photographic facts, tables, formulas and procedures that has ever been compiled. It consists of a new type of waterproof buckram binder that opens flat for easy use, and a series of self-perpetuating, loose-leaf pages, sectioned off by index cards, which are supplemented at regular intervals by additional pages of new and revised material. In its present form it runs to 1624 pages, divided into 24 tab-separated sections. If you are at all serious about your photography, the *Index* is well worth investigating. The new editor is *Ernest M. Pittaro.*

method is the one devised by the oldtime commercial photographers. It is used with any camera that has a ground-glass back (like a view camera or any single-lens reflex). It cannot be used with the twin-lens reflex.

The camera is set up, the picture composed, and then the diaphragm is closed down until details in the shadows disappear. (A black focusing cloth is used to cover head and camera.) The lens aperture is now checked. Then the diaphragm is closed all the way and slowly opened until details in the shadows *just* begin to appear. The lens aperture is checked again. The first and second aperture numbers should be the same; average them if they're not. Using this f/number now, refer to the following table, find the fadeout stop and ASA Exposure Index that

EXPOSURE DETERMINATION BY FADEOUT STOP

FADEOUT STOP	EXPOSURES AT f/16 IN MINUTES						
	ASA 4	8	16	25	32	40	64
f/64	224	112	56	28	14	7	3½
f/45	112	56	28	14	7	3½	1¾
f/32	56	28	14	7	3½	1¾	52″
f/22	28	14	7	3½	1¾	52″	26″
f/16	14	7	3½	1¾	52″	26″	13″
f/11	7	3½	1¾	52″	26″	13″	7″
f/8	3½	1¾	52″	26″	13″	7″	3½″
f/5.6	1¾	52″	26″	13″	7″	3½″	1¾″
f/4	52″	26″	13″	7″	3½″	1¾″	⅞″

apply in your case, and where the respective horizontal and vertical columns cross you'll find a number which will indicate exposure (in *minutes* at f/16, except where marked in *seconds*). To use stops other than f/16, refer to *A Table of Relative f/ Values*, and the directions for use given above.

OUTDOOR EXPOSURES AT NIGHT

Another useful table for estimating exposures under difficult conditions is the one that follows. It is used whenever the light outdoors at night is poor.

NIGHT EXPOSURE IN DIM LIGHTING

STOP	ASA 32	ASA 64	ASA 125	ASA 400
f/4	2 min.	1 min.	½ min.	10 sec.
f/5.6	4 min.	2 min.	1 min.	20 sec.
f/8	8 min.	4 min.	2 min.	40 sec.
f/11	16 min.	8 min.	4 min.	75 sec.
f/16	32 min.	16 min.	8 min.	150 sec.

FACTORS AFFECTING EXPOSURE

Here is a list of some factors, other than basic lighting, which may affect the exposure:

1. *The shutter.* Are its markings accurate? Is it a leaf or focal plane? (The focal plane delivers 30 per cent *more* light. When using monochrome film, this doesn't affect your exposure too much. But for color, where the exposure is critical, you may want to compensate for it. See *Fig. 5.1.*)

2. *The color of the light.* Morning, afternoon and tungsten light is red and yellowish; noon light is blue. Exposure should be decreased if type C *pan* is used (see section on *The Choice of Film* in this chapter).

3. *Temperature.* When the weather is cold, shutter mechanisms are likely to work more slowly.

4. *Focal length.* Have you allowed for this? The f/marking is accurate only at infinity; at twice the focal length the light is cut by ¼, or the f/stop should be doubled (from f/8 to f/4, which quadruples exposure).

5. *Meter.* Have you tested the film-speed rating for *your* conditions?

6. *Developer.* Some increase shadow detail; others cut it down. *Make tests!*

7. *Color of object.* When using monochrome film, objects colored green or red affect film less than those colored blue and yellow.

8. *Position of camera.* Closeups require more exposure than landscapes. See index.

9. *Subject contrast.* Flat scenes require less exposure than contrasty ones. Photoelectric meters are integrated for an even distribution of light and shade. Where this condition does not hold, adjustment should be made by increasing or decreasing exposure (which, in turn, will decrease or increase contrast). Some modern meters and cameras now offer *spot* reading for specific small segments of the scene. For an overall view with front lighting and an even distribution of dark and light areas, you use an average reading; but for a particular part of the

scene, such as a face, you use the spot reading. Of course, you can do the same with any meter, by coming in close (see *Some Meter Techniques*, #5, on page 190).

10. *Kind of subject.* Seascapes, beach scenes and distant landscapes with lots of sky require ½ exposure indicated by the exposure meter; objects with shadows in foreground require 2x exposure; portraits and groups, not in direct sun, require 4x exposure; against the sun pictures require 4x exposure. An excellent way of checking the exposure of *against the sun* pictures is to turn around and take a reading of the cast shadow.

USING A METER IN DIM LIGHT

If the reflected light from the object is so weak that a reading cannot be made in the regular way, try one of these supplementary methods of getting a reading:

1. Point the meter *at* the light *from* the subject, and multiply the reading by 30. Use twice the daylight reading in artificial light.

2. Place the meter at the subject position and point it halfway between the camera and the light source. Multiply the reading by 10.

3. Read a *white* surface, like the 90 per cent reflectance side of Kodak's *Neutral Test Card,* and then multiply the reading by 5 for color, and 8 for black and white.

SOME METER TECHNIQUES

There are many ways of using a photoelectric meter. Here are a few suggestions:

1. *Exposing for the darkest object.* Read the shadow or darkest part of the subject and set the "U" position on the dial (Weston) to the measured light value. Every part of the scene, from the darkest object to the brightest high light, will now be correctly exposed; provided, of course, the high lights do not extend beyond the range of the film (128 to 1). This span is shown by the distance between the "U" and "O" positions on the dial, so no calculation is needed to check this point. Simply read the highlight and check to see that it does not exceed the reading at "O."

2. *Exposing for the brightest object.* This method is good for dark subjects, poorly lit interiors, outdoor scenes where the sky is an essential part of the picture. Take a meter reading of the brightest object (the sky if it's outdoors; a white handkerchief or a piece of white paper placed near the brightest object if the object itself isn't bright enough to give a reading). Set the "O" position on the Weston dial to this light value and

THE EXPOSURE CONTROL DIAL OF THE WESTON IV METER

This computer dial is one of the most useful things about the Weston exposure meter. See text for explanation.

read off the aperture and shutter settings. On other meters, this would be equivalent to a dial setting 8x that of the original reading (1600, for instance, instead of the 200 arrow position on the Weston). *See reproduction of the Weston IV dial.*

3. *Exposing for the average.* Take a highlight and a shadow reading and average the two, placing the *arrow* at this measured value. These readings will also indicate, to some extent, the contrast range of your subject.

4. *Exposing for different lenses.* Use the meter at the camera position for the normal lens; behind the camera for a wide-angle lens; in front of the camera for the telephoto lens. The distance, in each case, depends on the lens. The wider-angle the lens, the farther from the scene should your meter be placed; the more telephoto the lens, the closer. The distance is not critical. For a 35mm wide-angle lens or a 90mm telephoto on a Nikon or Leica, the range could be 5 to 10 feet, behind or in front.

5. *When only part of a scene is important,* read that part of it by moving up as close to it as you can so that the meter reads just that portion. Roughly, the distance to the object should equal the diameter of an imaginary circle which encompasses it.

6. *Fatigue.* When exposed to bright light for any considerable time the cell of the exposure meter becomes fatigued (loses sensitivity). It recovers its power when it is kept in the dark for a while, but that's time consuming. To avoid this, *keep the meter in a case* (the ever-ready type is best) and always make sure it's covered when you're not using it. This applies especially to CdS meters which generally have a high fatigue factor, recovering slowly from prolonged exposure to bright light.

7. *Incident light.* Most exposure meters measure only the reflected

light from a scene in order to determine the intensity of illumination. There are disadvantages to this method of approximating exposure. If you're trying to photograph a light object against a dark background, or vice versa, your meter reading will throw your exposure off, unless you make a reading of the object close up, or unless you compensate in some way for the background. Another, and possibly more accurate, method of measuring the light is the incident light method. This measures the light actually falling directly on the subject. To measure incident light, you hold the meter in front of the subject and point it directly at the camera so that it's affected by the same light that falls on the subject. In that way, the meter measures *all* the light, that bouncing off surrounding walls, objects, ceilings, as well as the direct light from the sun, the sky, or any lamps.

There are several meters on the market which can be used to measure incident light as well as reflected light. Among them are the Gossen Luna-Pro (CdS), the Sekonic (Selenium, with rotating photosphere, like the old Norwood or the new Spectra), the Weston V (Selenium), and the Weston Ranger 9 (CdS, with provision for converting its computer dial to the Ansel Adams Zone System calculator).

One of the most interesting meters incorporating this new principle of incident light measurement (actually a variation or adaptation of the old *actinometer* principle) is the Spectra (formerly the Norwood Director). It is available in four models: Candela, Professional, Universal (all with Selenium cells), and the Combi-500, with CdS *and* Selenium cells. It has been adopted by many professional photographers in color work because its measurements are more precise. By means of a spherical light collector called a *photosphere*, this meter is designed especially for reading incident light, rather than reflected light. The swivel-top photosphere is pointed toward the camera instead of at the subject, thus recording exactly the light intensity as it *falls on the subject*. Accessory attachments extend the use of the meter for lighting contrast and brightness-range control. Weston has also made an incident light adapter for its Master Universal meters called the *Invercone*. This consists of an Integrating Cone (and auxiliary multiplier) which snaps into position when the baffle is swung back. This makes it possible to use the Weston for metering *incident* as well as *reflected light*. The Sangamo version of the Invercone (for the Weston IV and V) is larger and rounder, and it does away with the need for an auxiliary multiplier. The baffle can be moved either way, and only the new Invercone has to be put into position. Some reflected light meters use an incident light attachment, a sliding louver, or a screen, which is placed before the meter cell to convert to incident light metering. But they are all used in the same way, pointing the meter from the subject position to the camera.

THE EXPOSURE METER FOR ALL SEASONS

When it's a matter of life-or-death exposure control, and no goofs can be risked because too much is at stake, the photographers in Hollywood depend on the *Spectra* (formerly packaged as the *Norwood Director,* the invention of Major Don Norwood). This rugged and invariably accurate light meter is a joy to use. For one thing, it is an *incident light* meter, which means that you read the actual light *on* the subject, rather than the reflected light *from* the subject. This eliminates the problem of light or dark backgrounds giving you false readings. For another, it has a rotating head which houses the photosphere. This can be used to avoid shadows, or reflections from your own clothes. The movable head also makes it easier to see the reading, no matter what the position of the photosphere (provided it points at the camera lens).

Using the Spectra is very simple. Set the ASA rating, then stand at the subject position (or an equivalent position) and point the photosphere at the camera lens. This solves the worry about reading too much sky. The exposure this gives you is good for monochrome or color. The Photo Research Corporation, which produces the Spectra, is now a division of the Kollmorgen Corp., 3000 N. Hollywood Way, Burbank, California 91502.

8. *Gray card.* The electric exposure meter is more responsive to certain colors than to others. This presents an almost insoluble problem in the response of exposure meters to colored subjects. Professional photographers solve this problem simply by the ingenious use of a neutral gray card about a foot square. They place this card in front of, or near, the

subject to be photographed, and they hold the meter at such a distance (around a foot away is about right) that it reads only the card. Kodak sells four such *Neutral Test Cards* and an instruction sheet for one dollar and a quarter. Each card has a *gray* side with 18 per cent reflectance and a *white* side with 90 per cent reflectance. It is designated as Kodak Publication No. R-27. This 18 per cent gray target is also available as part of the *Kodak Master Darkroom Dataguide* for black and white.

9. *Metering the sky.* One of the most common faults in the use of a meter is tilting it to take in a lot of the sky, instead of *down*, to read the foreground. Hold the meter to get a reading of only that part of the scene you really want to take.

10. The engineers who test exposure meters have found that *for perfect color shots by meter* (and this applies as well to black and white) the following outdoor exposure allowances are advisable: Because the meter will receive more light and will read too high, for scenes where *sand, sky,* or *snow in shade* take up the full frame, open up one stop beyond normal exposure; for full-frame scenes of *sun on snow or water,* open up 2 stops beyond normal exposure. If such scenes take up only half the frame, use ½ of the above exposure allowance; if ¼ the frame, use ¼ the allowance. For example: normal exposure for a beach scene by meter is, say, f/16 at 1/100; half the frame requires ½ stop more, the other half (sun on water) requires 1 stop more. A compromise exposure might be ¾ of a stop more than normal (as, from ASA 25 to 20, or from 64 to 50).

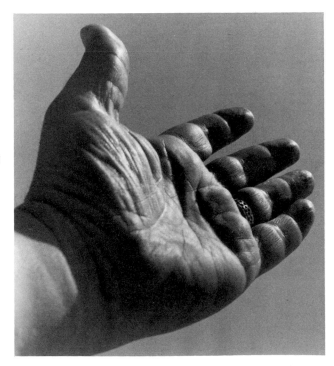

IF A GRAY CARD IS NOT AVAILABLE, use your hand. Your palm reflects about one f/stop more light than the 18 per cent gray card sold by Eastman Kodak. *Caution:* be sure meter reads only your hand, and avoid having shadows interfere. For *sidelighting,* open up one f/stop; for *backlighting,* make sure no stray light is hitting the meter, shoot at the indicated exposure, but make a bracketing second exposure, one stop wider, for insurance.

11. *For best color exposures*, Percy W. Harris, editor of *The Minia-ture Camera Magazine* of London, advocates incident light metering. If such a meter is not available, he recommends the following: Take a reading off a white card placed in the subject position. Measure reading from this card and then give 5 times that exposure (1/20, for example, if the meter says 1/100). For black and white, multiplying factor is 8 (1/12, or as close to that as you can get, instead of 1/100).

OTHER HINTS AND REMINDERS

1. Expose for shadow detail. In case of doubt, overexpose rather than underexpose. If you make several exposures, increase each new one by at least 50 per cent. The eye can't distinguish less of a difference. Besides, a good film will stand about 200 times as much exposure as is needed to produce the first faint veil of silver and still show all tones in correct proportion. Since average scenes are rarely more than 30 to 1, this gives plenty of leeway.

2. The wise photographer always carries a spare exposure meter along as insurance against trouble; preferably one with a *selenium* cell (no battery required).

3. Remember that it is *contrast* between light and shade that makes the picture. Avoid flat lighting. Use shadows to lend interest to the scene, to model it, give it emphasis.

4. Flat lighting requires a short exposure and increased developing time to produce a *normal* negative. If the indicated exposure is 1/50 or 1/60 for example, use 1/100 and increase development by 25 per cent.

5. Use the monotone viewing filter for outdoor as well as indoor photography. Outdoors it will tell you whether the scene is worth taking at all; indoors it will guide you in rearranging your lights to get more luminous shadows, avoid chalky white highlights. (See index, *monotone filter*.)

6. Contrasty subjects, or those that are lighted with harsh, strong light (as in summer sunlight) require slight overexposure and less developing time. If the normal exposure is 1/50 second, use 1/25 or 1/10 and decrease development by 10 to 25 per cent, depending on contrast desired.

7. Expose for weak lighting and for haze as for flat subjects. That is, underexpose a bit and increase the time of development.

8. *Check the speed ratings of your shutter!* You can do this by making a series of tests on an evenly lighted wall, using each shutter speed and adjusting the diaphragm openings to give you matched *thin* exposures (one stop below normal).

9. Do not use a larger or smaller stop than is absolutely necessary. The middle stops are the best for almost any kind of lens; at the larger stops the lens may still have some *uncorrected aberrations*, at the smaller stops it may suffer from *diffraction*.

10. To reduce contrast, make use of the principle of *less light*. All other things being equal, the less light on a subject the less contrast there will be. Consider the case of a white cube on a piece of black velvet. No matter how much light you use, the cube remains white and the velvet, black. Though the velvet cannot be made lighter, the cube *can* be made darker, by *reducing* the amount of light. Outdoors, the same principle applies. We can use haze, clouds, morning and afternoon light.

11. If you use a Weston meter, be sure to send for a copy of *Exposure with the Zone System*, by Minor White (published by Morgan & Morgan, Hastings-on-Hudson, N.Y. 10706). This is a brilliant condensation of the famous Ansel Adams system of "planned photography" (*Basic Photo Series*, Morgan & Morgan).

12. *How to tell whether a negative is underexposed or overexposed.* You can't tell by looking at the print. Examine the negative before a soft or reflected light. If it's *underexposed* it will look pale, with no detail in the light parts. If it's *overexposed* it will look dark, with detail in the dark parts hidden. If the negative is flat but retains all shadow detail, it is *underdeveloped*. If the negative is dense *and* contrasty, it's *overdeveloped* (and probably overexposed as well). Underexposure cannot be remedied; what isn't there, isn't. In case of doubt, overexpose slightly. (Excessive overexposure tends to increase graininess, which will show up in your enlargements, and it may adversely affect sharpness as well.) See 13, below.

A simple test for the perfect negative: Place negative flat on this page. If you can't see the type through the darkest portions, your print will be a "soot and whitewash" mess. Your *gamma* (see page 353) is probably about 1.2 to 1.7, when it should be .6 to .8. Blocked highlights and blank shadows—avoid them!

13. *How to overexpose and underdevelop.* When you're told to give ample exposure and brief development, do this: First divide the normal developing time by 2 (half is needed to register all the picture on the film, the balance is needed to build up contrast). Take half the developing time and multiply it by the reciprocal of the exposure increase ($\frac{1}{2}$ for 2x, $\frac{1}{3}$ for 3x, $\frac{1}{4}$ for 4x). Add this sum to half the normal developing time, and that will give you the new developing time. For example: suppose the regular developing time is 20 minutes and the film was overexposed 2x. Add to 20/2, or 10, $\frac{1}{2}$ of 10, or 5. The new developing time is 15 minutes. Similarly, 15 minutes normal developing time for 3x overexposure = 10 minutes new developing time.

14. *Mixing daylight and tungsten by meter*. To get meter reading for mixture of daylight and lamplight, use the following formula: $A / B \times D + (B - A) / B \times T$ = combination light speed. A = daylight; B = total light; D = daylight film value; $B - A$ = lamplight; T = tungsten value.

15. *Correcting exposure for bellows extension*. The formula is A^2/B^2 = correction factor (multiply exposure by this number). A is the bellows extension in use; B, the bellows extension for infinity. If a 6-inch lens, for example, is extended to 9 inches, we divide 81 by 36 to get 2¼. We then multiply the exposure by 2¼.

16. *Effective aperture*. Here's a simple way to *adjust exposure to bellows extension* (in copying) by using the dial of a Weston meter as your calculator. See reproduction of *Weston Master IV* above. Let's assume you have a 6 inch (150 cc) lens, are photographing a flower in bright sunlight, and have racked out your lens so that the *bellows extension* from film plane to lens is now 9 inches. This is what you do: 1. Set your emulsion speed (in this case, ASA 32). 2. Take a reading (200). 3. Set the arrow at that reading (see dial), but note where the f/number equivalent to the 6 inch lens size falls (between the 1/125 and 1/150 blocks). 4. Now set the f/number corresponding to the bellows extension (9 inches) at the point previously noted for the lens (6 inches). This will place the 9 where the 6 had previously been set (between the 1/125 and 1/150 blocks), and it will line up your f numbers (*diaphragm settings*) and your *shutter speeds*. 5. Now read off the combination you want, set, and shoot. What you've done is to work a slide-rule short-cut to your effective aperture.

17. *Outdoor color pictures* are usually improved by the use of supplementary flash to lighten (soften) shadow detail. This reduces contrast and enables narrow-range of film to get all of the picture. For bright sunlight, with front or side lighting, and the shutter set at 1/50 of a second, the following lens openings are recommended: for Kodachrome II, daylight type, between $f/5.6$ and $f/8$; for Ektachrome X, daylight type, between $f/8$ and $f/11$; for Kodacolor X, $f/11$. This presupposes the use of one No. 5B photoflash lamp at 8 feet or one No. 22B photoflash lamp at 12 feet. Adjustments in lens opening will have to be made if the distance from lamp to subject is changed. Beyond 12 feet, additional lamps are needed to reduce contrast. Electronic flash is better, but since units vary in power and reflectors vary in throw, testing is necessary.

18. *For taking sunsets in color*, on daylight Kodachrome II, best results for both sky and sun are produced by ignoring foreground landscape as well as sun and concentrating on the sky brightness. Point the meter at the sky just north or south of the sun (whichever portion is most like the picture you're planning) but be sure to shade the meter so that no direct sunlight hits it. To avoid flare, wait until sun is hidden

by clouds, or place the sun out of lens range by interposing some object in the foreground.

19. *Television screens* can be photographed by using panchromatic film similar to Kodak Tri X Pan or GAF Super Hypan at speeds of 1/5 to 1/10 of a second at $f/3.5$. Don't try to take faster exposures because the picture is composed of lines of light which scan the face of the viewing tube at intervals of 1/30 of a second. Put your camera on a tripod, set it as close to the screen as your camera permits (using bellows extension or a supplementary lens), focus the television set for maximum brilliance and contrast, and shoot as you would for stage shots (when there's a pause in the action). For meter readings of the screen, turn all other room lights off, take your reading, but remember to keep the shutter range between 1/5 and 1/10 of a second, adjusting the lens opening to match the meter reading at those shutter speeds. For *color* television, use Ektacolor S, Agfachrome CT18, or Ektachrome X, but make sure your screen image is tuned perfectly.

20. *If filter factors bother you,* try placing your filter over your meter (provided it's larger than the window). Your meter reading will then be automatically corrected for that filter.

21. *When you don't have a meter.* The exposure for average front-lighted subjects in bright or hazy sun (distinct shadows) is calculated this way. 1/daylight film speed is the shutter speed at $f/10$. For example, with Plus X Pan film the exposure is 1/125 at $f/16$. Also, the fact sheet supplied with boxed film is a good substitute for the light meter, outdoors.

22. *Photography is easily mastered.* The most important problem is *contrast* and its control. The rest can be broadly labeled *composition,* which includes lenses (and where they should be placed), and *timing* (or capturing the decisive moment). Master these three and you've got it. Well, almost.

23. I've always liked Morton Morrison's statement in the *Films and Formats* column of *U.S. Camera* for May 1965: "Photography never ceases to keep us alert to change. Just when we are all set in our ways, our methods, our materials, our cameras, along comes a major upheaval."

24. *Don't hurry.* All kinds of gremlins are invited when you rush. Take your time. Do things carefully, slowly, thoughtfully.

Don't, for instance, put the wrong sunshade on a wide-angle lens (vignettes, *unwanted*). Don't forget to watch that the film is properly loaded; otherwise 36 blanks. Don't let others push you into missing the *best* pictures because they're in a hurry, or impatient, or bored. Everyone will forgive you if you come back with good pictures; no one will remember that you were a nice guy and didn't keep them waiting.

Don't leave the right equipment home, where it will eat your heart out. Tripods, for example; or the right lenses; or the filters you desperately need.

25. The National Geographic uses 35mm Kodachrome II, Ektachrome X, and HS Ektachrome, and gets 8 x 10 full-color plates that look like contacts! They also use Panatomic X (ASA 32) at the same speed as the Kodachrome (ASA 25, but used at 32), and that way test one against the other. Philippe Halsman, similarly, uses a Polaroid camera to check his lighting for expensive color film. He uses neutral density filters (tones of gray) to match ASA of his Polaroid film to his color film.

26. *Double exposure is easy*, if you insist on taking out an unfinished roll, and "saving it for later." Or, if you shift from black and white to color. It is a nuisance to be stuck with one or the other for a full 36-shot roll. But don't overlook the convenience of not having to load so often. Even the 120-roll film proved such a pain that the new cameras provide for the 220 size, which gives you twice as many pictures for one loading.

The Choice of Film

Why such a variety of films, with so many different ASA exposure indexes? Can't you substitute one for another, with almost duplicate results?

The answer is *no*. One film cannot take the place of another without an advantage or a sacrifice. Panatomic X, for example, cannot be used as an exact replacement for Plus X. Panatomic X is slower, has a much finer grain, and it has greater contrast as well. It is for this reason that Windisch and Beutler concocted their special developers. Also, Panatomic X is a VTE film (it has a *very thin emulsion*), and that produces sharper pictures, greater acutance. You may not be able to see this if you use a Minox and enlarge to 2 x 3 or 3 x 5 inches, but you can be sure that a Leica or Nikon picture blown up to 11 x 14 inches will reveal the differences.

Plus X (ASA 125) is fast enough to be useful indoors and out. *Limitations*? Almost none. In bright sun it can give you an *exposure value* index of 14 or more, which translates to $f/11$ at $1/125$ or $f/8$ at $1/250$. Indoors, it can give you an EVS of 9.5 which converts to $f/4$ and $1/50$, $f/5.6$ and $1/25$ (tripod), or if you have a fast lens, $f/2.8$ and $1/100$. It has a moderately fine grain which is retained when you use the recommended Kodak developer Microdol X, and particularly in the 1:3 dilution suggested by Kodak, which also results in greater acutance (sharpness). Other films of this speed and type: Ilford FP4, GAF 125, and Anscopan All-Weather.

Tri X Pan (ASA 400) is the film for poor light conditions. It has an even grain that does not clump, and therefore does not get in the way of the picture. The photograph by Dominique of the bikini-clad model in Chapter 10 is a good example of this film in action. Many professional and press photographers prefer this film to all others because it is so versatile, and because of its reserve of speed when you need it. The fact that many users of 35mm cameras swear by this film would indicate that it has superlative qualities, even for blowups. Also recommended: Superpan Gafstar and GAF 500 (both ASA 500), and Ilford HP4 (ASA 400).

When you choose a film, select it deliberately to do a particular job: for texture and sharpness, use a film with an ASA rating of 25 or 32; for action, available light, or night photography, pick one that has a reserve of speed, like Tri X.

Don't assume that because *you* can't see the difference between films, there isn't one. Manufacturers never offer two products to do the job of one. As a matter of fact, they are constantly *dropping* otherwise good products because there isn't enough demand for them.

The best all-purpose film is a medium-speed *panchromatic*, also known as *type B*. Such a film is sensitive to all colors (unlike *orthochromatic* film, which is insensitive to spectral red), is balanced in color composition for the reds as well as the blues (which means that it records both as shades of gray instead of as black and white), has an emulsion with inherently fine grain (necessary if you plan to do any enlarging) and good contrast (to match the scene), which means that it neither requires an overlong developing time nor a superfine grain developer. It also has an *anti-halo* backing, to prevent intense light spots in the image from spreading by reflection through the film surfaces. The color sensitivity of this film with a K2 filter (see index, *filters*) exactly matches that of the eye. Good examples of such film are: [3]

SOME TYPE B PANCHROMATIC FILM

	ASA EXPOSURE INDEX
Minox 25 (36 exp.)	25
Panatomic X (35mm, roll, sheet film)	32
Minox 50 (36 exp.)	50
Ilford Pan F (35mm)	50
GAF 125, formerly *Versapan* (35mm)	125
Plus X (35mm, roll film)	125
Verichrome Pan (roll film, 126 cartridge)	125
Ilford FP4 (35mm, roll, sheet film)	125
Fujipan K126 (126 cartridges only)	125

[3] See end of chapter for a complete table of film speeds and developer combinations.

When the light is poor, where a high shutter speed is required, or where tungsten light is used exclusively, ultra-speed films are called for. These are also known as *hyperpanchromatic* or *type C*. Such films have a high sensitivity to blue, and an even higher sensitivity to red. Hence these emulsions render blues and reds too light on the print, while they reproduce yellow-greens and greens too dark. An X1 filter corrects this fault for daylight, while the X2 does the same for tungsten light. Examples are:

SOME TYPE C HYPERPANCHROMATIC FILM

	ASA EXPOSURE INDEX
Neopan (Fuji) SSS (35mm, 120, 127)	200
Superpan Gafstar (35mm, roll, sheet film)	250
Kodak Tri X Pan (35mm, roll, sheet film)	400
Ilford HP4 (35mm, roll, sheet film)	400
GAF 500, formerly Super Hypan (35mm, roll, sheet)	500
Kodak Royal X Pan (roll, filmpack, sheet film)	1250

Where correct color response is not essential, or where it is important to reproduce reds, oranges and yellows quite dark (as in pictures of Yellowstone Park) an *orthochromatic* film should be used. Such a film has a high sensitivity to green (which means that it reproduces landscapes well) but it renders blue skies as white and reds as black. A yellow filter will correct the hypersensitivity to blue, but nothing can be done to relieve the reds.

Orthochromatic film is no longer as popular as it used to be, so most of the roll-films (Verichrome, Plenachrome, etc.) have been discontinued. All that remains, it seems, is Minox with its ASA 12 Ortho in 36-exposure cartridges. However, ortho emulsions will probably always be available in sheet film, with Kodak, GAF, Ilford, and Afga-Gevaert offering a wide selection.

INFRARED FILM

For special effects, for distant scenes where haze interferes, for imitation night scenes taken in bright sunlight, or for dramatic cloud effects and startling landscapes, infrared film is recommended. It has to be used with a dark red (Wratten A) filter, and has an ASA Exposure Index of only 20 (tungsten, with filter), but even so, in bright sunlight, you can get good negatives with an exposure of about $f/3.5$ to $f/5.6$ at 1/25 of a second. On dull days, when the haze is heavy, longer exposures

will be necessary. As this is written, both Eastman and GAF market infrared film in most sizes, but there is no guaranty that they will continue to do so. It can also be used, incidentally, *without* a filter, as an ordinary film. The exposure for an open landscape in summer sunlight in that case would be $f/8$, $1/100$.

Infrared film is processed in exactly the same way as other films. For Eastman film, D 76 (10 minutes at 65° or 7¾ minutes at 70°) or Microdol X (12 minutes at 65° or 9 minutes at 70°) are recommended; it is fixed and washed in the regular way. All infrared film must be processed in total darkness.

To focus accurately on infrared film, the lens must be racked out a bit. Some cameras, like the Leica and the Koni-Omega have provisions for this refocusing.

Another type of infrared film was developed during World War II, as a method of detecting camouflage. It is Kodak's *Aero Ektachrome Infrared*, described as "a false color, reversal film." It has an ASA rating of 100, with the G filter providing the most pleasing colors. It can also be used with the A filter. Exposure in bright sunlight is of the order of $1/100$ of a second at $f/11$. The film is easy to use. Just follow the instructions in the fact sheet. If you want to process it yourself, you will have to use Kodak's E-4 Kit, and follow directions. If you give it to a lab, warn them that it's *Aero Ektachrome Infrared*. Some labs use infrared light in their darkrooms and may ruin your film if they are not cautioned.

TYPES OF FILM

The films listed above are supplied as daylight loading cartridges (for the Leica, Contarex, Canon, Minolta, Konica, Nikon); as 126 cartridges, used in the Instamatic and other cartridge cameras; as roll films on wooden or metal spools with an opaque paper backing (for folding, press, and reflex cameras with adapter backs); as film packs (for Speed Graphic and Graflex type cameras); as sheet films (which, though less expensive, must be loaded into metal holders and special magazines in the dark); and as plates (with the emulsion mounted on glass). Plates are not recommended for amateur use because they are fragile, require different developing and printing outfits, and are not enough better than sheet film in sizes up to 4 x 5 inches to be worth the extra bother. The recommended types are:

35mm—The Paper Leader Daylight Loading Spool.[4] This type does not have to be rewound, does not have a plush-lined slit that acts both as

[4] No longer available here, unfortunately, though Kodak, in 1965, released a 220 film with paper leaders which offers 24 pictures instead of the usual 12 in the 120 size. Many cameras (like the Rolleiflex, Yashica, Hasselblad, and the Koni-Omega) have been redesigned (sometimes with accessory adapters) to accept this new size.

a light trap and a dust trap (which may scratch the emulsion). If you have a Leica, use the film magazines (which you load yourself) in preference to the daylight loading cartridges which come ready packed. Wherever possible, avoid those plush-slit cartridges. Half the scratches found on 35mm film have been traced to this one source alone.

Roll Film—The Metal Spool. If your camera can use either the wood *or* the metal spools, always get the metal ones. The wood type, it has been found, leaves minute particles of wood fiber inside the camera. Eventually these get to the emulsion surface and may ruin a good picture.

Flat Film—2¼ x 3¼ inches and larger—Sheet Film. Though film packs in these sizes are more convenient, the films are thinner and are therefore apt to buckle in the enlarger. Besides, the emulsion on almost all film-pack negatives is scratched because of the way it is handled. Though these scratches are not deep, and may not even be noticed when you make the print, for best results sheet film is better. Once you learn that the emulsion is face up when the identification notch is at the top-right, you will have no trouble loading sheet film. Also, it's much cheaper that way than in filmpack form. The best way to use sheet film is in those neat, automatic film magazines (*Grafmatic Sheet Film Holders*) as supplied for Speed Graphic and Graflex type cameras.

HINTS ON THE USE OF FILM

Choose *one* film and stay with it until you've learned everything it *can* and *can't do*. If you haven't tried the newer *thin* emulsions (Panatomic X and H & W Control VTE Pan (36-exposure, 35mm film), by all means do so before you settle down with any one film. These amazing VTE (very thin emulsion) films will enable you to get the most out of your equipment.

1. The best investment you can make is in the series of film experiments suggested in the testing chapter, "What's Wrong?"

2. Use the *slowest* film you can get away with, for the shutter speeds you require. The slower the film (as a general rule) the finer the grain, the higher the resolving power, the faster the developing time, the sharper the image, the less need for fussy processing.

3. For scenes of great contrast outdoors in sunlight, use type C film (ultra-speed, *hyperpanchromatic*); it picks up more shadow detail, in proportion, than any other film. To photograph similar scenes with slower films, increase exposure about 50 to 100 per cent, and decrease developing time 25 to 30 per cent. A good type C film: *Kodak Tri X Pan.*

4. For portraits of men, use *orthochromatic* film; it gives them "character." For portraits of women, use *panchromatic* film; it gives them smoothness and softness. For portraits of babies, use *ortho* film;

it holds those lovely red and pink skin tones. (Orthochromatic film is available in Minox 36-exposure cartridges at ASA 12, or in sheet film.)

5. For photography of texture use the slow-speed *pans*, like Microfile, Panatomic X, and *Kodak High Contrast Copy* (with *H & W Control Concentrate* developer); see 10 below.

6. For copy work requiring high contrast, use Ilford Micro-Neg Pan, Pergrano, Microfile, or Fine Grain Positive.

7. If film is old and has been kept in a cool, dry place, it will still be good six months or even a year after the expiration date. It will, however, have lost some speed, so give it from a half to a full stop more exposure.

8. Since some fine-grain developers require extra exposure, it is better practice to use a slower film and develop in a normal developer.

9. To compensate for the color variation in sunlight from sunrise to sunset, reduce your film speed by ⅓ before 10 and after 2, and by ½ before 9 and after 4. A simpler method, preferred by some, is to use the film's *tungsten* rating at the beginning and end of the day.

10. For brilliant, grainless, continuous-tone negatives with high contrast film, try the amazing combination of *Kodak High Contrast Copy* film with *H & W Control Concentrate* developer. It is unlike anything you have ever used before. The combination has an ASA exposure index of 25. The concentrate can be bought directly from the H & W Company, Box 332, St. Johnsbury, Vermont 05819. And while you're at it, be sure to try the *H & W Control VTE* Pan film. It has an exposure index of 80. (Many feel this index is too high. My own tests have shown that it is. Try ASA 50, and bracket your exposures.)

Incidentally, the H & W stands for *Harold Holden* and *Arnold Weichert,* who deserve an award for their work in this field.

See description and photograph illustrating H & W Control technique in Chapter 13 ("Developers and Developing").

FOREIGN FILMS

Travel may be broadening, but it can also be frustrating—especially if you get used to one American film and then find yourself abroad without a continuing supply of this favorite emulsion. Here are some pointers on what to buy when your regular supply of film has been used up and you can't get any more, or when the excessive duty makes it wiser to use whatever you can get.

You can find good film almost anywhere in Europe, but you have to know your way around among the unfamiliar brands. Stay with such brands as Ilford, Kodak, Agfa-Gevaert, Perutz (sold only under private brand labels), Sakura, and Fuji.

SOME RECOMMENDED FILM-DEVELOPER COMBINATIONS

*Small roll-film tanks; agitation 5 seconds every minute; * 68° F.*

FILM	ASA **	DEVELOPER	MINUTES
Plus X (35, roll)	125/80	Neofin Blue [c]	24
Plus X (35, roll)	125/80	Microdol	11–13
Plus X (35, roll)	125–160D	D 76	10–12
Plus X (35, roll)	125–160D	D 23	12–13
Plus X (35, roll)	80–100D	Clayton P 60	10–12
Plus X (35, roll)	125–160D	Promicrol	7–10
Plus X (35, roll)	160–200T	D 23	12–13
Plus X (35, roll)	200–250T	D 76	12
Plus X (35, roll)	320–400D	Promicrol	12–14
Plus X (35, roll)	320–400D	Microphen	13–16
Plus X (35, roll)	320	Acufine	4
Plus X Pan (roll)	800	Diafine (2 bath) [e]	2A/2B
Plus X (35, roll)	160	X 22	9–13
Kodak High Contrast Copy	25	H & W Control Concentrate	12–16
H & W Control VTE Pan	50–80D	H & W Control Concentrate	12–16
Ilford Pan F (35)	50/32	D 76	8–9
Ilford Pan F (35)	50/32	Promicrol	7–9
Ilford Pan F (35)	50/32	P 60	6–8
Ilford Pan F (35)	50/32	Neofin Blue [c]	12–18
Ilford Pan F (35)	50/32	Minicol	6–8
Ilford Pan F (35)	50/32	Microdol X	8–10
Ilford HP 4 (35, roll, sheet)	400/300	Microdol X	11–13
Tri X (roll, 35)	400/320	Microdol X	12
Tri X (roll, 35)	400/320 [b]	D 76	8–9
Tri X (roll, 35)	650–800	Promicrol	10–15
Tri X (roll, 35)	650–800	Microphen	12–15
Tri X (roll, 35)	400–500	D 23	12–13
Tri X (roll, 35)	400–500	Clayton P 60	12–13
Tri X (pack, roll) Prof.	320/200	D 76	8–10
Tri X (pack, roll) Prof.	320/200	Microdol X	12
Verichrome Pan (R)	125/100 [b]	D 76	10–12
Verichrome Pan (R)	125/100	Microdol X	12
Verichrome Pan (R)	125/100	Versatol (1:15)	9
Verichrome Pan (R)	150/125	Neofin Blue [c]	20
Verichrome Pan (pack)	125/100	D 76	12
Verichrome Pan (pack)	125/100	Microdol X	12
Verichrome Pan (pack)	125/100	Versatol (1:15)	10
Panatomic X (35)	64/50 [i]	Neofin Blue [c]	12
Panatomic X (35)	32/25	Microdol X	6
Panatomic X (35)	32/25	D 76 (dilute 1:1)	8½
Panatomic X (R)	32/25 [b]	D 76	7
Panatomic X (R)	32/25	P 60	5
Royal X Pan (sheet, roll film)	800/650	DK 50	6–8

FILM	ASA **	DEVELOPER	MINUTES
Tri X (sheet film)	320/200	DK 50	7
Panatomic X (35)	50–64	X-22 [d]	6–10
Ilford Pan F (35)	50–64	X-22 [d]	9–13
Plus X Pan (35, roll, pack)	160	X-22 [d]	9–13
Panatomic X	32	D 25 (77° F.)	12–15
Plus X Pan	125	D 25 (77° F.)	13–16
Tri X	2400	Diafine (2 bath) [e]	2A/2B
Panatomic X	250	Diafine (2 bath) [e]	2A/2B
Ilford HP 4	1000	Diafine (2 bath) [e]	2A/2B
Ilford FP 4	800 [a]	Diafine (2 bath) [e]	2A/2B
Tri X (35)	1200	Acufine [f]	4¼
Panatomic X (35)	100	Acufine [f]	2¼
Ansco Hypan (35)	1000	Acufine [f]	7¾
Tri X (roll)	1200	Acufine [f]	6½
Royal X Pan (roll)	3000	Acufine [f]	11
Perutz Peromnia 21 (roll)	320	Acufine [f]	4½
Verichrome Pan (roll)	250	Acufine [f]	5
Most films (35, roll, pack) @ ASA		HC-110 [g]	3–8
Ilford Pan F (35)	50/40	FX 18 stock	6½
Ilford FP 4 (35, roll)	125/100 [a]	FX 18 stock	8
Ilford HP 4 (35, roll)	400/320	FX 18 stock	7½
Ilford Pan F (35)	50/40	FX 18 [h] 1:1 Dil.	9
Ilford FP 4 (35, roll)	125/100	FX 18 [h] 1:1 Dil.	11
Kodak Panatomic X (35)	40	FX 18 stock	5½
Kodak Panatomic X	40	FX 18 [h] 1:1 Dil.	8
Kodak Plus X Pan (35)	160	FX 18 stock	6
Kodak Plus X Pan (35)	160	FX 18 [h] 1:1 Dil.	9
Kodak Tri X Pan (35)	400	FX 18 stock	8
Kodak Tri X Pan (35)	400	FX 18 [h] 1:1 Dil.	10
Kodak Panatomic X (roll)	40	FX 18 stock	6
Kodak Panatomic X (roll)	40	FX 18 [h] 1:1 Dil.	9
Kodak Plus X Pan Prof. (roll)	160	FX 18 stock	7½
Kodak Plus X Pan Prof. (roll)	160	FX 18 [h] 1:1 Dil.	11
Kodak Verichrome Pan (roll)	125	FX 18 stock	7½
Kodak Verichrome Pan (roll)	125	FX 18 [h] 1:1 Dil.	11
Kodak Tri X Pan & Prof. (roll)	400	FX 18 stock	8
Kodak Tri X Pan & Prof. (roll)	400	FX 18 [h] 1:1 Dil.	12

* Except Plus X, Panatomic X, Verichrome Pan, and Tri X, which should be agitated 5 seconds every 30 seconds.

** These emulsion speeds are not always those suggested by the manufacturer. In some cases they make use of the safety factor provided in the original ASA rating (usually 2½x; in others, they recognize the emulsion speed increase produced by the developer. The times given are for *normal* contrast.

[a] Read shadow detail, agitate 10 seconds each minute, develop at 70° F.

[b] Fritz Henle suggests increasing this ASA rating to improve quality.

[c] Neofin was originally called *Neodyn.*

[d] Dilute according to manufacturer's instructions; agitate 10 seconds each minute.

[e] Follow manufacturer's instructions. Drain between baths, but do not rinse. 2A/2B means two minuts in solution A; two minutes in solution B.

[f] Can be used at a dilution of 1:1 by doubling the developing time. *Recommended.*

[g] Follow directions for *dilution* and time. Send for free Kodak Pamphlet J 13, Customer Service, Eastman Kodak, Rochester, N.Y.

[h] Use once and discard.

[i] Some users get better results with an ASA rating of 100/64.

Just a word of caution: If you buy foreign *color* film, have it processed where you buy it. You may save yourself some heartaches that way. But test the processing by letting them develop *one* roll at first.

NEGATIVE CONTRAST CONTROL

How to get an "ideal" negative with a contrast of 1:30 for normal or No. 2 paper

IF SUBJECT CONTRAST IS	READ HIGH LIGHT BY METER, THEN EXPOSE	AND DEVELOP TO GAMMA
1:500 Architectural interiors; night scenes	3–4 times normal	0.5 Shorten development by 10–25 per cent
1:200 Street scenes; back-lit subjects in daylight	normal	0.7 Normal development
1:30 Open landscape; front-lit architecture	⅓ normal	0.9 Add ⅓ to development time

This table was originally worked out by the Tetenal plant for Neofin and Adox film, based on recommendations by Willi Beutler, inventor of Neofin. It was reprinted, in revised form, by the *Leica News,* and is further revised here for use with other film-developer combinations.

HINTS FOR TRAVELERS

For best results have Kodachrome film processed by a Kodak house, and as soon after exposure as possible. There are five processing laboratories for Kodachrome still film in Europe—but do not have your film mailed across borders if you can help it. International mails are slow and uncertain, and you may lose your film.

If you plan to bring more film into a country than is allowed duty-free, and you expect to visit other countries, have the customs authorities seal up part of your supply in units of 5 or 10 rolls. You will thus avoid paying duty on the unused film, unless you break the seal.

To avoid paying duty at the borders, film should be processed in the country where you buy it. *There is no duty on processed film.*

Before you leave the United States, get a bill of sale, a copy of an insurance policy, or a notarized document, listing all your photographic equipment and supplies. This will come in handy at all borders to prove ownership for import and export.

Film sent to the States for processing should be accompanied by a declaration stating the pictures are for personal, not commercial use; otherwise duty will be imposed.

For information about allowances and duties abroad, get in touch with the nearest Field Service Office of the U.S. Department of Commerce.

Insure your equipment before you start out. The insurance is cheap, but absolutely essential.

Caution: because of the rash of skyjackings and air piracies in 1971 and 1972, security men for airlines and air terminals began to use *X-ray* and *fluoroscope* devices to probe unopened luggage. Such devices can *fog* film badly (whether exposed or not). For that reason, Eastman Kodak suggests you store all your unprocessed film in a carry-on bag which you can offer for *visual* inspection. *Magnetic* detection equipment does not affect film, so you don't have to worry about it.

The Ansel Adams Zone System

Amateur photographers may or may not be deeply religious. But there is one devotion common to all of them.

They pray.

For all sorts of things. For good weather, or luck, or enough film to carry them through the day, or even the secret of getting correct exposure *every* time.

This secret remained hidden until about 1940, when Ansel Adams, superb photographer, persuasive teacher, ingenious craftsman, and compulsive experimenter, got to work on a new photographic technique. It was a technique that eliminated the fumbling and the guessing, and enabled Ansel Adams to *predict* his final results. This method of exposure control became known as the *Zone System*. What it offered was *consistently perfect negatives.*

It would not be sensible to attempt, in short space, a full digest of this ingenious system. Ansel Adams himself has written a series of five books to explain it (*Basic Photo Series*, especially *Camera and Lens*, which has just appeared in a completely revised form). In addition, Minor White has filled two issues of *Aperture* with his analysis of the Zone System, as well as two booklets (*Exposure with the Zone System*, 1956; and *Zone System Manual*, 1961), all published by Morgan & Morgan, 385 Warburton Avenue, Hastings-on-Hudson, N.Y. 10706.

But it is pertinent to say this much. The Zone System is a simple, logical system of previsualized exposure, which makes use of a Weston Master meter (because the computer dial has two things which no other meter has: the A and C blocks separated by an arrow or triangle, which indicate exposures of 1/2, normal, and 2x the meter reading; and most valuable, the U and O blocks, which indicate the *under-* and *over-exposure* points).

The only other thing Ansel Adams uses is a gray scale. Normally, this is a continuous tone strip from black to white (as in the Goldberg Wedge), but he chooses to divide it (because that makes it less cumbersome) into ten sections called zones, each of which is identified by a roman numeral.

With these two tools, Adams makes it possible for any photographer to *see* his picture in terms of tones, and to place those tones accurately *on* the meter, and *in* his mind; and finally, to translate them *to* the print itself.

Essentially, the method involves making a series of meter readings of small areas (zones) of the scene to be photographed, then picking a *middle gray,* and exposing and developing the negative according to a preset standard in order to obtain a print which includes a medium gray tone. The middle gray is the key, since if it is correctly chosen and reproduced, the lighter and darker tones will automatically fall into place, with densities that correspond to the meter readings of the scene.

	SHEET NO.	PLACEMENT OF SUBJECT INTENSITIES ON EXPOSURE SCALE										EXPOSURE RECORD Designed and Copyright by ANSEL ADAMS Morgan & Morgan, Publishers Scarsdale, N.Y.									
	FILM	REL. LENS STOP F/	64	45	32	22	16	11	8	5.6	4	2.8									
	SIZE	REL. EXP. FOR V	1/32	1/16	1/8	1/4	1/2	1	2	4	8	16									
	DATE LOADED	REL. EXP. FOR I	1/2	1	2	4	8	16	32	64	128	256	FILM TYPE OR	LENS		FILTER					
	DATE EXPOSED	WESTON SCALE	–	U	–	–	A	↓	C	–	O	–									
NO.	SUBJECT	ZONES	0	I	II	III	IV	V	VI	VII	VIII	IX	SPEED	F. L.	EXT.	X	NO.	X	STOP	EXP.	DEVELOPMENT
1																					
2																					
3																					
4																					
5																					
6																					
7																					
8																					
9																					
10																					
11																					
12																					
PHOTOGRAPHER:			PLACE:						JOB:										REMARKS OVERLEAF		

The method is not difficult to learn, and other meters besides the Weston can be used (see the *Zone System Manual* by Minor White).

Glen Fishback adapted this system for 35mm photography in *Camera 35* for February/March 1968 in his article, *A Practical Zone System.* Look it up at your library, or get one from the magazine itself (U.S. Camera Pub. Corp., 132 West 31st Street, New York, N.Y. 10001). They may still have back issues when you write. Do the same with the Beaumont Newhall article, *How Ansel Adams Makes an Exposure,* in *Popular Photography* for February 1963.

For the books by Ansel Adams or Minor White, write for information to Morgan & Morgan (at their address, above).

On page 208 you will find a sample sheet from Ansel Adams' *Exposure Record,* which will give you an idea of how *he* keeps his records. You can get these, also, from Morgan & Morgan.

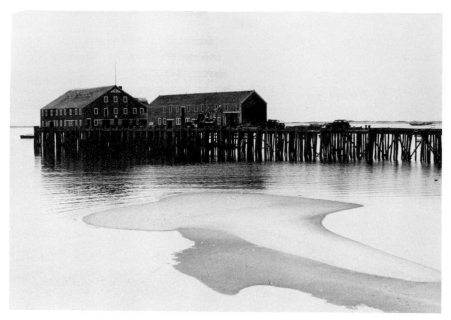

PATTERN ON CAPE COD. Taken with Rolleiflex 2.8 F, Planar lens. Plus X Pan developed in Microdol X.

8 The Picture

Seeing It

There are pictures everywhere. Can you learn to see them, or will you, like Peary's cook, be searching forever for a point of view? The explorer's cook is so perfect a symbol of the unseeing eye, that his story is worth repeating for that reason.

I first heard about him from Ruth Goode and her husband Gerald. It seems that a well-meaning friend stumbled on the cook one day and decided that there was a "marvelous story in the man." He had been with Peary through all of his historic adventures—and his point of view was *so* different; he saw it all against the background of food and hungry men. There was at least a *book* in the man, if not a whole series of magazine articles. And since Ruth and Gerry were "literary people" (they wrote stories and got them published), the friend insisted that they must do something about his "find." Ruth was skeptical (she had once been a book-review editor) but out of courtesy to the friend she invited Peary's cook to visit them at Croton.

He came with what he explained were "all his notes." Ruth and Gerry decided that perhaps they had been wrong about the man, invited him to stay for supper, and then took him out to see the local sights. One of these, of course, was the Croton Reservoir. When they got there, they found some other people looking around. This seemed to trouble the cook very much. No sooner did Ruth or Gerry maneuver him over to one interesting vantage point than the cook noticed some people elsewhere looking at something else, and he had to be taken *there* at once to see what the others were seeing. When he got there, the others had in the meantime moved on; so the cook lost interest in that place, wondered out loud about what the others had seen, and then noticed some people off in the distance pointing at something else. Which meant that Ruth and Gerry had to take him there, too. This kept on until Gerry got bored and Ruth got tired; so they took their guest home.

After supper they started checking through his notes. Have you guessed? Yes, his notes *were* complete. On the day, for instance, that the North Pole was discovered, his records showed that he had prepared and the men had eaten "so many pounds of *this* and so many pounds of *that*." How did the men feel about the discovery, what did they do, what did Peary say? Oh, he wouldn't know about that. *He was just the cook!*

Most of us are "just cooks" when it comes to seeing things around us. We need distant pastures to prove that grass is green; we need far horizons to prove that skylines have beauty; we must travel before we can shake our "picture blindness." But our picture sense *can* be developed, in two ways: (1) by looking at pictures made by others, and (2) by making an imaginative effort to create pictures of our own.

Study Pictures Made by Others

Pore over such fascinating picture collections as *U.S. Camera Annual, Photography Annual, Photography Yearbook, The British Journal of Photography Annual, Modern Photography Annual, Color Photography Annual,* such magazines as *International Photo Technik* of Munich, *Photography* and *Amateur Photographer* of London, *Camera* of Switzerland, *Aperture* of New York, *Foto Magazin* of Munich, *Leica Fotografie* of Wetzlar and *Réalités* of Paris (both available in English editions), *Audubon* (the exquisitely illustrated bi-monthly magazine of the National Audubon Society), and of course those wonderful American magazines *Popular Photography, Modern Photography, Camera 35, National Geographic, Vogue,* and *The New York Times Magazine* supplement.

That's one of the best and easiest ways of improving your own picture sense, and you can do it at home. As you look at each picture try to visualize where the photographer stood, where the light came from,

how the picture would have changed if either the camera position or light angle had been altered. Only by making a definite effort to visualize such changes can you learn how to take better pictures yourself. And don't restrict your "poring" to the editorial pages. Remember that the *advertising* pages feature what is undoubtedly the best photography in the world.

Your Own Library of Great Pictures

Start a scrapbook library of good photography. You can clip the photographs out of the magazines. I have about two dozen glassine-paged scrapbooks, about 10 x 12 inches in size, filled with some of the finest photographs I have ever seen (in color and monochrome). These scrapbooks are better than any course in photography—and they become more valuable as the library gets older and larger. Starting this library years ago was one of the smartest things I ever did. I refer to it constantly, for inspiration as well as pleasure. And I weed out pictures I have outgrown, replacing them with others that are better or offer more ingenious solutions of similar problems. Flipping through the pages of these scrapbooks is always a stimulating experience. One sometimes forgets how good modern photography can be; these scrapbooks help me to remember.

IMAGINE OBJECTS AS PICTURES

Let your mind create the picture before the camera does. Learn to see every object around you as part of a picture. Place it and light it (in your mind) to best advantage. This exercise in picture control will help you recognize the right conditions when you meet them. It is the most valuable practice you can get as a photographer. And don't worry about whether or not the picture is technically or artistically possible. After you've snapped a couple of dozen *impossible* shots you'll begin to recognize the possible ones on sight. The important thing is to get the practice, mentally and actually. In other words, the best way to learn to take pictures is to take them.

A FAVORITE PLACE

You do not have to travel thousands of miles to find scenes worth photographing. Your own street, your house or country place, the park near you—all lend themselves to the making of an interesting series of pictures. One good way to do this is to take a familiar scene under all

The Cloisters, north, from a courtyard. Outside the Cloisters looking south.

At the Cloisters. The Chapter House
from Notre-Dame-De-Pontaut.

Arcade facing the garden
court of the Cuxa Cloister.

THE CHALICE OF ANTIOCH. Discovered in 1910 by Arabs digging a well near Antioch. Some believe that this is the Holy Grail used at the Last Supper. It is only one of several chalices to be found at the Cloisters.

Garden court of the Bonnefont Cloister.

Arcade and courtyard of the Cuxa Cloister.

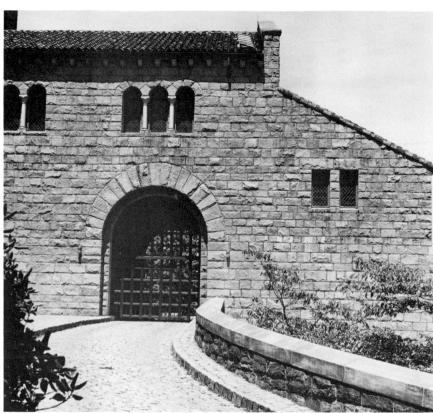

The Cloisters. A back view.

The cobblestone driveway leading to the Froville
Arcade and the gateway at the Cloisters.

A DIFFICULT SHOT AT THE CLOISTERS. The range of tones runs from bright sunlight to deep shadow. The trick was to overexpose by one stop and underdevelop by about a fifth of the time. Rolleiflex, Plus X Pan, Microdol X.

A closeup of the gateway at the Cloisters.

sorts of conditions: summer, autumn, winter, spring, morning, noon, night, in bright sun, on cloudy days, during rain. I took such a set of the Bryant Park side of the Public Library in New York. I did the same thing with the lions in front. I have also taken hundreds of pictures of Central Park. But my favorite place, at any time of the year, indoors and out: the Cloisters at Fort Tryon Park in Manhattan. Above are some pictures of this lovely place.

HOW TO RECOGNIZE A PICTURE

Almost anything which makes you want to stop and look has the makings of a picture. It may be the representation of a person, a place, or an object. Whether it's a good picture or a bad one depends, of course, on what you do with it. The secret of most successful pictures is *simplicity*— the shearing away of everything that does not help the mood or idea you're trying to convey. We'll go into this, later, when we take up *the arrangement* of the picture. The difference between a *snapshot* and a *picture* is that one is of interest only to ourselves, as a simple record of experience, while the other serves to recreate in others the feeling or sensation we had when we took it. In other words, the snapshot is *personal;* the picture, *universal.*

Here are some other types of photographs that have good picture quality:

1. *Closeup.* The power of a good lens to record detail is nowhere so evident as in a closeup. The threading of a needle, a jeweler repairing a clock, the iris of an eye—all these are fine subjects for closeups. This one of some leaves and fungus was taken with a Koni-Omega Rapid M.

2. *Odd angle.* This photograph of the railroad tracks adjoining Freedom Road on 70th Street in Manhattan was taken from the 29th floor. The angle, and the bird's-eye view, helped create the picture.

3. *Pattern.* The most familiar example of this type of picture is the country fence photographed when the shadows are long. This one was taken at the Queens Botanical Garden in New York City.

4. *Texture.* The surfaces of objects are always fascinating if properly lighted. Our illustration shows the effect of sunlight on an old barn.

5. *Detail.* If you can't make an interesting picture of the whole scene or object, let a part of it symbolize the rest. Here we show a waterfront scene on one of the wharves in Provincetown at Cape Cod.

6. *Humor.* Genuinely humorous photographs are rare, and opportunities for taking them do not occur often. These three amusing portraits by the Knill Studios of London prove again that an idea (with a wink) is as important as technical skill.

7. *People.* Almost any *unposed* photograph of people doing some-

thing makes a good picture. The two shown here were taken by Paul Michael: the one of a singer at the Bethesda Fountain in Central Park; the other, of two girls at the window of a New York apartment, from across the street. To take unposed pictures of people, whether here or in any of the "forbidden" countries (USSR, Egypt, Arabia, China, etc.) where the natives are suspicious, or where the officials frown on photography, pretend you are taking something or someone else (which you can do with an angled viewfinder, or with a twin-lens camera turned at a 90° angle horizontally). Also, you can focus your camera at a predetermined spot or distance, and snap when your subject, or your camera, reaches it.

8. *Water* is the most prolific source of pictures in the world. This *contre jour* (against the light) scene illustrates one way of avoiding trouble when taking pictures of this kind: arrange everything so that the actual light source, in this case the sun, is hidden by something (here, by the smoke stack).

9. *Mood.* Any arrangement of objects, natural or otherwise, which evokes an emotion or a mood is a good picture. This excellent one by Stephen Sugar certainly caught a mood.

10. *Selective focusing.* This is a simple technique for subduing unwanted backgrounds and for placing emphasis where it belongs. Our illustration shows hows a background can be controlled by throwing it out of focus. Otherwise, the plants in the foreground wouldn't have a chance.

11. *Patience.* One of the best accessories in a photographer's gadget bag is *patience* . . . the ability to wait until the light is just right. Paul Michael's photograph of the Venus of Milos at the Louvre in Paris illustrates this perfectly. He waited two hours for the sun to move into position. The wait paid off.

12. *Stalking a picture.* Here is a photograph of a familiar sight, the lions in front of the Public Library on Fifth Avenue in New York. But it doesn't make much of a picture. Now see what you can do by getting closer and manipulating the light.

13. *Seeing what isn't there.* It's not difficult for a painter to rearrange a scene to please him, but how does a photographer do it? By putting his imagination to work, and by letting his camera skills recreate what is in his mind's eye. Stephen Sugar's photograph, *Silver Frieze,* is a good example of how a photographer with vision can capture what isn't really there.

14. *Frame.* The success of many pictures depends on how they are framed. Though in most cases the background is the picture, it's the foreground that makes it possible. Our photograph of the boardwalk at Jones Beach would have failed without that railing and the wisp of cloud in the upper right.

CLOSEUP of a log and some friends. Taken with a Koni-Omega
Rapid M on Tri X Pan and developed in D76.

ODD ANGLE. This aerial view of the railroad yard between Freedom Road and the Hudson River in Manhattan was taken with a Speed Graphic and Plasmat lens, a 70mm back, and Isopan F developed in Rodinal. The conjunction of the bird's-eye view and the angle helped make the picture.

PATTERN. The most familiar example of this type of picture is the country fence photographed when the shadows are long. Another is the slat-type windbreaker used at some beaches. Our sample is a scene at the Queens Botanical Garden, New York. Taken with a Rolleiflex, Plus X Pan film developed in Acufine, with exposure by Rollei meter at ASA 160.

TEXTURE. The surfaces of objects are often of unusual interest, if properly lighted. The shot above illustrates the effect of sunlight on the side of an old unpainted barn. Rolleicord, at $f/16$, 1/10, Panatomic X, developed in MCM 100.

DETAIL. If you can't make an interesting picture of the whole scene or object, let a small part of it symbolize the rest. Our photograph of a view at Cape Cod illustrates this simple method. Rolleiflex, Plus X 1/25 at f/16 developed in Microdol X.

HUMOR IN PHOTOGRAPHY is a rare commodity,
and always welcome. Here are three amusing portraits
taken on Ilford FP4 roll film by Knill Studios of London.
They prove again that a wink is the most precious
accessory in every photographer's gadget bag.

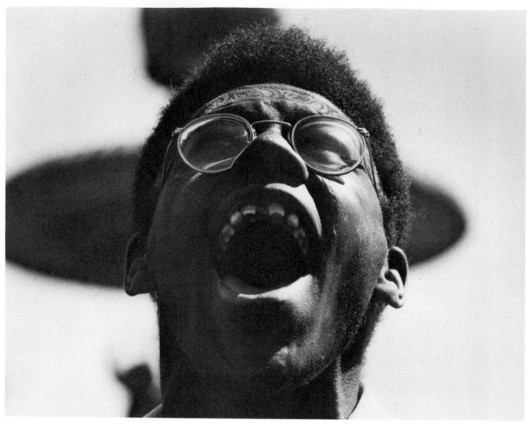

PEOPLE

Almost any *unposed* photograph of people doing something makes a good
picture. Paul Michael shot these two. The one of the singer was made with
a Konica Autoreflex T with Tri X shot at 800 ASA (f/5.6 and 1/1000 of a
second) with a 135mm telephoto lens. Paul Michael explains: "Every
Sunday, hundreds of young people come to the Bethesda Fountain, in
New York's Central Park, to sit, to sing, to talk, to be seen. This young man
sat singing for quite a long time. The fountain in the background was kept
out of focus, by a shallow depth of field, to avoid its looking like a halo."
The picture of the girls at the window was taken from an apartment across
the street. "The problem I had to solve," explains Mr. Michael, "was how
much of the wall to show. I tried it with various lenses (200mm, 135mm,
85mm, and 35mm), cropping the print in various ways. This one, taken
with a Konica Autoreflex T and Tri X, was shot at 800 ASA. The 85mm lens
was set at f/8 and 1/500 of a second."

WATER is the most prolific source of pictures in the world. Whether it's the restless movement of sea waves, or the sleek motion of sailing ships, whether it's a busy harbor scene or a sunlit seascape, a beach and a girl or an *against-the-light* scene like this one, you can always be sure of a picture if you include water. The trick here was to wait until the sun was directly behind the smoke stack. Just enough light spilled around it to throw a long shadow over the water, without blinding the lens. Rolleiflex, Panatomic X developed in D76. Exposure was $f/16$ at $1/100$.

FISHERMAN'S WHARF, CAPE COD. The tiny wriggle of reflected light to the right of center is typical of how *water* can help create a picture. Taken with a Rolleiflex on Plus X Pan film, developed in Microdol X. Enlarged on *Luminos Bromide RD*, a resin-coated instant high-gloss white paper (needs no ferrotyping) that is waterproof and rapid drying. Available in five contrasts. For information, write to Luminos Photo Corporation, 25 Wolffe Street, Yonkers, N.Y. 10705.

MOOD. Any arrangement of objects, natural or otherwise, which evokes an emotion (hate, love, joy, fear) or a mood (nostalgia, wanderlust, reverie) is good for a picture. This one by Stephen Sugar certainly caught a mood. It was taken with a 35mm Nikkormat FTN and a 105mm lens. Tri X Pan at f/16 and 1/250 of a second. The ingenuity of the photographer helped him convert a dull horizontal picture into a fine vertical one. It was cropped severely to eliminate the arch of a tunnel at the top, and then dodged (held back) at bottom to lighten the foreground and bring out the crack in the pavement.

SELECTIVE FOCUSING. You can eliminate troublesome backgrounds and place the emphasis where you want by using the principle of selective focusing. Open the lens to the widest aperture that is convenient, and focus accurately. This illustration shows that a background can be subdued by throwing it out of focus. Otherwise, the plants in the foreground wouldn't have had a chance.

PATIENCE. One of the most important accessories in photography, no matter what kind of a camera you have, is *patience* . . . the ability to wait until the light is just right. Paul Michael is a real photographer; he waits. His photograph of the famous Venus de Milo at the Louvre in Paris is unusual because it proves that a tourist *can* outwit museum lighting, when flash is forbidden. Paul waited *two hours* (from 2:30 to 4:30 p.m.) until the sun moved into the position he wanted. The wait paid off. He used a Konica Autoreflex T, Tri X Pan film shot at 800 ASA (*f*/5.6 and 1/60 of a second).

STALKING A PICTURE. *The Scene:* The lions in front of the Public Library, Fifth Avenue and 42nd Street, New York, as most people view them. A Polaroid shot taken with a 4 x 5 Speed Graphic, a Polaroid back, and type 55 P/N film. Now see what you can do by getting closer and playing with the light.

STALKING A PICTURE. *The Shot:* To get this photograph of the lion against a dark background, you have to wait until the sun has moved west behind the lion. The light then separates the sculpture from its setting. Expose for the sunlit granite. Taken with a Leica M4, 50mm Summicron lens, on Panatomic X developed in Acufine.

SEEING WHAT ISN'T THERE. It's easy enough for a painter to reconstruct a scene, but how does a photographer do it? By putting his imagination to work, and then by letting his camera skills recreate what is in his mind's eye. Stephen Sugar admired how nature had sculpted a dragon out of branches and ice. His abstract, *Silver Frieze*, is a good example of how a photographer with vision can capture what isn't really there. This was taken with a 35mm Nikkormat FTN, using through-the-lens metering.

FRAME. The success of many pictures depends on the way they are framed. Arches, doorways, branches, windows—these are just a few ways to enclose a scene to make a picture. This one of Jones Beach was taken with a Rolleiflex. Plus X film, developed in Microdol X, K2 filter, $f/16$ at $1/100$ speed.

WHEN THERE AREN'T ANY PICTURES

The usual complaint of most amateurs is that there are no pictures around where they happen to be. The pictures, according to them, are where the other fellows are. This is nonsense. There are pictures everywhere. But you've got to open your eyes and look. I was discussing this with a young photographer one Saturday afternoon at Jones Beach and a remark he made led to a bet, the results of which I'll show you in just a moment. He said: "Aw, that's a lot of bunk. How are you going to make a picture out of a sandy waste like this?" I bet him that I could take at least five pictures within twenty-five feet of where we sat. I took a set of five. Turn to pages 236–237 where four of the pictures are reproduced; I don't claim that these are works of art. They're far from that. But they *are* pictures, and he saw absolutely none.

Arranging It

The planning and placing of the various parts of a picture in such a way that they satisfy the eye is the function of *composition*. Some amateurs think they don't have to worry about this; but what they get instead is *bad composition*. While a picture may accidentally happen to be well composed though the photographer has given its composition no thought at all, it is dangerous (provided, of course, you care about the impression your picture makes on others) to let things take their course in that way.

The rules of composition are the *fruit* of all the good pictures that have ever been created. In other words, the pictures came first and then the rules were devised to explain why the pictures were good to look at. If we once realize this simple fact we can use the rules without getting hurt, or without tying ourselves up in knots. One of the rules, for instance, says that we must never place the main object of interest in the dead center of the picture space. It's a good rule most of the time. But there are many exceptions. Some photographers, trying to avoid the dead center, end up with a lot of weird, psychedelic, pseudo-artistic, off-balance shots. As you gain experience and confidence, you will learn when and how to depart from the rules. But first, learn to follow them. Once you have mastered the rules, you can go your own way without fear that you may be designing something freaky. That is where your creative instincts will come into play.

A PICTURE OF WHAT?

A large proportion of the photographs taken by amateurs fail because they forget one thing. That thing is expressed in the question

WHERE THERE AREN'T ANY PICTURES. The four in this series were all taken, incidentally, with the Contax and Sonnar $f/1.5$ at $f/8$ to $f/11$, 1/125 to 1/250 with a light green filter.

AN EXERCISE IN COMPOSITION. *Above:* The scene as I first saw it. Interesting, but confused; little to capture and hold the eye; everything fighting for attention. *Below:* The same scene after it had been studied and composed. Nothing was moved except the camera. White boat eliminated entirely; foreground boat enlarged by moving camera closer. Everything else remained the same.

above. Every picture, if it really be one, must be a representation of *something*. Does this sound too simple and elementary? Does it seem too obvious to be worth mentioning? It's nothing of the kind! The *something* may be an *egg* or a *crowd*, a *boy* or a *box;* it may even be an abstract like *jealousy*, or *romance*, or *power*. The subject doesn't matter. What *is* important, though, is that the picture has to show that thing, whether it's an idea, an object, or an emotion. If it's power you're trying to express, don't clutter up the picture with fine samples of *texture* which steal the show and make you forget all about the idea of power. If it's *boy* you're showing, make sure that the things in back of him aren't more attractive, larger, clearer.

KEEP IT SIMPLE

No picture should have more than one subject. If it's *tree* you want to show, be sure that it doesn't unintentionally become *landscape with heavy clouds and little barn plus tree*. If it's *dog* you want to show, be sure it doesn't turn out to be *two people talking, with dog on leash held by man*.

GET CLOSER

The difference between a picture and a snapshot is often no more than the distance between the camera and the object. See our photographs of the lions in front of the Public Library in *Stalking a Picture*, earlier in this chapter.

EXPOSURE FOR PORTRAITS

To get an accurate meter reading of the highlights on the face, place a white card in front of the face and read that. Set the "O" position (on the Weston meter) to the high-light reading and use the exposure indicated. This will give you the minimum correct exposure for portraits.

FIND THE BEST ANGLE

The position from which you see a thing is often as important as the thing itself. A reflex camera, twin-lens or single-lens, is a great help when you start to hunt for the best vantage point. The ground-glass image gives you a sense of picture reality.

BALANCE

Large and small objects can be balanced in a picture by use of the principle of the fulcrum. A large object in the foreground, for instance,

can be balanced by a small object in the distance, just as a see-saw can be evened up if two children of unequal weights are so placed that the heavier child is nearer the fulcrum, and the lighter child is moved further out. In perspective this balancing is simple, since it means that the heavier objects are placed nearer the viewer and the lighter objects farther away. At other times it must be remembered that the nearer an object is to the picture edge, the more weight it carries; thus a comparatively small object near the right or left edge can balance quite a large object near the center. Other important factors are the color and shade of the objects. A large, white object can be unbalanced by a red or black one, for example.

LINE

Every line in a picture has a special meaning. *Straight lines*, for instance, suggest solidity, strength, vigor; *curved lines* suggest beauty, softness, grace. Every good picture contains a blend of both straight and curved lines, with one definitely predominating. *Vertical lines* suggest power, hope, courage; *horizontal lines* suggest quietude, balance, rest. *Diagonal lines* suggest speed, motion, activity. *Zigzag lines* are the most active; *S-shaped curves* the most graceful. Two lines *crossing* each other suggest violent action; two lines running parallel to each other (one repeating the pattern of the other) suggest sympathy, understanding, acceptance. Such lines are often used to emphasize the main line form.

OUTWITTING A TRAVEL GUIDE

This is the record of a misadventure. I went to Taxco, Mexico, to take some pictures, but my wife and I fell into the hands of an over-zealous driver-guide whose mission in life seemed to be to drag us to every shop in town, so that we would buy, *buy*, BUY! We got so tired of this super-salesman, and his scheming maneuvers to outwit my picture-taking, that I finally arranged not to be picked up until ten the next morning. But at eight I was out with my two Leicas (one loaded with Kodachrome II, the other with Adox KB 17, which is no longer available here). I walked up and down that town, free of the elbow-nudging pest of a driver. Since I knew I would probably never come back to Taxco, I shot three rolls of 36-exposure monochrome, and two rolls of Kodachrome II, and lost only two shots. Normally, if I am not in the grip of one of these monster guides, I take about three to six pictures of any *special* scene, bracketing the exposures. I like the Leica for color, and the Rolleiflex with the $f/2.8$ Planar lens for monochrome (because of

ZIGZAG LINES (see text: *Line*). This photograph of a scene in Taxco,
Mexico, illustrates the importance of *line* in the composition of your picture.
Burt Martinson took this with his Ikoflex II on Panatomic film developed
in D76 at ƒ/22 and 1/50 of a second. He used a K2 filter.

CONTACT SHEET. A roll of 35mm film taken in Taxco, Mexico. Leica M4,
50mm Summicron *f*/2, Adox KB17 developed in Neofin Blue (see text).

A cobblestoned street in Taxco (see text and contact sheet).

the larger negative); though I have frequently, as in this case, taken just one Leica and its complement of lenses for color, and an extra body for monochrome. Life becomes simpler that way.

Here, also, is one enlargement of a cobblestone street in Taxco; it is negative #14 on the contact sheet.

A FEW HINTS ON COMPOSITION

Here are a few *do's* and *don'ts* culled from the words of the masters, the men and women whose work has consistently "crashed" the big salons, and who have in lectures, in conversation, or in print, tried to reveal the secrets of how they do it. Just as every good photographer has a pet developer formula, so he has a set of rules which help him arrange his pictures. At least that's what they say. I suspect, myself, that most of them invent the rules to explain the miracle of their good pictures. However, since they all feel that these rules have really helped them, here they are for what they are worth; but don't dismiss them lightly, there is much golden wisdom here.

1. Don't place the main object at dead center. (Unless you're a genius, that is, as Alfred Stieglitz was.)

2. Keep the main object away from the outside edges of the picture area.

3. Arrange your light and shade so that the greatest contrast falls at the point of greatest interest.

4. Divide the picture space into thirds, horizontally and vertically, draw imaginary lines separating these portions. Where the lines cross are four magical points near which the main or subsidiary objects should be placed.

5. The closer an object is to dead center, the less it catches the eye; the nearer the edge, the more it attracts.

6. Lines intersecting at angles draw the eye; the nearer the angle is to a right angle, the stronger the pull.

7. Parallel lines that run across a picture area tend to carry the eye right out of the picture.

8. For greatest interest divide the picture area into *unequal* divisions; do the same with the area around the main object.

9. Don't include too much in the picture. Artists rarely show more on a canvas than can be seen from an angle of view of about 30 to 40 degrees. Wide-angle pictures, like those of the painter *Pieter Brueghel the Elder* (with an angle of view of between 80 to 100 degrees), seem unreal for that reason. The eye has an angle of view of about 50 degrees (like that of the normal 50mm lens of a 35mm camera).

BLENDING THE INCONGRUOUS. By itself, the house with its
octagonal captain's turret and its rococo decorations is only mildly interesting.
But viewed through the odd frame made of what seem to be two elephant
tusks, it becomes a haunting view of another time and place. Taken with a
Rolleiflex, Plus X Pan developed in Microdol X, enlarged on Luminos
RD Bromide instant gloss paper.

10. If the object doesn't look interesting when photographed head
on, try taking it from an angle. This applies to buildings as well as
people, or to objects as well as subjects.

11. Everything in the picture must be in some sort of harmony
with the main idea or object. A vase of flowers and a kippered herring,
for example, would not be in harmony.

12. Never let a line cut your picture exactly in half, either horizon-
tally or vertically.

WHERE ARE THE PEOPLE OR THE SHADOWS?

Compare this bad shot of the cobblestones in the courtyard of *The Cloisters* with the lovely shot of an early morning in Finland by Eric Muller in Chapter 2: *The Magic of Light.* Contrast makes the picture. Avoid flat lighting. You can get a picture with almost any degree of light, and especially when it rains. But regardless of subject matter, you cannot make an interesting picture unless the light is interesting.

an appropriate filter (see "All About Filters"), or by the use of one of the modern panchromatic films, any one of which gives good sky rendition when slightly underexposed, and a more dramatic sky with gross underexposure. Don't forget that overexposure will cancel out the effect of a filter, while a slight underexposure will take the place of one. (2) Flat lighting can be overcome by avoiding the middle of the day for photography. Sometimes we can't wait all day to find out when, or if, the light will be better, and the Sun Direction Indicator, shown in *Fig. 8.1,* is a clever device which helps to shorten this waiting time by indicating the approximate position of the sun, hour by hour, in advance. We are indebted for the idea to Mr. George H. Sewell, A. R. P. S., and to the *Miniature Camera World* of London.

The directions for its use are very simple. Place it horizontally with the line marked S facing *true south.* The *direction* of sunlight at any other hour can now be predicted. At 6 P.M., Eastern Standard Time, for instance, the sun will be shining from due west, while at 9 A.M., it will be shining from the southeast.

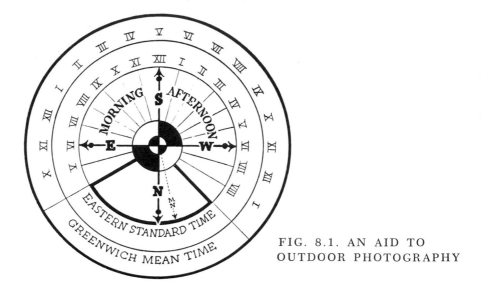

FIG. 8.1. AN AID TO
OUTDOOR PHOTOGRAPHY

To find true south hold the disk horizontally and place a match or toothpick vertically with its foot resting on the figure which represents the hour at that time. Move the dial until the shadow of the match falls along the radial line which joins the hour and the center of the dial. XII noon will then be facing due south.

If the sun is not out when you make the reading, you can orient the dial with a compass, but remember that the needle points to the *magnetic* north and must be corrected. The line marked MN should be placed parallel with the needle.

Since the noon sun is almost directly overhead,[1] calculating the *height* of the sun at other times of the day should present no problem to anyone familiar with the use of a protractor. *Fig. 2.4* would also be helpful in this connection.

One other point. The differences in standard time across the country have to be taken into account. Eastern Standard and Greenwich Times are shown on the dial. Eastern Daylight Time is one hour more advanced than Eastern Standard; Central Standard, six hours less advanced than Greenwich; Mountain Standard, seven hours less advanced than Greenwich; and, Pacific Standard, eight hours less advanced than Greenwich.

[1] Actually (as Arthur J. Hickman of Milwaukee, Wisconsin, points out), the noon sun is never *directly* overhead north of the Tropic of Cancer, nor south of the Tropic of Capricorn. But whatever the error this creates, wherever you happen to live, it is small, and hardly enough to interfere with the basic use of our direction indicator. It was designed to give us some idea of how long we may have to wait to get better lighting. This it will do, even if not as accurately as a sextant and a chronometer bring a sailor home from the sea.

13. Never let an uninterrupted line run parallel to any side of your picture.

14. Eliminate useless foreground or sky.

15. Remember that every spot in the picture attracts the eye; the force of this attraction depends on the size of the spot, its shape, its position, and the contrast it creates with its surroundings.

16. The main object should be the most conspicuous by size, contrast, or position.

17. The various elements of a picture should be so arranged that the eye is led in orderly progression from one element to another, resting longest on the principal object.

SUNSET AT PROVINCETOWN. You can *take* a picture, or you can *make* one. For instance, you can hardly miss if you point your camera at a street in Taxco, the Swiss Alps, or a shapely girl in a bikini. But here the simplest of elements have been arranged in a way, and at a time, to *create* a picture. It was done by placing the camera close to an interesting pattern of seashore plants just before sundown (to get that reflection on water). What might appear to an unseeing eye to be nothing more than some sand, sea, and grass has suddenly become a nostalgic reminder of a perfect day near the seashore anywhere in the world. Taken with a Rolleiflex on Plus X film, developed in Microdol X.

18. The skyline should never be in the center of the picture; place it about a third of the way from either the top or bottom.

19. The eye naturally follows light. Glancing across a picture it goes from the dark areas to the light ones. A white spot on a black background pulls the eye more than a black spot on a white background. And a *small* white spot on a dark background pulls more than a large white spot on the same background.

20. If there are people in the picture, give them plenty of room to move about in, or they will seem cramped.

21. If the picture shows people moving, leave more space in front than behind them. Similarly, leave more room in the direction in which people are facing or looking.

22. If the picture seems spotty, cover each spot in turn with a finger and notice what this does to the picture. If that improves it, remove or subdue the spot. Do this to all the offending spots.

23. Light and dark masses in a picture should always be unequal.

24. A continuous series of spots acts like a line.

25. Small spots, either light or dark, away from the principal object, only tend to distract the eye. The same is true for spots of unusual shape, or those placed in corners.

26. Long lines that run right out of the picture should be interrupted before they leave the picture area. This will help to keep the eye within the picture.

27. Arrange the pattern of the picture so that the eye enters from the lower left or right hand corner.

28. To test the composition of any picture, turn it upside down.

29. *Strome Lamon,* talented book publisher, once asked *Alfred Eisenstaedt,* dean of *Life* Magazine photographers, how to improve his pictures. Eisenstaedt's faultless advice was: "If your photographs are no good, you're not close enough."

30. Strategic skill is required to arrange a picture in color; tactical skill, to compose it in black and white. To put it another way: in color photography, the most important element is color; in black and white, it is contrast.

31. Finally, keep in mind what St. Exupéry, that extraordinary author-artist-aviator said in *Wind, Sand and Stars:* "It seems that perfection is attained not when there is nothing more to add, but when there is nothing more to take away."

Outdoors

There are three things to watch out for: *bald skies, flat lighting,* and *incorrect exposure.* (1) Bald skies are easily corrected by the use of

(3) The *best* way to avoid incorrect exposure is to use any reliable photoelectric exposure meter. See "Film and Exposure." The danger with most outdoor shots, especially landscapes and distant shots, is *over-exposure*. For distant scenes, Weston recommends that you give one half the regular exposure. For a normal-speed film like Plus X, used outdoors in bright sun during midsummer, the exposure would be about $f/16$, $1/100$, with a light yellow (K1) filter or no filter at all. For closeups under the same conditions, the exposure might be $f/11$, $1/100$.

A VITAL ACCESSORY: THE SUNSHADE

If you really want your lens to produce sharp, brilliant pictures, it is absolutely necessary for you to get a good *sunshade*. If you doubt this, stand near a window with the light coming from your left or right side and look at the opposite wall. Now cup your eye with your hand and notice the difference it makes. The camera lens reacts in the same way. For better pictures, use a sunshade to cut out all stray light and haze. With a sunshade you can safely take pictures with the light almost at an angle of 30 degrees facing the camera. You can thus get all the interesting effects produced by side and front lighting, without any of the attendant dangers. Be sure the shade is large enough for your particular lens; if it isn't, the corners of the picture will be cut off, especially when you use the sunshade *over* a filter. If you're worried about the space it will take up, get one of those that folds flat. Most photographic dealers stock a variety of sunshades at prices to suit any purse.

MOUNTAIN SCENES

There's always more light and more haze than you think, with over-exposure (and a loss of the mountains) almost inevitably the result. Distant views, from 1000 feet to 2500 feet above sea level, usually require only about ¼ as much exposure as the average, normal subject. When you get to about 5000 feet you can cut this down to ⅛ as much exposure. Another reason to cut exposure for such scenes is that they are usually flat and therefore need more developing time to bolster contrast. To increase developing time we must cut down on the exposure.

The best time to take mountain scenes is when the shadows are long. When there are clouds, or if there is haze, shoot across the direction of the sunlight and you'll get some excellent pictures. Panchromatic film and either the Aero or K series of filters are recommended for this use. The orange (G) filter can also be used if a darker sky is wanted. If rocks are an important part of the picture, use a light green filter such as the X1. This restrains the reds and makes the rocks print darker. With

Plus X and an ultra-violet or light yellow filter, the correct exposure for a mountain scene on a bright summer day would be about $f/11$, $1/300$. If the foreground were important the exposure would be about $f/8$, $1/100$.

LANDSCAPES

Besides the flat skies mentioned above, another important factor in pictures of this type is the matter of *scale* or relative size. The introduction of a foreground object, such as a person, a tree or a house, will help establish the scale while it enhances the effect of perspective.

Don't try to get *everything* sharp in your landscapes. The eye doesn't see things that way so there's no need to force the camera to do it. Distant objects should look somewhat softer than foreground objects. And watch the foreground particularly: It should be somewhat dark, and not too fussed up with eye-catching details.

Fig. 8.2 illustrates various positions of camera and sun with respect to the landscape. The heavy horizontal lines in the diagrams represent

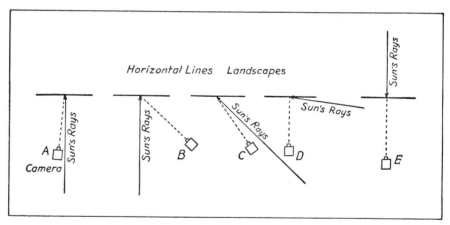

FIG. 8.2. HOW TO TAKE LANDSCAPES

the landscape or view, the arrows the rays from the sun and the broken lines the direction in which the camera is pointing. In the position shown at *A* the sun will pass over your head or shoulder in the same direction that you are pointing your camera, and this will tend to give you a rather flat picture. If you will stand in the position shown at *B* or *C* you will get one that has considerably more *snap* in it.

By standing in the position shown at *D* so that the sun shines on the view from one side, especially when it is low and near its setting

time, you can get some very soft, pleasing effects. It is never good prac-
tice for a beginner to stand at the point shown at *E*, with the sun shining
from the opposite side, unless you have taken the precaution of shielding
the lens. Such *contre jour* (against the light) shots are safe only if the
source of light is hidden from the camera.

There are two other things for you to remember when you are taking
a landscape, especially if there is a road or a building in it, and that is
(1) not to take a direct front view of it as shown by *A* in *Fig. 8.3*, or your
picture will look like *B;* instead, take it at an angle as shown by *C* and
your picture will look like *D*.

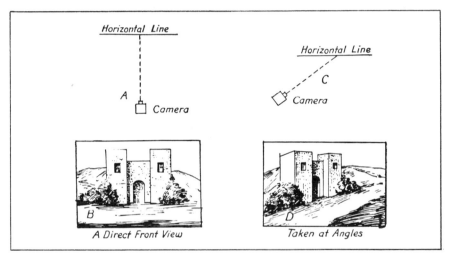

FIG. 8.3. HOW TO GET LINEAR PERSPECTIVE

When you stand directly in front of the view, the lines of the road
will run parallel with the bottom of the picture, which will give it a
mathematical appearance that is not at all pleasing to the eye. On the
other hand, when you take the picture at an angle, the road shows *linear
perspective;* the effect of distance is improved; and the result is much
more interesting. And (2) do not have the building, or other chief object
in the view, set right in the center of the film. Place it to one side, as
this also tends to enhance its picture quality.

ARCHITECTURE

The main problem here is what to do about those *converging verti-
cals* (they make tall buildings topple or look like pyramids) which
appear whenever we tilt the camera up to include all of a structure. To

make a picture of a high building, or other architectural or engineering work, and keep the vertical lines straight (that is, to have the *plane perspective* of it true) you must use a view camera with a *swing-back* (the back of a camera with a focusing screen so hinged that it can be turned at an angle to the axis of the camera to improve image perspective and extend depth of field sharply covered by lens). If you have to take it where you must stand close, which frequently happens when a tall building is hemmed in by others, you have to use a wide-angle lens.

To understand how the *swing-back* of a camera keeps the vertical lines of a building straight, let us first see how a camera whose front and back are fixed parallel to each other acts when it is held in a horizontal position. This is shown by *A* in *Fig. 8.4*. In this case, the upper part of the building will be cut off, as diagram *B* shows.

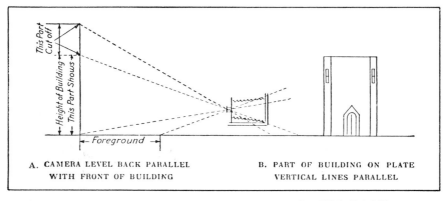

A. CAMERA LEVEL BACK PARALLEL B. PART OF BUILDING ON PLATE
WITH FRONT OF BUILDING VERTICAL LINES PARALLEL

FIG. 8.4. WHEN THE CAMERA HAS NO SWING-BACK

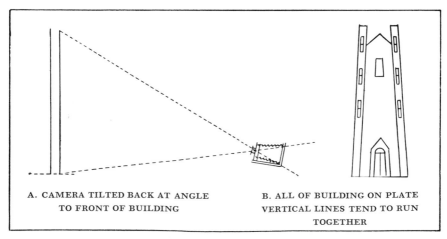

A. CAMERA TILTED BACK AT ANGLE B. ALL OF BUILDING ON PLATE
TO FRONT OF BUILDING VERTICAL LINES TEND TO RUN
TOGETHER

FIG. 8.5. WHEN THE CAMERA HAS NO SWING-BACK

Now if you tilt the camera up, as shown at *A* in *Fig.* 8.5, so that all of the building can be seen, as diagram *B* shows, then the vertical lines will converge at the top. To get all of the building in and still keep the vertical lines parallel to each other, the front of the camera must be tilted up, and the back, to which the ground glass is fixed, must remain in a vertical plane parallel to the building as shown at *A* in *Fig.* 8.6. The diagram *B* shows how the rays of light pass from the building to the screen.

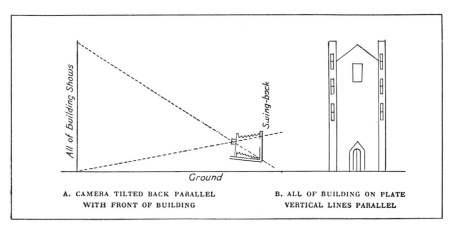

A. CAMERA TILTED BACK PARALLEL
WITH FRONT OF BUILDING

B. ALL OF BUILDING ON PLATE
VERTICAL LINES PARALLEL

FIG. 8.6. WHEN THE SWING-BACK IS USED

The reason a *wide-angle lens* must be used when you stand close to a building to take a picture of it is (as its name indicates) that it covers a wider angle of view than an ordinary lens. In consequence, it has a shorter focal length. Both the wide-angle lens and the swing-back can be used together.

About the Lighting

When you take the picture of a building, you should have either a bright sunny day when the play of light on it and the shadows cast by parts of it make it stand out boldly in relief, or else you should have a bright day when the sky is full of silvery clouds which diffuse the light. This gives a softer and more pleasing effect without sacrificing any of the sharp detail. The best lighting is from the side; front lighting is too flat.

The Best Position

Of course, the best position from which to take a picture is one that shows the most interesting sides of the subject; but the exact position you choose depends on the proximity of the other structures that sur-

round it, the angle that shows it to the best advantage, and your concept of what will make the finest picture. See *Fig. 8.3.*

The first feature is the one that very often dominates the other two. But assuming that you can take the picture from whatever angle you desire, then, in general, it is better not to make a direct front view of it. Take it so that the front and a side are both included. This gives it a sense of perspective that makes for solidity. Usually, the best angle at which to place the camera is about thirty degrees from the longitudinal axis of the structure, since this shows a little more of the front and a little less of the side than one made at forty-five degrees. If the position taken is less than thirty degrees, the foreshortening of the side causes a more or less squatty appearance. The diagram shown in *Fig. 8.7* clearly indicates this. The front of the building is at the left.

Many photographers point out that the picture should be taken on a level with that of the eye, at a height of about five feet, because architects design their works to be viewed normally from that height. But it seems to me that this does not always follow, and pictures taken from higher levels often look better, and have a more natural appearance.

One more thing before we leave the question of position. Get, if you possibly can, the same amount of foreground into the picture as you would if you were looking at the *subject* itself. When you view a building,

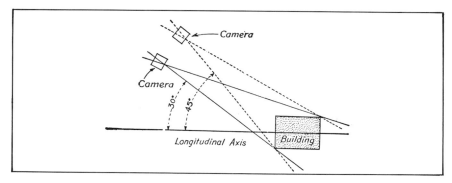

FIG. 8.7. HOW POSITION AFFECTS THE VIEW

like an old-world cathedral, you have to stand some distance away to see the full beauty of it. This gives enough foreground to show it off to best advantage. Do the same when arranging your picture of such a scene.

Focusing the Image

When you have set up the camera in the position which shows the building the way you want it, from the lighting as well as the perspective points of view, the next thing is to focus the image. A view camera that

focuses either from the front or back is the best for architectural sub-
jects, and it must have a very fine ground-glass screen so that you can
see just what you are getting.

Use the largest stop to focus the image on the screen; when you
have done this, set the stop and shutter speed as indicated by the meter,
then make your exposure. And don't forget that when you have to use
the swing-back, the more the camera is tilted up, the smaller the stop
must be to make everything sharp.

SNOW SCENES

If shadow detail is important in your snowscape, always give twice
the exposure indicated by a photoelectric exposure meter. The light re-
flected by snow is tricky, and the tendency is to underexpose when using
a meter. However, if the highlights are what you are most interested in,
expose just for them in the usual way. The shadows will go black, of
course, but you'll get what you want in the print. Remember that snow
shadows are blue. To darken them use a yellow filter. The best snow
pictures are made in bright sunlight early in the morning or late in the
afternoon. For unusual effects, try an orange or red filter with pan film.

Before putting the camera away, after you've been out on a snow-
picture binge, be sure to let the moisture caused by condensation evapo-
rate from the lens as well as the camera body. The camera should be
indoors awhile before you pack it up.

SEASCAPES

Reflections on water, and the distortions caused by the movement
of water, all make for fascinating photography, in color as well as in
monochrome. There is nothing more hypnotic than watching waves
break at the shore. I have done it for hours.

For water photography, the best shutter speed to prevent blur with-
out freezing all movement is about 1/100 second. To capture interesting
wave patterns, the camera must be above beach level. Snap the pictures
from the deck of a boat or from the end of a pier.

As for filters, the K2 yellow, or the X1 light green will lighten the
color of the water if you are using a monochrome pan film; the G yellow,
and the O orange will darken it. A polaroid filter (usable for color *and*
monochrome) will help control the reflections.

CLOUD STUDIES

Stop down to $f/11$ or $f/16$, use a yellow-green (K2) or orange (G)

filter, a shutter speed of between 1/50 and 1/100, and a film with an ASA Index rating of between 50 and 100. Do not overdevelop the film, and print it on a normal paper.

Indoors

You can take *interiors* with almost any kind of camera and a normal lens, by mounting the camera on a tripod and exposing the film for the requisite time (using a cable release). But you will probably not be able to get in much more than a wall, or a corner, unless the room is a long one or you can shoot it from an adjoining room, since your lens probably has too long a focal length. This situation can be improved by the use of an *auxiliary wide-angle lens* that can be placed over the lens of your normal camera lens, converting it to a short-focus lens that functions like a wide-angle. However, to take interiors best you should have a view camera with a *drop-bed* (which can be swung down when using a wide-angle lens) like the *Century Professional 23*, the *Pacemaker Crown Graphic*, or the *Super Graphic 45*, and use a wide-angle lens. You can also take such shots with a wide-angle lens on a 35mm camera, and by the use of one of those PC (perspective control) lenses like the Nikon PC Nikkor 35mm *f*/2.8.

WHAT TO GET IN

The first thing to do is look the room over to see from just what position it will make the best picture. In doing this you should be guided by the windows that light it.

Now, instead of crowding it with furniture, take away all you can without making it lose its homey aspect; this done, select one object as the point of interest (an armchair, a table, or a fireplace), but be careful not to get the movable pieces of furniture too close to the camera or they will take on a distorted perspective. Finally, have a smaller object or two, such as a book, or a mandolin, or a vase of flowers, or a statuette, on the table to lend a personal touch. You are now ready to look after the lighting of the subject.

Since interiors usually require time exposures, it is better not to try to have people or animals in the room. The better way to get a picture with life in it, is to take it by artificial light (either *flood* or *flash*).

In photographing the interiors of public buildings, churches, etc., never have the end of an arch, or the base of a pillar, cut off if you can possibly help it. The artistic effect is intensified by having a pillar come

AN INTERIOR IN WILLIAMSBURG, VIRGINIA. This was an
available light shot, taken with a Rolleiflex at *f*/8 and 1/100 of a second, on
Plus X Pan developed in Acufine.

close to the edge of the picture. In taking a picture of a long hall, it is
better to set the camera a little to one side, as a slight angle increases
the sense of perspective.

HOW TO CONTROL THE LIGHTING

The difference between a good and a poor picture of an interior is
largely a matter of lighting. Since rooms and other interiors are usually
lighted by windows, it is often quite difficult to take pictures of them
from the exact position you would like. Always try to have the windows
either at the back or at the side of your camera, for if they are directly
in front, *halation*, that is, the spreading of the highlights into the
shadows, is bound to occur, and, of course, this may ruin the picture.

Where windows at the side of the camera are to show in the picture,

they should be screened with muslin. By resorting to this expedient, and by raising or lowering the shades of other windows, you can control the lighting within certain limits. Where there are windows directly in front of the camera, you can get much better results by taking the picture on a bright day when the sun is shaded by clouds.

HOW TO FOCUS INTERIORS

In taking interiors it is usually quite difficult to see the image on the ground glass clearly enough to focus it sharply. There are two ways to get around this difficulty. First, shield the focusing screen from stray light by the use of a dark cloth and keep your head under it until you can see the object you are focusing on; or, second, light a lamp and stand it on, or in a line with, the object you want to focus sharply, and then focus on that. In either case, after you have focused the image as sharply as you can with the largest stop, use a smaller stop to make the exposure, then everything in view will be sharp. It is not, however, good practice to use too small a stop (*diffraction!*).

A simple but effective technique for taking interiors is to focus at about ⅓ of the total distance to be covered with the lens wide open (if farthest spot is 25 feet, focus at 8 feet). Then stop lens down to about $f/32$.

ABOUT MAKING THE EXPOSURE

While it is not absolutely necessary to use superspeed films for taking pictures of interiors, still it is a good idea to do so, as it cuts down the time of exposure. The films recommended are Tri X, Super Hypan, Plus X, Royal X Pan, or Ilford HP4.

The exact time of exposure, of course, depends on the way the room is lighted. Shadows in interior views usually come out very much deeper in the finished picture than they appear on the ground glass, so that, in the last analysis, the only sure guide to perfect exposure is the photoelectric meter. Using it for interior work, take a reading in the deepest shadow, if there is detail there that you want to show. (See "Film and Exposure" for a simple method of using the diaphragm in conjunction with the ground glass as an exposure meter for indoor pictures.)

Painting with light. A useful technique for illuminating interiors. The flood light is held in the hand and either swung in a circle (which tends to produce a shadowless light) or moved around to even out the dark and light areas or produce accents. The shutter has to be open while you are doing this, of course. You can also "paint" an interior with repeated bursts from an electronic flash source.

THE KIND OF LIGHT TO USE

The easiest light to use is the *photoflood*. There are many types of stands, reflectors, and bulbs available.

Check the Sylvania Sun Guns with the *quartz halogen* bulbs. The SG8 offers *broad* and *spot* beams, operates on 120 volts a.c., can be used for *bouncelighting* (bouncing light off a reflector, a wall, or a ceiling) and can be adapted to most cameras by special brackets.

Also, you may be able to pick up a *Baby Keglight,* a fine piece of equipment that will solve most of your lighting problems. It uses the T20 bulbs, or their equivalents, discussed below.

FIG. 8.8. A CLAMP-ON REFLECTOR FOR PHOTOFLOODS

FIG. 8.9. THE F.R. SPOTLIGHT

Another very useful light source is the spotlight. *Fig.* 8.9 shows a spot designed for amateur use. It is sturdily and scientifically built (in America); is equipped with a *fresnel* lens.

Later you might investigate the combinations that use the famous T20 projection bulbs or their equivalents. These are much better than photofloods, last longer (avoiding the nuisance of frequent burn-outs), give a more constant light of better color, but cost more than photofloods and must be burned base down in special reflectors. The reflectors for the 500-watt T20 bulbs *can* be used for photofloods, but not vice versa.

Night Photography

Outdoors at night you need a good strong tripod as well as a cable release for your camera. These are necessary to avoid vibration, since night exposures are usually long ones. With fast panchromatic films like

Super Hypan, Ilford HP4, or Tri X, the following suggested exposures will serve as a starting point for testing: with the diaphragm open to about *f*/4, a reasonably well-lit scene should be given about 10 seconds (if you can't see your watch in the dark count rapidly to 30); poorly lighted street scenes get about 20 seconds (or count rapidly to 60); badly lighted scenes get anywhere from 35 seconds to 5 minutes (or count from 100 to whatever time span you guess is right). Since an exposure meter is useless under such conditions, you'll simply have to try a series of shots to get the hang of it. With Plus X, Ilford FP4, or Verichrome Pan the above exposures should be doubled.

SAN FRANCISCO AT NIGHT. This is an example of a technique developed by Paul J. Woolf for taking pictures at just the right moment between dusk and night. Notice how the skylight silhouettes the buildings and separates them from one another. This photograph by Leon Arden was taken with a Rolleiflex on Plus X film developed in Acufine. The exposure, one of a series, was *f*/5.6 at 10 seconds.

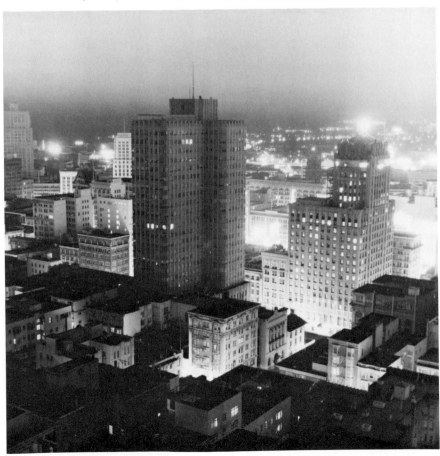

Some of the best night scenes outdoors, in the fall and winter, are taken during those few minutes between dusk and night when the shapes of things are still illuminated by a sort of faint afterglow. The impression made on the negative at this time is just strong enough to capture the full beauty of the large masses. Then the artificial lights begin to go on, adding sparkle to the scene.

CAUTIONS

(1) Use a lens hood at all times to keep stray light out of the lens. (2) Protect the lens against any naked lights that happen to be within range. (3) Use the cable release instead of the finger release and avoid jarring the camera. (4) Make sure your tripod is sturdy and reliable. (5) Shield the lens from car headlights or roving spotlights by covering the lens with your hand or a card until the light has moved on, and then continue with your exposure. (6) It's a good idea to have a little pocket flashlight with you to check adjustments. (7) If there's a strong wind, shield the camera with your body.

DEVELOPING AND PRINTING
OUTDOOR NIGHT PICTURES

Since contrast is extreme, use a soft working developer like Ansco 17 or D 76; or you might try that excellent developer for night work devised by M. U. Wallach, author of *How To Take Pictures at Night.* You'll find this formula (W 80) in the chapter on developing. Also good for this purpose is the Windisch formula for a Compensating Developer given later in the section, *Halation and How to Prevent It,* of chapter 13. And be sure to try the *Willi Beutler* fine grain developer, as well as the Tetenal version of it called *Neofin Blue.* It is excellent for all scenes of great contrast.

A VALUABLE HINT

Sometimes in taking outdoor night pictures we are bothered by objects moving back and forth in front of the camera. By using a small opening, such as $f/16$ to $f/32$, these moving objects will not show up at all, unless they are strong light sources, in which case you simply cover the lens as suggested above. In making these intermittent exposures, the interruptions and smaller f/stop must be compensated for.

IN THEATERS

To take pictures of a movie screen in a theater, use Tri X Pan film (Ilford HP4, or Super Hypan), a lens opening of $f/2$ or $f/3.5$, and a

shutter speed of about 1/50 second. Stage action can also be handled with such fast film at $f/4$ and 1/200, when the stage is fully lit, or for musical production numbers. The exposure otherwise will depend on the quality or quantity of the light; but a safe trial exposure is about $f/2$ to $f/3.5$, 1/25 to 1/50 second. *Caution:* There are restrictions against the use of cameras in most Broadway theaters, because photographers thoughtlessly use flash, which blinds or otherwise upsets the actors and disturbs the other patrons.

You can photograph color on the movie screen with 35mm High Speed Ektachrome, but you will have to make your own tests. You will need an $f/2$ lens, and an exposure of about 1/30 second. Bracket your exposures (adding 1/15 and $f/2$, then 1/60 and $f/2$; or $f/1.4$ and 1/60, then $f/1.4$ and 1/30, and finally $f/1.4$ and 1/125).

Sports

Exposures, inside and out, will depend on the light. Outdoors in daylight, use a photoelectric exposure meter. Indoors, unless the light is bright enough to move your meter needle, you'll have to guess at it. With a film like Tri X Pan (ASA 400) you can start your guessing at $f/2$ and 1/100 second. An ideal exposure for fast action would be $f/5.6$ and 1/500 second, outdoors in the sun; $f/3.5$ and 1/250 indoors, if brightly lit. Bracket your exposures, giving them one stop, or shutter speed, more, and one less, than your basic exposure.

If you do your own developing, you can increase the speed of your monochrome film by the use of such developers as Acufine, D 76, Microphen, Promicrol, Rodinal, as well as Developers 8, 9, 11, and 14 in the chapter on Developing (see index).

For most sports (like baseball, football, basketball, boxing, wrestling), depending on where you are sitting, you will also need a wide-angle and a telephoto lens, unless you are lucky enough to have a *zoom* lens to work with (see index). The preferred camera in such photography is the 35mm, because the film is cheaper, and the action is faster. And that applies to the single-lens reflex as well as the rangefinder types.

For color, use High Speed Ektachrome, adjusting your exposure according to whether you are using the Daylight or Tungsten type. The ASA speed for daylight, normally, is 160, but you can increase your film speed 2½ times (to 400) when you send your film for processing in the Kodak Special Processing Envelope, ESP-1, available from most photo dealers. For indoors, use High Speed Ektachrome (Tungsten) which has an ASA speed of 125, but can be increased to 320 by using the special mailer, ESP-1 as above.

If you are a ski buff, remember that snow will inflate your meter

reading and therefore underexpose your film. Use an incident light reading if your meter permits it, or read the palm of your hand (not the *glove*, unless it has an 18 per cent reflectance like the *Gray Target* which Eastman Kodak supplies in their Kodak Master Darkroom Dataguide). If none of these are available, read the snow in the normal way, and multiply the calculated exposure by 5 (example: 1/100 if the calculated exposure from the snow is 1/500).

Some Focusing Hints

By this time, no doubt, you are sufficiently impressed with the reasons for focusing carefully. Here are some suggestions on the technique for doing so:

1. You can increase the sharpness of ground-glass focusing by smearing a thin uniform layer of vaseline or glycerin over the coarse surface of the ground glass. This has the effect of making it more transparent and less grainy.

2. Another way of accomplishing this is by the use of a *clear spot* on the ground glass. Mark a cross in the center of the ground glass with a sharply pointed pencil and cover this with a square piece of microscopic slide cemented (to the ground glass side) with balsam. Let it dry thoroughly. Focus in the usual way, then examine the cross with a magnifier. If the image and the cross are not displaced when you move your eye, everything is in sharp focus. However, if the cross moves in the direction of the eye, the lens is racked out too far; if the cross moves in the opposite direction, the lens hasn't been racked out far enough.

3. In examining the edges of a ground-glass image, do so at an angle, in the direction of the lens center.

4. If you are working at close range on a subject that has a troublesome depth, and it all has to be sharp, use this method for determining the best point on which to focus: Let A represent the distance of the point closest to the camera and B the distance of the point farthest away. Then,

$$\text{the focusing point} = \frac{2(A \times B)}{A + B} \text{ or,}$$

if $A = 8$ feet and $B = 24$ feet then the point $= \dfrac{2\,(8 \times 24)}{8 + 24} = 12$

feet which means that the lens should be focused on a point about 12 feet away. Do this with the lens at its widest aperture, and then stop down to get the increased depth necessary to bring it all into focus.

5. However, for best results on other subjects, focus the way the eye does, on the principal object (the subject of greatest interest) and let the diaphragm bring the rest into focus.

6. When you are taking a picture in a mirror, your focus will be the sum of the distances from camera to mirror and from mirror to subject. Thus, if your subject is 5 feet away from the mirror and the camera is 10 feet away, set the focus for 15 feet.

7. To find the *hyperfocal distance* (infinity near point) at any given *f*/stop, square the focal length of the lens in inches (multiply it by itself), then multiply it by the reciprocal of the *circle of confusion* of the lens in inches (usually supplied by the lens maker on request; for most miniature camera lenses this figure is 500). Now divide this by the *f*/stop multiplied by 12 and you will have your answer in feet. Focus on this distance and everything from about half this distance to infinity will be in apparent focus.

8. If your camera has a coupled rangefinder and a ground glass, be sure to check one against the other, for infinity as well as for closeups. Though I have never been able to understand why, the men who put the rangefinders on cameras at the factory are not very fussy about whether the infinity stops are set right for the particular lens in hand. Their work of adjustment is a sheer waste of time unless this basic detail is taken care of, so be sure that it is. Check on the ground glass with a focusing magnifier.

9. *Learn how to use your rangefinder.* Each person has a different way of making the images merge. Check your method against the ground glass, to be sure that bringing the movable image *down,* for example, to meet the other is (or isn't) better than bringing it *up* or *sideways,* depending on whether you have a Leica, Nikon, or Contarex. This small difference in direction may be the difference between razor-sharp pictures and fuzzy ones.

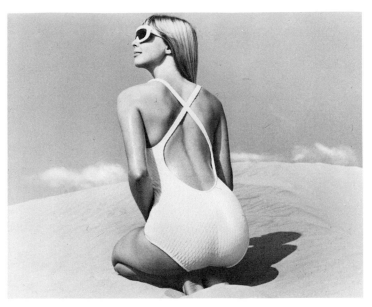

The incomparably attractive *Camber Sands*, on a Sahara hillock near London, photographed by Murray Irving. He used the Invercone attachment for the Sangamo *Weston Master* meter to get a perfect incident light reading of a difficult shot.

9 People and Closeups

Portraits, Texture, Still Life, Glassware, Copying

Portrait photography can be the most rewarding as well as the most thankless job in the world. As a general rule, people rarely like the way the camera sees them. Usually, the portrait is something of a shock. Though the skillful, and kind, photographer can do many things to soften this blow, by artful posing and lighting, he must be prepared for the kind of reaction that makes him wonder why he *ever* bothers to take pictures of people anyway, especially friends.

This has been summed up very cleverly by two talented amateur photographers (*Nina Bourne* and *Thomas Collins*) who worked out their despair in what they have named the Collins-Bourne Law of Portrait Photography. What follows is the bare text, minus the handsome calligraphy:

The Photographee is never more, and usually less, than one-half so pleased with any given photograph as the Photographer. I. The Photographer is: (a) Surprised to find that there is an Image on

the Negative, (b) Pleased if the Image appears to be of reasonable sharpness, Density & Contrast, (c) Delighted if it bears a resemblance to any Human Being, and (d) Overjoyed if it is recognizable as a Portrait of the Photographee. II. CONTRARIWISE, the Photographee (a) Remembers the tortures of Posing, (b) Knows that he or she is Beautiful, III. THEREFORE, If he does not look Beautiful in the Photograph, it is *only because* the Photographer is Fuzzy, Under-developed & Dense.

Lighting the Subject

To take a good portrait you need soft, diffused light. Your first attempts at such photography should be made out-of-doors, in the shade. Direct sunlight, or the use of photofloods aimed directly at the subject, produce too much contrast. For the best effect, use *available light* (low light without supplementary lighting) at the side of a white house away from the sun or, better yet, on the *north* side where the light is more diffused. You can also get good lighting under a tree, especially when the sun is screened by clouds.

THE GIRL WATCHERS. Three guys on a bench; two girls on the march. Central Park is full of shots like this. Taken with a Leica, 50mm Summilux lens, on Panatomic X developed in Neofin Blue.

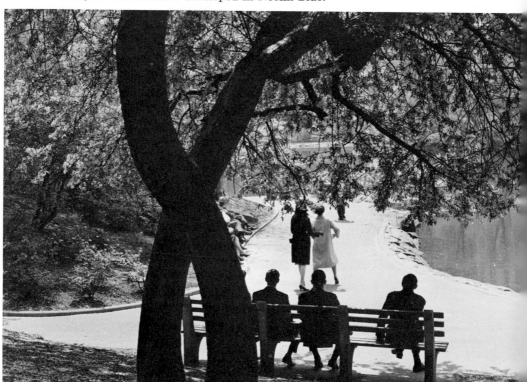

For portraiture, you do not need too much light; you want soft light, diffused by reflection from a mat surface or by interference (see below).

Reflectors and Screens

Two very handy gadgets for use in portrait photography are a folding reflector and a cheesecloth screen:

Reflector. The one I have is made of three pieces of three-ply cardboard, about 10 x 14 inches in size, taped together so that the outside leaves fold in on one another. The taping should be done inside and out along both folding edges. Make sure you allow folding room or the top leaf won't close. After you've finished the taping and are satisfied that both leaves will lie flat, cover the inside surface of all three cards with some crumpled and flattened aluminum foil (like *Reynolds Wrap,* used to store food in your refrigerator). I used *rubber cement* to do the job and haven't had any pieces come off in three years. The trick is to cement both the card and the foil separately, let the cement dry, and then bring them together. It will take a bit of yanking to separate them if you do it that way.

Use the reflector to soften harsh contrasts in outdoor portraits. You will be amazed at what a difference it will make. Those dark, unpleasant shadows that usually spoil sunlit portraits will take on a luminous quality you've seen only in the work of professionals. And a secret: *that's just how they do it!* I place the reflector on the ground, on a rock, or a fence, stand it on end, or raise it at an angle using one leaf as a support. There are innumerable ways of putting it to good use. It's definitely worth the effort of lugging along when you expect to take pictures of people.

If you haven't any foil, a good reflector can be made out of some white showcards, newspaper, bedsheets, or towels. The side of a white house can also be used as a makeshift reflector.

Screen. Cinematographers use large ones, metal-mounted on tripods, to soften the lights when they take movies. But you can make your own out of cheesecloth tacked to a wooden frame of whatever size is called for. The important thing is that the screen must cut down on the light without its frame producing any unwanted shadows.

Both the reflector and the screen can be used indoors as well as outdoors.

A Word About Backgrounds

Next to the proper lighting of the subject in importance is the matter of a suitable background. A natural background such as the wall

PHOTOGENIC is a word that describes, but cannot explain, why some
people always take *good* photographs. I have never seen a bad shot of this
young artist. Taken with a Leica and 50mm Summicron lens on
Panatomic X, developed in Acufine.

of a house or a garden, provided it is not covered with distracting vines
or ramblers, can be used, but you must place the subject far enough
away so that the background can be shifted out of focus. Very few nat-
ural backgrounds are really suitable for taking bust portraits, but for
three-quarter and full-length figures they are extremely good. Natural
backgrounds are unsuitable for bust portraits because they are too "busy"
and tend to detract from the subject. A *prepared background* five feet
wide and six feet long (one made from a unitone paper, unrolled, to
supply an even backdrop) can prove very useful for bust portraits both
indoors and out. Such papers (*Savage* wide-tone background papers)

are available in 107 inch widths, in rolls of 12 or 50 yard lengths, and in 50 colors, from National Artist Materials Co., 222 East 43rd Street, New York, N.Y. 10017.

Available Light

This involves the use of whatever natural daylight, or daytime skylight (as distinguished from sunlight), happens to be available. The light usually comes from the sky, or through a door or window. Among the modern photographers who have made this "existing light" photography the rage are such men as Richard Avedon, Eugene Smith, John Rawlings, Bill Ward, Henri Cartier-Bresson, Leonard McCombe and, of course, that man with the amazing eye, *Life* photographer *Alfred Eisenstaedt*. The result of this lighting technique is that everything and everybody in a picture looks *real*. The impact of such photography is overwhelming. The pictures haunt you; you can't forget them.

However, there's nothing new about available light as a technique. It's a return to the luminous lighting of such masters as Alfred Stieglitz, Eugene Atget, David Hill, Lewis Carroll, Mathew Brady, and Fox Talbot. We could do worse, in these days of flash and strobe, than to relearn some of the simple methods that made these masters. And you don't need a garret skylight, either.

A CANDID SHOT taken with a Contax and a 135mm Zeiss *Sonnar* lens. The perspective is "agreeable" because of the great camera-to-subject distance. Taken from the boardwalk at Jones Beach. *Plus X Pan* developed in *Microdol X*.

AVAILABLE LIGHT.
A fine example of
photography indoors. The
subject faced the
window. Taken by
Stephen Sugar with a
Nikkormat FTN at f/16
and 1/30, using a tripod.

An important thing to remember when using natural light is that the contrast is usually weak. Therefore, the exposure, especially if done by meter, should be a bit less than normal; and the development should be ample (about 25 per cent more). However, if the light is strong only on one side, be sure to give ample exposure (metering the important shadow areas, if there's time) and use normal to brief development (about 20 per cent less).

Bounce Light

A variation of available light, using artificial light sources, is that which has come to be known as *bounce light*. The effect is very much the same as available light: soft, natural pictures that have no harsh shadows. The technique is quite simple; when the available light is inadequate, you supplement it. What you do is bounce the light off the ceiling or wall at an angle—the sharper the angle, the more directly overhead or to the side the light will seem to be. Experiment first with

floodlight before you tackle *flash* or *strobe*, to become familiar with the effect of bounce light on the object or the model. Exposure and development are the same as for available light. Among the bulbs available for this purpose are the 400-watt T20 projection lamps, or their equivalents, with the mogul, prefocused, or screw-in bases; the tungsten-halogen projection lamps with built-in reflectors; or the regular floodlamps, made in two sizes. For color photography, the lamps will determine the kind of film you have to use, or vice versa. I suggest you discuss this with your camera dealer, since much will depend on what lighting equipment, camera, and film you plan to use.

Indoor Portraits

In taking portraits indoors without artificial light, use as large a room as possible, preferably one that has a single window on one side. If you have to work in a room with two or more windows, pull down the shades so that light comes through only one of them. Just as in outdoor portraiture, it is the quality of light that is important, and the way in which it falls on the subject, not the quantity of light available.

PORTRAIT. *F. Matthias Alexander,* who taught *Bernard Shaw, Aldous Huxley,* and many other greats how to use their bodies more effectively through "constructive conscious control." Taken with a Speed Graphic and Optar lens, on Plus X film, developed in D 76.

Strong lights and deep shadows can be softened for indoor portraits in any one of a number of ways: placing the subject well away from the window; covering the window with cheesecloth; using a cheesecloth screen between the window and the subject; and by placing a reflector made of muslin at an angle of thirty to forty-five degrees to the window and the subject.

It is not a good idea to place the subject more than four or five feet from the window. Because light decreases as the square of the distance, the time of exposure would be too long. Covering the window with cheesecloth gives a soft effect, but it cuts off a considerable amount of light. By using the cheesecloth screen between the window and the subject, as shown in *Fig. 9.1*, more light is let into the room, which makes it brighter, but it cuts off more from the side of the subject's face nearest to it. This undesirable effect can be compensated for by using the muslin reflector on the opposite and darkest side of the subject.

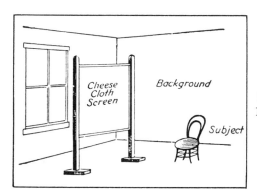

FIG. 9.1. A CHEESECLOTH DIFFUSION SCREEN

Now set your camera in one corner of the room, the background at approximately a right angle to the optical axis of the lens, and in the other corner nearest the window, place the subject in the middle of and about two feet in front of the background. Set the cheesecloth screen in front of the window, so that it diffuses the light that falls on the subject. Finally, move the reflector about three feet to the other side of the subject and approximately at a right angle to the background, as shown in *Fig. 9.2*. You are then ready to take a look at the image formed on the screen of your camera.

While you can always soften the contrast by placing the subject further from the window, this requires a longer exposure time. The muslin reflector eliminates this difficulty, enabling you to tone the shadows even when the subject is quite close to the window. You can thus control the lighting, getting it just the way you want, simply by moving the reflector around a little.

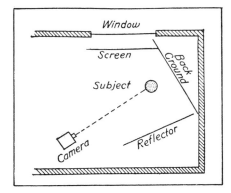

FIG. 9.2. HOW THE
REFLECTOR IS USED

THE BACKGROUND TO BE USED

A plain background is the best for taking bust pictures. If the walls of the room you are using as a studio are covered with plain paper this will serve your purpose very well. Paper with a pronounced design would give the picture a strange and freakish look.

For an occasional portrait you can use a very large sheet of rolled wrapping paper, but if you are going in for this kind of photography you had better buy a special background which is mounted on rollers, and can be hung wherever it best suits your purpose. Plain backgrounds can be bought that are stone-colored on one side and light gray on the other, in various sizes. These are so made that they will hang perfectly flat and free from creases; and they come in a variety of *colors*.

PORTRAIT LIGHTING CHARTS

You can buy a pocket-size *Portrait Lighting Chart* from your friendly, neighborhood camera dealer. There are two or three to choose from. They illustrate what happens as you move lights around horizontally and vertically, in about 24 basic lighting positions.

Also, about once a year the photo magazines, notably *Popular Photography* and *Modern Photography,* devote part of an issue to portrait photography. At that time they reprint revised editions of such lighting charts.

REMBRANDT LIGHTING

This is the kind of dramatic lighting frequently used by the Dutch painter Rembrandt van Rijn (1606–1669). What it does is to highlight parts of the subject, leaving the rest in strong but luminous shadows. To

FIG. 9.3. HOW TO GET THE
REMBRANDT LIGHTING EFFECT

get this effect, seat your subject near the window as shown in *Fig. 9.3* at
A, and have him look toward the point marked *X;* next put a dark back-
ground behind the subject and at an angle of about forty-five degrees to
that of the window; then set the reflector on the other side of the subject
and opposite the window, at a slight angle to the latter of about fifteen
or twenty degrees. Now bring the loaded camera to the position *B,* focus
the image on the screen, and make your exposure.

A STOUT PROBLEM AND SOME HELP

If your model is on the plump side, he (or she) presents a special problem. The trick is to place and light the model in such a way that the obesity is subdued. Dark clothes instead of light ones; dark backgrounds to minimize contrast between figure and background; use of less of the figure, by turning it sideways or by showing more of the head and less of the body—these are some of the ways to overcome the problems presented by the portly poser.

Remember that the phenomenon of *irradiation* will help you if you have trouble photographing fat women or slight men. See *Fig. 9.5.* The white square on a black background looks larger than the black square on white. White objects on a dark background always seem larger. The reason is that the impression made on the retina of the eye extends beyond the outline of the object. That's why the stars look larger than they are, and why stout women usually wear black. So, when you want *to reduce the apparent size of an object,* arrange the lighting (and the dress if it's a woman) so that the background is much brighter; *to increase apparent size,* do the reverse. A small thin man in a white palm beach suit against a dark background will look like Tarzan dressed up!

FIG. 9.5. THE PHENOMENON OF IRRADIATION
The white square looks larger, but they are both the same size.

Artificial Lighting of Indoor Subjects

Here the control is easier. Lights can be moved around, raised or lowered; you have a choice of many sizes of light bulbs and many shapes in reflectors; you can get a good small spotlight for around fifteen dollars; you can get gauze or spunglass diffusers to soften the light, and you

WHEN DOES A SQUARE LOOK SQUARE?

Why do people of average build sometimes look *dumpy* when photographed? Why do news photographers and cinematographers point their cameras *up*, to make people look taller? I wondered about this for some time, and finally discovered the answer in a brilliant book on, of all things, *The Origin of the Serif*, by Edward M. Catich. Father Catich has been (since 1939) the chairman of the Art Department of St. Ambrose College, Davenport, Iowa; and he is also well known as a stone-cutter, calligrapher, photographer, historian, and lecturer. He was reared in Butte, Montana (which Mary McLane made famous many years ago). This is what he says:

> We tend to expect important parallels to be vertical rather than horizontal. We see about us trees, and houses, people walking and standing, things which must achieve at least some degree of verticality to remain what they are. We associate living, dynamic qualities with the vertical while the horizontal is more suggestive of non-living and static states. Thus it is that we react to verticals more than to horizontals, and this visual habit plus the ever-present experience of gravity combine to form within us a convincing *pattern of expectancy* . . . the true square looks dumpy because of this optical downward thrust of its top and sides. A square looks square only when it is taller than it is wide.

See Fig. 9.4.

FIG. 9.4. WHEN IS A SQUARE NOT A SQUARE? *Left: a true square;* and *right: an optically compensated "square."* The dimensions of the *true* square are 1½" vertical by 1½" horizontal, with an overall thickness of ⅛". The compensated square is 1½" vertical, 1⁷⁄₁₆" *horizontal,* with an overall thickness of ⅛".

This light . . .

AN EXAMPLE OF
PORTRAIT LIGHTING

*Baby used as model
was sculptured by
Betty Burroughs
Woodhouse.*

plus this light . . .

produce this.

can even get *colored* lights (they make *green* and *blue* photofloods now —the green for portraits of women, where soft light is a blessing, the blue for portraits of men, or where you want extreme clarity and brilliance).

The important thing in indoor lighting is to keep it simple. One basic light, a supplementary light to soften shadows, and sometimes a light for the background—that's all you really need at the beginning. Get other lights only when you've exhausted the possibilities of these. (See the examples of portrait lighting reproduced earlier.)

SCHOOL FOR LIGHTING

The world's best technique for lighting has been perfected in Hollywood. The next time you go to a movie or watch television (especially the commercials), notice how shrewdly the lights have been placed so that no matter which way the actor turns the lighting is good. Notice

PORTRAITS ARE EASY WITH A 35MM CAMERA. Leica and Visoflex II with 90mm Elmarit f/2.8 at 1/100 second. Plus X Pan @ ASA 160, available light, developed in X 22.

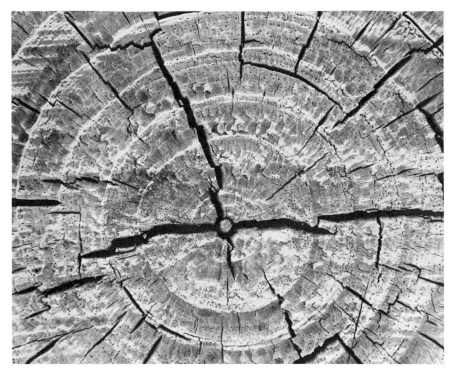

TEXTURE. Closeup of a cross-section of a log, with low sun providing sharp shadows. Taken by Stephen Sugar with a Nikkormat FTN and an *f*/3.5 Micro Nikor 55mm lens at *f*/8 and a distance of about 12 inches.

also how effectively outdoor scenes are photographed. You can learn more about lighting by sitting through a double feature or a TV spectacular (and again the commercials) than by reading all the books in the world about it. Watch especially for those photographed by that amazing Chinese genius, James Wong Howe. He has made motion picture photography a great art.

TEXTURE

All you need to know about it, despite all the books and articles on the subject, is that *texture is produced by strong shadows,* and strong shadows require contrasty lighting. Bring your light close (use a spotlight if you have one, but it isn't necessary) and place it so that the light glances across the surface at an extreme angle (but not so much that the long shadows obliterate detail). Flat, head-on lighting is death on texture; avoid it. Also, *one* light is better than two when texture is the goal; the second light may cancel out the very effect you are trying to achieve. Another thing, *be sure your image is in sharp focus all over* (stop down to *f*/16 or smaller to *make* certain); the sharper the nega-

tive, the better the rendering of texture will be. *One more hint:* under-expose slightly and develop a minute or two more than normal; the extra contrast you'll get that way will help.

GLASSWARE

Reflected backlighting is best for this kind of subject, with no *direct* light reaching the glass at all. The light should be fairly uniform and somewhat soft. Interesting effects can be gotten by placing the glassware on a glass plate supported at both ends, and lighting it at an angle from above or below. Panchromatic film is recommended for this use.

COPYING

The problem in this kind of photography is the balancing of the light. *The solution:* center a pin or tack just above the top edge of the copy and at right angles to the surface, and watch the shadows made by the light. When the shadows are of equal intensity, length, or angle, the lights are balanced. You'll find this easier than it sounds. The eye notes small discrepancies of lighting very quickly by means of these shadows.

Close-Range Work

For closeups it is very important to give increased exposures when the lens is racked out more than half again its focal length. The amount of extra exposure depends on the inverse square law. You simply find out how many times the old distance goes into the new, and square that number. That will be your new exposure factor. For example, if you're using a 6 inch lens focused at 10 inches, you divide 10 by 6, which gives you 1.7; you multiply that by itself, and your answer will be 2.89 which, technically, is the *exact* multiplication factor. But in this case, you can increase your exposure either 2½ or 3 times and be near enough correct for all practical purposes.

Some Hints on Portraiture

Here, boiled down to just a few sentences, is the result of years of experience on the part of hundreds of photographers:

1. To minimize face lines and shadow hollows in portraits of women use plenty of flat, front lighting.

2. Use the monotone *viewing* filter to test the lighting setup. If the shadows are too dark, or the highlights too strong, this will tell you the story at a glance.

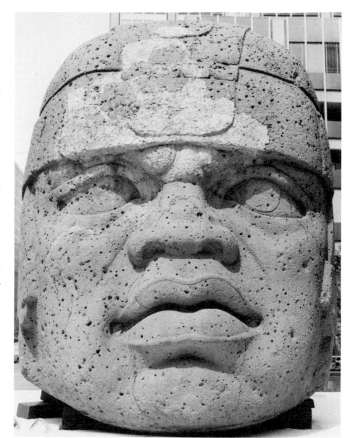

MEXICO'S GREAT OLMEC HEAD (*First Century* A.D.). This huge stone head made of *basalt* weighs in at sixteen tons. It represents a god of agriculture, a high priest, or a player of *pilato*, the ritual Olmec ball game. A visitor to New York briefly, it is now back in the Anthropological Museum of Veracruz, Mexico. Taken with a Rolleiflex, on Plus X Pan film, developed in Acufine.

3. Portraits of women should be so lighted that a meter reading from each side of the face shows a proportion of 2 to 1; men, 3 to 1.

4. Place lens of camera at height of eyes for true "drawing" or perspective.

5. Pointing camera down makes forehead large, nose long, chin small.

6. Pointing camera up makes jaw large, nose short, forehead small, neck long.

7. To lengthen the legs of women, use a low camera angle.

8. To see how position changes and distorts the face look in a mirror as you move your head around and notice what this does to your features.

9. When you notice flesh tones on your ground glass you'll get good tones in your picture (provided you expose correctly); however, if the shadows are grayish, not flesh colored, your light is unbalanced and you will lose detail in either highlights or shadows.

10. Don't light the face so that the shadows distort the features; the shadows are intended only to model the face.

THE PLAY OF LIGHT on the young fisherman's body made this an irresistible shot. Taken with a Rolleiflex, Planar lens, on Plus X Pan developed in Microdol X.

11. Don't use too much light in portraiture, and don't have the lights too close. Chalky faces and black shadows will be the result if you disregard this warning. Try one light only, with a reflector to illuminate the shadows. Rightly used, this combination should give you almost everything you need in the way of normal lighting.

12. Unless you want to have large hands and big noses in your portraits, don't bring your camera too close to the model. A good rule is to

include at least a half-length image in the picture area; if only the head is wanted, enlarge the negative or use a telephoto lens.

13. If your model has blonde hair, you can avoid a chalky mess around the head by diffusing the light (by reflecting it from a white surface).

14. To get good expression, pretend to snap one picture after warning the model you're ready; when she's relaxed take the actual picture.

15. Shadows thrown by vertical lines (arms, legs, etc.) should never show vertically. Place the lights so that the shadows are at a slant.

16. Top lighting helps give depth to the head and form to the hair.

17. Watch carefully what the lights do to the nose and the eyes. Bad lighting can ruin an otherwise good expression.

18. The 500-watt T20 projection lamps, or their equivalents, are recommended for portraiture because they give better flesh tones and crisper highlights. These are available with mogul, prefocused and screw-in bases. Also recommended: tungsten-halogen projection bulbs with built-in reflectors.

19. Do your men always look unshaven? Avoid the superspeed films and keep contrast down. The blue tone of the skin which shows up as a heavy beard is due to the darkening caused by the red in the photoflood light. Use the green photofloods, or tint the skin with a pure red make-up and then use white talcum over a powder base.

20. Keep the hands of your model edgewise toward the lens if you don't want them to look like pile drivers. Don't tell your model to do this; arrange the hands for her after she has assumed a natural position. Just tilt the hands a bit so they face the lens edgewise without bothering to explain; it will only confuse her if you try.

21. The best portrait lighting is the kind that simulates sunlight.

22. High lights should be prominent on forehead, nose, cheeks and chin.

23. *Stout people* should never be photographed in full front view. This makes them seem larger than they are, especially if they wear light clothes.

24. To focus attention on the face have the model wear dark clothes, and use a dark background.

25. The most pleasing pose is oblique, with one shoulder pointing towards the camera.

26. Sleeveless dresses make arms appear too prominent.

27. If your model has a double chin, turn her head so that she looks over one shoulder: the second chin will disappear.

28. If your model is too thin, photograph her full front view; have her wear light clothes and place her against a dark background. A dress material that has large patterns will also help to make her look plumper.

OOPS! Plus X Pan, developed in D 76. Taken
with a Leica and 50mm Summicron.

10 Action and Flash

Modern films and cameras are so "fast" that you rarely need more
than available light to capture your picture, even when the subject is in
motion. However, there *are* times when the light is inadequate or too
contrasty, the shutter is too slow, and the film needs a booster. In this
chapter we'll explore a few of those situations and tell you what you can
do to prepare yourself for them.

The Object Is in Motion

If a moving object is at a distance, and traveling *along* the axis of
the lens (that is, directly toward or away from the camera) you don't
have much of a problem. The greater the distance, the smaller the image
on the film. And for that very reason its motion on the film will also be
quite small. Therefore, an extremely short exposure (say 1/500 rather
than 1/50 of a second) is not really needed to get a sharp picture.

However, if the object is near the camera, or if it is traveling broad-
side, *across* the axis of the lens, you will need a shutter speed of from
1/100 to 1/500 second or more to retain sharpness, depending on the

THE RACE. This is a fine example of action photography on water, with the subject moving *toward* the camera, along the axis of the lens. Despite the wind, the waves, and the fact that the camera was on a sailboat directly ahead of the two being photographed, an exposure of 1/250 at *f*/16 stopped the action, on Kodak Plus X Pan, developed in Microdol X. To bring out the clouds, a K2 filter was used.

THE RUNNERS. An example of action *across* the axis of the lens. The safest shutter speed for this kind of sports photography is 1/500 to 1/1000 second. This one was made at *f*/11, 1/500 second, on Kodak Tri X Pan developed in D 76.

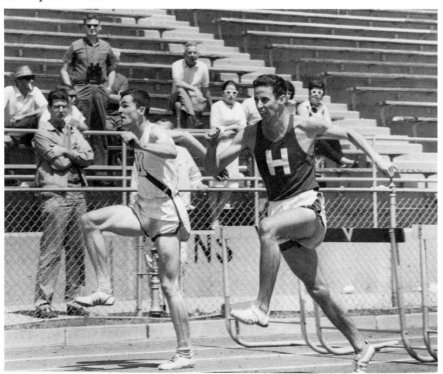

speed of the object (1/200 is usually fast enough to capture people jumping, and 1/500 for horses running).

To avoid blur, never use a shutter speed slower than 1/100 second for any hand-held shot. Below that speed (and certainly below 1/50) it is always better to use a tripod. There are some photographers who are blessed with rock-steady hands; they can get away with the slower speeds. Sometimes, when we can't help ourselves (and the tripod is home) we may have to use 1/50, or even 1/25, in dim light. But we should be aware that we are *flirting with blur.* One thing we can do is to brace ourselves, or the camera, against something firm, like a table, a fence, a wall. We are talking now about the motion of the camera, not that of the object. There is a method of taking action shots that involves *panning* (following the object with the camera . . . *swinging*). This makes it possible to freeze the action of the subject, while blurring the background, which intensifies the feeling of motion.

Refer to the table SHUTTER SPEEDS FOR MOVING OBJECTS given later in this chapter. Study it to get a general idea of what speeds are needed for the various situations.

SLOW-SPEED EXPOSURES

With a stop of $f/8$ and a shutter working at 1/50 of a second, the exposure is short enough to stop the motion of people who are walking, provided that (1) they are in bright sunlight, and (2) the camera is not closer than twenty-five feet. This assumes the use of a film like Panatomic X (ASA 32) with a K2 yellow filter; for Verichrome Pan (ASA 125) use $f/11$ at 1/100.

Where the lens can be used with a larger stop, shorter exposures can be made and better definition will be had of moving objects; thus, with a lens working at $f/5.6$, the exposure can be cut down to 1/100 of a second. With special, large-aperture lenses, shutter speeds five times as short, or even shorter, can be used. Where vehicles are in motion, a shutter speed of at least 1/100 of a second should be used.

Using a shutter speed of 1/50 or 1/25 of a second, you can, however, make some extremely interesting pictures, as, for instance, a train just pulling out of the station, a steamer leaving her dock, and numerous other objects in slow motion. When making slow-speed exposures, the best results are had by taking the picture at an angle instead of broadside on, as this not only cuts down the apparent speed at which the object is moving but also gives a pleasing perspective to the picture.

HIGH-SPEED EXPOSURES

To take pictures of objects and subjects in which all or parts are moving swiftly at close range, and often broadside on (commonly the case in newspaper work), requires a camera in which the operator can see the image full size, exactly as it will appear on the film at the instant of exposure, and a lens which will work at an aperture of at least $f/4.5$ with a shutter that has a speed of 1/500 of a second or faster. Recommended cameras for this type of work: Crown Graphic, Leica, Contarex, Nikon, Canon, Hasselblad, Exakta, Robot, Leicaflex, Yashica, Mamiya C330 or RB67, Rolleiflex 2.8F or SL66, Rolleiflex SL35, Fujica G-690, Koni-Omega.

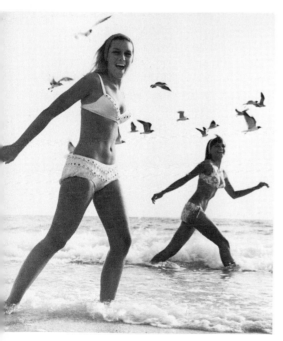

ACTION is often best expressed by shooting more slowly than is necessary to freeze it. The slight blurring of the birds in the background, which were moving faster than the shutter, helps suggest movement of the sea nymphs in the foreground. Shot at $f/11$, 1/250 second.

The horse and rider, on the other hand, were caught at the peak of the action, but with just enough movement in the head of the horse and the hooves to make the shot interesting. Exposed at $f/8$, 1/500 second. Both photos were made on Eastman Kodak *Tri X* film, developed in D 76. The camera was the 4 x 5 Pacemaker *Crown Graphic*.

FORMULA FOR FINDING THE EXPOSURE
FOR AN OBJECT MOVING ACROSS THE FIELD

Let D = the distance of the object in feet from the camera, F = the focal length of the lens, S = the speed of the object in feet per second, and E = the exposure for the object which is moving across the field of view, then

$$E = \frac{D}{100\, F \times S}$$

This isn't as difficult as it looks. Keep in mind that 3 miles per hour (the rate at which *walkers* travel) is 4.4 feet per second (S); that 25mm being equal to one inch, a 50mm lens is rated 2 (F). Therefore, the formula for snapping someone walking in front of my Leica and its 50mm Summicron, at a distance of 25 feet, gives me an answer of 1/35.5 of a second. The nearest marked exposure on my camera, then, would be either 1/30 or 1/50 of a second. I'd settle for 1/50. The formula works out this way: $E = D$ (25 feet), divided by 100 F (100 x 2 inches), times S (3 miles per hour, or *4.4 feet per second*). In other words, mathematically speaking, $E = \dfrac{25}{200 \times 4.4} = \dfrac{25}{880} = \dfrac{1}{35.5}$. If the distance between the walker and my camera were only 10 feet, the formula would become $\dfrac{10}{880}$ or $\dfrac{1}{88}$; and for that, a shutter speed of 1/100 of a second would be about right.

TABLE OF SHUTTER SPEEDS FOR MOVING OBJECTS

The table (page 290) gives, roughly, the shutter speeds necessary for various moving objects, using a lens with a focus of about five inches. For lenses of other focal lengths, multiply by the reciprocal. For example: to find the speed for a 2-inch lens, multiply by 2/5. Photographing a foot race with a 2-inch lens, we would only need a speed of 1/200 in column B instead of the 1/500 required for the 5-inch lens. Column A is for objects moving directly toward the camera; column B for objects moving obliquely toward or from the camera; and column C is for objects moving directly across the field of view, that is broadside on.

The formula and table given below show the shutter speeds that must be used to make negatives which will be sharp enough for *direct*, or *contact*, printing. For enlarging, give at least one-half to one-fifth these shutter speeds (1/20 to 1/50 for street groups under B, for exam-

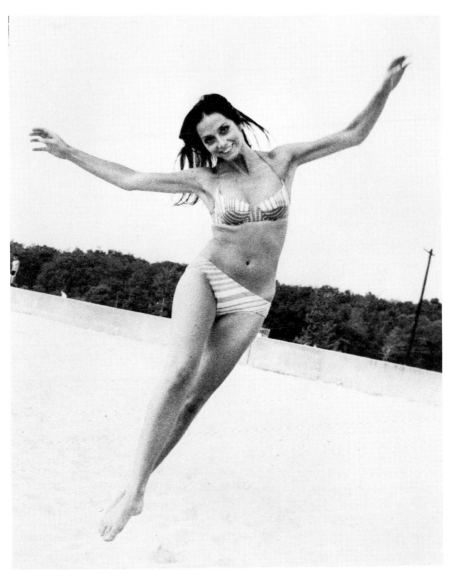

This delightful action shot of a bikini-clad model jumping is the work of *Dominique*, an ex-missionary who left the priesthood to begin a career in photography. Born near Salerno, Italy, he now lives in New Jersey. He used a Nikon F and a 28mm Nikkor lens at 1/250 second, with Tri X Pan film at f/11, developed in D 76.

ple), or take the picture further from the object. For a 2x enlargement give ½ the time; for a 3x enlargement give ⅓ the time, etc. These figures are not a guide to exposure; this can be found with a meter.

SHUTTER SPEEDS FOR MOVING OBJECTS

DISTANCE OF OBJECT 25 FEET, UNLESS OTHERWISE STATED	A ↓	B ↗	C →
	FRACTIONS OF A SECOND		
Street groups (no rapid motion)	1/5	1/10	1/20
Pedestrians (2 miles per hour)	1/20	1/40	1/60
Animals grazing			
Pedestrians (3 miles per hour)	1/30	1/60	1/90
Pedestrians (4 miles per hour)	1/40	1/80	1/120
Vehicles (6 miles per hour)	1/60	1/120	1/180
Vehicles (8 miles per hour)	1/80	1/150	1/280
Cyclists and trotting horses	1/160	1/300	1/500
Foot races and sports	1/240	1/500	1/700
Divers	1/300	1/600	1/800
Cycle races; horse galloping	1/300	1/750	1/900
Yachts (10 knots) at 50 feet	1/60	1/120	1/180
Steamers (20 knots) at 50 feet	1/120	1/240	1/360
Trains (30 miles per hour) at 50 ft.	1/150	1/300	1/450
Trains (60 miles per hour) at 50 ft.	1/300	1/600	1/900
Humming birds in flight	1/500	1/750	1/1000
Racing motor cars (90 miles per hour) at 50 feet	1/600	1/900	1/1200

At 50 feet the exposure may be half of that at 25 feet (1/100 instead of 1/50).
At 100 feet the exposure may be half that at 50 feet.

THE DISTORTION CAUSED BY THE FOCAL-PLANE SHUTTER

Since the focal-plane shutter exposes only a part of the film or plate at a time, the picture of the object thus taken, if the slit in the curtain of the shutter is very narrow and the object is moving ahead fast enough, will be distorted. As an illustration, suppose that a cyclist is moving broadside or across the axial line of the lens and that the narrow slit in the curtain moves across the film or plate from the top to the bottom. Now since the image of the cyclist is inverted and the slit in the curtain moves down, it is easy to see that the lower part of the cyclist will be registered on the film first and the upper part will be exposed last. The result is that in the interval of time which elapses between the exposure of the lower part and that of the upper part of the cyclist, he has moved forward in space. This makes the upper part project too far ahead; thus the picture is distorted, even to an untrained eye.

Another instance of the distortion caused by the focal-plane shutter is often seen in the pictures taken of a racing motorcar. In this case the car looks as if it were getting ahead of itself. This curious effect is due to the same cause explained above, but the distortion is even more obvious because the speed at which it is moving is greater. This defect

A NIKON SHOOTS A WILD KARMANN GHIA. The only difference
between an amateur and a professional photographer is ingenuity, patience,
and a couple of hundred feet of film. This unusual shot of a Volkswagen
Karmann Ghia in motion first appeared in *The New Yorker* of April 17, 1971.
I was curious about how they got that effect, so I checked with Bill Bernbach
of the Doyle Dane Bernbach advertising agency.

Harold Krieger and his associate Jerry Rosen did the actual shooting.
It was all done photographically; no retouching. They used a *white* car and
drove it around the Freeport Raceway on Long Island (which has a *black*
macadam roadbed). The camera was a Nikon with a 21mm wide-angle lens
(to assure sharpness at almost any distance); the film was 35mm Tri X,
developed in D 76. Several hundred exposures were made at various shutter
and lens combinations as the car raced around the course, some panning (see
Index) with the car and some against.

does not, as a rule, detract from the value of the pictures for newspaper
work, but it has undoubtedly caused no end of wonder.

HOW TO PREVENT SHUTTER DISTORTION

There are four ways to overcome focal-plane distortion. They are:
1) by increasing the width of the slit in the curtain, which happens auto-

matically in modern FP cameras when you reduce shutter speed; 2) by stopping down to a smaller aperture; 3) by following the action (panning or swinging) with the camera; and 4) by turning the camera so that the curtain is moving in a direction opposite to that in which the image is moving. What this does is to correct the image distortion caused by the narrow slit of the shutter (see page 290).

In the Speed Graphic, the curtain is like a window shade, on two rollers, with slits of five different widths. The focal-plan shutter of the Leica, on the other hand, has a slit of variable width instead of fixed slits. The film-winding mechanism has been geared to the shutter-winding shaft so that both operations are performed with just a thumb-flip of the lever. The Leica shutter is composed of two curtains, the separation between the ends forming the slit of varying width. The size of the slit (and the tension of the shutter) is determined when you set the exposure speed.

SOME HINTS ON HOW TO TAKE ACTION PICTURES

1. Press the shutter release *just* before the action peaks to allow for time lag between the eye seeing it and the brain sending an impulse to the muscle.

2. Outdoors in bright sunlight, Ivan Dmitri used 1/500 for his superb action shots of horses in motion. With Tri X, this would require $f/16$ or $f/22$, depending on the developer and the angle of lighting.

3. To express action in a picture, the exposure should be made just at the beginning or the end of the action. See photo at the beginning of this chapter.

4. The best shutter speed for pictures of the sea is 1/100 of a second. A slower speed would ruin definition; a faster speed would freeze the action.

5. Compur shutters are capable of giving speeds that are intermediate to those marked, except between 1/10 and 1/25 and between 1/100 and 1/250. Compur is the name of a diaphragm leaf shutter invented in 1912 by Friedrich Deckel of Munich, in which the speed of the blades that open and close the shutter is controlled by an intricate clockwork mechanism and gear train. Other leaf shutters of this type are manufactured by Prontor, Sekosha, Copal, Alphax, and Citizen.

6. To catch rapid subjects at slow speeds, follow the action (pan or swing) with the camera. The background will be blurred, but the subject will be clear.

7. The trick in taking all moving subjects is to avoid stopping the motion completely, otherwise the moving object will seem to be standing still. In basketball, show the ball falling into the net, with the player

jumping, his hands out in front of him; in swimming, show the diver during that moment of hesitation when the diving-board-jump stops, and gravitation takes over.

EYES CLOSED?

Were your subject's eyes closed when you took that flash picture? Ask if the flash appeared *pink* or *white*. If pink, you had better take another shot because closed eyelids would have made it seem pink.

Flash Photography

The first edition of this book, published more than 30 years ago, had quite a section on magnesium flash lamps. What devilish devices they were! A spark would ignite the magnesium, which would then explode with a blinding flash, after which a dense, acrid, white smoke would fill the air. We have traveled a long way since then. The invention of the flashbulb has made it possible to take pictures at any time and under the most adverse conditions, and today you can stuff a carton of minibulbs like the AG-1 into a pocket and have enough bottled sunlight for almost any photographic need.

The first appearance of the GE No. 5 midget bulb, soon followed by the Wabash Press 25 in the early 1940's, was a great advance in flash photography. After that came the still smaller Bantam 8 bulb, which is half the size of the No. 5, but needs only half an f/stop more.

In January 1956, General Electric brought out the tiny but powerful Powermite M2. This bulb was designed for the nonadjustable cameras and for all those having X or F synchronizer settings. Giving about half the light of a No. 5, though only ¼ the size, it is ideal for closeups and for medium-distance shots. It requires a special 3″ reflector, for contrasty directional light, or an almost flat reflector for softer results. In 1965 GE offered the M3 with a *rhenium* igniter.

Another improvement in flashbulbs was the importation by Amplex, in November 1956, of the PF1 baseless bulb (similar to the GE Powersprite AG-1). This reduced the cost of flashbulbs by half. A permanent adapter base fits into your flashgun. A pair of exposed wires, one on each side of the all-glass bulb, assures positive contact as the bulb is seated.

In 1965 Sylvania brought out the four-shot *flashcube*, which was first used in the *Instamatic* cameras, but was then adapted for use in *all* cameras. Agfa, Minolta, Soligor, Yashica, and Canon are just a few of the companies that produce flashcube adapters. Rowi has devised one that can even be tilted—to *bounce* the light. The Minolta Autopak 800 camera also uses a flashcube, but *decides for you* whether you need it or not. If there is enough light without it, the flashcube doesn't flash.

The *flashcube* was followed, in 1970, by Sylvania's and General Electric's production of the *Magicube,* which was also a *four-shot* but, unlike the flashcube, needed no batteries. The firing system uses a torsion spring held under tension by *an upturned pin* at the end of a spring arm. This is placed inside the flashcube, and released when the arm is moved up. It then strikes the bulb base, which sets off the detonator, which ignites the flash. The link to the camera is a striking pin which extends from the flashcube to a lever connected with the camera shutter. As you release the shutter, the lever raises the spring arm, which releases the torsion spring.

Subsequently, GE developed a *supercube,* which it heralded as an improvement on the electrically-fired *flashcube.*

Supercube is the GE *Hi-Power* flashcube. It produces 2½ times the light output of a standard flashcube. Its first use was in the Polaroid 450 camera, where it became part of *Focused Flash* (louvers control the light, *automatically*). Focused Flash measures the exact amount of light you need at any distance. As you focus for a closeup, for example, the louvers partly cover the flashcube, preventing burn-outs. Similarly, as you focus on a more distant group, about 10 feet away, the louvers open wide to give the powerful light extra reach.

Though Focused Flash with the supercube (GE *Hi-Power*) was first released for exclusive use in the Polaroid, it should soon be available for other cameras as well.

A wide variety of flash synchronizers is now available to meet almost every purse, and more and more cameras—even cheap ones—are appearing on the market equipped with built-in synchronizers which require only the simple connection of a battery case and reflector.

Flash, today, is an essential part of photography. Without it, it is impossible to make certain kinds of action shots. Also, it is often the only way to get natural, unposed pictures.

Using flash in large interiors. In big halls such as churches, movie theaters, or museums, midget bulbs (like the #5, #25 or AG-1) are most useful. There is one problem, however. The flashing usually annoys the other visitors (and often it upsets the actors, or those trying to carry on services). The best way to handle this problem is to arrange things in advance. Choose a day or a time to avoid the busy periods, and ask for permission to use flash or a tripod. Sometimes, if you're lucky, they'll let you do it. The Louvre in Paris is the most difficult; the Cloisters in Manhattan is the most gracious.

If you can get a battery-powered movie light, or a single-bulb photoflood (which should also be battery-powered), you may be able to use that technique for lighting interiors known as *painting with light* (see page 258). It works well in large, dimly lit places, provided they let you

use any supplementary light at all. You have to avoid glare on walls or paintings. And remember, *your camera must be on a tripod,* with the shutter open, at B (bulb) or T (time), and at an aperture of $f/16$ or $f/22$. Exposure may have to be a guess, but with Tri X, at $f/16$, you will get a printable negative with an exposure of from 2 to 5 minutes. Bracket your exposures: make three, one at 2 seconds, one at 1 second, and one at 4 seconds. One of these should do.

You can also use flash, of course, in which case the exposure can be determined in the usual way for each shot, using the open-flash guide numbers marked on the carton of bulbs. Cover the lens between flashes, to prevent stray light from entering.

Flash is also ideal for photographing children and animals, whose unpredictable activity makes the problem of shooting them with ordinary photoflood lamps very difficult. Flashbulbs do away with the uncomfortable heat and glare of photofloods which frequently cause squint and other evidences of strain in the expressions of babies and children.

Flashbulbs have still another valuable use: to fill in shadows in outdoor photography. This is called *fill-in flash* or *synchro-sunlight* flash. In photographing people in direct sunlight we are often confronted with the problem of extreme contrast. Such lighting usually casts large shadow areas over the faces. A flashbulb, properly placed, will throw enough light into these areas to counteract the shadows.

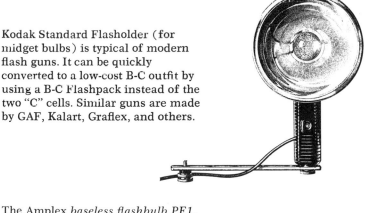

Kodak Standard Flasholder (for midget bulbs) is typical of modern flash guns. It can be quickly converted to a low-cost B-C outfit by using a B-C Flashpack instead of the two "C" cells. Similar guns are made by GAF, Kalart, Graflex, and others.

The Amplex *baseless flashbulb PF1,* which strikingly reduced cost of flash photography by eliminating the need for a metal base. It can be fitted to any bayonet-base flashgun by means of an inexpensive adapter base. New flashguns have been designed to take these bulbs directly.

The softness of the *synchro-sunlight* exposure almost did justice to this lovely model. The sun was overhead, about 15° from the vertical. The film was Eastman Kodak *Plus X*, developed in *Microdol X*.

Exposure for synchro-sunlight (sunlight fill-in). When combining sunlight and flash, base your camera setting on the sunlight, and use the flash as a supplementary light to soften shadows, avoid subject squint, and make it possible to use the sun for side or back lighting (which is much more comfortable for the subject, and usually makes for a better picture).

To *avoid overflashing*, don't come closer with the flash than is indicated by the guide number divided by the lens aperture.

This is what you do: determine your daylight exposure in the usual way. Let's assume it's *f*/8 at 1/100 second. Take your guide number (you are using an AG-1 bulb, class M, with a film of ASA 125 speed; reference to the table on page 301 indicates a guide number of 100) and divide that by the lens aperture (*f*/8). In other words, 100 divided by 8. This tells you where to place your flashbulb (distance from subject, in feet). The answer, of course, is 12½ feet.

Caution: if the subject is moving, and your shutter is working at 1/50 while your flash is working faster, you may get a double or *ghost image*. You can eliminate this by using a faster shutter speed (except with focal-plane shutters, which are pegged to speeds of 1/30 to 1/60). With FP shutters, use SF or SM bulbs, which have a flat peak (burn more slowly) and thus parallel more closely the speed of the shutter.

Don't forget to use *blue* bulbs with daylight color film.

For softer results and better flash quality indoors, try *bounce flash* (see index, *bounce light* and *flash*). To calculate exposure, measure the distance to the ceiling or wall *and back*, then divide your normal guide number by this figure, but open up 2 *f*/stops to compensate for light loss. Another useful technique for soft results is *bare-bulb* flash, if you can remove reflector from gun and *hold gun away from the camera*. As in bounce flash, open up one to two lens stops, depending on size and color of room. *Caution:* never use bare-bulb flash at the camera, unless you are using a transparent plastic cover for protection.

If your camera is not equipped for synchronized flash you can still take flash pictures of portraits, groups, or still lifes without difficulty. All that is needed is an inexpensive hand-battery case and reflector, which can be purchased for a few dollars. The procedure is called *open flash*, and it works this way: You place the camera on a tripod or other support, set the shutter on time or bulb, open the shutter, fire the bulb (an M2 or 5, SF, SM, or 25), then close the shutter again. The flash itself, which has a duration of about 1/50 to 1/200 second, acts like a shutter.

To get the effect of a speed flash without synchronizer equipment *for action pictures*, use open flash, as above, but substitute an SM or SF bulb. The flash of these bulbs is equivalent to 1/200 second synchronized flash. Where the action requires more speed, a flash synchronizer must be used. There are many good ones on the market. Shop around before you buy. Look especially at the ones made by Leitz, Nikon, Kalart, and Graflex.

While flash photography may seem complicated, it isn't really. In its simplest form, one bulb is used, usually clamped to the camera, but best results are obtained with two or more bulbs, as in the case of making pictures indoors with flood lamps. It goes without saying that one should learn the principles of lighting by using photoflood lamps before

going on to flash. By practicing with photofloods one can see exactly what effect a lamp at a certain position has on the subject.

Caution: Don't keep the flashgun *on* the camera unless you want washed-out, contrasty faces. Get a unit that *can* be taken off the camera. Hold the light above and to the side of the camera, at arm's length, and pointed down at about a 45° angle. A fill-in on the shadow side (either by supplementary flash or a reflector) will improve modeling and quality. For that, see *slave units,* later in this chapter.

CALCULATING EXPOSURE WITH FLASH

The problem of determining correct exposure with flashbulbs has been greatly simplified in recent years as a result of a simple discovery by Percy W. Harris, editor of *Miniature Camera Magazine,* who found that with a given flashbulb and a given emulsion speed, the distance in feet (from object to flash) multiplied by the stop number equaled a constant factor. This does away with complicated calculations, for once you have this flash factor for any given flashbulb, the correct stop for any distance (from object to flash) is determined by dividing the factor by the distance in feet. Conversely, if you wish to determine at what distance the flashbulb should be placed from the object for a predetermined stop, you divide the flash factor by the stop.

This factor system has been worked out by the manufacturers of flashbulbs, who in their exposure guides provide the factor numbers (usually referred to as *Guide Numbers* or *Flash Numbers*) for all bulbs and all films. A consolidated table giving the guide numbers for both between-the-lens and focal-plane shutters, will be found on page 301.

This table gives the guide number of each bulb for the film and shutter speed used. As an example of how to do this, let us assume that you have decided to use a Press 25 (No. 5) bulb with Verichrome Pan film (which has an ASA tungsten rating of 125), in your camera. You have decided to make your exposure at 1/100 second. In the table you find that for this bulb, shutter speed and film combination the guide number is 250. If you have placed your flashbulb 13 feet from your subject, you divide the guide number, 250, by the distance, 13, which gives you 19. This is your f/stop. You set your diaphragm at about f/19 and shoot.

If you should decide to use a second bulb at approximately the same distance and at an angle of from 0° to 10° from camera to subject, one full f/stop smaller should be used. Additional bulbs placed at wider angles from camera to subject for use as side or backlighting may be ignored.

Inexpensive *dial guides* are available to simplify these calculations; among them are the ones in the *Kodak Master Photoguide.*

How to synchronize flash (or electronic flash) and sunlight. For flash fill-in to soften shadows, set exposure (f/stop) as for sun, and use just enough flash or electronic flash to lighten shadow by adjusting distance of bulb. Shutter speed is then determined as explained on page 128. See also pages 296–297.

FEATHERING (BALANCING) LIGHT

When you have the problem of balancing flash exposure for near and far subjects (in a large room or around a big table), tilt the flash away from the nearest object to favor the farthest. This will prevent the light from petering out at the back, and will equalize your exposure. This technique is known to photographers as *feathering.*

Assuming that your flash head distributes light normally, this is what you do:

1. Position the flash above the group (using a floodlight tripod) and aim it at them.

2. Now tilt the reflector upward until the nearest subject can just see the base of the lamp socket.

3. Connect the unit to the camera shutter with a long extension cord (about 20 feet).

4. Measure the distance from the lamp to the nearest subject and calculate the normal exposure.

5. Now open the lens two stops more (as from f/8 to f/4).

If you are feathering *sideways,* tilt the reflector away from the nearest subject and aim it at the farthest (making sure that the nearest subject can still see the lamp base, as above). But in this case, use the normal exposure for the distant subject.

MAIN LIGHT VS. FILL LIGHT

Here's a simple way of deciding where to put your fill-in flash, using the aperture numbers on your lens as a scale. These numbers form a handy series of lamp-to-subject distances (in feet): 2 · 2.8 · 4 · 5.6 · 8 · 11 · 16 · 22. The periods between the aperture numbers are half-stops (and also measurements in feet).

Do this: Set your main light at any aperture number, let's say 4 (which also means 4 feet).

For a 3:1 light ratio, your fill light should then be set one full stop away (at 5.6) or a little more than 5½ feet.

For a 4:1 ratio, your fill light can be set a stop-and-a-half away (between 5.6 and 8) or a bit more than 6 feet.

For a 5:1 ratio, set your fill light two stops away (at 8) or 8 feet.

Your main light can be placed at any distance from 2 to 22 feet. For a 3:1 ratio, with the main light at 8 feet, you place the fill light at 11 feet.

RED EYE

Sometimes, when you are taking flash pictures of people (especially little children), you may get an effect known as *red eye*. On monochrome film, the pupil of the eye looks strangely light; on color film, the pupil looks *red*. This eerie effect is caused by internal reflections in or near the retina of the eye. It can be prevented by increasing the distance between the flashbulb and the lens of the camera, if the flash can be removed. Kodak makes a Magicube Extender which lifts the Magicube about three inches above the lens, but it can only be used with Instamatic X type cameras and Magicubes. Otherwise, red eye can be minimized by placing the subject in a brightly lighted area.

Electronic Flash

This has often been misnamed *strobe light*, which is like calling all electric iceboxes *Frigidaires*. The name *strobe*, which originally derived from Dr. Harold E. Edgerton's *stroboscopic* lamp, is now the legal property of Graflex Singer.

Electronic flash is also sometimes referred to as *speedlight*.

Your camera must have provision for "X" synchronization before you can use a speedlight—but this is becoming standard, even in the less expensive cameras. You usually have a choice of three power supplies: 1. the *A.C.*, which connects to your house current, is compact and economical, but limits your freedom of movement; 2. the *wet-cell*, which is powerful and rechargeable, but heavy; 3. the *dry-cell*, which can deliver a flash of 1/500 second (as contrasted with the usual 1/2000 or higher), is more portable, but expensive when you consider the cost of battery replacement (though recent models have begun to use flashlight batteries). The ideal power supply for electronic flash is the *nickel-cadmium battery*, with an A.C. converter for recharging. This new type of storage battery has an extremely long life, holds its charge well, and weighs no more than the lead acid battery, but gives twice the energy and number of flashes. Since it has no acid, it does not corrode. The fact that the manufacturers guarantee its life from 5 to 10 years speaks well for its ruggedness.

Graflex (Stroboflash), Braun, Honeywell (Strobonar), Mecablitz, GE, and Ultrablitz (Bauer) make excellent electronic flash units.

FLASHBULB GUIDE NUMBERS
FOR BETWEEN-THE-LENS (AND FOCAL-PLANE *) SHUTTERS
(For f/setting, divide guide number by lamp-to-subject distance in feet.)

CLASS	FLASHBULB SIZE	SHUTTER SPEED (seconds)	FILM SPEEDS (ASA Exposure Index)				
			20–32	40–64	80–125	160–250	400–500
X F	M2 *f* POWERMITE M2 7,000 LS *a*	Up to 1/50 3" polished refl. 4" satin refl.	90 70	130 105	180 140	250 190	300 210
M X F	AG-1 POWERSPRITE AG-1 *b* 7,000 LS *a*	M to 1/50 X-F 1/100 2"–3" 1/200 reflectors 1/400	55 48 34 28	70 60 44 36	100 85 80 50	150 130 100 75	190 175 130 100
F	SF *c* SM *c* 4,800 LS *a*	Up to 1/100 1/200	110 85	155 120	210 165	300 220	360 270
M	5 *d* M3 *f* PRESS 25 *d* 16,500 LS *a*	Up to 1/50 1/100 1/200 1/500	200 150 100 75	250 200 150 100	300 250 210 150	425 350 300 200	475 400 350 250
FP *	Focal Plane 6 FP 26 17,500 LS *a*	Up to 1/50 1/100 1/200 1/400	110 80 55 40	150 100 75 50	190 160 110 75	250 200 150 100	310 235 190 155
M	22 *e* 65,000 LS *a*	Up to 1/50 1/100 1/200	200 160 130	275 225 180	400 300 250	510 420 325	610 500 400
S	50 PRESS 50 100,000 LS *a*	Up to 1/50 1/100 1/200 1/500	260 190 130 110	370 270 190 160	480 360 270 230	680 510 360 300	760 650 450 375

Continued on page 302 (with explanation of use)

* Use only #6 or FP 26 bulbs with focal-plane shutters.
a Indicates approximate Lumen Seconds, which is the relative amount of light delivered by each bulb. Some deliver this light spread out over the full time of flash (as in SF or SM type); others pack a light punch at the peak (as in the #5 and #2).
b About half the size of the M2 bulb, easier to carry, but gives as much light.
c For use in midget reflectors; provides quick-freeze flash of between 1/100 and 1/200 seconds, even with open flash (for nonsynchronized cameras). Needs 1 f/stop more than #5 bulb.
d For use in midget reflectors specially designed for these bulbs.
e For extra light and wider coverage; used in large reflectors.
f Medium size bulbs with miniature metal base for use in 3" reflectors.

FLASHBULB GUIDE NUMBERS
FOR ADJUSTABLE CAMERAS

| | ASA FILM SPEED | | | | |
SHUTTER SPEED	25–32	40–64	80–125	160–200	320–500
X to 1/30 sec.	55	75	100	130	200
M to 1/60 sec.	36	50	70	90	130
M 1/100–1/125 sec.	30	42	60	75	110
M 1/200–1/250 sec.	24	34	48	60	90

Explanation for use. Read guide numbers under ASA film speed for X and M synchronization at the various speeds. For f/setting, divide guide number by flash-to-subject distance *in feet.* Open one stop more if used in large rooms or for outdoor night exposures.

Simple camera shooting distances: All color film types, 4–9 feet; black and white film, 4–15 feet.

Pictures made with speedlights, because of the split-second duration of the flash, freeze action completely, which is not always desirable. The slight blur of motion recorded with the slower shutter speeds used with flashbulbs gives a more realistic portrayal of action. Speedlight pictures of boxers, basketball players, or dancers give the subjects more the appearance of statues than of real people in motion.

Speedlights certainly widen the range of photography and for many purposes are definitely a boon. Press photographers make extensive use of them in sports coverage where it is practical to carry the power pack, and studios specializing in baby and child portraiture find them a godsend because they are much easier on the child than floodlights or the slower acting flashbulbs; and they recycle fast, which makes it unnecessary for the photographer to fuss (fussing makes the child nervous). As the size and price of these electronic flash units has come down, the amateur use of these portable suns increased. The light matches sunlight in sharpness and color. Perfect for color fill-in outdoors, electronic flash is also ideal for simulating sunlight indoors when your camera is loaded with outdoor color film. No conversion filters are required under these conditions, which is a comfort to the gadget-ridden photographer.

Other electronic flash units:

Vivitar 151. Operates on AC or standard AA penlight batteries. Can be used horizontally or vertically. Guide number is 30 for Kodachrome II, 55 for Kodacolor X.

Capro FL-6. Built-in *nickel cadmium* batteries. 120 flashes from a

3-hour charge. Amber flash tube keeps subjects from turning blue. 3-position swivel mount makes it possible to use unit horizontally or vertically. Guide number is 30 with Kodachrome II, 55 with Kodachrome X, 60 with Kodacolor X. Recycles in 3 to 5 seconds.

Graflex Strob 350. Variable power unit, uses a *nickel cadmium* battery, producing a light output of 3600 ECPS at full power, with a recycling time of 8 seconds. Recharges in 3 hours to full capacity for 100 flashes. Moisture-protected switch. Lamphead provides circular light of 52°, which can be extended to 80° with an accessory lens. Exposure calculator for film speeds ASA 25–1600. Capacitators automatically discharge when unit is turned off. Open flash button.

Automatic Electronic Flash

Automation has begun to take over photography in earnest. Now there's a slide projector (the Kodak Carousel 860 H) which focuses itself after the first slide is focused manually. Coming from Polaroid is a camera which can focus itself via sonic pulses and also set exposure automatically. And you remember the Minolta Autopack 800, which will not fire a flashcube if you have enough light without it.

The latest brain-saving device in electronic flash units is one that *automatically computes the exposure as it flashes at the subject.* These units were pioneered by Honeywell, which now offers the *Auto/Strobonar 332* (illustrated on page 305), as well as the *Auto/Strobonar 770* (portable one-piece) which automatically controls exposure for subjects from 2 to 22 feet, using a built-in sensor that reads the flash *reflected* from the subject and cuts off the exposure at precisely the right moment. The flash duration range is 1/100 to 1/50,000, and it operates on rechargeable *nickel cadmium* batteries, on AC, or on battery-and-AC. It can also be operated manually, with a flash duration of 1/1000. It has a guide number of 80 for ASA 25 color film, 80 flashes per charge; and a recycling time of 5 to 15 seconds, depending on whether you use batteries, AC, or AC-and-batteries. Coverage: 50° horizontally and vertically. The *Auto/Strobonar 880* (portable, two-piece) duplicates the 720, except for the better recycling time of 2 to 4 seconds provided by a *non-rechargeable high-voltage battery.*

All these use a *quench tube* (based on an Edgerton patent licensed to *Honeywell*) which shortens flash duration in proportion to the amount of light reflected by the subject to a CdS receptor cell on the flash unit. *Lowe Optatron* of Germany has an alternate method for reducing the effective flash output when the subject is close. Electronic flash guns with the Lowe Optatron system of exposure control have not as yet reached the United States market.

GRAFLEX *STROBO-MATIC* 500 RG (NICAD) ELECTRONIC FLASH. High voltage, high intensity light source. Also available as 500 HV (dry battery) and 500 AC (house current). RG unit uses *nickel cadmium* rechargeable battery.

BRAUN F700 FAST CYCLING NICKEL CAD ELECTRONIC FLASH. Uses 2 *nickel cadmium* batteries; delivers 400 flashes per charge at full power; 800 flashes at half power. *Kodachrome* guide number (ASA 25) is 85. Batteries are latest GE type, which cannot be damaged by overcharging. Has pushbutton controls; full/partial power.

BRAUN POCKET SIZE NICKEL CAD/AC ONE-PIECE UNIT. *Kodachrome* guide number is 37 for the F110; rechargeable *nickel cadmium* batteries and AC. All feature open-flash button, direct-reading exposure calculator, and neon-ready light. F280 also has a charge-indicator light. Battery charger/AC attachment supplied with each unit.

HONEYWELL AUTO/STROBONAR 332 ELECTRONIC FLASH. One-piece unit; *automatic* computer light for exposure control; can also be operated manually. *Kodachrome* guide number, 40; power supply, AC or *nickel cadmium* rechargeable batteries (50 flashes per charge); beam angle 50° vertically and horizontally. 50 flashes when fully charged; 30 flashes in 20 minute recharge; 10 flashes in 5 minute recharge. Flash duration 1/1000 to 1/50,000 second on *automatic* (which would need 25 per cent more developing time), 1/1000 second on *manual*. Recycles in less than 9 seconds to 65 per cent of full power, at which time the ready-light goes on. Other Honeywell automatic units worth checking: *Auto/Strobonar 220*, which works on AA alkaline batteries; *Auto/Strobonar 227*, designed for the 400 series Polaroid Land cameras.

HONEYWELL AUTO/ STROBONAR 880 ELECTRONIC FLASH. Built-in sensor reads reflected light 2–22 feet away; flash cuts off automatically at correct exposure. Uses high voltage battery (2–4 seconds recycling time) or AC (7 seconds). Guide number is 80 with *Kodachrome* (ASA 25). Angle of coverage 50° horizontally and vertically. Has outlet for *Prox-O-Lite* (ring light).

BRAUN F111 ELECTRONIC FLASH UNIT. Guide number is 42 with *Kodachrome II* (ASA 25); light output 1400 BCPS; uses rechargeable *nickel cadmium* battery with safety interlock to prevent charging while on; 9 seconds recycle time; 55° square angle of coverage; 50 flashes per charge. Flash duration 1/1300 second. The camera is a Ricoh Singlex, which has a *metal* focal-plane shutter.

A further refinement of the automatic electronic flash is the *instant recharge*, as offered by Braun in their *F 245 LSR.*

The Braun F 245 LSR is an unusual automatic flash unit, the special virtue of which is its ability to recharge almost instantly. Using a *nickel cadmium* battery, this unit and its supplemental AC quick charger, can replenish its power so rapidly that *the energy used by a single flash is replaced in 60 seconds.* After 10 minutes, 10 flashes have been replaced. A red light starts to glow on the charging plug as soon as the flash is connected and high-speed charging has started. It remains lit until the battery is fully charged, at which time the rapid charging stops. Then a small white light on the flash unit indicates that a trickle charge has replaced the other. This can stay on indefinitely without harm to the battery. The guide number is 70 with a film of ASA 50. Flash duration is 1/1000 second. When set on *automatic,* the working range is from 18 inches to 17½ feet, and the flash duration varies between 1/1000 second and 1/25,000. Recycling time is 9 seconds, and the angle covered is 50° horizontal, 53° vertical.

Other automatic electronic flash units:

Metz Telecomputer Mecablitz 196. Built-in *nickel-cadmium* rechargeable battery. AC charge 110/220. Recycles in 8 seconds on battery, 30 seconds on AC. 16 hour battery recharge time; 65 flashes per charge. Automatic minimum to maximum distance 3.3 to 23 feet at f/2.8 automatic f/stop; 3.3 to 14 feet at f/5.6. Also check models 193, 196, and the professional model 202 (which seems to be the only unit designed for *bounceflash.* It allows the flash head to point up while the sensor is still aimed at the subject).

Rollei E 34C. It is not surprising that Rollei was among the pioneers of automatic flash. This sophisticated one-piece unit is typical of their production. It has a rechargeable *nickel cadmium* battery. Twin sensors have been placed just below the reflector screen. These scan the subject over a small 15° angle, which makes accurate exposure easier. Also, the twin sensors can be covered by a clip-on neutral density filter which can be used in closeup work (to adjust flash duration). This is especially useful to avoid reciprocity failure and color imbalance. The AC charger can be adjusted from 110 to 240 volts. 110 flashes at half power; 60 at full. Can also be used on manual. The battery is easily removable, by unscrewing the handle base, so an extra charged battery can be taken on trips.

Vivitar Auto 281. Operates *automatically* from 2 to 21 feet, or you can switch to *manual.* The built-in *nickel cadmium* battery can be completely charged in 1 hour; in 15 minutes it will charge enough for 20 flashes; in 5 minutes, enough for 8 flashes. Recycles in 6 seconds on battery, 7 seconds on AC. Has built-in battery-saving circuit (1C mod-

ule). Plugs into 120/220 volt outlets, which means it will work here and abroad. Has a guide number of 60 with Kodachrome II, 110 with Kodacolor X, 150 with HS Ektachrome. Has an illuminated calculator dial for use in dim light. Flash tube is color corrected to match noon daylight. Swivel head makes horizontal or vertical use possible.

B-C (Battery-Condenser) Flash

This battery-condenser (or *capacitor*) system of flash (introduced by Busch, Jen, and Kodak in 1951) has been a real breakthrough for flash photography. It not only gives the photographer more power (as many as seven bulbs can be *perfectly* flashed on 100 feet of cord, provided they're wired in series), but it also makes him practically independent of such uncertain factors as age of battery, condition of metal contacts, and temperature. Besides, the peaking time of flash lamps fired by a B-C circuit is much more uniform.

Ordinary flash works on a direct circuit between batteries, bulb, and solenoid; that's why the batteries have to be at peak strength for efficient operation. B-C, on the other hand, works this way: A small 22.5 volt B battery (the kind they use in hearing aids) feeds power to a condenser which stores the power until you're ready to make the exposure. The circuit is so ingeniously wired that no current flows between battery and condenser until a flashbulb is inserted into the flashgun socket. Then the condenser begins to fill up (it takes no more than two seconds!) and you are ready to flash. Though the small B battery replaces the three large batteries normally used, it delivers fifteen times the voltage wallop of those regular 1.5-volt flashlight batteries. Long life (up to two years and thousands of shots) and consistent synchronization are among the advantages of this new power supply. You can buy either a complete B-C flashgun unit (such as the Busch, Kalart, Polaroid, Jen, Kodak, Standard) or you can buy B-C cartridges which, with a B battery, will convert your present gun to a B-C unit. Heiland, Kodak, and Linhof manufacture these inexpensive conversion cartridges. Almost all the new flash units are now made B-C.

SLAVE UNITS

Using B-C flash, it is possible to add a half-dozen more flash units to the main light and thus get all the modeling and fill-in that we want. But not without leaving a wild tangle of wires all over the place. The way to avoid this is to use *wireless* slave units that are triggered electronically by the flash at the camera. Such units work on a photoelectric relay that is activated by the main light. This focuses the light on a

photoelectric cell or resistor connected to an amplifier which, in turn, closes the contacts of an electro-magnetic relay. By plugging this into a socket on the slave unit, the supplementary bulb is fired at virtually the same instant as the main light. Since light travels at more than 186,000 miles per second, and the "X" delay built into the unit compensates for the time it takes for the shutter to open and close, photographically speaking, there is no time delay at all.

The slave units are available either as a complete electronic flash with slave, or as slave *switches,* with a *receptor* that can be turned to face the main flash. The switch plugs into the electronic flash to activate it as a slave. These can also be used to activate regular *flashbulbs,* if you don't have another speedlight unit.

Some electronic flash units, such as the Graflex Stroboflash, have built-in circuits for slave operation, and convert to this use by the addition of a photoelectric cell. They use *thyratron* triggers, a vacuum tube-type switching device which is incredibly sensitive and uses almost no current. Other units require small capacitors which serve as a base.

The Heiland Division of Honeywell manufactures a Universal PE triggering device called the Heiland *Fotoeye Model HR53.* This unit can operate almost any electronic flash now being made.

Other good slave units: Hico-Lite Model 228, with PE (photoelectric) cell and booster circuit; the Green Dome, omnidirectional, with reversible double-blade connector; Spiratone Electric Eye, selenium, directional, on-off switch, PC terminal for regular sync cord; the Blonde slave, two silicon cells in series, polarized double-blade connector and DC cord outlet, omnidirectional; Spiratone Micro slave, two silicon photo cells, two non-polarized blades which can be reversed if unit doesn't trigger; Braun F21, two 30-volt batteries, PC cord connector, three sensitivity ranges, two tripod sockets; Ultima Remote Control, CdS cell, mercury battery, PC cord outlet, has front cap to prevent battery drain and suction cup for mounting on flat surfaces; FR Model 140 converts to slave operation by the addition of the FR remote control slave unit.

Cautions: 1) Keep PE cells in a light-tight box or bag. Otherwise, they may be desensitized by long exposure to strong, stray light. If this does happen, you can restore sensitivity by putting the cell in a dark place for a week or so. 2) The greatest enemy of any electronic flash unit is a long, idle stretch between flashes. It *deforms the capacitors* and destroys their ability to hold a charge. You can prevent this by flashing the unit about 5 to 10 times and recharging for about 2 hours, *at least once a month.* Read the instructions on *recharging the capacitor* in the manufacturer's manual for precise information on how to protect your speedflash.

YOUR GUIDE NUMBER FOR ELECTRONIC FLASH

If you know the ECPS (effective-candlepower-seconds output) or the BCPS (beam candlepower-seconds rating) of your speedlight unit, you can determine guide numbers by using the table shown here (reproduced courtesy of Ascor Photo Lighting Division, Berkey). Place a ruler from the ASA index of your film across the ECPS figure. Your ruler will bisect a point somewhere on the center line. Read your guide number at that point. Use the guide number as you have been doing for *flash*, to get the *lens opening* and/or *distance*. Also, see *Exposure Chart* that follows.

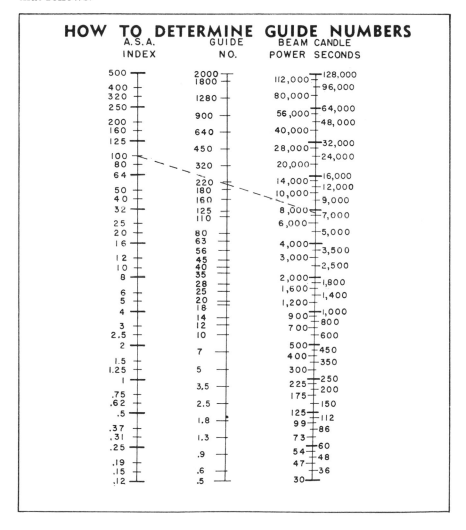

EXPOSURE CHART

(*For calculating* guide numbers, distance, *or* lens opening)

If you have any *two* of these: guide number, lens opening, or camera-to-subject distance (in feet), you can always get the *third* easily by placing a ruler or straight edge across the chart, between the two you already know. The third will be somewhere along that straight edge. For example, at 20 feet with an ƒ/8 lens aperture, your guide number will be 160. At 10 feet and ƒ/8, the guide number will be 80.

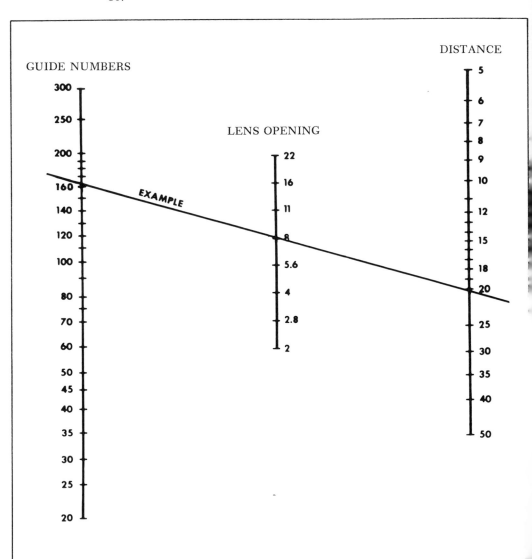

However, if you don't know the ECPS-BCPS of your unit, and can't get it conveniently from the manufacturer, you can figure out the guide number *by practical test*. The best guide number for *your* equipment is one you work out yourself, using your own equipment in your usual way, on a typical subject. Use *Kodachrome II* or *Ektachrome X* for the test because the exposure with these is more critical. With flash on camera, at a subject-to-camera distance of 10 feet, expose at these half-stops: $f/2.8$, 3.4, 4, 4.8, 5.6, 6.7, and 8. Include a record of the lens opening in each picture. After the film is processed, project the slides and choose the best one, then *multiply the f/number used by 10*. This is your guide number, for your equipment, and for your way of working. Eastman Kodak says that if this is carefully done, it is more accurate *for you* than a published guide number.

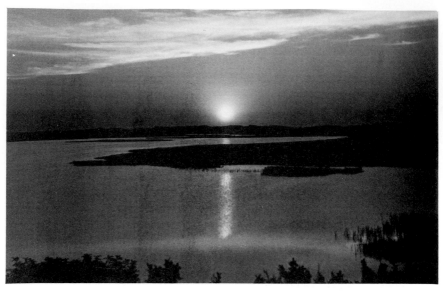

SUNSET AT PILGRIM HEIGHTS, Truro, Cape Cod. Taken with a Rolleiflex on Plus X film, developed in Microdol X, with a K2 (yellow) filter.

11 All About Filters

The most important fact to remember about a filter is that it is exactly what its name indicates, a *screen*. It *sifts* light rays. This means that *a filter adds absolutely nothing to a picture*. I know this may sound strange to some, but about the only positive thing one can say about filters is that the function of every filter is negative; it *subtracts* a part of the light, holds back certain of the rays in the rainbow of colors. All that a filter does is to convert a part of the object light to image shadow. It does this *selectively*, and that's why filters are so useful in photography. The result gives us clouds when we might otherwise lose them, darkens skies for better backgrounds, controls haze by increasing or removing it, softens shadows (or strengthens them), especially when taking portraits, lightens foliage when we want it lightened and, in many other ways, reshapes and sharpens the scene, as does the artist who works with paint and brush. For years, photography has been bad-mouthed because the camera is supposed to be able to *record* only what is placed before it. Well, the photographer *can* control his subject matter, and filtering is just *one* of the many ways by which he can do this.

The unfortunate thing about the *filter fetish,* as some have called it,

is that it leads either to hysteria ("I never take a picture without one")
or to bitter disappointment ("I wouldn't trade a plugged nickel for the
best filter; they're a racket"). It's just as silly to say that a filter can solve
all your picture problems as it is to say that it can solve none of them.
Many weird notions have been traded back and forth about filters. One
of the hardiest of these is that quaint one that "all filters require a
doubling of the exposure." Using a red filter on some orthochromatic
film in daylight would produce a blank film no matter how many times
you doubled your exposure.

To use filters effectively it is not necessary to dive into a lot of
technical charts and sensitivity curves. Let the experts have fun with
those things. All we want to know about filters is why they work, what
they do, the kinds there are, and how to use them.

How Filters Work

White light, as you may remember, is made up of seven *principal*
colors (though the spectrum is continuous). (See *Fig. 11.1.*) When a
red filter is interposed between the glass prism and a white card, certain
of the colors are absorbed by the filter (green, blue, indigo, violet) and
the rest are transmitted. You will notice (*A* in *Fig. 11.2*) that the red
rays come through strongly, the orange next, and the yellow less. This
is represented by the thickness of the lines in the drawing.

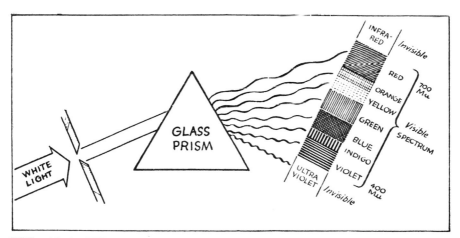

FIG. 11.1. THE DECOMPOSITION OF WHITE LIGHT

Next we try an orange filter (*B* in *Fig. 11.2*) and find that it passes
all the red and orange, some of the yellow, and none of the green, blue,
or violet.

Then we try a yellow filter (*C* in *Fig. 11.2*). This transmits all of the red, orange and yellow, a little of the green, and none of the blue, or violet.

Now we try a green filter (*D* in *Fig. 11.2*). In this case all of the blue is transmitted, most of the green, a little of the yellow, and none of the red, orange, or violet.

Finally we try a blue filter (*E* in *Fig. 11.2*) and discover that it lets through all of the violet, most of the blue, a little of the green, and none of the yellow, orange, or red.

The color of the light absorbed by any object is complementary to the color reflected or transmitted by it. We find therefore, from the action of these various filters, that

RED is complementary to GREEN-BLUE
ORANGE is complementary to BLUE-INDIGO
YELLOW is complementary to INDIGO-VIOLET
GREEN is complementary to VIOLET-ORANGE
BLUE is complementary to YELLOW-RED

The interesting thing about these complementary colors is that any pair of them (red and green-blue for instance, or yellow and indigo-violet) will create the effect of white light, or daylight. We can say, therefore, that yellow is daylight without indigo-violet; red is daylight without green-blue; orange is daylight without blue-indigo; green is daylight without violet-orange, and blue is daylight without yellow-red. All this has an important bearing on the actual use of filters, as we shall see.

Filters are *negative*, or *minus*, colors; they censor or destroy their complementaries. This action leaves blank patches on the negative, which in turn produce dark patches on the print. Keep this in mind when you use filters. Remember that you can't *add* anything to a scene or object by slapping a filter over the lens. Be sure that what the filter suppresses can be spared, and that its loss improves the picture.

Except for process filters and those made for scientific use and to get special effects, most of the filters used in amateur photography neither transmit all of any color nor do they block it out entirely. However, for general purposes, a good guide to filter use is the following brief summary of filter effects:

To photograph a color as *black* use a *contrasting* (complementary) filter. For example, a green or blue filter to make *red* go black.

To photograph a color as *white* use a *matching* (similar) filter. Or, in other words, a red or orange filter to make *red* go white.

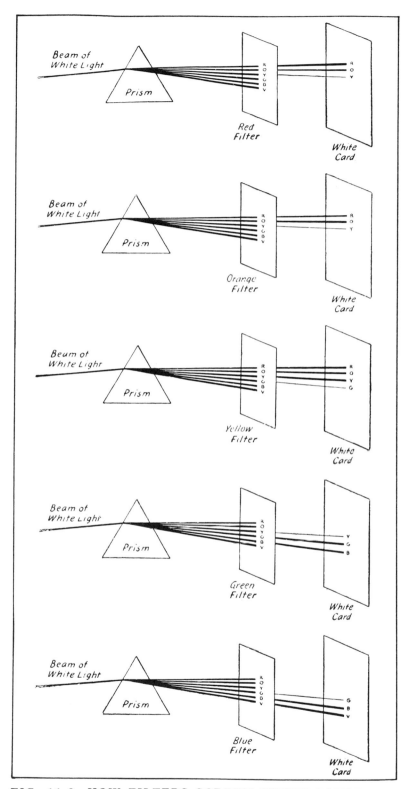

FIG. 11.2. HOW FILTERS SCREEN WHITE LIGHT

Why Photographers Use Filters

There are at least two reasons why photographers use filters: (1) to enable the emulsion to register the various colors as tones of gray more nearly the way the eye sees them, (2) to increase the contrast between these tones.

The Visual Curve

If we placed a series of color bars vertically on a card, one next to the other in the order of their decreasing wave lengths (red, orange, yellow, green, blue, violet) and then separated them by similar bars of gray tone that shade evenly from white at the top to black at the bottom, we could indicate on such a chart by means of points the intensities of gray which match the color intensities as the eye sees them. If we connected these points to make a continuous curve we would have what is known as the *visual* (or *eye*) *curve*. This would look like the outline of a mountain with its peak over the yellow and falling away gradually towards the red on one side and towards the blue and violet on the other side. What this would indicate is that the eye is most sensitive to *yellow* and least sensitive to *violet* (that being lower on the curve than the red). Now if we took the same chart and photographed it in daylight with an *orthochromatic* film [1] (sensitive to all colors except spectral red), matched up the color tones, and made another curve, we should find that it had flattened out, being very low in the red, lower in the orange and yellow, a little higher in the green, still higher in the blue, and highest in the violet. This would indicate that such a film was most sensitive to *blue-violet* and least sensitive to *red*. We see at once that this contrasts sharply with the way the eye sees things.

If we do the same thing with a *panchromatic* film (like Ilford FP4 or Plus X, sensitive to all colors) we find that the curve is just a little lower in the *yellow*, higher in the blue, and still higher in the violet, which indicates that the tonal sensitivity of such a film most nearly matches that of the eye. The crux of the situation, however, is that though the eye is most sensitive to the *yellow* region of the spectrum, photographic emulsions are most sensitive to the *blue-violet*. This explains why *blue* skies uncorrected by filters, often print as blank *whites*,

[1] Only available for commercial or professional use. But it can be bought on special order, or from European film manufacturers, who still offer it.

and why *red* lips print as *black* when photographed with *ortho* film. To make these visual and emulsion curves match, then, is one of the prime functions of filters.

We know, from the table of complementary colors above, that a yellow filter holds back the indigo-violet light and lets the yellow stream through unhampered. By placing a yellow filter over the lens when we use orthochromatic film, we *correct* the film and force it to register colors as gray tones the way the eye does.

Similarly, we know that a filter midway in color between yellow and green would hold back some of the indigo, violet and orange, in which panchromatic film is strong, while it would let through all the yellow and green, in which it is weak. A yellow-green filter, therefore, is the proper correction filter for panchromatic film.

Sometimes, however, we deliberately want to distort, emphasize, or change the contrast between colors. To do this we use *blue, green, orange,* or *red* filters. We'll explain the specific uses of such filters presently.

The Kinds of Filters

There are four general types of filters: sheets of plain gelatine film; sheets of film cemented between optically correct glass flats; dyed-in-the-mass glass; and those made of transparent plastics. The cheapest, of course, are the gelatine sheets, but they are very fragile and difficult to handle or keep flat. The cemented filters, which used to be made by Eastman Kodak, were discontinued in 1971. The all-glass filters are dyed in the mass, are accurately ground (if made by reputable concerns like Zeiss, Lifa, Optochrom, Schott, Rolleiflex, Goerz, Hoya, Vivitar, Ednalite, and Leitz) and are quite thin, which is an important consideration in view of the fact that heavy glass, especially if it is not absolutely plane parallel, spoils lens definition. The plastic filters are comparatively cheap, but cannot be surfaced as accurately as the glass flats, nor do they absorb colors as efficiently. The recommended type for amateur use is the all-glass.

A Table of Filter Facts

Reproduced below is a simple, compact color reference chart for use in altering the gray tones of colored objects:

USES OF FILTERS

COLOR OF SUBJECT	TO LIGHTEN, USE	TO DARKEN, USE
Violet	Blue	Red or orange
Indigo	Blue or green	Orange, yellow
Blue	Blue or green	Red or orange
Blue-green	Blue or green	Red
Green	Green or yellow-green	Red or blue
Yellow	Yellow, orange or red	Blue
Orange	Orange or red	Blue or green
Red	Deep red or red	Blue or green
Purple	Blue	Green
Magenta	Red	Green

What the Various Filters Do

Actually, the amateur photographer needs at most only three filters (a *yellow-green*, an *orange*, and a *red*) and he can even do without the orange or red. However, there may be occasions when other filters are called for. To help you recognize these, as well as to give you some additional clues on the use of the filters you already have, here is a description of what the basic filters can do and how to use them. After each one (in parentheses) you'll find listed one or more examples of this type of filter. We have not tried to list all the good filters of this kind now being offered. Check with your dealer to find out what others are available, and at what price, before you buy.

Yellow (Zeiss G2 or Lifa Y2). The only kind of filter to use with ortho film, which it corrects completely. Though it can also be used with pan film, it is not so effective in adjusting the visual curve differences. Absorbs ultraviolet light and some of the blue-violet. Lightens reds and pinks too much and is therefore not suitable for portraits. Good for landscapes and snow scenes and for cloud photography.

Yellow-green (Wratten K2 No. 8 or Hoya Yellow). Can be used for both *ortho* and *pan* film. It corrects type B pan completely in daylight. Absorbs ultraviolet and some blue light. Useful in darkening skies, emphasizing clouds, reducing haze, increasing contrast. Good for outdoor portraits (it darkens lips and cheeks) landscapes, distant views, water scenes, snow scenes, mountain scenes, sunsets, and for the photography of architecture. Adds brilliance to a scene of normal color distribution.

Green (Wratten X1, Tiffen, Hoya Green, or Lifa Green). For types B and C pan film. Absorbs ultraviolet, violet, some blue, and some deep red. Corrects type C pan in daylight; type B in tungsten. Though it tends

Illustrating use of the *yellow-green* (K2) filter. Made with a Rolleiflex, 1/100 second at f/11 on Plus X Pan developed in Microdol X. Enlarged on Luminos Bromide RD instant gloss paper (waterproof, rapid drying, resin-coated, does not require ferrotyping). The scene is Gay Head, Martha's Vineyard.

to soften *light contrast*, it increases *color contrast*. Good for pictures against the light, snow scenes, portraits outdoors.

Blue (Wratten C5 No. 47, Zeiss B40, Tiffen #47-C5, Spiratone Contrast Blue C5). For ortho and pan films. Absorbs red, yellow, green, and ultraviolet. Used for color separation with tungsten light. Makes an emulsion color blind (blue registers as white, other colors as dark gray or black). Increases the effect of haze outdoors. Indoors, the effect of this filter can be produced (more easily and more cheaply) by using blue photo floods. Good for copying, especially where yellows or reds have to be separated, and for photographing white objects against snow (most white objects have some yellow in them, and snow is bluish; by darkening the yellow the filter produces crisp separation). Can also be used as a monotone viewing filter.

Orange (Zeiss G4, Lifa RO, Wratten G). Absorbs ultraviolet, violet, and most of the blue rays. For pan and ortho film. Excellent for increasing contrast between colors. Lightens flesh tones and therefore good for suntanned subjects. Makes blue sky (and water surface reflecting skylight) quite dark. Improves rendition of texture outdoors in sunlight under a blue sky (by suppressing the blue shadows which create texture). Hence, ideal for rendering texture of architectural stones, sand, fabrics, outdoors. Penetrates haze, therefore it is good for mountain and airplane photography; also for contrast emphasis in studio work, and for bringing out the grain in wood furniture.

Red (Wratten A No. 23, Lifa Red, Zeiss R10). Absorbs ultraviolet, violet, blue, and green rays. For pan film. Darkens blue skies almost to black, producing spectacular cloud effects. Ideal for photographing light-colored buildings, statues, shiny metallic structures, faces against a dark sky; creates exquisite landscapes and airplane studies. Increases over-all contrast considerably, cuts haze entirely; good therefore for landscapes with distance where it penetrates mist and makes the invisible clear. Not good for shots of green vegetation, dark buildings, portraits (lips and cheeks go ghastly white), artificial light (the source usually has red in it and cancels out effect of filter). Slight underexposure with this filter produces night effects. Indoors it is useful for increasing contrast between colors (see color separation chart on page 324) as in photographing blue handwriting. It is also useful in photographing furniture (mahogany, for instance) where it helps bring out detail of the grain.

HOW TO PHOTOGRAPH ONE FLOWER: Blue sky, Rollei camera, Proxar 2 closeup lens, *orange* filter, slow panchromatic film, developed in Panthermic 777. Unless we had used the filter, the sky would have been *white*, which would not have been good as a background for the *white* flower.

Illustrating the use of a *red* filter. Rolleiflex camera,
Plus X Pan film, developed in D 76.

Illustrating the use of the *graduated sky* filter (yellow). This filter works best when used in front of the sunshade, as in the case of the Rollei cameras. Taken with a Rolleiflex at *f*/16, 1/10 second. A tripod was used.

Graduated Sky (Rolleiflex Graduated, Zeiss VG6). A yellow-green filter which is split so that only about half of it has color, the balance being clear glass. It is used mostly to compensate for contrast between sky and landscape, or foreground and background. Useful in photographing seascapes and landscapes. Requires no additional exposure.

For best effect, however, it should be held about one focal length away from the lens (as in the Rolleicord and Rolleiflex, where it is designed to be placed over the sunshade at the proper distance from the lens).

Ultraviolet (Lifa Haze, Zeiss G0). Absorbs only ultraviolet rays, which do not focus on the same plane as the other rays and therefore blur the image. At sea level, these rays have been filtered out, to a great extent, by the atmosphere and are not much of a problem; at high altitudes, however, they become very troublesome. Requires no additional exposure. Useful for mountain scenes and snow scenes.

Polarizing (Kodak Pola-Screen, Polaroid, Leitz Swing-out, Hoya, Tiffen, Enteco, and Rollei). Absorbs ultraviolet rays; transmits plane polarized rays of all visible colors. For pan, ortho, or Kodachrome. Good for darkening blue skies without distorting color rendering of foreground objects; the only filter that can be so used in color photography. Greatest effect occurs when you're photographing almost at right angles to the sun. By placing the filter over your eye and rotating it, you can tell easily

LOBSTER POTS (Digby, Nova Scotia). Illustrating the use of the *orange* (G) filter. Rolleiflex camera, Plus X film, developed in MCM 100.

which indicator position is best for the conditions at that time. (Caution: *Never look directly at the sun.*) When photographing through glass or water at an angle, surface reflections interfere with the visibility of detail below the surface; the polarizing screen subdues the reflections and shows the detail. It can also be used in the same way to bring out texture in such nonmetallic objects as grained wood, linoleum, tile, lacquered or varnished objects, glass, leather, etc. The most effective camera angle for its use is about 35 degrees to the surface. The polarizing screen at the lens only will not subdue reflections from metal surfaces; the light source would also have to be polarized. The polarizing screen is especially effective in photographing sunsets. *Caution:* When using the Leitz polarizing swing-out rotating filter with a *sunshade* on your rangefinder camera, you may find that you have *vignetted* the corners of your picture. Either get a shallower lens shade, or do without one; the filter has a lip on it which makes its own sunshade when swung back after viewing. That's why it gives you trouble when you add an additional sunshade.

COLOR SEPARATION CHART

COLOR I	COLOR II	FILM	FILTER	EFFECT
White	Black	pan or ortho	none	—
				—
	Red	ortho	yellow-green or green	—
	Yellow	ortho	blue	—
	Green	pan	red	—
	Blue	ortho	dark yellow or orange	—
		pan	red, orange or dark yellow	—
Blue	Black	ortho	blue	Blue goes white
	Red	ortho	yellow-green, green or blue	Red goes dark
	Red	pan	red, orange, dark yellow	Red goes light
	Yellow	ortho	orange, or dark yellow	Yellow goes light
	Yellow	pan	red, orange or dark yellow	Yellow goes light
	Green	ortho	dark yellow, yellow-green, green	Green goes light
Green	Black	ortho	yellow, orange, green	—
	Red	ortho	yellow, green, yellow-green	Red goes dark
	Red	pan	red	Red goes light
	Yellow	pan	red	Yellow goes light
Yellow	Black	ortho	orange, yellow	—
	Black	pan	red, orange, yellow	—
	Red	ortho	green, dark yellow, yellow-green	Red goes dark
Red	Black	pan	red, orange	Red goes light

There are similar rotating polarizing filters made for single-lens reflex cameras. They are offered in threaded mounts to fit your camera lens, by *Tiffen* Optical Co. of Roslyn Heights, N.Y., by *Enteco* Industries of Brooklyn, N.Y., by Minolta, and by Rollei.

The most spectacular use of the polarizing filter is in *color* photography. It darkens the sky to an intense, vibrant blue (if you are at a right angle to the sun), it brings out the gem-like green of the sea, it makes reds redder and yellows purer, and it eliminates reflections that dilute color. In general, the polarizer gives color film a saturation, a richness, a boldness that is unmatched. *Norman Rothschild* calls it "the filter that drives color wild."

Where two colors have to be separated, as in copy work, it is important to know what filters can accomplish this without upsetting, too much, the entire color balance of the subject. This chart will be of help if you find yourself in such a dilemma.

THE VIEWING (OR MONOTONE) FILTER

This one is not used over the lens but over the eye, so that you can tell approximately how any scene will look in shades of gray on the final print. It can be used indoors or outdoors. Originally made in only a deep blue color, it is now sometimes colored yellow, purplish-green, or green. The most valuable use of the monotone filter is in conjunction with the regular lens filters. We can try out the effect of any filter by first looking through the monotone filter (which shows us how the film will see what your eye sees) and then by placing the lens filter in front of the monotone and looking through both. You can eliminate a lot of time-consuming and expensive guessing that way.

The best of the monotone filters now available is Tiffen's series VI blue filter #47 (equivalent to the Kodak #47—C5, which has been discontinued). The Tiffen #47 in the series V1 size costs $3.50. Kodak has a #47 (C5) blue filter in cemented glass squares. The 2 inch size unframed is $6; the frame holder is another $2.15. The Photo Research Corp. of Hollywood, California 90038 offers two different viewing filters: the *Spectra Panchromatic* #621-157 for black-and-white film; and the *Spectra Color Contrast* #621-156. The idea is that color film has a short contrast range and therefore needs its own filter. These are made well, have extension grips, and sell for $7.50 each. Spiralite offers a *Contrast Blue* (similar to the C5). What I use now is an old Wratten C5 (#47) deep blue filter. If you can find one of these, you're in business. Otherwise, I suggest you get the Tiffen.

Or better yet: get the *Kodak Master Photoguide* (a pocket-size photographic encyclopedia chock-full of precious information about ex-

posure, filters, and optical data). It has a page on *Use of Contrast Filters*, with four, round cut-outs, each about half-an-inch in diameter, in which four gelatine filters have been sandwiched: A, G, 58, *and* 47 (C5). You can, of course, use the #47 (C5) as your *monotone viewing filter*. And by buying the inexpensive photoguide, you'll be getting not only the viewing filter, but such other items as a *daylight exposure computer*, a *fill-in flash computer*, a *flood-light computer*, a *depth of field computer*, an *effective aperture computer*, and much, much more. A terrific buy, under the circumstances.

Filters for unusual highlight effects. If you have been watching television recently (a fine school for photographic lighting) you have undoubtedly seen the strange new lighting devised by some fun-loving professionals, first with ordinary copper screening (the kind you use in summer to keep flies and mosquitoes in their place), and then with cross-hatch filters made more carefully and glass-mounted. What happens when you use the screening or a screened filter over your lens is that all the *bright lights* become starlights, with long and lovely tails streaming out at right angles to each other; a beautiful and haunting effect. And the rest of the scene does not seem to be affected. You can easily duplicate these results yourself by setting your camera on a tripod and fooling around with some screening. The Kenko Co. of Tokyo, which previously marketed a series of *Softon* cross-screen filters, is now offering an improvement on the original, a *Kenko Vari-Cross* filter. This consists of two rings, each holding a polished optical glass lens with a straight line. Each ring may be moved independently by a lever to *vary* the cross-line angle. When the two levers are aligned, the cross lines are at 90°. The effects you can produce are endless. The Kenko Vari-Cross filters are being marketed here by Aetna Optix Corporation, 44 Alabama Avenue, Island Park, N.Y. 11558.

Similar filters for *star-like* images (*Spiralite Crostar*), and for *multiple* images (*Spiralite Multimage*, #3P for three parallel, #3C for three concentric, and #5C for five concentric images), are available by mail from *Spiratone*, 135–06 Northern Blvd., Flushing, N.Y. 11354.

Filter Factors

Since every filter cuts out part of the available light, we necessarily have to increase the exposure to compensate for this loss. One of the tough problems in photography is determining how much this increase should be. Filter factors, as given usually (*yellow* 2x, *orange* 3x, *red* 6x, *green* 3x, etc.), are not much help because they may not apply at all to the conditions under which we happen to be working. The factor depends on the quality (spectral composition) of the light, on the color

sensitivity of the film (whether it's ortho or pan; and if it's pan, whether it's type B or C) and on the reflection and absorption characteristics of the object (a blue object will photograph lighter outdoors than a green one on type B pan, for instance). With all these complications entering into the seemingly simple problem of photographing a sky with clouds in it, it's no wonder that most amateurs throw in the sponge at this point and simply double or triple the exposure when using a filter and trust to luck.

There's an easier and more practical method. Use a *test chart* (see index); photograph it indoors and outdoors, with and without filters; with normal, half and double your *guess* exposures; develop the film. If you have three filters to test you can do this all on one roll of 35mm film, two rolls of the 120 size, or two film packs. This may sound like a waste, but it isn't. Provided you don't change your filters, and use the same type film, you'll have to do this only once in your entire career as a photographer. Then you'll know once and for all what the factors are for each filter under all your special conditions. The only variants (and they are constant variants which you can adjust for) will be the changes in light outdoors from morning to evening. If you make your test at about noon when the light is normal, you need only multiply the noon factor by 1½ before 11 A.M. and after 2 P.M.; and by 2 before 9 and after 4 P.M. And that is all the calculating of filter factors you'll ever have to do.

Checking filter factors with a photoelectric meter. Let's assume you are using *Verichrome Pan,* which has an ASA rating of 125. Set your meter to that rating. Now take a daylight reading in the normal way, without a filter. Take another reading with the filter covering the cell (if it doesn't, make a mask out of black paper or cardboard and cut a hole in it. The shape of the hole doesn't matter, provided the filter is now larger than the cell opening), otherwise you'll get a false reading. Now compare the two readings. If the filter cut your reading in half, it has a factor of 2x, in which case you reduce the ASA meter reading from 125 to 60 (close enough) and shoot away until you change your filter.

If your meter has EVS numbers (see index), remember that the progression from one number to another is equivalent to a shift from one f/stop to another (a *doubling* or *halving* of your exposure).

Using multiple filters. When you use two filters together, one for foreground control (2x yellow) and one for darkening the blue sky (3x polarizer), how do you calculate the exposure? There are two ways: first *multiply* the two factors together, which gives you a new filter factor of 6x. Now refer to the *aperture compensation table,* later in this chapter, and you'll find that you need an f/stop of 4.5 (if you had been

planning an *f*/11 stop *without* filters). The alternative procedure is to divide the final factor of 6x into your ASA speed (let's assume that you were going to use Verichrome Pan, therefore ASA 125, so 125 divided by 6 gives you a final result of 20 plus). Set your meter at 20, which is close enough, and use the meter reading you get. But if this is the first time that you have ever used multiple filters, *bracket your exposures* (*normal* meter reading, *half* that, then *double* the meter reading) to avoid losing the picture.

APERTURE COMPENSATION TABLE

Once you know your filter factor, you'll want to know how to adjust your exposure, if and when you alter your *f*/stop. The following lens aperture table will tell you what stop to use at a glance.

LENS STOP TABLE

WITHOUT FILTER	FILTER FACTORS									
	1.25x	1.5x	2x	2.5x	3x	4x	5x	6x	8x	10x
f/16	14.3	13.1	11.3	10.1	9.2	8	7.2	6.5	5.6	5.1
f/12.7	11	10	9	8	7	6.3	5.6	5	4.5	4
f/11	10	9	8	7	6.5	5.6	5	4.5	4	3.5
f/9	8	7.5	6.3	5.6	5.1	4.5	4	3.7	3.2	2.8
f/8	7.2	6.5	5.6	5.1	4.5	4	3.6	3.2	2.9	2.5
f/6.3	5.6	5.1	4.5	4	3.6	3.2	2.9	2.6	2.3	2
f/5.6	5.1	4.5	4	3.6	3.2	2.8	2.5	2.3	2	1.8
f/4	3.5	3.3	2.8	2.5	2.3	2	1.8	1.6	1.4	..
f/3.5	3	2.7	2.4	2.2	2	1.7	1.5
f/2.8	2.5	2.3	2	1.8	1.5
f/2	1.9	1.7	1.5

Filter Mounts

Be sure that your filter mount enables the filter to attach firmly to the lens and to lie parallel to the image or lens plane. The screw-in or bayonet type mounts are the most precise; the type that places the filter between the elements of the sunshade is most practical and least expensive. Kodak no longer supplies glass-mounted filters; but good ones are available from Hoya, Vivatone, Spiratone, Ednalite, Harrison & Harrison, Tiffen, Leitz, Rollei, Lifa, Nikon, and others. With care, and if properly made, any one of these will serve equally well. Sometimes, when the photographer is careless, the bayonet filter is mounted on the lens slightly askew; when that happens the image will be slightly distorted.

Filtering for Shadow Detail

An interesting method for improving detail, brilliance and tone renderings in shadows was suggested by Marshall Perham in *The Camera* magazine. The method, briefly, is as follows.

1. Take a light reading of the scene from the camera position.
2. Multiply that by *one-half* the factor of the proposed filter.
3. Take a direct reading from the shadow.
4. Multiply that by the factor of the proposed filter.

Readings 2 and 4 should equal each other, approximately.

A. If shadow reading is greater, *filter is too dense.*
B. If general reading is greater, *filter is too pale.*

This method is based on the principle that filters tend to lighten objects of similar color and darken objects of a complementary color. The color selection of the filter will depend, naturally, on the color contrast between object and background. The method works best with reddish objects.

Filtering for Intense Light

Two polaroid filters used together but rotating independently of one another, make one of the most useful accessories for your gadget bag. They form a neutral density filter (a gray filter that reduces the amount of light reaching the film without affecting its color response) which is ideal for recording full detail when shooting directly into any strong light source (such as the sun, arc lights, fires, etc.). Also useful as a variable density filter if you're caught with fast film, a speed lens that can't be stopped down enough, and an intensely lighted picture that won't wait. The density varies from light gray (when the axes of both filters are parallel) to almost black (when the axes are at right angles). You look through both filters to give you the scene density you want, set them that way in front of your meter, then your lens, and expose normally, disregarding the filters in your calculations.

Desert Exposures

To subdue desert contrast, use a light yellow filter. It holds back the ultraviolet rays in the highlights. But be sure to double your normal exposure for that particular filter, and underdevelop somewhat, using D 76. Don't trust your eye on desert light, especially for color shots. Use an exposure meter at all times.

Haze, and What to Do About It

There are times, especially in landscape photography, when you want to *increase* haze rather than minimize it. To eliminate haze in black/white photography, you can use, in order of increasing effectiveness, the yellow, orange, or red filters. To increase haze (which is important in pictorial work, to separate planes) simply go the other way, from light blue to dark blue. What this does is increase the photographic perception of the dust and water particles suspended in the atmosphere.

In color photography, haze can be accentuated by the use of a very light blue filter, or by not using one at all.

Some Hints on the Use of Filters

1. Using a yellow filter under artificial light is a waste of time. It has no effect at all because the light, being yellow, is its own filter. For the same reason yellow filters are not needed outdoors late in the afternoon. The light is weak in blue and strong in yellow at that time.

2. Shadows are usually made up of bluish tones of gray. To *soften contrast* between the shadows and the object, use a green or blue filter; to *increase contrast*, use a red, orange, or yellow (K2 or K3) filter.

3. Objects that are lighted by a source of their own color get more exposure and are therefore white on the print. Use a complementary filter to even things up when that happens.

4. White light is made up of the three basic colors: red, green and blue; a filter of any one of these colors will absorb the light of the other two.

5. Atmospheric haze (not to be confused with mist or fog which are white) is *blue;* it is reduced by almost all filters. Red reduces it most, green the least. The blue filter, however, increases haze. If haze adds to your picture, don't destroy it by using a filter; or, use the green or blue.

6. The sky near the sun, being brighter and having less blue in it, is less affected by filters; as you swing away from the sun the sky will gradually get darker, and it will be darkest when your back is to the sun. Similarly, a filter will not darken the sky along the horizon; the light there is weak in blue rays, strong in yellow and orange. (To understand why, refer back to *Fig. 2.4.*)

7. A filter will not darken a sky that is misty, overcast, grayish or whitish.

8. *Overexposure* will cancel out the effect of a filter; *underexposure* will often take the place of one.

9. If the sky is clear and blue, and you are photographing very light objects against it, on panchromatic film, you won't need any filter to darken the sky. Be sure to turn away from the sun, however, and don't overexpose.

10. Flat lighting, or a scene without contrast, needs strong filters like the red or orange; sharp lighting, or a scene of great contrast, needs the softening effect of the green or blue filters.

11. Early in the morning, and late in the afternoon, filters are needed only for *color correction* since lighting contrast is adequate; around noon however (and except for shots against the light) they are needed for *color contrast* as well.

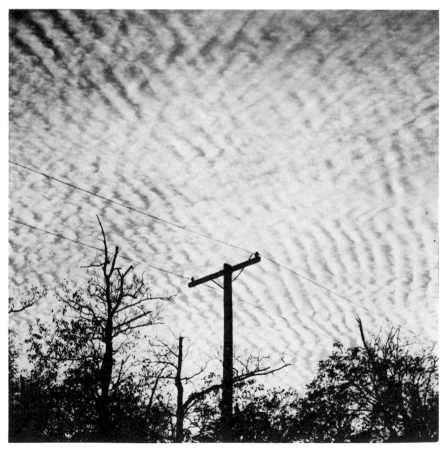

Illustrating the use of a K3 filter.

12 How to Photograph Children

It takes a mean man to resist the appeal of a child; which probably explains why there are more pictures taken of babies than of any other one subject in the world. The drugstore photo-finishers, who are certainly in a position to know, claim that the three most popular snapshot subjects, in order, are: (1) babies; (2) girl friends; (3) pets. But babies lead the others by a good margin.

And yet the process of taking snapshots of the baby, too often, is as distressing to the child as it is exasperating to the parent. Usually, after a picture session, both parent and child are exhausted.

To make things easier for you, *and* for the child, here are a few pointers on what to do and what to avoid the next time you start to take some pictures of the youngster. If you follow these suggestions, what has usually been a *trying* time may become a *pleasant* one, for both of you.

What You Need

1. A camera with a lens speed of about $f/3.5$ or $f/4.5$ and a shutter speed of about 1/500; you can get along with less, but you may lose some pictures when the light is dim, when you want to stop fast action with a

high shutter speed, or when you want to soften the background. Good baby pictures have been taken with a box camera, so don't weep if you can't get this equipment at once. The best cameras for this kind of work are the twin-lens reflex type, because you see in the ground glass, continuously, right through the exposure, what's going on before your eyes. Also, when you look *down* into the ground glass, the child is less self-conscious than he would be if you looked directly at him through that big metal and glass eye that is your camera. Nevertheless, the single-lens reflex and rangefinder cameras are usable for this kind of photography since they, too, make it possible to focus swiftly and accurately.

2. A tripod and a long cable release. With these you can move around as easily as the baby does. Of course, you'll have to stop down to about $f/11$, to be sure of enough depth of field should the subject begin to move out of range. Some photographers prefer to move around with the camera, snapping when the best point of view and the most appealing expression coincide. But this is a matter of taste. If you find it more convenient to carry the camera with you, do so; if you're the lazy type, set the machine on a stand, focus on the place where the baby is most likely to be, stop down to $f/8$ or $f/11$—and use that long cable release to capture the expression you want.

3. For indoor shots, two #1 photofloods in reflectors, a flash synchronized for GE 5 or Press 25 bulbs in reflectors (with which you can shoot at $f/11$ and 1/200 at a distance of about 6 feet, with the film suggested in item 4), an Amplex reloadable flashcube for the all-glass AG-1 flashbulbs, Norelco flashcubes (just follow directions on each package), GE flashbulbs (directions, ditto), and the new Magicubes (with the cameras for which they were designed).

Better still would be an inexpensive electronic flash unit (strobe) such as the Acculite Jr., Acculite 111; Braun F110-/F220; Capro FL3-/FL4, -/FL5, or -/FL7; Honeywell AutoStrobonar; Kako 77B-/88; Ultrablitz Bauer E160, Bauer E180 Autoblitz; Vivitar 90-/151 or -/160; Yashica Pro-50 Deluxe, Yashica Pro-100. Also useful are the Sylvania Sun Guns, which are rechargeable quartz halogen lights (originally made for cinema use) with a one-charge burn time of about 10 minutes.

4. Some rolls of fast panchromatic film—preferably Super-Hypan, Versapan, Ilford HP4, Kodak Tri X Pan, Plus X Pan, or Verichrome Pan.

5. A K2 filter if you want to soften the effect of skin blemishes, bruises, freckles, etc. Use the *outdoor* factor for the film and filter combination you choose. With Tri X this factor is approximately 2x, which means that using this combination indoors, you expose for twice the indicated exposure, whatever that happens to be: $f/11$, 1/200 would, for instance, become $f/11$ 1/100 or $f8$ 1/200.

A DAY AT THE SHORE

Caryl Wallack took these pictures of a lovely little lady named Sabina at Jones Beach with her Rolleiflex and Panatomic X developed in Acufine. The problem was how to keep restless Sabina from dashing off into space.
The photographer did it successfully with the aid of such simple devices as a fishing line, a swing, a corner of the fisherman's walk, and an ice cream cone.

6. A lens hood to keep out stray light.

7. An exposure meter like the Weston, Gossen Pilot, Sekonic, or Spectra.

What to Do

Have your camera loaded, set and prefocused before you bother the baby. Don't fuss with lights and gadgets on his time. It will make him cranky.

Choose a spot that gives the child room to wander, and still makes it possible for you to gauge your focusing distance accurately. With the lens set at $f/11$ and focused on 25 feet, the depth of field for a lens of about 2 or 3 inch focal length extends from about 12 feet to infinity. For closeups set your distance at 10 feet, and your range is from about 6½ feet to 18 feet. With this much depth to work in you should have no trouble keeping baby in focus. A simple trick is to anchor the child in a rocking or high chair.

Some Temper-Saving Precautions

PLAN EVERYTHING IN ADVANCE

Arrange the camera, lighting, backgrounds before you call the model. Have everything ready; don't tire the child by making him wait while you focus, rearrange, adjust. When you have everything in order, relax and get acquainted with the model. Play with him; talk to him; make him feel that you're someone to have fun with, not just a fussy man with a lot of lights. When you're all through taking pictures, finish any game you've started; otherwise the child may not let you take pictures of him again.

DON'T HAVE TOO MANY PEOPLE IN THE ROOM

Things get too noisy and distracting. The child tires quickly when there are a lot of faces poking around, raising bedlam. Grownups know this feeling when they shop in the department stores; the mere pressure of people seems to drain you of all energy. At the end of a good shopping spree, you really *are* spent, both ways. Children are even more sensitive to crowds than grownups are. Besides, a gang of people around a photographer is dangerous. Someone is liable to get hurt, if someone else doesn't, in the meantime, ruin your equipment. A wire tripped over, or a tripod leg accidentally kicked, can do terrible things to your poise and pleasant

AT THE ZOO IN CENTRAL PARK. A Rolleiflex shot on Plus X Pan, f/11 and 1/100, developed in Microdol X.

"THERE IT GOES!"
The picture, she means.
Next time, try to get the
face. Rolleicord, *f*/11 and
1/100, Verichrome Pan,
developed in D 76.

manner. If people will just not stay out of the room, save your film, *don't take any pictures*. The results would have been terrible anyway.

DON'T HURRY

If you're tense and sudden in your movements, the child will be nervous, and show it. *Easy does it.* Work slowly, carefully. Have patience. The child will feel more at ease, and so will you. Don't start snapping the moment the light goes on; let the child get accustomed to the light.

WATCH THOSE BACKGROUNDS

This seems to be about the most difficult thing in the world to learn. We get used to the presence of objects so quickly that we forget they're there almost as soon as we see them. Haven't you often been shocked

when someone else pointed out something that you've seen twice a day for ten years and didn't notice at all? It's such blindness that makes it impossible for most of us to see backgrounds until the final print is in our hand. The only way to protect yourself against backgrounds is deliberately to search them out. Check the background each time just before you shoot. You'll have to make a real effort every time, because your mind will continue to play tricks unless you're on guard.

The background, generally, should be as simple as possible—neutral in shade, contrasting with the subject, but without any strong, striped or fussy pattern. Remember that your lens records everything it sees. Watch out for telegraph poles, cans, cows, fences, branches of trees, other people's feet. The best background for indoor shots is a plain wall; outdoors, a filtered or gray sky.

For the tiny infant, a blanket or pillow makes a good background. Don't lay him down on a large flat surface; it looks hard and unpleasant. An older baby can be placed in a chair, or on a blanket spread out on the floor.

Bring attention to the child in your picture by throwing the background out of focus (with a large lens stop). Professional portrait photographers use lens stops of $f/4.5$ and $f/5.6$ for this reason.

Place the camera low, on a line with the child's head. A point of view as low as this seems more natural for pictures of children.

Use *bounce light* (light reflected from a ceiling, a white card, a wall, or a sheet) to get a soft, glareless light that is more comfortable for the eyes than direct light. If you're bouncing the light from a ceiling or a wall, remember that the distance and color will affect your exposure and, if you're using color film, the hue. Use two or three times your normal exposure for light bounced from a wall or ceiling.

CANDIDS OF YOUNGSTERS

To catch children unawares is no easy task, especially if they're less than six years old (when they are most alert and curious). But here are some tips that may help: 1. Use a twin-lens reflex camera and turn it so that you seem to be looking at a right angle away from the child. 2. If you have a 35mm single-lens reflex or rangefinder camera, use a telephoto lens (about 135mm) which will enable you to get far enough away so that the subject will not feel that you are photographing him. 3. Prefocus your camera at a spot toward which the child is moving, if you can outguess him, and snap when he reaches it. 4. Let the child become accustomed to your being there. In fact, show him how the camera works, if he's old enough to understand. This usually does the trick. (But be sure to hold on to the camera by its strap; he may drop it.)

SOLITARY BUT NOT ALONE. This appealing picture of a little boy
was made by *Roy Arenella*. He used a Leica M3 with a 35mm Summicron lens,
on Tri X film developed in Edwal FG7. The picture is also the book jacket
for *City Talk*, a charming collection of verses by children compiled by
Lee Bennett Hopkins, with photographs by Mr. Arenella, and published by
Alfred A. Knopf. If you're wondering how the photographer kept the child
from looking up, it's easy. He took many pictures; at one point, the boy was
tired and rested his head in his hands. That's when this shot was taken.

CURIOUSER AND CURIOUSER. This was taken under the
Triborough Bridge on Long Island, with a Kalart camera, Raptar lens, on
Plus X film developed in D 76. The boys were examining a stray log that had
found its way, strangely, into a space in the abutment.

GET THEM WHILE THEY'RE BUSY

The best pictures of children are made when they're not aware of
what you're doing—when they're not bothering about you but are doing
something they like—playing a game with a friend, reading the funnies,
building sand structures, digging a hole, filling a pail, eating ice cream,
putting a doll to sleep. It doesn't really matter what they're doing, as
long as it holds their attention and leaves you free to take pictures. In
other words, if you want a good picture of a child, your problem isn't the
camera and how to operate it, but finding something pleasant for the
child to do. Incidentally, be sure (this can't be repeated too often) to let
him get used to you being around with the camera before you actually
start taking any pictures. One ingenious photographer worked out an
infallible system for keeping a toddler busy. He put a small piece of
cellophane tape on the child's finger and had no more trouble with him.

TRY A PICTURE STORY. These four shots were not taken in rapid sequence. The boy was seated, given a cup of ice cream (the kind *he* liked), and from then on he was lost to everything. A dozen pictures were snapped in about ten minutes, and the final selection was made after the negatives were printed. Caryl Wallack shot this sequence with her Rolleicord at *f*/8, 1/100, using Panatomic film developed in D 76.

LIGHT ON THE SUBJECT

Though we can't control the sun, we can still exercise plenty of control over the lighting of our picture outdoors. We can choose a time when the light is soft and diffused—in the mornings and late afternoon. And we can place our subject in the shade, away from the harsh glare of direct sunlight. Keeping the light soft avoids those black shadows which spoil so many pictures taken outdoors. A simple way to soften harsh shadows, by the way, is to use a folding reflector—a piece of white cardboard, or a large handkerchief, held a few feet from the subject. Watch the shadows under the nose and the eyes; avoid ugly shapes and dark sockets. Outdoors, let the light come from the side; indoors use a flat front light for general illumination and to soften shadows, and model the face with a stronger side light.

1. *An effective arrangement for two photofloods in reflectors:* place one 6 feet from subject and to the left; place the other 4 feet from subject and to the right. An additional overhead light is useful, sometimes, to add sparkle to dull hair.

2. *Another good arrangement for two photofloods in reflectors:* place one 2 feet in back and to the left; the other 3 feet in front and to the right. Place a reflector to prevent stray light hitting the lens (from the lamp facing the camera).

Much can be done with only a single light source, using a reflector to soften the shadows.

WHEN THEY WON'T SIT STILL

To get sharp pictures of children in action, use the fastest shutter speed your camera offers. This applies, of course, not to the miniature cameras with $f/1.5$ lenses and $1/1000$ shutters, but to the ordinary cameras with more modest equipment. The following table, calculated for moving objects in sunlight, may help you decide which shutter speed to use, depending on which angle of action you are photographing. Remember that distance also alters your shutter speed requirement. The greater the distance between object and lens, the less speed you need. A boy running toward you can be sharply photographed at, let's say, 30 feet, with a shutter speed of $1/200$; at 15 feet you'll need $1/300$. But a boy moving *horizontally* across the field of view will need a shutter speed of $1/500$ to stop motion.

Indoors, where the action is necessarily more restricted, a shutter speed of $1/200$ or even $1/100$, will prevent blur.

If your shutter does not have sufficient speed, you can still get sharp

TAKE THEM TO THE BEACH. The sand will make them happy, and the pictures will make you happy. This was taken with a Leica M3 and a 90mm telephoto lens on Panatomic X, developed in D 76 diluted 1:1.

pictures of moving objects by adopting a device used by news photographers: *follow the action with your camera.* The background will be blurred of course, but your subject will be sharp.

GO WHERE HE GOES

If the child won't stay where you put him, if he feels like traveling, let him alone; just follow him. He'll undoubtedly head for some nice spot where he feels at home—and if you don't like it there, why that's just too bad. But as a matter of fact, you'll probably find this spot as suitable for your use as any other. So whenever you start taking pictures don't drag the child around. If you do, he won't stay there; and if you fight him about it, he'll start to cry; and if he cries, where are you? Let *him* decide where the photographing is to take place. It'll be simpler that way.

DON'T FORCE HIM

It's not a good idea to make the child do anything he doesn't want to do. Don't *make* him pose, or perform, or play with others, or act like a grownup (except in fun). Don't dress him up in fancy (but uncom-

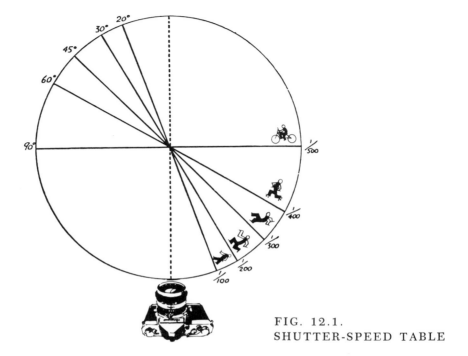

FIG. 12.1.
SHUTTER-SPEED TABLE

fortable) clothes; you'll get better pictures if he's wearing his ordinary ones. Don't take pictures of him in hot weather, if he doesn't feel like it. And don't use make-up on a child at all, whether boy or girl. Avoid such blighting expressions as *Stand still for a moment, Put your hands down, Raise your head a little;* they simply petrify your subject.

BE YOUR AGE

Don't try to amuse the baby by making funny faces or funnier sounds, hopping up and down, waving a newspaper, or rattling keys. Let him amuse *himself.* He's much better at it anyway.

DON'T SKIMP ON FILM

Always have plenty of it with you, and use it freely. Your best pictures will happen suddenly; be ready for them. The cost of an extra negative is only a couple of cents, at most—so it's very poor economy to save on film when there's a priceless gesture or expression you want to capture.

I had already wasted quite a bit of film on this little fellow playing at the water's edge and had almost given up hope of getting a real picture . . . when suddenly he reached up—a man-sized stretch that said, "Isn't everything just wonderful!"

I had been snapping this young lady as she walked back and forth very busily, but caught nothing that looked like a picture . . . when she suddenly stopped to examine something in the sand. The lighting was better, and that forefinger gesture was perfect.

All pictures taken with Contax and Sonnar f/8, 1/250.

BE CAREFUL

Especially indoors, where hot photoflood bulbs, trailing wires and clumsy tripod legs always seem to be getting in the way.

If you want to avoid hurting the child, perhaps seriously, take steps to prevent accidents, *before they happen*. Don't leave things lying around; be neat. And don't let other people clutter up the scenery. The best place for people who aren't really helping you is on the other side of a closed door.

Just to Remind You

1. Have everything ready before you call the child.
2. Use low camera angle.
3. Use small lens openings for depth of field ($f/8$ to $f/16$).
4. Use fast shutter speeds to avoid blurring ($1/100$ or faster).
5. Watch those backgrounds.
6. Have light come from side or rear; avoid strong front light or direct sunlight.
7. Don't tell the child to smile or to look at the birdy.
8. Don't make him do anything he doesn't want to do.
9. Don't take pictures of him in hot weather if he doesn't feel like it.
10. Have patience, don't hurry!
11. Use plenty of film, preferably a pan film of between 160 and 400 ASA speed.
12. Don't make the child pose or perform.
13. Snap him while he's busy.
14. Finish a game if you've started one; don't let the child suspect you weren't really playing.
15. Don't dress him up for the occasion; his regular clothes are more comfortable.
16. The best time to take pictures of any baby is after he's rested or had a nap.
17. Let the child go where *he* wants to; you follow him.
18. Don't start snapping as soon as the lights go on; let the child get used to the lights and to you.
19. Don't use make-up on children at any time.
20. Be careful.

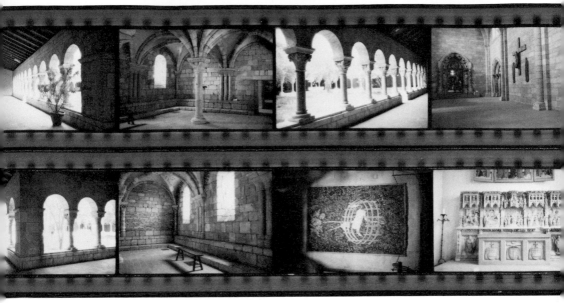

Strong contrasts like these call for compensating developers. Plux X developed in Neofin Blue.

13 Developers and Developing

If you're only interested in *taking* snapshots, and don't want to be bothered *making* them, just "press the button" and let the corner drugstore do the rest. Your results will not be as good, but you may never know the difference. If you want to have some *control* over your picture taking, and want the fun, too, of doing your own developing, printing, and enlarging, you'll find this chapter and the next one helpful.

The technique of the darkroom involves the selection and use of the following:

1. A *developer* that will bring out the latent image and create a negative of correct contrast and fine grain.

2. A *fixer* (hypo) that will keep the negative from fading or spoiling; and a *short stop* that halts development.

3. A *printer* or *enlarger* that will reproduce it as a positive, after it has been exposed, developed, short-stopped, and fixed.

Though none of these things presents any difficulty, especially with modern methods and materials, all require some attention to detail, some care in the choice of materials, and some skill in the use of equipment. The purpose of this chapter is to give you the basic essentials of good technique—the technical details (and some shortcuts) that will

make it easier for you to create better pictures. No attempt will be made to cover the ground completely. Confusion would only be the result of trying to include *all* the soups, films, papers, and devices that are on the market or are being whispered about in the darkrooms.

Of the materials and methods recommended here, just two things need be said: (1) *they work;* and (2) *they are easy to get and to use.* If, however, you prefer fancier folderol, you'll find thousands of glib amateurs, with secret formulas bulging out of all pockets, ready and willing to oblige. Remember, though, that most secret formulas lead nowhere. They usually waste time and money, and they serve only to prove that the standard formulas are better after all. If it's *pictures* you want, don't get cluttered up with experimental chemistry. As we said before, earlier in this book, the manufacturer of a photographic product usually knows how to use it to best advantage. That's his job. What he recommends is certainly worth trying before you go on to something else. And when you do try something new, be sure to compare the new results, critically, with the old. Only in that way will you learn *where* you're going and *what* you're doing in photography, and so profit from experience.

The Choice of a Developer

HOW A DEVELOPER WORKS

Photographic films and papers are coated with a gelatine emulsion that holds in suspension minute grains of a chemical salt of silver (*bromide* in the case of films, *bromide* and/or *chloride* in the case of paper). When light strikes these grains, a strange thing happens: their chemical composition is altered. The image thus formed is known as the *latent* image, since the human eye cannot detect it. However, this image can be brought out (developed) in a chemical solution called the *developer*. Such a solution has the property of breaking down light-affected particles into their molecular constituents (*reducing* the so-called halides of silver to the pure metal, which looks black in its naked form), and converting the bromine or chlorine into a photographically inactive *salt* (bromide or chloride). This process, as you might guess, is called *reduction*.

Most of the chemicals used to do this work do not function well alone; they are either too slow in getting started, or too fast once they have started. To balance the activity of a developer, therefore, we use an *accelerator* (like borax, carbonate, tribasic sodium phosphate, or Kodalk) and a *restrainer* (like potassium bromide). To preserve the solution (prevent it from oxidizing too rapidly) we also add sodium sulphite. This snares the dangerous oxygen before it can harm the developer and so

converts the *sulphite* to *sulphate*. Some reducers work only on the highlights, producing negatives of great contrast; others work on the shadows almost as much as on the highlights, producing *flat* negatives. The perfect developer adjusts these chemical peculiarities so that normal contrast is produced by normal use.

Another important property of a developer is its power to cut down the *clumping* of grain. No negative is grainless. What we object to as "grain" is the bunching of silver particles that produces a mottled effect on the print. When these bunches are small and evenly distributed we have a negative of *fine grain;* when the bunches are large and spotted, the negative is *coarse grained.* Grain is affected by the type of emulsion, the amount of exposure, the temperature and time of development, the kind of reducer (paraphenylene diamine produces finer grain than most), the speed of drying. The developer, you see, is only *one* of many factors in the production of grain.

RECOMMENDED DEVELOPERS

The easiest to use are those that are already made up in powder or liquid form. The powders should be dissolved, as directed, in distilled water, in filtered rain water, or in boiled and filtered tap water (add a pinch of *Calgon*, 1 gram in 1000 cc., or ½ gram of Kodak *Anti-Cal* in 1000 cc.). These are all good:

EASTMAN'S	D 76 (powder), DK 50 (powder), HC-110 (concentrated liquid),[a,c] Microdol X (powder or liquid),[a,b] Versatol (concentrated liquid) [a]
AGFA-GEVAERT'S	Atomal (powder),[a] Rodinal (liquid concentrate)[a]
H & W'S	Control (concentrated liquid) [a] for continuous tone with Kodak High Contrast copy film and Fuji Microfilm
EDWAL'S	FG 7 (liquid),[a] Super 12 (liquid), Super 20 (liquid), Minicol (liquid) [a]
GAF'S	Hyfinol (powder),[a] Hyfinol L (liquid),[a] Isodol (powder),[a] Permadol (powder) [a]
F-R'S	X-22 (liquid, one-time tubes),[a] X-100 (liquid) [a]
BAUMANN'S	Acufine (powder),[a] Diafine divided developer (powder),[a] Autofine (powder) [a]
HARVEY'S	Panthermic 777 (powder or liquid) [a]
TETENAL'S	Neofin (concentrated liquid ampules) [a,b]
PATERSON'S	Acutol [a] (liquid concentrate for maximum sharpness); Acuspecial [a,b] (liquid concentrate surface developer); FX-18 [b] (powder)

Continued

MAY & BAKER'S	Promicrol (powder or liquid) [a]
CLAYTON'S	P 60 (liquid) [a]
ILFORD'S	Microphen (powder or liquid) [a]
ETHOL'S	Blue (liquid concentrate, for one-time use),[a] 90 (powder),[a] UFG (powder) [a]

[a] These developers are available *only* in prepared form. Manufacturers have not made formulas public.
[b] For new thin-layer emulsions such as Panatomic X and Plus X.
[c] Works exceptionally well with Tri X Pan.

How to Develop the Film

The easiest way is in a tank (either the plastic, adjustable-reel, self-loading type, or the stainless-steel type). In either case, the film has to be loaded in a darkroom or in a changing bag (which is virtually a *pocket darkroom,* and one of the most useful photographic gadgets you can get). Follow the simple instructions supplied by the manufacturer of the tank, and you'll have no trouble. Be sure the reel is dry, or the film will stick. Hold the film by the edges as you move it into the grooves of the reel; avoid touching the emulsion surface. If the film sticks, cut the corners a bit and the film will move more easily. After the reel is loaded and the cover replaced, you can take the tank out of the changing bag or darkroom and do everything else with the lights on.

After you buy your tank, begin by experimenting, to find out how much liquid is needed to cover your size film. Too much solution is as bad as too little. Measure out the amount needed each time *exactly;* otherwise you'll have parts of your film undeveloped (if there's not enough solution) or drooling all over the place when you start twirling the reel (if there's too much). Another important thing to find out, once and for all (and you can do this with plain water as well as developer), is just how long it takes to fill and empty the tank. You'll have to know this later in order to make allowances in your developing time. It's a good idea to learn how to fill the tank rapidly. The faster you do it, the more evenly will your film be developed. There's a knack in pouring the developer smoothly so that you avoid splashing and making air bubbles,

A STAINLESS STEEL
DAYLIGHT DEVELOPING
TANK

which clog the spout. Practice this a few times before you actually load the tank with film.

Excellent inversion tanks are available from *Omega* and from *Nikor* (Honeywell) in various multi-units and for almost all film sizes. *Kindermann* also makes some good ones with PVC (*polyvinyl chloride*, chemically neutral, dent resistant) lids and stainless steel spirals.

Other good *inversion* tanks (for agitation by turning them upside down) are made by Johnson, and by Paterson (especially their System 4, the spirals of which are made from heat-resistant *nylon* and the tank bodies of *polystyrene*). These are *adjustable*, for various sizes of film. They are also self-feeding and offer three-way agitation.

Tanks using agitator rods are made by *Yankee* and *F-R*, among others. Some of these can hold 2 rolls of film at a time.

Bakelite tanks are not so susceptible to temperature changes; stainless steel tanks arc more durable. Avoid tanks with celluloid aprons.

A few other things you'll need:

1. A cellulose sponge or a piece of chamois. Both should be kept in jars filled with water and squeezed out (*not by twisting!*) just before using. Twisting will *tear* the sponge.

2. A pair of clips with which to hang up the film when drying it. Find a dust-free corner, away from drafts and human traffic, where drying can be done. A closet is a good place.

3. Two graduates, a four-ounce and a quart size. The larger one can be a pyrex beaker marked off in *cc.* and/or *ounces.*

4. An interval timer to check your processing along the way.

5. A reliable thermometer. Amend Drug & Chemical Co., 83 Cordier, Irvington, N.J. 07111, offers an inexpensive glass-mercury type, packed in a wooden tube. Or you can get the all-metal Weston, or True-Temp, with its handy dial at top. Eastman, Ansco, and Paterson (in plastic container) also make excellent thermometers. Be sure to say you want it for "round tank" use; there's another type made for tray use (when printing).

Have everything ready before you start. Cool the developer to the required temperature (if you're bothered much by the problem of high temperature, use Harold Harvey's Panthermic 777 which was compounded to solve just this problem); make up the short stop (1 ounce of Kodak Liquid Hardener or 28 per cent *acetic acid* in each 16 ounces of water) and the hypo (4 ounces of *plain* hypo crystals in each 16 ounces of water, with 1 ounce of Kodak Liquid Hardener added. This is the best and least expensive way of making up a hypo solution. You can buy plain hypo for a few cents a pound; why pay more for the packaged kind?) Both the short stop and the hypo should be used at the same temperature as the developer. One way to assure this is to keep the glass containers for all three solutions in a large tray of cold, or iced, water.

Now proceed as follows (*time and temperature* method):

1. Load the tank in the darkroom, or in a changing bag.

2. Fill the tank with water. Some photographers prefer to dispense with this step. If you want to save time, you may do so, though it's really worth the effort. This preliminary water rinse gets rid of air bubbles, prevents streaky development, and removes the backing dye which interferes with the action of certain developers. It also reduces the temperature of the film (which is usually warmer than the developer) making it possible for the developer temperature to remain constant.

3. Pour out the water after 2 minutes and pour in the developer. *Start the interval timer when you start pouring the developer.*

4. Agitate the film *gently*, rotating spiral half a turn backwards and forwards for about five seconds (by means of center rod). Repeat the agitation at intervals of 30 seconds for the new thin films, and of one minute for the others. If it's a stainless-steel Nikor tank, or one of the three-way Paterson Adjustable tanks, it can be turned upside down at the above intervals without losing any liquid.

The important thing is to keep this agitation uniform and gentle; otherwise streaks and uneven development may ruin your film.

5. At the end of the development time (*and not before* . . . that's why, in 3, we started the timer when we did) start pouring out the developer. Don't try to pour it from the tank right into the bottle; use an intermediate beaker.

6. Pour in the short stop and agitate briskly.

7. At the end of three minutes *discard* the short stop.

8. Pour in the hypo solution.

9. At the end of ten minutes, pour out the hypo. You can use this hypo later to fix prints, so store it in a large (half-gallon) bottle. However (*caution*), see *Some Hints on the Use of Hypo*, Chapter 14, item 3.

10. Remove the cover of the tank, fill it with water and empty it again three or four times, and then set it under the faucet, with the stream playing on the center of the reel. Paterson offers an inexpensive *force film washer* which consists of a rubber tube, one end of which has a faucet connector, while the other end has a plastic fitting for use with all System 4 developing tanks. When this is pushed gently into the center hole of the tank it forces water out through the rest of the reel and effectively washes the film.

11. After fifteen minutes, remove the film, hang it up to dry (using a clip at each end, the lower clip serving to weight the film) and wipe off the surplus moisture on both sides with the sponge or chamois. Don't *rub* the emulsion side. To avoid using sponges or chamois, dip film for 30 seconds in dilute *Photoflo*, or similar *Aerosol* compound (follow manufacturer's directions). Result: *no scratches!*

12. Leave film to dry.

The process of developing film packs or cut films is no different from the method described above for roll films when you use the Nikor adjustable cut film tank. This tank (for all sizes up to 4 x 5) is fool-proof and easy to use. It is recommended highly.

The only difference between the development of cut film or film packs and roll films is in the loading of the tank. Just follow the instructions supplied by the manufacturer. For the rest, follow the procedure outlined above. For *development by inspection* see page 381.

GAMMA

Messrs. Hurter and Driffield, who first used this term in explaining their *time-and-temperature* method of development, would be shocked, I'm sure, if they could hear the way it is now thrown carelessly about. Gamma is nothing more mysterious than the measure of negative contrast. Though it is useful in the laboratory, where controls can be enforced to give it meaning, it has no value to amateurs except in a rough sort of way. Unless we know what the contrasts were in the original subject as well as the characteristics of the printing medium to be used, the gamma of the negative is a meaningless bit of information. All you have to know about gamma is that it indicates the contrast relations between the original subject and the negative image. A gamma of 1, for instance, means that the contrast in the negative is just like the contrast of the original subject; a gamma of less or more than 1 indicates that the negative contrast is less or more than that of the original subject. Negatives for amateur use are developed to a gamma of about .8. Since contrast is usually *increased* by printing (or enlarging) the negative, this reduced gamma makes it possible to produce a print that seems to have normal contrast. Specimens of *underdeveloped, normal,* and *overdeveloped* negatives are on page 354.

The term *gamma infinity,* refers to the maximum amount of contrast that can be obtained with any given emulsion when developed to its fullest extent short of fog.

Speaking in less technical terms, I should advise you to follow this principle:

Develop for contrast; that is, develop for the time required to bring out correct contrasts between shadows and highlights. Usually that means developing for *less* time than is normally recommended. The negative will thus be a little softer (less contrasty) and will seem to have more quality. Most amateur negatives are frightfully overdeveloped; hard as nails. Cut down your developing time until you reach a point where the contrast of your negatives is right for the kind of prints you

An *underdeveloped* negative

A print from that negative

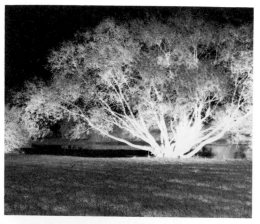

A *normally developed* negative

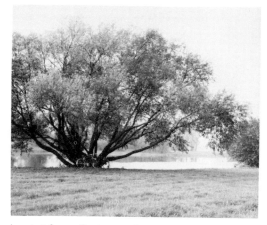

A print from that negative

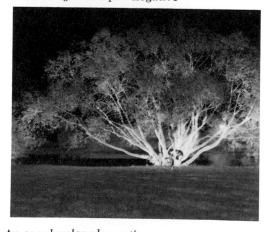

An *overdeveloped* negative

A print from that negative

All three negatives were exposed *normally* by *Minolta Autometer*. Their respective gammas would be about .4, .7, and 1.3. *Plus X Professional* sheet film developed in HC 110.

like. Don't be afraid to abbreviate developing time in this way (unless, of course, the developer is old and weak, in which case the best thing to do is to start with a fresh batch). See page 369, *How Long Should I Develop That Film* (using *new* developers or *old* emulsions).

HOW TO DRY A NEGATIVE QUICKLY

Formalin can harden the wet film of a negative so that heat will not melt it. If you're in a hurry, therefore, wash your negative thoroughly, empty the tank, and then use the following:

DRYING SOLUTION

	AVOIRDUPOIS		METRIC	
Sodium bisulphite	2¼	ounces	63.6	grams
Formalin	6	ounces	170	grams
Water	32	ounces	1000	cc.

Leave the negative in the tank, pour in the solution, and let it stand for five minutes. Then wash it, remove from tank, and heat gently. The solution can be kept and reused.

Alternate method: Remove surface water, dip negative in alcohol bath (90% alcohol, 10% water). Hang up to dry. *Do not use rubbing alcohol;* it leaves an opalescent deposit.

If you prefer to use a prepared film drier, try the *Yankee Instant Film Dryer.* It dries film in about two minutes. For information, write to Yankee, 3329 Union Pacific Ave., Los Angeles, California 90023.

Grain, and How to Control It

When the miniature camera first came on the scene, the photographer's biggest headache was grain. Everybody—chemists, film manufacturers, and photographers alike—did what they could to eliminate grain. But they failed to get rid of it entirely for a very simple reason: *no picture can be made without it.* Grain, you see, is the positive image of the spaces between the clumps of silver that make up the image on the negative. You can't eliminate it; you can only minimize its troubles. Since those early days, a new word has come into vogue: *acutance,* with its illusion of sharpness created by grain that has no soft edges. And now photography has come around full circle. Today, grain is the thing.

Here are some suggestions for getting *grainless* or *grainy* pictures, depending on your need and taste.

For grainless negatives: Use a fine-grain emulsion (the slower the

film, the finer the grain). Emulsions such as Plus X, Tri X Pan, and Verichrome Pan, are less grainy than the old films of equal speed. *Do not overexpose.* Use a fine-grain developer such as D 76, D 23, D 25, Microdol X, MCM 100, Edwal Super-12, Promicrol, Microphen, X 22 or X 100, Clayton P 60, Ethol UFG or Acufine. *Keep all solution temperatures uniform.* For *best* results try those wonderful thin-emulsion films (Panatomic X, Isopan F and FF, Ilford Pan F, and FP4). These give spectacular results when developed in Neofin Blue, X 22, Clayton P 60, D 76, Windisch 665, or Willi Beutler's Developer (the original of Neofin Blue).

For grainless prints: avoid hard, glossy paper, condenser enlargers, concentrated paper developers; use mat surface paper or soft or diluted developers. Some amateurs minimize grain by throwing the enlarged image slightly out of focus, or by enlarging through a mesh screen or a nylon stocking stretched taut over a sewing hoop.

For negatives with grain. Probably the easiest way to get coarse grain is to use Tri X Pan and overdevelop it in D 76, HC-110, or Dektol. But this will not work too well with contrasty subjects, since overdevelopment adds to the contrast and may make your negatives unprintable. Another film that can be depended on to produce coarse grain is *Kodak 2475 Recording Film* (available in 36-exposure, 35mm cartridges as well as bulk rolls). It has an Exposure Index of 1000, but can be used at speeds of up to 1600 for general use (follow instructions in data sheet supplied with film, and *don't overexpose*). It can be developed, as Kodak recommends, in DK 50, undiluted, for 7.5 minutes at 68° F.; or in Diafine, a two-solution developer that is quite easy to use if you dunk film for at least 3 minutes in Solution A; drain, but do not rinse, and then repeat process in Solution B. Almost any temperature between 70° F and 80° F can be used.

Geoffrey Crawley, editor of *The British Journal of Photography*, suggests the following developer for grain effects on high-speed film (ASA 400 and over). It will give a speed increase of 50 per cent.

FX-16 FOR GRAIN

	METRIC		AVOIRDUPOIS	
Metol	.5	gram	7.72	grains
Glycin	.5	gram	7.72	grains
Sodium sulphite, anhydrous	4	grams	61.7	grains
Sodium carbonate, anhydrous	50	grams	1	oz., 334 gr.
* Pinacryptol yellow, .05 per cent sol.	250	ml	9	ounces
Water to make	1000	cc.	32	ounces
* For Kodak Royal X Pan use	350	ml	12 oz. 235 minims	

Dissolve solids in half the total quantity of water at 90° F. (30° C.). Add dyes, and then add the rest of the water. *Make up as required;* use within six hours, adding dyes just before use. Use once and discard. Pinacryptol yellow is available from Amend Drug & Chemical Co., 83 Cordier, Irvington, N.J. 07111, or most of the other chemical supply houses listed on page 442. The .05 per cent solution (1:2000) will keep indefinitely if stored in a brown bottle, away from the light. At 68° F. (20° C.) with normal agitation of 10 seconds each minute, use these development times: Royal X Pan, 20 minutes; Tri X Pan (roll), 12 minutes; Tri X Pan (35mm), 12 minutes; Ilford HP4 (rolls), 13 minutes; Ilford HP4 (35mm), 11 minutes.

Geoffrey Crawley also suggests that if agitation is reduced to every other minute or third minute, with an increase in time of up to ⅓ or ½, "negatives of interesting internal gradation and acutance may be obtained." Agitation can be abandoned altogether, with a further increase in time. Dilution may be doubled or trebled, to form *stand* developers acting over 1 to 2 hours at room temperature.

Halation and How to Prevent It

Halation—that is, the halo of light that is formed around the edge of a brightly illuminated surface, and which cuts into the shadows—is often found in landscape and other kinds of photography, but it is particularly troublesome in interior views, especially around the windows. The cause of halation is easily traced to the rays of bright light which strike the sensitized surface and pass on through it to the back of the film base. When the rays reach that surface they are reflected back, and so act again on the sensitized emulsion. This fogs the film, especially around the brightly-lit areas. Overexposure tends to increase halation problems by forcing the development of otherwise weak halo images.

Films are not subject to halation as much as plates are, because they are thinner; in any case, most modern films and plates are already coated with a non-halation gray backing which is satisfactory protection for most purposes. For still greater protection it is better to develop the film in a *compensating developer* (one that acts on the *surface*, does not penetrate to the bottom of the emulsion). Such a developer (recommended by Hans Windisch, author of *The New Photo School*) is given below. The virtues of this developer are that it equalizes extreme light contrasts, requires no extra exposure, and produces fairly fine grain. The developer consists of two stock solutions, which are mixed in certain proportions and diluted for use.

WINDISCH COMPENSATING DEVELOPER
FOR EXTREME CONTRASTS

Dissolve in this order:	METRIC	AVOIRDUPOIS
A Water (boiled)	100 cc.	3 ounces, 183 minims
Pyrocatechin	8 grams	123 grains
Sodium sulphite (crystal)	2.5 grams	38.6 grains

This solution can be stored in a brown bottle if filled almost to the brim.

B 10 per cent caustic soda solution, made by dissolving 10 grams (154 grains) of caustic soda in 75 cc. (2 ounces, 257 minims) of *cold* water and then adding enough cold water to make 100 cc. (3 ounces, 183 minims)

This solution can also be stored for about 2 months if kept in an ordinary bottle filled almost to the brim.

Directions for use. For tank development take 500 cc. of water plus 12 cc. of solution *A* plus 7 cc. of solution *B*. Development time is 15 to 20 minutes.

For contrasty negative material take 500 cc. of water, 20 cc. of solution *A*, 5 cc. of solution *B*. Develop for 18 to 20 minutes.

The developer should be used only once.

For still softer negatives curtail the development time; for more contrast, increase time.

For tray development of large negatives, development can be stopped after 12 to 14 minutes. The best concentration for this purpose is 100 cc. water, 4 cc. of solution *A* plus 3 cc. of solution *B*.

The best way to buy caustic soda is as Kodak sodium hydroxide, *granulated*, in one-pound jars. Caustic soda attracts water. If you get it as *pellets* or *sticks*, it will lump up and become a useless mess. *Always keep the jar air-tight.* I don't know why it stays drier in its granulated (crystal) form, but it does; and Kodak recommends this form for storage. The fact that a saturated solution deposits crystals as it loses water by evaporation may be a key to the answer. Perhaps the sodium hydroxide crystal is "water-satisfied."

The After Treatment of Negatives

A negative that is too thin will make a flat print, and one that is too dense will not show the proper gradation in the finished print. There are two ways in which these defects can be rectified, namely, (1) by using the proper paper for making the print, and (2) by *intensifying* or *re-*

ducing the negative as the case may be. It has to be a pretty poor negative that will not make a fair to middling print if you use the right kind of paper, or variable contrast paper with the proper filter. If it is too thin, try intensifying it; if too dense, try reducing.

HOW TO INTENSIFY A NEGATIVE

A negative that is too thin can be considerably bettered by intensification, but you must not be led to believe that this treatment will improve the detail for all it can do is to strengthen that which is already present in the negative. A negative may be thin because (*a*) the film was underexposed, or (*b*) it was underdeveloped, or both.

(*a*) Where the negative was *underexposed*, fix and wash it thoroughly and then immerse it in the following intensifier:

CHROMIUM INTENSIFIER

STOCK SOLUTION	METRIC	AVOIRDUPOIS
Potassium bichromate	90 grams	3 ounces
Hydrochloric acid	64 cc.	2 ounces
Water to make	1000 cc.	32 ounces

For use, take one part of stock solution to 10 parts of water. Bleach thoroughly (until the image disappears), then wash for five minutes and redevelop fully (about 5 minutes) in artificial light or daylight in any quick-acting, non-staining developer (such as D 72 diluted 1:3). Then wash thoroughly and dry. Greater intensification can be secured by repeating the process. The degree of intensification can be controlled by varying the time of redevelopment. This treatment, of course, does not produce detail that was lost through underexposure; it only increases contrast in the existing weak detail.

Warning. Developers containing a high concentration of sulphite such as D 76 or DK 76 are not suitable for redevelopment since the sulphite tends to dissolve the silver chloride before the developing agents have time to act on it. However, films developed in D 76 or DK 76 can be intensified in the mercury bleacher and ammonia blackener given on pages 360 and 361, or in one of the prepared intensifiers now on the market.

The Eastman chromium intensifier powders are as satisfactory as the above formula, and are supplied in prepared form ready to use simply by dissolving in water.

Stains are sometimes produced during intensification or reduction unless the following precautions are observed: (1) The negative should be fixed and washed thoroughly before treatment and be free of scum or stain. (2) It should be hardened in the formalin hardener given below before reducing or intensifying. (3) Only one negative should be handled at a time and it should be agitated thoroughly during the treatment; then washed thoroughly and wiped off carefully before drying.

FORMALIN HARDENER

	METRIC	AVOIRDUPOIS
Water	500 cc.	16 ounces
Formalin (40 per cent Formaldehyde sol.)	10 cc.	2½ drams
Sodium carbonate (dry)	5 grams	73 grams
Water to make	1000 cc.	32 ounces

This formula is recommended for the treatment of negatives which would normally be softened considerably by intensification or reduction.

After hardening for three minutes, rinse the negative and immerse it for five minutes in a fresh acid fixing bath. Wash well.

If your negative has been *underdeveloped,* then make up the following solutions which may be used over and over again. These solutions are called the *bleacher* and the *blackener* respectively.

MERCURY BLEACHER

	METRIC	AVOIRDUPOIS
Mercury bichloride (*poison!*)	30 grams	1 ounce
Hot water (about 120° F)	500 cc.	16 ounces

When this solution is cool (about 70° F.) pour it off from the white feathery crystals that are thrown down and then add

Hydrochloric acid	2 cc.	½ dram

Now put the negative in this solution and rock the tray until the solution has turned a creamy color all the way through. Then wash the bleached negative thoroughly and immerse it in the following for about one minute, when it will be greatly intensified and of a good black color.

AMMONIA BLACKENER

	METRIC	AVOIRDUPOIS
Ammonia (0.880)	30 grams	1 ounce
Water	1000 cc.	32 ounces

HOW TO REDUCE A NEGATIVE

A negative that is too dense will not only take a long time to print, but it will make a picture which is too full of contrasts. This contrast may be so great that the thinner parts will print first, before the light makes an impression through the darker parts, and there will be neither detail nor gradation; hence, a reducer must be used to improve it. The cause of dense negatives is either (a) overexposure, or (b) overdevelopment. These problems can be remedied by immersing the negatives in the following reducer which greatly decreases the contrast by lightening the shadows while leaving the high lights as they are.

FARMER'S REDUCER

	METRIC	AVOIRDUPOIS
Hypo solution (1 part hypo to 5 parts water)	226 cc.	8 ounces
Potassium ferricyanide (10 per cent solution)	Q. S.	Q. S.

The abbreviation Q. S. stands for *quantum sufficit* (as much as suffices). In this case it means adding as much ferricyanide to the hypo as will give the solution a light lemon color. Now immerse the negative in this solution and rock the tray; if the negative does not get thinner add more ferricyanide until it has the desired action. When the negative is reduced as much as you want it, take it out and wash it *quickly* or the reducing action may go on and spoil the negative.

See the supplemental glossary, under *reducer*, for further notes on *cutting*, *flattening*, and *proportional* reducers. Also, see *index*.

HOW TO REMOVE FOG

A fogged negative is one that looks as if it were covered with a thick layer of smoke. Fog is often caused by white light striking the plate and this may occur (a) while the plate or film is being put in the holder or the camera, (b) while it is in the camera, or (c) while it is being devel-

oped. It can also be caused (*d*) by the developer itself. If the fog is slight, it can be cleared away by immersing the negative in the following solution:

FOG REMOVER

	METRIC	AVOIRDUPOIS
Alum	42.4 grams	1½ ounces
Citric acid	42.4 grams	1½ ounces
Ferrous sulphate	113 grams	4 ounces
Water	1000 cc.	32 ounces

As this solution does not deteriorate, you can pour it back in the bottle after you have used it and keep it for the next time you have a fogged film. After the negative has been fixed and washed put it in the solution and rock the tray until the fog disappears. If the fog is very bad put the negative in a weak solution of Farmer's Reducer, previously described, but be careful not to leave it too long or there may not be anything left to tell the story except blank film.

HOW TO GET RID OF BLEMISHES

First be sure your negative is spotlessly clean. Use carbon tetra-chloride,[1] or Edwal Film Cleaner (removes dirt *and* eliminates static). Then, use any of the following: (1) Retouch negative (see later). (2) Make soft-focus prints by interposing something like a gauze, a screen, or a nylon stocking stretched over a hoop. (3) Use rough, mat instead of smooth, glossy papers. (4) Use a cold-light enlarger instead of the condenser type. (5) Throw your enlarger lens slightly out of focus. (6) Subdue lips, freckles, blemishes by using *pan*chromatic film, instead of *ortho*. (7) Clean film with ammonia. See also *How to avoid and overcome spots and scratches*, later in this chapter.

HOW TO SPOT A NEGATIVE

You may find, after you have made a negative, that the film has transparent spots and pinholes in it. These must be painted over or filled in, or *spotted out* as it is called. To spot a negative you can use a little India ink or you can buy a cake of *opaque*, and this you put on with a No. 3 red sable brush, one that has a fine point. An improvement over India ink or opaque are the recently perfected dye retouching mediums: *Spotone, Dyene, Kodak Retouching Dye* (originally the dyes for *Flexi-*

[1] *Toxic!* Be careful: See item 38, chapter 19, *Hints and Suggestions*.

chrome, now discontinued); the reducers, *Spotoff* and *Etchadine;* and *Perfect Liquid Opaque*—a free-flowing, smooth-working dense black liquid that never cakes, chips, or lumps—with which you can produce sharp lines or blended edges at will. These are all easy to use and easy to control. You can get full information about them, and instructions for their use, *free,* by writing to Retouch Methods Co., P.O. Box 345, Chatham, N.J. 07928; and to Jamieson Products Co., 9341 Peninsula Drive, Dallas, Texas 75218 for *Etchadine* and *Hibadye* color correction (see chapter 18, *Better Color Photography*). The manufacturer of Etchadine, Paul H. Jamieson, has made the following offer as a service to our readers: "I will do small area testing on scrap pieces of their prints. I will not undertake any complete retouching or coloring jobs but will return any small (no value) prints which are sent to me with a report on how the work was done. This offer will be good on either *Etchadine* retouching, monochrome dye work, or *Hibadye* color correction. I cannot be responsible for loss or damage to pictures sent to me."

HOW TO RETOUCH A NEGATIVE

You need: (1) a retouching desk, (2) a medium soft lead pencil, (3) a retouching knife, and (4) a bottle of retouching medium (which gives the polished side of the negative a surface that takes pencil). The

FIG. 13.1.
A RETOUCHING DESK

FIG. 13.2. A HOLDER FOR RETOUCHING LEADS *(left)*
AND A RETOUCHING KNIFE

tools of a retouching outfit are shown in *Figs. 13.1* and *13.2*. The re-
touching desk is used to support the negative and allow light to pass
through it. It has either a fixed or pivoted reflector at the back, and the
upper board serves to shade the negative.

The first thing to do, when you start to retouch a negative, is to
clean the polished side of it (see item 38, chapter 19, *Hints and Sugges-
tions*), then make a little pad of a soft, old cotton rag and moisten it
with a little retouching medium, which you can buy ready to use. Rub
the negative with the pad, giving it a rotary motion; this will produce a
surface with a "bite," so that the pencil marks can take hold.

Having prepared the negative, set it on the frame of the desk which
should stand in front of a window or near some other light source; then
put a medium-soft lead with a very sharp point in the pencil holder and
touch out blemishes first. This you do by beginning at the center of each
light spot and make little marks on it with your pencil like a lot of com-
mas, gradually easing off as you get to the edge. This done, work over
the other parts of the negative (lines and scratches), giving your pencil
a repetitive, rotary motion until you have produced a stipple effect that
hides the scar. Where the negative is too dense, you can lighten it by
using your retouching knife on the *emulsion side* (but be very careful
not to scrape through the film). A better way to reduce those areas is to
use *Spotoff, Etchadine,* or *Dyene.*

HOW TO VARNISH A NEGATIVE

When you are going to make only a few prints from a negative, it
is not at all necessary to varnish it, but a coat of varnish will give it an
extremely hard surface that will protect it for all time against wear.
Negative varnish can be bought (as in Kodalak Clear) or you can make
it up:

COLD NEGATIVE VARNISH

Celluloid	⅛	ounce
Amyl acetate	6	ounces
Oil of lavender	3	drops

The amyl acetate gives off a sickly odor and the oil of lavender is put
in to kill it. This varnish can be poured on the negative and flowed over
it, or it can be put on with a brush while both are cold. To retouch a
varnished negative, use retouching medium as before. The *celluloid* is
obtained by boiling film negatives in a 5 per cent solution of sodium
carbonate to remove the gelatin. The film is then cut into small pieces

and dissolved in the amyl acetate. *Caution:* solution is inflammable; keep away from open flame.

Negative Faults

Here are the most common negative defects and a few ideas on what you can do to avoid or correct them.

STREAKS OR OTHER IRREGULARITIES

1. *Cause:* Insufficient or improper agitation. *Cure:* Constant agitation during development, changing motion at frequent and regular intervals.

AIR BELLS

2. *Cause:* Air bubbles clinging to emulsion surface and preventing action of developer. *Cure:* Place film *into* solution instead of pouring solution into tank. Agitate. Knock tank against table to dislodge bubbles.

BLACK SPOTS

3. *Cause:* Undissolved developing agent particles settling on emulsion surface. *Cure:* Better preparation of solution, and filtering.

UNEVEN DEVELOPMENT

4. *Cause:* Developer poured into tank too slowly. *Cure:* Pour solution into tank quickly and continuously.

PINHOLES

5. *Cause:* Gas bubbles formed when film is placed in acid rinse or acid hypo baths. *Cure:* Avoid strongly acid afterbaths. Agitate. Avoid developer with carbonate; use those which contain borax or sodium metaborate (Kodalk), neither of which produces a gas on contact with acid.

RETICULATION

6. *Cause:* Sudden *drop* in temperature between developing and fixing, or the use of an exhausted fixing bath. *Cure:* Avoid both causes. Don't dry processed film in an air-conditioned room, where cold air currents may chill it.

FOG

7. *Cause:* If margins are clear, fog was produced in camera; if margins are also fogged, fogging occurred while loading or developing and may have been caused by light leaks, unsafe safelight, high temperature, overdeveloping or old film. *Cure:* Obvious precautions.

To keep fog down, turn to the chemical with the unpronounceable name, *Benzotriazole* (Kodak Anti-Fog #1), which is the one to use when your film suffers from age or unfavorable storage conditions (as, for instance, long storage between exposure and processing). You can also use *potassium iodide;* 1 grain to each 20 ounces of developer.

WATER SPOTS

8. *Cause:* Uneven drying, or failure to remove all excess water. *Cure:* Wipe film carefully after washing. Water spots can usually be removed by soaking film in water, wiping and drying. If this doesn't work, try softening the film with weak ammonia water or a solution of sodium carbonate (3 ounces of sodium carbonate in 32 ounces of water at about 80° F.). When film is rubbed with cotton dipped in the same solution, the spots should disappear. *Caution:* rub gently. You can also use plain water at 80° F., followed by an alum acetic bath and washing. Sometimes that works as well. Then refix, wash, and dry.

BLUE OR RED STAINS

9. *Cause:* Halation backing not completely dissolved. *Cure:* Bathe in a weak solution of ammonia, or a ten per cent solution of sodium sulphite.

THIN

10. *Cause:* If shadow detail is lacking, it was *underexposed;* if the negative is flat, but with shadow detail, it was *underdeveloped. Cure:* Underexposure cannot be remedied; you can only improve what detail there is by intensification with chromium intensifier, which at the same time increases contrast. Underdevelopment can be corrected by *intensification.*

DENSE

11. *Cause:* If the negative is flat, fogged, with too much shadow detail, it was *overexposed.* If it is contrasty, it was *overdeveloped. Cure:* chemical reduction.

MILKY

12. *Cause:* Incomplete fixation. *Cure:* Replace negative in fixing bath, then wash and dry.

GREEN STAINS

13. *Cause:* Too high a concentration of chrome alum in hardening bath. *Cure:* Soak negative in a 5 per cent solution of potassium citrate or potassium hydroxide for a few minutes. But precede this treatment by dipping negative in the *formalin hardening solution* given earlier.

YELLOW STAINS

14. *Cause:* Dichroic chemical fog. *Cure:* Wash in a dilute solution (.25 per cent) of potassium permanganate. If brown stain results, wash in a ten per cent solution of sodium bisulphite.

FUNGUS — AND WHAT TO DO ABOUT IT

Moisture is usually the villain. Storage in dry, air-tight containers (using a moisture remover like *silica gel*) is often the cure. Clean the unmounted transparencies with Kodak film cleaner or carbon tetrachloride (*poison!* ventilate room well). Another way is to dip the transparency in alcohol or methylated spirits, which will kill fungus by dehydration. *Do not use water* (fungus makes gelatin water-soluble)! A few drops of *formaldehyde* added to final rinse, if you do your own processing, will prevent this in the future.

To *prevent* the growth of fungus, use a coating like Edwal *Permafilm,* Kodak *Film Lacquer,* or *Micro-Cote.* These will make your film tough but not brittle. They will also slow down color fading due to prolonged projection, reduce static, and make it easier to remove fingerprints. Apply the coating with a freshly washed cotton cloth or an applicator.

For more information on the subject, write for Kodak Customer Service Pamphlet AE-22: *Prevention and Removal of Fungus on Processed Film,* Department 841, Eastman Kodak Co., Rochester, N.Y. 14650.

See also item 40 of chapter 19, *Hints and Suggestions.*

HOW TO AVOID AND OVERCOME
SPOTS AND SCRATCHES

Keep dust out of camera; blow it out with a rubber ear syringe. Keep tanks clean. Filter all solutions. Don't cinch the film by pulling it

too tight. Stay clear of felt-mouthed film cassettes. Harden the film after development. View with suspicion all sponges and chamois. If you do swab the film after washing, do so very gently. Make sure that the pressure plate in your camera is absolutely smooth and *clean;* if there's any grease on it, it will become a dust trap. Use reloadable cassettes in preference to the daylight-loading cartridges; film with paper leaders is best of all. See item 40, chapter 19, *Hints and Suggestions.*

Here's a simple technique for overcoming pinholes and scratches:

1. Place the negative in the enlarger. With orange filter in place, project the image on the paper. Scratches and pinholes will show up clearly.

2. Fill in blemishes *on the paper* with medium-soft lead pencil.

3. Swing filter out of the way and make the exposure.

4. The pencil marks on the printing will protect the emulsion from the light that streams through the pinholes or scratches.

5. Erase pencil marks, before developing.

6. Retouch after drying.

John Adam Knight, former N.Y. *Post* Camera Editor, suggests this way to get rid of scratches:

1. Make a solution of 1 part glycerin to 6 parts water (70° F.).

2. Soak the scratched film in this bath until it becomes damp.

3. Very gently wipe *across* the scratch with a wet chamois squeezed almost dry. Do this once only. Then hang up to dry.

Four other ways to overcome scratches:

1. Make a sandwich of negative in *glycerin* or *carbon tetrachloride* [2] between two thin glass slides. Eliminate air bubbles before removing sandwich from liquid. Wipe edges and both faces and enlarge at once.

2. Place a bit of Vaseline between thumb and forefinger, then spread thinly on both sides of negative before enlarging. Works like magic!

3. Use *Refractasil,* a unique silicone compound produced by General Electric. It hides scratches because it has the same refractive index as film. It cannot be absorbed by the emulsion, is easily wiped off with clean chamois or tissue.

4. Use *baby oil,* one small drop spread across scratch with a clean finger.

NEWTON'S RINGS

These troublesome color rings may appear when the film touches a glass surface in the enlarger. Suggested cure: After the film is developed and dry, roll the film backwards (reversing its natural curve). Let it stay

[2] *Dangerous!* See item 38, Chapter 19, *Hints and Suggestions.*

that way about 12 hours. Clean pressure plate with slightly damp cloth (not *chamois*). Pass cloth over glossy side of film.

HOW LONG SHOULD I DEVELOP THAT FILM?

(Using *New* Developers or *Old* Emulsions)

When you are trying a new developer (or one that has been around for a while, and you're not sure how good it still is) or some old, outdated film that you want to check on, here's one way for you to get a "fix" on how long you should dunk your film in the solution:

1. Cut off a small piece of the film.

2. Expose it to white light (*not sunlight*, because that will hasten development).

3. Immerse half the piece of film in the developer. Note the time (use a stopwatch).

4. At the first visible darkening of the submerged portion of the film, note the time again (stop the watch at that point).

5. The time interval multiplied by 20 is the time required to develop your film to normal contrast.

These are the only variations: a) for panchromatic film in ultra-fine-grain developer, use a factor of 30; b) if the film is very stale you may also have to use a factor of 30. Keep the temperature at 68° F.

The time normally required to produce the first visible darkening of the film is somewhere between 6 and 60 seconds, which is equivalent to 2 and 20 minutes of negative development times, respectively. *If first darkening is more than 60 seconds, the developer is tired. Throw it away.* If nothing happens after 3 minutes, your *developer* may be *hypo*.

We are indebted for this idea to *H. W. Hyde* and *The Amateur Photographer*.

Formulas

You'll need an accurate pair of scales, preferably *metric*, a quart pyrex beaker, an asbestos coated screen to place over the raw flame when you heat the solutions, a fluted funnel (quart size), filter paper (preferably the gray Prat-Dumas No. 33), a good thermometer, another Pyrex beaker or two for transfer of solutions, a stirring rod, some brown bottles (quart size, with bakelite-type screw caps). *Filter all solutions.* Never dissolve developing agents in water hotter than 125° F. Always

dissolve chemicals *completely* in the order given in each formula; otherwise, some may not dissolve at all. Dissolve all chemical solutions in distilled water, or filtered rain water, or boiled and filtered tap water to which a pinch of *Calgon* has been added (1 gm. in 1000 cc., or ½ gm. of *Anti-Cal* in 1000 cc.). See special note on sulphite in Formula 7.

Never use a developing solution immediately after it has been prepared. Let it stand an hour or two before using, preferably overnight. Keep all developing solutions at the same temperature; where a choice of several temperatures is offered, use 70° F.

1. FINE GRAIN, SOFT WORKING (SAME AS D 76)

For maximum emulsion speed and fine grain. Use without dilution except where noted. This standard formula, against which all other developers are now measured for film speed, grain, sharpness, or definition, was devised by J. G. Capstaff of the Kodak Research Laboratories in 1927. Hans Windisch, author of *The New Photo School*, says that the grain of D 76 is finest when the film is developed for 10 minutes. He adjusts the exposure to match.

Dissolve chemicals in this order:	METRIC	AVOIRDUPOIS
Water, about 125° F. (52° C.)	750 cc.	24 ounces
Elon (Metol)	2 grams	29 grains
Sodium sulphite, dry	100 grams	3 oz. 145 grains
Hydroquinone	5 grams	73 grains
Borax, granular	2 grams	29 grains
Cold water to make	1000 cc.	32 ounces

Average time of tank development at 68° F., intermittent agitation (5 seconds every 30 seconds): Panatomic X (roll and 35mm), 7 minutes; Plus X Pan (roll and 35mm), 5½ minutes; Verichrome Pan (roll and pack), 6½ minutes; Tri X Pan (roll and 35mm), 7½ minutes; Panatomic X (*diluted 1:1*), 8½ minutes; Plus X Pan (*diluted 1:1*), 8½ minutes; Verichrome Pan (*diluted 1:1*), 8½ minutes; Tri X Pan (*diluted 1:1*), 10½ minutes; Isopan FF, 7 minutes; Isopan F, 9 minutes.

Contrast can be altered by varying development times.

Diluted 1:1 means: make a solution consisting of equal parts of developer and water.

2. FINE GRAIN, METABORATE (SAME AS DK 76)

For greatest shadow detail on fine-grain film.

Dissolve in this order:	METRIC	AVOIRDUPOIS
Water, about 125° F. (52° C.)	750 cc.	24 ounces
Elon (Metol)	2 grams	29 grains
Sodium sulphite, dry	100 grams	3 oz., 145 grains
Hydroquinone	5 grams	73 grains
Kodalk (sodium metaborate)	2 grams	29 grains
Water to make	1000 cc.	32 ounces

Development times at 68° F., one minute more than for D 76.

If the Kodalk concentration is increased to 5 grams (2½ times normal) reduce developing time to ½; if Kodalk is increased to 10 grams (5 times normal), reduce development to ⅜; if Kodalk is increased to 20 grams (10 times normal), reduce development to ¼.

Richard W. Vesey, writing in *Leica Photography,* named D 76 the "middle-aged *wunderkind.*" With Tri X Pan, which he rates at 650 ASA (instead of the 400 recommended by Kodak), he gets detail, texture, contrast, and fine grain. He agitates continuously for the first 30 seconds; thereafter 5 seconds of each minute.

3. FINE GRAIN, SUPERB GRADATION (SAME AS D 25)

Dissolve in this order:	METRIC		AVOIRDUPOIS
Hot water (125° F. or 52° C.)	750	cc.	24 ounces
Elon (Metol)	7.5	grams	¼ ounce
Sodium sulphite, dry	100	grams	3 oz., 145 grains
Sodium bisulphite	15	grams	½ ounce
Cold water to make	1000	cc.	32 ounces

Do not dilute for use.

Average developing time for roll film: 11 minutes in a tank at 77° F. (25° C.). *Temperature is important.* This is one of the best of the fine-grain developers. It is nontoxic and nonstaining, and gives beautiful gradations. Introduced by Kodak in 1944, it has become an international favorite. It was worked out by R. W. Henn and J. I. Crabtree.

For Panatomic X, Plus X, Verichrome Pan, and Isopan F, Kodak has not released revised developing times. Try 8–10 minutes at 77° F.

For replenishment, add DK 25R (see below) at the rate of 45 cc.

(1½ ounces) per roll for the first 12 rolls per liter (or 50 rolls per gallon) and thereafter 22 cc. (¾ ounce) per roll for the next 12 rolls per liter (or 50 rolls per gallon). The developer should then be discarded and replaced with fresh solution. Dissolve chemicals in order given.

D25 REPLENISHER (DK 25R)

	METRIC	AVOIRDUPOIS
Hot water (125° F. or 52° C.)	750 cc.	24 ounces
Elon (Metol)	10 grams	145 grains
Sodium sulphite, dry	100 grams	3 oz., 145 grains
Kodalk	20 grams	290 grains
Cold water to make	1000 cc.	32 ounces

4. FINE GRAIN, FOR LONG SCALE SUBJECTS (SAME AS D 23)

Dissolve in this order:	METRIC	AVOIRDUPOIS
Hot water (125° F. or 52° C.)	750 cc.	24 ounces
Elon (Metol)	7.5 grams	¼ ounce
Sodium sulphite, dry	100 grams	3 oz., 145 grains
Cold water to make	1000 cc.	32 ounces

Do not dilute for use.

Average developing time about 19 minutes in a tank. For thin-emulsion films (Panatomic X, Isopan F and FF) and for Plus X and Verichrome Pan, try 8–10 minutes at 68° F.

Replenish with DK 25R at the rate of 22 cc. (¾ ounce) per roll. Discard after 25 rolls per liter (32 ounces).

Diluted 1:3, use with slow and medium speed films, 20–30 minutes at 68° F. Use once and discard.

5. METOL SULPHITE (WINDISCH)

This is a compensating, fine-grain developer that acts without an alkali.

Dissolve in this order:	METRIC	AVOIRDUPOIS
Water, boiled	500 cc.	16 ounces
Metol	2.5 grams	38.5 grains
Sodium sulphite, *crystal*	50 grams	1¾ ounces
Water to make	1000 cc.	32 ounces

Dissolve the metol in warm water, then add the sulphite. If the anhydrous (dry) form of the sulphite is used, only half the above quantities should be used. Average tank developing time, 18–25 minutes at 68° F. For thin emulsions try 10–15 minutes at 68° F.

6. GEOFFREY CRAWLEY'S FX 18

(Compact Grain, Good Resolution, Normal Exposure)

This is one of a series of solvent or *physico-chemical* fine-grain formulae proposed by Mr. Crawley in 1961 after considerable research into the structure of modern films. It is a P-Q version of D 76 which offers better resolving power, some reduction in grain, and a slight increase in speed. It is suggested that minimum meter readings now in use can be advanced about 30 per cent (ASA 50 to 64; ASA 100 to 125) when exposing for FX 18, though normal ratings are recommended. The developer is available in packaged powder form from Paterson (Products) Ltd. and distributed by Johnsons of Hendon Ltd. Can be used as a one-time-and-discard developer by diluting 1 to 1.

Dissolve in this order:	METRIC		AVOIRDUPOIS	
Water (80°–100° F.)	800	cc.	24	ounces
Sodium sulphite (anhydrous)	100	grams	3	oz., 231 gr.
Hydroquinone	6.	grams	92.6	grains
Phenidone	0.10	gram	1.54	grains
Borax	2.5	grams	38.6	grains
Sodium bisulphite	0.35	gram	5.35	grains
Potassium bromide	1.6	grams	24.66	grains
Water (cold), to make	1000	cc.	32	ounces

To avoid trouble, be sure to dissolve the sulphite first, a little of the Hydroquinone, then the Phenidone, followed by the rest of the Hydroquinone, which helps the rapid solving of the Phenidone. Stores perfectly for at least half-a-year in filled screw-capped bottles, unused; partly used, it will keep for three months.

Develop at 68° F., with normal agitation once per minute. Here are the times in minutes for some of the more frequently used films: Ilford 35mm Pan F stock, 6½; dilute 1:1 and discard, 9; FP3 stock, 6½; 1:1, 12: HP3 stock, 8½; 1:1, 13; HP4 stock, 7½; 1:1, 11; roll film HP3 stock, 10; 1:1, 14; HP4 roll stock, 9; 1:1, 13; Kodak 35mm Panatomic X stock, 5½; 1:1, 8; Plus X Pan stock, 6; 1:1, 9; Tri X Pan stock, 8; 1:1, 10; roll film, Panatomic X, 6; 1:1, 9; Plus X Pan Prof. stock, 8½; 1:1, 11; Verichrome Pan stock, 7½; 1:1, 11; Tri X Pan stock 8; 1:1, 12.

7. WINDISCH 665 (FINE GRAIN)

This superb developer requires 2x normal exposure, gives very fine grain, full shadow detail, highlight compensation.

Dissolve in this order:	METRIC	AVOIRDUPOIS
Water (boiled)	500 cc.	16 ounces
Sodium sulphite, dry	90 grams	3 ounces
Orthophenylenediamine	12 grams	180 grains
Metol	12 grams	180 grains
Potassium metabisulphite	10 grams	150 grains
Water to make	1000 cc.	32 ounces

Do not dissolve the sulphite in hot water. Dissolve all chemicals separately. The metol and orthophenylenediamine dissolve completely only after the two solutions have been mixed. Add the sulphite solution, then the bisulphite to the developer solutions. Stir until clear, then filter.

Average developing time for medium-speed film, 13 minutes at 68° F. For thin-emulsion films, 8–9 minutes at 68° F.

8. WILLI BEUTLER'S FINE-GRAIN DEVELOPER

For Maximum Emulsion Speed and Sharpness

Yields delicate, fully graded negatives, high emulsion speed, and exceptional resolution. Willi Beutler is also the inventor of *Neofin* (a surface developer that hardens the emulsion), which is said to be a variation of this formula. Make two stock solutions:

Dissolve in this order:	METRIC	AVOIRDUPOIS
A:		
Water	1000 cc.	32 ounces
Metol	10 grams	154 grains
Sodium sulphite	50 grams	1 oz., 334 gr.
B:		
Water	1000 cc.	32 ounces
Sodium carbonate (dry)	50 grams	1 oz., 334 gr.

To mix, add 50 cc. (1 oz., 332 minims) of *A* and 50 cc. of *B* to 500 cc. (16 oz., 435 min.) of pure water.

Develop slow emulsions (Panatomic X, Isopan FF) 7 to 10 minutes at 65° F.; medium-speed emulsions (Plus X, Isopan F) 8 to 12 minutes at 65°. *Do not use higher temperatures.*

9. PHENIDONE FINE GRAIN (HIGH EMULSION SPEED)

Phenidone (or 1-phenyl-3-pyrazolidone, as the chemists know it) was first compounded in 1890, but it wasn't until 1940, when Drs. J. D. Kendall and A. J. Axford of Ilford, Ltd., rediscovered it as a possible substitute for metol that it began to have its present vogue. First marketed in 1952, it has since become a vital ingredient in many excellent fine-grain developers, notably Microphen and Clayton P60. Among its many remarkable properties: it is nontoxic, gives very fine grain, and increases speed of film.

Here is a fine-grain, high-emulsion-speed formula using Phenidone that shows little change of activity in use. It resembles Microphen in action.

Dissolve in this order:	METRIC		AVOIRDUPOIS	
Sodium sulphite, dry	100	grams	3	oz., 231 gr.
Hydroquinone	5.0	grams	77.2	grains
Borax	3.0	grams	46.3	grains
Boric acid	3.5	grams	54	grains
Phenidone	0.2	grams	3.09	grains
Potassium bromide	1	gram	15.4	grains
Water to make	1000	cc.	32	ounces

This developer is used undiluted. Average developing time for medium-speed film is 7–11 minutes at 68° F.

Another interesting formula for the use of Phenidone, this time as a stock solution, is the following. It was suggested by Ilford and is reprinted from *The British Journal of Photography*. The advantages of a stock-solution developer are many: you are using fresh developer each time; and it resists oxidation.

PHENIDONE STOCK SOLUTION

Dissolve in this order:	METRIC		AVOIRDUPOIS
1. Potassium sulphite, dry (in 400 cc. warm water)	297.2	grams	9 oz., 212 gr.
2. *Then add to 500 cc. or 16 oz. water* (*plus a pinch of potassium sulphite*):			
Glycin	50	grams	1 oz., 334 gr.
Phenidone	1.75	grams	27 grains
Potassium bromide	8	grams	123 grains
Mix 1 and 2, then add:			
3. Potassium hydroxide, granulated	34	grams	1 oz., 87.7 gr.
Finally, add water to make	1000	cc.	32 ounces

This concentrated stock solution is diluted 1:7 for use.

Average developing time for medium speed film is 7 minutes at 20° C. (68° F.) for a gamma of 0.7. For the new thin emulsions (Panatomic X, Isopan F) try 5 minutes.

One of the special characteristics of all Phenidone developer formulas is their unusually long life. They resist oxidation and exhaustion, can activate other chemicals at low concentrations, can produce active developers at lower pH's (measure of acidity), and are unlikely to cause dermatitis.

When a PQ developer (Phenidone-Hydroquinone) finally oxidizes, which it does slowly, the oxidation product is colorless, so it doesn't stain.

10. SUPERFINE GRAIN W 80 (M. U. WALLACH)

This developer was originally designed for use in photographing night scenes or scenes of extreme contrast. It can, however, also be used for other scenes with good results. Complete details for its use may be found in Mr. Wallach's booklet, *How to Take Pictures at Night*. It produces very fine grain without any appreciable loss of speed.

Dissolve in this order:	METRIC		AVOIRDUPOIS	
Water (about 100° F.)	600	cc.	24	ounces
Metol	10	grams	155	grains
Sodium sulphite, dry	125	grams	4½	ounces
Paraphenylenediamine hydrochloride	16.6	grams	257.3	grains
Glycin	8.3	grams	128.6	grains
Pyro (or rubinol)	1.6	grams	24.8	grains
Trisodium phosphate, monohydrate	3.3	grams	51	grains
Water to make	1000	cc.	32	ounces

Develop all type of film at 70° F., from 17 to 28 minutes, depending on gamma desired. For thin emulsions (Plus X, Verichrome Pan, Panatomic X) try 10 to 20 minutes at 70° F.

11. EDWAL 12 (FINE GRAIN)

For maximum emulsion speed and enlargements to 15 or 20 diameters. (*Formula at top of facing page*). Dissolve in order given.

Edwal 12. Fine grain	METRIC	AVOIRDUPOIS
Water (125° F.)	600 cc.	20 ounces
Metol	6 grams	90 grains
Sodium sulphite, dry	90 grams	3 ounces
Paraphenylenediamine	10 grams	150 grains
Glycin	5 grams	75 grains
Water to make	1000 cc.	32 ounces

Average developing times at 70° F.: 12½ to 18 minutes.

For modern thin emulsions (Panatomic X, Plus X, Tri X, Verichrome Pan), developing times of 8 to 13 minutes are suggested. *Cut developing time 20 per cent on first roll of film.* Roll film should be developed 10 per cent longer than 35mm film; cut film and film pack should be developed 20 per cent longer than 35mm film.

For best results add 20 per cent of old used Edwal 12 to each new batch. If the developer is stored in a quart bottle, 6 ounces of fresh solution can be kept aside in a small bottle when the developer is made up, and 6 ounces of old solution added to the remaining 26 ounces of fresh developer. Then, as a little solution is lost each time a roll is developed, the loss is made up from the 6 ounces of fresh solution in the small bottle.

There are three other ways of using Edwal 12:

1. *Replenishment method.* Develop 4 rolls of film in a quart of fresh solution (or 2 rolls in a quart that has 20 per cent of old Edwal added), discard enough solution so that 29 ounces remain and add 3 ounces of fresh developer from another bottle. From this point on, repeat the replenishment *after every roll*, discarding enough solution so that 3 ounces of fresh solution can be added. A quart of the developer will last indefinitely when used this way, provided the solution is not exposed too much to air. If the developer begins to get weak, discard 6 ounces instead of the usual 3 and it will be brought back to full strength. After developing about 25 rolls let the precipitate settle and pour off the clear solution. Filter after every forty rolls.

2. *Dilution method.* Dilute one part of *fresh* developer with 9 parts of water (for instance, 50 cc. of unused Edwal 12 with 450 cc. of water); develop one roll of film in this solution for *twice* the developing time of the regular concentrated developer, and then discard the solution.

3. *Thiocyanate method.* This is simply a variation of method 2. Add ½ gram (7½ grains) of potassium thiocyanate to each liter (quart) of diluted developer. Since this amount is hard to weigh accurately, it is better to add 5 grams (75 grains) of potassium thiocyanate direct to the liter (quart) of concentrated Edwal 12. *Do not use with thin emulsions!*

12. GLYCIN FINE GRAIN, STOCK

For clear, clean negatives with very fine grain.

Dissolve in this order:	METRIC	AVOIRDUPOIS
Hot water (125° F.)	750 cc.	24 ounces
Sodium sulphite, dry	125 grams	4¼ ounces
Potassium carbonate	250 grams	8½ ounces
Glycin	50 grams	1½ oz., 80 gr.
Water to make	1000 cc.	32 ounces

For tank development take one part stock solution, fifteen parts water, and develop 13 to 22 minutes at 68° F. For modern thin emulsions (Plus X, Panatomic X, Tri X, Verichrome Pan), try 8 to 13 minutes at 68° F.

13. MCM 100

This developer does not require any increase of exposure, gives very fine grain, superb tonal gradations, and produces some of the best-looking negatives you've ever seen. The emulsion side has so high a polish that it will be difficult to distinguish it from the other side.

Dissolve in this order:	METRIC		AVOIRDUPOIS
Water (125° F.)	750	cc.	20 ounces
Sodium sulphite, dry	88	grams	2 oz., 360 grains
Meritol *a*	16	grams	224 grains
Borax	2.3	grams	32 grains
Tri-sodium phosphate, *crystalline*			
(*not* the monohydrate) *b*	6.9	grams	96 grains
10 per cent potassium bromide	2	cc.	32 minims
Water to make	1000	cc.	32 ounces

a If Meritol is not available, use 7 grams of *paraphenylenediamine* together with 9 grams of *catechol* to replace the 16 grams of Meritol.
b If *monohydrate*, use 3.5 grams; if *dry* (anhydrous) use 2.9 grams.

Use weak acid short stop (15 gm. citric in 1000 cc. water plus 5 drops Aerosol).

For tank use at 70° F.: 8–20′ (minutes); Isopan F, 10–12′; Plus X and Verichrome Pan, try 10–12′; Panatomic X, try 9–11′; Tri X, 18–20′. After first two films add 10 per cent to each film up to 6. If used infrequently, add 20 per cent to the above times. Reasonable agitation. *Presoak roll film in plain water or a 5 per cent sulphite solution for 2–3*

minutes (to remove soluble backing material which restrains developing action). If *crystalline* sulphite is used, double the quantity.

14. CHAMPLIN 15 (FINE GRAIN)

Despite the uproar that exploded on publication of this controversial formula in 1937, it is still one of the best of the classic fine-grain developers. If you reread all the articles about it, you'll come away with the impression that no one could fault the formula, so they shot down the *speed claims* made for it by Harry Champlin.

This was the era when Kodak refused to rate their films at the *minimum* exposure possible (which they have since done) so Champlin may have been right after all. Let's grant that Champlin 15 is no faster than D 76; it's a great developer, nevertheless. As Merlyn Severn said in *Camera World:* "For my work it is unsurpassed, giving high speed, fine grain and a smoothness of gradation which I have never found equalled by any other developer." And she said this twenty years after the big "flap" about it.

Dissolve in this order:	METRIC		AVOIRDUPOIS	
Water (125° F.)	600	cc.	12	ounces
Rubinol or pyro	3.5	grams	32	grains
Sodium sulphite, dry	60	grams	1½	ounces
Benzoic acid	1.2	grams	12	grains
Salicylic acid	0.5	grams	4	grains
Boric acid	2.5	grams	25	grains
Tannic acid	1	gram	9	grains
Glycin	11.5	grams	¼	ounce
Paraphenylenediamine	11.5	grams	¼	ounce
Isopropyl alcohol				
(97 per cent)	50	cc.	1	ounce
Nickel ammonium sulphate	1	gram	10	grains
Water to make	1000	cc.	20	ounces

Dissolve the nickel ammonium sulphate in a small quantity of water and add *slowly* to developer after it has *cooled* to 70° F. A precipitate may form. *Whether it does or not, filter the solution!*

For tank use at 70° F.: 16–20 minutes. For more recent and thin-emulsion films (Panatomic X, Plus X, Verichrome Pan, Isopan F, Pergrano), try 8–12 minutes. You can alter these times if you prefer more or less contrast. Increase developing time 2 minutes for each additional roll of film. Champlin can also be used by the dilution method described under Edwal 12, but the developing time has to be tripled. Champlin 15 can also be used by the replenishment method, adding 3 ounces of fresh developer after each roll of film.

15. CHAMPLIN 16 (FINE GRAIN, STOCK)

The advantage of this developer is in its method of use. One part of the stock solution is diluted with 9 parts of a 10 per cent sodium sulphite solution, and the working solution is thrown out after use. Negatives developed in fresh solutions of this sort are, naturally, much more uniform.

Dissolve in this order:	METRIC	AVOIRDUPOIS
Water (cold)	300 cc.	10 ounces
Sodium sulphite, dry	50 grams	1⅔ ounces
Chlorhydroquinone	25 grams	¾ ounce
Triethanolamine *a*	11 cc.	⅓ ounce
Water, to make	500 cc.	16 ounces

a Original formula listed a proprietary chemical, Tironamin C, which was used in the proportions of 60 cc. in 1000 cc. of water. Other substitutes for Tironamin C suggested by Dr. Edmund W. Lowe in his book *What You Want to Know About Developers:* TSP Monohydrate, 11 cc. in 500 cc., 22 cc. in 1000 cc., ⅓ ounce in 16 oz.; Kodalk, 10.5 gm in 500 cc., 21 gm in 1000 cc., 153.3 gr in 16 oz. *Mix without heat.*

For tank use at 75° F. (the recommended temperature): 6¼ to 8½ minutes.

Do not use chrome rinse or sodium bisulphite with this developer.

Method of use: Take 1½ ounces (45 cc.) of stock solution and add enough 10 per cent sulphite solution (3 ounces of sulphite in 32 ounces of water) to make 16 ounces (500 cc.) of working solution. *Agitate constantly.* For rinse, Kodak Liquid Hardener or *stock hardener* formula, item 2, *Some Hints on the Use of Hypo,* chapter 13, *Developers and Developing.*

16. LEICA DIVIDED DEVELOPER

A two-bath formula for greatest possible sharpness without loss of speed, and for unblocked highlights. The first bath develops out the highlights, hardly affecting the shadows; the second solution brings out all the detail in the shadows without blocking up the highlights. Both solutions can be used about four times for full-length films, though an increase of 5 per cent in developing time is required for each successive film.

Solution *A* contains 5 grams metol and 100 grams sodium sulphite (dry) in 1000 cc. of water; solution *B* contains 6 grams sodium sulphite (dry) and 15 grams sodium carbonate (dry) in 1000 cc. of water. Develop films 2–5 minutes at 68° F. in solution *A,* followed by 3 minutes in solution *B. Don't rinse films between baths.*

Heinrich Stöckler of Leitz revised this formula in 1939. He substituted a 1 per cent solution of borax for the sodium carbonate and sulphite. Solution *B*, therefore, now contains 10 gm. of borax in 1000 cc. of water. Since borax is a milder alkali, it tends to improve grain structure *at the slight expense of speed*. If you need the speed, use the original formula. *Developing times*, Bath *A*: Isopan FF, 2½ minutes; Isopan F, 4 minutes; Panatomic X, 4 minutes; Pergrano, 4 minutes; Plus X, 4–5 minutes; Perpantic, 4–5 minutes. All films, 3 minutes in Bath *B*. *Do not rinse between baths.*

Development by Inspection

The time-and-temperature method of development is fine if there are no special problems of *under-* or *over-*exposure, and if you are quite sure that your meter and shutter are working perfectly. But if you've taken a problem shot that you must desperately get right, especially if a retake is impossible and time is urgent, you can protect yourself against disaster by using one of the oldest methods of development known to photography: *inspection development.*

In the early days of orthochromatic film it was easier than it is now because a red safelight (Wratten Series 2) made it possible for you to inspect the progress of development to your heart's content, without endangering the film. Now, in these days of fast panchromatic film, you have to use a dark green safelight (Wratten Series 3), with a bulb no larger than 25 watts, and placed about 2–3 feet from the tank.

You start developing as if for *time-and-temperature* (see page 352). When you reach step 4, and have completed *half* the indicated time, turn out all other lights, turn on the green safelight, and wait until your eyes have become accustomed to the dark. Now open the tank and, pulling out a bit of the film, glance at the *emulsion* side to see how it's coming. Look *at* the film, not through it, and remember that the smaller the film size, the darker it will look under the green light. (You'll have to try this out on a test film once or twice to get the hang of it and to learn how a good negative should look under the safelight.) Don't expose the film to the green light for more than a few seconds each time. When you think development is done, recap the tank, turn on your white light, and proceed with items 5 to 12, under *How to Develop the Film*, using the time-and-temperature method.

George Jewell Baker, an instructor at the Fred Archer School of Photography, suggests this clever way to tell when your negative is ready: place a finger between the safelight and the film, letting it cast an opaque shadow with which you can compare the dark high-light areas.

At first the image will seem flat and fogged. But soon the outlines will become clear. When the finger shadow matches your high-light density, development is done.

Developing Time at Various Temperatures

t	64°	65°	66 °	67°	68°	69°	70°	71°	72°	73°	74°	75°	76°	77°
T	1.23	1.16	1.10	1.05	1.00	.95	.90	.85	.81	.78	.75	.72	.69	.66

This table gives the *ratio* of the developing time for any desired temperature (indicated by top line *t*) to that at 68° F. Given the developing time at 68°, you convert to the time at any other temperature by *multiplying* the given time by the *desired* temperature factor *T*. To convert from the time at any temperature other than 68° to any other temperature, you *divide* the time of the *given* temperature by its own factor and then *multiply* by the factor of the *desired* temperature.

Example: Film develops in 9 minutes at 68°; what time at 65°? *Answer:* Multiply 9 by factor 1.16. Result is 10.44, or about 10½ minutes. *Example:* Film develops in 14 minutes at 65°; what time at 68°? *Answer:* Divide 14 by factor 1.16. Result is 12 minutes. *Example:* Film develops in 10½ minutes at 65°; what time at 75°? *Answer:* Divide 10½ by 1.16 (factor at 65°) and multiply by .72 (factor at 75°). Result is 6½ minutes.

These new times are not always the ones specifically recommended for certain formulas, but they are close enough to be workable. If precise results are necessary, test first or keep to the original time and temperature. If more than one reducing agent is included in a developer, changes of time will not compensate for changes of temperature since it is more than likely that the reducing agents will have unequal temperature coefficients, one being affected more than the other and thus altering the final result.

A Continuous Tone Print from High-Contrast Film

The picture here is witness to a photographic upheaval. It is the visual record of what happens when an improbable film meets an impossible developer.

The film is Kodak *High Contrast Copy* panchromatic VTE (very-thin-emulsion) film. It has an ASA tungsten rating of 64, was devised

TESTING FOR SHARPNESS. Leica M4, Summicron lens at $f/5.6$ and 1/125 second. The print, on an 8 x 10 sheet, covered an area over 53 times larger than the original negative.

primarily to reproduce *line,* and yet it can also be used to make tremendous enlargements without showing grain, losing tones, or "softening" acutance (sharpness).

The developer is *H & W Control* concentrate. What it promises, and what it delivers, are sensationally sharp and practically grainless *continuous tone* prints from 35mm negatives. Used in H & W Control developer, High Contrast Copy film drops its ASA rating to about 25. Average exposures in bright sunlight, therefore, run between 1/60 at $f/5.6$ and 1/100 at $f/8$.

H & W Control concentrate may be bought directly from the H & W Company, Box 332, St. Johnsbury, Vermont 05819. It has been tested and recommended by *Camera 35, Photography, Popular Photography,* and *Leica Photography.*

Another very thin emulsion that can be used with this developer is *Fuji Microfilm* Negative HR, also at an ASA rating of 25.

The H & W Company is now distributing a 35mm *very thin emulsion* of their own to be used with H & W Control concentrate. This

unusual film (*H & W Control VTE Pan Film*) has been made for them, to their specifications, by one of the giant photographic manufacturers in Europe (Agfa-Gevaert). It has a claimed exposure index of 80 (which I found, on tests, to be too high), as against the 25 of Kodak *High Contrast Copy* and *Fuji Microfilm*.

Some Developing Hints

1. Check your timer and thermometer for accuracy.

2. *Caution:* change of time does not compensate for *all* chemical changes caused by change of temperature!

3. For a free *Handy Dilution Formula Chart* printed on stiff cardboard, ready for hanging in your darkroom, send to Mallinckrodt Chemical Works, Photo Department, 223 West Side Ave., Jersey City, N.J. 07305.

4. To bring the temperature of the film to the working temperature of the developer, give it a preliminary soak in water of that temperature.

5. See chapter 19, *Hints and Suggestions*, for more developing hints.

6. Take the advice of famous Leica expert Anton Baumann and filter *all* your solutions *before* use. That's the best way to prevent spots on your negatives and so avoid tedious retouching on your prints. You can filter with cotton or gauze if you don't have filter paper. Some developers, like Microdol X, precipitate a dark sludge of free silver; it's a good idea to filter it out.

7. *Acetic acid substitutes* (in case there's a shortage): *Short stop for paper or negatives:* 3% solution of sodium bisulphite or sodium metabisulphite, 30 gm. in 1000 cc. of water (1 oz. in 32 oz.); citric acid, 15 gm. (½ oz.) in 1000 cc. (32 oz.) of water (see also item 26, page 523). *Short stop for negatives only:* potassium chrome alum, 20 gm. (290 gr.) in 1000 cc. (32 oz.) of water. Use immediately (for 5 minutes at 68° F.) as it will not keep. *Fix negatives or prints* in F-24: water, (125° F.) 16 oz.; hypo, 8 oz.; sodium sulphite, *dry,* 145 gr.; sodium bisulphite or metabisulphite, 365 gr.; cold water to make 32 oz. Regular fixing baths such as F-1 (see page 406) can be made with citric or tartaric acids in place of acetic. For each 1½ fluid ounces (48 cc.) of 28% acetic, replace with ¾ ounce (21.3 gm.) of citric or tartaric acid. Or, use white vinegar. A 28 per cent acetic acid is made up by dissolving 3 parts of glacial acetic acid with 8 parts water.

8. To remove color backing from film, and to prevent opalescence, soak films after fixing and before washing in dilute solutions of sodium carbonate, ammonia, or even plain sodium sulphite.

9. See chapter 14, *Printing and Enlarging,* for some hints on the use of hypo.

10. Polyethylene squeeze-type bottles are not recommended for long storage. *Air diffuses through the walls.*

11. If *Rodinal* is one of your favorite developers, and you've had difficulty measuring out the small quantities needed for the 1:50 to 1:100 dilutions, get yourself a *martini spike* (a syringe precisely graduated from 1 to 12 cubic centimeters). Or, perhaps your doctor will let you have his old *hypodermic*, which you can force through the rubber cork of the Rodinal bottle.

12. Among the great bargains in photographic accessories are the data books offered by Kodak. My favorites are:

the *Master Darkroom Dataguide* (which not only has an 18 per cent gray target; a bellows factor table; a reciprocity correction table; a developing computer dial; a papers table for safelight filters, image tones, speeds, developers, and times; paper samples; shadow speeds and printing indexes of polycontrast and panalure papers; an enlarging computer dial with suggested times for a test-exposure series; conversion tables; but much, much more); and

the *Master Photoguide* (which tells how to get the best film speed number for your exposure meter; has a daylight exposure dial; a light balancing filters dial; four contrast viewing filters, *including #47 or C5, which is a monochrome viewing filter as well;* a photolamp exposure dial; an available light exposure dial for every kind of light from evening skylines to neon lights, street lights, stage shows, even indoor and outdoor Christmas lights), and so much more.

Hundreds of thousands of dollars have been invested by Kodak in the preparation of these data guides. You get the benefit of all this research and know-how for very little, really. *Highly recommended.*

13. Don't develop *important* pictures in an unfamiliar tank, with an untried developer, etc. The tank may not properly separate the turns of wound film, and ruin three or four pictures. The developer may *increase* your exposure, or *decrease* it, and until you test-run it you won't know which way to go. The best rule is to process one film in a known developer, using familiar tanks and techniques. Then, adjust your methods accordingly. This may seem like a time-wasting procedure; but believe me, *it is not.* Once you know what to expect from your equipment and methods, you will be a happier photographer.

14. There are new methods and materials available. *Try them.* Don't be reluctant to take advantage of the best that is being produced. But test against the ones you know and like. If the new can't outperform the old, forget it. But suppose, just suppose the new turns out to be much better. Wouldn't you feel silly not to have tried it?

"Anyone who uses a camera but does not have a darkroom is depriving himself of half the fun of photography. It's a little like owning the leash without the puppy."—PAUL FARBER

14 Printing and Enlarging

The process by which you make a positive from a negative is called *printing* (*contact* printing if there is no increase in size) or *enlarging* (if the picture is reproduced larger in size, by projection). The resultant picture is sometimes called a *contact print* or an *enlargement*, but most often it is simply referred to as a *print*.

Kinds of Printing Papers

There are two types of photographic papers used for making prints. These are: (1) *Printing-out* paper, and (2) *developing-out* paper. The printing-out paper is so called because the image appears when the paper is printed out in the sun or strong daylight. This process takes from five to thirty minutes, depending on the density of the negative; its progress can be followed by lifting a corner of the print as it rests in one of the split-back printing frames especially made for this purpose. Printing-out papers are rarely used by amateurs; their chief use is by professional portrait photographers who submit them as *proofs* to clients. These proofs are not *fixed;* this means they darken after a few

days' exposure to light. However, they *can* be fixed and made permanent by placing them in a regular hypo bath.

The developing-out paper (unlike the printing-out paper, which needs only strong daylight or sunlight) must be chemically treated (as was the negative) to bring out the latent image.

KINDS OF DEVELOPING-OUT PAPERS

There are three types of developing-out papers: (1) *chloride;* (2) *bromide;* and (3) *chlorobromide.* Chloride papers, so called because they are coated with a silver chloride emulsion, are slow (not very sensitive to light), and are used mostly for making *contact* prints; that is, prints made by placing the paper directly on the negative and exposing to daylight or artificial light. They are ideal for subjects with strong contrasts; are poor in their ability to reproduce delicate gradations of tone. Their contrast cannot be changed by varying the time of development without degrading the print.

Bromide papers (silver bromide emulsions) are *fast*, and are therefore used mostly for making *enlargements*, where increased sensitivity of the paper is essential to avoid overlong exposures to the inherently weak light of *projection* printing, further weakened by the distance from the light to the easel, according to the *law of inverse squares*. They arc about one hundred times as fast as chloride papers. They reproduce middle tones superbly, but the blacks are often dingy. Their contrast cannot be controlled in developing.

Chlorobromide papers, coated with an emulsion that combines the chloride and bromide salts of silver, are medium fast and can be used either for contact printing or enlarging. They can produce beautiful prints with good tones and rich, lustrous blacks; they are also better in rendering shadow detail. They are twenty times as fast as chlorides.

The chlorobromides are made in only one grade of contrast, for *normal* negatives. The other papers are made in three or more grades (*soft, medium* and *hard*) for hard, medium, and soft negatives, respectively. There is also a large choice of surfaces, which may be roughly classified as (1) *glossy* (for detail and brilliance), (2) *semi-mat* (a compromise surface with a slight sheen), and (3) *mat* (with a dull surface).

Most papers are usually supplied in two weights: *single weight* and *double weight*. Though the single-weight papers are less expensive, they are more likely to curl.

A newer type of enlarging paper that provides *variable contrast* control in *one* contrast grade by the use of intermediate filters is now available. The secret of this unusual paper is in the split-sensitivity of the

emulsion. Marketed as Dupont's *Varigam* and *Varilour*, Kodak's *Poly-contrast* and *Polylure*, and GAF's *Vee Cee Rapid*, this paper requires a *special safelight* (the SS 55 X or Kodak OC orange-brown or amber-colored safelight filter, rather than the yellow-green-colored OA type used for conventional papers), but otherwise it is treated like any other *chlorobromide* paper. The necessary filters are available from your dealer.

When *Varigam* first appeared in 1940, only two gelatin filters were available, the *yellow* for softness and the *blue* for contrast. The use of these had always presented a problem. Any in-between contrast required the alternate use of both filters (a time-fraction of each, depending on what print contrast you wanted).

Later, Dupont offered a complete set of 10 card-mounted gelatin filters for evenly spaced contrast. These produced the conventional paper grades of 0 to 4 in half-grade steps. This set was replaced in 1953 by the *all-plastic* filter sets which are ruggedly made of an optical grade plastic which will neither buckle nor warp. Plastic filters resist heat, the ravages of most photographic chemicals, and are easily cleaned with soap and water (Ivory soap, preferably).

Harrison & Harrison offer a set of 10 comparable glass filter sand-wiches, with the color imbedded in the cementing material. The contrast characteristics of these are about the same as the Dupont filters. Kodak also has a set of 7 Polycontrast filters marked from 1 to 4, in half-grade steps, designed for their Polycontrast papers.

Kodak makes a dandy *Exposure Computer* for their Polycontrast filters. Having exposed and developed one print properly (with one or no filter), you can get the correct time for all the other filters by setting the filter arrow you used (or no filter) to the time exposed, and reading off the new time from the adjustable wheel. It is well worth the half-dollar.

The filters of all manufacturers can be used for their *regular* as well as their *rapid* variable contrast papers.

WHY VARIOUS CONTRASTS?

All other things being equal, the best print (full scale from white to black, with rich contrasts) can be produced only by a normal negative and a normal paper. Hard or soft papers are only compensating devices, at best, but very useful ones sometimes. Test strips *A* to *E* on page 389 show the effect of printing a uniform step-wedge negative on a variable contrast paper with various filters. The practical result of this is shown in prints *A* to *E*. In both cases Kodak Polycontrast N was used.

The trick in printing or enlarging, to produce a full-scale print, is to match the negative to the paper. If it is a *soft* negative, a *hard* paper is called for, and vice versa. What this does is to expand or contract the image tones in such a way that they produce a print of approximately

CONTROLLING CONTRAST. For best results,
match the negative to the printing paper (or the filter,
if you are using a variable contrast paper). Only in that
way is it possible to get a rich, brilliant, full-scale print.
If the negative is soft (lacking in contrast), a hard
paper or equivalent filter is called for, and vice versa.
Here we show the effect of various filter contrasts on a
normal negative. Kodak Polycontrast N was used, with
filters 1 through 4, corresponding to prints A to E.
Print B, enlarged through filter No. 2, is normal. If too
hard a paper or filter is used, Print E is the result; most of
the middle tones have been lost. If too soft a paper or
filter, all the tones tend to flatten out and there are no
strong blacks or brilliant whites. Note that print and
step wedge A have the most medium tones (10), while
print and step wedge E show only 6 clearly defined tones
in the original print. Some of these may be lost in the
engraving. Eastman Photographic Step Tablet No. 3 was
used to produce step wedges.

→ A B C
D
E

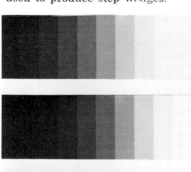

A

B

C

D

E

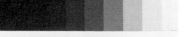

KODAK POLYCONTRAST FILTERS
AND COMPARATIVE EXPOSURES

A. #1, 11 sec. D. #3, 16 sec.
B. #2, 12 sec. E. #4, 40 sec.
C. #2½, 13 sec.

*Head of child was sculptured by
Helen Webster Jensen,
Box 308, Santa Monica, California 90406*

normal tone range. However, there is one other factor affecting contrast which we should not overlook. It is paper *surface*.

Depending on the surface chosen, a full-scale normal negative printed on a full-scale normal paper (or its filtered equivalent) will reflect, roughly, the following range of tones:

Glossy	1 to 50
Semi-mat	1 to 30
Mat	1 to 15

The loss of tones then, as you can see, may be due as much to the paper *surface* as to the paper *contrast*. If a long range of tones is called for, it is best to use a glossy paper, or one with a smooth surface, like Polycontrast N.

How to Save a Picture

There are many compensating devices in photography that can "save the picture" at almost any stage. If you snapped it without setting your camera for the correct exposure (as, for instance, if you saw an accident about to happen and had no time to think it out, but realized your mistake later), you can "push" development to make up for *underexposure*. On the other hand, if you *overexposed*, you can "hold back" on development, or use a *compensating developer* (for which see *index*). If your picture is part of a roll that includes other important shots, you can move about ten to twenty-five per cent in whatever direction can help the "accident" shot, without ruining the other pictures on the roll. Then, later, you can cut away the negative of the accident and treat it separately, by *intensifying* or *reducing* it (see *The After Treatment of Negatives*, page 358).

If you have made the print, and it's *too dark* or *too light*, you may be able to save it by *toning* or *redeveloping* it (see *How to Save a Bad Print*, page 409), where you first *bleach* the print, and then *tone* or *redevelop* it to the color or density you want.

You can control *density* and *contrast* in the original printing, or, as you see, you can do something about it later.

But all of these devices are marginal.

You may be able to alter or correct a negative by as much as 25 per cent, or a print by as much as that again, making a total of 50 per cent, but that's it; you can't do more, and you may need more.

The best way to get a perfect print is the hard way: perfect exposure and correct development of the negative; and perfect exposure and correct development of the print.

If you didn't focus properly, or forgot to have your lens set at the

hyperfocal distance (see *index*) and at $f/8$ to have everything usably sharp from 8 feet to infinity, for the 35mm lens of a 35mm camera), you may not have to bother about any of this. Your negative will probably be out-of-focus, and worthless.

So the answer still is, *do it right to begin with*. What else is new?

How to Make Contact Prints

You'll need the following materials and equipment: (1) A safelight, with filters for prints and negatives. (And be sure it is *safe*. Test it by placing a coin over a piece of print paper and leave it as close to the light as you expect to be working. After five minutes, develop the print in the usual way. If the outline of the coin is visible on the paper, the light is *not* safe.) (2) A printing *frame* or a contact printing box. (3) Four trays (the hard-rubber kind are best; they are light in weight, will not chip or crack, and are quieter in use). (4) A four-ounce graduate (if possible, get one that is marked for metric as well as ounce measure; if you can't, just remember that 1 ounce is approximately 30 cc.). (5) A package of printing paper. (6) A developer. (7) An acid rinse bath. (8) A fixing bath. (9) Three pairs of tongs (the wooden or plastic ones that are rubber-tipped, are the best). (10) Some ferrotype tins (if you plan to make glossies). (11) A print roller; check the one made by Paterson. (12) A stirring rod. (13) A thermometer; the Weston stainless-steel, with a round dial at top, is recommended. (14) An interval timer or a wall clock with a sweep second hand. (15) A sponge; the Dupont cellulose variety is good. (16) Weighing scales, if you're going to make up your own developer.

Arrange your trays in such a way that your print can be carried in orderly progression from developer to acid rinse to hypo to water bath. (See *index* for *Richard Tray-Rak*, a space saver.) Fill each tray to within a half or three-quarters of an inch from the top.

THE PRINTING FRAME

A printing-frame is a wooden frame with a hinged back to it, as shown in *Fig. 14.1*. The back can be taken out by releasing the springs. If you use a *film* negative (instead of a *plate*, the emulsion of which is already mounted on glass) you must put a sheet of clean glass in the frame first (they are usually supplied with such glass) and lay the film on top of this with the emulsion side away from the glass. This done, lay the paper on top of the negative with the emulsion surface facing that of the negative; finally put the back in and slip the springs under the clips. The negative and the paper will now be held in close contact, as shown in the cross section view in *Fig. 14.2*.

FIG. 14.1. PRINTING FRAME FIG. 14.2. HOW IT WORKS

Since some parts of the negative are transparent, while others are varyingly opaque, the light will pass through the transparent parts and darken the paper. Where the opaque parts (depending on your exposure) prevent them from passing through, the paper remains white (or shows tones of gray). In this way, then, the picture printed on the paper is the reverse of that on the negative. Hence, it looks like the original scene, object or subject.

MAKING THE PRINT

First put the negative-paper sandwich in the printing frame as described above. You can then hold the frame up to (or under) a light. The easiest way is to place it on a table and hang a lamp over it, or set a gooseneck lamp with the proper bulb (see below) in position.

The length of exposure depends on a number of factors which include (1) the kind of paper you use, (2) the density of the negative, (3) the kind and strength of the light you are using, and, finally, (4) the distance you hold the frame from the light. The exact distance does not matter, but ten inches is about right for negatives 4 x 5 and smaller, while larger negatives must be held farther away so that the light strikes all parts of them equally. Here's a table to guide you on exposures.

TABLE OF APPROXIMATE EXPOSURES

Size of negative	4 x 5 and smaller
Distance from Light	10 inches
25 Watt Electric Lamp	12 seconds
40 Watt Lamp	6 seconds
60 Watt Lamp	4 seconds
100 Watt Lamp	2 seconds
200 Watt Lamp	1 second

You can find the exact length of time required for the exposure by cutting a sheet of the kind of paper you are going to use into strips about one inch wide, placing a strip under a part of the negative with lots of detail in it, then making a test exposure, noting the exact time and precise distance, and developing it. By exposing two or three strips and giving them slightly different exposures, you can easily find out what the proper time is; this done, you can duplicate prints by repeating same time and distance.

An alternate method: Place printing frame on a table, face up, and rig the bulb so it can be raised or lowered. You then vary exposure by changing distance, leaving the time constant at, say, 10 seconds. You can also alter exposure by changing the watt size of the bulb, or by cutting in a variable voltage transformer (like the PA-1 *Adjust-A-Volt* made by the Standard Electrical Products Co. of Dayton, Ohio, which has an input of 120v/60 cycle and an output of 1.25 amperes, or 150 watts).

Still another, and simpler, method (if you have an enlarger) is to place the printing frame or a *plate-glass easel* (a paper easel with a heavy glass hinged at one end) under the enlarger lens and use that as a light source. Control is easier, since both the diaphragm and the enlarger head can be adjusted.

THE PRINTING BOX

The most satisfactory contact printing method is by the use of a *printing box*. This is an oblong box made of wood or metal. Inside the box are one or more bulbs (usually 40 to 60 watts each) as well as a small ruby bulb. The hinged cover is connected with a switch so that when the cover is pressed down, the exposing lamps are turned on and the ruby lamp is turned off; when the cover is raised, the reverse happens. The inside of the box is usually coated white or silvered to give maximum even illumination, and in the better quality boxes there is an intermediate diffusing screen (a piece of ground glass or milk glass) to even out the light and eliminate hot spots. If the hot spots persist, there are two ways of dealing with them: (1) place a piece of heavy white bond paper over the intermediate screen, so marked with pencil or crayon that the hot spots are toned down and the lighting is even over the entire area. This requires a few trials until you get it just right, and the best way to test the result is to expose a piece of contrasty *chloride* paper on the upper glass *without* a negative, expose for a very brief time, and develop fully. If the lighting is uneven, this test will show it at once. (2) Paint the upper portion of the lamps so that only *reflected* (instead of *direct*) light reaches the negatives. This method, also, requires some testing. And since it is a fussier procedure, the first method is preferred.

Once this adjustment has been made, the printing box is ready for use and will need no further adjustment.

A modified kind of dodging, or retarding the printing of certain parts of a negative, is possible with a printing box by using white paper on the diffusing screen. If the negative, for instance, has a very dense sky, simply place an extra piece of tissue (tracing paper or bond paper will do) over the corrective tissue described above, and darken this supplementary tissue on one side, grading it evenly so that a sharp separation doesn't show. The darkened side should be placed, of course, so that the foreground is held back, permitting the sky to print through.

With a printing frame, dodging is accomplished by tilting the frame so that one portion of it is nearer the light than the other, or by interposing a card or any other opaque material between the light and the loaded frame.

Contact printing is the only method to use if you want the *ultimate* in sharpness of detail. However, for most practical purposes, and provided the final print does not exceed a 10x enlargement (1 inch of the negative blown up to 10 inches on the print), printing by projection furnishes prints of sufficient crispness to look sharp when viewed at a *normal* viewing distance. Very roughly calculated, this normal viewing distance should *exceed* the diagonal of the picture size. For a print that is 11 by 14 inches in size, the viewing distance should therefore not be less than 18 inches. At this viewing distance (which may seem unfair to the picture *sniffers*) grain will also seem less of a problem.

Projection Printing

If the print is to be made larger (or smaller) than the size of the original negative, projection printing (by means of a lens) must be used. If your camera has a detachable back and a bellows extension front, you can use that as your projector. However, you will have to rig up a holder for the negative, a firm support for the camera, and a light-proof cooling system for the light source. When you get through, the result will be almost as expensive, but not quite so good, as one of the excellent enlargers now on the market; so our advice is to save up for a good enlarger and be content with contact printing until you can afford the other.

THE KINDS OF ENLARGERS

There are two types: the *manual focusing* and the *autofocusing*. Though they are made for various negative sizes, some of the models are almost *universal* in scope, with a wide assortment of condensers,

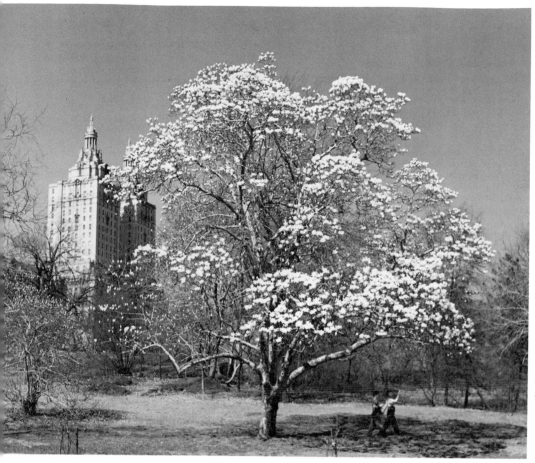

SPRING IN CENTRAL PARK. Taken with a Kalart camera and Raptar lens, at $f/8$ and $1/100$ of a second, K2 filter, on Plus X Pan developed in Acufine. Print made on Opal developed in Versatol.

light sources, and lens adapters. The best type for amateur use is the variable-focus condenser or cold-light system, as in the *Omega*, the *Focomat*, the *Beseler*, and the *Durst*. These are *vertical* enlargers, which are preferred for amateur use.

A good enlarger provides the following:

1. Focusing adjustments that are precise and easy to use.
2. A tall, *rigid* support for big enlargements.
3. A simple method for changing lenses.
4. A negative carrier that holds the film flat without resorting to glass plates.
5. Adequate heat control that does not leak light.
6. Adequate balance or control for ease in raising and lowering the lamphouse.

THE DURST J35 ENLARGER
(For 35mm and Instamatic negatives)

Includes 50mm lens, rack and pinion focusing, self-locking magnification adjustment, 1.8 to 10x enlargements on baseboard, column reverses for floor projection, triple condenser system, adjustable lamp socket, red filter above lens, convenient on-off switch.

THE OMEGA D-3V ENLARGER. A variable triple condenser autofocusing enlarger for continuous automatic focusing with up to three lenses of varying focal length (for Minox and 35mm to 4 x 5). Can also be supplied with fluorescent (*Omegalite*), point source (*DM type*), variable contrast (*Omnicon*), and Xenon (*Xenomega*) lamphouses. The *floating action* autofocus tracks are matched to your lens at the factory, but you can install them yourself quite easily.

7. If possible, some method for correcting or exaggerating perspective. This is done by tilting the negative, or by turning the enlarger head on a swivel joint.

8. A heavy, well-seasoned, plywood baseboard.

9. Adequate, convenient, well-insulated electrical connections.

10. A red or orange filter that can be swung under the lens while composing the picture.

In the long run, a *good* enlarger is a wise investment. A faulty machine will not only spoil your pictures, but it will destroy your interest in photography and ruin your disposition.

The Omega enlargers, manufactured by Simmon Brothers, now a division of Berkey Photo, Inc., of Woodside, New York, are among the very best in the field. They are scientifically designed, precisely manufactured to rigid standards, are really inexpensive for the materials and workmanship involved, and are certain to produce superb pictures if intelligently handled. There are supplementary accessories now available for making color separations from Kodachrome originals, and for other uses. Some experienced workers have their own preferences, which are listed below:

Vivitar (for all negatives 35mm to 2¼ x 3¼, with oversize condensers and micro-focusing).

Automega (with continuous automatic focusing for up to three lenses).

Chromega (for color and black-and-white negatives up to 4 x 5 inches in size).

Omega Omni-Con (for automatic variable contrast printing without external filters).

Super Chromega (a complete color enlarging system).

Omega B7 (automatic focusing from 35mm to 2¼ x 3¼).

Durst (for color, black-and-white, and autofocus). Made in Italy. Available in various sizes, 35mm to 4 x 5. One model (the M-600) has a built-in *rangefinder* focusing device.

Beseler (8mm to 2¼ x 3¼, others to 4 x 5).

Leitz Focomat (a marvelously engineered instrument that focuses automatically and precisely to every print size, once you have adjusted it to the focal length of your lens and the thickness of your easel). Primarily designed for 35mm negatives, it can also enlarge from other sizes: 18 x 24mm to 6 x 9cm (2¼ x 3¼). The model that takes the larger size accommodates lenses of two focal lengths (50mm and 95mm) in a rotating lens turret. Both models can be used for making color prints.

How to Make an Enlargement

As all the operations for making an enlargement are carried out in a darkroom, to avoid fogging the paper use an orange safelight for bromide paper and a green-yellow (Wratten OA filtered) light for chlorobromide and chloride paper. Having placed the negative in its holder, focused the image, stopped the lens down to about $f/8$ or $f/11$, and

turned off the switch, you are ready to make the print. But first, you will want to check the exposure.

You can do this in one of these ways: (1) use a *print meter* such as the MCM oil-spot *Photometer*, the *Spotomatic*, the *Analite* CdS (cadmium sulphite sensitive light cell) Enlarging Meter, the *Paterson CdS Enlarging Computer*, the Soligor *Fixomet* (Allied Impex Corp., 168 Glen Cove Road, Carle Place, N.Y. 11513), the Weston *Fotoval*, the Corfield *Lumimeter*, or the Karl Heitz *Volomat* densitometer with the Goldberg continuous-tone wedge (shown here). Also, see *The Perfect Print* (and some ways to get it) at the end of this chapter. (2) Use a *Kodak Projection Print Scale* by placing the scale over a sheet of print paper; with the negative in the enlarger expose through the scale for one minute and develop in the usual way; the correct exposure time can then be read directly from the best-appearing sector in the enlargement. (3) Make one or more *test exposures*. To do this, cut a small sheet of paper into strips about an inch wide and five or six inches long; then lay one of them directly across the center of the image on the easel or table and lay a ruler on each edge to hold it down flat. You can also use a sheet of glass, if you prefer (or what is known as a *plateglass easel*, a heavy piece of glass, hinged at one end).

The range of exposures should bracket what you consider to be the correct exposure. For example, if you guess (from previous experience) that 20–25 seconds would be right, make this series of exposures: 5, 10, 20, 40, and 80 seconds. You do this by covering the entire sheet first with

FIG. 14.3. THE VOLOMAT DENSITOMETER
(indicates exposure and contrast)

a piece of cardboard or black paper and then uncovering inch segments in this order: 40 seconds for the first, then 20 more for the second, 10 more for the third, 5 more for the fourth, and finally 5 for the last. When you develop, fix and wash this test sheet, you will find that you have a series of exposures, each step of which is double or half that of the one next to it: 80, 40, 20, 10 and 5 seconds. It shouldn't be difficult to gauge the correct exposure from this sample. *Caution:* Develop and fix the test sheet in exactly the same way as your final print; and judge the exposure (after fixing and washing) under *white* light, not the safelight.

An easier way is to use one of the *print meters* mentioned above.

CONTRAST AND HOW TO CONTROL IT

One of the most serious problems in photography is the difficult one of adjusting the contrast of the scene to the contrast of the negative, and then to the contrast of the print. The scene contrast (or brightness) range may vary from 2 to 1, for landscapes in misty weather, to more than 1000 to 1, for an interior with windows showing a sunlit landscape. The negative emulsion, however, can record a range (by *transmitted* light) of only 130 to 1. The print, to add to our woes, can record a maximum brightness range, by *reflected* light, of only about 30 to 1 (see *paper surface* in the *index*). The main technical effort of amateurs and professionals alike is to capture the scene on paper, just as it is, without losing highlights or shadows. Actually, that's impossible. But practically, it is feasible by exposure-development manipulation, and by using special developers, enlargers, papers, and printing techniques, to expand or contract the range of the scene as captured on the negative until it precisely fits the range of the paper. When the scene range and the negative range are the same, we say the negative has a *gamma* of 1 (see page 353), but it is not always necessary, or even desirable, to print the scene as you see it. You may want to lighten, darken, or emphasize parts of it. Here are some of the controls, to use as you see fit:

The Negative

Exposure. In general, if the scene is long range, *underexpose;* if short range, *overexposure* (see item 13, *Exposure hints,* page 521, and reverse the procedure for underexposure). You can also *filter* for shadows and bright lights (see page 330). Some years ago, William A. Oberlin tried an unorthodox way to adjust exposure to planned development. Assuming that a scene range of 1–200 is normal and gets normal exposure and development, he found the following variations worked for other scene ranges: scene range 1–90, exposure 85% normal, development 125% normal; scene range 1–400, exposure 115% normal, de-

THE HARBOR, Bahia, Brazil. Burt Martinson took this with his Ikoflex II, on Panatomic film developed in D 76, with a K2 filter. Print on Polycontrast N developed in D 72.

velopment 75% normal; scene range 1–850, exposure 133% normal, development 62% normal; scene range 1–1700, exposure 180% normal, development 50% normal. He used Superpan Press and Ansco 17 (similar to D 76). But these figures will be useful as a starting point for testing other combinations. Another method (*for extreme contrast* only) suggested by Joseph Foldes in *The Camera:* Meter the darkest part of the scene where details are important (disregard highlights entirely), give 10 times that exposure (yes, 5 seconds if your meter said ½), then develop your *pan* film in fresh Microdol X, diluted 1 to 10 (one part developer to 10 parts water) for 1 hour at 68° F., agitating (important!) at least 5 seconds every 2 minutes. See also item 10, *Hints on the Use of Film*, page 521, for some expert advice on how to use your meter for special conditions; and see *index* for a useful *Negative Contrast Control* table.

Development. Use *compensating* formulas for excessive contrast. See the Windisch *Compensating Developer* formula, also D 76, D 23, and D 25, the metol-sulphite formula, W 80, and the Leica two-bath *divided development* formula. (See *index, compensating developers.*)

Rudolph Simmon suggests a new and better way to use Microdol X: Dissolve ½ gallon of the developer and condition it (to reduce contrast and grain) by developing 6 rolls of 120 film or 36-exposure 35mm film *without adding anything.* This is your *stock solution.* Now dissolve some more Microdol X (*not* the replenisher) and store in 32-ounce bottles. This is your *replenisher.* Add 8 ounces to your stock solution each time while you are developing the film. When development is complete, pour the tank developer into the stock solution bottle until full and discard the rest. Develop Plus X and Verichrome Pan about 11 minutes at 70° F.; Tri X about 16 minutes at 70° F. Another good developer for contrasty subjects is Edwal's Minicol II.

If your film has already been processed and proves too contrasty, try this: bleach in a solution that contains 45 cc. of 10 per cent potassium ferricyanide; 15 cc. of 10 per cent potassium bromide; 100 cc. water. Then redevelop in a fine-grain developer of your choice, fix, wash, and dry. Make sure that on this second go-around you do not, again, over-develop the film.

The Print

Paper. The easiest way to control contrast is by using *Varigam, Polycontrast* or some other variable contrast paper and its various filters (see page 388). For the treatment of other papers, see below.

Exposure. To determine normal exposure, see *How to Make an Enlargement*, above; for the probable effect of under- and over-exposure, see below.

Enlarger. Condenser enlargers give more contrast, so do coated lenses. For softer results remove the lower condenser lens and replace with a disk of diffusing opal glass (but remember that this reduces your light intensity). A better way is to use a cold-light enlarger, or get an Aristo cold-light unit for your own enlarger. To increase contrast, replace the opal lamp in your condenser enlarger with a regular (sandblasted or etched) household lamp of 25–40 watts. (Exposure is shorter, but it *increases grain!*)

Development. For soft enlargements use GAF 120 (formula on page 405), or Selectol Soft (packaged by Kodak), or Mark Shaw's *water-bath* method for high-key prints (page 436), or try the bichromate *pre*-rinse (item 29, chapter 19, *Hints and Suggestions*, page 523). To increase contrast, use your developer without dilution.

Other Techniques. Here is a variation of an old method called *visible enlarging.* You soak your print in the developer (under darkroom light, of course) for about half a minute, lift by one corner and place it on a sheet of glass, remove surplus developer, and place in position under your enlarger lens (having prefocused your enlarger on the back of an old print). Now make your exposure for the shadows (about ½ to ⅒ of the normal time previously indicated by your print meter). Turn the enlarger light off and watch the image come up by safelight. After the developer is exhausted, give another exposure for the highlights and then back into the developer. Fix and wash as usual. The first exposure creates a mask which keeps the dark areas from being overexposed.

Another unusual method for softening a contrasty negative (even on hard paper) is called *flashing.* First find out by testing what exposure is best for the shadows (leave highlights white). Then give the new print a pre-exposure flash, without the negative, of about ½ second or less (stopping the lens way down). Now replace the negative, expose for the time previously indicated, develop, fix, wash, and dry.

DEVELOPING THE PRINT

After the exposure has been made, remove the paper from the printing frame or enlarging easel and slide it quickly, edgewise, into the tray of developer. Sliding the paper into the solution prevents the formation of air bells—bubbles of air that cling to the paper and cause white spots on the print. To prevent streaking and uneven development it is a good idea to rock the tray gently from side to side.

For amateur use, the best paper developers are Eastman's famous D 72 (formula given later in the chapter), which is really a universal developer in every sense of the term, and the two splendid Edwal developers, 102 and 111. D 72, however, in prepared form is no longer avail-

able, having been replaced by Eastman's Dektol, which comes in powder form. Also recommended: Kodak's *Versatol,* available in liquid form. The formulas for the Edwal developers are as follows (*always mix ingredients in order listed*):

PLATINUM PRINT DEVELOPER

Edwal 102. For delicate gradations	METRIC	AVOIRDUPOIS	
Water about 125° F.	500 cc.	16	ounces
Sodium sulphite, dry	100 grams	3⅓	ounces
Trisodium phosphate, *monohydrated*	125 grams	4⅙	ounces
Monazol (glycin)	25 grams	375	grains
Potassium bromide	3 grams	45	grains
Cold water to make	1000 cc.	32	ounces

For use, dilute 1 part stock with 3 parts water for chloride and chlorobromide papers; with 4 parts water for bromide papers.

Normal developing time is 3 to 6 minutes at 70° F., but it can also be used at temperatures between 50°–90° F.

If exposure is adjusted to produce the best possible print in 2 to 3 minutes, the tones will resemble those of the beautiful, old platinum prints.

Rinse prints for at least 2 minutes in a short-stop bath containing 1 ounce of citric acid per gallon of water. *Otherwise a scum of aluminum phosphate will form on page surface in fixer. Dissolve in order given.*

UNIVERSAL PRINT DEVELOPER

Edwal 111. Lustrous blacks, highlight detail	METRIC	AVOIRDUPOIS	
Water (125° F.)	500 cc.	16	ounces
Metol	5 grams	75	grains
Sodium sulphite, dry	80 grams	2⅔	ounces
Monazol (glycin)	6 grams	90	grains
Chlor-hydroquinone (C.H.Q.)	15 grams	225	grains
Potassium carbonate, dry	120 grams	4	ounces
Potassium bromide	3 grams	45	grains
Cold water to make	1000 cc	32	ounces

For use, dilute 1 part stock with 7 parts water for bromide papers; with 5 parts water for fast chlorobromides (Velour Black, Kodabromide); with 4 parts water for slow chlorobromides (Kodak Opal, Ektalure) and contact, or chloride, papers.

Normal developing time is 1½ to 3 minutes. The best black tones are obtained with a developing time of 2 minutes or more.

Prints should be rinsed after development, as above, for Edwal 102.

With most developers, the print will be fully developed in about 90 seconds. This means that, normally, the print should not be removed from the solution before that time. It is always better to leave the print in the solution for 2 to 3 minutes. By doing that you make it possible for the developer to penetrate to the full depth of the emulsion and so produce rich, lustrous blacks and full detail in the highlights.

If the print gets too dark when you develop it for more than 90 seconds, you've overexposed it. Cut down the exposure and try again. By using a photometer you can reduce these wasteful trials and errors to a minimum. The temperature of the developing solution should be 70 degrees F. If you find it hard to keep the developer at that temperature, place the tray in a large container of water of the correct temperature. Or, better still, place *ice cubes* or *hot water* in a *cellophane* bag (tied, of course) and let that cool or heat the developer.

Small changes in contrast can be effected by over- or underexposing and over- or underdeveloping the print. However, these changes are slight and will never equal the difference in contrast between two contrast grades of the same paper. It is best to stick to the latter method and use the developer according to the manufacturer's directions. If you want brilliance and good black tones use D 72 or the new Dektol. If you are using a warm tone paper such as Kodak Opal and you want the tones warm and the gradation soft as with portraits, then Eastman's D 52 or the new Selectol, which replaces D 52 in the prepared form, should be used.

Here are the two Eastman formulas (dissolve in order given):

FOR WARM TONE PAPER

Eastman D 52 (like Selectol)	METRIC	AVOIRDUPOIS
Water, about 125° F.	500 cc.	16 ounces
Elon (metol)	1.5 grams	22 grains
Sodium sulphite, dry	22.5 grams	¾ ounce
Hydroquinone	6.3 grams	90 grains
Sodium carbonate, dry	15.0 grams	½ ounce
Potassium bromide	1.5 grams	22 grains
Cold water to make	1000 cc.	32 ounces

For use dilute 1 part stock solution with 1 part water. Normal developing time is about 2 minutes at 68° F.

FOR BRILLIANCE AND RICH BLACKS

Eastman D 72 (like Dektol)	METRIC		AVOIRDUPOIS	
Water (about 125° F.)	500	cc.	16	ounces
Elon (metol)	3.1	grams	45	grains
Sodium sulphite, dry	45	grams	1½	ounces
Hydroquinone	12	grams	175	grains
Sodium carbonate, dry	67.5	grams	2¼	ounces
Potassium bromide	1.9	grams	27	grains
Cold water to make	1000	cc.	32	ounces

For use, dilute 1 part stock solution with 2 parts water.

Normal developing time 1 to 1½ minutes at 68° F. Greater or less contrast can be obtained by varying dilution.

For GAF papers, the two developers suggested are:

SOFT-WORKING DEVELOPER 120

Dissolve in this order:	METRIC		AVOIRDUPOIS	
Water (125° F.)	750	cc.	24	ounces
Metol			¼ oz., 70 gr.	
Sodium sulphite, dry	12.3	grams	1	oz., 88 gr.
Sodium carbonate,	36	grams		
monohydrated	36	grams	1	oz., 88 gr.
Potassium bromide	1.8	grams	27	grains
Cold water to make	1000	cc.	32	ounces

For use, dilute 1 part stock solution with 2 parts water.

Normal developing time, 1½ to 3 minutes at 68° F.

UNIVERSAL PAPER DEVELOPER 130

Dissolve in this order:	METRIC		AVOIRDUPOIS	
Water (125° F.)	750	cc.	24	ounces
Metol	2.2	grams	32	grains
Sodium sulphite, dry	50	grams	1¾	ounces
Hydroquinone	11	grams	¼ oz., 50 gr.	
Sodium carbonate,				
monohydrated	78	grams	2½	ounces
Potassium bromide	5.5	grams	80	grains
Glycin	11	grams	¼ oz., 50 gr.	
Cold water to make	1000	cc.	32	ounces

For use, dilute 1 part stock solution with 1 part water.

Normal developing time at 68° F. for bromide papers, 2 to 6 minutes; for chlorides and chlorobromides, 1½ to 3 minutes.

For greater contrast, use full strength; for softer prints, 1:2.

RINSING

After development, rinse prints for about 5 seconds in a short-stop bath made up with 1½ ounces (48 cc.) of 28 per cent acetic acid (made by diluting 3 parts of glacial acetic in 8 parts water) in 32 ounces (1000 cc.) of water. *This does not apply, of course, to the two Edwal formulas which require a special citric rinse as explained above.* The rinse stops development and neutralizes the alkali in the developer, which would otherwise spoil the hypo solution.

HOW TO FIX PRINTS

To avoid staining, marring, or blistering your prints, and to help preserve them, use a fresh *acid fixing bath* made with a *hardener.* You can buy such a *fixer* (powder or liquid), or you can make up this one:

ACID HARDENING FIXING BATH (F-1)

Dissolve in this order:	METRIC	AVOIRDUPOIS	
Water, hot (125° F.)	500 cc.	16	ounces
Hypo	240 grams	8	ounces
Cold water to make	1000 cc.	32	ounces

Dissolve completely, then add 2 ounces (64 cc.) of any good Liquid Hardener (Kodak, Edwal, F-R), or *all* of this *hardening solution:*

Water, hot (125° F.)	80 cc.	2½ ounces
Sodium sulphite, dry	15 grams	½ ounce
Acetic acid, 28 per cent	48 cc.	1½ ounces
Potassium alum	15 grams	½ ounce

The sulphite should be fully dissolved before adding the acetic acid. Mix these thoroughly, then add the potassium alum while stirring continuously. Cool the hardening solution and add it slowly to the cool hypo.

Complete fixing of prints takes about 15 minutes, provided they are placed face up in the bath, and agitated, separated, and turned at three-minute intervals. Don't use a fixing bath previously used for *film.* The backing dye may stain the print. See also page 421, *Some Hints on Hypo.*

HOW TO WASH PRINTS

The prints can be washed in any one of several ways: (1) by placing them in a tray of water and then constantly turning them over

and changing the water at least a dozen times at five-minute intervals; (2) by using two trays of water and taking them from one and putting them in the other when the water is changed; (3) by keeping them moving in a tray in which a stream of water is running, and (4) by washing them for the same length of time in an automatic washer. Whichever way you follow, the water should be kept at as nearly the same temperature as possible all during the process of washing.

If washing is not complete the prints may later fade, darken, or stain. The *Richard Print Washers* (available in three sizes), the *Paterson Print Washer* (an automatic print washer of a new type, shown in *Fig. 14.4*), or any of the *siphon* attachments that can convert your own trays into print washers, are all good ways of washing your prints thoroughly and quickly. When one of these is used, the washing time can be cut to 30 minutes without affecting the permanence of the print.

FIG. 14.4. THE PATERSON PRINT WASHER

HOW TO TELL WHEN PRINTS ARE PROPERLY WASHED

You can tell when a print is properly washed by making and applying the following simple test solution:

HYPO TEST SOLUTION

Dissolve in this order:	METRIC	AVOIRDUPOIS
Potassium permanganate	0.6 gram	8 grains
Caustic soda	0.5 gram	7 grains
Distilled water	240 cc.	8 ounces

To make the test put four drops of the above test solution in about eight ounces of pure water; it will have a violet tint. Now take some of the prints from the water you are washing them in and let the latter drain off in the glass containing the test solution. If there is still hypo in it, the violet tint will change to a delicate green; this is your cue to keep on washing the prints until a like test shows that all of the hypo has been removed.

For absolute print permanence, soak the prints after fixing and rinsing, and before washing, in a 1 per cent solution of sodium carbonate for 1 minute. Then each 10 minutes of washing time thereafter will be equivalent to 30 minutes for prints not so treated.

HOW TO DRY PRINTS

After you have washed the prints, lay them with the picture-side *up* on a clean blotter, and then remove the excess of water by pressing another sheet of blotting paper down on them, or better yet, by removing the surface moisture with a folded section of a paper towel.[1] When you do this, rub from the center outwards, to avoid frilling the emulsion at the edges. Then lay the prints with the picture-side *down* on a *cheesecloth stretcher* (made by tacking the cloth over a wooden frame) or lay them face down on *dry* paper towels. Don't dry prints between blotters; they'll stick and spoil. For faster drying get yourself a Lott rotary or one of the other *electric* dryers. *Caution:* Use blotters made for photographic use.

HOW TO SAVE A BAD PRINT

If the print is no good because it was *over-* or *under*-developed (or if the developer was stale) bleach it in the solution suggested for negatives (see page 360) or in a bath of equal parts of potassium ferricyanide and bromide in about 20 parts of water. When the image has almost disappeared, wash thoroughly in running water for about thirty minutes. Then redevelop in any fresh print developer *by weak white light,* and finally fix and wash.

HOW TO KEEP PRINTS FLAT

To overcome a natural tendency to curl when drying, immerse the prints for a minute or two after washing in a bath containing 1 part glycerin to 10 parts water. This will remove all tendency to curl and will also add depth and luster to the blacks.

[1] Some paper towels are more absorbent than others, and chemically purer. I found the *Viva, Bounty,* and *Scott* towels excellent; some of the others only fair.

If the print still curls after it has dried, dampen the back with a solution of 1 part glycerin to 3 parts water and place under pressure. The old-style letter presses or some modern variant of them are best for this purpose. I have also placed prints, after they are *dry*, between the pages of an unabridged dictionary to good effect.

Kodak, Edwal, and others offer print flattening solutions that can be diluted for use. They are sold in 8 ounce bottles, or larger, for dilution 1:10 or more.

HOW TO MAKE GLOSSY PRINTS

The prints have to be made, of course, on *glossy* paper; that is, paper with a special, smooth surface, designed for that use. After the prints are fixed and washed, slap them face down while still wet on a *ferrotype tin*, squeegee into perfect contact, let them dry (*Fig. 14.5*). The best roller squeegee made is the one craftily designed by *Paterson;*

A. Flat squeegee B. Roller squeegee

FIG. 14.5. KINDS OF SQUEEGEES

you can put your full weight on it most effectively. When the print is thoroughly dry, it will peel off of its own accord with the desired luster.

After you have used the ferrotype tin for some time, the prints may have a tendency to stick. To prevent this, rub the surface of the tin with a soft piece of flannel on which you have put a few drops of ferrotype waxing solution. After you have rubbed the surface thoroughly, polish it off with a piece of dry flannel. It is also a good scheme to clean the tin once in a while with hot water and a little Ivory soap to remove such particles of matter as may have stuck to it. Another good polisher: *Sight Saver* silicone tissues.

See also *Glossy Troubles* and *Tips on Better Glazing*, pages 420 and 421.

HOW TO DIFFUSE PRINTS

For soft pictures, especially portraits of women, and for certain types of landscapes, a pleasant effect can be produced by stretching a woman's sheer stocking or some similar material over a sewing hoop and interposing this between the lens and paper during all or part of the enlarging time.

HOW TO DODGE PRINTS

This is done by placing the hands or some other opaque object between the lens and the paper during part of the exposure. In this way a foreground or some other part of the image can be held back while the sky or a face is printed in. To avoid having the outlines of the hand or card show, it should be moved around during the exposure. A few actual trials will teach you just how to do this and what to avoid. For spot printing, which is the reverse of dodging, a card with a small hole is placed between lens and paper, to accent with additional exposure some overexposed part of the negative. In spot printing, also, it is impor-tant to keep the card moving to avoid sharp edges.

For better control in enlarging you may want to invest in a few worthwhile accessories: 1. *Variable Vignetter*. There are a few on the market. Look them over in your photo shop. You may even be able to make one yourself. 2. *Visible Dodger*. Made of two sheets of heavy-duty *red* cellophane pinned together in the center. One has a large round

FIG. 14.6. A VISIBLE DODGER
For burning in odd-shaped areas. See text, above.

hole; the other has a series of openings of various sizes and shapes (circles, squares, triangles, ovals, tubes, etc.) which can be moved into position under the larger hole. Make sure there is enough room between the holes and the edge of the card, to avoid light spill. 3. *Dodger Kit.* A series of opaque shapes of many kinds and sizes fastened to wire stems to help block the light. *Caution:* everything we have said above about *keeping things moving* applies as well to each of these.

How to Spot Prints

After the print has been dried and flattened, it usually needs spotting (depending on the care with which you processed and handled the negative, or the amount of dust in your darkroom). You touch up the *white* spots by dotting gently and slowly with a sharp, *soft* pencil or by dotting with a fine-pointed sable brush dipped into a spotting color that is either mixed from opaque, diluted from India ink, or worked up from a card or jar of spotting color (white, black, or brown, or the proper matching mixture of these). *Caution:* keep the brush pointed, use as little water as possible, and fill the blemish with many minute dots, rather than with one big blob of color.

But better than these spotting colors, which have the disadvantage of showing marks (especially on glossy prints) are the new *dye* products: *Spotone* and *Dyacol* (see index). These sink right into the emulsion, leaving no trace on the surface. *Black* spots are removed by using iodine (see item 28, chapter 19, "Hints and Suggestions") or by reducing with *Spotoff, Flchudine,* or *Dyacol* (see chapter 13 "Developers and Developing," *How to Spot a Negative*).

Margins

On contact prints: Whether you are using a printing frame or a contact printer, first place a mask of the correct size and shape (see *Fig. 16.1*) next to the glass, then place the negative on top of that, with the emulsion side up, now place a sheet of printing paper against the emulsion side of the negative, and finally close the back and lock it. You can cut these masks yourself, from black paper or a transparent red Kodaloid, or you can buy the masks ready made.

On enlargements: If you use a printing frame, the method is the same as above, except be sure to use *enlarging* paper and not *contact* paper. A more convenient method is to use an enlarging easel with adjustable leaves, one of the Saunders single-size easels, or a *Speed-Ez-El* (made by A. J. Ganz Co. of Los Angeles, California 90036, in 6 sizes).

If you don't want margins: On contact prints, simply have the nega-

tive extend slightly beyond the paper. On enlargements, to get prints that bleed to the edges, use a sheet of *spotlessly clean* plate glass to hold the paper down, or place some sticky tape triangles, face up, at the four corners of the easel, just under the leaves, so that the tape grips the underside of the paper and keeps it from curling. A simpler method is to use a *Saunders adjustable borderless easel;* its unique design permits edge-to-edge enlarging without the use of adhesives, vacuum suction, or glass.

The Bodine Way for Better Prints

A. Aubrey Bodine devoted the last fifty years of his life (he died October 1970) to photographing the Maryland scene for the *Baltimore Sun* papers. His pictures were a beautiful rememoration of the places and people he liked best and loved most.

And they returned his love. Marylanders thought of him as their very own photographer. For most of my years in photography, I knew of him as a key figure in the camera world. The first *divided developer* I ever used bore his name. (See *index.*)

His prints were exquisite: deep, rich blacks; brilliant highlights; luminous middle tones that gave a three-dimensional effect to his photographs.

His secret was really no secret at all, because he kept explaining it to anyone who would listen. *"Cut your exposure so that you can develop your print from three to eight minutes."* Since most amateurs "pull" their prints in sixty to ninety seconds, perhaps it is time we tried the Bodine way.

Spray Can Developer

A new aerosol spray process for developing black-and-white prints, devised by a British inventor named Douglas Johnson, may be the beginning of the next upheaval in photographic technique.

If it stands up to time and test, it may: 1) do away with tray development and the need for much darkroom equipment; 2) speed up and simplify the making, fixing, and washing of prints; 3) increase the variety of materials on which a photograph can be made—walls, doors, glass, cloth (as for a mural), and an endless list of other substances, like wood, rock, and brick—almost anything on which an emulsion can first be brushed, or sprayed (see page 439).

This new method of developing works best on *double*-weight paper. No need to worry that the part of the sheet that gets the spray first will

Enlarging Dataguide Focus and Magnification Finder

MADE BY
Eastman Kodak Company
ROCHESTER, N. Y.

½ C M.

CENTIMETERS

1 C.M.

½ "

INCHES

1"

A TEST FOR SIZE AND SHARPNESS

The original 35mm sprocket film from which this print of Kodak's
Enlarging Dataguide Focus and Magnification Finder was made is the
same size as a Leica or Nikon negative. It can be used to compare size of
enlargement (1-inch bar at bottom, for example, measured against size
on final print), and to check sharpness of focus and quality of lens
by studying reproduction of sunburst design.

begin to develop out first. Douglas Johnson is an ingenious man and he
devised a *fail-safe device for even development.* The temperature of the
solution drops considerably as it leaves the nozzle of the container, and
*no development can begin until the layer of the chemical solution on the
paper reaches 65° F.* This ensures smooth development. As a matter of
fact, if the room temperature is below 65° F., the developer will not work.

Of course, the spraying has to be done in a darkroom, under safe-
light (preferably placed at the other end of the work area), and so
arranged that you get a glare reflection of the light, to be sure you aren't
missing any dry spots. By spraying back and forth slowly (about 10″
away), and placing the print face up over some newspapers on a flat
surface, you will avoid overlooking any areas.

Exposure will have to be tested; but it should be short enough so
that you can get a good print with a 90-second exposure.

After development, you have a choice: either spray some fixer on
the print (by means of an *Aerofix Spraymaker,* or a *Preval Power Unit*

that you can buy at almost any hardware store), or dunk in the usual way in a tray of fixer. The Preval unit is an aerosol can with a valve at one end and a screw-cap bottle at the other (which can be filled with something like Edwal's Quick Fix). You can also apply the fixer with a wide brush.

After fixing, wash in the usual way, or in a bathtub. The washing (because the print base remains dry) can be reduced to as little as 15 minutes.

Aeroprint is manufactured in Great Britain by D. J. Photographic Developments Ltd., Aeroprint Division, Wharf Way, Glen Parva, Leicester, and distributed in the United States by *Aeroprint Products USA, Inc.,* 27 Bland Street, Emerson, N.J. 07630, to whom you can write for information.

Later, in the chapter "Better Color Photography," page 515, we will discuss the three-stage Aeroprint Color System for producing perfect color prints from color *negatives* and (with the addition of the black-and-white Aeroprint developer) color *transparencies* as well, *all without the use of color-correcting filters.*

Do You Need a Darkroom

No, you don't absolutely *need* a darkroom, but Paul Farber's words bear repeating: *"Anyone who uses a camera but does not have a darkroom is depriving himself of half the fun of photography. It's a little like owning the leash without the puppy."*

If you can't build a darkroom of your own, improvise. Bathrooms and kitchens have been happily pressed into service as temporary darkrooms. The only problems: 1. securing the *dark*, and 2. working out an arrangement with spouse or mother. Keep things spotless, avoid contaminating the room, and no one can have any serious objections.

DARKROOM SPACE SAVER

Few of us have too much space in our darkrooms. It is therefore a source of pleasure when someone comes up with a clever way to make every inch of that space count.

The *Richard Tray-Rak* holds 3 trays for vertical, stair-step processing. And it saves a lot of room. As a matter of fact, it saves *two-thirds* of your counter or sink space. And it stores *flat* when not in use.

It is made of heavy-gauge welded steel coated with corrosion-resistant, white vinyl plastic. The assembled frame interlocks with rolled rims of trays for positive stability and strength. Model 1400 is adjustable for 8 x 10 or 11 x 16 trays; model 2000 is adjustable for 11 x 14, 14 x 17,

DARKROOM
SPACE SAVER
The Richard Tray-Rak

16 x 20 or 20 x 24 tray sizes. At most dealers, or write for information to Richard Manufacturing Co., 5914 Noble Ave., Van Nuys, California 91401.

CLUES TO A DUSTFREE DARKROOM

Wet-mop the floor, and "dust" with a *wet* sponge or a *damp* cloth, before each and every session. Ground your enlarger electrically (to a cold water pipe), and always keep it covered when not in use. If you spill anything, make sure to clean it up (dried hypo or developer is death on spotless enlarging). And in ventilating your darkroom, blow the air *in* through a screened or filtered blower, set high, away from the floor. That will raise the pressure in the darkroom just enough to keep dust *out*. An exhaust fan, on the other hand, makes a vacuum cleaner out of your darkroom, and that will suck the dust in.

PRINT PERMANENCE

To wash a print properly usually takes from one to two hours in running water, and even then much depends on the temperature of the water. If it's too cold (55° F.) you need more washing time; if it's too warm (85° F.) you may be softening and frilling the emulsion. However, if you first soak the print in a 2 per cent solution of *Kodalk Balanced Alkali* for two minutes, it will wash in *half* the usual time, and much more effectively.

See also *Some Hints on the Use of Hypo* (items 14 and 15), later in this chapter.

CONTRAST CONTROL, FREE

If you are using the test-strip method of *exposure* control (or a Kodak Projection Print Scale), you may be getting a method of contrast control *free*, as an extra bonus. Here's how: let us suppose you increase

each step by approximately 50 per cent (2, 3, 5, 7, 10, 14 seconds) and you find that the proper exposure is 5 seconds, while the highlight exposure requires 10 seconds. That means your negative requires a *softer* paper than you are using by about *two* grades. If the highlight needed 7 seconds, that would require a paper only *one* grade softer. If, on the other hand, your proper exposure is 7 seconds, while your highlight exposure is only 3 seconds, you need a paper that is *two* steps *harder*.

The Kodak Projection Scale can also be used for this kind of calculation, but keep in mind that their steps (2, 3, 4, 6, 8, 12, 16, 24) are arbitrary and not true 50 per cent increases. The regular 50 per cent increments would have been 2, 3, 4.5, 6.75, 10.125, 15.187, 22.77, 34.155. Nevertheless, their steps will indicate roughly what you need to do, and if you recall what the true increments should be, you'll soon become proficient in making the necessary adjustments. All that this is supposed to reveal is whether you need a *softer* or *harder* paper, and approximately to what degree.

ABOUT ENLARGER FOCUSERS

One of the fun things in photography is fooling around with the gadgets. A good one, because it's so useful, is the device known as the *enlarger focuser*.

There are two types: 1. the *ground-glass* focuser, like the *Magnasight;* and 2. the *grain* focusers, like the *Scoponet*, the Bausch & Lomb *Enlarging Focusing Magnifier*, and the Paterson *Micro Focus Finder*. I prefer the grain type. Focusing is sharp and sudden with one of these. For greater convenience, get one that has a focusing eyepiece which can be adjusted to your eye and permits you to get close to the eyepiece (to view a large bright field). This makes grain focusing easier.

Cautions: Be sure to place a piece of unexposed paper in your easel before you start focusing. The thickness of double-weight paper *will* make a difference, especially with 35mm negatives. Try to persuade your dealer to let you *try* two different focusers before you buy. And test them against your naked eye by exposing and developing a few prints both ways (mark them on the back).

The *Magnasight* is made by Bestwell Optical Instrument Co., 209 Beverly Road, Brooklyn, N.Y. 11218; the Thomas *Scoponet* Magnifier is manufactured by Thomas Instrument Co., 331 Park Avenue South, N.Y. 10010; and the Paterson *Micro Focus Finder* is made in England but distributed by many firms in the U.S., including *Treck Photo Graphic*, 1 West 39th Street, N.Y. 10018. The Bausch & Lomb is made here, of course, and is available at all camera shops.

Strip diaphragm. Another way of insuring perfect focus. You place

FIG. 14.7. STRIP DIAPHRAGM
(an aid to enlarger focusing)

an opaque strip about ⅛ inch wide (it can be made of black paper, wood, or tin) across the face of your lens. This bisects your lens into two halves, creating two images that will coincide *only* when the lens is focused accurately. If there are any lines in the negative, they should run *parallel* to the strip for best results. (See illustration.)

How to Mount Prints

The best way to mount prints is with *dry tissue* like *Technal Dry Mount Tissue*, made by Bogen Photo Corporation, 100 South Van Brunt St., P.O. Box 448, Englewood, N.J. 07631; *Fotoflat,* manufactured by Seal, Inc., of Shelton, Conn.; or *Kodak Dry Mounting Tissue*. It forms a *permanent* bond between print and mount and, most important, it *does not stain* or discolor the print. The semitransparent tissue melts under heat and welds the print to the mount. If you can't afford a mounting press, use a flatiron, but keep it at about 140° F. (just hot enough to sizzle a wet finger), and cover the print with a sheet of heavy paper, to keep from scorching it. The tissue is first tacked to the untrimmed print at several spots, using tip of iron or a small mounting unit made for this purpose. Then trim print to size, arrange on mount, cover with protective paper (avoid shifting position) and smoothly, carefully iron.

How to Tone Prints

When bromide or chlorobromide prints are normally developed, the images are black and white. But you can tone them *red, blue, green,* or *sepia* simply by immersing them in the following solutions:

RED TONING SOLUTION

Dissolve in this order:	METRIC	AVOIRDUPOIS	
Copper sulphate	10.4 grams	160	grains
Potassium ferricyanide			
(*poison*)	20.8 grams	320	grains
Ammonium carbonate	99.2 grams	3½	ounces
Water to make	1000 cc.	32	ounces

After the prints are washed, and while they are still wet, put them in this bath until all of the shadows take on a red hue. Then wash for ten or fifteen minutes.

BLUE TONING SOLUTION

Dissolve in this order:	METRIC	AVOIRDUPOIS
Bleaching Solution		
Potassium ferricyanide		
(*poison*)	21.3 grams	¾ ounce
Ammonium carbonate	212.6 grams	7½ ounces
Water	1000 cc.	32 ounces
Toning Solution		
Ferric chloride	10.4 grams	160 grains
Hydrochloric acid	85 grams	3 ounces
Water	1000 cc.	32 ounces

Put the print in the bleaching solution first, then immerse it in the toning solution until it takes on the desired color.

GREEN TONING SOLUTION

Dissolve in this order:	METRIC	AVOIRDUPOIS
A Solution:		
Potassium ferricyanide (*poison*)	5 grams	77 grains
Ammonia	5 drops	5 drops
Water to make	100 cc.	3½ ounces
B Solution:		
Iron and ammonium citrate ferric	2.2 grams	33 grams
Hydrochloric acid (concentrated)	5 cc.	80 minims
Water to make	100 cc.	3½ ounces
C Solution:		
Sodium sulphide (pure crystal)	1 gram	15 grains
Water, then (and only then)	100 cc.	3½ ounces
Hydrochloric acid (concentrated)	5 cc.	80 minims

Bleach the thoroughly washed print in solution *A*. Now wash until stain has disappeared, and immerse print in solution *B* for about 5 minutes. Wash print once more, and place in solution *C* for about 5 minutes. Finally, wash print again after removing from solution *C* and dry as you usually do.

SEPIA TONING SOLUTION

Dissolve in this order:	METRIC		AVOIRDUPOIS	
A Solution:				
Alum	28.4	grams	1	ounce
Hypo	113.5	grams	4	ounces
Boiling water	1000	cc.	32	ounces
B Solution:				
Silver nitrate	1	gram	15	grains
Sodium chloride	1	gram	15	grains
Water	7	cc.	¼ ounce	

When the *A* solution is cold, add the *B* solution. Heat the bath to 120 degrees Fahrenheit, immerse the prints in it, and they will tone to a fine sepia color in about thirty minutes. The exact time you leave the prints in the bath does not matter, for when they reach the sepia color the toning stops. Eastman and GAF make a prepared sepia toner that can be used at room temperature.

Trim When In Doubt

When there's something wrong with the composition and you can't decide what it is, start trimming. Nine times out of ten that's about all that is necessary to improve your picture. The best way to do this without injury to the print itself is to make up two L-shaped pieces of card to form an adjustable frame. These can be moved around until the best composition is found, whereupon the print is trimmed accordingly. After you've found the best arrangement for a certain negative it's a good idea to make a contact print which should be marked, to indicate the way it should be trimmed, and then filed with the negative for future reference.

Print Faults

Here are the more common print defects and some suggestions on what to do about them.

TOO DARK

1. *Cause:* Overexposure. *Cure:* Try again, but use less exposure.

TOO LIGHT

2. *Cause:* Underexposure. *Cure:* Make another print, but give more exposure.

TOO FLAT

3. *Cause:* Either wrong grade of paper was used, or print was jerked from the developer too soon. *Cure:* Use a more contrasty grade of paper and leave print in developer between two to three minutes.

TOO HARD

4. *Cause:* Wrong grade of paper. *Cure:* Use a softer grade of paper, or increase exposure and shorten period of development.

FRILLED EDGES

5. *Cause:* Solutions or wash water too warm, or hypo or short stop too acid. *Cure:* Keep solution at seventy degrees. Replace hypo and short stop with correctly acidified solutions.

PURPLE STAIN

6. *Cause:* Improper fixation which permitted developer to continue action, thus producing stain. *Cure:* Rinse prints quickly and thoroughly before placing in hypo, and be sure that when in the hypo they are *below* the surface of solution.

UNEVEN DEVELOPMENT

7. *Cause:* Failure to immerse print quickly and smoothly in developer. *Cure:* Slide paper *quickly* into developer and rock tray from side to side.

GLOSSY TROUBLES

8. *Cause:* If prints stick to ferrotype tins, the tins were not cleaned, or the gelatin was too swollen (inadequately hardened) or the wash water was too warm, or the ferrotyped prints were dried at too high a temperature. *Cure:* Clean tins with hot water and rub with ferrotype waxing solution. Avoid excess heat for washing or drying. If dull spots

appear, squeegee better. Use roller squeegee (the rugged one made by *Paterson* is especially recommended).

Some Other Tips on Better Glazing:

1. The less hardening used in the fixer, the better the ferrotyping. 2. Most variable contrast papers are strongly hardened by the manufacturer, so they do not need any further hardening. Use a non-hardening fixer. 3. If sticking occurs on tin or drum, wash with ordinary *Ivory* soap solution and polish without rinsing. 4. Avoid prolonged immersion in any fixing bath; it coagulates gelatin and makes for poor glazing. Avoid two-bath fixing. 5. Shorten fixing time. The shorter the fixing, the better the ferrotyping. Use a fast fixer, and if a longer fixing time (3 to 4 minutes) is desired, you can dilute Edwal's Quick-Fix 1:7. 6. *George L. Wakefield* of London recommends leisurely drying: "One of the secrets of a good glaze is slow drying so that there is no violent contraction of the paper base to pull the gelatin from the glazing sheet." This is especially true of double-weight paper.

If glazing is a bother, look into that wonderful new paper *Luminos Bromide RD* (rapid drying). It has an instant high-gloss surface that needs no ferrotyping, is resin-coated, waterproof, comes in a vibrant-white stock, can be developed in your favorite developer to give deep, rich blacks, and is available in four contrasts. For information about this fine paper made in West Germany, write to the *Luminos Photo Corporation*, 25 Wolffe St., Yonkers, N.Y. 10705.

Some Hints on the Use of Hypo

1. A stock solution of freshly dissolved hypo should not be used until a couple of hours after all visible particles are gone. The mixture is not fully dissolved until then. For the same reason a solution of hypo in water should stand for at least two hours before other chemicals (hardener or acid) are added.

2. The most convenient way to use hypo is as a *concentrated stock solution* made up as follows:

HYPO STOCK SOLUTION

Dissolve in this order:	METRIC	AVOIRDUPOIS	
Water, *warm (100° F.)*	500 cc.	16	ounces
Hypo	800 grams	28	ounces
Sodium sulphite, dry	40 grams	1½	ounces
Cold water to make	1000 cc.	32	ounces

For use, dilute 1 part stock with 3 parts water, and add 1 part Kodak Liquid Hardener to each 15 parts of working solution, or 1 part of the following hardener to each 15 parts of working solution. Add ingredients in order listed.

STOCK HARDENER

Dissolve in this order:	METRIC		AVOIRDUPOIS	
Water, *warm* (100° F.)	600	cc.	20	ounces
Sodium sulphite, dry	85	grams	3	ounces
Glacial acetic acid	66.5	cc.	2¼	ounces
Sodium citrate	21.3	grams	328	grains
Potassium alum	85	grams	3	ounces
Cold water to make	1000	cc.	32	ounces

3. *Hypo becomes exhausted from use,* despite the serene faith with which amateurs continue to dump more and more prints into a single tray of the stuff. Chemists estimate that each pint (16 ounces) of fresh hypo can properly fix about 700 square inches of emulsion surface. This works out as follows for the various sizes, leaving a safety margin to avoid trouble:

75 prints, 2¼ x 3¼ inches
34 prints, 4 x 5 inches
20 prints, 5 x 7 inches
8 prints, 8 x 10 inches
4 prints, 11 x 14 inches

Since hypo is cheap, don't be a hypo miser. Above all, *use fresh hypo for all your films!* If you want to economize, store the hypo that you've used once for negatives and use it later for prints. There's a danger of staining the prints, however, if the films you use have a colored backing dye that attacks the print surface. If the margins of your prints show even the slightest stain, use *fresh* hypo thereafter.

4. *Acid hypo solutions must include some sodium sulphite* or a precipitate of sulphur will be thrown down. The sulphite redissolves the free sulphur and reforms hypo (sodium thiosulphate). Sodium bisulphite or potassium metabisulphite can also be used.

5. *The temperature of hypo solutions* should not exceed 70° F., or the salts will be decomposed. If an acid solution (hardener) is added to warm hypo, a white precipitate will form.

6. The concentration of the hypo solution determines the speed of fixation. *A 40 per cent solution fixes the fastest.* Higher concentrations, strangely enough, fix more slowly. The 20 per cent solution is the one recommended for normal use (4 ounces of hypo in 16 ounces of water).

7. *For rapid fixation, ammonium chloride* is added to the hypo in the following proportions:

2 per cent in a 40 per cent hypo solution
4 per cent in a 20 per cent hypo solution
5 per cent in a 10 per cent hypo solution

The fastest acting is the 20 per cent hypo solution with 4 per cent of ammonium chloride. Here is the formula for a *Two Minute Hypo Fixer* used by press photographers. It will clear a negative in 1 minute, fix it completely in 2 minutes:

TWO MINUTE HYPO

Dissolve in this order:	METRIC		AVOIRDUPOIS
Water, *warm* (*100° F.*)	500	cc.	16 ounces
Hypo	200	grams	8 ounces
Sodium bisulphite	19.6	grams	322 grains
Chrome alum	19.6	grams	322 grains
Ammonium chloride	85	grams	3 ounces
Cold water to make	1000	cc.	32 ounces

8. *Prints should not be left in hypo* for more than fifteen minutes, provided of course that the hypo has had access to the emulsion surface (piling prints on top of one another makes this impossible). A fresh hypo bath will bleach prints if they are left in for more than that time; it will also degrade images, dissolve shadows, discolor or stain prints. This is more likely to happen where an acid rinse is used before fixing, the acid serving to soften the gelatine. The acid short stop should not be too strong (1½ per cent is about right, and that's what is usually recommended). *Caution:* Don't leave prints in *rapid* hypo solutions more than 5 minutes!

9. *Hypo is at its best* (for prints) after it has been used a little while.

10. The addition of other chemicals to hypo will affect *the color and contrast* of the final print. Adding sodium chloride, for instance, gives the print a bluish tinge; adding potassium iodide gives it a warm tone (the print will turn yellow; when the tint vanishes, fixation will be complete); adding potassium iodide and silver nitrate will increase contrast and give warm tones; adding sodium chloride and silver nitrate will give blue tones and intense contrast.

11. *A single print will fix completely in 30 seconds* in a fresh hypo bath which has not been used previously, especially if the print is moved about or if the tray is rocked back and forth and sideways during the entire 30 seconds.

12. When compounding the hardener for a hypo bath, *don't mix the sodium sulphite with the potassium alum* before adding the acid; a sludge of aluminum sulphite will be the result if you disregard this warning.

13. *The best way to fix prints* is to use two trays of hypo, one old and one new. Transfer the prints from the short stop to the old bath for 5 minutes, and then to the new bath for another 5 minutes. Then wash. When the first tray is exhausted, dump the solution, refill with fresh hypo and shift trays. (*Does not apply to prints that are to be glazed.*)

14. *The hypo can be washed out of a print faster* if it is soaked for one minute in a dilute (1 per cent) solution of *sodium carbonate.* Take the print out of the hypo, rinse in plain water, soak in the carbonate, and then wash for 15 minutes. A 1 per cent solution of carbonate is made up by dissolving 10 grams of the chemical in 1000 cc of water (⅓ ounce in 32 ounces). Don't use so-called *hypo killers;* they're a cure that's worse than the disease.

15. *A simple test for determining whether the prints are washed* sufficiently: drop a crystal of *potassium permanganate* in about 10 ounces (or 300 cc) of water. Shake until water has a slightly pink tinge. Pick up a print by one corner and let some water from it drip into the solution. If the solution changes color continue washing.

The Perfect Print

(*And Some Ways to Get It*)

If you're a photographer at heart, there is nothing that will give you a greater lift than the sight of a perfect print, especially if you've made it yourself. But for that you need a good negative.

What is the difference between a good negative and a bad negative?

In a bad negative, the highlights are so dense you cannot print through them; and the shadows are so thin, they print solid black. Prints from such negatives used to be called "soot and whitewash."

How can you tell when you have a good negative? Here are some of the ways:

1. A perfect negative is thin, but it has all the essential detail in both shadow and highlight areas.

2. Because it has been fully exposed but not overdeveloped, every important part of the scene or image is there, and can be printed easily on a paper of normal (#2) contrast.

3. One test of a good negative is to place it over a page of print like this. You should be able to read the print clearly through the densest areas.

4. There should be some tone or detail in even the thinnest parts.

You now have one of the most beautiful things in the world, a *perfect negative*. You want to convert this precious film into a print spectacular. How do you go about it?

Let's assume you already have an enlarger and all the other essential chemicals, material, and equipment. What you don't have is the knack of getting at the right print exposure without wasting a lot of paper and developer and time.

Is there an easy way?

An honest answer to this question would be, "No." There is no *easy* way. The oldest, *no-gadget* method is the making of *test strips*. This involves the exposing and developing of a test print (from the original package of paper). The test strip (which can be a full sheet or a one-inch section down the long side of the sheet) is used the same way, and with the same variable contrast filters, as your final print. Focus and arrange the image (on a sheet of paper of the same thickness as the final print) set your lens diaphragm, turn on your safelight, turn off your printing light, and replace the focusing sheet with the test strip (placing it over an area of the image which includes representative *shadow, medium tone*, and *highlight* areas). Cover the strip with a piece of cardboard or black paper (securing it first with a sheet of glass or some Scotch *Magic Tape*). Switch the enlarger light on. Then withdraw the light shield (about an inch at a time), at 5-second intervals, until the whole strip has been exposed. If there are ten steps, the first will have been exposed for 50 seconds, and the last for 5 seconds. The strip is then developed in the same solution, at the same temperature, and for the same time (90 to 120 seconds) as your final print.

When development is complete, fix for 2 minutes, wash briefly, wipe off excess moisture, and examine under white light. The time segment that looks like the best exposure is then duplicated for the actual print. If none of these look right, try it again, moving up or down the time scale.

This method can give you normal, full-scale prints, if that's what you're after. But sometimes you may want to *overprint* or *underprint*, to get special effects. Don't hesitate to do so, despite what your test print indicates.

Caution: When you place the test strip on your easel before exposure, make sure that the entire slice (and each 5-second segment) covers an important and typical part of the image, including a highlight (*orange filter under lens!*). Some photographers prefer to use an entire sheet for that reason, but that's expensive and wasteful.

An alternate method: Use a *Kodak Projection Print Scale* (see illustration). You place this negative over the image on your print paper

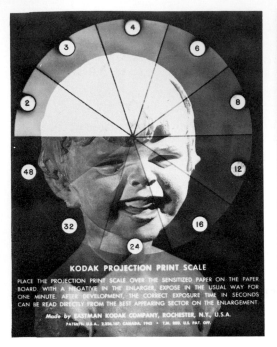

HOW TO USE A KODAK
PROJECTION PRINT SCALE

FINAL PRINT (32 seconds)
based on test made with
KODAK PROJECTION SCALE.

(after you have sized, focused, and set your diaphragm at *f*/8). Then expose for 60 seconds, develop as you would the actual print, fix, and rinse. *Inspect under white light.* The pie-chart wedge that matches your notion of what the enlargement should be has a number which indicates the exposure time in seconds at *f*/8. That's the exposure for your print. Include a highlight (see *Contrast Control, Free,* earlier).

Is there an *easier* way?

Yes, by the use of a *photometer.* If the intensity of your regular darkroom white light can be adjusted by lamp *distance,* a *voltage regulator,* or by *lamp wattage,* you have a print meter built into your darkroom that will cost you nothing. (Be sure the light source is *diffused.*)

This is what you do:

Take a medium contrast negative of average density. Make the best print you can, adjusting your enlarger lens midway between the largest and smallest opening (*f*/8). *Note the time required to make this print.* Without changing lens *stop* or *size* of enlargement, adjust the light until the projected image just fades out. This is your setting for any new negative of similar contrast and density. Keep the light at this strength or distance.

Now, no matter what size enlargement you plan to make, your *dim-out point* for the diaphragm adjustment will always be the same, pro-

vided you do not change paper, developer, temperature, or time of development. (If you change any of these factors, you will have to make new test strips.)

But there is a better way.

This involves the use of a *print meter*. However, unlike regular (film and flash) exposure meters, darkroom meters are not *pre*calibrated. In other words, there is no ASA reading for enlarging paper, as there is for film. That's why each print meter has to be calibrated for the conditions under which it operates. The ultimate objective, of course, is to arrive at a reading which tells how much light is hitting the print paper, and what the negative contrast happens to be. In order to calibrate the meter, you have to repeat the process described earlier (under *Is there an easy way?*). After arranging everything, as before, you make one perfect print. This gives you a reading which supplies two answers: 1. The *exposure* time, and 2. the *contrast* factor. If your test negative had a contrast factor of .7 and your new negative duplicates that, you're all set. If it's more or less, an adjustment has to be made (see your instruction manual), or you will need new test strips, using variable contrast paper and the filters that apply.

Besides the *mechanical* contraptions that enable you to make test strips, there are three main types of print meters:

1. The *extinction* meters which use a mirror that reflects the image to a graduated scale;

2. The *comparison* meters, divided into two categories:
a) the kind, like the *Fixomet*, that compares tones in your negative with the tones in a 10-step translucent bar of varying densities; and
b) the kind, like the *Volomat*, that compares the light from a preselected portion of your enlarger image with the light that travels from a small bulb through a *Goldberg Wedge* (a density-graduated piece of optical glass, clear at one end but then increasing in density); or the MCM *Photometer*, which does the same sort of thing by using an *oil spot* and a built-in area mask (a small dark spot in the center of a white disk);

3. The *electrical* type (represented by the *Melico*, the *Paterson CdS Computer*, the Photophia *Printometer*, the *Analite*, and the *Spotomatic*), all usually made with a combination of *CdS light cells* and *neon lights*, to fathom the reading of a middle tone.

Unfortunately, this important tone has to be selected *visually*, but few of us can remember, from one enlarging session to another, the precise tone we had in mind. The Weston *Fotoval* solves this problem by supplying a *standard* negative to help you calibrate the computer accurately. Though this negative can also be used to calibrate other print meters, you cannot buy one unless you own a *registered* Fotoval.

Here is another method for calibrating your own darkroom meter:

1. Take a reading of the *darkest* spot on the easel (the area of brightest highlight in which you still want detail in the print).

2. Take a reading of the *brightest* spot on the easel (the area of the darkest shadow in which you still want detail in the final print).

3. Now split the difference between the readings and either add this to the lowest reading, or subtract it from the highest. *This will give you a middle gray tone.*

4. Now make the best print you can, and record the exposure time. If your paper speed is calibrated to this reading, you will get a perfect print every time.

This is how it works. Let's suppose your first reading (of the dark tone) is 25, and your highlight reading is 55. The difference between them is 30. Half of that is 15. Now *add* 15 to 25 (or *subtract* 15 from 55), and your medium gray tone will be the spot on your easel where your meter gives you a reading of 40. If your perfect print took X seconds for this read-out point at $f/8$ with developer Y at 2 minutes, all future prints will take X seconds under similar conditions to give you a medium gray tone where your meter reads 40. The only thing you have to worry about: *Do you want a medium gray at that point?* But isn't it nice to know that if you *do* want it, this method makes certain that you can get it?

If you use this spot for your final reading each time, gradually stopping down your lens until you reach it, you should always get the correct exposure.

This method will work with any print meter that uses a light intensity scale. What it does is to pinpoint the middle tones without your having to *guess* at them. Naturally, if you change the conditions (such as paper, filter, developer, lens stop, or whatever), you have to recalibrate the meter. *But only once for each change.*

Here are some recommended print meters:

Karl Heitz *Volomat* (Goldberg Wedge, extinction type)

Durst *Analite* (electronic, with CdS photoresistor and glow-lamp indicator)

Spotomatic (electronic, with CdS photoresistors, from Arkay Corp., 228 First St., Milwaukee, Wisconsin 53204)

Weston *Fotoval* (with standard negative for easy calibration)

Paterson *CdS Enlarging Computer* (electronic, with CdS photoresistor)

Melico (electronic, some models with timer) available only from Medical & Electrical Instrumentation Co., Ltd., 32–34 Gordon House Road, London, NW5 1LP, England. *Be sure to ask for the 110V model* (for use in the U.S.).

Photophia *Printometer* (electronic, from Photophia, Ltd., Regent House, 235 Regent St., London, W.1)

Gossen *Majosix* (electronic, may have to be imported through Kling Photo Corp., 25–20 Brooklyn-Queens Expressway, Woodside, N.Y. 11377)

Corfield *Lumimeter* (can be imported from R. G. Lewis, Ltd., 202 High Holborn, London, W.C. 1)

Soligor *Fixomet* (mechanical and optical, from Allied Impex Corp., 168 Glen Cove Road, Carle Place, N.Y. 11513)

MCM oil-spot *Photometer* (no longer made here, but may still be available in England through Wallace Heaton House, 47 Brunswick Place, London, N1 6EE)

Beseler (Phillips) *Darkroom Analyzer 8720-P21*, combination exposure meter and timer. Probe has a CdS photocell for measuring projected image. Automatically turns safelight off to prevent its influencing reading. The reading automatically sets timer for exposure. *See illustration.* Distributed by Beseler Photo Marketing Co., Inc., 219 S. 18th St., East Orange, N.J. 07018.

The Beseler (Phillips) Darkroom Analyzer 8720-P21. *See text.*

Should you have any difficulty making your print meter repeat exposures accurately, remember that voltage fluctuations (which can be eliminated by a voltage regulator) and *warm-up* time for CdS cells may be factors. It takes about ten minutes for a CdS cell to adapt to the dimness of your darkroom. Keep that in mind when you plan your enlarging sessions. This warm-up time, incidentally, is not a factor with extinction meters like the *Volomat*.

PHOTOGRAM. See text for an explanation of how you can make *photograms* and the pendulum patterns called *pendulographs.*

15 Fun with Your Camera

There is a difference, as Alfred A. Knopf once wisely pointed out, between *fact* and *truth*. The camera can be used to record facts, but those very facts may actually be "false," or give an impression that is false. There is danger here, as well as the possibility of innocent fun. Following are some ways in which your camera or enlarger can be used to afford amusement, surprise, or wonder, by altering facts seen by the eye.

How to Take Moonlight Pictures

Imitation moonlight effects are easy enough to get. All you have to do is to put a print of almost any kind of a landscape or other scene in the following solution. There it will turn a blue color, which makes it look as if it were taken by pale lunar light instead of by the bright light of the sun. After the print is blued, wash it until the white parts are perfectly clear.

MOONLIGHT BLUE

Dissolve in this order:	METRIC	AVOIRDUPOIS
Ferric ammonium citrate	1.2 grams	19 grains
Potassium ferricyanide	1.2 grams	19 grains
Nitric acid	22 cc.	6 drams
Water	240 cc.	8 ounces

Another simple way to simulate moonlight effects is to take the pictures outdoors when the sky is clear and blue and use a deep red filter. Type B pan (such as Plus X, Verichrome Pan, Versapan, Ilford FP4, or Anscopan All-Weather) are the films to use.

It is not, however, so easy to make a photograph by actual moonlight. If you will follow the method of A. W. Dryer, who specialized in this branch of photography, you will meet with success. To take an actual moonlight picture you must have (1) a full moon, (2) a rapid lens, and (3) a moving body of water. The best time to take the picture is soon after the moon has risen but it must be high enough to be above the haze that hangs on the horizon.

The lens should be an anastigmat, and the faster it is the better. O' course, it must be used wide open. The water should preferably be a running river, as this will reflect the light in a broad band which is much more effective than a thin streak such as a still lake gives. In taking the picture, set up your camera so that it includes the moon, the water in the middle ground, and a tree or a bridge in the foreground. Use an ultra-rapid film like Kodak Royal X Pan, Tri X, or Ilford HP4 and do not give it an exposure of more than eight seconds; otherwise the apparent movement of the moon will make it appear a spheroid instead of a disk. The negative will, of course, be underexposed but this is necessary to give the appearance of moonlight. It is best to use a dilute developer and develop very slowly.

Photo Drawing

The interesting process which goes by this name is the invention of Leonard Misonne who described it in the *American Annual of Photography*. Many variations have since been suggested, some of them quite ingenious, but none has improved on the simplicity of Misonne's original conception.

The process is based on the notion that an enlarged image of a negative is a reversed positive. That is, whites are where the blacks ought to be and vice versa. If you have ever placed a negative over a contact

print and shifted it about a bit, you must have noticed how the image is suddenly and completely neutralized when the two match exactly. Everything looks gray or black, and there's no picture. Misonne's method is to make the matching positive by hand in pencil, by filling in the gaps or blank patches in the projected image on a sheet of white paper. If all the blank areas are filled in correctly, so that everything is one uniform tone, the result will be a startling reproduction of the original scene, drawn by hand! The beauty of this method is that you don't even have to be able to draw to be an excellent artist—and you don't have to mess around with developers or hypo. The final result is a pencil drawing made by you, and no one who sees it will deny that it's remarkably and incredibly good.

These are the only things you have to do:

1. Project the negative image on a white sheet of paper.

2. Fill in all the white so that you see a uniform expanse of black or gray. Use a carbon pencil and whatever strokes seem easier for you to make.

You'll find that the process works best for portraits, that the negatives ought to be of average transparency, and that the image should be sharp and have some snap to it. Later, as you acquire skill, you'll be suppressing backgrounds and eliminating unwanted details. The whole operation is very swift, taking only from about 5 minutes to half an hour, depending on how carefully you want to do it.

Two-Tone Pictures

A variant of Leonard Misonne's photo drawing technique is the method of converting a photograph in tone to an ink sketch in sharp *black* and *white:*

1. Make a strong bromide or chlorobromide print.

2. Bleach it until all the blacks have become a medium gray and all the lighter tones have disappeared.

3. Wash and dry.

4. Paint over all the remaining tones in India ink.

If you want to study the composition of any scene, this is an ideal method. The clutter of small details is removed at one fell swoop. Nothing but the bare bones of composition remain. An illustration is reproduced on page 433 to show the results you can get.

Photos That Tell Fortunes

Pictures made by the following process were first produced by Sir John Herschel, the great astronomer, more than a century ago, and were

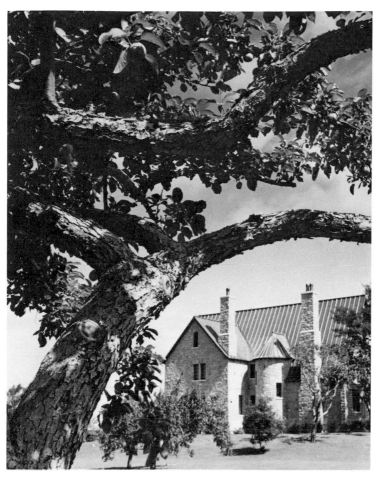

Illustrating a simple and ingenious method for making two-tone pictures. Full directions are given in text (see *Two-tone pictures*). If you want to study the bare composition of any scene, this is the technique to use. No special equipment is required—and the only supplementary chemicals needed are a bleach, such as Farmer's reducer, and India ink.

called by him MAGIC PHOTOGRAPHS. These pictures have been used ever since by fortune-tellers the world over, to show a girl how her future husband looks, and a man how his future wife looks. You can do the same wherever two or more are congregated together and thereby much harmless pleasure can be got out of them. This is the effect you get:

You show a piece of perfectly blank paper about one inch square, dip it into a saucer of what appears to be pure water, and then with all the impressiveness of a master prestidigitator you press it on the forehead of the person who would pry into the future and see at any cost what his or her life partner is to be like. This done, remove it with all due solemnity when, lo and behold! a photograph has really appeared on it of a handsome youth or a beautiful maid as the case requires.

The way it is done is at once simple and quite scientific. Take a little picture of a nice young man and a pretty girl and make a print of each negative on smooth solio paper (the kind professional photographers use for proofing portraits) in the usual way. After washing them thoroughly, fix them in a plain hypo bath made as follows:

PLAIN HYPO BATH

	METRIC	AVOIRDUPOIS
Hypo	28.3 grams	1 ounce
Water	240 cc.	8 ounces

After they are fixed and washed thoroughly bleach them out in the following solution:

BLEACHING SOLUTION

	METRIC	AVOIRDUPOIS
Mercury bichloride		
(*Poison!*)	14.1 grams	½ ounce
Potassium bromide	7 grams	¼ ounce
Water	240 cc.	8 ounces

When the salts are completely dissolved, filter the solution and pour it into a dish or tray, then put the prints into this and let them stay there until every trace of the image has disappeared; now pour the bleaching solution into its bottle again, as it can be used over and over. The next step is to wash the bleached pictures thoroughly and let them dry, when they will seem to be perfectly plain pieces of paper however closely they may be examined. To bring out the picture you need only put it in a

strong solution of hypo, which seems to be just pure water to the on-looker; let it remain for a few moments, when it will reappear. But just before this happens, place it on the forehead of the curious fortune-seeker.

How to Make High-Key Pictures

After you've learned to take and print a *full scale* picture (one that has *all* the tones from white to black (and a good print *should* have all the tones, even if only in minor accents) you may want to try your hand at some high- and low-key subjects. The photography of such subjects is not difficult, and the results are surprising and rewarding. But you will have to learn some new techniques, and may have to unlearn others.

The first thing you have to remember is that all good photographs, whether they be high, low, or medium key, use the full range of tones from white through all the thirty shades of gray to black. The difference between the various keys is merely one of *emphasis*. In every high-key picture there should be some accents of black; in every low-key picture there should be some brilliancies for contrast.

If you will glance back at the top picture on page 38, you will see three geometric shapes so lighted that practically all shadows have been eliminated. Imagine these shapes placed against a white background and you'll begin to understand some of the problems of high-key photography. While it is true you have to eliminate strong shadows, which you can do by flooding the subject from all sides with soft, *feathered* (edge) light, diffused light, and/or with lots of reflected light (from walls, ceiling, or reflectors), you still have to separate the delicate tone differences which help define the subject. (Your main light, by the way, should be closer to the subject than for normal-key lighting.) The way to capture those subtle tone differences is not to underexpose or overexpose but to give the negative *correct* exposure. This places the gray tones in the middle of the density range, where they belong, instead of at either end, where they would be thinned out or wedged together. The method, and you will need a good exposure meter for this unless you have a lot of patience to test and try again, is to read the highlights and favor the "O" reading slightly. (see page 189). Development should be *normal*. Thin, underdeveloped negatives are not true high key; they tend to create shadows without glow or detail. Overdeveloped negatives, on the other hand, increase contrast.

Now you're ready to make the print. You can, of course, use Vari-gam, Kodak Polycontrast, or GAF Ve Cee variable contrast paper and get the exact effect you're after by using one or more of the various fil-ters, and exposing just enough to develop out in 4 or 5 minutes. But if

you've ever seen one of Mark Shaw's magnificent fashion shots you may want to try his technique. He uses conventional paper. The secret is in an extra print tray which contains nothing but plain water. He uses this either to presoak the paper, which seems to soften the tones by diluting the developer upwards, or he uses it after partial development (about when the blacks *begin* to come up strong). The print is then quickly, but *gently*, transferred from the developer tray to the water bath, and then left there to soak *undisturbed* until it looks right. *This is what happens:* while the print is soaking, the dark portions use up the developer right away and then stop, while the highlight areas continue to work. The result is a handsome print with pearly whites and glowing blacks. To *water-bath* prints successfully you have to have a full-bodied negative and give ample exposure in the enlarger. *Caution:* If, after soaking, you want to put the print back into the developer, be sure to agitate constantly *or your print will mottle.*

How to Make Low-Key Pictures

For *low-key*, the techniques of exposure, development, and printing are exactly the same as those described above for high key. The only difference is in the choice of subject (dark instead of light) and in the lighting. Normally, only *one* light is needed. If two lights are used, the main light can be shot from the side, and the fill-in light can then be weaker than the one used for medium key. An interesting variation is to place the strong light behind the subject, and fill in from the side. It's a good idea to have shadows somewhere in each low-key picture, to accent the mood. Low key needs strong blacks, so use dark, unlit backgrounds; don't worry about printing the pictures dark if they look better that way; and, if they need it, you can even flash the corners and edges of the print with a small searchlight (making sure to protect the areas you don't want darkened). *Caution:* Don't underdevelop your prints; they'll come out gray and dull. Adjust your exposure so that you can leave the prints in the developer *at least* 2 minutes. As with high-key prints, an exposure that permits development of from 4 to 5 minutes usually gives better results.

How to Make Silhouettes

Originally the profile view was cut out of some black silk and this was mounted on a white card. It got its name from M. de Silhouette who was the French Minister of Finance in 1759; his rigid economy in the conduct of his office caused everything that was cheap to be called by his name.

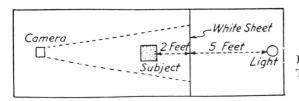

FIG. 15.1. HOW TO
TAKE SILHOUETTES

To make silhouettes with your camera is the easiest thing in photography. You can use any kind of a camera and the only other piece of apparatus you need is a strong light source. When you have this in readiness hang a sheet, after you have ironed the creases out of it, in an open doorway. Now place your subject in the middle of the sheet and about two feet in front of it, and set the camera in front of the subject.

These preliminaries attended to, turn his or her head so that it will be at right angles to the axis of the lens and then focus it sharp. Now place the floodlights, so that the light, the subject and the camera are all in a straight line, as shown in *Fig. 15.1*, and setting your shutter on *bulb* or *time*, hold it open for about as long as it takes you to say "Oh where are the circles of confusion?" Now close the shutter, turn off the floodlights, and process the film, increasing the developing time 25% to get maximum contrast.

A New Way to Photograph Your Friends

Though the effect is striking, the procedure is quite simple. It involves nothing more than the making of two negatives; one, a simple sil-

Illustrating
A NEW WAY
TO PHOTOGRAPH
YOUR FRIENDS

Photograph
by Leon Arden

houette by the method described earlier; the other, a straight portrait shot. By placing both negatives together in the carrier and enlarging through them simultaneously, you will get the effect shown here.

To be sure that the silhouette is positioned properly, set your camera on a tripod as you take both shots. A twin-lens reflex, or any other ground-glass camera, is best for this purpose, so that you can trace the outlines of head and silhouette to make sure one fits within the other. You can also combine *two* subjects this way.

Pendulographs

Though we use the camera to get these beautiful pendulum patterns, we do not do so in the usual way. All we need is a piece of string about three to five feet long, something to hang it on (what one of my friends calls a *skyhook*), a floor or table on which to rest the camera, and a light source (preferably a vest-pocket flashlight, which has a tiny bulb and therefore makes *thin* tracings, which have much more beauty).

The pendulum itself is the most important piece of equipment. To make straight lines, circles, and ellipses, the simple vertical string is enough. But if you want to make more sophisticated designs, you'll have to have a "Y" suspension with the "V" and "I" segments each about one to three feet long, depending on the height of your hook. A "Y" suspension enables you to have movement in two separate directions, producing patterns that combine both. If the light produces jerky, uninteresting results, you need more weight (almost anything, from metal washers to nuts and bolts, will do).

Since small penlight batteries get used up quickly when run continuously, have plenty of additional batteries on hand.

A reflex camera is better for this purpose because you can see the outside limits of the swing when all other lights are turned off. That way you can adjust everything before you open your lens to start making your *pendulograph*.

Focus on a point between the lens and the light at its nearest distance. And for variety, you can superimpose one tracing on another, by covering the lens for a moment as you start each new swing. You will find that a stop of $f/16$, and an exposure of 60 to 120 seconds, is about right on medium-speed film. Wait until the swing settles down a bit, and is included in your ground glass, before you open the shutter to *bulb* (B) or *time* (T). In the case of bulb, if your camera shutter happens to have only B, the shutter will stay open only as long as the release is pressed down; it will snap shut when you let go. In the case of *time*, one squeeze will open it and keep it open; you have to press it down again to close the shutter.

PENDULOGRAPHS. See text for an explanation of how these pendulum patterns were made. Courtesy of William Farrell and U.S. Camera.

Photograms

This is another method for using the *materials* of photography, without requiring the technique of the camera. You need little more than some print paper, a piece of glass, and your normal darkroom facilities for developing and fixing the print.

As you see from the examples shown, you can use plants, leaves, butterflies, flowers, netting, almost anything that can be made to lie flat, to create a picture. Your enlarger light can be your source of illumination, but you'll have to resort to trial and error to determine your f/stop and exposure time. For a start I'd suggest f/8 at 30 seconds for a chlorobromide paper like Kodak *Opal*.

How to Make Pictures on Cloth, Leather, Wood, Etc.

Here are four ways to sensitize materials other than paper (though paper itself can also be used):

1. *Emulsion in a spray can.* The Dupont Company has announced *Dylux 915* photosensitive aerosol spray. All kinds of material can be photosensitized by coating with this emulsion. No processing is required after exposure. The spray is applied in subdued room light on whatever

PHOTOGRAMS. By placing plants, butterflies, or netting *under* a sheet of plate glass and *over* a sheet of enlarging paper, and using your enlarger as the source of light, you can make beautiful photograms like these. They can then be enlarged or reduced in size, photographically, for use as framed pictures, lamp shades, screens, box covers, or whatever. *See text.* Courtesy E. Scaioni, and Photo Almanach Prisma, Paris.

surface you want sensitized, and allowed to dry. This takes about a minute. A negative or photographic mask is then placed on the sensitized area. After exposure to *ultraviolet light* the negative is removed. All areas exposed to the UV light show an image. Everything else retains the color of the original material. Exposure to normal light deactivates unexposed areas and permanently fixes the image. This process can be hastened by exposing to intense white light.

2. *Aeroprint Spray Developer.* This is supplied in a triple container kit consisting of a *surface agent,* a *developer,* and a *fixer.* A room temperature *above* 65° seems to be the only requisite. Corrections can be made (using only the surface agent and the developer). Not until the image pleases you do you fix it. Neither temperature controls, other than the one noted above, nor messy trays are needed. Washing time is trimmed by a third. The spray does not deteriorate. For more information, write to *Aeroprint Products,* Wharf Way, Glenhill, Glen Parva, Leicester, England.

3. The following formula has been suggested as a sensitizing solution for paper, cloth, wood, etc., by the editors of the *Photo-Lab Index* (published by Morgan & Morgan):

Dissolve in this order:	METRIC	AVOIRDUPOIS
Ferric ammonium citrate (green)	85 grams	2 ounces, 367 gr.
Tartaric acid	14 grams	197 grains
Silver nitrate	35 grams	1 ounce, 75 gr.
Water to make	1000 cc.	32 ounces

Dissolve ingredients separately in water. Mix the *ferric ammonium citrate* solution and the *tartaric acid* solution, then add the *silver nitrate* solution, stirring with a glass rod as you do this. Finally, add enough water to make 1000 cc. (1 liter) or 32 ounces. Store in a brown glass bottle, away from light.

Sensitizing of material (cloth, wood, etc.) can be done in dim artificial light, though a bright yellow safelight is recommended. Dip material in solution and hang up to dry in the dark. A brush or a wad of absorbent cotton can also be used (in the dark, of course). Print in sunlight or strong artificial light, under a normal or contrasty negative (flat negatives produce poor prints). Then wash for about one minute in running water. The result will be a yellow image which will turn to a stable brown if dried in daylight. Fix in *plain* hypo, but remember that hypo reduces image somewhat (so print darker than you normally would). Ironing a print after washing tends to darken image, so keep that in mind also. And use a *warm* flatiron.

4. *For prints on wood,* use this method of sensitizing:

Beat whites of two eggs and let stand for one or two hours, until the albumin is reduced to liquid form. Add enough *zinc oxide* to make a thin creamy liquid. Brush a smooth, *thin* coating on wood. When surface is dry, flow on a small quantity of the following sensitizer:

	METRIC	AVOIRDUPOIS
Silver nitrate	1.6 grams	50 grains
Distilled water	15 cc.	1 ounce

Dry thoroughly in the *dark,* then print under negative in *bright sunlight.* Fix in a 5 per cent solution of *plain* hypo, wash and dry.

To buy the chemicals mentioned above, you can write to any of the following supply houses: Amend Drug & Chemical Co., 83 Cordier, Irvington, N.J. 07111; Studiophot Co., 10322 Carnegie Ave., Cleveland, Ohio 44115; Clayton Chemical Co., division of Apeco, 2100 Dempster St., Evanston, Illinois 60204; Ciba-Geigy Chemical Corp., 449 Saw Mill River Road, Ardsley, N.Y. 10502; Porter's Camera Store, 2002 College Street, Cedar Falls, Iowa 50613; Dignan Photographic Inc., 12304 Erwin St., North Hollywood, California 91606.

Slide, courtesy of E. Leitz, Ltd., of London

16 Slides and Transparencies

Until the arrival of *35mm* color film in 1936, the making and projecting of slides was a messy and costly business. The transparencies were monochrome glass plates, usually 3¼ x 4 inches in size, and the projectors were clumsy, inefficient, and expensive.

The appearance of *16mm* Kodachrome in 1935, and of *35mm* Kodachrome in 1936, followed a few years later by Anscochrome, Ektachrome and all the other color films, brought about a revival of interest in photography in general and the 35mm camera in particular. Color film presented no processing problem since Kodak, Ansco, or their licensed processors, did all the work—and, in the miniature size, it was less expensive, easier to use, and placed at the photographer's disposal the vast and ingenious capabilities of the miniature camera. This was followed by the production of beautifully engineered, efficiently cooled, and inexpensive slide projectors—culminating in those wonderful *automatic* projectors which show 100 slides at one loading (some as many as 140) merely by turning a dial and pushing a button, *and that by remote control!*

We will discuss this new material and equipment later in this chap-

TWO-WAY SLIDE PROJECTOR. *The Rollei Universal Automatic,* designed to show slides of all three amateur sizes, automatically and interchangeably. The projector accepts magazines on both sides, one to hold the 2¼ inch square size, the other to hold the 35mm and Superslide sizes. Has remote control focusing and slide changing; motor drive for focus, forward and reverse; accepts trays holding 50 2 inch square slides, 30 2¼ inch square slides, in all mounts; remote control is standard equipment; uses Rollei, Agfa, Leitz or Zeiss trays; uses 300- or 500-watt DAK-type lamps; is blower-cooled.

ter, and in the next. But for those who still want to make *monochrome* slides, here are some tested procedures. Like any other monochrome negatives, slides can be reduced, intensified, cleared of fog, spotted, colored by tinting (in a solution of dye so that highlights and shadows are colored), colored by toning (in which the chemical solutions replace the silver image, with the result that only the image is colored, the highlights remaining clear), or hand colored. Full instructions for these processes are available in a booklet entitled *Lantern Slides,* issued free by the Sales Service Division of the Eastman Kodak Co., Rochester, N.Y. See chapter 13, "Developers and Developing," for formulas and techniques of *after-treatment of negatives.*

Monochrome Slides

Any negative that would make a good print will make a good slide. It must, however, be free from spots, scratches, and other defects, for these will be magnified on the screen.

HOW TO PRINT MONOCHROME SLIDES

A slide can be made in either of two ways: (1) *by contact,* placing the slide emulsion directly under the negative, emulsion sides facing

each other, and putting both together in a printing frame just as if you were printing a sheet of sensitized paper; and (2) printing it by *projection* with an enlarger, as you do when making an enlarged, or reduced, print. See chapter 14 (*How to make contact prints* and *Projection printing*).

To make a slide by direct contact, the portion of the negative you use must be the same size as the transparency you want (2 x 2, 3¼ x 3¼, or 3¼ x 4).

To make a slide by projection, you can use a negative of any size, provided it fits your enlarger.

As it is much easier and cheaper to make slides by the *contact* method, it is best, if you plan to make many slides, to buy a camera that takes a picture which is the exact size of the slide you plan to use.

DIRECT POSITIVES FROM NEGATIVE FILM

In the 35mm size, you can use Panatomic X, the negative emulsion, and convert it to a direct positive film by processing it in the Eastman Direct Positive Kit. When used this way, the ASA speed jumps from 25 to 80. This b/w transparency can then be mounted or bound between glass like a color transparency.

You can also use Kodak Direct Positive film to make b/w transparencies. It is available only in 100-foot 35mm bulk rolls (enough for 18 36-exposure rolls). This film has an ASA speed rating of 80 for daylight and 64 for tungsten. It can be processed in the direct-positive-film processing kit. You can also use this same film to make negatives by developing normally (9 minutes at 68° F.) in D 23. Furthermore, if you have a transparency on Direct Positive film and want to make a print from it, you can do so by using Kodak Super Speed Direct Positive Paper, which is available in many sizes. It is processed like the direct positive film (developed, bleached, cleared, redeveloped, and fixed).

EXPOSURE IN CONTACT PRINTING
OF MONOCHROME SLIDES

The trial-and-error method of determining exposure when making slides may be sure, but it is also time-consuming and costly. A more efficient way is to find the correct exposure for *one* negative and then to use that, with the aid of an electric exposure meter, to give you the correct exposure for other negatives.

The method is quite simple. First you place a "normal" negative in position on the contact printer, set the meter over a representative sec-

tion, turn the light on and note the meter reading. Then, by trial and error, expose and develop a series of plates until you get the best result possible. The exposure time for that "normal" negative is then marked beside its meter reading. The same procedure is carried out for a "thin" negative and also for a "dense" one. With the meter readings for each of these now recorded, it should be quite easy to calibrate all the intermediate exposures for negatives of varying density.

How to Develop the Slides

You can use almost any of the popular negative developers to process slide *plates*. It is best, however, to use whatever the manufacturer suggests in the instruction sheet packed with the plates. If, for any reason, that is not possible, here are some good developers you can rely on.

The most convenient one to use is Versatol solution, diluted about 1:3. The development time is from 1½ to 3 minutes at 70° F.

Another good one that you can buy already compounded is Dektol. For slides it is diluted 1:2. Develop 1 to 3 minutes at 70° F. For greater or less contrast, dilute to suit.

To develop the plate pour the developer into a tray and slide the *dry* plate into it. (Your darkroom is illuminated, of course, by a green-yellow Wratten OA safelight.) Don't wet the plate in advance. If any air bubbles form on the surface, you can remove them by touching them with your finger. The temperature of the developer should be 70° F. If the negative is properly exposed it will develop in from one to five minutes, depending on which developer you use. If you prefer to mix your own, try this one. Dissolve chemicals in the order given.

FOR WARM BLACK TONES

D 32	METRIC		AVOIRDUPOIS
Stock Solution A:			
Water (125° F.)	500	cc.	16 ounces
Sodium sulphite, *dry*	6.3	grams	90 grains
Hydroquinone	7	grams	100 grains
Potassium bromide	3.5	grams	50 grains
Citric acid	.7	gram	10 grains
Add cold water to make	1000	cc.	32 ounces
Stock Solution B:			
Cold water	1000	cc.	32 ounces
Sodium carbonate, *dry*	30	grams	1 ounce
or, Sodium carbonate,			
monohydrated	35	grams	1 oz., 70 gr.
Sodium hydroxide			
(caustic soda)	4.2	grams	60 grains

Caution: Cold water should always be used when dissolving caustic soda because it generates considerable heat; if hot water were used the solution would boil up with explosive violence and cause serious alkali burns. Stir solution B when adding the caustic soda, otherwise heavy caustic solution will sink to the bottom.

For Use: Take 1 part A and 1 part B. For still warmer tones, 1 part of A and 2 parts of B. Develop for 5 minutes at 70° F.

See chapter 13 for other developers. Keep in mind, however, that they should be diluted when used with slides, as is Dektol, above.

UNDEREXPOSURE AND OVEREXPOSURE

You can easily tell whether you have *under-* or *over*exposed the plate almost as soon as you have put it into the developer. If it is underexposed, the image will appear very slowly, and this is your cue to add more full-strength stock solution to the developer tray or transfer the slide carefully to a tray of more concentrated solution; on the other hand, if the image appears very quickly, add water to the developer, or slow up development by shifting the slide to another tray with plain water or dilute developer.

While underexposed slides can be intensified, and overexposed slides can be reduced, it is better to perform these operations while they are in the process of development.

How to Fix, Wash, and Dry the Slides

When the slide is fully developed, soak it in water to rinse off the developer and then fix it in an acid fixing bath which is made up as follows:

THE FIXING SOLUTION

	METRIC	AVOIRDUPOIS
Hypo	240 grams	8 ounces
Water to make	1 liter	32 ounces

When the hypo is thoroughly dissolved then add the entire amount of the following hardening solution. Dissolve in the order given.

THE HARDENING SOLUTION

	METRIC	AVOIRDUPOIS
Water (125° F.)	160 cc.	5 ounces
Sodium sulphite, *dry*	30 grams	1 ounce
Acetic acid, 28 per cent	96 cc.	3 ounces
Potassium alum	30 grams	1 ounce

If you prefer a *stock* hardening solution, use the Kodak Liquid Hardener, 1 ounce in each 16 ounces of hypo solution, or make up the following, which is used in the same way:

STOCK HARDENER

	METRIC	AVOIRDUPOIS
Sodium sulphite, *dry*	45 grams	1½ ounces
Acetic acid (28 per cent pure)	500 cc.	16 ounces
Potassium alum	60 grams	2 ounces
Water to make	1 liter	32 ounces

Add two ounces of this stock solution to the hypo solution, and then dip the developed slide in it. You can tell when the slide is fixed by looking at the back of it and noting when the milky color disappears. The slide should be left as long again in the fixing bath to make sure that it has been permanently fixed.

After the slide is fixed, either wash it in running water of about 70° F. for fifteen minutes or in half a dozen changes of water of the same temperature. Then wipe the surface with a moist piece of absorbent cotton or chamois, to remove the particles of dirt and water. *Gently does it;* the emulsion side is still very tender, so take it easy when you rub; and don't leave cotton lint on it. Finally, put the slide in a rack to dry, away from any air currents that might blow dust on the vulnerable emulsion surface.

How to Improve the Slide

BY INTENSIFICATION

If the slide is too thin, it can be intensified with the following *acid-metol-silver* intensifier:

DR. MEES' INTENSIFIER

Dissolve in this order:	METRIC		AVOIRDUPOIS	
Solution A:				
Metol	9	grams	140	grains
Glacial acetic acid	45	cc.	1½	ounces
Citric acid	18	grams	280	grains
Water	1	liter	32	ounces
Solution B:				
Silver nitrate	42.5	grams	1½	ounces
Distilled water	1	liter	32	ounces

When you are ready to intensify the slide, take

Solution A	15 cc.	½ ounce
Solution B	± 1 cc.	10 to 20 minims
Warm water (80° F.)	15 cc.	½ ounce

These solutions must be mixed immediately before using and the slide put into them *dry* for one-fourth to one and one-half minutes. It must then be washed in running water of about 70° F. for a minute, again put in an acid fixing bath for five minutes, and washed.

BY REDUCTION

If the slide shows too much contrast, it can be reduced; and if a little fogged, it can be cleared by immersing it in a weak solution of the following *hypo-ferricyanide reducer*.

FARMER'S REDUCER

	METRIC	AVOIRDUPOIS
Solution A		
10 per cent of plain hypo	30 cc.	1 ounce
Solution B		
10 per cent solution of		
potassium ferricyanide	30 cc.	1 ounce

Add enough of the *A* solution to the *B* solution to make it lemon-colored. Let the slide remain in the reducer for a minute or so and then wash. If any great amount of either intensification or reduction is needed, it is better to discard the slide and make a new one.

How to Protect the Slides

The slide should now be covered with a protective coating to keep it from absorbing moisture in damp weather. (This moisture is released by the heat of the projector.) Kodachrome transparencies are delivered with such a lacquer coating.

A varnish or lacquer for this purpose can be bought ready-made in any photo supply store. Kodak makes one called Kodalak WP Clear. There is also a Kodalak Thinner, to dilute the solution when it thickens. You can also get plastic or lacquer solutions that are packaged in convenient spray cans. It's a good idea to spray the slide first with an anti-static solution like Edwal Anti-Static Film and Glass Cleaner, or Anti-Stat 6, made by Braun Laboratories, Philadelphia 19107. This eliminates static from color film, b/w film, plastics and glass—and it dries rapidly. You spray it on, and then wipe it off, thus removing dirt, dust, finger-marks, etc. *Caution:* Some of these sprays should not be used on color film because they may destroy the dyes. *Test, first, on discarded film.*

MASKING SLIDES

The next step is to put a paper *mask* on the film side of the slide. The opening of the mask must be of the shape you want the picture to appear on the screen and this is usually rectangular, oval or round, as shown in *Fig. 16.1.* You can either cut your own masks out of a sheet of black paper or buy them already made. It is better to buy the ones ready-made for they are accurate and clean-cut, with the openings exactly in the center.

After you have selected the mask you want and put it on the slide, you should place a small white sticker, made for this purpose, on the lower left-hand corner so that you will know the right way to put it into

FIG. 16.1. MASKS FOR SLIDES

the projector (the sticker will be on the upper right-hand corner, with the image upside down).

BINDING

The final operation is to put a *cover glass*, which is simply a thin sheet of perfectly clear and clean glass of the same size as the slide, on the film side over the mask. The slide and cover glass are then bound all around the edges with a strip of black tape coated with adhesive. When this is done your slide is ready for use.

The Polaroid Slide System

Dr. Edwin H. Land of Polaroid is the father of so many photographic innovations, it is not surprising that he has worked out an ingenious slide system for instant projection as well. First announced in 1957, this Polaroid system for monochrome transparencies now encompasses two continuous-tone transparency emulsions with an ASA speed rating of 800 (Type 46 for the 2¼ x 2¼ inch size, and Type 46L for the 3¼ x 4 inch size), and a high-contrast line-copy transparency (Type 146 for 3¼ x 4 inch size, with an ASA speed rating of 120). These are reversal films that are virtually grainless, even when blown up to wall mural size. After a two-minute development in the camera in the conventional Polaroid manner, the transparency is removed from the camera and dipped into a plastic leakproof container to harden the emulsion in *Dippit* solution. The transparency can then be easily and quickly mounted in special plastic mounts.

A Polaroid projector of unique design is also available which makes it impossible to project slides upside down or backwards when using the Polaroid plastic mounts.

The Polaroid Land Projection film can be used in any of the *roll film* Polaroid cameras (except the J66). No equivalent of Type 46L continuous-tone transparency has been released for *film pack* cameras.

There is not, as yet, any *color* transparency available for direct use, but if you send any of your Polaroid color *prints* to the Polaroid Corporation at 730 Main Street, Cambridge, Mass. 02139, with instructions and your address, they will make 2 x 2 inch *slides* from your prints for use in your 35mm slide projector. Your dealer will know the current price for this service.

Slides in Color

As we pointed out at the beginning of this chapter, the appearance of Kodachrome in 1935 started a revolution in photography. Color slides,

mounts, binders, 35mm cameras, projectors and screens—all suddenly became big business. This was followed by the release of Ektachrome and Anscochrome in various sizes, including the 120. Since the best projectors were those made for 35mm film, it was only natural that someone should eventually come up with a practical method for making slides in 120 size cameras that could also be shown in the 35mm projectors.

The first solution to this problem was the Rolleikin adapter for Rolleiflex and Rolleicord cameras. This permitted the use of 36-exposure cinefilm (the kind used in all 35mm cameras) in Rollei cameras. But this had many disadvantages, not the least of which was the fact that the resultant slides were always vertical pictures.

SUPERSLIDES

A better solution was the invention, by Frank Rizzatti of Burleigh Brooks (then the distributors of Rollei products) of the *Superslide*. This is a supersize color slide that can be made in any reflex using 120 size films. By using a 38 x 38mm film-gate and viewing-screen mask, you can make a 2 x 2 inch slide that is completely interchangeable with the standard 35mm slide—*and you produce it with the regular 120 size film.* The field angle for *Superslides,* if you have a 75mm lens (as in the Rolleiflex) is 39°, as compared with 50° for the picture area of a regular 2¼ x 2¼ inch slide. That means you get a slight telephoto effect with the *Superslide.* This, together with the fact that you get a picture that is 85% larger in area than that of a 35mm slide, makes the *Superslide* projections on a screen seem spectacular. See *Fig. 16.2.*

The success of the *Superslide* has had two other good effects: it has persuaded Kodak to release Ektachrome in the 127 size, which is the

FIG. 16.2. Comparison of 35mm slide area (dotted lines) with 38 x 38mm *Superslide* area (inner rectangle with rounded corners). Outside size of both slides is, of course, the same.

Superslide size (38 x 38mm) without waste; and it convinced Franke & Heidecke to reissue the 127 size "baby" Rolleiflex in a vastly improved model. Unfortunately, a slanderous report from a consumer testing organization (*which was subsequently reversed*) put this beautiful little camera on ice (temporarily, we hope). Also, though it is still around, 127 film has been giving way to the 126 28 x 28mm Kodapak Instamatic slide format in recent years.

A kit similar to the *Superslide* has been introduced by the FR Corporation for other cameras, notably the Minolta Autocord, Yashica, Accuraflex, Ikoflex, and others. HPI has also released a Master Kit for *Superslides* that can be used with either *single-* or *twin-*lens reflex cameras. For the Hasselblad single-lens reflex there is the 16 Roll Film Magazine which produces 16 *Superslides* on a single roll of 120 film. The new magazine back actually makes an oversize *Superslide* (45 x 60mm). Hasselblad does not make any mounts of its own.

If the kits are not available, a template can be made from Fig. 16.2, page 452, to mark and cut your transparencies for *Superslide* mounts. Check your dealer for what's currently available.

HOW TO MAKE SURE OF GOOD COLOR SLIDES

It is no great trick to get perfect results if, like the professionals, you expose your film indoors under controlled lighting conditions and then develop it yourself under ideal darkroom conditions. But if you're an amateur, that's another story. Laboratory developing is often whimsical, if not uncertain. And the manufacturer may have altered the film a bit—not much, but just enough to confuse both the exposure and the processing. Result: no picture. Take a tip from a very successful amateur, Jack A. Goldsack, who has won more awards and honors in photographic contests and exhibitions than many in the field. His method is quite simple. He makes at least three exposures of every color shot he feels is worth taking: one according to the meter reading; another at one stop *above* that reading; and, finally, one at a stop *below* the meter reading. This not only protects you against errors in exposure or processing, but intentional *over-* or *under-*exposure often produces a better, more dramatic slide. If the picture you're trying to capture is especially *important*, take five exposures; four of these can be in half-stops, two above and two below the meter reading.

A HINT FOR TESTING COLOR EXPOSURES

By using Panatomic X as an alternate for Kodachrome II D, and shooting both at ASA 32, you can tell without delay whether your color

exposures are going to come out all right. Panatomic X can be processed at once, and at home. One look at the negatives and you'll know whether you have to retake your color shots. This method was devised by Arthur Rothstein, Director of Photography for *Look* magazine. He worked it out originally as a way of teaching photography to correspondents (*in from three days to two weeks!*). A full report appeared in *Popular Photography*, March 1957, if you hold on to back issues.

SPOT-TINTING COLOR TRANSPARENCIES

If it becomes necessary to spot-tint your color transparency, the best method involves the use of transparent dyes, like those made with discontinued *Flexichrome,* the dyes for which are still available. These should be diluted in an acetic acid solution (about 2 cc. of 28% acetic acid per quart of water). If you have to do this on Kodachrome, remove the lacquer first by using a 1% solution of sodium carbonate. Before you attempt this, get a copy of *Storage and Care of Kodak Color Films* from the Sales Service Division of Eastman Kodak, Rochester, N.Y. You'll find complete details there on how to remove lacquer from Kodachromes. See also *Hibadye,* in the index.

HOW TO MAKE COLOR TRANSPARENCIES FROM KODACOLOR NEGATIVES

Normally, Kodacolor X being a negative emulsion, it is used to make color *prints.* But it is easy enough to make a color transparency by using Ektacolor Print *Film.* This material was designed for use with *Type S* Ektacolor film, which produces negatives like Kodacolor, but excellent transparencies have been made on it with Kodacolor negatives as well. It requires care in processing, but is well worth trying. See page 518 for a list of recommended books and pamphlets on color photography.

HOW TO MOUNT AND BIND COLOR SLIDES

The simplest way to project color slides is in the glassless cardboard mounts similar to those used by Kodak for Kodachrome 35mm transparencies. The trouble with these is that the slides pop or buckle in the projector (due to heat) and they are not protected against dirt, dust, moisture and mishandling. There are also many *plastic* mounts now on the market, with and without glass. Especially recommended are the glassless *Clark Plastic Slide Mounts,* which come in *all* sizes. The 2 x 2

size fits the Carousel 140 without jamming. These are preassembled, ultrathin, reusable mounts, made of two pieces of plastic (dull black and dull white) between which the film is cleverly slipped and held flat without heat or adhesives. For information, write to Photo Plastic, Intl., Culver City, California 90230. They are available from Treck Photographic, 1 West 39th Street, New York, N.Y. 10018, from Porter's Camera Store, 2002 College Street, Cedar Falls, Iowa 50613, and from other camera supply houses.

Also highly recommended are the Swedish System *Gepe* glass mounts. These are preassembled, superthin, reusable plastic mounts which offer two *anti-newton* ring features (see index and glossary, *Newton Rings*): 1) thin metal masks that are preset on the inside faces of the slide, to keep the emulsion from touching the glass; and 2) in the case of the larger (2¼ inch square and Superslide) sizes, glass that is fine-grained on one side, thus acting as a newton ring preventive when the grained side faces the polished emulsion surface. There are 15 sizes to choose from (in the 2 x 2 to 2¼ x 2¼ inch outside dimension). The cost is within range of other mounts not nearly as well made. The slides can be opened easily by running a thumb nail or thin knife blade around the edge. *Caution:* To avoid binding and jamming, do not use in Carousel 140, which needs the glassless mounts. For more information write to Mr. Herbert Peerschke, H. P. Marketing Corp., 98 Commerce Road, Cedar Grove, New Jersey 07009.

You'll want to keep your best slides, however, in glass mounts. These can be bound with tape, as with the Leitz Bindomat (though you can also do this by hand), or you can use any of the many metal-and-glass or plastic-and-glass ready mounts now on the market. Two particularly good ones are the Lindia all-plastic mounts and the all-metal Leitz Pro-Color push-together binders, which can be sealed with the Leitz Proloc crimping device.

HOW TO PREVENT NEWTON RINGS

You first met these colorful little monsters when you started to enlarge your negatives and a condenser surface came into contact with the film. There are two simple and effective methods of eliminating this nuisance in glass-mounted slides: 1. Use the Leitz *Pro-Color* (or Agfa *Dia* K) mounts with their thin foil masks which keep the film from touching the glass, or 2. Use the *Lindia* mounts with the *Newlo* glass (Karl Heitz). The glass has a specially etched surface just rough enough to eliminate the rings, but the roughness does not show up on projection. (See index and glossary, *Newton Rings*).

HOW TO SHOW COLOR SLIDES

The best way, of course, is with one of the modern slide projectors, of which there are many now on the market. Most of these, quite naturally, are made for the 2 x 2 inch (35mm, Instamatic, and Superslide) sizes. But there are some fine projectors that will not only take care of these but of the 2¼ inch square size as well. Among them are the *Rollei Universal*, the *GAF Zoom Lens Automatic* (with 4 loading systems), the *Realist 620* (with an adapter), and the *Honeywell 650* (which takes all sizes, from 35mm, Superslide, Bantam, Robot, Type 46 Polaroid, split 2¼ inch, to full 2¼ inch square).

Below are shown some of the slide projectors now available. Other good ones worth investigating are the *Nikkormat*, which offers a choice of rotary trays, straight trays, or no trays at all, as you prefer; the *Argus*, available in four models; the *Revere 808;* and the *Honeywell Preview Projector*, which accepts 120 capacity *round* and 40-slide *straight* trays (it is *self-focusing,* has a 500-watt Halogen Quartz lamp, reversible motor to prevent jamming when metal slides are used, a preview editor, a built-in timer; and there are 16 models to choose from).

THE KODAK
CAROUSEL 860

An automatic *rotary* tray projector that provides some unusual features. Uses all 2 x 2 inch sizes (35mm, Superslide, Instamatic, etc.), has *autofocus* and *remote* controls; spillproof 140 slide tray; Halogen Quartz lamp; 500-watt power; $f/2.8$ lens (as well as a complete range of other lenses). This model of the *Carousel* offers a unique system for focusing. The first slide is carefully focused by hand; thereafter, the internal gadgetry takes over and, with a soft purring sound that's almost inaudible, each slide is focused perfectly, most of the work being done during the blackout as the slides change. The secret is in a beam of light that hits a cadmium *selenide* cell; the light is thrown through an infrared filter and onto the transparency. The cadmium selenide cell responds to light 10 times faster than a cadmium sulfide cell. If the exact angle of reflection is altered by *popping* (the bellying out of the film due to heat), the lens is moved back or forth until the focus is corrected, *and all this in a fraction of a second.* For editing or previewing, there is a compact and convenient *stack loader* which fits this model and most of the earlier ones; it holds 40 cardboard or thin plastic mounts, and it is used in place of the regular tray.

THE GAF ZOOM LENS
AUTOMATIC SLIDE PROJECTOR

This is the 737Z, with a zoom lens that enlarges your slides as much as you wish at any distance, a Halogen 500-watt lamp, and four different loading systems (two circular trays, one straight tray, and a stackloader). Automatic operation includes remote control forward and reverse, and a variable slide-changing time cycle.

THE BELL & HOWELL
SLIDE CUBE PROJECTOR

Offers convenience in storage: cube cartridges that hold 40 slides (with a capacity of 640 slides in the same space a round tray stores 140). With a 500-watt (50-hour life) Halogen Quartz lamp for true color rendition. The projection lens can be raised or lowered independently of the body; has automatic electronic focusing for perfect screen sharpness. Among its other features are preview editing, remote control, drop-in loading, a slide ejector, a slide recall; and some models are prewired for sound (synchronizing with any tape recorder by use of the *Audio Cube*). Zoom lenses are optional, but remote extension cord is standard.

LEITZ PRADOVIT COLOR
AUTOFOCUS PROJECTOR

Fully automatic for all 2 inch square slides (35mm, Superslides, etc.). *Pushbutton* control or *remote* control for slide changes (forward and reverse) and focusing. Built-in interval timer. Magazine loading for 36 or 50 slides. Built-in transformer for 24v/150w Halogen Quartz lamp with new type of small filament and high color temperature. Remains cool, preventing card-mounted slides from "popping" out of focus (bellying out because of heat). The lamp's narrow cone of light gives high depth of focus, perfect overall definition. Has an aspherical condenser. Can also accept impulses from tape for tape-and-slide presentations. Hard plastic cover serves as projector stand or demonstration screen.

PROJECTION SCREENS

To show your slides effectively, you need something better than a wall (even if it has no cracks) or a bedsheet (even if it has no creases). What you want is a good projection screen, at least 40 inches square, that unrolls smoothly on a sturdy, lightweight tripod.

When considering screen surfaces, think in terms of *brightness, angle-of-view,* and *contrast.* These three variables usually are interrelated. The brighter the screen, the narrower the audience angle (the positions from which people can view the screen) and the greater the contrast (when contrast is low, the pictures are hard to see). The contrast is especially important if you are planning to have more than just a few people in to see your slides.

There are three popular screen surfaces, each with a special advantage coupled to a limitation. In order of descending brightness, the surfaces are:

Silver lenticular. This is the recommended surface. It gives the brightest picture, best contrast, maximum clarity, and minimum grain; it even works well in partially lit rooms. Moreover—and this is its particular advantage—the silver lenticular screen can be viewed from almost any angle. *But beware:* some lenticular screens have *hot spots* (places where the projector light is not diffused evenly). Before you buy a lenticular screen, test it with one of your own slides.

Glass beaded. A good surface for darkened rooms, the glass beaded screen offers moderate contrast and medium-wide audience angle; when viewed at wide angles, it shows more brightness fall-off than the other surfaces.

Mat white. This is a lightly embossed dull vinyl surface that works well where a wide audience angle and image detail are more important than brightness.

How to tell whether a projection screen is worth buying:

1. Is it easy to set up and take down?

2. Is the spring-loaded extension rod dangerous (*i.e.,* will it poke your eye out unless you're extremely careful)?

3. Does it show your slides clearly and brightly?

4. Is it free of wrinkles and other surface imperfections that may spoil the image? (Remember to make sure of this before you take it home.)

5. Can the maximum number of people see your slides comfortably and without strain—or will everyone have to huddle within 15° of the screen-projector axis?

6. Can the rolled screen be carried easily?

A lens resolution chart that can be used for testing camera and projector lenses.

17 What's Wrong?

Sooner or later in his camera career, every amateur runs into the same ditch. When that happens, he usually asks himself: "Why must this happen to *me*? One day everything seems to be going well; the next day everything's in a mess. *Why*?"

It isn't always easy to answer that question. Yet it is terribly important to track the trouble to its source lest it sour your pleasure in photography. If you're bothered by film scratches, it may be the camera; but then again, it may not. Your film cartridge may be at fault. Or you may be placing an oily finger (unsuspectingly) on the emulsion (which oil gets transferred to the pressure plate and becomes a trap for stray dust or dirt).

If your pictures are not sharp, it may be the lens. But then again, it may be nothing more than hand "shake" or a badly constructed tripod. If your negatives are underexposed, especially when you use a filter, it may be the exposure meter, or the shutter, or the developer. But more than likely it's none of these. You're simply using the wrong filter factor.

If your negatives are sharp (by inspection with a 10x or 20x pocket magnifier) and your prints are not, it may be your enlarger, or the lens.

But it probably is neither. More likely, your negative buckles (from too much heat, *after* you've focused sharply) or your light source has too much red-yellow light and you're having *visual-chemical image* trouble (which can be corrected to some extent by the use of a heat-proof blue glass to intercept the heat rays). It may even be the kind of paper you are using. If you've been using a mat or semimat paper, shift to a semi-gloss stock like Kodabromide N, Ektalure K, Opal B, or Polycontrast N, and you'll note an immediate improvement.

The purpose of this chapter, then, is to point out a few of the things that may go wrong, things that you might otherwise overlook, and to give you a few ideas on how you can do your own testing all along the line.

Checking Your Camera

The only piece of equipment you need for this purpose is a *test chart*. You can make one up yourself. It consists of a step wedge (made by exposing a piece of print paper in successive steps of a geometric progression such as 1 second, 2 seconds, 4 seconds, 8 seconds, etc.; this is used to check against exposure and processing, since a loss of certain of the steps in reproduction indicates a fault in exposure or development); an area ruled off with varying spaced fine pen lines; some pure color swatches of blue, red, and yellow; and some assorted curves and circles, all mounted flat on a card.

An easier way, perhaps, is to get a ready-made test chart. The plate on page 461 shows how one looks. If you can't get one of these, make up one of your own, or send $2.00 (price may be more when you read this) to the Superintendent of Documents, U.S. Government Printing Office, Washington, D.C. 20402, and ask for NBS Circular 533 (Method for Determining the Resolving Power of Photographic Lenses). You will get an excellent 27-page explanatory booklet, well illustrated, and a supplement consisting of two sets of two resolution test charts (high and low contrast) printed from intaglio plates that are engraved and reproduced the way postage stamps are made.

Other good lens test wall charts are made by Morgan & Morgan and by Paterson (*Optical Test Target*), and one used to be available on request from Dr. Schleussner's *Adox* plant in Frankfurt, Germany (*Resolving Test Object after Horst Blüm*), a reproduction of which is shown here. If you want to copy this, do so with your best lens and your camera on a tripod. Use a median lens opening (about $f/8$), a speed of at least 1/100 second, focus carefully, and bracket your exposures for depth of focus as well as for intensity of light, to be sure of getting the sharpest possible negative.

A LENS TESTING CHART. This one is available from Morgan & Morgan, Inc., Hastings-on-Hudson, N.Y. 10706. It is printed in four colors on a 20 x 30 inch special paper, rolled unfolded, in a heavy tube.

THE XEROX TEST CHART
See the text (next page) for a description of how you can get one of these and how to use it.

Adox *Resolving Test Object*, after Horst Blüm.

If your office uses a Xerox duplicating machine, or if you know someone who does, you may be able to persuade him to get you one of the Xerox test charts (page 461). It is used to check the Xerox machine, but you can use it to test your lens, your camera, your enlarger and your slide projector. Set it up on a board or wall, plane-parallel to the film. Fill your negative with the chart, to get as much of it in as you can. Then follow the procedure suggested in the paragraph below. Develop your film (preferably a slow emulsion like Panatomic X) in fresh Microdol X, diluted as directed for greatest acutance. Finally, make a perfect print and examine it carefully.

This is the way you use a test chart. First hang it up somewhere as if it were a picture you were going to copy. Illuminate it evenly; place your camera about 10 to 15 feet away, on a *sturdy* tripod; load it with the finest-grain film you can get for your camera. The reason we want a fine-grain film is to be sure that any loss of definition is not due to the film. This eliminates one known factor, which makes it that much easier to track down the cause of any trouble.

Now focus sharply upon the very fine lines. Take this series of exposures:

Top: Another pattern that could be used for lens testing.

Left: The Paterson Optical Test Target. This is just one segment of the entire chart. It is repeated 63 times in checkerboard fashion in black, gray, and three colors. It measures 26 x 28 inches, and is shipped rolled, unfolded, in a heavy mailing tube with a most comprehensive instruction manual. The chart was designed by *Geoffrey Crawley*, editor of the British Journal of Photography, and inventor of the *Acutol* and *FX18* developers. It can be bought from Wallace Heaton, 127 New Bond St., London WIY OAB.

1. Lens wide open: normal exposure (preferably by meter), then half normal, and twice normal.

2. Lens stopped down about half way (about $f/8$ for an $f/3.5$ lens): repeat normal, half-, and twice-normal exposures.

3. Lens stopped way down ($f/11$, 16, 22, or 32, depending on your lens): repeat normal, half-, and twice-normal exposures.

4. Place a filter over the lens, the one you normally use indoors. For pan film this usually is the light green, Wratten X1, or perhaps the yellow-green, Wratten K2. Note the filter factor you ordinarily give, then use that exposure for one shot, snap another at half, and a third at twice.

That makes 12 exposures which, if you're using a film pack or a 120 roll film, completes your exposures for the moment. Develop this film according to the directions given by the manufacturer; fix, wash, and dry it in the usual way, and then examine it carefully with a 10x or 20x magnifying glass, or, better still, make a series of test enlargements. These are some of the things you'll learn:

1. *Your Lens.* You'll find out if the lens works best wide open, or stopped down; whether it has astigmatism, coma, or any of the other aberrations; whether your rangefinder (if that's what you used to focus with) is correctly synchronized to the lens.

2. *Your Exposure.* A glance will tell you if you muffed the exposure. If you *underexposed*, two or more of the dark steps of the wedge will be merged into *black*. If you *overexposed*, the lightest parts of the step wedge will run together into *white*.

3. *Your Developing.* If you haven't developed the film long enough, you'll see each step of the wedge distinctly, but the whites will be gray and the blacks will be gray. If you've overdeveloped, the white steps of the wedge will become quite dense in the negative, though the dark ones will remain almost transparent.

4. *Your Printing.* The tests for printing and enlarging are similar to the others made above. If the negative is sharp and correctly exposed, then the cause of your bad prints can be checked right at the enlarger. In the same way you can also check your print-developing methods.

SOME TYPICAL TEST PATTERNS. The one at the top, *left*, was used to test the ability of fast film (*vs.* slow film) to record *detail*. The two smaller reproductions show what happened: the *top* right was how it was seen by *slow* film; the *bottom* right, by *fast* film. Note the larger blur in the center when fast film was used. The test pattern used is known as the *Siemens Star*. The hexagon pattern is the *Schumann Hexagon*. The two at the bottom right are portions of the National Bureau of Standards test patterns, available from the Superintendent of Documents. Ask for Circular 533 and Supplement. Cost is $2.00.

5. *The Filter.* If your factor was high, the filtered shots will be overexposed; if low, they will be underexposed. You will also be able to tell whether the filter affects the sharpness of the lens, and how it alters the color response of the film.

6. *Paper Contrast.* If the negative is normal and the print shows the wedge steps at both ends running together with almost no grays, you are using too *hard* a paper. Conversely, if there are no blacks or whites and the entire wedge is an unhappy looking series of dull grays, your paper is too *soft.*

That isn't all the test chart will reveal, of course, but this much will at least give you an idea of the technique involved. Other tests that can be made with this chart include:

1. Tests for resolving power
 a. Depth of field
 b. Effect of supplementary lenses
 c. Characteristics of emulsions
 d. Breakdown due to grain size
2. Rectilinear lens field
3. Flatness of field
4. Astigmatism
5. Chromatic aberration
6. Spherical aberration
 a. Coma
 b. Zonal aberration
7. Exposure
 a. Film sensitivity
 b. Checking exposure meter. (Send also to Kodak Sales Service Division at Rochester, N.Y. 14650 for a *free* leaflet on *How to Check Your Exposure Meter and Camera.*)
 c. Lens-shutter efficiency
8. Developers
 a. Optimum time and temperature
 b. Comparative *gamma* (a measure of contrast)
 c. Comparative developer tests. After checking the recommended developer, try one of your own choosing. The best way is to repeat a set of exposures *twice* on one roll, then cut the film in half and develop each section separately. What you learn from this kind of test is worth all the time, effort and materials it takes.
9. Papers
 a. Sensitivity
 b. Contrast grade
 c. Exposure
 d. Developing time

Checking Your Enlarger

If your prints are not as sharp and clear as your negatives indicate they should be, your enlarger lens may be suffering *chromatic aberration, curvature of field, spherical aberration,* or perhaps a few other things. Here's how you can find out. Make a negative from the diagram shown in *Fig. 17.1.* Try to fill as much of the negative as possible. Stop down to be sure every part of it is in focus, underexpose the negative a trifle and overdevelop it to get the maximum contrast (the fine-grain pans are better for this purpose than the others) and then fix, wash and dry it in the usual way. The result will be a projection tester, by which you can check the accuracy of your focusing. But it can also be used in other ways:

1. To check *chromatic aberration*, focus carefully, stop down to about $f/8$ or $f/11$ and make a print. If it's uniformly unsharp all over, and none of the lines or curves seem otherwise distorted, the lens probably has that fault. Try printing through a green or yellow-green filter (which will cut out some of the offending rays) or have your dealer get you a piece of heat-resistant blue glass to fit your enlarger. It is usually placed above the condensers or, where there is one, in the filter drawer, as in the Omega D enlargers, for which a rectangular glass, #473-103, is supplied as an accessory.

Perhaps because of more efficient design, or the use of *cold* light sources, some modern enlargers no longer need the help of heat-absorbing glass. However, for all other enlargers, heat resistant glass in blue, blue-green, or in clear or frosty white, is still helpful, and may be necessary. It is available as follows:

Simmon Omega enlargers; 4¾, 5, and 6½ inch diameters, at about $5 each; order by catalogue #473-106 and by size, from your camera dealer, or directly from Simmon Omega, Inc., 25–20 Brooklyn-Queens Expressway, Woodside, N.Y. 11377.

Corning Glass Corp., Consumer Products Division, Corning, N.Y. 14830. Heat resistant glass for photographic use available in rough flats, code #4602.

GAF Corporation, Consumer Products Division, 140 W. 51 Street, New York, N.Y. 10020. Glass available in various sizes, though it is difficult to cut to size and needs heat treatment. While they have such glass in stock now, they do not plan to restock.

Arkin-Medo, Inc., 30 E. 33 Street, New York, N.Y. 10016; they have in stock, or can get, cut flats (round or rectangular) for most enlargers.

Edmund Scientific Co., 300 Edscorp Bldg., Barrington, N.J. 08007. (Send for free catalog of these and other photo products and accessories.)

Pittsburgh Plate Glass Co., Forge City, Pa. They still have some of

FIG. 17.1. AN ENLARGER FOCUSING TESTER
(Make a copy for your enlarger)

this glass in stock, though it will be discontinued when present stock is exhausted.

United Lens Co., South Bridge, Mass. (Mr. Joseph Tiberii); molded lens flats, made to size with extra lip to be ground down to fit. Expensive if ordered in single units.

2. To check *curvature of field,* focus carefully in the center (with the lens wide open) and notice whether the corners are sharp. Now focus

so that the corners are sharp and notice whether the center is sharp. If one or the other is unsharp, your lens does not have a flat field. The worst offenders in this regard are regular camera lenses used on the enlarger; having been corrected for infinity, they do not work as well at close distances. It is better to get a regular *enlarging* lens (like the EL Nikkor, the Componon, the Enlarging Ektar, the Omegaron, the Rodagon, or the Componar). Such a lens has been corrected for close-ups and has a flatter field. The correction for curvature of field is to stop down until edges and center are all in focus. Make a series of tests to determine at what point this is true for your enlarger (it will vary, of course, with the distance, but since the majority of your prints are made about the same size, this variation will not be serious).

3. To check *spherical aberration,* focus carefully with the lens wide open. Assuming that your lens is otherwise okay, you will have no problem in regard to flatness of field and can therefore leave the lens open. Make a print. If all the lines have a gray edge around them, the lens has not been corrected for spherical aberration. The only cure (outside of replacing the lens with a better one) is to stop down until this fault disappears. The point at which this happens can only be determined by making some test prints at various apertures (and marking them on the back before placing them in the developer). After the prints have been fixed, washed and dried, examine them, select the one that looks best, and then use the *f*/aperture indicated on the reverse side.

4. To check *vibration,* place a shallow saucer filled with some water or ink on the easel, focus on the surface of the liquid, and then watch the reflection of the image. Do all the things you ordinarily do around the enlarger when you make a print and watch what this does to the surface reflection. If there's an unusual amount of vibration you'd better do something about it. If the problem stumps you, call or write to Mr. Tuthill Doane of Target Enterprises, P.O. Box 672, Westbury, N.Y. 11590. He will probably be able to work something out for your particular case.

Checking Bellows for Light Leaks

If your negatives are light-fogged, show uneven densities, have a veil or fog over the whole image area, the bellows of your camera may have begun to leak light. If it only happens occasionally it may mean that the holes are deep within the leather folds and are exposed only when the bellows are extended or pushed out of shape. Examine the outside surface carefully for obvious holes and thin spots, and if none are found remove the back and put a lighted bulb inside the bellows (with the camera in a dark closet or corner). The lamp need not be large or very bright. If you see spots of light, take the camera to your dealer

for fixing, or see the section on *How to Take Care of Your Camera* in Chapter 6 ("What Camera Shall I Get?"). To prevent this deterioration of the leather parts of your camera use Leather Vita (sold by Brentano's), Collectors' Book Dressing (Haas Pharmacy, New York), or any of the other preservatives mentioned earlier, in Chapter 6. Follow directions and you can keep leather pliable miraculously for years.

Checking Your Shutter

If you have, or can borrow, a phonograph turntable this test is easy. It can be used, however, only for between-the-lens shutters. Get a Haynes Shutter Checker, if you can find one (they're no longer being manufactured); if not, photograph the reproduction in *Fig. 17.2*, below, to the diameter of your turntable, floodlight it, and shoot away at the rotating spot, as described below.

How to use the Shutter Checker and interpret the results. First make a series of exposures, using all the speeds on your between-the-lens shutter (1 second to 1/500 second or beyond). Keep in mind that though the film can compensate for one stop more or less than the normal, you should try to adjust your exposures to get equivalent light values throughout the range of your speed-diaphragm combinations. For example, this might be a typical series: $f/2$ 1/250, $f/2.8$ 1/125, $f/4$ 1/60, $f/5.6$ 1/30, $f/8$ 1/15, $f/11$ 1/8, $f/16$ 1/4, $f/22$ 1/2, $f/32$ 1 second. Using a film of 125 ASA speed, and a light intensity of about 6.5 (on a Weston meter, though you can use any meter that you have available), your exposures for the entire series should show the *same tone of gray*, and each segment of arc should be double that of the one preceding. If they are not, make the necessary adjustments when you go out to take pictures (raise or lower your ASA ratings for the shutter speed that is slow or fast) or take the camera to a reliable repair shop for correction.

It is unlikely for a between-the-lens shutter to go much higher than

FIG. 17.2. THE HAYNES
SHUTTER CHECKER

1/500 second. If you want to start there, instead of 1/250, simply increase your light to a reading of 13 and shift all your exposures, thus: f/2 1/500, f/2.8 1/250, f/4 1/125, etc. Since the chart is black, make the reflected light reading on a gray surface like the 18% Gray Target supplied by Eastman Kodak. This is also available in their Kodak Master Darkroom Dataguide, or use an *incident light* meter exposure (see index).

Then, process the film in your usual way and, when washed and dry, make a contact sheet of all nine negatives on one sheet of 8 x 10 paper.

An alternative method for testing your shutter is given in Chapter 7 "Film and Exposure," *Some Exposure Hints.* See hint No. 8.

Checking the Filter

Besides the color-response test which can be made with a lens testing chart, there's another important test that should be given each filter. That's the test for *distortion* or optical faults. A filter that has lumps on it will ruin the resolving power of the best lens. A filter that hasn't any lumps, but the sides of which are not plane-parallel, is just as terrible an offender, since it acts as a prism and disperses the light. The extent of the damage depends on how far from parallel the plane surfaces happen to be.

There are two ways of testing the filter for these faults:

1. Hold the filter in front of your eye at an angle, look at any stationary object that has straight edges (a building, a box, a book), and jiggle the filter up and down quickly. If the object remains stationary, the filter is okay. If the object moves, return the filter and get another.

2. Hold the filter in front of your eye at an angle, but instead of looking *through* it, search out the *reflection* of some illuminated object that has a sharp edge. You will see a double image, one above or to the side of the other and one tinted the color of the filter. Now slowly turn the filter in your hand and watch carefully what this does to the *thickness* of the space between both images. If the filter is optically correct, there will be no variation. If it is not, this space will get thicker and thinner as you revolve the filter.

Checking the Print Rinse Bath

Dip a piece of blue *litmus paper* into the solution. If it turns *red* it's still good. You can buy the litmus paper in any drug store or chemical supply house (Amend Drug and Chemical Co., 83 Cordier, Irvington,

N.J. 07111, or Studiophot Co., 1032 Carnegie Ave., Cleveland, Ohio 44115, for example). It comes in two varieties, red and blue. Acid turns the blue to red; alkali turns the red to blue.

Checking the Hypo

Make up a 10 per cent solution of potassium iodide (10 grams in a little water and then add enough water to make 100 cc., or 1 ounce in a little water and then add water to make 10 liquid ounces). Add 3 or 4 drops of this solution to about 20 cc. (or a little more than half an ounce) of the hypo bath. If there is no precipitate, the hypo is still good. If a precipitate forms but redissolves when the mixture is shaken, the bath is still usable. If a heavy precipitate forms and does not redissolve when shaken, throw out the hypo.

Checking Flash Synchronization

Put a 2.2-volt flashlight bulb (not a *flash*bulb) into the socket of battery unit with suitable adapter. Hold in front of lens, and watch from other side as you fire. A bright light means close synchronization. Adjust until it is brightest. Start at 1/25 and go higher as you make finer adjustments. To check speedlight is even simpler. Just watch bulb through lens as you fire. A round hole means perfect sync; if you see shutter blades, adjust until they disappear.

The Dangers of Loading Film

New advances produce new problems. For instance, the Leica M4 eliminated the removable take-up spool, with the result that the three-pronged rapid loading permanent spool was responsible for a lot of blank film and heartaches. If you drop the film and leader into position and don't make absolutely sure that the film has caught and is *winding* (watch that rewind spool!), you'll come home with 36 blanks, and won't know it until after you've cleared the film with hypo. It's interesting that in the M5, Leitz has gone back to the removable take-up spool.

Similarly, if you are using the Rolleiflex (with the adjustment for 220 film), be certain that you don't inadvertently nudge the little change-over lever. If you do, the counter will jump back to zero, with you-know-what results.

Sometimes, the infrequent photographer will forget that the paper leader has to go *through* the rollers of the film-feeler mechanism. If this happens to you, *don't force anything* (unless you want to pay a big

repair bill). Just make up your mind that you've lost the film (unless you can get to a darkroom) and remove it, gently, with the necessary scissor surgery.

Twelve Fingers?

This caution shouldn't really be necessary, but there are photographers who insist on functioning as though they have an extra finger, probably a thumb, on each hand. Don't block the lens view of the scene with your fingers, your hand, your camera strap or your cable release.

How to Avoid Light Flare

Use a lens shade that masks out all unwanted light, which would otherwise bounce around inside your camera. But make sure by testing or viewing (if you have a single-lens reflex) that the shade does not vignette (cut off) part of your image, especially at the corners. A square or rectangular shade is, for that reason, preferable to a round one.

Why Stainless Steel Tanks Leak

This usually happens when the tops are switched accidentally (by you, if you have more than one, or sometimes by the dealer). Before it leaves the factory, each tank fits perfectly. If yours leaks, the top and tank are mismatched. Return it for a better fit, unless you like the developer to dribble all over your hand, your arm, and the floor, as you invert the tank for agitation.

Seven Ways to Avoid Trouble

1. Don't move the camera. Use a tripod, or at least 1/100 second exposure to minimize the trembles.
2. Make sure your camera is in good condition *before* you go out with it.
3. Take the lens cap off before you start shooting. Don't laugh; even professionals sometimes forget.
4. Keep your thumb away from the lens (before and especially *while* you are taking the picture).
5. Focus carefully (by footage, by ground glass, or by rangefinder).
6. Don't tilt your camera, unless you *want* converging verticals.
7. Use a lens shade or some other means of protecting the lens against front or side-light (see *index*, under *sun shade*).

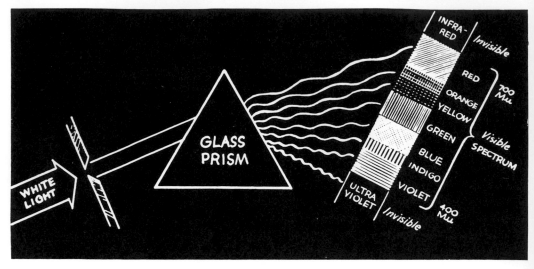

Between the invisible and the unseeable

18 Better Color Photography

Like the man who discovered to his surprise that he had been talking prose all his life, we often forget that we see the world in color. For more than a hundred years, men have tried to find some simple way to capture this color photographically, on film as well as on paper. The methods devised were ingenious, but too often difficult or expensive. In 1956, after Kodachrome (a *positive* transparency) had been on the market for twenty years, Eastman solved another phase of the problem by improving Kodacolor (a *negative* emulsion) and releasing Type C paper (later renamed *Ektaprint C*) for direct printing from *negative* emulsions. What had only been a dream began to take shape as a photographic reality.

Now the amateur working in color has a wealth of materials and techniques at his disposal.

For Making Slide Transparencies: *Kodachrome II, Ektachrome X, Fujichrome,* and *GAF Color Slide Film.*

For Making Color Prints from Transparencies: *Ektachrome RC, GAF Ansco Printon* papers, the *Cibachrome* dye-etch process with fade-proof color fidelity.

For Making Color Prints from Color Negatives: *Ektacolor S* and *L*, *Kodacolor X*, *Agfacolor CNS*, *Fujicolor*, and *GAF Color Print Film*.

For Making the *Best* Color Prints, especially if you have the time, the skill, the equipment, and *care:* the *Dye Transfer Process*, or the *Carbro Print Process*.

If Colors Need Changing *After* Exposure: Jamieson's *Hibadye*, Kodak *Retouching Colors* (formerly Flexichrome dyes).

For Color Pictures in a Minute: *Polacolor*.

And that isn't all.

But first let's review briefly what the scientists have told us about how light produces the sensation of color.

The Science of Color

Sir Isaac Newton, using a glass prism, split up white sunlight into seven *identifiable* spectral hues. He proved that these were *basic* or primary colors in that series of classic experiments described in the chapter "The Magic of Light." Other scientists, notably Young, Helmholtz, and Clerk-Maxwell, continued the experiments on color vision and discovered that the retina of the eye has three kinds of nerve ends, each sensitive to a different range of color. Arbitrarily grouped, since the spectrum is really *continuous*, these bands of color are *red, green*, and *indigo*, or blue. When spectral light of these hues is mixed in the right proportions, as with three projectors focused on a white surface to form three circles arranged like those in *Fig. 18.1A*, the eye gets the sensation

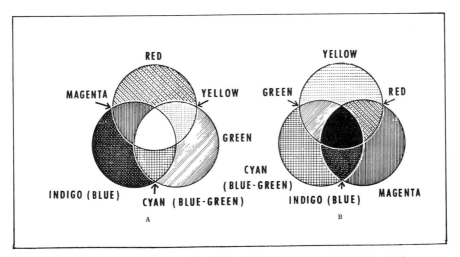

FIG. 18.1. THE ADDITIVE (*A*) AND SUBTRACTIVE (*B*) METHODS OF MIXING COLORS

of *white* light in the center. Further, by altering the proportions of these three spectral hues, we can produce not only the seven *principal* spectral colors but all the intermediate hues as well; red and *indigo* (blue), for instance, produce *magenta;* red and green produce *yellow;* while green and blue (indigo) produce *blue-green.* This method of mixing colors is called the *additive process,* because the colors are produced by *adding one to another.*

Now, if instead of using *green, indigo (blue),* and *red* light (the primary colors), we placed filters of the three complementary colors (*magenta, yellow,* and *blue-green* or *cyan*) over a light box in the very positions shown in *B* of *Fig. 18.1,* a strange thing would happen. Instead of white, as before, we would see *black.* No light would come through where the filters overlapped. The same thing would happen if we used *paint* instead of *light.* Mixing yellow and cyan (blue-green) paint would produce *green;* adding magenta would result in *black.* Mixing yellow and blue-green (cyan), moreover, would give us *green;* yellow and magenta would give us *red;* and magenta and cyan (blue-green) would give us *indigo* (blue). This second method of mixing colors is known as the *subtractive process* (because one color is produced by the *absorption* or *filtering* out of others).

Thus, mixing pigment yellow with pigment cyan produces *green,* while if spectral colors of these hues were mixed a dull *white* would result. The reason for this difference in action lies in the fact that the pigment blue in the paint *absorbs* most of the yellow and red light, while the pigment yellow *absorbs* the blue and violet light, leaving only the green. You may remember that in the chapter "The Magic of Light" we explained that a red safelight was red because it absorbed all the other colors, while blood was red because it absorbed green. The color of any object then depends on its *selective absorption*—its ability to filter out colors. Those colors which it does *not* absorb or filter out are the ones we see as the colors of the object. *In other words, a yellow filter does not add yellow to a scene; it subtracts blue.* That's why a K2 filter turns a *blue* sky to *gray.*

At this point you are probably wondering what this has to do with taking photographs in color. Well, if James Clerk-Maxwell hadn't proved, in 1861, that our eyes have *three-color* vision, other men who followed him might not have discovered such secrets of color photography as are revealed in the revolutionary *two-color* experiments of Dr. Edwin H. Land of Polaroid, and the *EVR System of Color Photography* (from black-and-white film) announced by CBS Laboratories.

An amazing experiment in color vision. By photographing a full-color scene on monochrome film through a #25 *red* filter, and again

through a #58 *green* filter, Dr. Edwin H. Land created two transparencies which he later flashed simultaneously from a pair of projectors placed side by side. What you saw on the screen were two *black-and-white* reproductions of the same scene. But they were subtly different when compared (because of the filtering). By aligning both projectors so that the two images merged, he produced what appeared to be one black-and-white picture.

Then, like the magician he is, Dr. Land held up a red gelatin filter and slowly positioned it in front of one of the projectors. On the screen, incredibly and suddenly, appeared a *full-color transparency matching every color of the original scene!* And he had performed this miracle with only *white* light from one projector, *red* light from the other, and two monochrome slides.

For more on this experiment, see *An Astonishing New Theory of Color* by Francis Bello in the May 1959 *Fortune;* Paul Farber's *Color Vision: An Experiment,* in *U.S. Camera* for January 1964; Edwin H. Land's *Experiments in Color Vision* in the May 1959 *Scientific American;* and *A Student's Introduction to Color Synthesis* by R. M. Callender, FRPS, in *The British Journal of Photography,* November 27, 1970.

Electronic color photography from monochrome film. Drs. Peter C. Goldmark and William E. Glenn, Jr., of CBS Laboratories in Stamford, Conn., were granted a patent, February 1971, for a method of electronic color photography using black-and-white film. This *Electronic Video Recording* system (EVR) for color photography on black-and-white film is compatible with television standards and systems all over the world. The color, moreover, is *permanent* because it is photographed in encoded form on monochrome film.

Separation Negatives

Color prints used to be made by exposing three separate black-and-white films through a series of red, green, and blue filters and then, by an elaborate process, converting these so-called *separation negatives* into a print in full color. If the object to be photographed was a still life, the regular camera could be used to expose three negatives, each through one of the three filters, and adjusting the exposures to compensate for the filter factors. If the object was in motion, however, the photographer was in serious trouble. He could, of course, use Kodak *Tri-mask* film, which consists of a three-layer film sandwich so treated with backing dyes that each film is sensitive only to one of the primary colors. The image produced by this film, however, is neither sharp (since the three films can never lie in exactly the same plane), nor can one exposure

produce equal densities in all three negatives. A better way of exposing these three films is in a specially designed *tricolor camera* which is so constructed that the image beam is split (by prisms and mirrors) into three parts, each part passing through an appropriate filter before it registers on one of the films. Since all three films are exposed at one time, such cameras are called *one-shot cameras.* They are not suitable for amateur use, however, since they are quite expensive, are heavy and therefore difficult to handle, and require considerable skill in manipulation both before and after exposure.

Separation negatives, it is important to remember, use black-and-white film, whose images are *afterward* converted by an elaborate and difficult process into a single, full-color print. Although this method remains the best for the making of high-quality color prints, and is still used in commercial photographic studios in conjunction with the *Carbro* [1] and *Wash-off Relief* printing processes, it is beyond the skill of even the advanced amateur. Let us therefore proceed to the more practical aspects of color photography, color film, and color printing.

Modern Color Film

KODACHROME

The problem of separation negatives, so far as the amateur is concerned, was overcome in 1935 when Eastman Kodak introduced Kodachrome film (first in 16mm film; a year later for 35mm still photography), which makes use of the subtractive process of color rendition. In this film, the color separations *are built right into the emulsion.* To make this possible, the film has to be coated five times and finally resembles a three-layer cake with three coatings of emulsion separated by two of gelatine. Like the jelly fillings of a layer cake, the gelatine layers separate the first, second, and third emulsion layers and so prevent the emulsion sensitizers from spreading.

The coating of each layer of emulsion is selectively sensitized. The bottom coat, next to the film base, is *red* sensitive; the center coating is *green* sensitive; the uppermost layer is *blue* sensitive. The combined thickness of all five coatings, however, is only microscopically greater than the coating of regular black-and-white film. When finally processed, the blue sensitive layer becomes a yellow image; the green sensitive layer, a magenta image; and the red sensitive layer, a blue-green image. The

[1] *Carbro* (from *carbon* and *bromide*) is the oldest color printing process still in use today. The quality of carbro prints is unmatched. The three color images are in relief, which gives an illusion of depth to the print. Also, the registry can be corrected, even if the separation negatives vary slightly in size.

separation negatives and their conversion into positive color images are thus achieved in a single process. The film is exposed in the camera like black-and-white film, and processed by Kodak or other licensed processors. What you get back is a full-color *transparency* which you look at by transmitted light. The three colored images blend to form a single image which reveals all the colors of the original subject.

Kodachrome film in its new form (sharper, better color balance, wider exposure range) is now supplied in three types:

Kodachrome II, daylight type, ASA 25. Available in 135 and 828.

Kodachrome II Professional, Type A (photoflood), ASA 40. (With tungsten 3200° K and No. 82A filter, ASA 32; in daylight with No. 85 filter, ASA 25.) Available only in 135.

Kodachrome X, daylight, ASA 64. Available in 126 and 135 cartridges.

OTHER COLOR FILM

Since the advent of Kodachrome, several other color films have appeared on the market employing, for all practical picture-making purposes, the same general principle.[2] These are: *GAF Color Slide Film* and *Ektachrome* (reversal films which can be processed in your own darkroom to yield full-color transparencies), *Agfachrome* (marketed abroad as *Ayfacolor*), *Ferraniacolor CR50, Fujichrome R100*, and *Perutz 18*. In addition, there are *Kodacolor X, Agfa CNS,* and *Fujichrome Negative*, which differ from the others in that processing converts the film into a *color negative* from which positive prints in color can be made (or full-color transparencies, as well). These will be discussed more fully later.

Another film worth trying is *Dynachrome 25*, manufactured by a subsidiary of the 3M Corporation. Though less expensive than the standard brands, it seems to have the same high quality. The ASA rating is 25, and it is available in the 35mm size. It has extremely fine grain, very sharp, with good shadow contrast. Latitude is about 1 to 1½ stops over or under. There is also a faster type, *Dynachrome 64*, which has very good sharpness, medium grain, and moderately low contrast, ASA 64. The negative film is called *Dynachrome 64 Print*, and also has an exposure rating of ASA 64.

The presence of all these materials has caused considerable confusion. Most amateurs are awed by the phrase "color photography." They

[2] Many of the color films that followed *Kodachrome* have been changed in name (*Anscochrome* to GAF, for example) or been discontinued or replaced by newer and faster or more flexible versions. Others have been absorbed by company mergers (*Adox* by Dupont, *Perutz* by Agfa-Gevaert, and *Ilford* by Ciba-Geigy).

believe it requires elaborate equipment and complex techniques. But that isn't so. All the films referred to in the foregoing paragraphs are made for use in cameras designed for black-and-white film, and are used in the same way. There is no mystery about making pictures in color, but there are some limitations and conditions. Let us try to clear these up now.

TRANSPARENCIES

Color photography today can be undertaken with almost any type of camera. But it is important to remember that, except for such *negative* emulsions as *Ektacolor, Agfacolor CNS* and *Kodacolor X*, modern color films are designed to produce *positive transparencies*. Unlike the black-and-white negative, the full-color transparency is a *picture complete in itself*. Its drawback is that it must be viewed by *transmitted* light, or projected on a screen.

Color prints on paper, or on opaque material, *can* be made from color transparencies, but because of limitations inherent in the process of viewing by *reflected* light, some of the color fidelity and brilliance of the original transparency are lost. The new negative emulsions, matched to Kodak's remarkable *Ektaprint C* for making color prints, have to some extent overcome this defect.

The very drawback of reversal, or *positive*, film, however—the necessity for viewing it by transmitted light—has proved one of its greatest boons; having opened up a whole new field of photographic enjoyment. Various devices for viewing color transparencies in the smaller sizes (35mm, Bantam, 126 cartridge, 120, and 620) have been developed and are available at reasonable prices. There are hand viewers into which transparencies mounted in the form of slides are inserted and viewed through a magnifying eyepiece. Others contain their own means of illumination, obviating the necessity for holding the device up to light. But by far the greatest pleasure is derived from projecting the transparencies onto a screen where they can be seen and enjoyed by many.

COLOR FILM SIZES

This form of color photography, however, may now be enjoyed by those owning roll-film cameras using film of the following sizes:

Positive Color Film Sizes (The italic numbers indicate ASA indexes)

35mm (Agfachrome CT18/*50*, Agfacolor CT18/*50*, GAF *64* Color Slide Film, Kodachrome II *25*, GAF T/*100* Color Slide Film (balanced for 3200° K tungsten), Kodachrome

X 64, Ektachrome X 64, Ferraniacolor CR 50, Fujichrome R100, GAF 200 and 500 Color Slide Film, Dynachrome 25 and 64, Kodachrome II Professional Type A 85, HS Ektachrome 160, HS Ektachrome T 80, Agfachrome 50 S Professional, Agfachrome 50 L Professional)

126 Cartridge Instamatic	(Kodachrome X 64, Ektachrome X 64, HS Ektachrome 160, Agfachrome/50 CT18)
127	(Kodacolor X 80, Berkey Color Triprint Film 80)
828 Bantam	(Kodachrome II 25)
120	(Agfachrome CT18/50, Agfacolor CT18/50, GAF 64 Color Slide Film, Ektachrome X 64, Fujichrome R100, HS Ektachrome 160, HS Ektachrome T 80)
620	(GAF T/100 Color Slide Film, GAF D/200 and D/500 Color Slide Film, Ektachrome X 64)
70mm	(GAF T/100 Color Slide Film, GAF D/200 and D/500 Color Slide Film, Ektachrome X 64)

Negative Color Film Sizes (The italic numbers indicate ASA indexes)

35mm	(Agfacolor CNS 80, Ektacolor Professional Type S 100, Dynachrome 64 Print Film, Fujicolor 100, GAF 80 Color Print Film, Kodacolor X 80, Tessina Ektacolor 100)
828 Bantam	(Kodacolor X 80)
126 Cartridge Instamatic	(Agfacolor CNS 80, Berkey Color Triprint Film 80, Dynachrome 64 Print Film, Fujicolor 100, GAF 80 Color Print Film, Kodacolor X 80)
127	(Kodacolor X 80, Berkey Color Triprint Film 80)
120 620	(Ektacolor Professional Type S 100, Fujicolor 100, Kodacolor X 80)
116 616	(Kodacolor X 80)

Though these film sizes (for color *transparencies*) are *now* available, this situation may change, as it often does; so check with your dealer. Owners of other size *roll-film* cameras will have to confine their color photography to whatever is available in *negative* film, from which color prints can be made on *Ektaprint C*, 35mm transparencies on *Ektacolor Slide Film 5028*, and larger transparencies (sheet) on *Ektacolor Print Film 6109*.

Bantam 828 negative film (Kodacolor X) is still being made and sold as this edition goes to press, according to Kodak. But some of the photo magazines have begun to label it *obsolete*.

Users of view and press-type cameras, accommodating cut film

holders or cut film magazines, have practically every size of sheet film at their disposal.

These larger sheet film sizes yield transparencies that can be viewed by transmitted light without any need for magnification. That's why they are preferred by magazines, advertising agencies, and calendar manufacturers, photomechanical reproduction being easier in these larger sizes. The chief drawback to sheet film is its cost.

The Economical Way

The least expensive way to enjoy color photography is with the smaller cameras utilizing roll film. For those considering the purchase of a camera for color photography, especially where economy is important, the small camera using 35mm, 126 cartridge, or Bantam-size film is the logical choice for several reasons: (1) film cost is lowest, and (2) these sizes are returned to you mounted in 2 x 2 cardboard slide mounts which are accommodated by the greatest variety of available viewers and projectors. Until recently, only a few viewers or projectors were made for 120 size film. But the situation has changed, and now you can find a wide choice of models in the stores.

Up to now we have discussed color films in more or less general terms. Let us now point out the important differences in available color films. We have already described Kodachrome, which because of its intricacy is processed by Kodak or a licensed processor. The cost of the film does not, as a rule, include finishing. But many of the camera shops offer a package deal which includes development, on the theory that the combination price is less than the sum of the film and processing bought separately. Personally, I prefer Kodak processing, so when I expose Kodachrome II, I buy a Kodak mailer and send it directly to the manufacturer. Their know-how is reassuring; it makes me feel that my film is getting the royal treatment. So far, and I've been doing this ever since the mailers became available, I've been lucky. No spots, no scratches, no misses. It's less than solace to get a free roll of replacement film when something goes wrong at the plant, if what you were waiting for were 36 great pictures made in Europe on the Grand Tour.

The other films we have mentioned—*GAF Color Slide Film* and *Ektachrome*—differ from *Kodachrome* in that they make it possible for you to process the film yourself in your home darkroom.

Processing your own color film, of course, is neither as simple and foolproof as developing black-and-white film, nor as inexpensive. It requires more trays or tanks for sheet film, though not for roll film, and demands far more care and accuracy with respect to time and temperature control. Nevertheless, it can be a convenience, and is worth trying.

GAF Color Slide Film

GAF Color Slide Film is used in the camera just like black-and-white film. It is supplied in 35mm and most roll-film sizes, in three speeds and two emulsions: D 64, D 200, and D 500 for daylight with the ASA exposures of 64, 200 and 500; and T 100 for tungsten, with an exposure index of 100 when used with the recommended filters.

Although the user of *GAF Color Slide Film* may, if he wishes, have his film processed by his photo dealer, a local commercial laboratory, or the GAF Color Laboratory (Building 6, Binghamton, New York 13902), he can also, if he has the patience, is in a hurry, or just wants to enjoy the fun of developing his own film, buy a home-processing developing outfit which GAF Ansco supplies in a 16-ounce size.

HOW TO PROCESS GAF COLOR SLIDE FILM

You can develop *GAF Color Slide Film* almost as easily and quickly as black and white, but there are a few important differences. Black-and-white film requires three solutions and takes about half an hour; *GAF Color Slide Film* uses six different baths and takes a little less than an hour. Any roll-film tank which has a reel that can be easily loaded is suitable, though those with the translucent or transparent reels, or the open-wire-frame type like the Nikor, can save you the messy job of unloading and reloading the film when you have to fog it by exposing it uniformly to white light (step 4).

All the chemicals you need are supplied in the Anscochrome developing outfits. Just mix the chemicals in water, as directed, and you're ready.

Complete and detailed processing directions are given in the instruction sheet packed with each developing outfit. *Since these recommendations are changed from time to time, make sure to follow the latest directions as packed with the outfit you buy.*

After the previous edition of *The Amateur Photographer's Handbook* had gone to press, GAF changed its procedures and went to GAF Color Slide 80° F. processing chemistry. But having tested this "in the field," they discovered it didn't work out too well and are now back to 75° F. and the procedure detailed below.

For the best quality and color rendition, *GAF Color Slide Film* should be exposed and processed normally, according to the manufacturer's directions.

Certain techniques which you may have used successfully in de-

	SQUARE INCHES OF FILM	12 EXP. 35MM	20 EXP. 35MM	36 EXP. 35MM	127 ROLL	120/620 ROLL	4 x 5 SHEET	5 x 7 SHEET	8 x 10 SHEET
Process this much film at the times given	160	4	3	2	4	2	8	5	2
Then increase processing times to:									
First developer: 13 min.									
Color developer: 14 min.									
Bleach: 6 min. All other times remain the same.									
Process this much additional film at these times.	65	2	2	2	2	1	4	2	1
Discard solutions after this total amount of film has been processed.	225	6	5	4	6	3	12	7	3

veloping black-and-white film may harm your processing of *GAF Color Slide Film*, so it is important to observe these six simple cautions:

1. Do not presoak *GAF Color Slide Film* in water before processing.
2. Do not use water rinses between the two developers and the shortstop-hardeners.
3. Do not extend the washes beyond the recommended times.
4. Hold the temperatures of solutions and wash water at 75° F. (or as indicated).
5. Use regular tap water for washing whenever possible.
6. Do not keep shortstop-hardener solutions longer than 14 days, or use them beyond the recommended number of *GAF Color Slide Film* rolls (as indicated in the instruction sheets supplied with each kit).

It is always best to process GAF Color Slide Film as soon as possible after the roll is exposed. Nevertheless, if you have to keep exposed film for prolonged periods, or under unfavorable conditions of heat or moisture, you can protect the color quality of the image by running it through the first three steps of processing (*first development, short stop, wash*) then drying it. The film can then be stored indefinitely, provided it is not exposed to sunlight or strong daylight.

To finish the transparencies later, they are given normal second exposure and the rest of the processing is carried out as though uninterrupted. Such partially processed film can also be sent to the GAF Color Laboratory in Binghamton, New York, for completion of processing, *but the package must be clearly marked "Department K"* or it will get full processing and be spoiled.

There are 15 steps in all, taking 58 minutes. As indicated above, it is best to follow the latest directions as supplied in the kit itself. Here, in skeleton form, is an outline of the various steps and what each accomplishes. *The first two steps are carried out in total darkness,* or with the light-tight cover of the daylight tank in place. Temperature must be 75° F. (or as indicated), and agitation, which is important, should follow the directions given in the instruction sheet.

1. *First Development.* Has the same effect as the developer in black-and-white. It develops or reduces to a metallic silver negative image, the silver halides affected by the camera exposure. *12 minutes* (75° F. ± ½° F.).

2. *Short Stop.* Neutralizes developer and halts action, as in black-and-white.
 Hardener. Conditions film for processing steps to come. *3 minutes* (75° F. ± 3° F.).

3. *Rinse.* Removes hardener and other chemicals. *Keep temperature between 70–75° F. 1½ minutes.*

Following twelve steps are carried out in bright room illumination.

4. *Second exposure.* Here film is evenly fogged in *bright* white light (flood lamp or equivalent) which exposes silver halides not previously exposed in camera. *2 minutes.*

5. *Color development.* This bath creates colored dyes and forms a metallic silver positive image in those parts of film that were exposed in step 5, above. *Caution:* Don't immerse hands in this solution; if any of it gets on you accidentally, *wash off at once!* It's a good idea to keep a tray of 2% acetic acid (or vinegar diluted with an equal amount of water) handy. Rinse hands, dip in acetic solution, and rinse again to remove all color developer. *12 minutes* (75° F. ± ½° F.).

6. *Short Stop Hardener.* Same as step 2. *3 minutes* (75° F. ± 3° F.).

7. *Rinse.* Same as step 3. *4 minutes* (75° F. ± 2° F.).

8. *Bleach.* Converts negative and positive metallic silver images formed during steps 1 and 6 to soluble compounds. *4 minutes* (70–75° F.).

9. *Rinse.* Same as step 7. *4 minutes* (70–75° F.).

10. *Fixation.* Removes compounds formed in film during bleaching, leaving only dye images which form color picture. *3½ minutes* (75° F. ± 3° F.).

11. *Rinse.* Same as step 9. *4 minutes* (70–75° F.).

12. *Stabilizer. 1½ minutes* (75° F. ± 3° F.).

13. *Rinse* in running water for *3 minutes* (70–75° F.).

14. *Final rinse, ½ minute* (75° F. ± 3° F.).

15. *Dry* in a cool, dust-free room, with the windows closed.

Ektachrome X

Like *GAF Color Slide Film, Ektachrome X* is a reversal color film intended for processing by the user to produce positive color transparencies. It first appeared in 1946 as a film with a daylight exposure index of 10, later corrected to 8. This has since been speeded up to 64, daylight. An improved High-Speed Ektachrome, daylight, is available with a speed of ASA 160.[3] Also, an HS Ektachrome (tungsten type) has been added to the line, with an ASA speed of 125 under 3200° K lighting. Unlike GAF, Kodak does not offer a processing service for Ektachrome. It must be developed by the user or by independent finishers. The film is available

[3] On August 4, 1971, Kodak introduced a new Ektachrome 160 (Type A) movie film for their new XL high-speed movie system (it converts to ASA 100 with a daylight filter).

only in the daylight type which, however, can be used indoors at night with photoflood (at an ASA speed of 20) provided an 80B filter is added. The average exposure in bright sunlight is $f/11$ at 1/100 second. Blue flashbulbs are helpful in softening harsh shadows, a typical exposure being $f/16$ at 1/50 second with the subject about 8 to 10 feet away.

PROCESSING EKTACHROME ROLL FILM

The developing of *Ektachrome X* is similar to that of GAF Color Slide Film, and takes about the same time. But there are two important differences: Kodak adds a *stabilizing* bath as the final step, followed by heat drying (not over 110° F.); and the *Ektachrome color developer is very toxic*. The agent responsible for the chemical reversal (which eliminates the need for re-exposure of the film) is a *poisonous* "borane," actually *tertiary butylamine borane*. Each (E4) developing kit has complete instructions, *which should be followed exactly*.

Kodacolor X

When *Kodacolor*, a negative film, was first announced in 1942, it offered the simplest method of making color snapshots. There were two types of film then, one for daylight and another for flash and flood. Now there is just one *Universal Type* with a daylight exposure index of 80. It can be used for daylight *or* flash without any filter (but remember to use *clear* lamps indoors and *blue* lamps outdoors). The price of the film does not include processing. But you can buy a processing kit (C22) for use at home.

Kodacolor X is as easy to use as black-and-white. The processed film produces a strange-looking color negative in reverse from which both monochrome prints on *Panalure* photographic paper, and color prints on *Ektaprint Type C* can be made. The basic exposure in bright sunlight is $f/11$ at 1/100 second. It is available in most roll-film sizes, including 35mm and 126 cartridge.

Ektacolor

This happy addition to the Kodak family of *negative* color films was released in 1951. *Ektacolor* is a tripack emulsion (like Kodachrome and GAF Color Slide Film) consisting of *red-*, *green-*, and *blue*-sensitive layers coated on a single sheet of film. After processing, it looks like a *Kodacolor* negative (with densities inverted and colors complementary), but it's on a heavier film base. It is excellent for making dye transfer

prints, since *no separation negatives are required*, and it can be processed in your own darkroom.

There are two types of *Ektacolor: Type L* (Long Exposure) designed for exposure times of 1/10 second to 60 seconds with 3200° K lamps, or, with appropriate filters, by *photoflood* (#81A, 1 second), or *daylight* (#85, 1/10 second), all at an exposure rating of 64; and *Type S* (Short Exposure) for exposures of 1/10 second or less, with a daylight index of 100. Color prints can be made from these negatives on *Ektaprint Type C* paper, or by the *Dye Transfer* process (see *index*). Positive color transparencies can be made from them on *Ektacolor Slide Film 5028* (35mm) or *Ektacolor Print Film 6109* (sheet). *Note:* Use the corrective filter suggested on the data sheet enclosed in each box of film. This will compensate for the slight differences in the emulsion, from batch to batch.

Cibachrome

From Switzerland now comes an important addition to the wonderful world of color transparencies, prints, and processes. *Cibachrome* is noteworthy for many things, but primarily for its resistance to fading (it seems to be impervious to light, no matter how intense) and to all other forms of attack and deterioration.

What *Cibachrome* offers is a *positive to positive* approach to picture taking:

1. A way of getting good quality *prints* or *transparencies* directly from color slides on color-fast materials.
2. Color saturation, on a pure white *plastic* base, so intense as to seem incredible. The method involves the use of *azo dyes* and the *Cibachrome* silver dye-bleach process.
3. A print or transparency that will neither fade nor deteriorate within a man's life-span.
4. A plastic base that increases the durability and enhances the beauty of either print or transparency.
5. No image deterioration. If the original transparency is sharp, the *Cibachrome* print or transparency will be.
6. Price? About half of what the best methods for making color prints now cost.

For more information about this exciting new color process for making prints and transparencies, write to Cibachrome, Ilford, Inc. (a division of Ciba-Geigy), West 70 Century Rd., P.O. Box 288, Paramus, N.J. 07652.

AGFA CU 410

This is Agfa-Gevaert's version of the Ciba process. At the moment, it is only available from Agfa-Gevaert in Germany, but it will be coming to the United States. Like the *Cibachrome* process, the print base is a very white, durable plastic. And the process is called *dye-bleach*, or *dye-destruction*, as distinguished from the older *dye-coupling* methods. The idea is not new. It was invented in 1905 and perfected in 1931 by *B. Gaspar* (Gaspar Color Process). Agfa has merely updated it, now that the later patents have expired.

CU 410 requires about one stop more enlarging exposure than Agfa-color reversal paper, but that's not much of a problem. It will be available in kit form for home processing, according to Agfa. This would make it possible to correct the positive image on your enlarger baseboard with *additive* rather than *subtractive* filters. Should you need more of any color, you simply add more of that color. What a lift this will give to home color processing when it does become available!

Which Film?

At this point you are probably wondering, "Which color film should I use?" As in black-and-white photography, that is a matter of individual choice. All the materials described will do what is claimed for them, provided that *all* the conditions of exposure and processing are carried out faithfully.

Transparencies made on *Kodachrome, GAF Color Slide Film, Fujichrome, Ektachrome, Agfachrome,* and *Dynachrome* are all beautiful and exciting if properly handled; but there *are* differences.

Kodachrome II and *Dynachrome 25* offer the finest grain and the greatest acutance, or sharpness. Though the color saturation of these is excellent, they are only moderately vivid in bright light. Their rendition of pastel hues and skin tones, however, is unbeatable. Dynachrome 25 gives warmer, and softer, color than Kodachrome II. Both have moderate contrast and excellent shadow penetration, with an exposure latitude of about 1 to 1½ stops under or over.

Kodachrome X is closest in results to the original, discontinued, *Kodachrome I*. Though color saturation is stronger than in the old Kodachrome, it is not as good as that of Kodachrome II. Expose for the highlights. Use it for brilliance in soft, flat lighting.

The daylight films, GAF 64 Color Slide Film and GAF 200 Color Slide Film, have good saturation, but not as much as some of the other transparency films. For that very reason they are more "natural" in their

approach to colorful scenes and portraits. They do not distort the reds or the greens. And you can process them yourself with the GAF Color Slide kits.

Agfachrome CT18 is a German import (sold as *Agfacolor CT18* abroad). It is very sharp, with a medium fine grain, moderate contrast, and good shadow penetration; but it has an exposure latitude of only one stop either way. You can also process this yourself; kits for amateur use in home darkrooms are available.

Ektachrome X and *HS Ektachrome* resemble each other in color balance, but high-speed Ektachrome's color is less saturated. Ektachrome X gives warmer results and is brilliant in strong sun (intensifying blue skies, bright reds, vivid greens and yellows). It is superb for pepping up a scene that is softly lit.

You can now make excellent color prints from transparencies, as easily as from negative materials, just by making an *intermediate* negative on *Ektacolor Internegative 6110* (sheet) or *Internegative color 6008* (roll) through your enlarger, or contact printer. Your enlarger will have to be equipped with a heat-absorbing glass, and you may need an ultraviolet absorber in the filter pack, but otherwise the processing procedures for both the negative and the print are standard. Follow the instructions on the Supplementary Data Sheet packed with the film. You will have to make test prints, and adjust the filter packs you use to make a satisfactory print, as a filter correction for your technique and equipment. If you are interested, send for Kodak's *free* 15-page booklet, No. E 51: *Printing Color Negatives on Kodak Ektaprint Type C*. It will tell you all you need to know about how to use this remarkable paper. Write to the Sales Service Division, Eastman Kodak Co., Rochester, N.Y. 14650. If booklet E 51 is not available, invest in their Data Book E 66: *Printing Color Negatives*.

Users of sheet film have a choice of two *negative* emulsions (Ektacolor Professional S, Ektacolor Professional L) and four *transparency* types (Agfachrome CT18, Agfachrome 50 L Professional, Agfachrome 50 S Professional, Ektachrome D Type E-3).

Costs are a factor in choice. Size for size there is little difference in the cost of color film. The smaller the size film you use, however, the less color photography will cost you. If you process your own films you reduce the cost, naturally.

WHAT THOSE FILM DESIGNATIONS MEAN

In monochrome films, you come across strange labels like *Estar* and *Mylar*, which refer to the emulsion bases (Estar being the thicker); *HS*, which stands for high speed; and *Professional*, which is used to indicate three things: 1) that it is a different, and often slower, emulsion (as in

Color is better. Top, a Leica shot
of a Roman ruin taken by Leon Arden
on Kodachrome II, 50mm Elmar lens.
Left, Spring at Detmar Gardens,
New York, Leica M4, Kodachrome II.
Bottom, an interior view of The Cloisters,
Leica M3, Kodachrome II, tripod.

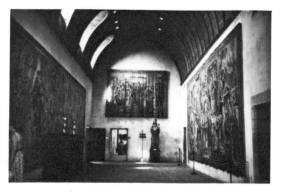

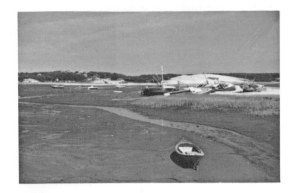

Three Leica shots: The Red Boat and *Ship's Gear* were both taken at Cape Cod with a 50mm Summicron; *Yosemite* was taken with a Summilux lens. All on Kodachrome II film in an M4 . . .

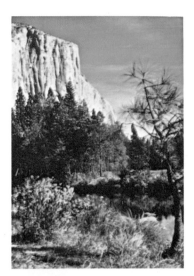

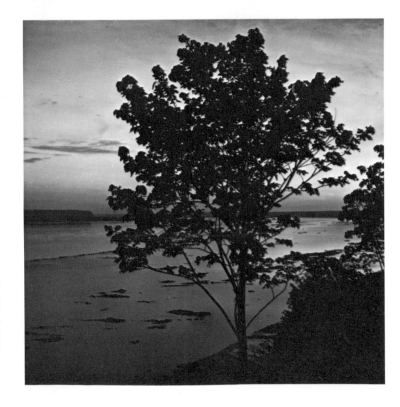

and a Rolleiflex exposure of a tree silhouetted against the sunset, taken on Ektachrome X, at Cape Cod.

Tri X Pan Professional which has a speed rating of ASA 320, while Tri X Pan regular has a rating of ASA 400); 2) that the film is available with a *retouching surface,* not needed by the amateur; and 3) that the film is available in the double-roll 220 film size (as in Plus X Pan Professional and Tri X Pan Professional).

In color films, however, the designations mean different things.

The word *Professional,* in color, indicates that the film is designed for *refrigeration* before use, and swift use thereafter (what the technicians call an *in-and-out-of-the-camera* film).

Type B indicates the way in which the film will react to Kelvin degrees of color temperature, as in *tungsten* (3200° K), *photo lamps* (3400° K), *daylight* (5000° K), and *blue flashbulbs* (6000° K). It also determines what filters you need to correct for the various degrees of color temperature.

Type S stands for *short* exposure (1/10 second or shorter) and is available in *negative* color film like Ektacolor Professional S.

Type L stands for *long* exposure (1/10 second to 60 seconds) and is available in *negative* color film like Ektacolor Professional L.

Exposure for Color Film

The exposing of color film differs from black-and-white film in two ways. It is considerably slower, and it has far less latitude. For this reason greater care is essential in determining correct exposure than with black-and-white film. Compensations in developing and printing can be made for errors of exposure in monochrome film. With color film, exposures should be accurate within half a stop, *if one wants the best possible results.* Errors in exposure, remember, not only affect the density of the transparency, but the color as well. *Accurate color reproduction demands accurate exposure.*

But this exposure problem is not as difficult as it sounds. A photoelectric exposure meter is, of course, an important aid, but it is not absolutely essential. Color films can be exposed very accurately with the aid of the simple directions that are packed with the film. Eastman markets the popular snapshot and flash color *Kodaguides* by which exposures are quickly and easily calculated. And be sure to look into the *Kodak Color Dataguide* #R-19 if you expect to do much exposing, processing, and printing of color film.

A SAFE RULE

If you ever happen to find yourself with a roll of Kodachrome II (ASA 25) film in your camera and you have lost the instruction sheet

RECOMMENDED SETTINGS FOR COLOR FILMS

FILM	LIGHT	ASV [a]	ASA	FILTER
Kodachrome II (daylight type)	Daylight [c]	3°	25	None [b]
35mm and 828 film	Photoflood	1°	8	Wratten 80B
Kodachrome X	Daylight [c]	4°	64	None [b]
35mm and 126 Instamatic film	Photoflood	2.5°	20	80B
Kodachrome II (Type A)	Daylight	3°	25 [h]	85
35mm film	Tungsten	3°	32	82A
	Photoflood	3.5°	40	None [b]
Ektachrome X	Daylight	4°	64	None [b]
35mm, 126 Instamatic roll film	Photoflood	2.5°	20	80B
High-Speed Ektachrome	Daylight	5.5°	160	None [b]
	Tungsten	5°	125	None [b]
High-Speed Ektachrome B	Photoflood	5°	100	81A
35mm and roll film	Daylight	4.5°	80	85B
GAF Color Slide Film (daylight) [g]	Daylight	4°	64	None [b]
35mm, 126, 120	Tungsten	2°	16	80A
	Photoflood	3°	32	80B
GAF 500 Color Slide Film	Daylight	7.5°	500	None [b]
35mm	Tungsten	5°	125	80A
	Photoflood	6.5°	250	80B
GAF 200 Color Slide Film	Daylight	6°	200	None [b]
(daylight) [g]	Tungsten	4.5°	80	80B and 82A
35mm	Photoflood	5°	100	80B
GAF T-100 Color Slide Film	Daylight	4°	64	85B
35mm	Tungsten	5°	100	None [b]
	Photoflood	4.5°	80	81A
Agfachrome CT18	Daylight	4°	50	None [b]
35mm, 126, 127, sheet	Tungsten	2°	12	80A
	Photoflood	2.5°	16	80B
Kodacolor X Neg.	Daylight	4.5°	80	None [b]
roll film, 35mm, 126	Tungsten	2.5°	20	80A [h]
	Photoflood	3°	25	80B [d]
Ektacolor (Type S) [e] Neg.	Daylight	5°	100	As noted in
roll, 35mm, and sheet film				carton
Ektacolor (Type L) [f] Neg.	5 seconds	4°	64	None at 3200° K
sheet film only	(3200° K)			81A (photoflood)
				at 1 second
Agfacolor CNS Neg.	Daylight	4.5°	80	None [b]
35mm, 126	Tungsten	2.5°	20	80A
	Photoflood	3°	25	80B

and exposure guide, fix this key exposure in your memory and you won't go very far wrong: 1/100 second at *f*/8 for use on a bright sunny day for average front lighted subjects. If the day is somewhat less than bright and sunny, try either halving the speed, 1/50 at the same stop, or 1/100 at a stop wider, *f*/5.6. If you are at the seashore where the light is brilliant, go the other way, shoot at 1/100 and *f*/11 or 1/50 at a stop smaller, *f*/16. But remember what we have said, all through the book, about the danger of *blur* due to hand motion for any shutter speed slower than 1/100 of a second.

If this should happen to you when your camera is loaded with either GAF 64 Color Slide Film, Ektachrome X, or Kodacolor X, just keep in mind that your basic exposure in bright sunlight is *f*/11 at 1/100 second for all three.

Remember that no matter what method you use you will have to experiment with your own camera before you can determine correct exposure with any degree of accuracy. Camera shutters vary in their performance. An indicated speed of 1/50 in one shutter may be actually slower or faster in another. If you keep a record of everything you do from your first roll of color film, you will know whether an exposure indicated by a given exposure table or guide is correct for *your* shutter. If your results show up in transparencies that are too dark, you will know that your exposures were insufficient and that next time you will have to open up a half or full stop wider, or shoot at a slower shutter speed. If the slides are too light and washed out, you will have to reduce the stop or use a faster shutter speed.

USE OF AN EXPOSURE METER

These cautions are equally applicable to your use of a photoelectric exposure meter. The same factor of shutter performance enters into your calculations, and another is added: Exposure meters themselves vary in accuracy of light measurement and must be used carefully. If, for instance, you hold your meter in such a way that too much direct light

from the sky is allowed to enter the cell, you will get a reading that is *too high* for the subject you are photographing, and if you calculate your exposure on that reading your subject will be underexposed. *It is most important with an exposure meter to take your readings directly from the important subjects you wish to be correctly exposed in the picture.*

Recommended meter settings and filter recommendations for color film will be found in the table below. These have been revised in accordance with the latest information. Where the manufacturer's rating disagrees with the ASA rating, the system rating has been given to avoid exposure error. *Caution:* Do not interchange system ratings for color film. Exposure in color *must be exact,* and it is therefore unsafe to use an ASA rating on, say, an old GE meter not calibrated on the ASA system. In any case, the ASA ratings for *color* are merely approximations; no final *standard* determinations have as yet been made. The wisest course, therefore, is to make tests on your own methods of working, using the ratings given as a starting point.

Lighting for Color Photography

Whereas in black and white photography we are concerned mainly with light intensity and contrast, another factor enters into the problem of lighting for color—*the color quality of the light source.* It is because of this factor that manufacturers have had to make color films in two basic emulsions. Light itself has color, and its degree varies from light source to light source. This aspect of light is measured as its *color temperature,* and this measurement is stated as *Kelvin temperature,* named after Lord Kelvin, the great physicist. The difference in color temperature between daylight and tungsten light is so great, daylight being toward the blue-violet end of the spectrum and tungsten light toward the yellow-orange area, that two distinct emulsions balanced for those color temperatures have been devised. Daylight film is therefore balanced for *bright sunlight* whose Kelvin temperature is around 5600 degrees. *It cannot be used under tungsten light* except with a special blue filter over the lens. But this filter reduces the speed of the film by a factor of about four times.

Tungsten-type color film is balanced for use with light in the yellow-orange area and should be used only with lamps of a color, or Kelvin temperature, specified by the manufacturer of the film. In the case of the Agfachrome, GAF, and High Speed Ektachrome Professional films, for instance, the light source must have a rating of 3200° Kelvin.[4] A specially designed filter used over the lens renders tungsten film usable in

[4] Agfachrome professional films are all balanced for 3200° K when intended for *tungsten* use.

daylight. Unlike daylight-type film used with a blue filter, the tungsten-type emulsion, which is faster than the daylight type, does not in combination with the special filter lose sufficient speed to make it a problem, photographically.

Although these special filters are available to convert daylight film for use in tungsten light and tungsten film for use in daylight, *it is never advisable to do so except in cases of absolute necessity.* For best color results use film designed for the type of light under which you intend to use it.

There are many filters used in color photography for correcting the color temperature of the light. These are listed for all the popular color films below. Filters used in black-and-white photography *should never be used with color films (except to get special effects; not for color correction).*

FILTERS FOR COLOR FILM

(See also table for Recommended Settings, given earlier, page 492)

Wratten 1 (Haze)	Used with daylight Ektachrome sheet film type (E-3), and other daylight type Kodak films (unless contra-indicated by respective film instructions), to reduce bluishness in (a) pictures taken on overcast days, (b) pictures taken in shade under clear blue sky, and (c) distant scenes, mountain views, aerial photography.
Skylight (1A)	For use with daylight type Kodachrome II, Ektachrome X, Agfachrome, Dynachrome, and Fujichrome, to reduce bluish haze in distant scenes, on cloudy days, and for snow, water scenes, mountain and aerial photography.
Wratten 2A (Haze)	Used like Wratten 1, above, and permits use of Type B film with clear flashbulbs.
80A	Permits use of Kodacolor X a, Kodachrome II, Kodachrome X, Ektachrome X, and HS Ektachrome with ordinary tungsten home lighting lamps. Permits use of GAF Color Slide daylight type film with 3200° K tungsten and 3400° K photofloods.
80B	Permits use of Kodak and GAF Color Slide daylight films with photofloods (3400° K).
80B + 82A	Permit use of daylight GAF Color Slide film with (3200° K) tungsten lights.
81A	Permits use of Type B color films with photofloods (replaces CC13). Permits use of GAF Color Slide daylight type film with

electronic flash, Magicubes, flashcubes, and blue flash-cubes (interchangeable with UV15).

Permits use of GAF Color Slide (tungsten 3200° K) sheet film with (3400° K) photofloods. (Interchangeable with UV15.)

81C	Permits use of Type A color films with clear flash lamps, except SM, SF and M2. (*No filter is needed for Type A film with SM and SF flash lamps.*) Permits use of Type B color films [b] with clear flash lamps, except SM, SF and M2. *See instruction sheet packed with film.*
81D	Permits use of Type A color film with type M2 flash lamps. Permits use of GAF Color Slide Film (tungsten type, 3200° K) with clear flash lamps.
82A	Permits use of Type A color film with (3200° K) tungsten lights. Permits use of Kodacolor X color film with photofloods (3400° K). Use with daylight type Kodachrome, Ektachrome, Kodacolor, and GAF Color Slide Film, in early morning or late afternoon light, to reduce excessive redness. Also permits use of Kodacolor X daylight film with 3200° K photofloods.
85	Permits use of Type A color film in daylight. Reduces bluish haze in open shade or overcast, in distant scenes, mountain and aerial photography.
85B	Permits use of Type B color film,[b] GAF Color Slide Film tungsten (types 3200° K and 3400° K), and HS Ektachrome (tungsten) in daylight. Reduces bluish haze in open shade or overcast, for distant scenes, mountain and aerial photography.
85C	Reduces bluish haze in open shade or overcast. For distant scenes, mountain and aerial photography. Suggested for use with Ektacolor Type S [c] in daylight.
UV15	Interchangeable with 81A. Also used with GAF Color Slide daylight type film for *slight* haze correction, and for electronic flash. Used with GAF T/100 Color Slide Film (type 3200° K) for 3400° K photoflood.
UV16	Used with GAF Color Slide (daylight type) film for *medium* haze correction.
UV17	Somewhat denser than UV16. Used with GAF Color Slide (daylight type) film for *full* haze correction, and for aerial photography.

a Kodacolor X film is balanced for daylight, blue flash, and electronic flash. No filters are required when so used.
b High-Speed Ektachrome (tungsten type) is balanced for exposure with 3200° K lamps.
c Ektacolor film, type S (for short exposures, less than 1/10), has filter suggestions noted, for each batch of film, on data sheets packed in film carton.

FLAT LIGHTING IS BEST

Because of its high contrast, color film should always be used with fairly flat lighting, which means that shadows should be held to a minimum. In black-and-white photography we make our pictures effective by getting as much contrast into them as the limited scale of the printing paper will allow; hence, whenever we can, we use sidelighting and backlighting, working for roundness and long dramatic shadows. But in color we do the opposite. We keep shadows weak and we rely on the colors themselves to produce the effect of contrast, which would be lacking in black-and-white pictures lighted in the same way.

OUTDOORS

Always shoot with the sun behind the camera, outdoors, and you'll never have excessive contrast. If you shoot with the sun coming from an angle or overhead you'll get harsh, unpleasant black shadows which are the bane of color photography. If you want the sun coming from the side, it is necessary either to place a reflector on the shadow side of your subject to throw light back into those shadows, or to fill in the shadows with synchronized flash using a blue flashbulb designed especially for use with daylight color film. (See Item 17, *Some Exposure Hints;* refer to *index.*)

A photoelectric exposure meter is most helpful in keeping the range of contrast within the recommended limits of color film (a ratio of 1 to 4). It is simply a matter of taking two closeup readings of the subject— the brightest area and the darkest. If the latter is more than four times darker than the reading from the brightest color, the contrast range is too great for good color. But if you are not too critical, you will find that even if you violate this rule, you will often get pictures suitable for viewing and projection, *if not for prints.* A ratio of 1 to 6 or 1 to 8 may produce fair exposures, though there will be some deterioration in the shadow color. In general, though, *keep the contrast within narrow limits, making sure that everything important in the picture receives full illumination.*

On overcast and hazy days and when you are photographing a subject in the shade, or for distant scenes, mountain views, and high alti-

tude aerial shots, a haze filter should be used for daylight color films (see table of Filters for Color Film). These filters reduce the excessive blue in the light.

INDOORS

The same contrast principle applies to the indoor or tungsten-type films. Lighting should be relatively flat. But with artificial illumination this problem is simpler than it is in daylight since the lights are more easily controlled. The best setup is two lamps close to the camera, one on each side. If the main light is placed so that its light strikes the subject at an angle, the shadows cast by this light must be counteracted with a light placed near the camera. The shadow areas should receive at least one-fourth (by meter reading) the illumination reaching the high-lighted areas.

It is important to remember that indoors, backgrounds require attention, too. The light striking the subject falls off by the time it reaches the background with the result that the background, although it looks all right to the eye, turns out too dark and of indeterminate color. The remedy is to provide additional illumination for the background, of an intensity equal to that reaching the subject.

Here again the photographer has a variety of lighting arrangements at his disposal. But no matter what the arrangement, he should see to it that the shadows receive sufficient illumination to prevent them from going harshly black. The background, when it is neglected, becomes a large shadow area.

IMPORTANCE OF COLOR TEMPERATURE

In photography by artificial light it is important to keep in mind the color quality of the light source. Kodachrome II Professional (type A) roll film is balanced for use with 3400° K photoflood lamps. It should be used with such lamps. HS Ektachrome (tungsten) for 35mm and roll film, on the other hand, is balanced for 3200° K lamps, and should always be used with these. Such lamps are available in any photo-supply store. GAF T/100 Color Slide Film tungsten type and Ektacolor *type L* sheet film are also balanced for 3200° K floodlights, though the manufacturers suggest that each can be used under 3400° K photofloods with an 81A filter.

Color temperature of the light source is extremely important. Except for special effects, light sources of two different temperatures should

never be used together. With tungsten-type film in the camera it is fatal to mix daylight with artificial light. With daylight film, however, blue photofloods may be used as fill-in lights, for indoor subjects in which the main source of illumination is daylight. These blue bulbs are not recommended as the sole source of illumination with daylight-type film mainly because, as we explained previously, the blue dye reduces light intensity so much that extremely long time exposures are necessary.

Thus, in making color photographs indoors by artificial light, tungsten-type film should be used in combination with a light source of the correct color temperature. There are exceptions to this rule and the following table shows at a glance the color films that may be used in artificial light and the filters required to adjust the color temperature to the emulsion:

COLOR TEMPERATURE TABLE

| | | ILLUMINATION | |
| | | 3200° K | 3400° K |
FILM	TYPE	*Tungsten*	*Flood*
Kodachrome II	Daylight	80A	80B
Kodachrome X	Daylight	80A	80B
Kodachrome II Professional	A	80A	None
Ektachrome X	Daylight		80B
High-Speed Ektachrome	Daylight	80A	80B
High-Speed Ektachrome	Tungsten	80A	81A
GAF 64 Color Slide Film	Daylight	80A	80B
GAF T/100 Color Slide Film	Tungsten	82A	81A
GAF 200 Color Slide Film	Daylight	80A	80B
GAF 500 Color Slide Film	Daylight	80A	80B
Kodacolor X [a]	Daylight	None	80B
Ektacolor Professional Type S	Daylight and flash	80A None	80B
Ektacolor Professional Type L	Tungsten	T 64 ASA, 1/5 sec. plus exposure F 81A filter, 1/10 sec. plus exposure D 85 filter, 1/10 sec. plus exposure	

[a] Kodacolor requires clear flashbulbs indoors, or outdoors at night, but blue flashbulbs in daylight.

With this table you can quickly determine whether, and how, you can use 3400° K photofloods or 3200° K floodlights with a given type of film.

Color Fidelity

Since this chapter, of necessity, cannot be a complete treatise on color photography, material of an advanced technical nature has been omitted.

The main purpose has been to explore the field, tell you what materials are available, and explain how to use them. With reasonable care, existing color films are capable of yielding beautiful, natural-color transparencies, and the instructions given should prove an adequate introduction for the photographer who has not yet attempted this fascinating new photographic field.

Just as in radio the practiced ear is not satisfied with sets of poor tonal fidelity, so in color photography the practiced eye soon becomes critical of color fidelity. For such workers there is a wide field for experimentation. Existing color films, for example, are capable of high color response; when they fail, assuming correct exposure, it is usually due to departures from normal in the *color quality* of the light. If an emulsion is balanced for light whose color temperature is 3200° K, and the light source under which it is used has a color temperature of, say, 3000° K, then the resultant transparency will be somewhat warmer in color than the original subject, though perhaps not perceptible to the inexpert eye. If the color temperature is higher than it should be, the result will be cooler or bluer in color. There is an accurate way to prevent such fluctuations from the normal.

COLOR TEMPERATURE METERS

Variations in light-source color temperatures can be measured with an instrument called a *color temperature meter*. With this instrument, the actual color temperature of *any* light source, including daylight, can be measured. Daylight itself is constantly fluctuating throughout the day. When the color temperature of the light is known, it is then a simple matter to use a filter to bring it into line with the color temperature for which the emulsion you are using is balanced.

Such meters are made by Photo Research Corp. (*Spectra Three-Color Meter*), *Minolta Color Temperature Meter*, Gossen (*Sixticolor* meter), *Rebikoff* (distributed by Karl Heitz).

Harrison also manufactures an excellent, yet inexpensive, color temperature attachment for use with Weston and other exposure meters. For average use, however, such color meters are not essential, though helpful.

Color Photography with Photoflash

Because the best color emulsions are slow, flashbulbs are even more valuable in color photography than in black and white. It is practically impossible to photograph children and pets in color by ordinary tungsten light. To stop action, a shutter speed of 1/100 second is necessary; and, to shoot that fast, light of such intensity is needed as would cause discomfort to the subject. Flashbulbs solve the problem. With their flash of high intensity and short duration (1/100 to 1/200 second) the sudden unpredictable movements of a child or pet can be stopped on the film without blur. The quantity of illumination is so great that quite large areas may be covered with a single flashbulb.

Here again we must observe the rule of matching color temperature of light source with the type of film we are using. The color temperature of clear flashbulbs (those of all makers) varies from the temperature required for tungsten-type films, but filters are available to bring the Kelvin temperature of the flashbulb in balance with the emulsion.[5] These are listed in the table of *Flashbulb Guide Numbers* in the next section. The flashbulb manufacturers make *blue* flashbulbs especially for use with *daylight*-type films. Because the color temperature of these blue bulbs is correct, you will notice in the table on page 499 that they require no filter.

GUIDE NUMBERS AND EXPOSURE

The use of flashbulbs in color photography is exactly the same, mechanically, as it is in black-and-white photography. (This was discussed on page 293.) Flashbulbs may be used with a synchronizer or by the simpler open-flash method. In either case, aperture and speed settings are easily determined by means of the flash guide numbers system explained on page 298. Such information is usually supplied with the instruction sheet packed with the film, but it is more completely available in exposure guides published by the flashbulb manufacturers.

The table of *flashbulb guide numbers* that follows is used the same way as the table for black-and-white film in Chapter 10. The *guide number* is divided by the *distance* in feet (between flashbulb and subject) to get the *f/stop*. Similarly, the *guide number* divided by the *f/stop* will give you the *distance*.

[5] Kodacolor requires clear flashbulbs indoors, or outdoors at night, but blue flashbulbs in daylight.

The same principle observed for color photography in sunlight, and by photoflood illumination, applies also to flash. Contrast must be minimized. The simplest foolproof method of using flash is to use one bulb at the camera. This provides a direct, flat light, and a single bulb is ample to cover relatively large areas. In using a single bulb, it is important to place the subject close to the background, not farther away than one foot, in order to make certain that the single source of illumination does not fall off sufficiently to cause imperfect reproduction of the background.

USING MORE THAN ONE BULB

In using two or more flashbulbs it is essential that these be placed so that the light from each one balances the other. If one light is placed so that it overpowers the other, thus causing deep shadows, the resulting transparency will be poor. Judgment as to the relative distances of each lamp from the subject is developed with experience, but there is a more accurate way of setting the lights correctly.

By using the regular photoflood reflectors, the lighting setup can first be arranged with photoflood bulbs. In this way the effect can be inspected visually and the relative intensity of the light from each bulb as it falls upon the subject can be checked with the exposure meter. If the ratio is greater than 4 to 1, the lamp farthest from the subject should be brought closer until the correct ratio is established. When this is done you know that the contrast range of the lights is correct. You now remove the photoflood bulbs and replace them with flashbulbs, calculating your exposure on the basis of the distance of the main, or closest light, to the subject.[6] This distance is divided into the guide number of the flashbulbs you are using. It is essential, of course, that the photoflood bulbs you use for establishing the placement of your reflectors be of equal size, either two No. 1's or two No. 2's, and that the two flashbulbs likewise match each other. This procedure, remember, has nothing to do with *exposure;* it is merely a guide for arriving at correct *placement* of the lights.

The photoflash exposure guides, it should be remembered, are merely *guides* and cannot possibly be expected to yield accurate results in all cases. Here again one has to reckon with the variable factors of shutter behavior and individual judgment. The guide numbers have been calculated for average conditions, but conditions are not always average. A white-walled room will reflect more light than one painted dark blue or brown. It should therefore be remembered that the reflecting quality of the walls as well as the size of the room affects the exposure. Dark

[6] *Caution:* Do not use house current for flashbulbs (especially midget bulbs) unless manufacturer's instructions permit. Use a *B-C flash* setup instead. (See page 307.)

FLASHBULB GUIDE NUMBERS FOR COLOR FILM

For clear bulbs with tungsten *film* (*or filters*)

BULB	SHUTTER SPEED	KODACHROME X (80D) / GAF T/100 COLOR SLIDE FILM (85B)	GAF 200 COLOR SLIDE FILM (80D) / FUJICOLOR (80D)	AGFACOLOR CNS (80D) / KODACOLOR X (80D) / HIGH SPEED EKTACHROME T(85B)
M3	1/30 (X or F)	180	300	170
3–4″ polished	1/50 (M)	160	260	150
reflector	1/100 (M)	150	240	130
	1/200 (M)	120	200	120
	Focal Plane 1/125	100	160	90
5	1/25	170	340	130
or 25	1/50	150	300	120
4–6″ polished	1/100	130	260	100
reflector	1/200	110	220	90
SM	1/25	90	150	75
or SF	1/50	85	140	72
4″ polished	1/100	80	130	68
reflector	1/200	75	125	65
AG-1 or	1/25	90	130	70
Flashcube	1/50	70	110	55
	1/100 (M)	60	90	48
	1/200 (M)	44	75	34
Focal Plane				
6	1/25 or slower	170	260	130
or 26	1/50	150	225	110
4–5″ polished	1/75	125	175	85
reflector	1/100	90	110	55
2	1/25	280	450	220
or 22	1/50	220	350	170
6–7″ polished	1/100	200	300	160
reflector	1/200	100	225	130
Press	1/25	150	300	140
40(M)	1/50	130	260	125
6–7″ polished	1/100	110	220	100
reflector	1/200	90	170	85

(M) denotes M synchronization only.
For satin-finished reflector, use ½ lens opening larger.

FLASHBULB GUIDE NUMBERS FOR COLOR FILM

For blue bulbs with daylight *film*

BULB	SHUTTER SPEED	KODACOLOR X FUJICHROME POLACOLOR	HIGH SPEED EKTACHROME GAF 200 COLOR SLIDE FILM	EKTACHROME X KODACHROME X
M-2B 3″ polished reflector	1/30 or slower X-F setting	75	130	65
M-2B 4″ polished reflector	1/30 or slower X-F setting	50	100	45
5B/M3B or 25B 4″ polished reflector	1/25 1/50 1/100 1/200	60 50 46 40	150 130 120 100	95 80 75 65
Focal Plane 6B/26B 4–5″ polished reflector	open 1/50 1/75 1/100	110 85 75 55	190 175 130 95	95 85 65 48
Flashcube or AG-1B 2–3″ polished reflector	1/25 1/50 1/100 1/200	70 55 46 36	130 95 80 65	65 48 40 32
SM SF 4″ polished reflector	1/25 1/50 1/100 1/200	65 65 60 55	50 50 45 40	40 40 35 32

Note: *No filter needed when using blue bulbs with daylight film.*

walls *absorb* a lot of light, white walls *reflect* light, and a large white-walled room will not reflect as much light back to the subject as will a small light-walled room. Photography will never be so simple that guide numbers or gadgets will completely eliminate the factor of human judgment.

Color Prints

The thrill of capturing a scene *on reversal film* (for color projection) is exceeded only by the thrill of recording such a scene in vibrant

color *on paper*. Advances in photographic technology are making it easier for the amateur to confound the skeptics by producing color prints that resemble *carbros* (see *index*), and this without having to spend a fortune for equipment or a whole day making one print.

Color photography has come of age.

And here are some of the reasons:

1. The new, improved *Kodacolor X*, which is faster, better color-corrected, and sharper than the old film which it replaces. It can also be used to make negatives from positive transparencies.

2. *Ektaprint C* for making brilliant color prints with a single exposure from Kodacolor X and other *negative* color emulsions. Can be processed at home. One of the most useful accessories for this kind of color photography is Kodak Data Book E 66: *Printing Color Negatives.*

3. *Ektachrome RC Paper* for making excellent color prints with a single exposure from *Kodachrome II* and other *positive* transparencies. The RC in the name refers to a *resin coating* on both sides of the paper which gives the print greater durability and less curl, while making it more resistant to water and chemicals during processing.

4. *Ektacolor* roll and sheet film, which can be processed at home, and is used mainly as an intermediate, or *internegative*, film in the preparation of color transparencies on Ektacolor Print Film (sheet).

5. *Unicolor Print System* (with *Uniguide Calculator, Unidrum,* and *Uniwheel Filter* set). Makes the *"lights-on"* processing of color *prints* from color negatives as easy as black-and-white. Also simplifies the processing of color *negatives*. All containers are color coded. For information, write to Unicolor, Photo Sciences Division, KMS Industries, Inc., Ann Arbor, Michigan 48106.

6. *Color Canoe.* Dreamed up by Robert Mitchell and manufactured by Heath, this ingenious color print processor makes darkroom printing of color materials a joy. The Color Canoe is marketed by Allied Impex Corp., Photo Division, Carle Place, N.Y. 11514. *Nikor* also offers a stainless steel *rocking print tray*, distributed by Honeywell.

7. *Kodak Drum.* Officially known as the *Kodak Rapid Color Processor*, Model 11, this compact, motorized, stainless steel drum processor can produce an *Ektaprint C* color print in about 7½ minutes. The secret is in the new chemistry (CP-5) and the 100° F. temperature. The rotating drum turns at 200 surface feet a minute, lapping up solution from a shallow tray which is washed over the print surface. The print is kept in place by a webbed nylon blanket. See illustration.

There are other processing drums now on the market. The best among them is the Arkay *Color-Pro*, a self-contained unit which accommodates all papers and chemistry systems. It has visual temperature control, and comes complete with all you need, for about $50. Write to

KODAK DRUM. Officially named the *Kodak Color Processor Model 11.* It can produce an *Ektaprint C* color print in less than eight minutes. *See text.*

Arkay Corporation, 228 South First Street, Milwaukee, Wisconsin 53204.

8. *The FR Mini Darkroom Kit* for printing from color *negatives.* Includes 25 sheets of color paper, all the necessary chemicals, 15 printing filters to assure color balance, a stainless steel thermometer, and a one-shot drum processor complete with instructions.

9. *Color Printing Without Fuss or Fury.* Talk about simplifying photography! With the *Rapid Access* method of printing from color *negatives* (RAP), the total processing time at the recommended 85° F. comes to only 10 minutes; at 75° F., the cumulative time is only 20 minutes! You can use either the Kodak *Drum,* the *Arkay Color-Pro,* the *Unidrum,* the Heath *Canoe,* or the RAP *One-Shot* drum for processing. The seven steps include a presoak, the developer, a quick wash, the short stop, bleach and fix, another wash, and then the stabilizer. The safelight suggested is the Wratten 10 (dark amber). For information, write to Technology Incorporated, RAP Division, 951 Brook Avenue, Bronx, N.Y. 10451.

Before the amateur can get the most from all this wonderful stuff, he has to make sure his enlarger has the proper white light, that the light remains constant by the use of a preset or variable voltage control transformer, and that he learns how to use the Color Compensating Filters made to help control color value and intensity.

EKTAPRINT C PAPER (FORMERLY EKTACOLOR C)

This excellent material is a multilayer paper which was designed for direct printing or enlarging from Kodacolor and Ektacolor *negatives.*

It can be exposed with ordinary enlarging equipment and processed with ordinary darkroom equipment. When care is taken, the color reproduction possible with this material compares favorably with that obtainable through the Dye Transfer Process, explained below.

Ektaprint C is a sandwich of three emulsions, sensitive to blue, green and red light, coated on a medium-weight paper base. The emulsion surface has a fairly high gloss, which permits the prints to retain a long tonal range. It is available in sheets (from 8 x 10 to 30 x 40 inches in size) and in rolls (from 3½ to 40 inches wide, and from 50 to 250 feet long). To protect it against deterioration, it should be stored in a refrigerator at 50° F. or lower. It can be handled for a limited time under a safelight fitted with a Wratten Series 10 filter.

There are two methods of exposure: by a single *white light* exposure, or by three successive exposures through tricolor (red, green, and blue) filters. Prints of excellent quality can be made by either method.

EKTAPRINT RC (FORMERLY EKTACHROME RC)

This can be used in very much the same way as *Ektaprint C*, above, except that it is a reversal color-print material designed to yield prints by either contact or enlargement from *positive* color transparencies. It can also be handled under a Series 10 (dark amber) safelight filter, with a bulb of between 15 to 25 watts, preferably with the light used indirectly. For full information on how to test your safelight, write to the Sales Service Division of Eastman Kodak, Rochester, N.Y., for free pamphlet K-4, *How Safe Is Your Safelight?*

EASTMAN DYE TRANSFER PROCESS

The best and most difficult color printing process is *Carbro*, which requires about eight hours to make one print. The *Dye Transfer Process*, a simplification of wash-off-relief, shortens this time considerably, and simplifies the method. Here, briefly, is the way it works:

Three separation negatives must first be made either directly from the subject in a one-shot camera, or from a color transparency. The negatives are printed, by contact or projection, on Kodak Matrix film. Each exposed film is then processed to obtain a relief image in gelatin— the actual thickness of the gelatin varying in accordance with the density of the image. The relief films, known as matrices, are soaked in appropriate dyes. The amount of dye taken up by each matrix is proportional to the height of its relief image. The dyes are then transferred from the matrices to a sheet of Kodak Dye Transfer Paper by successively placing them, gelatin side down, in contact with the paper. Registration of the

images is obtained mechanically through the use of a *Kodak Dye Transfer Blanket*. The three dye images combined on the paper form the final color print.

Prints resulting from this process compare favorably with *Carbro*. They are excellent in color fidelity and brilliance.

GAF ANSCO PRINTON (REVERSAL COLOR PRINT MATERIAL)

GAF Ansco Printon solves the separation negative problem by incorporating the color separations (*tripack*) in the material itself in the same way that it is done in color film. Prints can be made with it by contact or enlargement in a single exposure, just as with black-and-white printing paper. Instead of a negative, a color transparency is placed in the negative carrier, and is then projected directly to the sheet of Printon on the easel. Printon is processed with the chemicals supplied in the GAF Ansco Printon Developing Outfit.

Although any ordinary enlarger or contact printer may be used without radical adaptation, the process requires the use of color filters to adjust the color quality of the exposing light. Ansco heat absorbing glass is also necessary for enlargers not already equipped with such glass. There are eleven filters available, and these are used at one time or another for the purpose of achieving correct color balance in the final print. It is this problem of color balance which makes the use of Printon far trickier than making black-and-white prints on ordinary sensitized papers.

In making color prints by direct exposure on Printon, the worker has to contend with color temperature as he always does and always will in color photography. A tungsten enlarger or printer lamp operating at a color temperature of approximately 3000° K, such as a GE #211 or #212, is recommended. A light source that varies from this standard can be used, but that requires correction by means of filters.

COMPENSATING FILTERS

Each package of Printon comes with a label that gives the specific color compensating filters needed for that emulsion. These filters are used simultaneously with the GAF heat-absorbing glass and the UV16P or Wratten 2B filter. This combination, says GAF, should yield a print of *approximately* the correct color balance. This combination is also recommended as a guide for test exposures. But such are the vagaries of color that one always has to contend with these perversities: the quirks of individual optical systems, the color of condensing lenses, the fluctua-

ENLARGERS FOR COLOR PRINTING

The Super Chromega B-8, with two interchangeable light-integrating spheres for shortening exposure times. For all negatives, color and black-and-white, to 2¼ x 2¾. Has a 150-watt, 24-volt Tungsten Halogen lamp for condenserless enlarging. Three one-piece color filter discs (cyan, magenta, and yellow) provide completely stepless color filtration over entire density range (0–180), and are controlled by color-coded knobs.

The Super Chromega D-4, for all film sizes to 4 x 5. Has three interchangeable light-integrating spheres, and accommodates three auto-focus cams simultaneously for *automatic focusing* of all film sizes.

tions of line voltage which changes the color of light, and the alterations in color which occur progressively with the aging of the lamp itself. The use of filters for these corrections is covered in GAF's own instruction material, and although somewhat complicated, can easily be followed.

The processing of Printon is similar to the method used for GAF Color Slide transparencies, and it takes about an hour. *Cleanliness and accuracy of time and temperatures are absolutely essential.*

SELECTING TRANSPARENCIES FOR PRINTING

For best results with any color printing process, accurately exposed transparencies of normal contrast are needed. Such transparencies should have no black or very dark underexposed areas, the colors should be rich, and the flesh tones should be warm. If the transparency is thin and pale, it will not make a good print, since the printing process tends to dilute colors under the best circumstances. Slightly underexposed transparencies in which the contrast is not excessive, and in which there is good detail and color in the shadow areas, usually make the best prints. Transparencies made in flat, evenly distributed light make better prints than those in which side lighting created strong, contrasty shadows. Shadows will always print darker than they appear in the transparency. Needless to say, good prints cannot be made from transparencies that are not sharp.

Storage of Color Film

The reader should be cautioned that the dyes in existing color film are not permanent.[7] If pictures are intended as permanent records, they should be made on black-and-white film. Color films are adversely affected by heat, light, and moisture, and these factors can destroy the film both before and after it has been exposed and processed. Excessive heat and humidity will deteriorate the structure of the three emulsion layers in unexposed film and so result in defective colors in the final picture. Therefore, after film is purchased *it should be stored in the coolest and driest place in the house.* Damp cellars and other humid locations should be avoided. Home refrigerators usually have a high humidity percentage, and it is advisable, should it be necessary to store film there, to enclose it in an airtight plastic container.

Excessive heat rather quickly affects color film. Storage near steam pipes, in top floors of uninsulated buildings during the summer, or in automobile glove compartments, should be avoided. Eastman Kodak Company recommends maintenance of the following storage temperatures:

For storage periods up to	2 mos.	6 mos.	12 mos.
Keep film below	75° F.	60° F.	50° F.

Whereas black-and-white film may usually be kept for long periods after the date of expiration stamped on the package, it is best to expose color film *before* that date if satisfactory color is to be assured.

[7] With the exception of Cibachrome, that amazingly durable Swiss film described on page 488.

COLOR TEMPERATURE METER

This *Minolta 3-Color Temperature Meter* is one of the latest in the field. It has been designed to measure the precise color temperature of *any* light source, daylight to fluorescent. It can simultaneously measure the color temperature of different kinds of light, from a single source or from a blend of sources. It gives direct readings for the correct balancing filters. A special feature is its exclusive use of *blue silicon cells* which are said to be more sensitive and faster reacting than selenium or cadmium sulphide cells. To facilitate one-hand operation, a single switch activates the meter; the indicator needle locks when switch is released. To make it easier to use from a fixed position, the flat *incident* receptor rotates 330° on its axis. The Minolta Color Meter can also be used as an ordinary exposure meter. Zero adjustment screw and battery check button are built-in. The hermetically-sealed transistor circuit requires no warm-up.

After exposure and processing, color transparencies should likewise be kept in the coolest and driest place in the house. While the colors can maintain their richness for long periods under adverse conditions, they will last for many more years if properly stored. Keep them out of the direct rays of the sun, and avoid excessive exposure to heat in viewers and projectors. Do not purchase projectors which are not equipped with heat-absorbing glass between the lamp and the slide carrier, and do not allow a slide to remain in the projector for more than a minute and a half. Excessive exposure to heat will soon cause the colors to fade.

The foregoing warnings are also applicable to *GAF Printon, Ektacolor Paper,* and *Ektachrome Paper,* prints of which should not be exposed for long periods to sunlight. If they are to be framed, hang them on a wall which is shaded from direct sunlight.

A Color Miscellany

Odds and ends of color technique that you will want to know about: how to *correct* color prints, how to *add* color to a black-and-white print, Willi Beutler's universal *negative* color developer, how to make good black-and-white *slides* and *prints* from color *negatives* and color *transparencies,* how to make color *negatives* from color *transparencies* (and

vice versa), how to *copy* color *transparencies* or *negatives,* and how to make color prints from color negatives and transparencies using a *spray developer.*

CONVERTING A MONOCHROME PRINT TO COLOR

Now that *Flexichrome* has been discontinued by Kodak (leaving only the dyes), your best bet for correcting color prints, coloring black-and-white prints, and retouching monochrome prints, is something called *Hibadye,* a system of tone and color control that uses 16 dyes (14 colors plus a warm and a cold tone black dye for retouching black-and-white prints). In addition, there is a *regulator* that dilutes dyes and conditions the print surface, a *color remover* for getting rid of unwanted dye, and a *cleaner* for removing traces of the undesirable whatevers that may be left on the print. For information about this useful process write to *Paul N. Jamieson,* Jamieson Products Co. (who also manufactures *Etchadine*), 9341 Peninsula Drive, Dallas, Texas 75218.

COLOR TONERS

Prints and slides can be toned almost any monochrome color by the use of special toning baths. There are three possible methods of toning: 1. by direct development, 2. by the use of inorganic salts (metal tones) which replace the silver image, and 3. by toning with dyes.

If you want to avoid making your own chemical baths, you can buy prepared toners in liquid or powder form from *Edwal* (5 colors, all in liquid form: red, brown, yellow, green, and blue), *FR, Kodak,* and others (see your camera dealer for what's currently available).

If you like to make up your own solutions, you can get the necessary formulas from *Kodak, Ilford, Agfa-Gevaert, GAF Ansco,* or from the *Photo-Lab-Index.* Agfa-Gevaert, for instance, has a brown toner (G411), a blue-green toner (G416), a gold toner for red chalk tones (G418), and a hypo-sulfide toner for brown tones (G420). You can also find formulas and instruction on the use of red, blue, green, and sepia toners in chapter 14 of this Handbook: *Printing and Enlarging.* (See *index, toning of prints.*)

NEOFIN COLOR TECHNIQUE FOR NEGATIVE FILM

Anyone who has ever used Willi Beutler's exceptional negative developer, *Neofin Blue,* will be interested in his new formula for processing color negative film: *Neofin Color.* It is a universal *one-time-only* developer that can be used in regular developing tanks for Agfacolor CNS,

Kodacolor X, Ektacolor S, and Ektacolor L (a 5-step process for Kodak film; a 4-step process for Agfa film). Among its other virtues, it increases the normal emulsion speed of film (Kodak film, for example, from ASA 80 and 100 to ASA 200 and 250). Even higher speeds are possible, but at the cost of greater contrast and grain size.

The developer is smartly packaged in a sealed glass ampule (similar to that now used for Neofin Blue), the top of which is easily snapped off for use. Manufactured by the house of *Tetenal* in Germany, it is distributed in the United States by *Studiophot Co.*, 1032 Carnegie Avenue, Cleveland, Ohio 44115, to whom you may write for information.

BLACK-AND-WHITE PRINTS FROM COLOR NEGATIVES

If you have a color negative (like *Kodacolor X* or *Ektacolor S*), it is no trouble at all to produce a positive print that holds middle tones the way a color emulsion does. All you have to do is use Kodak's *Panalure*, or the new *GAF Panchromatic Paper PP-763* (fast, neutral tone, glossy), or *GAF PP-675* (a warmer tone, mat finish version). The recommended safelight for these is a Kodak Wratten Series 10 (dark amber). The negatives listed above have colored couplers which provide automatic masking for color correction, but this interferes with printing on regular monochrome papers (warm colors are rendered too dark; cold colors, too light). Panalure, and the GAF Panchromatic PP-763 and PP-675 papers, are especially sensitized to give a better rendering of these colors in tones of gray.

BLACK-AND-WHITE PRINTS FROM COLOR TRANSPARENCIES

To make a black-and-white print from one of your reversal (positive) color slides, you need a *direct positive paper*. Such papers are manufactured or distributed by the following: Eastman Kodak Co., 343 State Street, Rochester, N.Y. 14650; Anken Chemical & Film Corp., Williamstown, Mass. 01267; General Photographic Supply Co., 307–11 Cambridge St., Boston, Mass. 02114; Peerless Photo Products, Inc., Route 25A, Shoreham, N.Y. 11786. Write to them for information on what they have available, and a price list.

BLACK-AND-WHITE SLIDES FROM COLOR TRANSPARENCIES

You can make a monochrome slide (positive transparency) from a color slide in one of three ways:

1. *By contact*. Use either 35mm emulsion, or sheet film (back to back, emulsion sides touching). You will have to remove the slide from its readymount or glass mount.

2. *By using your enlarger*. Place the transparency in the negative carrier upside down (emulsion side toward enlarger lamp) and project at 1:1 (same size) ratio.

3. *By using your camera*. This becomes easier if you have a single-lens reflex. You'll have to rig up a method for 1:1 photography. And using daylight, diffuse it with a piece of opal glass, to which you can tape the slide.

The best film to use is a slow panchromatic like *Panatomic X*. Rate it at ASA 64, and develop in *Acufine, Diafine,* or *Microdol X*.

COLOR NEGATIVES FROM COLOR TRANSPARENCIES

The method is the same as that given above (for making black/white slides from color transparencies), except that you substitute *Kodacolor X* for *Panatomic X*. Use an ASA rating of 80/64, depending on whether you expose by daylight or tungsten. And either develop it yourself, using the *Neofin Color* or *Kodak Process* C-22 techniques, or send it out to be processed.

COLOR TRANSPARENCIES FROM COLOR NEGATIVES

The method of exposure is similar to that used for making black/white slides from color transparencies (see above) except that the slides are made on *Kodachrome II* or *Kodachrome X*, for reversal processing by Kodak or a licensed lab.

If you want to do the processing yourself, expose the slides on *Ektacolor Slide Film* 5028 (35mm) or *Ektacolor Print Film* 6109 (sheet), and use the *Neofin Color* or the *Kodak Process* C-22 techniques for developing negative film. You'll have to do this in total darkness.

Here are some color labs licensed by Kodak to process your *reversal* film if, for some reason, you don't want to send it to Rochester: Authenticolor Labs, Inc., 525 Lexington Ave., New York, N.Y. 10017; Berkey K & L Color Service, 222 East 45 St., New York, N.Y. 10017; Modernage Photographic Services, Inc., 319 East 44 St., New York, N.Y. 10017.

You can also send your *Ektacolor Print* or *Slide Film* to these same labs.

COPYING COLOR TRANSPARENCIES OR NEGATIVES

You can duplicate your color slides or negatives, altering or cor-

recting them as you do so (for color or contrast), with any one of the many duplicators now on the market. You can also make monochrome copy negatives, from which you can later make prints.

Special mention must be given to the ingeniously constructed Honeywell *Repronar 805*, which was designed to make this job easy (if somewhat expensive at the start). The Repronar consists of a special single-lens reflex camera, that moves on a helical rack. A variable-powered electronic flash unit is built into the rugged base, as well as an incandescent light source, an easel with slide and filter holders, and an adjustable exposure calculator. Color correction, multiple exposures, and tilt adjustments are possible. Accommodates 2 x 2 and 2¼ square sizes.

There are other and less expensive units available from these sources:

Accura, from RH Division of Interphoto Corp., 45–17 Pearson St., Long Island City, N.Y. 11101

Alpha and *Color Contact*, from Karl Heitz, Inc., 979 Third Ave., New York, N.Y. 10022

Topcan Model II #528, from Beseler Photo Marketing, Inc., 219 S. 18th St., East Orange, N.J. 07018

Minolta, which attaches directly to the track of the Minolta bellows, from Minolta Corp., 200 Park Ave. S., New York, N.Y. 10003

Miranda Optical, for all SLR cameras. Same-size duplication of slides or negatives, for use with daylight, electronic flash, photo flash, or whatever. From Allied Impex Corp., 168 Glen Cove Rd., Carle Place, N.Y. 11514

Rollei 2¼ Square, for Rolleiflex SL66. Holds transparencies from 1¾ x 2¼ to 2¼ square.

Rollei 35mm, for Rolleiflex SL66. Similar to above but for 2 x 2 slides. Holds transparencies from 12 x 17 to 24 x 36mm. Both from Rollei of America, Inc., 100 Lehigh Dr., Fairfield, N.J. 07006

COLOR PRINTS FROM A SPRAY CAN

Aeroprint, the monochrome spray developer that jumped the Atlantic and started to revolutionize printing and enlarging techniques in the United States (see page 414), is responsible for two more darkroom miracles:

1. A three-stage spray process for making color prints from color *negatives*.

2. A four-stage spray process for making color prints from color *transparencies*.

The chemistry for both processes is the same, except that in the second process (for transparencies) the original Aeroprint developer is also used.

Among the advantages of this new process for making spray color prints from transparencies are such considerations as these: *no inter-negatives, cold water washing* (no worry about temperature control), a total processing time of *less than half an hour, no need for trays,* and *no filters.*

While filters are not needed, they *can* be used to correct or change the color values of the original transparency. And working *positive to positive,* the picture on your easel will tell you whether you need filtration, and how much. What you see there is a projection of your natural color transparency as it will appear on the final print, not reversed, as it would be if you used a *negative.*

All you need to make color prints from color *transparencies* are some good color slides, an enlarger, a working surface no more than a foot square (for 8 x 10 prints), a dark amber No. 10 safelight, some *reversal* color paper (Kit A for Kodak, GAF, and similar papers; Kit B for Agfa, Unicolor, Rapid Access, and similar papers), the Aeroprint 3-stage Aerosol Color Kit, the black-and-white Aeroprint developer, and some time.

The only *caution,* repeated by all those who have used this new color process, is *"Keep your print wet."*

That's all there is to it.

To make color prints from color *negatives,* you use the three-stage spray process, but with a direct paper like *Ektaprint C* instead of a reversal paper like *Ektachrome RC.*

For more information write to Aeroprint Products USA, Inc., 27 Bland Street, Emerson, N.J. 07630; or in Great Britain, to D. J. Photographic Developments Ltd., Aeroprint Division, Wharf Way, Glen Parva, Leicester, England.

THE SLIDE SHOW

One of the nice things about photography is the many ways you can enjoy it. If you're a loner, you can preview your transparencies on your own version of a desert island, with a small slide viewer like the ones GAF makes (which work on pen-light batteries or an AC transformer). Or, you can throw a party for friends, bolt the doors, and give a sneak slide show. But here are a few cautionary hints.

1. Keep the show mercifully short. One Carousel tray of 140 slides is about the outside limit. After that, your captive audience will start to get restless. Leave them *wanting* more.

2. Sort out your slides *before* you put them in the tray. Discard the weak shots, weed out the duplicates, arrange them in some sort of meaningful order.

3. Prepare a tape-recorded commentary to run along with the slides. This need not be synchronized. A simple way to do it is to go through the slides and make notes. Then, set the projector for a comfortable interval between slides, and start recording. If you need more time for a special anecdote, turn from automatic to manual, tell your story, and switch back. But remember to do this at the actual showing or the slides will make a mess of your now-unsynchronized tape. Incidentally, you can also add music.

Getting ready for a show is easier with a *slide sorter*. Eliminating duplicates, selecting the best in a series, arranging them by subject, by time, or by place, all become a snap when you edit your slides on a sorter.

There are two kinds:

The electric type, made of embossed white plastic, held at a 45° angle by two metal side supports that swing out from a metal casing for use. The slides rest flat on the plastic, held there by five horizontal ridges. Behind the plastic is a receptacle for a 60 watt bulb which illuminates the slides. Each of the five rows holds eight slides, so 40 can be viewed at one time. A good example is the *Slide Sorter* (*Model SS40*) manufactured by Smith-Victor Corp., Griffith, Indiana 46319. Available from any camera shop, or from Treck Photographic at 1 West 39th Street, New York, N.Y. 10018. Cost, about $6.

The non-electric type, also made of embossed white plastic, but the grooves are deep enough to hold the slides upright, at an angle of about 75°. The sorter is placed flat on a table and lighted from the back, or overhead. This one holds 36 slides. Available from your camera store, or from Treck Photographic. Made by B-W Manufacturers, Inc., Kokomo, Indiana 46901. Cost, about $2.

COMBINATION CONTAINER-VIEWER FOR SLIDES

At least one firm (*Technicolor*) which processes 35mm color slides is alert to the needs of the amateur photographer. They return your transparencies in a clever black-and-red plastic container that has a lens embedded in the bottom section, with four prongs cut out at the other end to hold a slide. By snapping a slide to the pronged end, and looking through the enlarging lens, you can aim the container at a light source (sky or bulb) and use it as a viewer. For more information write to Technicolor, Inc., Consumer Products Division, P.O. Box 4, Springfield, Mass. 01101.

BLACK/WHITE SLIDES AND NEGATIVES FROM ONE FILM

Now you can have a *slide* for projection, as well as a *print*, by using one film. The film is 35mm *Panatomic X*. You can use it normally to produce a *negative*, from which you can make a print. But by *reversal processing* in Kodak Direct Positive Film Developer you can also get a monochrome *transparency* for projection. The speed of Panatomic X when it is processed for reversal becomes 80/64 as against 32/20 when it is developed as a negative. You can also use Kodak *Direct Positive Panchromatic Film 5246* in the same way, but you have to buy it in 100 foot rolls. For detailed information on these reversal films, write for a *free* copy of *Formulas and Processing of Kodak Direct Positive Panchromatic Film, 35mm* (Kodak Pamphlet J6, Dept. 412-L, Eastman Kodak Co., Rochester, N.Y. 14650.

The entire process has to be done in the dark. Re-exposure, as with color, is not needed.

Using Panatomic X and the Direct Positive developer, you can also make monochrome transparencies at ASA 64 from *cinema* or *television* screens.

Some Recommended Books on Color Photography

Color Photography Indoors (Kodak Color Data Book E76)
Color Photography Outdoors (Kodak Color Data Book E75)
New Adventures in Indoor Color Slides (Kodak Photo Information Book AE7)
New Adventures in Outdoor Color Slides (Kodak Photo Information Book AE9)
Simplified Color Printing (Kodak Bulletin C53)
Flash Pictures (Kodak Photo Information Book AC2)
Enlarging in Black and White and Color (Kodak Publication G16)
Printing Color Negatives (Kodak Data Book E66)
Kodak Color Data Guide: Exposing, Printing, Processing (R19) Including Gray Card, Gray Scale, Color Control Patches, Processing Steps & Chemicals E-3, C-22, E-4, Ektaprint R, Ektaprint C, CP-5, CP-100, C-22, Standard 35mm Negative and Color Print, Color Printing Methods 1 and 2, Color-Print Viewing Filters, CC Filter Computer, Color Printing Method #3, Color-Printing Computer, Exposure Adjustments for Filter-Pack Changes, Printing on Ektacolor Print Film, Printing on Kodak *Panalure* Paper, Printing on Kodak *Ektachrome RC* Paper.

Adventures in Outdoor Color Slides (Kodak Publication E9)

Color as Seen and Photographed (Kodak Data Book E74)

Kodak Color Films (Kodak Data Book E77)

Filters for Black and White and Color Pictures (Kodak Information Book AB1)

For information on above, write to Dept. 454, Eastman Kodak Co., Rochester, New York 14650.

Colour Films by C. Leslie Thomson, Chilton Book Co. (4th revised edition)

Color Printing by David A. Engdahl, Chilton Book Co. (3rd revised edition)

Colour Prints by Jack H. Coote, Focal Press Ltd. (3rd revised edition)

Color Photography Now by Arthur Rothstein of *Look*, Amphoto-Chilton

Better Colour with Walter Bensen, Morgan & Morgan

Photographing Color with Walter Bensen, Fountain Press

Free Pamphlets

The following pamphlets may be obtained *free* by writing to the Sales Service Division, Eastman Kodak, Rochester, N.Y.; or to Customer Service, GAF Ansco, Inc., Binghamton, N.Y. These lists change from time to time. If an article or booklet has been discontinued or is out of stock, others may come into print. Ask for a list of what is currently available on the subjects that interest you. These pamphlets are produced to make the products of the manufacturer easier to use, and more appealing. If you are a serious amateur photographer, they want you to have them.

Color Prints with the Kodak Dye Transfer Process (Kodak E65)

Color Separation Negatives for Kodak Dye Transfer (Kodak E64)

Retouching Color Separation Negatives (Kodak E67)

Retouching Dye Transfer Prints (Kodak E69)

Retouching Ektacolor Negatives (Kodak E71)

Flower Pictures in Color (Kodak C12)

How to Take Bird Pictures (Kodak C29)

List of Kodak Publications and Photographic Aids (Kodak L8)

Making Duplicates on Miniature Kodachrome Film (Kodak E33)

Prevention and Removal of Fungus Growth on Film (Kodak E22)

Processing Ansco Color Sheet Film, GAF Ansco, Inc.

Exposing and Processing Ansco Color Roll Film, GAF Ansco, Inc.

Making Color Prints with Ansco Color Printon, GAF Ansco, Inc.

Processing Formulas for Ansco Color Film, GAF Ansco, Inc.

AND SO FORTH. A Rolleiflex picture taken with a light green (X1) filter on Plus X film developed in Microdol X.

19 Hints and Suggestions

1. The simplest 126 cartridge cameras (today's box cameras) have shutter speeds of 1/40 or 1/50 second and usually an f/11 aperture.

2. A piece of sponge rubber such as you can get at the dime stores will make it easier for you to jiggle and bounce your tank around as you agitate it; this is a good thing to do even with those tanks that have a twirler in the center spout.

3. If you're apt to forget what kind of film you loaded into the camera, and you have the type camera that has an accessory clip on top, fit a little card into this clip marked with the film you are using.

4. To clean stained trays pour in some acetic acid solution, add a little saturated potassium permanganate solution, empty and refill with old hypo solution, then wash thoroughly.

5. To keep an accurate check on the temperature of chemical solutions in your darkroom, keep the thermometer standing in a bottle of water near the other chemicals. A glance at the thermometer will tell you instantly the temperature of all solutions in the darkroom.

6. Film hung up to dry *horizontally* (instead of *vertically*) dries

more evenly. Use wooden clips, which grip film by the edges and hang the clips on a horizontal rod or taut wire.

7. Developing solutions are likely to be mixed with air (and oxidized) when poured in the usual way. A better method is to use a stirring rod, touching the lip of the pouring vessel to the rod (which rests in the receiving vessel) and letting the solution run smoothly along the rod into the container below.

8. If you have trouble cleaning developer bottles, pour a nickel package of BB shot into the bottle, add some soapy water, shake well, and rinse. The shot can be reused.

9. Kodalk makes an excellent hand cleaner. Sprinkle a little on your wet hands, rub well, and rinse.

10. Don't leave film in your camera too long, especially in hot weather; fog, grain, or streaks may develop. And if you are using color film, do not leave it in the camera partially used for longer than a week, especially in hot or humid weather; the colors may not come out the same at both ends of the emulsion. Plan your picture expedition so that you can use up full rolls; if there are a few blanks left over, use them for the experimental shots you have always been meaning to do.

11. To preserve developers in trays, cover with Dow *Saran Wrap* plastic film, or *Handi-Wrap* (the kind they sell for kitchen use, in rolls). Place the plastic gently on top of the solution. The plastic will cling to the sides. If airbells form, move them to the edge and expel. Preserved in this way, developers can be kept for twenty-four hours or longer.

12. To cool chemical solutions quickly, pack a test tube or plastic bag with ice and salt and use it to stir the solution.

13. To preserve print developers that are kept in half-filled bottles, blow some carbon dioxide (from your lungs) into the bottle. The carbon dioxide will form a protective layer over the surface of the solution and seal out the air that oxidizes it. Chemists object to this crude method on the basis that carbon dioxide converts sodium carbonate to sodium bicarbonate, which is true. But experiments conducted by Eastman Kodak show that the bicarbonate acts as an antifogging agent, so decide for yourself. I've preserved my D 72 in this way—with the result that the stock solution has never discolored, and there's no perceptible difference between the action of a fresh solution one hour old, and a stored solution six months old. At any rate, I've made the necessary tests and have proved this to my own satisfaction.

14. To avoid fogged negatives with film-pack cameras: (1) don't tear off the tabs; just fold them out of the way until you get ready to develop them; (2) keep direct sunlight away from the tab end of the film-pack; cover it with a hat or a newspaper or anything else that's handy. Incidentally, film-packs now offer 16 exposures, instead of the previous dozen.

15. Always dissolve acids *in* water, never the reverse, otherwise they may bubble over with explosive violence, throwing hot acid solution into your face.

16. Don't leave your enlarger uncovered. It will collect dust and grease, neither of which is good for it. Make a dust cover, or buy one of the ready-made kind.

17. Acquire the habit of washing up all darkroom equipment right after each developing session. *Leave nothing for tomorrow!* This may seem hard·at first, but it's the only sensible way to work.

18. Too much washing of film is almost as bad as none at all. Five to ten minutes, with rapid flow of water, is usually sufficient.

19. *Desiccated, anhydrous* and *dry,* used interchangeably in chemical formulas, all mean exactly the same thing: *without water.* Chemicals in *crystal* form contain water in varying amounts and allowance must be made for this when substituting *dry* chemicals for the *crystal* form. Two ounces of crystal sodium sulphite or 2¾ ounces of crystal sodium carbonate equals 1 ounce of the dry variety.

20. Always dissolve sodium hydroxide (caustic soda) in a little *cold* water. It creates intense heat when dissolving and the mixture may otherwise boil over. Add it last to the solution.

21. Keep such chemicals as potassium ferricyanide, potassium bromide, and sodium carbonate in 10 per cent solutions (1 gram in each 10 cc of *distilled* water). Each cc will then contain one tenth of a gram, and solutions can be made quickly by adding as many cc's of stock solution as we need to make up gram volume. For example, if the formula calls for

Potassium ferricyanide	6	grams
Potassium bromide	2.3	grams
Water	1000	cc

measure out 60 cc of the 10 per cent potassium ferricyanide stock solution, 23 cc of the potassium bromide, and add water to make 1000 cc. Sodium sulphite can be kept in the same way, except that the concentration should be 20 per cent, using the *dry* form. Be sure to make these stock solutions with *distilled water* (which can be bought, delivered, in 5-gallon jugs from your corner druggist or the man who supplies him; the cost is about a dollar a jug, exclusive of the deposit). Or, if you prefer, you can make your own distilled water in two other ways: 1) Use an *Aquaspring* distiller or water purifier, which is available from almost all household supply houses (like Hammacher & Schlemmer in New York, or most large department stores), or 2) collect the water from your *dehumidifier* and filter it through regular filter paper or a wad of drugstore absorbent cotton.

22. Metol dissolves with difficulty in a strong sulphite solution. Dissolve about a tenth of the required sulphite in the water (to prevent oxidation), then the metol, then the balance of the sulphite.

23. Never pour water over chemicals such as sulphite, hypo, or carbonate; they will cake. Pour the salts into the water, a bit at a time, stirring vigorously as you do so.

24. Sodium sulphite is very soluble in cold water, still more in warm water, *not at all in very hot or boiling water.*

25. Two parts of Kodalk, weight for weight are equivalent to 1 part sodium carbonate in all formulas (except those containing Pyro) which do not contain bisulphite or other acids. Kodalk is borax which has a little caustic added to it, just enough to form sodium metaborate.

26. One part of citric acid by weight equals two parts of 28 per cent acetic acid by weight or one part of glacial acetic by weight.

27. For opening reluctant jar or bottle *screw caps,* get yourself a "Top-Off" opener. I bought mine in Woolworth's, but I think you can buy them at almost any hardware or house furnishings store. They are made by the Edlund Co., Inc., Burlington, Vermont. Another good opener is the *Gilhoolie,* made by Riswell, Inc., Greenwich, Conn.

28. Black spots on prints (due to pinholes in negatives) can be bleached out by touching them with iodine (the household tincture will do) applied with a brush or a toothpick. If the print is now placed in a plain hypo bath, both iodine and spot will be removed. This will leave a white spot which can be retouched in the regular manner.

29. For the negative of *extreme contrast* that won't print on even the softest paper, try the following:

(*a*) Expose print as usual.

(*b*) Soak in plain water for 30 seconds.

(*c*) Soak in a solution of potassium bichromate, 2 grams in 1000 cc of water for bromide; 5 grams in 1000 cc for chlorides. Let it remain in the solution from 3 to 4 minutes; the longer the immersion, the softer the print.

(*d*) Wash this undeveloped print thoroughly (5 changes of water at least).

(*e*) Develop in usual way.

30. A quick and simple print reducer is made by adding some tincture of iodine to a tray of ordinary water. Place the dry print into this solution and remove it when the highlights take on a slightly blue tinge. A short soak in hypo will remove the blue tone. Wash and dry as usual. See index and glossary for more on this subject (reducers).

31. Regardless of the percentage actually marked on the labels, the following chemicals are rated at 100 per cent when diluted, and are treated accordingly:

Ammonia 28 per cent
Nitric acid 45 percent
Formalin 37 per cent

32. Except for such liquids as nitric and sulphuric acids, which attack both cork and rubber, use *rubber corks* in preference to regular cork or glass stoppers. They will not stick (as do those blasted glass stoppers), and they eliminate the hazard of explosions caused by expanding liquids or gasses.

33. To prevent them from getting stuck in the bottle, glass stoppers should be lightly smeared with vaseline. If you've got one that *is* stuck, tap it lightly with another glass stopper (or a glass rod) and it will come out easily. If that doesn't work, dip a strip of cloth or a wad of cotton in some very hot water and wrap around the neck of the bottle. This expands the bottle without affecting the stopper, which you can now remove.

34. The most stable form of sodium carbonate is the monohydrate. Use 15 per cent *more* of the monohydrate when the *dry* (anhydrous or desiccated) is specified in a formula; use 57 per cent *less* monohydrate when the *crystal* variety is specified. If you have the *dry* form, and the *monohydrate* is specified, use 15 per cent *less* of the dry.

35. Stock solutions of developers need *not* be kept in *brown* bottles. However, the brown bottles made for storing photographic chemicals are made of a glass that does not have an excess of alkali and are therefore preferred for storing *fine grain* developers.

36. Never fill bottles right up to the cork. Liquids expand and contract with temperature variations and may either blow caps off or suck corks in (especially if bottled when hot). Leave about one inch of air space between cap or cork and liquid.

37. There are three forms of tribasic sodium phosphate available:

(*a*) anhydrous (dry)
(*b*) monohydrate (1 molecule of water)
(*c*) crystalline (12 molecules of water)

Unless otherwise stated, the form generally supplied is the crystalline. Edwal's TSP is the monohydrate. If you are using TSP formulas which specify the crystalline (or fail to mention which form is to be used) use half as much as is specified. *Crystalline* is the same as *dodecahydrate*.

38. Films can be cleared of oil and finger marks with carbon tetrachloride, Edwal Film Cleaner (which also neutralizes the static that attracts dust), and ammonia. *Caution:* Carbon tetrachloride is a deadly poison. Use it with care. Avoid its use entirely if ventilation is poor, or if you have cuts on your skin.

39. Manufacturers issue all sorts of free literature which is very

helpful. Make use of it. Most of them maintain service departments, to help amateurs with their problems. Write to them when you run into difficulty with any of their products.

40. To prevent air-bells, developer spots, and pinholes from ruining your negatives, and to be sure that your film subsequently dries evenly without watermarks and without curling, use a wetting agent. One of the best and least expensive is Aerosol OT Clear 25 per cent. You can buy this from Amend Drug & Chemical Co., 83 Cordier, Irvington, New Jersey 07111, or from any reputable chemical supply house. (Here are a few others that you might put into your address book: Studiophot Co., 10322 Carnegie Ave., Cleveland, Ohio 44115 [for *Neofin* and other photographic chemicals]; Clayton Chemical Co., division of APECA, 2100 Dempster St., Evanston, Ill. 60204; Ciba-Geigy Chemical Corp., 449 Saw Mill River Road, Ardsley, N.Y. 10502). Using the 25 per cent solution, dilute with 24 parts water to make a 1 per cent solution. *Be sure to filter the solution!* Add 1 ounce of the 1 per cent solution to each 32 ounces of developer but *not* if the developer is "maximum energy" or strongly alkaline. Aerosol may be added, without danger, to *any* fine-grain developer. *Caution:* Diluted wetting agents decompose in a short time, especially in warm weather. You can prevent this by adding a small amount of formalin to the bath. The solution will then keep indefinitely. Formalin hardens film. If the amount of formalin is raised to 4%, and the film is left in the final rinse for 5 minutes, the gelatin will be protected against bacteria as well, according to *Leica Fotografie*.

41. Some chemical equivalents: (1) sodium sulphite, (2) sodium metabisulphite, (3) sodium bisulphite. You can substitute (2) and (3), one for the other, and weight for weight. (2) is more expensive than (3). (2) and (3) are preferable in two-solution developers, since (1) is alkaline while (2) and (3) are acid. (Oxidation proceeds more slowly in acid solutions.)

42. To photograph waterfalls, exposures should be fast enough to slow up action of the water without "freezing" it. Shutter speeds of 1/25 to 1/100 second are recommended. Faster than 1/100 second makes the water look glassy or icy; speeds slower than 1/25 second blur the water altogether. Diffused sunlight is best to avoid overexposure of the water and underexposure of the rocks and foliage.

43. The point to focus on, when trying to photograph a scene in which both foreground and background must be shown clearly, has always been a problem for the inexperienced amateur. Focusing on a point midway between the nearest and farthest object sounds reasonable, but doesn't work out in practice. The best way to find the correct distance requires a little bit of elementary mathematics. Multiply the far and near distance together, double that, then divide by the two distances

added together. The result will be the distance to focus on. For instance: a man at 10 feet and a house at 22 feet. 10 x 22 = 220. Doubled, this gives us 440. Add the two distances and you get 32. 440 divided by 32 gives us 13¾ feet, the best focusing point. This does not mean that both points would be in focus at a large lens stop; merely that this way you will be able to use a larger stop than would otherwise be possible. This method is useful if you have no depth-of-field scale.

44. Against-the-light scenes are easy if you remember these three things: (1) Shade the lens with an adequate hood or by throwing a shadow across it with a hand, a hat, a tree, a sign, a flag. (2) Give ample exposure; two to four times normal is not too much. (3) Abbreviate developing time more than usual to avoid excessive contrast.

45. Reducing the aperture of a good enlarger lens will not sharpen your picture if the easel, lens board, and negative are all plane-parallel. Reduce the aperture only to increase exposure time and to allow for dodging and other manipulation. Depth of focus at the large apertures is shallow enough to aid in avoiding scratches, hair, dust, etc. *Caution:* Sometimes the heat from your enlarger head will cause your negative to buckle. Opening the lens aperture shortens the exposure time, which reduces the danger of buckling.

46. Enlarger lens sharpness can be improved, generally, by printing through a blue filter such as the tricolor C5. The printing time will be increased, but your pictures will be sharper. *Explanation:* Light from an incandescent lamp has radiations of all the visible wave lengths, as well as infrared and ultraviolet. If all these rays are to be focused sharply, the lens must be specially corrected. Few enlarger lenses are corrected that much.

47. If the black markings on your thermometer are wearing off, here are two ways you can renew them. The markings on most good thermometers are etched in the glass and filled. Photographic chemicals, especially the alkalis, have a tendency to eat the filling away. Dip the thermometer in black paint, or smear the paint over it. Then wipe it off. Enough will remain in the etched parts. Finally, wipe the thermometer dry, and let it stay overnight to give the paint a chance to get hard.

You can also do this with shoe polish, rubbing the thermometer with a soft cloth impregnated with boot black, and drying it with another piece of the same cloth. If you let it dry overnight, you can then lacquer the surface with clear nail polish, for permanence.

48. *Some color hints.* Never load color film (or any other kind for that matter) in bright sunlight; check your color technique by photographing scenes or objects that you can repeat easily; to avoid muddy color, don't mix daylight with tungsten; when you send color film for processing, *print* your name and address clearly, to avoid losing the

film; when you use haze or conversion filters, remember that they become part of the optical system when you place them over your lens (so keep them clean!).

49. *Opening 35mm cassettes*. I have used can openers, screw drivers, tapping on the table (as Kodak suggests), and strong language, but the best thing so far devised is that honey of a gadget, the *Honeywell Nikor Cassette Opener*. It was designed to pop open both the reusable and crimped-end type of cassettes. It is made of sturdy metal, with an easy spring action. And it is inexpensive.

50. *Sunrises and sunsets*. The trick in such color photography is to remember that the brightness range of the scene is many times greater than the ability of the film to record it, so you will have to sacrifice something. Let the shadow detail go dark; in fact, try to work in some foreground object (a tree, a figure, a house) to stand out as a silhouette in black against the colored sky (and to act as a shield against the direct rays of the sun). For maximum color saturation, *favor* the exposure of the bright sky, but don't point your meter directly at it. And *bracket* your exposure (see glossary).

51. *Museums*. For best results indoors, a *tripod* and a *polaroid filter* are essential, especially if you are using color film. Every museum has its own rules, but you can usually get permission to use the tripod if you come early, and during the week (rather than on weekends, when the crowds are heavy). Also, assure them that you will not make a nuisance of yourself, and will be careful. The filter will be needed for those glass-enclosed exhibits. Test the reflections by rotating the filter and changing your position. Sometimes you can get better pictures at an angle, rather than head-on. The tripod will also enable you to get longer exposures when the light is dim (don't forget to bring a long cable release, preferably one that has a lock for time exposures. And reread the item in the glossary on reciprocity failure).

52. *Photographing the type in books*. For this, use Kodak High Contrast Copy film (available in 36-exposure 35mm magazines). Its Tungsten ASA rating is 64, when developed in Kodak's packaged developer D-19 (6 minutes at 68° F.). In a museum, you have to accept the conditions and the lighting that exist. At home, or in a studio, you can control the flatness of the page, as well as the lighting.

53. *Photographing the illustrations in books*. If you are not interested in color, you can use Kodak High Contrast Copy film, but expose at ASA 10, and develop in H & W Control developer for continuous tone (16 minutes at 68° F., diluted as directed). If you can't find this at your camera dealer, write to the H & W Company, Box 332, St. Johnsbury, Vermont 05819. For color, see the suggestions in item 51.

54. *Architectural photography*. What you really need for success in

this field is a studio camera on a tripod, with all the tilts and swings; and a lens as sharp as a *Dagor* (discussed earlier). But the amateur usually wants to take such pictures with his 35mm or 120 camera. The problem, then, is how to avoid converging verticals. If you have a PC (perspective control) lens, you're half-way there. But you still need a tripod. And it would be helpful if you could find a building across the street from which to take the picture. Pick a floor about half the vertical height of the one you are shooting, and try to get permission to take pictures from one of the front offices, apartments, or terraces. For best results, take the building at an angle, and wait for the sun to light it at an angle, too (to bring out the texture of the stone or wood. Shadow patterns are part of the picture). Use figures or objects, the size of which are known, to establish relative dimensions (*scale*).

The films I would recommend for this kind of photography are Panatomic X at ASA 32, developed in Microdol X (or at ASA 50 in Acufine, diluted as recommended), and H & W Control VTE Panchromatic film, exposed at ASA 50–64, developed in H & W Control developer (follow instruction sheet).

Supplemental Glossary[1]

ABERRATION. An optical defect in a lens.

ABRASION MARKS. Can occur on both negatives and papers. Usually the result of friction or pressure during some part of development process or subsequent handling. Sometimes such marks are due to defects in film spools or winding mechanisms. The light traps in some cassettes cause scratches when the felt captures dirt which then rubs against the negative. Avoid any rough handling of materials.

ABSORPTION OF LIGHT. Of the light that hits any subject, part is *reflected*, part *absorbed*. For example, a light object may *reflect* most of the light, while a dark object *absorbs* most of it. Similarly, objects appear *colored* due to selective absorption of the colors in the spectrum.

ACCELERATOR CONTROL. By varying the proportions of an accelerator in a developer, the time of development and the highlight details can be controlled. With overexposed highlights, much detail can be brought out by reducing the amount of accelerator and prolonging the time of development.

ACCENTUATION. An art term denoting special emphasis upon some particular part of a photograph. Accentuation may be secured by a strong highlight, a strong contrast

[1] Partially excerpted from *A Glossary for Photography* by Frank Fenner, Little Technical Library, copyright 1939 by Ziff-Davis Publishing Company. *Revised 1973.*

of light and shade, or a dark mass in a relatively light area.

ACETONE. A highly volatile, inflammable liquid solvent (*dimethyl ketone*) for nitrocellulose, etc. Ingredient of film cements.

ACETONE SULFITE. $(CH_3)_2CO \cdot Na HSO_3$. A compound formed by mixing acetone and acid sodium sulfite. Used in some developer formulas as a substitute for sodium sulfite or potassium metabisulfite.

ACUTANCE. A measure of sharpness of a photographic image. It is not the same as "resolving power." The resolution of a photographic image depends as much on the resolving power of the lens as on the acutance of the emulsion. Both are necessary to produce a sharp image. It was Lloyd Jones of Eastman Kodak who gave it that name. He was evaluating sharpness on the basis of the effects of photographing a *knife-edge* on film. He termed the measurable difference in density between the dark and the light areas as *acutance.*

AERIAL IMAGE. An image existing in space which can be captured on a ground glass, film, or any other suitable surface. It can also be caught by another lens system.

AERIAL PERSPECTIVE. An impression of depth or distance in a photograph that depends upon the effect of the atmospheric haze in suppressing distant detail.

AGED DEVELOPERS. Certain classes of developers, employed for suppressing grain in miniature negatives, give much better grain suppression after they have been held or aged for several months after mixing.

ALUM, CHROME. $Cr_2(SO_4)_3 \cdot (NH_4)_2 SO_4 \cdot 24H_2O$. A deep purple salt soluble in cold water and alcohol. It is used for hardening gelatin emulsions to prevent frilling in warm weather.

ALUM, COMMON WHITE. Same as potassium alum.

ALUM, POTASSIUM. $K_2SO_4 \cdot Al_2(SO_4)_3 \cdot 24H_2O$. Used for hardening and clearing stains from emulsion. Soluble in water but not in alcohol. Commonly used as the hardener in acid fixing baths.

ALUM, POTASSIUM CHROME. $KCr(SO_4)_2 \cdot 12H_2O$. Plum-colored crystals used in the chrome-alum fixing bath to harden the gelatin of film.

AMIDOL. $C_6H_3(NH_2)_2OH \cdot 2HCl$. A developing agent (Diaminophenol hydrochloride) that will develop successfully without the addition of an alkaline accelerator. It does not keep well in solution and must be mixed when needed.

AMMONIUM BROMIDE. NH_4Br. Used in developer as a restrainer and also in preparation of gelatino-bromide emulsions.

AMMONIUM PERSULFATE. $(NH_4)_2 S_2O_8$. Used for reducing the density of negatives; a flattening reducer.

AMMONIUM SULFIDE. $(NH_4)_2S$. Used for intensification.

AMMONIUM SULFITE. $(NH_4)_2SO_3 \cdot H_2O$. Soluble, colorless crystals which may be substituted for sodium sulfite in pyro-ammonia developer, and to darken negatives in mercury intensification.

ANHYDROUS. Signifying "without water." Thus, anhydrous sodium carbonate is without water of crystallization.

ANNULAR. Ring form or ring-like.

APERTURE. The lens opening that is controlled by a diaphragm.

APOCHROMATIC LENS. Such a lens is corrected for chromatic aberration for three wave lengths of light (as compared with the two in the achromatic lens).

ASA. These letters, which stand for the American Standards Association, are now used (with a number) to indicate the emulsion speed of film. All American film and

meter manufacturers, and most of the European ones, now use ASA figures. These film speeds have replaced the Weston, GE, Din, and BSI (British) film speed designations. Also, see *Index*.

AUTOFOCAL. A term describing enlargers having a link mechanism which keeps the image in focus on the easel as the enlarger head is moved up or down to secure the necessary degree of enlargement.

AVAILABLE LIGHT. A system of photography which uses whatever light happens to be available, without resorting to additional artificial light. This requires fast films such as Tri X and Royal X Pan, or medium speed films such as Plus X with speed-increase developers like Promicrol. Also called *existing light* (and most recently by Kodak when introducing their new Super-8 movie system August 4, 1971, as *XL*).

BACK CLOTH, BACK DROP. Any drapery used as a background in photographic work.

BACK COMBINATION. The half of a doublet lens nearest the film.

BACKLIGHTING. A style of photographic lighting which illuminates the side of a subject opposite the camera. Such lighting results in pictures with a "halo effect" around the edges of the subject.

BARE BULB FLASH. The use of flash without a reflector. The effect is a mixture of bounce and available light, less harsh and directional than reflected flash, not as soft as bounce light. *Caution:* Should not be used too close to the face of the photographer, to avoid injuring the eyes in case the bulb accidentally shatters. *Use plastic cover.*

BARREL MARKS. The lettering on a camera barrel that indicates the focal length, f/number, maker's name, and the serial number.

BARTOLOZZI RED. A red tone obtained by the use of a three-solution toning bath containing copper sulfate, ammonium carbonate, potassium ferricyanide and boric acid.

BAYONET MOUNT. A device used on some cameras to facilitate the exchange of lenses. Lens has prongs fitting into camera, and a lever locks them in place from within.

BED. The foundation structure of a bellows camera including bottom plate and the focusing slide rails.

BELITSKI REDUCER, MODIFIED. A single-solution reducer for dense, contrasty negatives; it keeps well.

BENZENE. C_6H_6. A light volatile aromatic and inflammable liquid distillate of coal tar, much used as a solvent and cleaning agent. It dissolves rubber, bitumen, mat varnishes, and many other gums or tars. It should be carefully distinguished from the "benzine" obtained from petroleum.

BENZINE. A light distillate of petroleum and consisting of a mixture of light hydrocarbons, frequently used as a solvent, but its use is more limited in photography than benzene. Benzine is now more properly known as naphtha.

BENZOL. Same as benzene.

BENZOLINE. Same as benzine; do not confuse with benzene or benzol.

BLISTERS. Small bubbles formed under the emulsion due to the detachment of the emulsion from the paper or film.

BLOCKED UP. Highlights in a photograph that are so over-exposed that no definition or detail is to be seen are said to be "blocked up."

BLOCKING-OUT. Painting over portions of a negative with opaque paint (usually an uninteresting background) so that the portions so covered will not print. The backgrounds of machinery photographs are usually blocked out to eliminate uninteresting and distracting detail.

BLURRED NEGATIVES. Any negative showing indistinct outlines of the image or double outlines is "blurred." This may be due to: (1) A poor lens, (2) Camera out of focus, (3) Holding the camera in the hands with a shutter speed of less than 1/100 second, (4) Object moving too rapidly for the shutter speed, and (5) Underexposure or underdevelopment.

BLURRED PRINTS. The loss of sharp detail and confused outlines on the print (when the negative is good) may be due to (1) Imperfect contact between the paper and negative, (2) The paper may be against the glass or celluloid back of the negative instead of against the emulsion, (3) Loose paper slipping over the negative, (4) The lamphouse or holder of the enlarger may vibrate during the exposure, and (5) The enlarger lens may be out of focus.

BOOM LIGHT. Light on a long arm or spar that is easily adjusted over model or set up at a height of several feet from floor.

BOUNCE LIGHT. A softer light than regular flash or flood, produced by reflecting the light from a ceiling, wall, or other surface. If color film is being used, make sure the reflecting surface is white or neutral, otherwise there will be an over-all tint to the light. The additional exposure required depends on the color and distance of the reflecting surface, usually from 3 to 5 times the regular exposure.

BORAX. $Na_2B_4O_7 \cdot 10H_2O$. A white crystalline salt used in toners and as an important element in fine grain developers. It acts as a restrainer with pyro developers and as an accelerator with hydroquinone. Also known as sodium borate, biborate, tetraborate, pyroborate.

BORIC ACID. H_3BO_3. A slightly soluble, very weak acid used in the boric acid fixing bath. Boric acid in the fixing bath tends to prevent the formation of aluminum sulphite sludge and adds to the hardening properties of the potassium alum.

BRACKETING EXPOSURES. A method of insuring perfect exposure by taking (usually) three exposures: 1) meter reading, 2) meter reading plus one stop, 3) meter reading less one stop. Invaluable when testing equipment or film. Not recommended as a permanent crutch in general photography.

BRILLIANT. A term used to describe a print or negative with fairly strong contrast and sharp detail. In other words, a print with plenty of "snap."

BUFFERED. A developer so compounded as to retain its power and chemical balance while in use. Usually applied to a solution containing an acid and one of its salts. This increases the stability of the developer since the extra acid is brought into action only as it is needed.

BUILDS UP. A term applied to the gradual increase in density as metallic silver is set free in a print or negative during development.

BURNED UP. Badly overexposed.

BURNING-IN. A process used in enlarging. It means to give excessive exposure to certain portions of the print while other parts are held back by dodging. Used to darken light areas which detract, or to bring up detail in very dense portions of the negative without overexposing other portions.

CADMIUM SULPHIDE. (See CdS.)

CAMERA ANGLE. The point of view from which the subject is photographed.

CAMERA EXTENSION. Strictly, the distance between the exit node of the lens and the focal plane in which the film lies. When focused

on infinity the camera extension equals the focal length of the lens.

CARTRIDGE FILM (126). As in the Kodapak cartridge, used in Kodak's Instamatic cameras. This is a plastic insert with a film supply on one side and a take-up spool on the other, which is dropped into the camera to load it, and removed when the film length has been completely exposed. (Also 110 size.)

CASSETTE. A container for roll film which may be loaded in the darkroom and used subsequently for daylight loading of the camera.

CATCH LIGHTS. Reflections, generally in the subject's eyes when portraits are being made, from the light sources used for illumination.

cds. Cadmium sulphide light-sensitive cell, used in enlarging *photometers*, as in *Analite, Melico, Paterson CdS Computer*, and Ideax *Photo-Genie*. Also used in automatic-camera exposure systems and in independent exposure meters like the Weston Ranger 9, Gossen Luna-Pro, and Minolta Autometer.

CENTILITER. A unit of capacity in the metric system; the hundredth part of a liter; 2.705 fluid drams.

CENTIMETER. cm. A unit of length in the metric system; the hundredth part of a meter; equal to 0.3937 inches.

CHALKY. Applied to negatives or prints which show excessive contrasts.

CHEMICAL DEVELOPMENT. Development by chemical action in a solution, in distinction to physical development.

CHEMICAL FOG. Fog produced on paper or films by chemical means, such as too energetic or contaminated developer.

CHIAROSCURO. The effect of the distribution of light and shadow in a picture.

CHROME ALUM. See *alum, chrome*.

CINCHING. Tightening loosely-wound film by pulling on the free end of it. Invariably causes scratches on the surface of the film which reproduce as black lines on the print or enlargement.

CIRCLE OF CONFUSION. The diameter of the circle created by a lens photographing a point source of light at infinity. The smaller the circle of confusion, the sharper the print will be when the negative is enlarged.

CIRCLE OF ILLUMINATION. The circular area on the focusing screen illuminated by light passing through the lens. There is no sharp boundary, as the amount of illumination decreases gradually at the edge of the circle.

CLOGGED. Term used in reference to shadow parts of a print or highlights (dense portions) of a negative when they are one heavy tone instead of showing differences in tone in the subject.

COLLAGE. A term used to designate a montage effect made by pasting up a composite photograph from portions cut from other photographs. The paste-up is usually copied on a new negative.

COMA. An aberration of the lens which affects the rays not parallel to lens axis. Causes images of points near edges of picture to appear as ovals directed at center.

COMBINATION PRINTING. Combining parts of several negatives in one print; a method by which a sky can be printed into a landscape, etc.

COMBINED BATH. A mixture which both tones and fixes the prints.

CONCAVO-CONVEX LENS. A lens, one surface of which is a concave spherical surface and the other a convex spherical surface. Such a lens may be either convergent or divergent, depending on the radius of curvature of the surfaces. If the middle of the lens is thinner than

the edges, it is divergent; if thicker, it is convergent.

CONTRAST FACTORS. The amount of contrast in a finished photograph may be attributed to several factors. These are: the exposure given the negative, the filter used, the kind of film, the duration of development, the duration of exposure and development in printing, the paper used in printing, and the developer used both for the negative and the print.

CONTRASTY. Applied to prints with very dark shadows and white highlights, due to underexposure or overdevelopment of the negative, or where the paper used is of the wrong contrast (too hard).

CONTROL PROCESSES. Photographic processes in which the operator exercises a considerable amount of control over the tone values. Not only can the tonal key be controlled, but the relative value of tones can be altered. Gum bichromate, oil, and bromoil processes are examples.

COVERING POWER. The capacity of a lens to give a sharply defined image to the edges of the plate it is designed to cover, when focused with the largest stop opening.

CROP. To trim or cut away a part of a print to eliminate some undesirable portion or to improve the composition.

CRYSTALLIZED. The form of a chemical produced either by deposit of crystals from solution or by solidification of a liquid into the crystalline solid form. Formation of ice is an example of the latter.

CUBIC CENTIMETER. cc. A unit of volume in the metric system equal to 1,000 millimeters (mm³); 0.0610 cubic inches; approximately 17 drops. A cubic centimeter is almost exactly equal to a milliliter, or 1/1000 liter.

CUTTING REDUCER. See *reducer, cutting.*

DELAYED ACTION. An adjustment on a camera shutter by means of which the photographer may set the shutter and then take his place in a group or view so that he is included in the picture.

DENSITOMETER. An instrument (usually electrical, and with a comparison step-wedge) designed to measure the density of a negative.

DESENSITIZER. An agent applied to films or plates in the dark after which development can be conducted in comparatively bright yellow light.

DESICCATED. The dry or anhydrous form of chemicals as distinguished from the crystallized (cryst.) form.

DETAIL. In pictorial photography, detail includes everything which does not contribute to the motif of the photograph. In commercial photography, detail is desirable; in pictorial photography it detracts.

DEVELOPMENT. See chemical, fine-grain, physical, and surface development.

DIAMINOPHENOL HYDROCHLORIDE. $C_6H_3(NH_2)_2OH \cdot 2HCl$. A substance commonly known as Amidol, the peculiar characteristic of which is that it will develop without the addition of an alkali.

DIAPOSITIVE. A positive image, as on a film; a transparency.

DICHROIC FOG. A condition in a negative where the film or plate looks red when seen by light coming through, and green by light reflected from it. Due to defects in the emulsion, hypo in the developer, etc.

DIFFUSION OF FOCUS. Also called "soft focus" or "soft definition." Lack of sharpness in the picture image due to a defective lens, imperfect focusing, or a special lens made to give soft effects.

DIN. The official German standard for

rating the speed of photographic film, widely used in Europe.

DIRECT POSITIVE. The positive image obtained by exposure in the camera with subsequent chemical treatment to develop and "reverse" the image.

DODGING. The process of shading a part of the negative while printing or enlarging.

DOPE. A varnish used on a negative to facilitate retouching, by giving a surface on which the pencil marks will "hold."

DOUBLE COATING. Many films, particularly those prepared for amateur use and X-ray photography, are coated with two emulsions, either one on top of the other, or one on each side of the base. One coating is a slow-speed and the other a high-speed emulsion. The slow emulsion provides correct exposure of the highlights and the fast emulsion provides detail in the shadows. The effect is to increase both the latitude and the tone scale of the film.

DOUBLE EXTENSION. A term applied to a camera or bellows which allows a distance between the lens and focusing screen about double the focal length of the lens.

DOUBLE IMAGE. A duplication of the outlines of a photograph due to a movement of the camera or subject during exposure. Also used in reference to a print where the paper has been moved during printing.

DOUBLE PRINTING. See *combination printing*.

DRACHM, DRACHMA. Same as fluid dram.

DRAM. A unit of weight in the avoirdupois system, one sixteenth part of an ounce, or 27.34 grains. Also a unit in apothecaries' weight, equal to ⅛ ounce or 60 grains troy.

DRAW. The draw of a camera is the extent to which the bellows will permit the lens board to be racked forward.

DRYING NET. A sheet of thin, fluffless material such as mercerized lawn stretched out flat. Used for drying mat prints. The prints are laid on the net face down which prevents the formation of blobs of water as well as undue curling.

DYE TONING. The process of toning a photograph with a dye which will replace the silver image.

DYES, SENSITIZING. In 1873, H. W. Vogel discovered that the sensitivity of the silver halides could be extended to include the longer wavelengths of light by treating them with certain dyes.

EAU DE JAVELLE. A reducer for negatives the active ingredient of which is sodium hypochlorite. It is also used to remove the last traces of hypo from film, and as a stain remover. Made by shaking together sodium carbonate and calcium hypochlorite then decanting the clear liquid.

EBERHARD EFFECT. The name given to the phenomenon which darkens the edges of developed film, though the entire area has been uniformly exposed.

EDGE FOG. The fog on film that is due to the leakage of light between the flanges of the spool on which the film is wound.

EDGE LIGHT. In portraiture, a light placed behind the subject to give a halo effect and illuminate the edges of the head and shoulders.

EFFECTIVE APERTURE. The diameter of the diaphragm of a lens measured through the front lens element. Sometimes this may be larger than the actual opening in the lens diaphragm because of the converging action of the front element of the lens.

EFFLORESCENCE. The process in

which a salt gives up its water of crystallization to the air.

ELON. One of the many trade names for a developing agent the full name of which is para-methyl-amino-phenol sulphate. Elon is one of the constituents of MQ developers. See metol.

ELON-HYDROQUINONE DEVELOPER. Same as metol hydroquinone.

ELON-PYRO DEVELOPER. Any of several developing solutions compounded from pyro and Elon. To improve keeping qualities, this developer is generally prepared in three stock solutions which are mixed for use.

EMBOSSED MOUNT. A mount whose center portion is depressed with a die (plate-sunk) or an embossing tool (embossed), leaving a raised margin to frame the print.

EMPHASIS. Same as accentuation.

EMULSION. The sensitive coating on films, papers, and plates used in photography. It consists principally of a silver salt or salts suspended in gelatin.

EMULSION BATCH NUMBER. A number placed on the label of film and paper packages which identifies the batch from which that particular film or paper was made.

ENCAUSTIC PASTE. A wax paste used to impart a slight gloss to mat or semi-mat prints.

EQUIVALENT FOCUS. The focal length of a group of lenses functioning as one lens.

ETCHINGS, PHOTO. Photographic etchings differ from sketches in the subjugation of the photographic image, the main part of the picture being completely redrawn in pencil.

EVEREADY CASE. Camera case with drop front and openings to permit viewing film window and operating parts, so that camera can be used without removal from case.

EVERSET (RESETTING) SHUTTER.

Everset is obsolete term for a shutter which does not require cocking or resetting between exposures.

EXPOSURE COUNTER. All cameras taking 35mm or roll film, in which the exposure numbers are not visible in a window, are equipped with an exposure counter. Some work from 1 to 36, while others count backward, from the maximum number of exposures down to 0, to indicate the number of frames left to be exposed.

EXPOSURE FACTORS. The difficulty encountered by beginners in photography may be attributed to the large number of factors which must be taken into consideration in arriving at correct exposure time. Following is a list of the more important factors: (1) relative aperture of lens; (2) kind of film used; (3) reflecting power of the subject; (4) season of the year; (5) time of day; (6) if artificial light is used, color of the light; (7) geographical location and altitude.

EXPOSURE METER. An electrical or optical device that measures the amount of light reflected from or directed on a subject. This is done by converting or translating light energy to exposure units, thus indicating lens aperture and shutter speed.

EXTENSION. Extension of the camera is the distance to which the front of the camera (lens mount) can be drawn out from the back.

FARMER'S REDUCER. A solution to increase contrast by lowering the density of developed negatives; invented by Howard Farmer. Contains potassium ferricyanide and sodium thiosulfate (hypo).

FEATHERING LIGHT. Letting only the soft, outside rim of light hit the object.

FERRIC SULPHATE REDUCER. A proportional reducer used in very

dilute and slightly acid solution. It keeps well.

FERRICYANIDE REDUCER. Another name for Farmer's reducer; the active ingredient is potassium ferricyanide.

FERROUS SULPHATE DEVELOPER. A physical developer using acetic acid as a restrainer.

FIELD. The space within which objects are seen on a viewfinder, lens, microscope, telescope, etc.

FILL-IN LIGHT. In portraiture or other photography by artificial light, fill-in lights are used (in addition to main lights) to fill in the dark shadow portions of the subject so that some detail will be recorded.

FILM CLEANER. (1) Any liquid which may be used safely to remove dust and grease from film. One such is:

Ethyl alcohol	85%
Methyl alcohol	10%
Strong ammonium hydroxide	5%

FILTER, CHEMICAL. A device used to remove suspended matter from a solution.

FILTER, NEUTRAL. A filter which has no color absorption or selectivity.

FINDER, ANGLE. A finder so arranged that the photographer may take a picture in a direction at right angles to the direction he is facing—used in candid camera work.

FIXING-HARDENING. A bath in which film, plates, or prints are freed from the unaltered silver bromide and at the same time the gelatin film is toughened.

fl. dr. Abbreviation for fluid dram.

FLARE SPOT. A fogged spot, generally near the center of the film or plate. It is usually circular or arc-shaped, and may be due either to reflection from the lens surfaces or from the interior of the lens mount.

FLASH EXPOSURE. A photograph made with a flashbulb, cube, or electronic flash unit.

FLASHING. A means of hypersensitizing film by exposing it very briefly, using an evenly illuminated subject such as open sky. This exposure overcomes the inertia of the film. An exposure of 1/300 second at $f/16$ is about right for most film.

FLATNESS. Lack of contrast in print or negative, generally due to flat, even lighting, overexposure, or incorrect concentration of developer.

FLATTENING REDUCER. See reducer, flattening.

FLUID DRAM. A unit of fluid measure in the apothecaries' system; equal to 60 minims, .125 fluid ounce, or slightly less than 3.7 milliliters.

FOCUSING MOUNT. The lens mount which permits the lens to be moved toward or away from the film in order to focus it accurately on given distances. All fast lenses are in focusing mounts, and the slower ones may or may not be.

FOCUSING NEGATIVE or TARGET. A developed negative consisting of a geometrical design which may be placed in the negative holder of the enlarger for focusing. The extreme contrast and detail in the negative permit exact focusing, and the negative to be enlarged is substituted after the focusing is complete.

FOG FILTER. Actually not a filter, but a diffusion screen, used to give the effect of fog in a picture.

FORCING. Continuing development for a long time in order to get detail or density, or treating underexposed films or prints by adding alkali.

FORMIC ACID. $HCHO_2$. Sometimes used as a preservative for pyro.

FRILLING. A photographic defect in which the emulsion separates from

the plate or film in folds and wrinkles. Frilling usually starts at the edges of the plate, during fixing, but may occur at other stages in the photographic process. It is caused by differences of temperature between solutions, etc. See *reticulation*.

g. (gm.) Abbreviation for gram.

GAMMA. A measure of photographic contrast (written with the Greek letter γ) *resulting from development*. A gamma of 1 indicates that the emulsion has recorded *all* the tones which occur in an outdoor scene. This is important to an amateur photographer only as a guide for time-and-temperature development. Manufacturers of film and developers usually indicate how long, and at what temperature, you should develop your film to arrive at a suitable gamma for enlargement. With condenser enlargers, a gamma .65 to .7 is called for; cold light enlargers, on the other hand, can use more contrast (gamma of .8). An infinitely contrasty subject can be developed to a low gamma by shortening the development or reducing the developing temperature, but it may still be *contrasty*. A flat subject can be developed to a very high gamma and still be *flat* or lack sufficient contrast to produce a useful or pleasing print on a printing material of *normal* contrast characteristics. See *index* for more on gamma.

GENRE. A type or style of photograph or other art which illustrates common life.

GLOSSY. The kind of photographic papers that can be ferrotyped to a high gloss.

GLYCIN. $CH_2(COOH)\cdot NH\cdot C_6H_4OH$. A slow, non-staining and particularly clean acting developing agent. Its chemical name is *p*-hydroxyphenylglycin. It should be distinguished from glycine, an entirely different compound. Glycin may be used either as a one- or two-solution developer, and is often used for tank development. It is also used for producing various tones in chloride and bromochloride papers by direct development in dilute solution.

GLYCOLIC ACID. $HOCH_2CO_2H$. Added to amidol developers to improve the keeping property.

gm. (g.) Abbreviation for gram.

GRADATION. The tonal range in prints and negatives. If there are only a few tones between the deepest shadow and the brightest highlight, the gradation is "steep"; if there are many tones, the gradation is "long."

GRAIN. A unit of weight common to the avoirdupois, troy, and apothecaries' systems. It is equal to 0.064799 gram; there are 437.5 grains to an ounce avoirdupois; 480 grains to the ounce troy and the ounce apothecary.

GRAM (METRIC SYSTEM). The international unit of weight. It is almost exactly the weight of a cubic centimeter of pure water at its maximum density. It is equal to 15.432 grains avoirdupois.

GREASE PAINT. A flesh-toned cream used to provide a base for rouge, powder, and other make-up.

GREEN FILM. Newly developed film which, although apparently dry, still contains a considerable amount of moisture. Even in a warm room film does not become completely dry in less than six to twelve hours, and it is best not to attempt printing or enlargement of film sooner than this.

GREEN FOG. Same as *dichroic fog*.

HALFTONE. In a photographic print, the darkest portions are called shadows, the lightest portions are

called highlights, and all intermediate tones are known as halftones.

HALO EFFECT. A lighting effect secured by backlighting.

HARD-WORKING. Describes developing solutions which tend to produce contrasty negatives or prints.

HOGARTH'S LINE. A double curve in the form of a letter S, frequently employed in photographic composition; it is sometimes called the line of beauty or "S" curve.

HUE. That attribute of a color by virtue of which it differs from gray of the same brilliance, and which allows it to be classed as red, yellow, green, blue, or intermediate shades of these colors.

HYDROQUINONE. $C_6H_4(OH)_2$. A developing agent whose chemical name is paradihydroxybenzene. It is commonly used in combination with metol, whose action it supplements. It is non-staining, produces high contrast, and keeps well in concentrated solution. It is also called hydrokinone, hydrochinon, and quinol.

HYPERFOCAL DISTANCE. The distance from the camera to the nearest object in focus when the lens is focused at infinity. The smaller the aperture of the lens, the shorter the hyperfocal distance will be, and consequently, the greater the depth of field.

HYPERSENSITIZING. The process of increasing the sensitivity of a photographic emulsion by bathing it in distilled water or a dilute alcoholic solution of ammonia, exposing it to vapor (such as mercury), or exposing it to light. See *flashing*, above.

HYPO. Sodium thiosulfate, sometimes incorrectly labeled sodium hyposulfite. Used in fixing baths, which are often known as hypo baths, though they also include acids and hardening agents.

IMPRESSIONISM. That style of pho-

tography in which the essential features are brought out forcefully, while the rest of the picture appears indefinite, in a minor tonal key.

INCIDENT LIGHT. The light falling *on* the subject, as distinguished from the light reflected *by* the subject. When using an incident light exposure meter, it is pointed in the direction of the light falling on the subject at the angle of incidence *observed* by the camera lens: indoors, from the subject position; outdoors, from the camera position as well. Recommended for exposure of reversal color film, like Kodachrome and Ektachrome. Many reflected light meters now have white plastic accessories to make conversion to incident light possible.

IRRADIATION. The spreading of light in an emulsion due to reflection from the surfaces of the silver halide crystals. The slight blurring due to irradiation should not be confused with the more noticeable and extensive blurring known as halation, which is due to reflection from the back surface of the plate or film on which the emulsion is supported.

KEY. See *tonal key*.

kg. Standard abbreviation for kilogram.

KILOGRAM. kg. A metric unit of weight; equal to 1,000 grams, or 2.2046 pounds avoirdupois.

l. Abbreviaion for liter.

LATENSIFICATION. An acronym for "latent image intensification." The process of increasing the sensitivity of a photographic emulsion *before* or *after* exposure. See *hypersensitizing*, above.

LATENT IMAGE. The invisible image, registered by light on a sensitive photographic emulsion, which does not appear until development.

LENS BARREL. The metal casing in

which camera lenses are supported or mounted.

LENS CAP. A covering for the protection of a camera lens. Also used for making exposures in the studio by momentarily removing the cap from the lens.

LENS FLARE. A light-flash on the film caused by using a very fast lens at a very small diaphragm stop. Usually happens only rarely with the better fast lenses.

LIGHT TRAP. (1) An arrangement of doors or a curved passage by which one can enter a darkroom from a lighted room without permitting actinic light to shine into the darkroom. (2) Any arrangement for preventing light passage through an opening which must admit a moving part such as the felts on plate holders.

LINEAR ENLARGEMENT. When the degree of enlargement is figured on the basis of increase in one dimension, such as length, it is referred to as a linear enlargement of so many times. The alternate basis is the increase in total area. Enlarging a 4 x 5 inch negative to 8 x 10 inches is a two-time linear or a two-diameter enlargement, but a four-time area enlarging.

LITER. 0.908 quarts, dry measure; 1.0567 quarts, liquid measure.

LITMUS PAPER. A paper used for testing the acidity of solutions. It turns red in acid solutions, blue when they are alkaline. The paper is soaked in azolitmin, then dried and cut before use.

LOCAL CONTROL. Term which applies to dodging and burning in as practiced in enlarging.

LOCAL INTENSIFICATION AND REDUCTION. The application of an intensifier or reducer with a brush or swab to one portion of a negative or print.

LOW KEY. See tonal key.

m. Abbreviation for meter.

METER. m. 39.37 inches.

METOL. Trade name (Hauff) for the developing agent para-methyl-amino phenol sulfate. This compound is also available under such trade names as Elon, Pictol, Rhodal.

METOL-HYDROQUINONE DEVELOPER. Any developer compounded with metol and hydroquinone. These two developing agents have properties which supplement each other and consequently they are often used in combination.

METOL QUINOL DEVELOPER. Same as metol hydroquinone.

mg. Standard abbreviation for milligram.

MIDDLE DISTANCE. That portion of a scene, especially of a landscape, which lies between the foreground and the background.

MILK GLASS. Same as opal glass.

MILKY. A term used to describe the appearance of developed and unfixed film, or film which has been incorrectly or insufficiently fixed.

MILLIGRAM. mg. A unit of mass in the metric system; the thousandth part of a gram; equal to 0.01543 grains.

MILLILITER. ml. A unit of capacity in the metric system; the thousandth part of a liter; equal to 16.231 minims; almost exactly equal to 1 cubic centimeter.

MINIM. min. 1/480 fluid ounce, or just slightly more than 0.06 milliliter; roughly, one drop.

ml. Standard abbreviation for milliliter.

MONOHYDRATED. A term used to describe a substance from which most of the water of crystallization has been removed, leaving only one molecule of water combined with each molecule of the substance.

MONTAGE. See *photomontage*.

MOTIF. The theme or dominant feature of a photograph or other work of art.

MOTTLING. Marks which often appear on negatives when they are not sufficiently agitated to keep the developer in motion.

M. Q. TUBES. Containers of dry ingredients for making a given amount of metol-hydroquinone developer. Generally used by amateurs.

NEAR POINT. The nearest object point lying between the camera and the object in critical focus which is reproduced without perceptible unsharpness.

NEWTON RINGS. These are the irregular colored rings that appear when two polished surfaces come into partial contact. The phenomenon is caused by the interference of light reflections from both surfaces.

OBJECTIVE. A term sometimes applied to the image-forming lens of an optical instrument; for example, the lens used on a camera or enlarging apparatus.

OPAL GLASS. A translucent milky glass used in enlargers to diffuse light before it reaches the negative.

OPTICAL AXIS. The imaginary line joining the centers of the two spherical surfaces of a lens; also called the principal axis. A ray of light entering the lens along this path will continue through the lens and emerge without being bent or refracted.

ORTHOCHROMATIC. The word means *correct* color, though in photography it is applied to a film sensitive only to blue and green light, not to red. See *panchromatic*.

OXIDATION. The deterioration of a developer caused by its contact with air.

PAM (PAN) HEAD. The mechanism at the top of a tripod which permits the camera to be moved in horizontal or vertical planes. May be fixed to the tripod, or detachable.

PANCHROMATIC. Photographic emulsions that are sensitive to the entire visible spectrum, including red (as distinguished from orthochromatic, which is sensitive to blue and green, but not to red).

PANNING. Swinging the camera to keep a moving object in your line of sight as the shutter is released. This keeps the subject sharp while the background is blurred, which intensifies the feeling of movement.

PAPER NEGATIVES. Negatives on a paper base rather than a film or glass base, generally used in enlarging. They can be made by two methods, one in which a small positive transparency on film is first made from the small negative. This is projected to the desired size just as a bromide enlargement is made, resulting in a negative on paper. Another method is to make a large positive (in reverse) on a smooth paper from which a paper negative is made by contact printing, the light passing through the paper base to the sensitized paper which has been placed in contact with it. The use of paper negatives permits a great deal of modification and retouching which is done with pencil. The mechanical grain due to printing through the paper base lends a pictorial quality to the finished contact print.

PARA-AMINOPHENOL. $C_6H_4NH_2OH$. A rapid soft-working developing agent of the Rodinal class which produces fine detail but yields contrast and density with prolonged development only. It is characterized by good keeping qualities in concentrated solution.

PARA-METHYLAMINO-PHENOL SULFATE. $CH_3NHC_6H_4OH \cdot \frac{1}{2}H_2SO_4$. A developing agent with high reduction potential, generally used in combination with hydroquinone. It is marketed under a great variety

of trade names, including Elon, Rhodol, Metol, Genol, Pictol, Photol.

PARAMINOPHENOLATE. See *sodium para-aminophenolate.*

PHOTOMETER. A darkroom exposure meter designed to simplify print making with the enlarger. Can be of the *mechanical, comparison, extinction,* or *electrical* type. Also *printometer.*

PHOTOMONTAGE. A composite picture made by a number of exposures on the same film, by projecting a number of negatives to make a composite print, or by cutting and pasting-up a number of prints and subsequently copying to a new negative, or by any of a number of similar processes. See *collage.*

PILLOW DISTORTION. The kind of lens distortion which causes lines in the image to be bowed inward toward center of field. Also *pincushion* distortion.

POLARIZED LIGHT. Light that is vibrating in only a single plane. Light can be polarized by a filter over the light source or, if that is impractical, by a filter over the lens.

POLYVINYL CHLORIDE (PVC). A rubberized high-impact synthetic used for developing tank lids and reels. It is chemically neutral, dent resistant, and heat tolerant.

PORTRAIT ATTACHMENT. A supplementary lens which shortens the focal length of the objective with which it is used so that near objects may be brought into sharp focus.

PORTRAIT PANCHROMATIC FILM. A high-speed panchromatic film whose color sensitiveness is approximately the same as that of the human eye. It is somewhat less sensitive to red than supersensitive panchromatic film.

POSITIVE FILM. A non-color-sensitive film, much slower than negative film but faster than positive plates.

It is used as an intermediate in making a copy negative.

POSITIVE IMAGE. An image that corresponds, in light and dark tones, to the original. (As distinguished from a negative, in which dark tones are light, and light tones dark.)

POTASSIUM ALUM. See *alum, potassium.*

POTASSIUM CHROME ALUM. See *alum, potassium chrome.*

PRESERVATIVE. A chemical put into a developer to prevent oxidation, usually sodium sulphite.

PRINTING-IN. Combination printing of two or more negatives on a single positive; especially the "printing-in" of some detail from one negative on the background from another negative.

PRINTOMETER. See *photometer.*

PRISMATIC EYE. A device which may be attached to some viewfinders permitting the scene to be viewed and filmed while the operator is facing 90° away from it.

PROCESS FILM. A slow film of steep gradation, useful in making photographs of line drawings, type matter, etc., in which there are no middle tones. It may also be used in copying monochrome originals when it is desirable to increase the contrast.

PROPORTIONAL REDUCER. See *reducer, proportional.*

P. S. A. Abbreviation for Photographic Society of America.

PVC. See *polyvinyl chloride.*

RACK. (1) A metal strip with cogs on the upper surface. These cogs engage the cogs on a pinion, permitting the two to be moved relative to each other. Many camera and enlarger adjustments, such as focusing, are made by means of a rack and pinion. (2) Wood or metal frame upon which film is wound during processing. (3) Term applied to the movement of the cam-

era lens toward or away from the film plane as the focusing ring is turned. The lens is said to be "racked" in or out.

RAPID DEVELOPER. Any of several developing solutions which produce maximum density in minimum time. One such formula is:

Elon	4	grams
Sodium sulfite	65	grams
Hydroquinone	2	grams
Borax	7.5	grams
Water	1,000	cc.

Time: Three minutes at 65° F.

RAPID FIXER. A fixing bath which dissolves the undeveloped silver halides in prints and films in minimum time. Such a fixer is useful in hot weather when the tendency of gelatin to soften is increased by long soaking.

RECIPROCITY FAILURE. The inability of film to compensate for unusually long or short exposures. Normally, the *reciprocity law* determines how constant exposures (light intensity × time) are produced. In other words, two exposures such as 1/25 at *f*/8 and 1/50 at *f*/5.6 should affect the emulsion in exactly the same way. But that isn't what actually happens. Each emulsion is sensitive to a particular intensity of light. When there is a wide variation from this intensity (as in the high speeds of electronic flash or the low light levels of astronomy) the reciprocity law breaks down and more exposure (up to 3x normal) is needed. In addition to requiring more exposure, reciprocity failure causes color distortion in color photography, requiring the use of color compensating filters.

RED FOG. Same as dichroic fog.

REDUCER, CUTTING. An oxidizing agent which removes equal amounts of silver from all parts of the negative, therefore removing a larger proportion of the silver image from the shadows than from the highlights. Such a reducer will increase contrast, and is suitable for negatives which have been overexposed. Also called *subtractive reducer.*

REDUCER, FLATTENING. A reducer which reduces highlights without affecting the detail in the shadow; ammonium persulfate is most commonly used for this purpose. See also *Belitski reducer; reducer, superproportional.*

REDUCER, PROPORTIONAL. A reducer which acts on each portion of the negative in proportion to the amount of silver deposited. Since this is exactly the reverse of the developing process, a negative which is correctly exposed but overdeveloped should be treated with a proportional reducer. One may be made by mixing a cutting reducer, such as potassium permanganate, with a flattening reducer, such as ammonium persulfate. See *ferric sulfate reducer.*

REDUCER, SUPERPROPORTIONAL. A reducer which removes a greater amount of silver from the denser portions of a negative than from the lighter portions. Used to reduce contrast. See *reducer, flattening.*

RELATIVE APERTURE. The ratio between the effective aperture of a lens and its focal length. This ratio is usually given in numbers, not fractions. For example, a lens with a relative aperture of ½ is known as an *f*/2 lens.

REMBRANDT LIGHTING. Portrait lighting, three-quarter view, in which the shadow side faces the camera, named after the painter who used this kind of lighting for many of his portraits.

RESETTING SHUTTER. See *Everset Shutter.*

RETICULATION. A network of minute depressions or corrugations in a negative, produced—either ac-

cidentally or intentionally—by any treatment resulting in rapid expansion and shrinkage of the swollen gelatin. Reticulation may be produced by solutions which are too cold, too warm or too alkaline, or by any sudden changes of temperature during processing. When a reticulated negative is printed, the corrugations show up as a network of fine lines due to the scattering of light by the uneven gelatin surface. See *frilling*.

RISING AND FALLING FRONT. An adjustment provided on some cameras which makes it possible to raise or lower the lens in relation to the film, in order to increase or decrease the amount of foreground included. This adjustment is very useful in photographing tall buildings. It is essential that the principal plane of the lens and the focal plane be kept strictly parallel in order to avoid distortion.

RODINAL. See *sodium para-amino-phenolate*, below.

ROLL HOLDER, ROLL-FILM ADAPTER. An accessory permitting the use of roll film in cameras designed for plates or cut film.

R. P. S. Royal Photographic Society; founded in England in 1853, it was the first photographic society.

SAFELIGHT. A darkroom light that does not affect sensitive photographic materials.

SCALE. The full range of tones which a photographic paper is capable of reproducing.

SCREW MOUNT. Term applied to lenses or filters which screw into camera and lens, respectively.

SELF-CAPPING SHUTTER. A focal-plane shutter that closes automatically to exclude light while the curtain is being rewound (otherwise, the film would be fogged).

SHORT-FACTOR DEVELOPER. A developer in which the image comes up slowly but builds up density

rapidly when it does appear. Hydroquinone is an example.

SILK SURFACE. A term used to describe the texture of the surface of a photographic paper. This surface has a texture which simulates silk fabric.

SLR. Single lens reflex.

SLUDGE. A muddy or slushy precipitate formed in a photographic solution, generally upon standing or when it has been used too long. The term is frequently used to describe the precipitate of aluminum sulfite which forms under certain conditions in potassium alum fixing baths.

"SNAP." See brilliant.

SNAP-ON-MOUNT. Method of mounting lens on camera by means of spring clips concealed within the camera housing.

SODIUM PARA-AMINOPHENOLATE. $C_6H_4ONaNH_2$. A developing agent; the substance formed when sodium hydroxide is added to a para-aminophenol developer. This derivative of para-aminophenol has been marketed under a variety of trade names: Rodinal, Citol, Azol, Activol, Certinal, Paranol, and Kalogen.

SOFT. Lacking contrast; having a long tone scale.

SOFT-WORKING. Developers or papers yielding a long tone scale from normal negatives or normal prints from contrasty negatives.

SOLARIZATION. A reversal of the image in a negative or print caused by great overexposure. Partial solarization is often intentionally obtained in a print for odd or pictorial effect.

SPILL. A colloquial term applied by photographers to the marginal rays from a photographic light. The concentrated light from a spotlight has no "spill"; a floodlight has a great deal of "spill."

STATIC MARKS. Dark streaks found

on developed negatives, due to static discharge when the film was drawn too quickly from the pack, etc.

STREAMER MARKINGS. Dark strips in a negative in which the density of some long narrow object in the image is extended to adjacent parts; generally due to lack of agitation.

STRESS MARKS. Marks on prints due to mechanical contact or pressure. See also *abrasion marks*.

SUPERPROPORTIONAL REDUCER. See *reducer, superproportional*.

SURFACE DEVELOPMENT. Development in which only the superficial layers of silver in the emulsion are acted upon. Characteristic of fine-grain developers.

TL. Twin lens.

TONALITY. An art term, used to describe the effectiveness with which the photographer has reproduced the tonal gradations of his subject, or the effectiveness with which he has used tonal gradation to express an idea or feeling.

TONAL KEY. The balance of light or dark tones of a photograph. If light tones prevail with few or no dark tones, the photograph is said to be "high key"; if the opposite, "low key."

TRANSLUCENT. Permits the passage of light, but scatters it so that no image can be formed.

TROPICAL DEVELOPER. Any developer prepared especially for developing under tropical conditions. Such developers must yield satisfactory results when working at temperatures up to 90° F. or even higher.

TTL. Through the lens (in reference to meters).

VIGNETTE. The process of regulating the distribution of light in such a way that the image obtained fades out toward the edges, leaving no sharp boundaries.

Index